GOLD, SILVER AND BRONZE

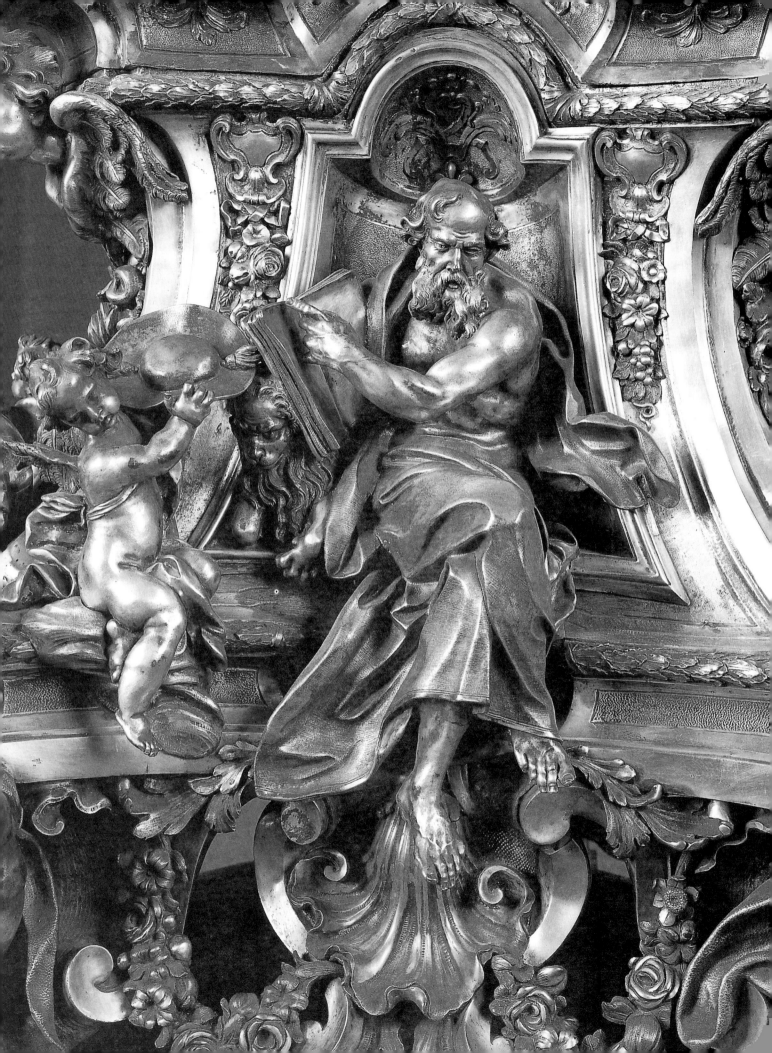

GOLD, SILVER AND BRONZE
Metal Sculpture of the Roman Baroque

JENNIFER MONTAGU

THE A.W. MELLON LECTURES IN THE FINE ARTS, 1990
The National Gallery of Art, Washington, D.C.
Bollingen Series XXXV:39
Princeton University Press
Princeton, New Jersey

Published by Princeton University Press, 41 William Street,
Princeton, New Jersey 08540

This is the thirty-ninth volume of the A. W. Mellon Lectures
in the Fine Arts, which are delivered annually at the National
Gallery of Art, Washington. The volumes of lectures constitute
Number XXXV in Bollingen Series, sponsored by Bollingen
Foundation.

Frontispiece: Giovanni Battista Maini and Giuseppe Gagliardi,
St Jerome; silver-gilt. Lisbon, Museu de São Roque

Library of Congress Cataloging-in-Publication Data

Montagu, Jennifer.
Gold, silver and bronze: metal sculpture of the Roman
baroque / Jennifer Montagu.
p. cm. — (Bollingen series: XXXV. 39. The A.W.
Mellon lectures in the fine arts ; 1990)
Includes bibliographical references and index.
ISBN 0-691-02736-6 (CL : acid-free paper)
1. Metal sculpture, Baroque–Italy–Rome. 2. Metal
sculpture, Italian–Italy–Rome. I. Title. II. Series:
Bollingen series ; 35. 39.
III. Series: A.W. Mellon lectures in the fine arts ; 1990.
NB1220.M65 1996

730'.0945'63209032–dc20 95-41525

This book has been composed in Bembo by Best-set
Typesetter Limited, Hong Kong

Princeton University Press books are printed on acid-free
paper and meet the guidelines for permanence and
durability of the Committee on Production Guidelines for
Book Longevity of the Council on Library Resources

Printed in Hong Kong

10 9 8 7 6 5 4 3 2 1

THE ANDREW W. MELLON LECTURES IN THE FINE ARTS
Delivered at the National Gallery of Art, Washington, D.C.

1952 Jacques Maritain, *Creative Intuition in Art and Poetry*
1953 Sir Kenneth Clark, *The Nude: A Study of Ideal Form*
1954 Sir Herbert Read, *The Art of Sculpture*
1955 Etienne Gilson, *Art and Reality*
1956 E.H. Gombrich, *The Visible World and the Language of Art*
1957 Sigfried Giedion, *Constancy and Change in Art and Architecture*
1958 Sir Anthony Blunt, *Nicolas Poussin and French Classicism*
1959 Naum Gabo, *A Sculptor's View of the Fine Arts*
1960 Wilmarth Sheldon Lewis, *Horace Walpole*
1961 André Grabar, *Christian Iconography and the Christian Religion in Antiquity*
1962 Kathleen Raine, *William Blake and Traditional Mythology*
1963 Sir John Pope-Hennessy, *Artist and Individual: Some Aspects of the Renaissance Portrait*
1964 Jakob Rosenberg, *On Quality in Art: Criteria of Excellence, Past and Present*
1965 Sir Isaiah Berlin, *Sources of Romantic Thought*
1966 Lord David Cecil, *Dreamer or Visionary: A Study of English Romantic Painting*
1967 Mario Praz, *On the Parallel of Literature and the Visual Arts*
1968 Stephen Spender, *Imaginative Literature and Painting*
1969 Jacob Bronowski, *Art as a Mode of Knowledge*
1970 Sir Nikolaus Pevsner, *Some Aspects of Nineteenth-Century Architecture*
1971 T.S.R. Boase, *Vasari: The Man and the Book*
1972 Ludwig H. Heydenreich, *Leonardo da Vinci*
1973 Jacques Barzun, *The Use and Abuse of Art*
1974 H.W. Janson, *Nineteenth-Century Sculpture Reconsidered*
1975 H.C. Robbins Landon, *Music in Europe in the Year 1776*
1976 Peter von Blanckenhagen, *Aspects of Classical Art*
1977 André Chastel, *The Sack of Rome: 1527*
1978 Joseph W. Alsop, *The History of Art Collecting*
1979 John Rewald, *Cézanne and America*
1980 Peter Kidson, *Principles of Design in Ancient and Medieval Architecture*
1981 John Harris, *Palladian Architecture in England, 1615–1760*
1982 Leo Steinberg, *The Burden of Michelangelo's Painting*
1983 Vincent Scully, *The Shape of France*
1984 Richard Wollheim, *Painting as an Art*
1985 James S. Ackerman, *The Villa in History*
1986 Lukas Foss, *Confessions of a Twentieth-Century Composer*
1987 Jaroslav Pelikan, *Imago Dei: The Byzantine Apologia for Icons*
1988 John Shearman, *Art and the Spectator in the Italian Renaissance*
1989 Oleg Grabar, *Intermediary Demons: Toward a Theory of Ornament*
1990 Jennifer Montagu, *Gold, Silver and Bronze: Metal Sculpture of the Roman Baroque*
1991 Willibald Sauerländer, *Changing Faces: Art and Physiognomy through the Ages*
1992 Anthony Hecht, *On the Laws of the Poetic Art*
1993 Sir John Boardman, *The Diffusion of Classical Art in Antiquity*
1994 Jonathan Brown, *Kings and Connoisseurs: Collecting Art in Seventeenth-Century Europe*
1995 Arthur Danto, *Contemporary Art and the Pale of History*

CONTENTS

Money and Measurements

The Roman *scudo d'oro* was a gold coin, weighing 3.319 grams.

The *doppia* was also a gold coin, weighing 6.781 grams.

The *scudo*, the most frequently encountered coin, was of silver, and weighed 31.788 grams.

The *scudo* was divided into 100 *baiocchi*.

The *giulio* was a coin worth 10 *baiocchi*.

The Roman *palmo* measured 22.3422 centimetres; it was divided into 12 *once*, divisible into 10 *decime*.

The Roman *libbra* weighed 339.07 grams; it was divided into 12 *once*, each of which was subdivided into 24 *denari*, divisible into 24 *grani*.

Abbreviations

Ajuda	Biblioteca da Ajuda (Lisbon)
A.Pal.	Archivio Pallavicini Rospigliosi (housed in the building of the Administrazione)
APEF	Archives des Pieux Etablissements de France
Arch.	Archivio
Arch. Cap.	Archivio Capitolino
Arch. Urb.	Archivium Urbis
Sez.	Sezione
Arm.	Armadio
AOMS	Archivio dell'Opera della Metropolitana di Siena
ARFSP	Archivio della Reverenda Fabbrica di S. Pietro
ASB	Archivio di Stato di Bologna
ASR	Archivio di Stato di Roma
Cam.	Camerale
CO	Congregazione dell'Oratorio
Cong. Relig.	Congregazioni Religiose
Fem.	Femminili
Masc.	Maschili
FSV	Famiglie Spada Veralli
Not.	Notari
Cap.	Capitolini
RCA	(della) Reverenda Camera Apostolica
Trib. AC	(della) Tribunale dell'Auditor Camerae
ASV	Archivio Segreto Vaticano
AA	Archivium Arcis
SPA	Sacro Palazzo Apostolico
A.Val.	Archivio della Congregazione dell'Oratorio di S. Maria in Vallicella
BAV	Biblioteca Apostolica Vaticana
AB	Archivio Barberini
AC	Archivio Chigi
Vat. Lat.	[Codices] Vaticani Latini
BL	British Library (London)
BN	Bibliothèque Nationale (Paris)
BUB	Biblioteca Universitaria di Bologna
Giust.	Giustificazione; Giustificazioni
Mand.	Mandato; Mandati
MS; MSS	Manuscript; Manuscripts
P.Pal.	Archivio Pallavicini Rospigliosi (housed in the Palazzo)

LIST OF ILLUSTRATIONS

(Unless otherwise stated, the photographs are supplied by the owners.)

COLOUR PLATES

BLACK AND WHITE

PREFACE

THIS BOOK IS derived from the Andrew Mellon lectures, delivered at the National Gallery of Art in Washington in the spring of 1991. I should like to thank Professor Henry A. Millon for having invited me to give the lectures, and the staff and colleagues at Center for Advanced Study in the Visual Arts, and at the National Gallery, for their support and hospitality during that time.

It is in no sense a general history of the sculpture produced in metal during the period of the baroque in Rome; rather, it is an examination of a limited number of works in bronze and silver from the seventeenth century and the first half of the eighteenth, mostly small in scale, which exemplify various aspects of sculpture in metal during that period.

My interest, however, is directed primarily to what happened *in* the workshops, rather than what came out of them. The sculptures discussed in the following pages have been selected because they exemplify the relationship between those who provided the drawings or models and those who produced the finished sculptures, the ways in which the artists worked, the methods by which the sculptures were produced, or the interaction between the artists and the patrons.

A second principle of choice has been the wish to add something to what was previously known about the sculptures. This may be through the discovery of new information, usually in the form of new documents, or by examining more thoroughly those that were already known, but were not relevant to the purpose of those who cited them. So, for example, the account for the metalwork of the font in St Peter's would have added nothing to Hellmut Hager's fundamental analysis of Carlo Fontana's designs, but is highly illuminating for my purpose; similarly, the evidence taken in the trial concerning Giuseppe Gagliardi's work for Lisbon has frequently been cited, but has never been exploited for what these depositions can tell us about workshop practice. The possible exception to this is the tabernacle of St Peter's, which has already been abundantly studied; but no book on baroque art can omit Bernini. A third principle was to avoid, so far as possible, works that I had already discussed in my book on *Roman Baroque Sculpture; The Industry of Art*; if I have ignored other works of major importance, such as the altar of St Ignatius Loyola in the Gesù, which has been the subject of a thorough study in the thesis of Evonne Levy for Princeton University, I believe that those introduced here, including several that may be unfamiliar even to specialists in the subject, deserve to be considered in any history of the art of the period.

The introductory chapter, as well as setting out in greater detail the programme of the book and my reasons for undertaking it, is largely concerned with the problems confronting any such study. In the second chapter, the tabernacle of Sta Maria Maggiore illustrates the reemployment of existing models, complicated by the extensive and heavy-handed restoration that so often occurs on objects that are in continuing use, rather than cocooned in the artificially protective environment of a museum. Other works are introduced to illustrate the extraordinary diversity of small-scale sculpture produced around 1600, and in particular the tabernacle of S. Luigi dei Francesi is a reminder that, although most of the rest of the book will deal with documented sculptures, art history can never dispense with the 'old fashioned' techniques of connoisseurship. Continuing on the subject of tabernacles in the third chapter, that of Sta Maria in Vallicella

presents the case of a project that went wrong, while Bernini's tabernacle for St Peter's introduces the complexity of the relationship of the artist and his workshop.

Medals, though undoubtedly sculpture, and, moreover, produced in all of the three metals with which this book is concerned, are none the less rather different from the other sculptures treated here. Although the papal medals on which I have concentrated have been widely studied, there remain so many problems concerning their production and function that in the fourth chapter it has been necessary to deal with these general matters at some length. However, my main topic is the question of who provided the designs, and here again they differ from the other categories of metal sculpture in that, in many cases, the designs were provided by the executants. This question is studied in particular through a group of drawings related to the Hamerani family, who dominated the production of medals for the papacy over more than a century. The fifth chapter takes as an example of secular art the series of silver plates presented by the Pallavicini to the grand dukes of Florence. This too is rather different from the more obviously 'sculptural' metal discussed in other chapters, but, besides providing some relief from the concentration on ecclesiastical works, it exemplifies the stylistic changes that were possible within a very limited format over a period of more than fifty years.

The sixth chapter examines some of the major (and a few of the minor) works of Giardini and Giardoni, both of whom combined the roles of silversmith and founder, illustrating the diversity of the output of the leading exponents of these arts in the first half of the eighteenth century, and the relationship between the metal-workers and the architects or sculptors who provided the designs or models. The concluding chapter, which is mainly devoted to one of the few surviving complete sets of altar furniture, serves as a reminder of the importance of foreign patronage, and the difficulties that are always likely to occur between patrons and artists, while the evidence submitted in the course of the legal disputes surrounding some of the silver illuminates the practices of the workshops.

Appendix A summarises what is known about the tabernacle Jacomo del Duca made from the designs of Michelangelo. Appendices I–V reproduce documents: these are primarily concerned with the technique of casting, but they also illustrate the problems that may confront the founder when things go wrong, and the demands to which he may be subjected by those in control of the work.

Sculpture in whatever medium raises fundamental questions regarding the relationship between the inventor of the design and the executant, or executants. But the technical expertise required for metal-casting resulted, almost invariably, in the separation of the sculptor who made the model from those who cast it and were responsible for the finished surface. This leads to complications in the history of the work which, wherever possible, I have attempted to explain, even if in some cases a close examination of the evidence only increases the confusion. Similarly, while the reutilisation of models was not confined to sculpture in metal, nor indeed to sculpture, the employment of moulds undoubtedly encouraged the habit, whether they were reused by the artist who had originally created the model, or by another. I hope that the recurrence of these and other such themes throughout the century and a half covered in this book will give some unity to the following chapters dealing with disparate aspects of metal sculpture, while justifying the decision to treat metal sculpture as an art *sui generis*.

I am grateful to the editors of *Source* for permission to reuse my article 'Ciro Ferri's Ciborium in Santa Maria in Vallicella', which was given at a symposium dedicated to the memory of Rudolf Wittkower, and published in that periodical in 1989. The final chapter is closely related to the work that I did for the exhibition 'Roma Lusitania – Lisbona Roma' (Rome, 1990), for which I was generously provided with access to the information from the archives in Lisbon compiled by Sandra Vasco Rocca and Gabriele Borghini, which they have selflessly allowed me to use for this book. On the basis of their indications, I was also able to undertake a limited investigation of these documents for myself.

Among the many friends and colleagues who have assisted me in the course of this work, I should like particularly to thank Giancarlo Alteri, Mario Bevilacqua, Gabriele Borghini, Jose Buces, Monika Butzek, Jane Clark, Bruno Contardi, Simon Ditchfield, Oreste Ferrari, Marie-

Thérèse Mandroux-França, Peter Fuhring, Philippa Glanville, Ernst Gombrich, Alvar González Palacios, Richard Kagan, Elisabeth Kieven, Michael Koortbojian, Anna Lo Bianco, Maria Luisa Madonna, Geneviève and Olivier Michel, Angela Negro, Arnold Nesselrath, Andrew Oddy, Steven Ostrow, Ursula Fischer Pace, Principesa Pallavicini Rospigliosi, Antonella Pampalone, Kirsten Aschengreen Piacenti, John Pinto, Sebastiano Roberto, Béatrix Saule, Pierluigi Silvan, Julien Stock, Luke Syson, Christina Thon, Ilaria Toesca, Ubaldo Vitali, Sandra Vasco Rocca, Nuno Vassallo e Silva, and Marc Worsdale.

Throughout my research I have enjoyed the unstinting support and assistance of my colleagues at the Warburg Institute, without whose help it could not have been brought to a publishable conclusion. Mary Carruthers has dealt cheerfully with the many difficulties of editing the text, and designing the highly complicated layout.

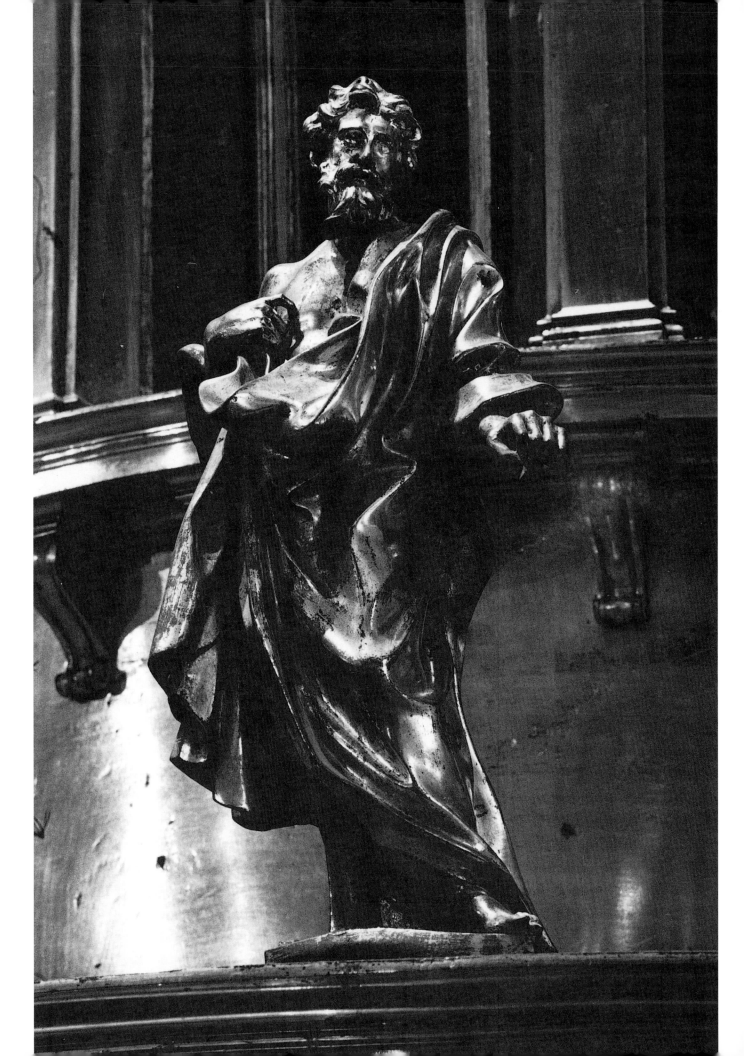

I

Introduction

IN THE VAST literature on Bernini there is no illustration of the bronze figure of *St Simon* (Fig. 1); nor will one find *St Ambrose* (Pl. I) illustrated in any book on Italian baroque sculpture.[1] Yet every book on Bernini will certainly include the tabernacle in St Peter's on which the *St Simon* stands, and very probably one of the huge gilt bronze kneeling angels which flank it (Fig. 2), and which have even made the status of postcards. The *St Ambrose*, on the other hand, does have a respected place in the bibliography of art, but it is the art of the eighteenth-century silversmith, and there one will find it reproduced in colour in Costantino Bulgari's fundamental work on Roman silversmiths.[2]

Yet the *St Simon*, despite his relatively small size, has a monumental presence, his drapery forms great sculptural folds, an abstract pattern of ridges and valleys that define his body and emphasise its compact three-dimensionality, and his strongly modelled face conveys a quality of intense spiritual life. The *St Ambrose* too has a firm sculptural weight, though he is less broadly treated, as befits both the fact that he is to be seen close-to at slightly below eye-level, and that he is surrounded by richly detailed decoration; yet the forms are clearly defined, and the search for divine inspiration in his upturned gaze is unmistakable even at a distance.

Why, then, are these figures overlooked in the literature of sculpture? The simple answer is that the *St Simon* is a small bronze statuette, and baroque art is epitomised by great monuments, dominated by architecture, with which the painters and sculptors collaborated to create all-enveloping works of art. A small bronze has no place in this simplistic definition, and Bernini, even more than most of his contemporaries and followers, was someone whose genius flowered in works that overwhelm the viewer by their size and prominence. Of course it might also be argued that the *St Simon* is overlooked because it was modelled by one assistant, and cast by others, but then the same could be said of the kneeling *Angels*.[3] If we know of neither drawings or sketch-models for the *St Simon*, such as proliferate for the *Angels*, there is every likelihood that Bernini made at least drawn sketches, which is as much as could be said about the travertine figures on the colonnade outside St Peter's, or many other sculptures which are generally admitted into the canon of his work. As for the *St Ambrose*, it is enough to say that it is of silver-gilt to demonstrate that it must be ranked in the minor, or applied arts, and, *ipso facto* cannot rank as sculpture. It is therefore sufficient to look for the silversmith's stamp, and not to worry about the more difficult question of who might have conceived the work, or provided the models which the silversmith cast. Admittedly, in the case of the candlestick of which this statuette forms part any such investigation may have seemed unnecessary, as the silversmith Giuseppe Gagliardi signed it, and claimed to have 'invented' as well as cast it; but it would not have taken very much research to discover that Giovanni Battista Maini was at least partially responsible for providing the models, and, as will be shown in my final chapter, he must at the very least have made those for the *Church Fathers* incorporated in the base.

It was because I share neither this views of baroque sculpture, nor of the status of silver, that I undertook to write this book. I hope that it will demonstrate that small bronzes form an essential part of Roman baroque sculpture, while silver can be a sculptural medium quite as valid

1. Gianlorenzo Bernini and Giovanni Rinaldi, *St Simon*; gilt bronze. Vatican, St Peter's (detail of the *Tabernacle*)

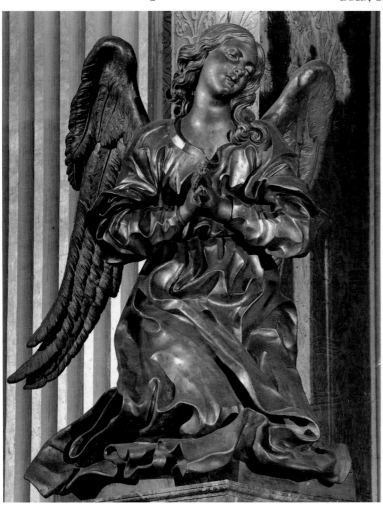

2. Gianlorenzo Bernini, *Angel*, gilt bronze. Vatican, St Peter's

3. Antonio Montauti, *Wrestlers*, after the antique; bronze. Rome, Galleria Nazionale d'Arte Antica

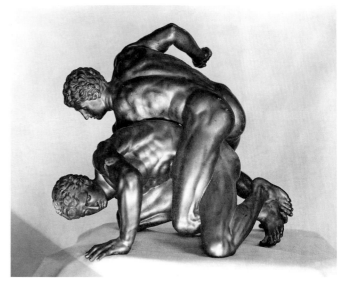

as bronze, and, indeed, that it was a medium used to create some of the masterpieces of the period.

To be fair, there may be other reasons for the neglect of such works, reasons of which I became increasingly aware as I attempted to study them: it can be frustratingly difficult, and any investigation turns up more questions than answers. Whereas in the following chapters I shall deal with examples where I believe that something positive can be said, or at least a hypothesis advanced, in this introduction I shall concentrate rather on the problems of such research, and the tantalising incompleteness of our knowledge, despite the wealth of varied evidence that exists. However, I shall also provide some, I hope more encouraging, examples to show that the attempt is worth undertaking, not only for the quality and beauty of the objects themselves, but also because, whatever the difficulties, it is possible to make at least some partial progress towards a firmer and more complete knowledge and understanding of their origins.

There is a well-known story of a thesis on 'Landscape Painting in the Catacombs', of which chapter 1 was headed 'Why There Is No Landscape Painting in the Catacombs'. I began this research in the belief that, just as there were seventeenth-century small bronzes in Florence and Venice, in France, and even in England, they must also have existed in Rome. But the more I looked for the Roman baroque bronze statuette, the more I began to doubt whether such a thing did indeed exist, at least as an independent object to be collected.

If one looks at the great collections, such as that of the Barberini, it is true that Maffeo Barberini did own some forty miscellaneous small bronzes (their number swelled by small busts

of the twelve Caesars), but these were predominantly sixteenth-century models, or copies of the antique, and hardly constitute an impressive collection. Even so, it was more extensive than that of his nephew, the great collector of paintings and ancient sculpture, Cardinal Francesco Barberini senior, who owned only a very few bronzes, most of which were antique.[4] When in 1674 Urban's great-nephew Cardinal Carlo Barberini bought a bronze of the *Laocoon* from the estate of Cardinal Aquaviva this was a very unusual purchase for him,[5] nor is there any reason to assume that it was a recent cast, rather than one dating from the sixteenth century.

The Ludovisi had a rather more substantial collection of bronze statuettes, but, as with the collection of Maffeo Barberini, it was made up almost entirely of sixteenth-century examples, with a number that can be identified as after models by Giambologna. Significantly, they kept them in a special 'Room of the Bronzes',[6] and clearly did not regard them as part of the normal decoration of a princely house.

We shall return in the next chapter to consider one bronze that belonged to Duke Francesco Sannesi, whose very eccentric collection listed in his inventory of 17 February 1644 included two bronze groups of hunts (a mounted huntsman, with three dogs and a boar; another mounted figure, with four dogs and a stag), as well as cupboards full of mainly broken terracottas and waxes.[7] Other larger collections of bronzes are listed in inventories of the end of the seventeenth century, such as those of Antonio Amice Moretti, who was a silversmith and most probably collected them as models, or that of Giovanni Andrea Lorenzani, who was a descendant of a long line of bronze-founders and himself a medallist and maker of bronze plaquettes, and therefore in an exceptional position to appreciate the medium. Moreover, in that most of Lorenzani's bronzes were reliefs, and anonymous, it is legitimate to assume that they were his own copies (or casts), and constituted his stock of bronzes for sale, rather than a genuine collection.[8]

One noble family that not only collected bronzes, but exhibited them throughout the palace, was that of the Corsini, who were Florentine in origin; interestingly enough, so too were almost all their bronzes, with the exception of Algardi's *Infant Hercules*, and the same artist's *Baptism* to which we shall return.[9] Some were most probably acquired in Florence, such as the two *Rape* groups by Giovanni Battista Foggini,[10] and possibly some of the works by Montauti. But, although Antonio Montauti was, like Foggini, a Florentine, he passed the latter part of his life in Rome, and died there in 1746; in his will he requested that his possession should be sold for the benefit of his heirs (his two sisters) and named Cardinal Neri Corsini, 'mio singolare Padrone', as his executor.[11] If one compares the list of works left in his studio with those in the Corsini inventory, and still in the Palazzo, it is apparent that all of Montauti's small bronzes must have been acquired by the cardinal himself.[12]

These include not only the works long recognised as by Montauti, such as the great relief of *The Triumph of Neptune/Rape of Europa* (Pl. II) which passed later to the Palazzo Corsini in Florence (and is now in Los Angeles),[13] the group of *Venus and Adonis with Amor* and the figure of *Ganymede*, but also four bronzes after the antique: the *Medici Venus*, the *Dancing Faun*, the *Wrestlers* (Fig. 3) and the group which Montauti called 'Alexander', but which is now identified as *Menelaus Supporting the Body of Patroclus*.[14] These bronzes are of interest not only as evidence that when copying the antique Montauti could suppress all signs of his usually very recognisable personal style,[15] but because all the originals were in Florence. According to Francesco Maria Niccolò Gaburri's contemporary short Life of Montauti, when he moved to Rome 'several of his beautiful works in marble and in bronze' were lost at sea,[16] but the fact that these models were in his studio is evidence that some bronzes, or the models, or at least the moulds, must have arrived safely. As for the splendid relief of a sea-triumph with its elaborate frame, this is so typically Florentine that it is impossible to doubt that it was made there, in direct competition with the similar reliefs by Massimiliano Soldani. In so far as these works were by an artist living in Rome, and were presumably for sale there, they scrape into a book on Roman sculpture – but only just, and neither they, nor their purchaser, can be regarded as typical of Roman taste.

If one turns to the artists, the picture becomes slightly less dismal, and a little clearer. Gianlorenzo Bernini cannot be regarded as contributing anything to this genre:[17] the figures of the *Living* and *Dead Christ* that he provided for the crucifixes for St Peter's were modelled with

4. Anonymous founder,
after a model by
Gianlorenzo Bernini,
St Catherine; gilt bronze.
Christie's 1986

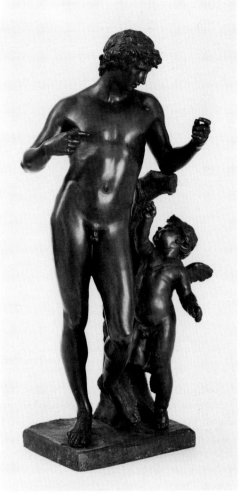

5. François du Quesnoy,
Apollo with Cupid; bronze.
Vaduz, Collections of the
Prince of Liechtenstein

the assitance of Ercole Ferrata, and the extent of Bernini's own contribution can be debated;[18] there are a few bronzes that can be regarded as having been cast from his models, of which one of the earliest (so far as there is documentary proof) is the rather dreary *Countess Matilda*, of which Maffeo Barberini had no less than three casts.[19] There are also three casts known of models prepared for the statuettes of the colonnade in front of St Peter's, of which the *St Agnes* may well be from Bernini's own model,[20] and a bronze of *St Catherine* which shows notable differences from the travertine statue on the colonnade[21] and may well record a preliminary idea of the master, even if the cast is of rather lower quality. Another, recently discovered, *St Catherine* (Fig. 4) corresponding to the statue is less refined, particularly in the treatment of the face, and was more probably prepared in the workshop; it is none the less more likely to have been cast from the model than made later as a replica of the travertine statue.[22] There are also numerous reductions of his statues, none of which can be traced back to the master, or even his studio, and few of which can be securely assigned to the seventeenth century. Girardon owned a wax of the *David*, which he may not even have regarded as original,[23] and by 1673 Louis XIV had a gilded bronze of the same figure, a silver replica of the *Apollo and Daphne* which was described as 'designed by Bernini', silver figures of the *Four Rivers* from the fountain in the Piazza Navona, which were not attributed, and a silver figure of Bernini's *Moor*, which is also described in such a way as to imply that the reduction was not by Bernini himself.[24] If this proves that some moulds of such reductions existed during Bernini's life-time, there is nothing to disprove the impression that these had been made by enterprising copyists, and very probably without the master's authorisation.

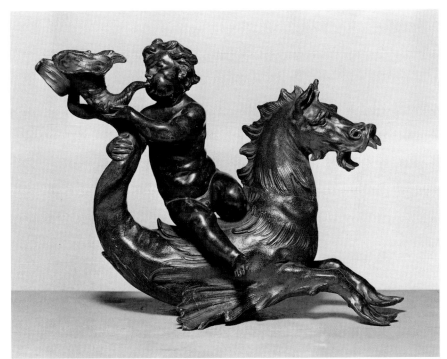

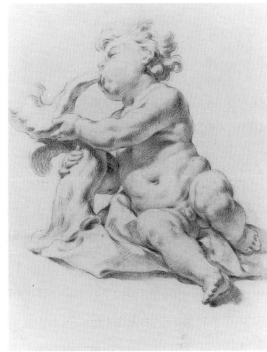

François du Quesnoy, 'il Fiammingo', did indeed make two bronze statuettes, but the *Mercury* was commissioned by Vincenzo Giustiniani to accompany an antique *Hercules* in his collection, and the *Apollo* (Fig. 5) to accompany the *Mercury*.[25] His biographer Bellori wrote that he modelled many putti to be cast in bronze and silver,[26] and many bronze casts exist. But one has a strong impression that silver was the medium preferred by the patron, whether this was the Conestabile Colonna, with his silver ink-well adorned with a putto blowing bubbles[27] (a model well known in both bronze and in plaster, if one can believe the evidence of paintings), or Cardinal Francesco Barberini who owned the terracotta models of the busts of *Christ* and the *Virgin*, sending silver casts of them to the Queen of England and Cardinal Massimi.[28] A discerning collector such as François Girardon, who was in Rome in 1668, preferred to acquire terracottas by du Quesnoy, which he certainly believed to be originals.

Bellori's comments on Alessandro Algardi are particularly revealing: when the sculptor first arrived in Rome he had difficulty in finding work, and spent his time 'making models of putti, little figures, heads, crucifixes and ornaments for goldsmiths', and the biographer laments the fate of both the artist, and the art of sculpture, since he had 'wasted his best time, and the flower of his youth, and his genius, without working, spending his days in making little models in clay and wax, not being regarded as capable of working in marble'.[29] Certainly many of these were cast in bronze, but it is questionable how many were really intended for this medium. The Corsini may have owned a bronze of his *Baptism of Christ*, but the original model was made to be cast in silver for Pope Innocent X (Giovanni Battista Pamphili);[30] Algardi's group of the *Flagellation*, however, still exists in many casts in both media, and, in fact, while I was delivering the lectures on which this book is based the National Gallery in Washington was acquiring a particularly fine silver cast of one of the *Flagellators* (Pl. III).[31] I believe that the models of many of his small bronzes, like the *Putto with Two Horns* which is known in many casts made from his original silver *Putto on a Hippocamp* (Fig. 6),[32] were originally created as models for silver. It may be remarked that this model was sufficiently popular that a version, presumably in plaster, was drawn by Pietro Ligari (1686–1752) (Fig. 7);[33] this example may serve as a reminder that such small sculptures entered into the artists' studios and academies, where they were to influence painters as well as sculptors of later generations. Although I have no proof, I also believe that most of Algardi's

6. Alessandro Algardi, *Putto on a Hippocamp*; bronze. Baltimore, Walters Art Gallery

7. Pietro Ligari, after Alessandro Algardi, *Putto Holding two Horns*; drawing, red chalk. Sondrio, Museo Valtellinese di Storia e d'Arte

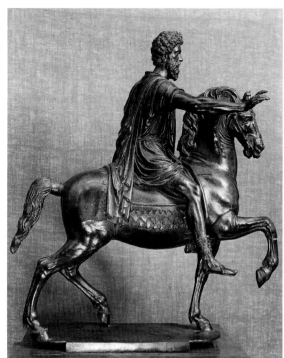

8. Antonio Giorgetti, *The Nativity*; gilt bronze. Private Collection

9. Orazio Albrizi, *Marcus Aurelius*, after the antique; bronze. Formerly London, art market

bronze reliefs may also have been originally modelled for silver casts, just as Antonio Giorgetti's relief of the *Nativity* (Fig. 8), which is now known only in bronze or wax, can be plausibly identified as that which was cast in silver by Michele Sprinati for their patron, Cardinal Francesco Barberini.[34]

Partial though the evidence cited above may be, it suggests that there was little appreciation of small bronze statuettes in baroque Rome. Where bronzes were collected, they tended to be works of the sixteenth century, and those who acquired contemporary small-scale sculptures preferred silver. Even when they did buy bronzes, these were very frequently gilded, which would justify the conclusion that there was little feeling for the qualities specific to bronze, or the beauty of the various patinations to which it was susceptible.

But, if founders such as Lorenzani were making and offering bronzes for sale, and sculptors such as du Quesnoy and Algardi were providing models to be cast in bronze, one must ask who was buying them. Some of the sculptors' models would be used for the adornment of reliquaries, tabernacles, and so forth; but, obviously, it would be absurd to pretend that no one in Rome bought bronzes, even if there were few serious collectors. Nor should one forget the many visitors to the Holy City who may have bought contemporary works, and certainly acquired copies of the famous antiques just as their successors were to do down to our own day. It may be significant that a founder such as Orazio Albrizi, who is known for his participation in such major works as Bernini's *Baldacchino* in St Peter's, Francesco Mochi's equestrian statues in Piacenza and Pietro da Cortona's altar in the lower church of SS. Luca e Martina in Rome,[35] should have cast models of the *Farnese Hercules*, the Borghese *Centaur*, and the *Marcus Aurelius* on the Capitoline, all of which in 1875 were listed in Genoa in the collection of the Marchesi Spinola, sons of Luigi Spinola.[36] A cast of the *Marcus Aurelius* (Fig. 9) is inscribed on the base 'made from a model by Horatio Albrizi',[37] which implies that Albrizi himself made the model, although he is not known to have practised as a sculptor. More usually someone else made the models for the founder. It could be a young sculptor who, like Algardi, earned his living by providing models for bronze-founders and silversmiths, or who had made these copies for his own instruction. It seems that du Quesnoy had made such copies, and many others certainly did – one may think of Girardon[38] – but some never achieved fame as original artists.

For one fact must be emphasised: the metal sculpture that is the subject of this book is the work of at least two, and quite possibly more, artists. With rare exceptions, such as Francesco

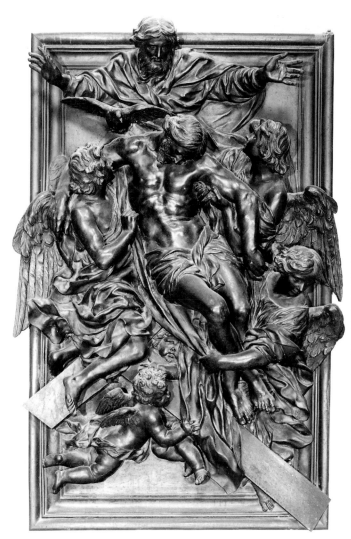

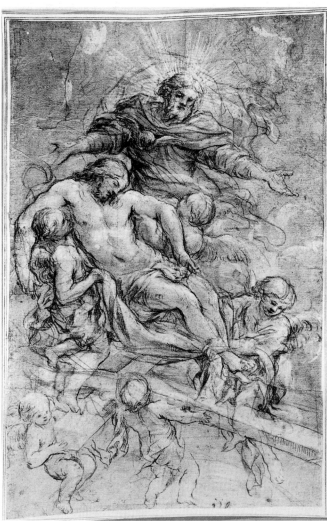

Mochi or Domenico Guidi, virtually no sculptor cast his own models in bronze,[39] and still less in silver where guild rules ensured that only members of the gold- and silversmiths' guild were allowed to sell works in precious metals. Just how many artists may have been involved can be exemplified by a work (admittedly not very small) such as the altar relief of the *Trinity* in Sta Maria della Pace (Fig. 10): here the design was provided by Pietro da Cortona (Fig. 11),[40] the model by Cosimo Fancelli, the plaster moulds by one Carlo Luna, and the bronze cast by Giovanni Artusi.[41] If the minor artisans involved are generally forgotten (and Carlo Luna, who is otherwise unknown to me, must have been similarly unfamiliar to Pietro da Cortona who was in charge of the work, for in his letter of 16 September 1657 detailing the expenditure he left a blank for his surname, which is recorded by Giovanni Maria Bolina, the architect who oversaw the work),[42] it is usually impossible without the survival of documents to identify the founders, whereas in the case of silver, as we shall see, even where a stamp identifies the silversmith it is frequently impossible to name the modeller, or the designer.

The investigations that have been summarised above may make my comparison with landscape painting in the catacombs appear exaggerated. Undoubtedly many Roman baroque sculptors made models that were cast in bronze, and many such bronzes exist today – fine, even superb works of art. But I do believe that it is true to say that there was not a Roman baroque school of sculptors of small bronzes, such as had existed in Florence since the renaissance, nor was there a cultivated class of collectors capable of appreciating those qualities that are peculiar to the small bronze.

If these statements are valid, two conclusions can be drawn. Firstly, one would do well to look for more utilitarian objects, not only crucifixes which were required in great quantities in

10. Giovanni Artusi, from a model by Cosimo Fancelli, *The Trinity*; bronze. Rome, Sta Maria della Pace

11. Pietro da Cortona, *The Trinity*; pen and brown ink over balck chalk, heightened with white, on brown paper. Hobhouse Collection?

Catholic Rome, but also church fittings, and above all the ciboria, or tabernacles, which are to be found in all churches, and which were often highly elaborate objects, and decorated with small bronze statuettes. Secondly, one should remember the relative importance of silver statuettes, even though few examples survive today.

Since tabernacles will figure so largely in the following pages, and not only in chapter 3, it may be advisable to digress, and provide an explanation for non-Catholic readers of why they were of such importance.

The tabernacle is the structure in which the consecrated host was reserved on the altar. The host, a small wafer, is consecrated during the Mass, that is to say, it is transubstantiated into the body of Christ, in conformity with Christ's words during the last supper when 'he took the bread, and gave thanks, and brake it, and gave it unto them saying, This is my body which is given for you: this do in remembrance of me. Likewise also the cup after supper, saying, This cup is the new testament in my blood, which is shed for you.'[43]

The taking of the eucharist is common to both Protestants and Catholics, but, while Protestants regard the bread and wine as symbolic, Catholics believe that when they are consecrated during the Mass they are transubstantiated, that is to say they actually become the body and blood of Christ. During the bitter wars and martyrdoms that followed the Reformation many human bodies were broken and much blood shed as a result of this disagreement (among others, of course), and much Counter-Reformation iconography is concerned with the glorification of the eucharist. This may be by means of stories that confirmed this dogma, such as the Mass of Bolsena, where the doubting priest saw the wafer bleed onto the cloth below, or by allegorical or symbolical images of the wheat of the bread and the grapes of the wine.

During the Catholic mass the priest alone drinks the wine; he drains the chalice and wipes it dry, but any left-over wafers of the consecrated host are reserved for future use. Obviously, the body of Christ cannot just be put in any old cupboard, so special tabernacles were made in which it could be kept, both for security, and for the veneration by the faithful of the real presence of Christ in the eucharist. These might be placed in a special side chapel, or very often they were set upon the high altar, and in some dioceses, including that of Milan, this became a rule. In the late sixteenth century, at the height of the Counter Reformation, S. Carlo Borromeo, who was Archbishop of Milan, wrote instructions to ensure proper and decent order in the churches of his diocese, which included his ideas of how the tabernacle was to be constructed.[44] It was preferably to be made of silver or gilded bronze, or of precious marbles, and he suggested that it should be octagonal, hexagonal, square, or round, as befits the shape of the church; moreover, it should be suitably decorated with images of the mystery of Christ's passion, and the decoration should be enriched in places with gilding. It should be surmounted by a figure of Christ, either resurrected, or showing his wounds, or, in smaller churches where there is not room on the altar for both the cross and the tabernacle, the crucified Christ. The door too should be decorated with a pious image, and Borromeo suggests various images of Christ – crucified, rising from the dead, or showing his wounded heart. This tabernacle should be placed on a firm base on the altar, possibly supported by angels.

None of this was new, but Carlo Borromeo's influential treatise had a profound effect on the way that subsequent tabernacles were made, as will be seen in the following chapters. It also gave scope for far more decoration than he proposed, including the inclusion of small bronze statuettes. The effect of this will be seen in the next two chapters.

The second conclusion I drew from the scarcity of independent bronze statuettes was that one should look at the relative popularity of silver, and this was also one of my motives for undertaking this book.

It is evident from what has been said above that many models were cast in both bronze and silver, but there is another reason for regarding the study of bronze and silver as inseparable: while bronze founders were forbidden by the guild rules from selling silver, they might work for silversmiths in preparing the moulds for their silver casts.[45] More importantly, there was nothing to prevent silversmiths from working also in bronze. Many of the silversmiths who will be discussed in the following pages, such as Giuseppe Gagliardi, Giovanni Giardini and Francesco

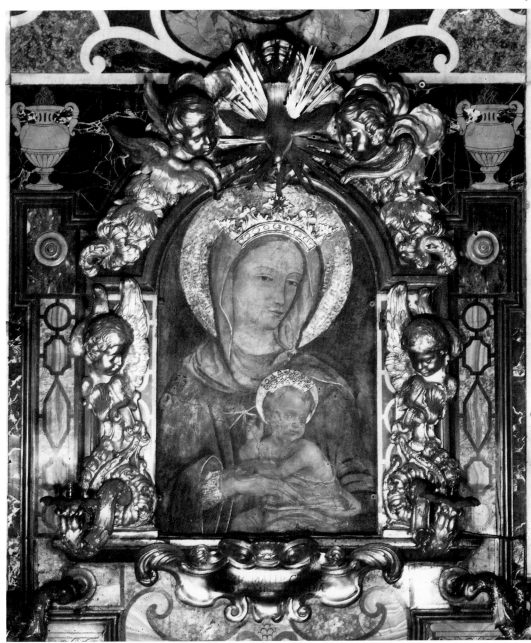

12. Here attributed to Marco Gamberucci, *Frame*; gilt bronze. Rome, S. Giovanni dei Fiorentini

Giradoni, were equally famous as bronze founders, and, although I know of no evidence that the Florentine-born silversmith Marco Gamberucci worked in bronze, it seems highly likely that the gilt bronze frame for the image of the *Madonna* in S. Giovanni de' Fiorentini (Fig. 12), which he gave to the church in 1674,[46] was his own work. It may be noted that Orazio Spada saw in the shop of 'the silversmith Gamberucci' a 'beautiful bas-relief of gilt bronze designed by Algardi, with a silver frame', which was for sale for 600 *scudi*.[47] Presumably Gamberucci had made the frame, but had he also cast the bronze relief? It is also from the letters of Orazio Spada that we learn that another silversmith, Rocco Tamburone, sent a colleague in Paris a number of models and moulds 'to be cast in silver, or bronze';[48] presumably Tamburone too would have made use of them in this way. Moreover, numerous decorative works such as the holy-water stoups that will be discussed below (pp. 10–13, 15–16) combine both metals in a single unified whole.

If few silver casts survive today, that is because it is a depressingly vulnerable material: it is too precious to be stored, and domestic silver has often been altered, melted down to be remade into something more up-to-date, or sold for the intrinsic worth of the metal. Accounts for the making of silver usually contain statements of the weight of silver in the form of old plates and candlesticks etc. that were given to the maker, and if one looks, for example, at the account-books of the Oratorian church Sta Maria in Vallicella, which was chronically short of money but which regularly received a gift of a chalice from the city of Rome on the feast day of St Philip Neri, it will be seen that these were almost as regularly melted down.[49]

Political circumstances have also played their part in the destruction; it became a patriotic duty to turn in one's silver and gold so that it could be converted into bullion for the needs of the government – if one were not sufficiently patriotic to do so voluntarily, it would be confiscated anyway. In one rather interesting case in 1643, when Urban VIII desperately needed money to pursue the War of Castro, he issued an edict that everyone having silver with figurative decoration (*argentaria historiata*) was to show it to the mint, but not actually to hand it over, because it was recognised that the value of the work was greater than the material; but this reprieve was only temporary, and scarcely more than a week later another edict decreed that this too was to be melted down.[50] In Italy, and particularly in the Papal States, there was also the devastation caused by the Napoleonic War; it was not a case of bombardment, or pillage in the normal sense, though that also occurred, but in 1796, by the terms of the Treaty of Tolentino, the papacy had to pay an enormous indemnity to the occupying forces of the French, and throughout the Papal States the 'Commissaires de la République' despoiled both the churches and private houses of the greater part of their silver, which was melted down for bullion.[51] However, some works did escape through the devotion of the populace: for example, the statuette of *St Ambrose* (Fig. 13) which had been made by Fantino Taglietti in 1641 and sent to Ferentino, was taken to be melted down to pay the French; but the women of Ferentino gave their golden jewellery to redeem it,[52] and so it survived the destruction that befell so much bronze and, particularly, silver and gold, both ecclesiastical and secular.

But the rarity of such survivals is only one of the difficulties in studying Italian baroque silver.

With a bronze, if one is lucky enough to have a document or skilled enough as a connoisseur, the name of the modeller can be deduced, but only a document will provide the name of a founder. Where silver does survive it might reasonably be hoped that the name of the maker will be known, since at least in theory it had to be assayed and stamped by both the Roman mint and the maker; however, this rule did not apply to silver made for the pope or the cardinals, and, cardinals being for the most part relatively rich, they were an important source of patronage. For whatever reason, much of the surviving silver bears no stamps, or at best that of the mint, providing at least an approximate date.

None the less, even without a stamp it may be possible to find a document which provides an attribution. One such example is the beautiful holy-water stoup now in Versailles (Pl. IV), which bears no stamp, but which can be identified as that which was taken by the papal nuncio, Fabrizio Spada, and presented to Marie-Thèrese, the Queen of Louis XIV, on 24 July 1674.[53] At the time of his appointment Fabrizio was papal nunzio in Turin, and it was left to his father, Orazio, to busy himself in Rome not only finding secretaries for his son, but amassing a quantity of gifts including gloves, fans, various perfumes, scented soaps, silk flowers, rosaries and religious medals. The king presented a particular problem, as he was known to have little taste for modern Italian painters, and the old masters were too expensive, as well as being hard to come by.[54] Fortunately, at the last moment, Orazio's son-in-law, Duke Girolamo Mattei, gave him a painting of *Diana and her Nymphs* by the Cavalier d'Arpino (or Domenichino) in a landscape by Paul Brill,[55] which, together with a porphyry table and an oriental alabaster vase (with a cover newly made to the design of Carlo Maratti) and a number of soaps etc., did for him.[56]

As for the queen, on 28 March 1674 Orazio wrote to Fabrizio that he had had two silver reliquaries made for relics of the Virgin's veil and St Joseph's cloak.[57] From Urbano Bartelesi he bought a reliquary combined with a holy-water stoup,[58] which had been made for Cardinal de' Medici; Bartelesi told him it had been destined as a gift for the Queen of England, but Orazio

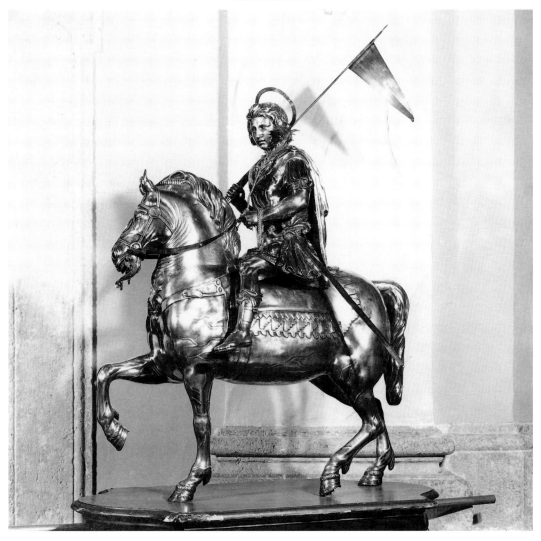

13. Fantino Taglietti, *St Ambrose*; silver. Ferentino, Cathedral Church of S. Giovanni

thought it was more likely to have been for the Duchess of Innsbruch, a relative of the cardinal, or for another member of the Austrian royal family. He did not like the idea of putting candles in the cornucopias held by the angels, so had flowers placed there instead, and Bartelesi fitted the relic into the garland held by the cherubs above.[59]

Orazio told Fabrizio that the design was by Ciro Ferri, a pupil of Pietro da Cortona, who 'has this misfortune, as I understand it, that he is not esteemed by the French', and he advised his son not to mention the name.[60] This was, in fact, easily avoided: the queen was more interested in the relic which, so she said, 'would be a great treasure if it were true', which she accepted on hearing that it had an official authentication, and how it had been carried to Rome.[61] From our point of view, however, the truth of the attribution is of greater interest than the relic, and, perhaps, rather easier to accept. The miniature painting of the *Annunciation* is an adaptation of the altarpiece by Pietro da Cortona in the church of S. Francesco in Cortona, painted ca. 1665.[62] One would expect the design to have been made by a close follower of Cortona, not only because of the painting (which is of rather lower quality than the models of the angels), but because the style, both that of the figures, and that of the architecture with its curved volutes and the form of the pediment, fits well into the Cortonesque vocabulary. Ciro Ferri is known to have designed many works of small-scale sculpture,[63] and there are quite similar drawings of angels with cornucopias.[64] If the physiognomies of the angels are rather diferent from his usual facial types,

14. (*above, left*) Design for a firedog; brown ink and grey wash, possibly over pencil, BAV, MS. Barb. Lat. 9900, f.7 recto

15. (*left*) Design for a handle; brown ink and brown wash. BAV, MS. Barb. Lat. 9900, f.9 recto

16. (*below, left*) Design for a vase on its pedestal; pencil and brown wash. BAV, MS. Barb. Lat. 9900, f.44 recto

17. (*above, right*) Drawing of a brazier, a vase, and a bowl; black ink. BAV, Archivio Barberini, Indice II, 2696 (b).

18. (*below, middle*) Design for a mirror frame; brown ink and grey wash over pencil. BAV, MS. Barb. Lat. 9900, f.12 recto

19. (*below, right*) Franceso Romanelli, and an anonymous draftsman, designs for *Cardinals' Maces*; brown ink. Talman album, Private Collection

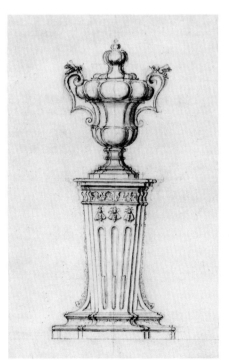

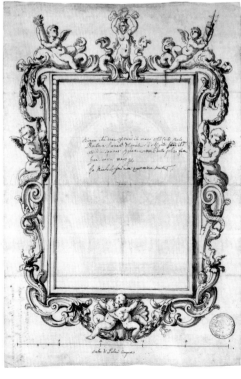

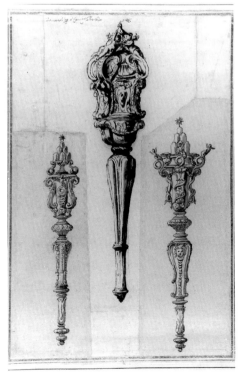

it is possible that in this case he merely povided designs, and that it was left to Urbano Bartelesi, a silversmith well accustomed to making figurative sculpture, to model the figures himself.

The question of who made the model, even when a stamp allows one to say who made the actual piece of silver, is one which it is seldom possible to answer with certainty. There are, of course, innumerable descriptions of works in bronze, and especially silver, in the archives, whether in accounts or inventories, but the reading of a lengthy description in the absence of the actual object is an acquired taste; moreover, in the case of silver, inventories do not provide the name of the maker, and still less that of the designer. More appealing are drawings for metalwork; there is no shortage of these either, but most are anonymous (and attributions such as 'School of Bernini' are unhelpful, and usually wrong), and frustratingly few can be related either to existing obejcts, or to documents. A volume from the Barberini collection contains a number of attractive, and occasionally entertaining objects, such as perfume-burners, braziers, etc., most of which are decorated with the bees of the Barberini coat of arms, or the sun or laurel, both of which were Barberini symbols.[65] Some of them have inscriptions, such as the amusing design for a firedog (Fig. 14) with bees round the central band, and its base bizarrely ornamented by a grotesque mask sporting an ecclesiastical hat. It was to measure nearly 75 cm., and the pair, together with their accompanying shovels, tongs, poker, fork, bellows etc. would apparently weigh some 31.838 kg.[66] Some, such as this handle (Fig. 15),[67] appear more enjoyable to look at than practical or comfortable to use.

Only rarely can such drawings be related either to documents, or to surviving pieces, and this is undoubtedly one reason why such small-scale sculpture in silver has been little studied. However, one does occasionally strike lucky, and it would be wrong to paint too depressing a picture, even if such successes are seldom without their own problems.

In the same Barberini volume of drawings the great vase included in what was most probably a drawing for its pedestal (Fig. 16)[68] corresponds very closely to the description of the parts of two silver vases made by Marco Gamberucci, each of which was weighed by Domenico Bucelli on 20 November 1673, totalling 161 *libre*, 7 *oncie* for one, and 156 *libre*, 3 *oncie* and 18 *denari* for the other.[69] But, alas, the drawing also corresponds even more closely to that of 'a brazier and vases of silver' from the Barberini palace handed to the mint in 1797 (Fig. 17).[70]

Possibly the same fate befell the splendid frame for a mirror to be made by Michele Sprinati in the same volume (Fig. 18).[71] Cardinal Carlo Barberini's accounts are regrettably very incomplete, and for much of his life only the minor payments are recorded, but these include a payment of 13.80 *scudi* on 25 May 1660 for the carriage of two mirrors from Venice, via Florence, another of 4.20 *scudi* on 17 August 1661 to the workmen (*giovani*) of the unnamed silversmith as 'a tip given by His Eminence for the silver adornment made to the glass of the mirror', and one of 90 *baiocchi* on 19 August to the six porters who carried the mirror from the Cancelleria to the 'S.ri Colonesi'.[72] In fact, one did not need the documents to show that this frame was made for the Colonna, the siren of whose arms sits so proudly atop it, but the dates give it a particular interest: in 1660 Carlo Barberini's cousin Lorenzo Onofrio Colonna, who had inherited the title of Conestabile, arranged to marry Maria Mancini, and the ceremony was performed by proxy in the Louvre on 11 April 1661. Almost certainly this exceptionally large mirror in its luxurious frame with its frolicking putti was a wedding-present for Lorenzo Onofrio's marriage to one of the most intriguing women of the Roman Seicento.[73]

In the case of the mirror, the drawing formed part of a contract, and it can therefore be assumed that it was followed precisely (though there may have been changes subsequently). In other cases, even when one knows what the drawing was made for, there can be no certainty that it was the one chosen to be made. This applies to the design for a mace with the inscription 'Romanelli for the Cardinal Carlo Barberini' (Fig. 19) which belonged to the English collector John Talman.[74] The drawing is perfectly acceptable as the work of Romanelli, and the heraldry on what is clearly a cardinal's mace is consistent with that of Carlo Barberini, raised to the purple on 23 June 1653: as usual with such maces, the reigning pope's arms (here the dove with an olive-branch of Innocent X) take pride of place at the top, while those of the cardinal (the three bees of the Barberini) appear on the body of the mace-head. Francesco Barberini paid most of

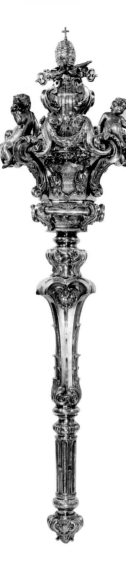

his young nephew's bills, and in this case it was he who paid the silversmith Domenico Brandi 450 *scudi* for a silver-gilt mace for his nephew.[75] Neither the cardinal's payments, nor Brandi's own account of the last day of November 1653,[76] provide any description of the mace, though Brandi's account proves that it was of silver-gilt; more interestingly, on 20 December 1653 an account by Brandi for miscellaneous work claims payment for four ounces of silver added to the mace, and for the making of two extra pieces soldered in various places, the 'recolouring of the whole, burnishing, and enamelling the arms'.[77]

But the two other drawings stuck to the same page in the album present a warning, for they are evidently alternative designs for a mace which can be identified as having been intended for Vitaliano Visconti, elected cardinal in 1666–7. As there is no mention in the accounts of who designed the mace that Brandi made for Carlo Barberini, nor is there any payment to Romanelli (indeed, it would be unusual to pay an artist who worked regularly for Cardinal Francesco for such a drawing) we cannot be sure that this was the design followed by the silversmith, or whether, like at least one of the drawings for Visconti's mace, it was a rejected design.[78]

Another very splendid cardinal's mace in the Victoria and Albert Museum (Fig. 20)[79] exemplifies a further problem facing the historian of silver, for it has the stamps of Giovanni Giardini (1646–1721), and of Andrea Pini, warden of the silversmith's guild from 1696 to 1710, and is fully consistant with what one might expect from a silversmith of the turn of the seventeenth/eighteenth centuries. But the papal arms (which have been applied to the top) are those of Benedict XIV (1740–58), and below are inserted inscriptions with the name of Pius VII (1800–23) and the arms of Cardinal Oppizzoni (elected 1804). Evidently, rather than melt down a fine piece of silver, it was simply adapted twice to suit new owners.

Even when a drawing can be securely identified as representing something that was actually made, and fully documented, there may be seemingly irreconcilable discrepancies in the evidence. Talman also possessed two drawings of 'the hammer of silver gilt, with which Pope Urban VIII beat down yᵉ holy door of Sᵗ Peter's Church in Rome in yᵉ Jubilee Year MDCXXV' (Fig. 21).[80] This should be clear enough, and the fact that it has a relief of two pilgrims flanking the *Porta Santa* on the striking head is not a problem, as the hammer-blow was purely symbolic, the door having been discretely weakened in advance. But in the account of the silversmith Pietro Spagna for 'the silver hammer for the Porta Santa' it is described as 'all of silver-gilt, and completely worked with little angels, figures, imprese and arms'.[81] While there are small figures on the hammer, for a piece of baroque metalwork it is quite remarkably lacking in angels of any size.

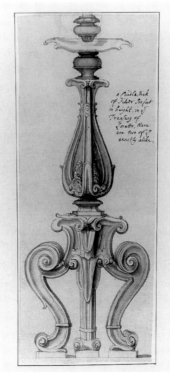

It is rare for an artist's accounts to be inaccurate, but it must be admitted that Spagna's are rather exceptionally vague, and perhaps we should be satisfied with the presence of insignificant cherub-heads. There is no reference to a model, which would normally have been of wood,[82] and he may well have included it in the cost of manufacture, which would explain why I have found no payment to a carver for the work.[83]

Another of Talman's drawings (Fig. 22) is identified as being of one of a pair of candlesticks which the Barberini gave to the Santa Casa in Loreto,[84] and the inscription states that it was made of silver and six feet high (2.88 m.). There is no reason to doubt this, although I have found no mention of this relatively modest gift in the extraordinary treasury of often vulgarly bejewelled offerings to the Virgin, all of which were destroyed during the French occupation. A very similar candlestick (Fig. 23) is to be found in the Barberini volume of drawings from which I have already reproduced a number of sheets.[85] The addition of hanging foliage in the centre of the Barberini drawing is less of a problem than the fact that this was to be six and a quarter *palmi* high (1.40 m.), which proves that the drawing cannot have been made for the Loreto candlesticks. If 1.40 m. is too short for Loreto, it is too high for the set of four candlesticks (Fig. 24), with a crucifix on an identical base, which stand on the altar of the Spada chapel in S. Girolamo della Carità in Rome. However, these follow the design exactly, apart from lacking the foliage under the drip-pan – but everything above the capital looks suspicious, as does the whole of the cross above this motif.

To complicate the matter further, Minna Heimbürger Ravalli has published documents proving that Virgilio Spada commissioned Francesco Travani to cast these candlesticks and their accompanying cross, following the design of candlesticks belonging to Duke Mattei, which had been made by 'Faenza', which can mean only Antonio Gentili (1519–1609), and to which was to be attached a Corpus made by François du Quesnoy.[86] But the form of these candlesticks in the chapel, with their restrained use of decorative motifs, is very unlike the designs for such objects from the turn of the century[87] and suggests a considerably later date than that of Antonio Gentile. Moreover, while the measurements of the Christ (23 cm.) exactly match the Roman *palmo* mentioned in the documents, it is one of innumerable examples of a type that certainly goes back to the sixteenth century, and has been convincingly connected with Guglielmo della Porta.[88]

This is one case where, although we have complete documentation, it would be preferable to regard the documents as misleading, and to assume that the original altar furniture has been replaced. However, the existence of this altar furniture, and Talman's drawing for the silver candlestick in Loreto, is also a reminder that the same designs can serve for a number of different objects, and that these might be made in both silver and bronze.

It seems likely, if uncertain, that the two (or, assuming that the drawing in the Vatican Library was not made for either of the two known examples, three) candlesticks made from the same design could well have been produced by one artist, but this is by no means necessarily the case. Favoured designs would be copied, or adapted. This applies even more obviously to pattern-books, such as those produced by Giacomo Laurenziani in 1632 and by Giovanni Giardini in 1714:[89] they were intended to serve as models for other artists, who might copy the designs precisely, or, more often, use them as a basis for some adaptation. Can one, therefore, assume that a piece of silverwork created in the style of such a print, and displaying a more or less evident relationship to it, should be attributed to the author of the print by the usual process of stylistic analysis, or is it by another artist who was inspired by such prints?

This question arises with the beautifully made and designed holy-water stoup in Minneapolis (Pl. V), constructed from gilt bronze, silver and lapis lazuli, with a stamp of the Reverenda Camera Apostolica dating it ca. 1715.[90] It shares with the designs of Giardini (Fig. 25) the firm architectural structure that remains in control, however much it is overlaid by the decoration. The particular skill of its maker lies in the way these two elements are kept distinct, yet fully integrated, so that the basic gilt bronze form demands the inclusion of the ornament (which, apart from the gilt bronze dove and its glory, is made of silver), and the angels, cherub-heads and garlands never appear to be merely added to it; yet the distinction between this basic structure

24. Attributed to Francesco Travani, *Candlestick*; bronze. Rome, S. Girolamo della Carità, Spada Chapel

facing page

20. (*top*) Giovanni Giardini, and others, *Cardinal's Mace*; silver, partly gilt. London, Victoria and Albert Museum

21. (*left*) Drawing of a hammer made for Urban VIII for the Jubilee of 1625; watercolour over pen. Talman album, Private Collection

22. (*middle*) Design for a candlestick; brown ink and grey wash over pencil. BAV, MS. Barb. Lat. 9900, f.6 recto

23. (*right*) Drawing of a candlestick in Loreto; brown ink and wash. Talman album, Private Collection

25. Maximilian Joseph Limpach, on the design of Giovanni Giardini, *Design for a Holy-Water Stoup*; engraving. London, Victoria and Albert Museum

facing page, left to right

26. Golden rose; gold and gilt bronze. Siena, Museo dell 'Opera del Duomo

27. Gianlorenzo Bernini, drawing for a golden rose; brown ink and wash. Paris, École Nationale Supérieure des Beaux-Arts

28. Francesco Bartoli, drawing of a golden rose by Giovanni Giardini; watercolour over pencil. Talman album, Private Collection

and the decoration remain clearly legible, and would be so even without the pleasing contrasts of colour. These same characteristics undoubtedly underlie the designs of Giardini, but they are also typical of Roman silverwork of the early eighteenth century, and distinguish it from similar pieces produced in the Germanic or Spanish lands. In Minneapolis this stoup is attributed to Giardini, and there is no evidence to dispute this attribution; equally, I consider that there is insufficient evidence to support it, and in particular the scale-decoration below the basin features only very rarely, and much less significantly, in Giardini's designs, while the angels with their rather angular forms and flying draperies are very different from those found on his secure works.[91] There are many payments in the accounts of the Sacro Palazzo Apostolico of the period for stoups of this type, made with similar materials and incorporating similar, though, alas, not identical, sacred images, made not only by Giardini but also by other silversmiths as well.

So far I have concentrated on the difficulties confronting the student of Roman baroque sculpture in bronze or silver, but in a book entitled *Gold, Silver and Bronze*, something should be said about gold, even if only to admit that golden sculpture does not exist – with the exception of golden medals, though even those survive only as extreme rarities.

This is not only because all the reasons for the destruction of silver apply even more forcefully to gold, but this soft and malleable metal was ill-adapted to the production of sculpture. It would, however, be used for crosses and objects small enough to be cast solid, most of which might be classed as jewellery rather than sculpture. It might also be used for crucifixes, which would be firmly attached to a cross,[92] such as that which Cardinal Francesco Barberini Senior commissioned from Baldovino Blavier in 1657 to give to the Vicereine of Naples.[93] Occasionally, too, a chalice, or even a tabernacle with sufficient sculptural decoration to qualify for my purpose, might be made of gold, but few such works survive.

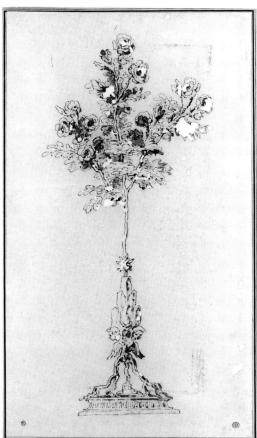
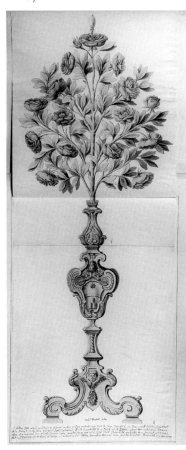

Although the pope made an annual gift of a golden rose to a cathedral, seminary, Catholic ruler or prince, or someone he regarded as worthy of this signal honour,[94] it is depressing to note the rarity of such examples of high-quality goldsmiths' work from the baroque period. Amongst such survivals we may note one which Paul V gave in 1609 to the Archduchess Anna of Austria,[95] another which Urban VIII presented in 1635 to Maria Anna, the wife of Maximilian I of Bavaria made by Francesco Spagna,[96] and that which Alexander VII presented to Siena Cathedral in 1658 (Fig. 26). For this rose I have been unable to find any payment, and I can only suppose that it was made by Antonio Moretti, the leading papal goldsmith of the time, with the title of Papal Jeweller.[97] There is a drawing by Bernini for such a rose (Fig. 27),[98] clearly made for Alexander VII as it incorporates the three *monti* of the Chigi arms, and the leaves appear to be of his armorial oak-tree, but this iconographic and botanical peculiarity may have been seen as too radical a departure from the norm, or the whole structure may well have appeared too precarious, and there is no evidence that it was ever made. As for the later baroque, Talman had a drawing by Francesco Bartoli of the rose which Clement XI had made in 1715 (Fig. 28), and this can be related to an account of 1,106.37½ *scudi* from Giovanni Giardini, a silversmith to whom we shall return in chapter 6.[99] If the mass of roses is more conventionally naturalisitic (with the saphire, set in the topmost bloom), and the arms of the Albani pope are placed within the confines of the knop, the stand has long abandoned any pretence at representing a vase; instead, it combines a number of traditional decorative motifs in a way that could equally well serve as a support for a candle or crucifix.[100] I have not found the detailed accounts for this, but one may assume that it was similar to that which Francesco Giardoni made in 1738, with the usual thirteen roses with a saphire set in the topmost rose, a triangular foot with three arms of the pope on the baluster, all of gold, a silver-gilt stem supporting the roses, and an iron armature, for which he received

1,139.44 *scudi*.[101] Interestingly, he claimed that the base was made with a 'new model', which may imply that sometimes the bases were repeated from old models, and indeed, this would not be surprising, given the remarkable similarity of these bases over long periods.

Even in a book which attempts to break down the division between the work of the goldsmith or silversmith and that which would generally be accepted as sculpture, it would be hard to make a case for the inclusion of such roses, attractive though they may be. My excuse for including gold in the title is rather that gilding was used so extensively both on bronze and on silver that one cannot appreciate the taste for metal sculpture in the baroque period without taking into account this love for the brightness of shining gold. In the works that will be discussed in the following pages, although the underlying metal may be bronze or silver, the surface that was sought by those who commissioned them, and extolled by those who admired them, was most often the brilliant opulence of gold.

It should, however, be borne in mind that the use of gold on ecclesiastical objects was not just an aesthetic choice, nor a vulgar sign of the wealth of the donor, nor was it just a practical recognition of the fact that it would require little maintenance or polishing. Gold had long had divine associations, derived not only from its beauty but also from its incorruptibility, and supported by the interpretation of numerous passages in the scriptures.[102] Gold had been extensively used in the temple of Solomon, and demands for the use of gold, or gilding, appear frequently in the *Instructiones* of Cardinal Borromeo.[103] There can be no doubt that gold was regarded as specially and uniquely suited to those objects made for the service of God, and particularly for those which would come into direct contact with the body of Christ or his saints.

So the inclusion of gold, or at least gilt, in this book was an inevitable consequence of the position this metal held in the minds of those who commissioned the sculpture with which we shall be concerned.

Roman Bronze Sculpture around 1600

BEFORE TURNING TO the baroque proper, in this chapter I shall examine some small-scale Roman bronzes of the end of the sixteenth and the early years of the seventeenth centuries, a time when the previously settled renaissance style went through a period of flux, before the arrival of the baroque. I shall avoid referring to them by the word 'mannerist', usually applied to the painting of these years, because the bronzes I shall be discussing are hardly typical examples of that style, and it is preferable to see them as individual expressions of the various artists, rather than to apply conventional labels.

I shall begin with the tabernacle of Sta Maria Maggiore, constructed in 1587–9 (Pl. VI). Although Steven Ostrow has analysed the chapel in which it stands,[1] and I shall draw extensively on his work and the archival references he cites, he was not concerned in his thesis with the making of the tabernacle, or the questions raised by its connection with related works.

Cardinal Felice Peretti Montalto had a particular interest in Sta Maria Maggiore: it was there that he erected the tomb of Pope Nicholas IV (like Sixtus, a Franciscan, and also from the Marches), and it was nearby that he built his family villa. His decision to build a family chapel there was taken even before his election to the papacy as Sixtus V, and at the same time there were discussions in the church as to where to place a new tabernacle for the sacrament: the Sistine chapel (this chapel is, of course, not to be confused with the more famous chapel of the same name built by Sixtus IV in the Vatican Palace) offered a solution to this dispute, and became both a burial chapel for the pope, and a setting for the tabernacle of the eucharist.

The *tempietto* that forms the tabernacle itself is of octagonal form, which, although it was one of the shapes suggested by Cardinal Carlo Borromeo in his influential *Instructiones Fabricae et Supellectilis Ecclesiasticae*,[2] was relatively rare, and, in view of the many references to the Temple of Solomon and to Jewish ritual which Ostrow has perceived in the chapel, it may look back to the traditional idea that the Temple of Solomon had been octagonal in plan. There is no scriptural justification for this, but there was a much-disputed belief that the octagonal Dome of the Rock in Jerusalem preserved some of Solomon's temple, or that it had been built by St Helen as a substitute for the temple, and subsequently turned into a mosque:[3] indeed, there are a number of renaissance paintings in which the temple is shown in this form.[4]

Whether or not it was intended to convey any such iconographic significance, this tabernacle is undoubtedly one of the most magnificent in the city of Rome.[5] The *tempietto*, richly adorned with reliefs and figures, and surmounted by a small cross above the three *monti* and star of the Peretti Montalto arms, is miraculously supported without any apparent effort on the shoulders of four over-life-size candle-bearing angels.[6] This association of the tabernacle with the representation of angels has been seen as a reference to the traditional description of the eucharist as the *Panis Angelorum* (the Bread of Angels), a symbolism taken up in the repeated reliefs of angels bearing up the monstrance of the host.[7] The whole, shimmering with gold, and rich with inlaid precious marbles, stands isolated above the altar in the centre of the chapel, while the figure of Pope Sixtus in his tomb on one of the side walls kneels in perpetual adoration of the sacrament.

Domenico Fontana made the design of the chapel, and was in charge of its construction, including the difficult engineering feat of transporting the shrine of the nativity here from its

previous position in the church, and it seems reasonable to suppose that he, as the leading architect of the period, designed the *tempietto*, which looks very like contemporary church designs; indeed, it resembles quite closely the structure of the chapel itself.[8] It should moreover be noted that Fontana was to include engravings and a description of the tabernacle in his *Della Trasportatione dell'obelisco vaticano e delle fabriche di Nostro Signore Papa Sisto .V. Fatte dal Cavalier Domenico Fontana* (Rome, 1590) with the implication that it was his own work.[9]

If there appears little reason to doubt Fontana's ultimate responsibility, the question of both the designer and the maker has been muddied by the early guide-books. In one it is ascribed to 'Riccio the stucco-maker',[10] and another attributes it to him, together with Sonzino;[11] the others name only the founder, Ludovico del Duca.[12] They are right about the founder, as we shall see, but who were Riccio the stuccoist, and Sonzino? Riccio is now so totally forgotten that a modern guide-book can rather desperately identify him with Giovanni Battista Ricci of Novara, a painter who is never known to have sullied his hands with stucco,[13] which is at least better than the attribution on the Alinari photo to 'A. Riccio', presumably for the Paduan Andrea Briosco, called Riccio. Almost equally implausible, and without any foundation, is Bertolotti's implied identification of him with the painter Riccio Bianchini da Urbino.[14] As for Sonzino, his name is attached to only one other work, the rather dreary *St Matthias* on the outside of the Pauline chapel of the same church of Sta Maria Maggiore,[15] but documents confirm that he is to be identified with the relatively well-known sculptor Francesco Caporale, who was born in Soncino in the diocese of Cremona, and that in fact, together with Stefano Maderno he was responsible for both the *St Matthias* and the *Epaphra*.[16] However, there is no documentuary confirmation of his involvement with the tabernacle, and no evident stylistic similarity with his other works.

The known documents consist of payments to both Torrigiani and Ludovico del Duca, and allow us to attribute the casting of the angels to Torrigiani, and the tabernacle itself to Ludovico del Duca.[17] There is also a final *stima* dated 1590, a statement of the work and its cost drawn up by experts working for each side, Antonio [Gentili] da Faenza and Cavalier [Domenico] Fontana for the Pope, and Paolo Tornieri for the founders, which is very specific as to what was actually done.[18]

For the angels, with their wings and torches, Torrigiani was accorded 200 *scudi* for having made the two clay models, and the wax casts of them ready for casting in metal. For the two moulds which served for making the wax casts for all four angels he was paid 120 *scudi*, and for having cleaned the wax casts of all four with their torches a further 130 *scudi*. For the actual casting they agreed on a total of 2,400 *scudi*, which included the following: the wax for the models, and also for the wax that would be attached to them (to form the tubes for pouring in the molten metal and allowing the gasses to escape); for casting them in pieces, fitting these together, making the bases and adjusting all four angels so that they would support the tabernacle; for the iron which included both the rods that passed through the mould to hold the core in place, and what was presumably the basic armature which extended beyond the heads of the angels; for the making of the core, including the cost of the plaster and other material; the making and attachment of the wax conduits; the making of the moulds,[19] with iron wires to give them further strength; the adaptation of the furnace; the introduction of the moulds into the furnace by means of pulleys, and filling up the spaces between the various moulds; the wood to heat the moulds (so that the wax would run out) and the metal (so that it could be poured into the space so formed), and, finally, the extraction of the moulds from the furnace, breaking them open, cutting off the conduits (in which some of the metal would have been left) and sawing off the projecting iron rods, and cleaning the casts and carrying them to the church. While the accounts later list the amount of metal Torrigiani used, this was not included in his expenses since it had been provided for him.

The description of these tasks provides a fairly clear account of how such metal sculptures were cast by the lost wax process, and only a few words of further explanation may be necessary. It would begin with a model, usually, as here, of clay, from which a mould was made in many pieces, by means of which one, or, in this case, where each angel was doubled, two wax casts would be made. These would need cleaning, since they had been made from piece-moulds, and

it was fairly inevitable that some wax would seep into the joins even if there were no more serious accidents, so that they would have to be worked over and cleaned up. At this point in the process it would be possible to introduce some changes, so that not every bronze cast from the same original, by means of the same piece-moulds, is necessarily identical. These waxes would not be solid, but merely a thin coating of wax round a core of some friable material, for when the wax had been covered with its mould the whole would be heated so that the wax would run out, and the space where it had been would be filled with molten metal. Obviously, the thinner the wax, the less of the expensive metal would be required – a consideration that was even more important in a silver cast – but also the thinner the cast the less risk there was that it might crack as it cooled. Iron rods had to be passed through the outer mould and into the core, so as to hold the core in place when the melted wax ran out. The placing of the wax conduits was a matter of great importance, since they would have to distribute the metal to every part of the figure. As for the cleaning of the cast, this would almost certainly include some repairs, as well as chiselling, chasing and punching to sharpen the details and enliven the surface.

If the estimate of Ludovico del Duca's work provides no such detailed description of the making, it does list all the features of the tabernacle, which included heads of cherubs, garlands of foliage, and pears (which were part of the Peretti arms) on the underside of the base, the four figures in the niches, the sixteen on the balustrade, the eight reliefs 'of the mysteries of the passion', the sixteen little putti around the base of the drum and the mountains and star (of Sixtus's arms) and the cross on the top. He also put a drum of poplar-wood inside to keep out the damp, and provided the cypress-wood casing for the sacrament within, which was lined with red velvet and decorated with gold braid and gilded nails in the form of rosettes.[20] He was responsible for the scaffolding for the gilding, which was apparently done after it was set up in the church; this cannot have been the real gilding, which would have been done before the tabernacle was set up, and must refer to the cold-gilding of grottesques which he did himself (see below).

Today all the metalwork of the tabernacle is gilded, but, as we shall see, it has been subjected to extensive restoration. The estimate of Giovanni Piccardi's work in gilding the tabernacle lists every detail of the structure from top to bottom, including the cherub-heads within the triangular pediments, and the frames below them, each with a further cherub-head and the monogram of Christ within the rounded pediments (Fig. 29), but none of the sculpture.[21] Yet it would be wrong to conclude from this that none of it was gilt, for, rather surprisingly, in the estimate of work done by a gilder who appears to be called Ferrante Condopuli, whose main task was the gilding of the supporting angels, there is an item 'for the gilding of 16 figures . . .'.[22] It is not stated whether these are the sixteen statuettes on the balustrade, or the little angels around the dome, but as the latter are usually referred to as angels, one must assume that it was the statuettes of the *Apostles* – though it certainly seems strange that these should have been gilded, and not the other four statuettes in the niches. Finally, there is the last item in the work done by Lodovico del Duca, which is payment for cold-gilding grottesques, though where these decorations were put remains a mystery; presumably (if it was not a trial, later abandoned) it must have been on the background of the reliefs, and most likely those of the angels bearing the monstrance.

These grottesques were painted on the 'green bronze', which suggests that the sculptures – the reliefs and the statuettes, presumably those of the angels – were given a green patina. Certainly this would harmonise better with the brilliance of the gold than the usual rather dark bronze, and, creating less of a contrast, would leave the figurative parts more easily legible. This variety of colour was misunderstood in 1869, when the decision was taken to regild the tabernacle because of the deterioration of the gilding, particularly on the sculptures which displayed 'instead of the gilding a bronze patina'.[23]

Del Duca described the making of the tabernacle 'with all its ornaments' as 'delicate and minute work'.[24] So it certainly should be, but it is not, parts of it being quite extraordinarily crudely finished. Another fact which is more surprising is that most of the reliefs are second-hand, for, with two exceptions, the scenes of the Passion of Christ reproduce in a truncated form those on the tabernacle by Ludovico's brother, Jacopo del Duca, formerly in Naples, and now returned to S. Lorenzo in Padula (Fig. 30).[25]

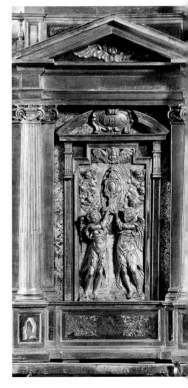

29. Ludovico del Duca, *Angels Holding a Monstrance*; gilt bronze. Rome, Sta Maria Maggiore (detail of the *Tabernacle*)

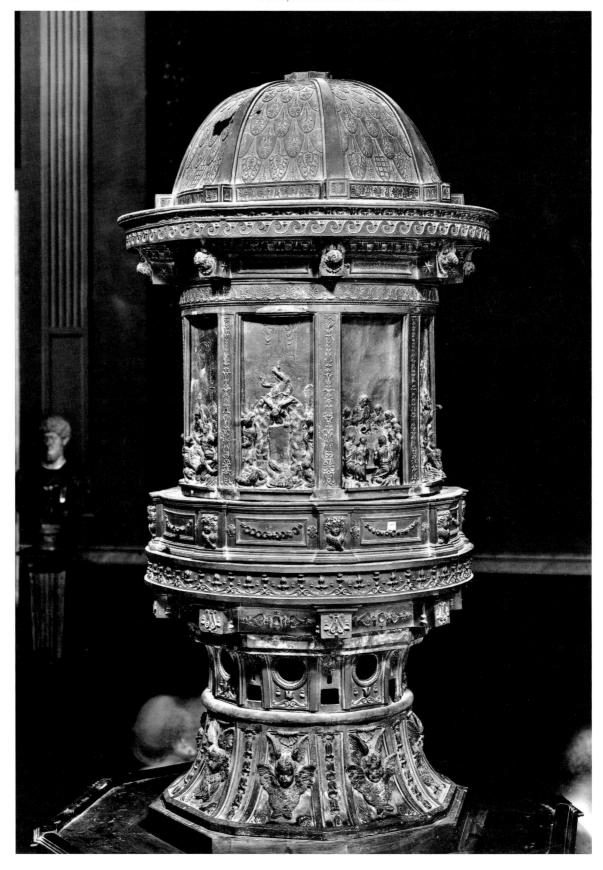

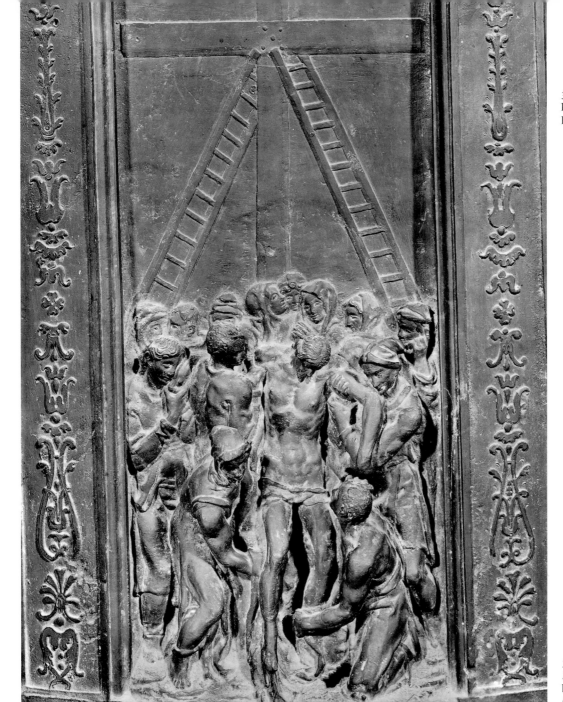

30. (*facing page*) Jacopo del Duca, *Tabernacle*; bronze. Padula, S. Lorenzo

31. Jacopo del Duca, *Descent from the Cross*; bronze. Padula, S. Lorenzo (detail of the *Tabernacle*)

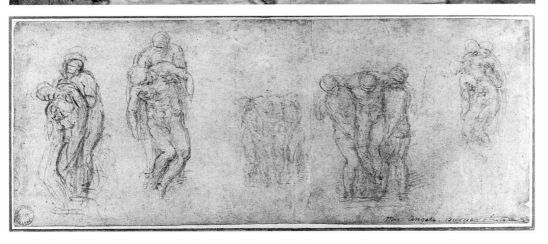

32. Michelangelo, *Study for the 'Rondanini Pietà'*; black chalk. Oxford, Ashmolean Museum

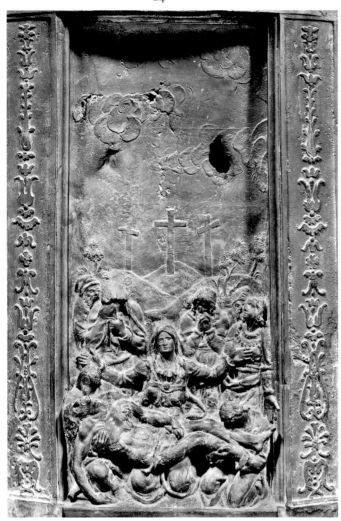

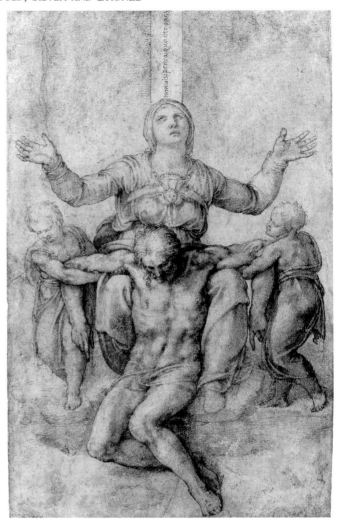

When the Padula tabernacle was made, and for whom, remains obscure, but it has a clear relationship with the designs of Michelangelo, and there is no reason to doubt its traditional attribution to Jacopo del Duca. It is not impossible that it was developed from the tabernacle that Jacopo del Duca was to cast from Michelangelo's designs for the church of Sta Maria degli Angeli in Rome.[26] What is beyond dispute is that several of the reliefs are in a style closely related to that of Michelangelo, and that two of them depend on Michelangelo's drawings:[27] the *Descent from the Cross* (Fig. 31), with the upright body of Christ, is related to a sheet of studies for the *Rondanini Pietà* (Fig. 32),[28] and in the *Pietà* (Fig. 33) the Virgin is directly imitated from the image Michelangelo designed for Vittoria Colonna (Fig. 34),[29] and which was repeated in numerous paintings by the master's followers. It has even been suggested that the crudity of the casting represents a deliberate *non finito*, as in many of Michelangelo's unfinished marbles.[30] Although the Padula tabernacle may never have been finished – certainly what we have today is incomplete, though it is also probable that some parts have been lost in its various peregrinations[31] – there are only a few signs of afterwork on the bronze, but many casting faults that have been left unrepaired; this would seem to confirm Vasari's description of Jacopo del Duca as someone who prided himself on the quality of his casting, which required only the minimum of afterwork.[32] However, while he may well have favoured a relatively unfinished surface, it is hardly likely that he would have intended to leave large holes and other casting faults unrepaired, even for reliefs intended to be seen at a distance. The surface of the reliefs on the Sistine tabernacle is completely

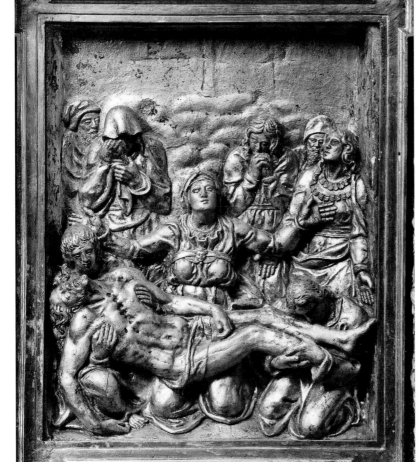

33. Jacopo del Duca, *Pietà*; bronze. Padula, S. Lorenzo (detail of the *Tabernacle*)

34. Michelangelo, *Pietà*; Black chalk. Boston, Isabella Stewart Gardner Museum

35. Ludovico del Duca, *Pietà*; gilt bronze. Rome, Sta Maria Maggiore (detail of the *Tabernacle*)

worked over, but with a heavy hand and a crude lack of sensitivity,[33] which, it must be emphasised, is visible only close to, and in no way affects the impression received as one looks at it from the floor of the chapel.

The two brothers Jacopo and Ludovico del Duca had collaborated before, most notably on the fascinating tomb of Elena Savelli in S. Giovanni in Laterano,[34] and in 1601 the Congregazione di Sta Maria di Loreto handed over to Lodovico the plaster models that Giacomo had left in their charge.[35] There is every likelihood therefore that Lodovico could have borrowed the moulds. Why he should have done so is more questionable: one might regard it as laziness, or, more charitably, one might suppose that their derivation from Michelangelo gave them a particular value that justified their incorporation here.

Whatever the reason, it is notable that the format of the reliefs in the Sistine chapel is much more satisfactory. In the *Pietà* of the Sistine chapel (Fig. 35) it might have been preferable to include a little more of the crosses, but in Padula the upper part of the relief looks like space filling, and in the *Last Supper* at Padula the upper part is left blank.[36] Similarly, in the *Flagellation* (Fig. 36) the composition of the Sistine relief works perfectly, whereas that in Padula (Fig. 37) splits into two halves: the windows above fulfil no narrative function, and, as Benedetti has noted, they are shown straight on, while the arcade below is viewed slightly from the side.[37] Only in the scene of *The Angel Opening the Tomb* is the Padula version preferable (Figs. 30, 38). This scene is usually called the *Resurrection*, but in fact it represents the story of the three Maries' visit to the

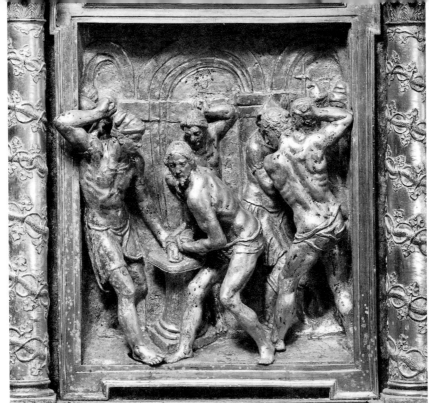

36. Ludovico del Duca,
The Flagellation; gilt bronze.
Rome, Sta Maria Maggiore
(detail of the *Tabernacle*)

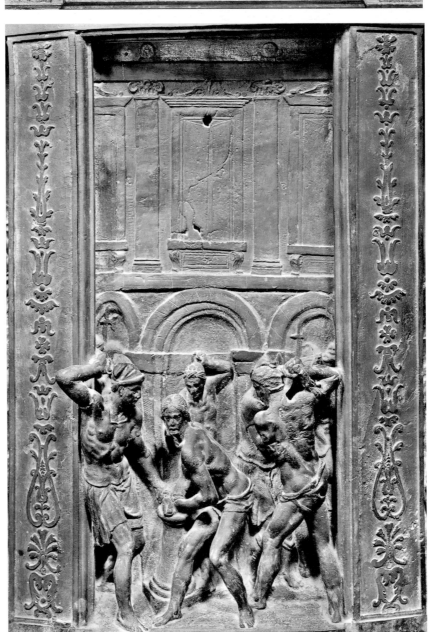

37. Jacopo del Duca, *The
Flagellation*; bronze. Padula,
S. Lorenzo (detail of the
Tabernacle)

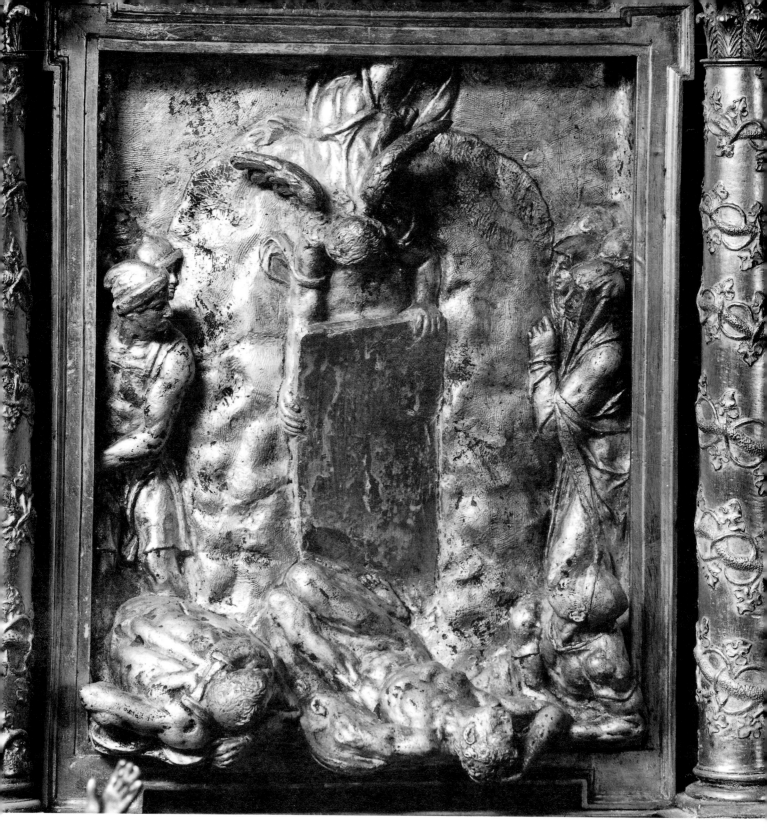

tomb as recounted by St Matthew, when, as they approached, there was an earthquake, and 'the angel of the Lord descended from heaven, and came and rolled back the stone from the door, and sat upon it'.[38] On the Sistine tabernacle the angel's legs appear uncomfortably truncated, and in the Padula version the rays of light, which still look like space-fillers, do at least suggest the terrifying appearance of the angel from on high in the midst of an earthquake.[39]

 Only one scene was indubitably designed for the higher format of Padula – the *Crucifixion* (Fig. 39), with its generically Michelangelesque figures of the Virgin and St John, and the crossed feet

38. Ludovico del Duca, *The Angel Opening the Tomb*, gilt bronze. Rome, Sta Maria Maggiore (detail of the *Tabernacle*)

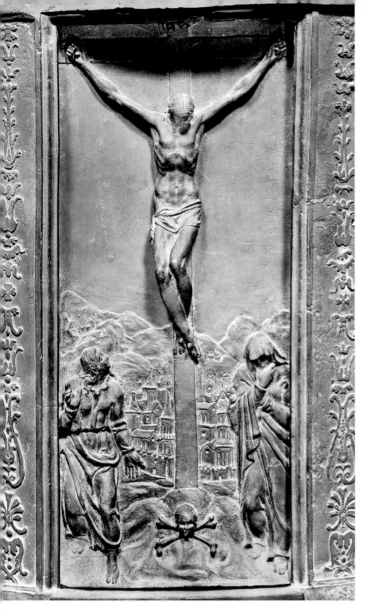

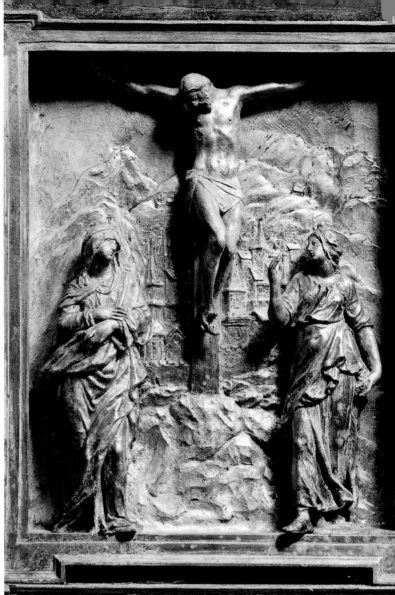

39. Jacopo del Duca, *Crucifixion*; bronze. Padula, S. Lorenzo (detail of the *Tabernacle*)

40. Ludovico del Duca, *Crucifixion*; gilt bronze. Rome, Sta Maria Maggiore (detail of the *Tabernacle*)

facing page bottom

45. Anonymous, *Moses*; bronze. Florence, Museo Nazionale del Bargello

46. Anonymous, *Elijah*; bronze. Florence, Museo Nazionale del Bargello

of Christ.[40] This is one of the two scenes which have been completely rethought by Ludovico del Duca for the Sistine tabernacle (Fig. 40), except for the northern-looking townscape in the background, though this has been given even more sharply pointed roofs. The Christ is no longer that of Michelangelo, but of a type known from innumerable crucifixes, and plausibly ascribed to Ludovico's teacher, Guglielmo della Porta.[41] As for the two mourning figures, they too are in a completely different style, and in place of the traditional St John we see, presumably, the Magdalen (who must originally have held something in her left hand, possibly an ointment-pot), an iconographic rarity,[42] for the use of which I can offer no explanation.

There can be no doubt that for most of these reliefs Ludovico was reusing moulds previously employed by Jacopo, and in all probability made on the directions of Michelangelo. It is also highly likely that originally these models were of the squarer format seen on the Sistine tabernacle, whereas for Padula Jacopo had made what are for the most part rather unconvincing additions to the upper parts. My suspicion that the employment of these second-hand reliefs had at least as much to do with their availability as their merits comes from a consideration of the bronze figures. Looking at those which were in the four niches, two of which have disappeared in recent years, the *David* (Fig. 41) and another figure (Fig. 42), who is possibly intended for *Abraham*, as Cannata suggests, are satisfactory enough, though one might criticise the lack of imagination in their poses, mirror-images one of the other, but *Moses* (Fig. 43) and *Elijah* (Fig. 44) are another matter. It is not that there is anything to criticise in the models, apart from the same rather crude finish that one finds on all the bronzes of the tabernacle, but that they are repetitions of a very much finer pair of anonymous bronze statuettes in the Bargello (Figs. 45–

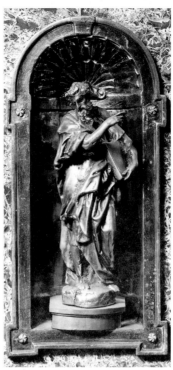
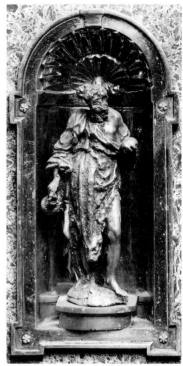

41. Ludovico del Duca, *David*; gilt bronze. Rome, Sta Maria Maggiore (detail of the *Tabernacle*)

42. Ludovico del Duca, *Abraham* (?); gilt bronze. Rome, Sta Maria Maggiore (detail of the *Tabernacle*)

43. Ludovico del Duca, *Moses*; gilt bronze. Rome, Sta Maria Maggiore (detail of the *Tabernacle*)

44. Ludovico del Duca, *Elijah*; gilt bronze. Rome, Sta Maria Maggiore (detail of the *Tabernacle*)

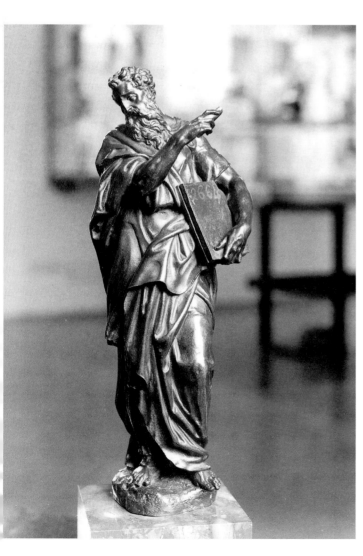
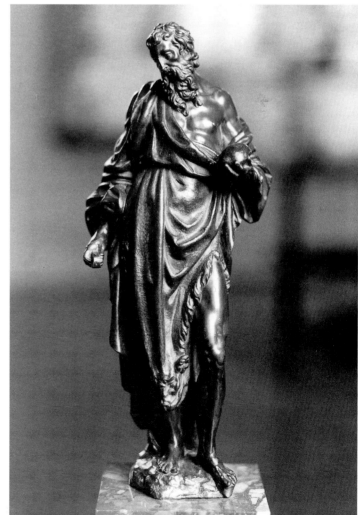

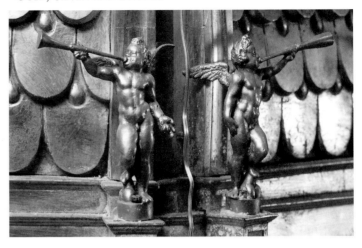

47. Ludovico del Duca and Alberto Galli, *Angels*; gilt bronze. Rome, Sta Maria Maggiore (detail of the *Tabernacle*)

6).[43] Those in the Bargello each measure 22.5 cm. in height, whereas the *Elijah* in the niche of the tabernacle is about 21 cm.;[44] as bronze shrinks slightly as it cools, this suggests that they might well be aftercasts. If one compares them, the superiority of the Florentine casts is obvious, so much so that I do not think one can harbour the more favourable interpretation that the Florentine pair could be earlier casts by the same Ludovico del Duca.[45]

The 1870 restoration was responsible for recasting seven of the little angels around the dome, and casting the wings and 'attributes' of the remaining nine. Assuming that this means their trumpets, one has only to look at the ugly and implausible misshapen instruments that most of them hold (Fig. 47) to form some idea of the inadequacy of the young sculptor Alberto Galli who was paid for this work. But the effects of his ministrations are at their most dire in the statuettes of the *Apostles* on the balustrade (Fig. 48), where he originally made four new models to replace statuettes that had been lost (and replaced by angels from around the drum), but three more were found irreparable when they were reheated in the furnace.[46] But while there are clear differences in style and facture, as is evident in comparing, for example, the *Sts Andrew* and *Simon* (Fig. 49), one cannot hold Galli solely responsible for the peculiar and ultimately unsatisfactory appearance

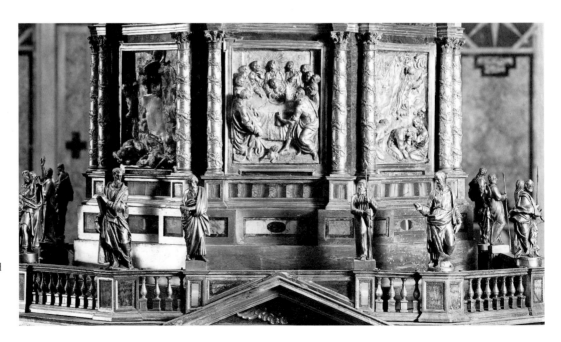

48. Ludovico del Duca and Alberto Galli, *Apostles*; gilt bronze. Rome, Sta Maria Maggiore (detail of the *Tabernacle*)

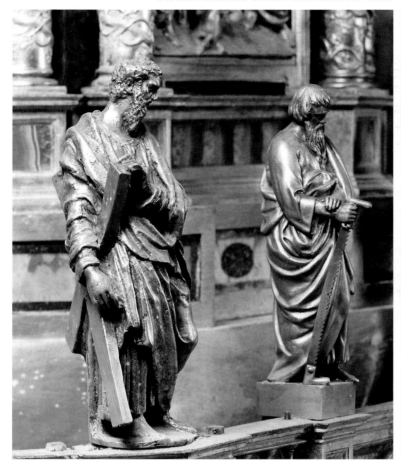

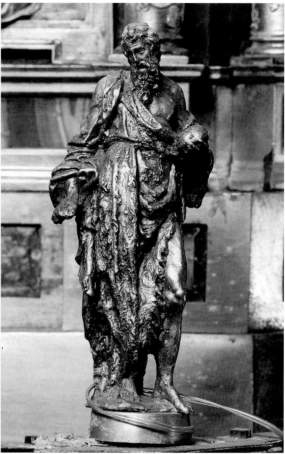

of this series: apart from the obviously defective casting (which was in part the cause of his intervention) there are differences in the heights of the statuettes which the varied types of bases, including their absence, cannot altogether remedy. It is notable that among these statuettes is a variant of the putative *Jeremiah* with a raised arm from the niche below, and also two of the *Elijah*, one at least of which (Fig. 50) is so far superior to the figure in the niche, and much closer to the Bargello prototype (though still incomparably cruder in facture and finish) as to suggest that perhaps they were transposed during the restoration; one might add that the versions of the putative *Jeremiah* on the balustrade is noticeably smaller than the same figure in the niche (20 cm., as against the 22 cm. of the niche figure), but one balustrade cast of the *Elijah*, on the other hand, is slightly taller (21.25 cm., as against 21 cm., but this is still smaller than the Bargello versions' 22.5 cm.), which, whether or not they were transposed, would strengthen the case for seeing the balustrade *Elijah* as del Duca's 'original', and the niche figure as an aftercast.[47]

Even making every allowance for the effects of Galli's replacements, and even admitting the possibility of earlier interventions, the obvious, and I fear inescapable conclusion is that on the ciborium of one of the great basilicas of Rome, standing in the centre of a papal chapel, the founder has been prepared to place a job lot of sculptures. This does no credit to Ludovico del Duca, or to Domenico Fontana, the architect in charge. But it has even worse consequences for anyone attempting to track down small bronzes made in Rome. When, many years ago, I first recognised that the Bargello bronzes corresponded to statuettes on this tabernacle, I thought I had discovered two; only after Oreste Ferrari had kindly arranged to make photos of the ciborium, which is difficult to study from the floor of the chapel, and thus proved the inferiority of the replicas on it, did this neat piece of evidence dissolve. Strangely, considering the quality of the

49. Here attributed to Alberto Galli, *Sts Andrew and Simon*; gilt bronze. Rome, Sta Maria Maggiore (detail of the *Tabernacle*)

50. Alberto Galli (?), *Elijah* (?); gilt bronze. Rome, Sta Maria Maggiore (detail of the *Tabernacle*)

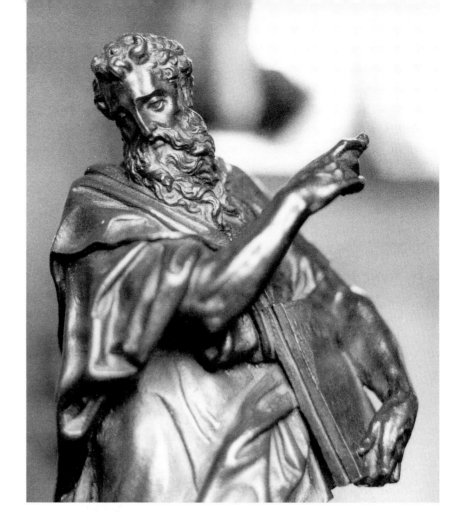

51. Anonymous, detail of *Moses* (Fig. 45); bronze. Florence, Museo Nazionale del Bargello

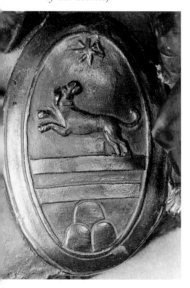

52. *Shield with the Arms of the Sannesi Family*; bronze. London, Victoria and Albert Museum (detail of the *Rape of the Sabines*)

Bargello bronzes (Figs. 45–6), and their very pronounced stylistic characteristics – note particularly the long straight noses (Fig. 51) – no one has been able to make any suggestion as to their authorship, or even where they were made;[48] they could, of course, still be Roman, but it must be admitted that small bronzes travel easily, and Ludovico del Duca could perfectly well have recast bronze statuettes that had originally been made elsewhere.

None of these considerations will bother the casual visitor to the church, any more than he will be aware of the low quality of the detail of the tabernacle. What will strike him is the splendour of the whole, the richness of the gilding and the touches of colour from the inlaid stones, against the multi-coloured inlay of marbles on the walls of the chapel. The average pilgrim, gasping in wonder at all this gold, is unlikely to regret the loss of the contrast that would have been made by the ungilded sculptures; but the historian can only lament the ill-informed and ill-judged perversion of the artists' intentions.

I can propose no attribution for the Bargello bronzes, and I must admit to a similar ignorance as to the maker of the bronze group of the *Rape of the Sabines* (Figs. 53–4) in the Victoria and Albert Museum;[49] but in this case I am at least convinced that it is Roman. Sir John Pope-Hennessy attributed it, if with some reservations, to the Venetian sculptor Francesco Bertos (active 1693–1733), which is understandable, in that I know of no earlier bronze of this type, with its central group of the mounted Roman bearing off his prize surrounded by six other figures, not to mention a dying horse, on a wide, almost circular, irregular oval base. The spirited action of the figures might have suggested that the artist was inspired by the vigorous scenes typical of the baroque period, but their rather loose and casual grouping, with no attempt to establish any close formal relationship between them, might have aroused suspicions; indeed, it may well have been one of the reasons for thinking of the very eccentric sculptor, Bertos. But Pope-Hennessy failed to identify the arms on a shield lying on the ground (Fig. 52), which are those of the Roman family of the Sannesi. Moreover, there is a list of sculptures owned by the Sannesi, with estimates

53. Roman, early seventeenth century? *Rape of the Sabines*; bronze. London, Victoria and Albert Museum

54. Roman, early seventeenth century? *Rape of the Sabines*; bronze. London, Victoria and Albert Museum

of their value by the antiquarian Leonardo Agostini, undated, but clearly from the mid-seventeenth century. In this is a group which was certainly related, if not identical (unfortunately, one key word is illegible): 'Rape of the Sabines with two equestrian figures, and six other figures in [illegible] and a dog chased [i.e. finished]'.[50] The value of 200 *scudi* is twice as high as any other single piece: even grouped pieces of a hunt, with one equestrian figure, a stag and four hounds was valued at only 60 *scudi*, and another with a boar and three hounds at 40 *scudi*. The casting is remarkable for such a complicated group, and it is, as described, chased, even though in unimportant places it is unfinished; for example, if one is indiscreet enough to look up the skirts of the old woman one can see that the inside has been left as it came from the foundry, with odd lumps of bronze, one of which is even visible from the front, hanging down below. Nor is the absence of a dog unduly worrying, since there are places, such as beside the old woman, where a dog could well have been placed, and there are marks on that part of the base which might indicate where the hind legs were set. Whatever the slight discrepancies between the inventory description and the Victoria and Albert bronze, they pale beside the unique character of this scene of many figures acting out a 'history', and the clearly depicted coat-of-arms.

However, it must be admitted that the list is late,[51] and the current label in the museum (based on the probable date of the inventory) states that it is from the second quarter of the seventeenth century. This seems impossible: even the most old-fashioned artist could hardly have produced something like this when Bernini was in his prime. Stylistically, it is a translation into three dimensions of the manner of the Cavalier d'Arpino, as can be seen from his fresco of 1597 depicting the *Battle between the Romans and the Veientes and Fidenates* (Fig. 55). Even the rather mask-like faces are similar, and figures such as the mounted Roman, or the fallen warrior, are quoted almost directly from this fresco. I should therefore be inclined to place it around the turn of the century, or at the latest within the first two decades of the seventeenth, and I introduce it here as evidence of our ignorance of the period, and the wide range of really surprising work, of extraordinary quality, that was being made at the time, and which remains to be investigated.

Among these, and certainly one of the finest and most fascinating, is the tabernacle of the church of S. Luigi dei Francesi. Until 1977 there was a fine gilt bronze tabernacle (Fig. 56) standing in the side chapel built by Plautilla Bricci for the Abbate Elpidio Benedetti, for which it was never intended. Separated from it, seated on the base of the cross on the high altar, were

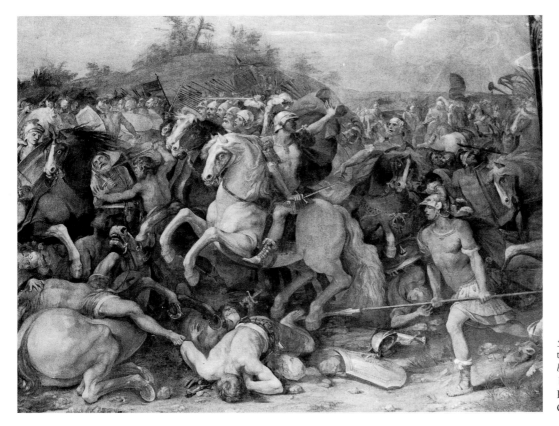

55. Giuseppe Cesare, called the Cavalier d'Arpino, *Battle between the Romans and the Veientes and Fidenates*; fresco. Rome, Palazzo dei Conservatori

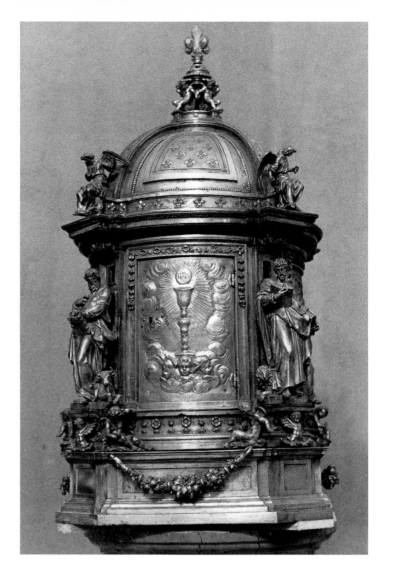

56. Here attributed to Jacob Cobaert, *Tabernacle*; gilt bronze. Rome, S. Luigi dei Francesi

four extraordinary gilt bronze 'Prophets' (Figs. 63–5, 67–8); they were so far from the balustrade closing off the sanctuary that they passed virtually unnoticed, except by Pico Cellini who had prowled around the church while he was restoring the frescoes in one of the chapels, and who generously pointed them out to me. They were quite unlike any other sculptures I had ever seen, and clearly of the highest quality, a fact that must have been equally apparent to the only other person who seems to have noticed them, an enterprising thief.[52]

The four seated figures gained some press notoriety in 1977 when they were returned to the church, the papers all citing their attribution to Benvenuto Cellini, and misguidedly calling them the four Evangelists.[53] Since I was not only the first person to have noticed their absence and alerted the church authorities to the theft, but also had some part in the recovery of two of them, I should here set the record straight: they never came to England, but were offered to a dealer (by, I should add, a perfectly reputable dealer, having by then passed through several hands) who showed me the photos in the hope that I could tell him who they were by; I could not, but I could tell him where they came from, and they thereupon went back through the chain of dealers of increasing shadiness, to return to S. Luigi. When the other pair were subsequently recovered it was decided that they were too precious to be replaced in the church, and that the tabernacle also would be more secure if it were no longer exposed, used, or admired. So this, one of the most beautiful of the small tabernacles of Rome, remains hidden from view. While I am deeply grateful to those who kindly let me study and photograph the bronzes,[54] it is the sort of fate that makes one wonder if it would not have been better to let the thief pass them to some great museum, where they would be properly cared for and displayed, as the patron had intended they should be.

This patron was Cardinal Matthieu Cointerel, who devoted much of his wealth to S. Luigi dei Francesi, the church of his nation. He is better known today under the Italian form of his name as Matteo Contarelli, and as the man who began the chapel in the same church dedicated to his patron saint, St Matthew, subsequently decorated with the famous canvases by Caravaggio. The entry on Matthieu Cointerel in the *Dictionnaire de biographie française* states that his contemporaries described him as 'a man of great learning and integrity',[55] and that, together with the Jesuits and Theatines, he belonged to the party that supported austerity. However, Matteo Contarelli is also included in the *Dizionario biografico degli italiani*, where one reads that after his death an enquiry was undertaken into the way he had run the dataria, which uncovered 'some very smelly material',[56] inculpating also his protector, the former Pope Gregory XIII Buoncompagni; indeed, the whole matter became so explosive that the enquiry was dropped, for fear of damaging Franco-Papal relations.

I have not myself gone into this evidence, but it does seem that Cointerel's generosity was suspiciously lavish for someone of very humble origins, even allowing for his possession of a number of wholly legitimate benefices. It would be more understandable if, as alleged, the sums devoted to the adornment of S. Luigi came from simony and from such activities as giving pensions on Spanish ecclesiastical benefices to non-existent persons, and then having them revert to himself.

At Cointerel's death in 1585 the tabernacle made at his command for the high altar was still ungilded, and, together with a quantity of gold intended for its completion, it apparently passed to his heir and executor Virgilio Crescenzi, who was the son of Cointerel's sister. While Virgilio immediately handed over the other objects the cardinal had left to the church, the Crescenzi held on to the tabernacle, presumably because it was unfinished, and it features in the lawsuit the church brought against them in an attempt to make them complete the chapel, as was also specified in Cointerel's will.[57] While the history of the chapel, with its Caravaggios, is well known, no further information is available about the tabernacle until it was finally passed over to the church in 1602, still ungilded.[58]

There can be no doubt that what we have today is indeed the remains of that tabernacle. Several documents refer to it as 'sprinkled with lilies' (Fig. 57),[59] but when it was handed over to the church in 1602 the receipt lists the four standing Evangelists, four small seated angels, clothed and holding the symbols of the passion (who are still there, seated around the dome, although the symbols of the passion are now lost), six little seated naked angels, four little terminal

57. Here attributed to Jacob Cobaert, Dome of the *Tabernacle*; gilt bronze. Rome, S. Luigi dei Francesi

figures, which represent half-length angels, and three festoons of metal, as well as four bronze seated 'Prophets'. Nothing is said of the three cherubs supporting the lily above the dome, because they would have been included as part of the structure, but it does specify six large bronze angels, 1½ *palmi* high (33.51 cm.) holding lamps, of which there is no longer any trace to be found.[60] Evidently the tabernacle itself, the seated 'Prophets', and these lamp-bearing angels were intended for some very elaborate structure, which we are no longer in a position to reconstruct.

In the 1670s the church was extensively altered under the direction of the architect Giovanni Antonio de Rossi, and the sculptor Pierre Mantonnois was paid 20 *scudi* for two different models for making the tabernacle for the altar of the church, on the orders of the architect.[61] There can be no suggestion that this work included the making of the bronze statuettes. Not only do they correspond too exactly to the figures listed in the receipt of 1602, but, although little is known of Mantonnois, he was a sculptor of the high baroque, whose very different style can be judged from the travertine statue of the sainted *Pope Fabian* (Fig. 58) on the colonnade of St Peter's.[62] Moreover, although Giovanni Antonio Pomini was paid to gild eight statuettes,[63] there are no payments for making such bronzes; on the contrary, the only payments related to the actual making of the tabernacle are to wood-carvers.[64]

It therefore seems obvious that by the last quarter of the seventeenth century the structure of the tabernacle appeared outmoded, or maybe it no longer fitted the remodelled high altar, and a new complex was created. Whether it was then that the lamp-bearing angels were lost, or whether they disappeared when this baroque tabernacle was in its turn dismantled, I have so far found no evidence.

The tabernacle itself is fairly conventional in form, a round *tempietto*, like those small images of the Church held by personifications of Ecclesia. It is distinguished by the fleurs-de-lis that decorate the dome, on the top of which, instead of the more usual cross, is another large fleur-de-lis, and by the quality of the statuettes which adorn it.[65]

The *Evangelists* were popular models, and a number of other casts of them are known, none of which approach the quality of the originals.[66] Their popularity is hardly surprising, for they are quite exceptionally fine examples of their type (Figs. 59–61), strong figures, the almost columnar simplicity of whose frontal view belies the depth and volume of their modelling as they stand not within niches, but upon projecting pedestals.[67] Their movements are restrained, their heavy draperies revealing the structure of their bodies with folds that add to the slight torsion and contraposto, and each head is carefully and distinctly characterised. Remarkable though they are in their weight and majesty, they obey the stylistic canons of the sixteenth century, and only the almost incorporeal angel by *St Matthew* (Fig. 61), with his fluttering, clinging draperies, provides a hint of the mannered, or bizarre.

With the cherubs and the angels seated on the cornice above (Fig. 62) we are still in the world of the normal: the angels' bodies may be slightly elongated, but they were to be seen from below; otherwise, they exhibit the same solid structure and carefully modelled draperies – good but in no way out of the ordinary examples of late sixteenth-century sculpture.

With the four seated 'Prophets', however, we are in a wholly different world: two of them are seated in unusually abandonned poses, and all of their draperies fall around them in great looping folds.[68] They are breathtaking in their daring and originality, and quite unrelated to anything else I know in Italian art of this period. Even their iconography is unusual, but that may be due to the nature of the commission rather than the will of the artist. *Moses* (Fig. 63) is easy enough to recognise, with his staff, the tablets of the law, and his hair rising like the traditional horns at either side of his forehead. The cloak lifted over a powerful knee, that had become almost *de rigeur* for Moses ever since Michelangelo's great marble image of the prophet, has been given to his similarly drapery-swathed companion (Fig. 64), and, although his head is covered with his cloak in the traditional manner of prophets, he has lost his original left arm, and with it what was probably a scroll which would have identified him most likely as either Jeremiah or Isaiah. Seen from the side (Fig. 65), the cloak which is fastened with a large button, or brooch, on his right shoulder, swings far back and curves forward again over his thigh, creating an extraordinary depth

58. Pierre Mantonnois, *St Fabian*; travertine. Vatican City, Colonnade of St Peter's

facing page top

59. (*left*) Here attributed to Jacob Cobaert, *St Luke*; gilt bronze. Rome, S. Luigi dei Francesi

60. (*right*) Here attributed to Jacob Cobaert, *St Mark*; gilt bronze. Rome, S. Luigi dei Francesi

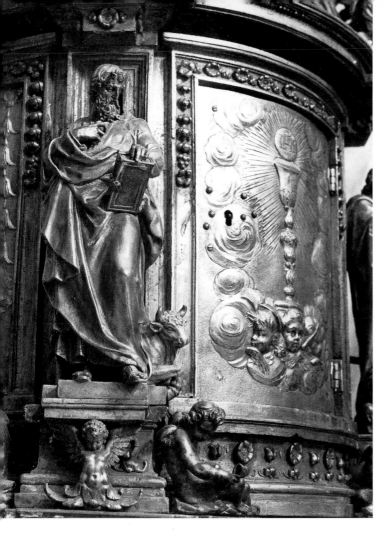

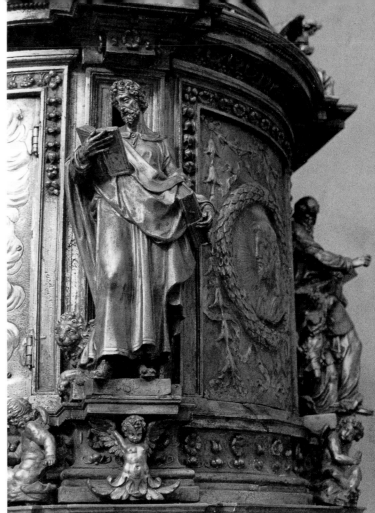

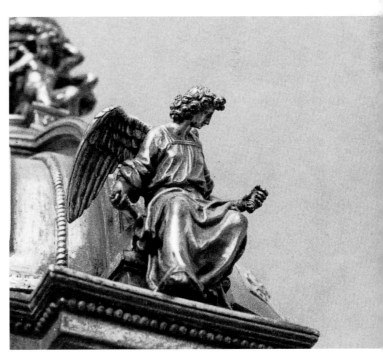

62. Here attributed to Jacob Cobaert, *Angel above St Mark*; gilt bronze. Rome, S. Luigi dei Francesi

61. (*left*) Here attributed to Jacob Cobaert, *St Matthew*; gilt bronze. Rome, S. Luigi del Francesi

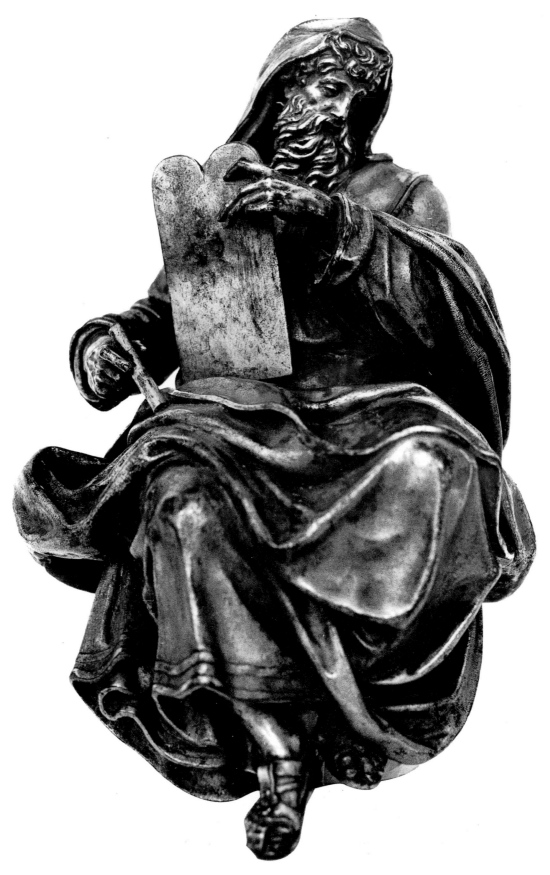

63. Here attributed to Jacob Cobaert, *Moses*; gilt bronze. Rome, S. Luigi dei Francesi

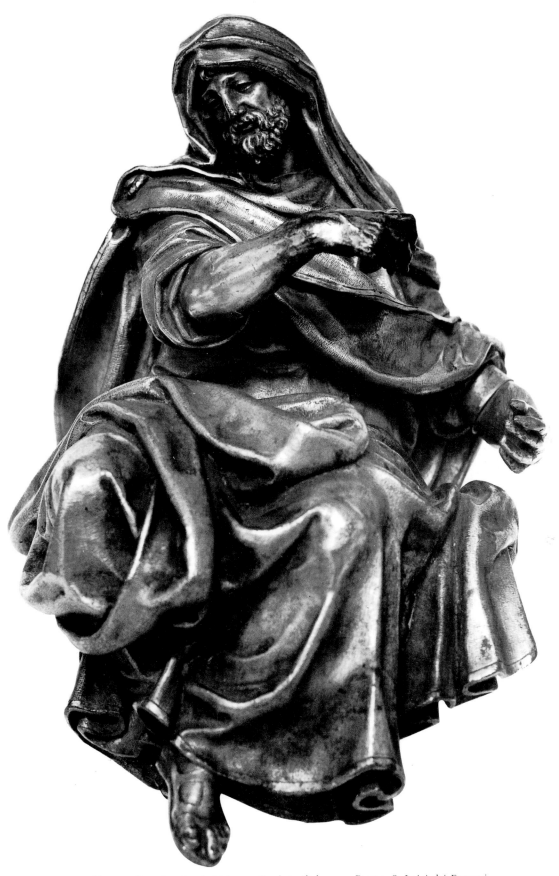

64. Here attributed to Jacob Cobaert, *Prophet*; gilt bronze. Rome, S. Luigi dei Francesi

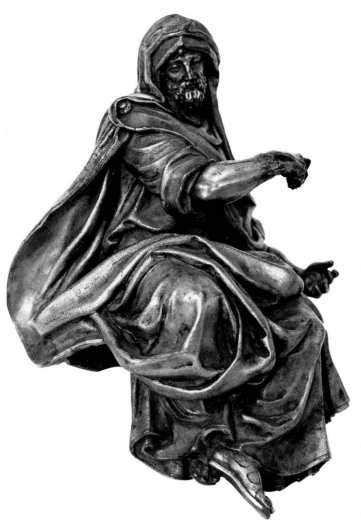

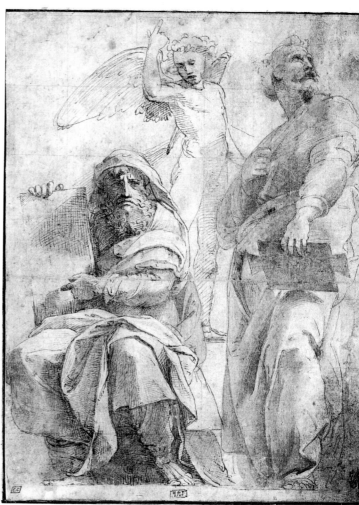

65. Here attributed to Jacob Cobaert, *Prophet*; gilt bronze. Rome, S. Luigi dei Francesi

66. Raphael, *The Prophets Hosea and Jonah*; pen and brown ink with brown wash over black chalk, heightened with white. Washington, National Gallery of Art

67. (*facing page*) Here attributed to Jacob Cobaert, *St Louis*; gilt bronze. Rome, S. Luigi dei Francesi

and openness, in contrast to the rather more closed and solid form of *Moses*. Seen frontally, these bronzes have more than a passing similarity to Raphael's design for the *Prophets* above the Chigi chapel in Sta Maria della Pace (Fig. 66).[69] They are marked below 'B' and 'A' respectively.[70]

Unique to this context is *St Louis*, King of France (Fig. 67)[71] (marked 'C'), holding a sceptre in his right hand, and gazing at the crown of thorns in his left – at least, the curved support which is all that remains suggests that he once held a circular object, possibly something prickly which he might have been well advised to handle with what looks rather like a kettle-holder, and the crown of thorns was the relic that St Louis brought back from his crusade in the Holy Land. Here the cloak takes on an almost independent life, flowing in heavy curving ridges and furrows down the body and over the legs.

The inclusion of the king to whom the church was dedicated meant that it would be confusing to show David in similar regal costume, which forms part of his usual iconography.[72] So the bronze marked 'D' (Fig. 68) provides the more idiosyncratic image of the young shepherd with his sling: the stone is still held in his left hand, but the thongs that would have explained the position of his right are no longer there. Again, there is an almost oppressive weight in the folds of the cloak, which leaves his bare leg and sandalled foot uncovered.

Notable on all the figures of the tabernacle is the fine finish, the quality of the chiselling, and the detailed texturing on the cloaks. The four 'Prophets' are contrasted in age as well as movement, forming two pairs which must have related to their positions on the original tabernacle, those with raised legs no doubt seated at the front, and the more compact pair at the back.

Not only are these figures rather different in style to the four Evangelists, but they are quite unrelated to any other sculpture of the Italian sixteenth century; in the context of the history of art, they ought not to exist.

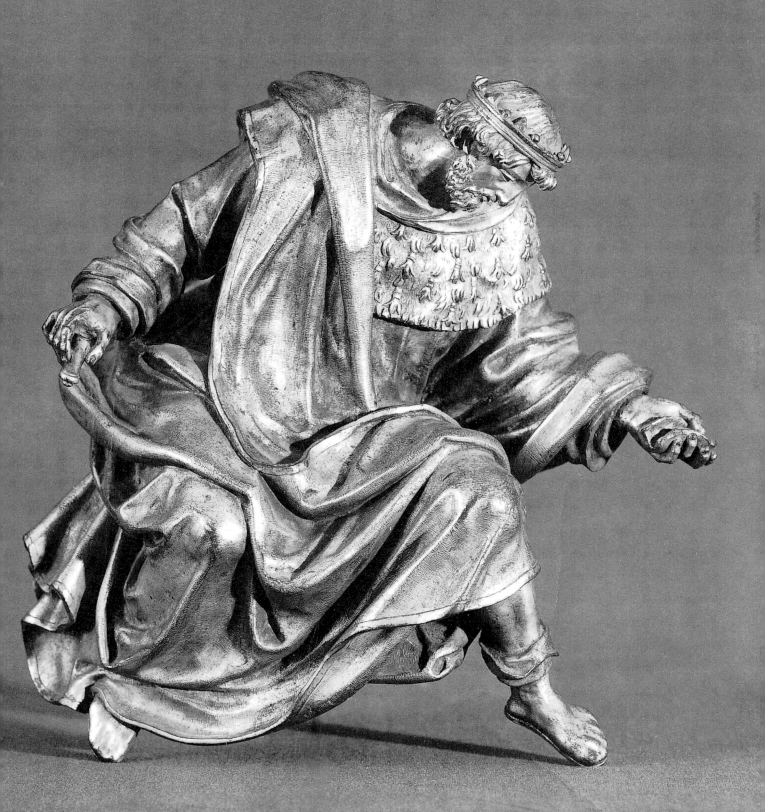

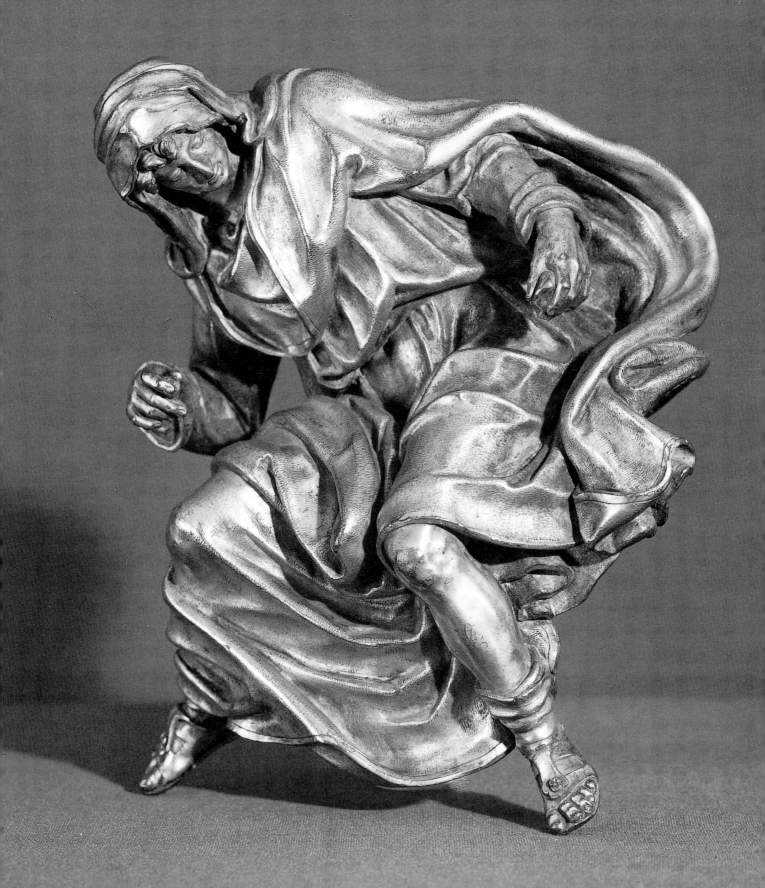

Who, then, are they by? We are looking for someone who can have made only very few original sculptures, or we should know him better, and someone who was distinctly eccentric. And someone who might have been patronised by Cardinal Cointerel.

There is one obvious candidate, the Flemish sculptor Jacob Cobaert, called in Italian Coppe Fiamingo, who, at some time after the death of Guglielmo della Porta (6 January 1577), lived in the same area of Rome as Cardinal Cointerel, possibly even in his house, and worked for him.[73] But any attempt to attribute these bronzes to him is confronted with one serious problem: very little is known about Cobaert, and only one other small-scale sculpture has been traditionally ascribed to him.[74]

We do know, however, that, as he himself testified at a trial, he had been 'brought up' in the house of Guglielmo della Porta,[75] where he had worked for him, making a roundel (probably a basin, with Jupiter and the gods) which no longer exists, and making the relief of the *Descent from the Cross* and the small reliefs of the *Metamorphoses of Ovid*, certainly following Guglielmo's designs.[76] We also know that he was extremely eccentric: according to the biographer Giovanni Baglione, by the end of his life he had become solitary, suspicious, and melancholic; he would allow no one into his house, where he lived 'like a beast', and, when ill, he would let down a basket on a cord from his window and call to a passer-by to get him what he needed.[77]

To discuss the art of Guglielmo della Porta would require not only more space than would be justified here, but also a digression far back into the Cinquecento. But his two sketch-books of drawings[78] are a reminder that, although della Porta's own sculpture is for the most part perfectly normal (though some of his small bronzes are less so than his marbles), his drawings are not. It is clear that such unconventional ideas were current in his entourage, and in his studio, a place where many workmen such as Cobaert were employed in executing his designs.[79]

Although, so Baglione says, it was in sculpture on a small scale that Coppe excelled, he is judged from his one spectacular failure, the large marble *St Matthew* (Fig. 69) which Virgilio Crescenzi, the heir of Matthieu Cointerel, commissioned in November 1587 (two years after the cardinal's death) for the altar of the Contarelli chapel in S. Luigi dei Francesi. Cobaert had no experience in marble carving, and would not ask for help or advice, but, despite many attempts to get him to finish it, continued working on it till 1602, still without making the angel that was to accompany the saint. In that year it was taken to the church, but judged unsatisfactory, and Cobaert renounced 300 of the 1,000 *scudi* that he was to receive.[80] Indeed, one can sense the obsessive reworking of the marble in the deeply gouged hollow of the cloak, and the niggling attention to the folds of the drapery on the saint's left arm and torso.

But why did Virgilio Crescenzi entrust this large and important figure to Cobaert?[81] The obvious explanation is that he was already familiar with other work which had satisfied him as to the sculptor's ability, and, if so, it was no doubt a small-scale work of the type that Baglione regarded as worthy of praise. Indeed, it could well have been this very tabernacle, made for the same church while Cobaert was working for Cointerel.

There are definite similarities between the marble *St Matthew* (Fig. 69) and the standing *Evangelists*, particularly in the bronze of the same saint (Fig. 61), with his frowning brow, the clinging drapery over his chest, and even the pose, looking down over one shoulder at the angel.[82] One can also compare the way his robe hangs loosely over the belt with the identical treatment of the angels, or the figure of *David* (Fig. 68). The similarities are even more marked in the four seated figures, particularly the deep swinging folds of the cloaks of the young *David*, and the *St Louis* (Figs. 68, 67). One might go further, and note that the pose of the angel that was later added to the marble group by Pompeo Ferrucci bears a strong resemblance to that of the angel by the bronze *St Matthew* on the tabernacle (Fig. 61), for all the obvious differences in the style of its execution; could it be that Ferrucci was here following the model left by Cobaert?[83]

The possibility that the *Evangelists* were derived from models by Guglielmo della Porta cannot be excluded. Admittedly, we have no evidence that such figures existed,[84] yet the popularity of these models requires some explanation beyond the fact that Evangelists are the most frequent figures to appear on tabernacles: not only were they the most important of the saints, but there

68. Here attributed to Jacob Cobaert, *David*; gilt bronze. Rome, S. Luigi dei Francesi

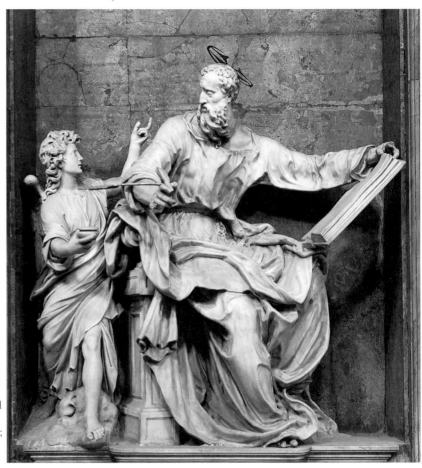

69. Jacob Cobaert and Pompeo Ferrucci, *St Matthew with the Angel*; marble. Rome, SS. Trinità dei Pellegrini

were four of them, which made them ideal for adorning four-sided structures. Their popularity (like that of Jacopo del Duca's reliefs based on designs by Michelangelo) could be due to the fact that they bore the name of one of the major sculptors of the second half of the sixteenth century, even though they might actually have been modelled by Guglielmo's assistant. But if there had been prototypes designed by Guglielmo della Porta, we must assume either that they had never been completed and set in place, or that they have since been lost, for those on the tabernacle in S. Luigi dei Francesi are vastly superior to any other casts known today.[85]

As for the four gilt bronze seated figures, they should be seen as adding not just further examples to the history of late Cinquecento sculpture, but a new chapter, in which the human figure takes on an unprecedented freedom of movement, forming solid and monumental masses, in which sweeping highlit ridges and deep shaded furrows harmonise perfectly with the fine detailing of the heads and hands. If my attribution is correct, the artist who could create such sculpture in metal lacked the experience to recreate a similar effect in marble in his one attempt. Perhaps it was this failure, and his realisation that it was on his marble *St Matthew* that his reputation would rest, that caused, or at any rate increased, Cobaert's melancholy.

The various sculptures examined in this chapter come from a period that was one of the most fascinating and fertile in the history of painting, but one in which the sculpture has been largely ignored, and this is particularly so for sculpture in metal. If one can overcome the prejudice which demands that sculpture should be monumental, and preferably of marble, and look also at small sculpture in metal, it may be possible not only to do justice to the forgotten merits of Jacob Cobaert, but also to discover a new world of art, complementary to, but in no way subservient to that of the standard histories.

3

The Adoration of the Host.
Tabernacles of the Baroque

THE PREVIOUS CHAPTER examined two tabernacles of the end of the sixteenth century, one large and imposing, the other relatively modest, but certainly no less remarkable for its sculptural quality. In this chapter I shall concentrate on two of the larger tabernacles of the later seventeenth century, but first it would be useful to consider the range and variety of forms that could be used to fulfil this function of safeguarding and glorifying the eucharist.

Throughout the seventeenth century Cardinal Carlo Borromeo's influential treatise continued to exert a profound effect on the way that subsequent tabernacles were made. A few were made of precious marbles;[1] most, however, were made of metal, and bronze was the ideal material: it was less prohibitively expensive than silver, and capable of being worked into interesting forms, with any amount of decoration.

It is surprisingly difficult to find any facts about these. Or perhaps not so surprising, given the preference of guide-books for paintings over sculpture, let alone the decorative arts, and considering that these ciboria are usually not even figurative, which does not mean that they are not works of fine craftsmanship, and often extremely beautiful.[2] For example, that in S. Andrea al Quirinale (Fig. 70), of gilded bronze and lapis lazuli, was made in 1697 and paid for out of the legacy of the great General of the Jesuit order, Giovanni Paolo Oliva.[3] But no book on the church mentions the name of its designer or maker, and one even confuses it with the much later urn beneath the altar of St Stanislas Kostka.[4]

Bernini had died in 1680; none the less, it is not impossible that this tabernacle was made from his designs, for the way in which the four volutes around the cupola are composed of palm-fronds rising like flames is very much in his style. However, I have found no documents to prove or disprove this, and the earliest reference to his authorship that I know of is of 1775, and refers not to the ciborium in S. Andrea, but to that in Monte Cassino (Fig. 71), which was copied from it, and was said to be 'made according to the beautiful design of Bernini'.[5] The Monte Cassino tabernacle was commissioned in 1727 from Francesco Arighi and his son Andrea, to be made on the designs of the architect Antonio Canevari 'similar to that of the high altar of S. Andrea a Monte Cavallo of the Jesuit Fathers'.[6] Indeed, the design is basically similar, with a number of differences,[7] such as the omission of the metal foliage over the semi-precious stones (which in Monte Cassino are of various types – agate, amethyst, lapis lazuli, etc. – whereas in Rome only lapis lazuli was used) and the addition of the figures, the gilt bronze angels with the instruments of the passion (both of these changes are specifically mentioned in the contract, which also states that the Arighi are responsible for the models),[8] though there is no mention of the other cherubs which Arighi has added to the basic structure. There is, however, one puzzling phrase in the contract: among the features of the S. Andrea tabernacle that are to be omitted are 'the silver heads of Cherubim at the foot'.[9] It is perfectly possible that these were additions to the S. Andrea prototype which Canevari had intended to make, but if one looks at the tabernacle in S. Andrea it is remarkable that these scrolling feet are the only parts of the whole structure to have no decoration. One should, perhaps, consider the possibility that at one time there were cherub-heads affixed to the tabernacle in S. Andrea.[10]

Late though this reference to Bernini's authorship may be, the fact that the S. Andrea al

 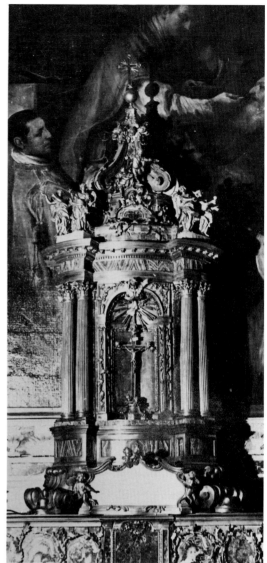

Quirinale tabernacle was regarded as something worthy to be copied some thirty years later is itself proof that it was appreciated, and an indication that its designer was believed to be someone whose works were still worth imitating. Moreover, there are other tabernacles in Rome, in Sta Maria dei Sette Dolore[11] and Sta Trinità dei Spagnoli, that are clearly derived from the same model, which was evidently regarded as a canonical prototype.

One minor ciborium made in Rome (Fig. 72) has aroused some interest among art historians, and for a similar reason: because it was believed to have been designed by the great baroque architect Francesco Borromini, and related to his remarkable perspetive *trompe l'oeil* in the Palazzo Spada in Rome. This is natural enough, since it was constructed on exactly the same principles for the Spada family, for the church of S. Paolo in Bologna, but more serious research has shown that the complicated calculations required for the perspective in Rome were in fact the work of an Augustinian friar, one Giovanni Maria da Bitonti, and it was he who provided the model for the tabernacle also.[12] The marbles used for the columns and the inlays on the sides were cut by Giovanni Somanzi.[13] The bronze work is by Francuccio Francucci and Giovanni Pietro del Duca, whose account for the 'ciborium in perspective' includes the capitals and bases of eight Corinthian columns against the inner wall, of the twelve Ionic columns which form the

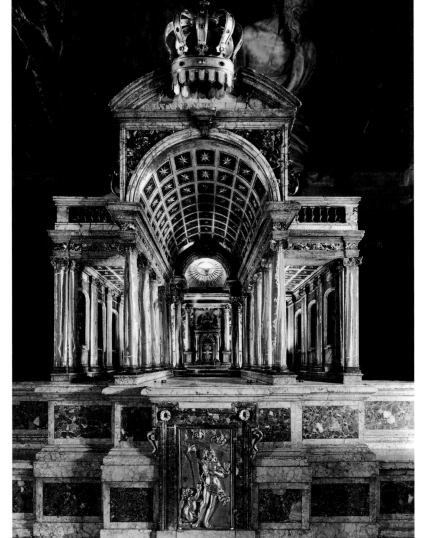

70. *Tabernacle*; gilt bronze and lapis lazuli. Rome, S. Andrea al Quirinale

71. Francesco and Antonio Arighi, on the designs of Antonio Canevari or Nicola Salvi, *Tabernacle*; gilt bronze and semi-precious stones. Monte Cassino

72. Giovanni Maria da Bitonti, Giovanni Somanzi, Francesco Francucci, Giovanni Pietro del Duca, and Francesco Perone, *Tabernacle*; gilt bronze, and precious marbles. Bologna, S. Paolo

perspective, and of ten further Ionic columns; they also made the relief of the Holy Spirit within, the rosettes ornamenting the spandrels of the entrance arch, the ribs of the dome, the balustrade, and the lily of the Spada arms with the (now missing) cross above.[14] The copper ceilings and rays were contributed by the founder and silversmith Francesco Perone.[15]

This tabernacle is extremely unusual in that, unlike those of Sta Maria Maggiore or S. Luigi dei Francesi which imitated the exterior forms of churches, this is a model of the interior view. In another respect it is also peculiar, though, as will be seen later, far from being unique: it does not contain the sacrament, that is to say that the doorway in the centre does not open, and the sacrament is placed below, behind the door decorated with a relief of the *Risen Christ* whose blood flows from a wound in his side into a chalice held by a small cherub. This work is mentioned in Virgilio Spada's accounts, but there is no specific payment for it, and no mention of either the modeller or the founder.[16] The tabernacle, therefore, is purely decorative, its gilded bronze and precious marbles calling attention to the holy sacrament reserved below. One might be tempted to interpret it as symbolising the Church, raised upon the sacrifice of Christ, but it would be more reasonable to see its form as an elaboration of the highly traditional use of an illusionistic perspective leading to the tabernacle door which had been common in Florentine

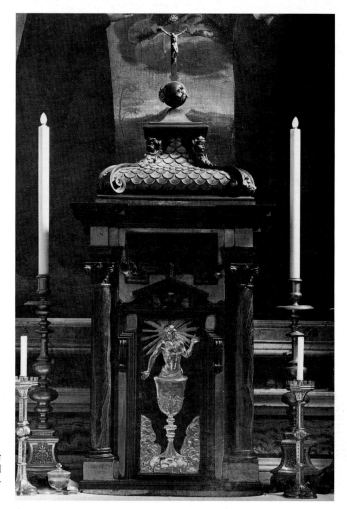

73. Giovanni Artusi and Michele Sprinati, *Tabernacle*; partly gilt bronze, and precious marbles. Grottaferrata, Abbey church of Sta Maria

ciboria since at least the Quattrocento.[17] Yet if one should not read too much into it, one should also avoid the opposite mistake of seeing it as merely an exercise in illusionism, a sort of folly like the colonnade in the Spada palace in Rome. Its intrinsic beauty and its artistry, which depends on the skill of the founders and the stone-cutters as well as the mathematical ability of Bitonti, make manifest the veneration due to the eucharist, and serve to direct the attention of visitors to this central feature of the church, the presence of Christ.[18] Both were as much a part of the tabernacle's function as the more utilitarian act of the preservation of the host.

As a typical example of a simple, small (a little over 1 m. high) ciborium one might take that made for the high altar of the church of the Abbey of Grottaferrata (Fig. 73), but now in the annexed chapel of S. Nilo, known to historians of art for its frescoes by Domenichino. This attractive tabernacle commissioned by Cardinal Francesco Barberini senior in 1664 appears to be simple, until one begins to look at the accounts. The model, it seems, was made by the Cardinal's sculptor Antonio Giorgetti: although Giorgetti's long account for work for Grottaferrata was mainly concerned with the altar,[19] it does include a reference to 'various other models for that altar and for the bronze ciborium and other work'.[20] However, the fact that Giovanni Mattia Sangle claimed that the payment for his gilding of the ciborium and its cupola was agreed by Cardinal Francesco's architect Paolo Picchetti, but that the additional gilding around the doors and on the four bees on the scrolls of the ribs of the cupola was done 'on the orders of Signor Giorgetti',[21] might suggest a divided responsibility. But Picchetti seems to have acted as overseer of the work on the altar in general, and, while I have no proof, I believe that Giorgetti was the real designer of the tabernacle.

The basic casting was done by Giovanni Artusi, one of the leading founders of the mid-century;[22] this included the cupola cast in one with its ribs, and the bases and capitals of the four columns, for which the marble columns had been provided by Giorgetti.[23] However, most of the

74. (*facing page*) Antonio Giorgetti and Michele Sprinati, *Christ in the Chalice*, partly gilt bronze. Grottaferrata, Abbey church of Sta Maria

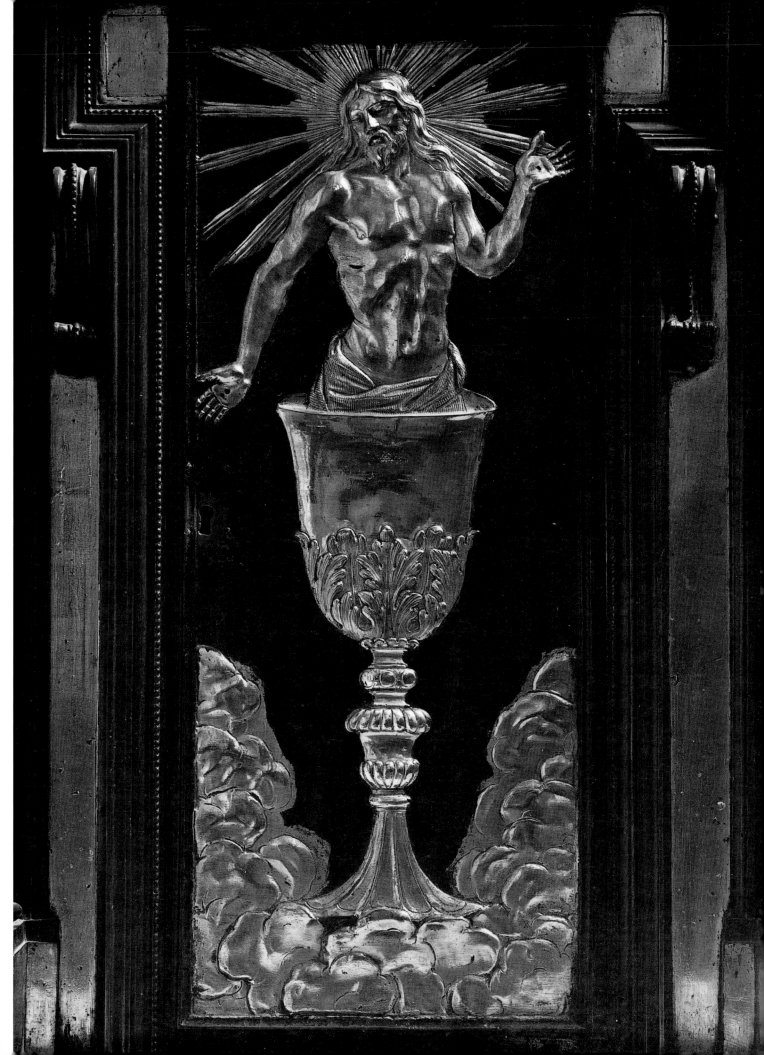

more 'sculptural' parts, including the side panels with their Barberini symbols of laurel and bees, the ball with its three bees and the cross on the cupola, and the door in the front, were cast and gilded by the silversmith and founder Michele Sprinati.[24]

Apart from the complexity of its making, two features of this tabernacle deserve attention: firstly, the *sportello* (Fig. 74), which we should be justified as seeing as the work of Antonio Giorgetti, is a striking visualisation of the doctrine of transubstantiation, making vividly apparent the identification of the eucharistic wine with the blood of Christ; the vine leaves with a bunch of grapes in the pierced relief above also allude to the eucharistic wine.

Secondly, Artusi's account includes the casting of the *finimento* above the cupola, that is to say the triangular base which supports the ball and cross made by Sprinati, and this *finimento* was to be cast 'so as to be able to take it off and put it back as one wishes'.[25] Why should one wish to take it off? This, I suspect, is so that the tabernacle could be used during the Forty Hours' Devotion to the Eucharist, a ceremony that had come into use during the sixteenth century, and was much practised in Italian churches, whether as a diversion from less elevated pursuits during the period of carnival, or during times of crisis.[26] Such Devotions might give rise to extremely elaborate settings for the chalice, as in Fig. 82, but in a small church such as this it would have been more usual to display the chalice and host on a base, surrounded with candles; this ciborium, with its eucharistic symbolism, would have made a most appropriate stand on which to place them.

If this is an example of a simple tabernacle, at the other extreme is that on the high altar of Sta Caterina a Magnanapoli (Fig. 75), which, having been made in 1786–7, is also at the other extreme of my period;[27] indeed, it is outside my stated limits, but, as will be shown, there is justification for assuming that the relief on the door was originally modelled considerably earlier. The design of the tabernacle was made by Carlo Marchionni (1702–86), and the nuns must immediately have begun to solicit the considerable sum of money required, 3,475.77½ *scudi*,[28] from a number of pious benefactors. Work on the tabernacle was under way by March 1786, but Marchionni died in July, and the architect Giovanni Antinori assumed responsibility for its completion.[29]

The work in stone was done by the *scarpellino* Carlo Lucatelli, and the high payment of 1,700 *scudi* included some stone of his own that he contributed. Although he agreed to this sum in March 1786, with the assurance that he would assist in setting it up without extra payment, he did in fact receive a further 100 *scudi* on 20 May 1687 for having covered the globe with a paste of lapis lazuli, adding some lapis lazuli, mending some of the *pietre dure*, etc., moving it many time so that the metal parts could be affixed, and finally setting it in place.[30]

It is this metalwork that is of relevance here. It was begun by Giuseppe Giardoni, the son of Francesco (with whom we shall be concerned in chapter 6), but he died on 13 January 1787, and the work was completed by his brother Nicola. Little is known of Giuseppe,[31] but Francesco must have been known personally to Carlo Marchionni, who made two sympathetic caricatures of him (Fig. 201).[32] Nicola Giardoni's account includes all the parts one can see: the various cornices, the bases of the columns and their carefully chased Corinthian capitals, the reliefs of grape vines and wheat below the door and that of two cherub-heads above, the relief of the pelican in its piety, the garlands of laurel and oak, the volutes, the clouds full of cherub-heads and little angels who hold the globe, the globe itself (which is covered with the lapis lazuli paste), the cross (which he insists is so attached that it can be removed), and the twenty-pointed star beneath the globe, as well as the door with its scene of the Resurrection.

But there is also an item in his account for 'having chiselled the arms of one of the two angels who are placed on the step, with their four wings put together, and soldered the other arm of the other [angel], adjusting both on the pedestal of the said ciborium which was awkward work; the said angels were paid for in the old account, except for the above work . . .'.[33] These angels, which must have been placed on the predella, presumably either side of the tabernacle, are no longer there. Moreover, this is not the only reference to a lost 'old account' (or 'old metal', which must mean metal that had already been partly worked), though it is doubtful that there was anything else of substance, since most such references concern chiselling metal that had previously

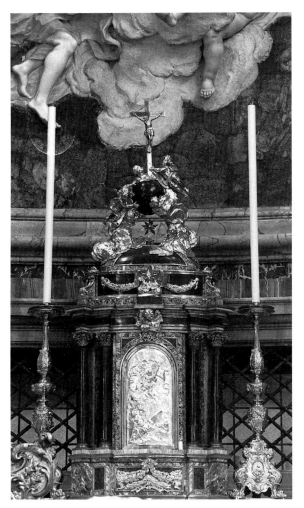

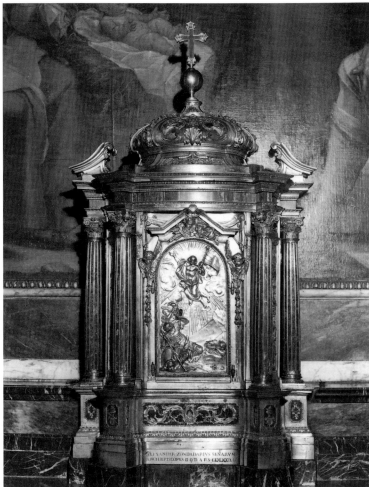

been cast. It is reasonable to assume that this previous work had already been done by Giuseppe Giardoni.

This is, or was, certainly one of the most splendid, as well as one of the most elaborate of the small tabernacles of the Roman *barocchetto*, both in the brilliance and richness of its colours – the deep blue of the lapis lazuli contrasting with the mottled mauve of the marble, and set off by the glowing gold of the metal (which has unfortunately been recently regilded with a vulgarly bright modern gold, which makes it impossible to read, or photograph, the modelling) – and also in its design, with its gentle oval shape, and the remarkable conception of the blue globe borne on the angel-filled clouds and supporting the cross. The use of such spheres supporting a crucifix above the top of a tabernacle is by no means unusual; as we have seen, it was employed also at Grottaferrata, but here its blue colouring gives it a particular significance, as if it represented the sphere of the heavens.[34]

Nicola Giardoni's account includes the sum of 16.75 *scudi* 'for models of every sort used for the said ciborium'.[35] This is not a high sum, and unfortunately it is not clear whether he paid it to a sculptor, or whether he himself made the models. He might well have made the little cherubs and decorative details, but it would be more surprising if he had modelled the *sportello* (Fig. 77), with its splendid relief of the *Resurrection*, though the casting is included in his account.[36]

In fact, there is good reason to believe that the original model had been made many years previously. On the altar of S. Vittorio in Siena Cathedral is a relatively simple but beautifully designed tabernacle of gilt bronze and lapis lazuli (Fig. 76), and on the door is exactly the same relief of the *Resurrection* (Fig. 78).[37] Very little is known about this tabernacle, for which no

75. Carlo Marchionni, Carlo Lucatelli, Giuseppe and Niccola Giardoni, *Tabernacle*; gilt bronze, lapis lazuli and precious marbles. Rome, Sta Caterina a Magnanapoli

76. *Tabernacle*; gilt bronze and lapis lazuli. Siena Cathedral

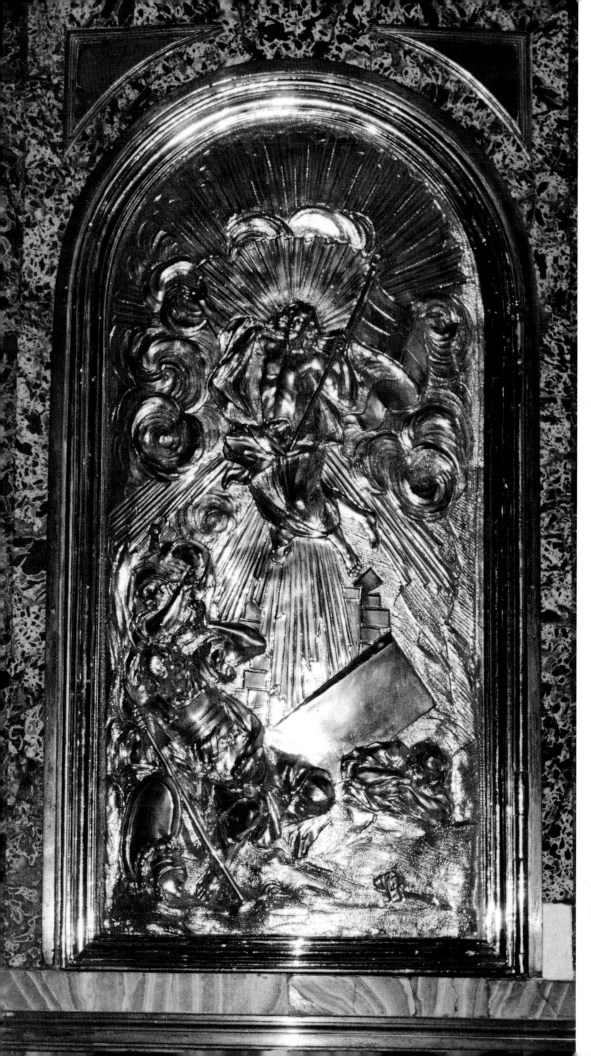

77. (*right*) Niccola Giardoni, possibly on the designs of Carlo Marchionni, *Tabernacle door*; gilt bronze. Rome, Sta Caterina a Magnanapoli (detail of Fig. 75)

78. (*facing page*) *The Resurrection*; gilt bronze. Siena Cathedral (detail of Fig. 76)

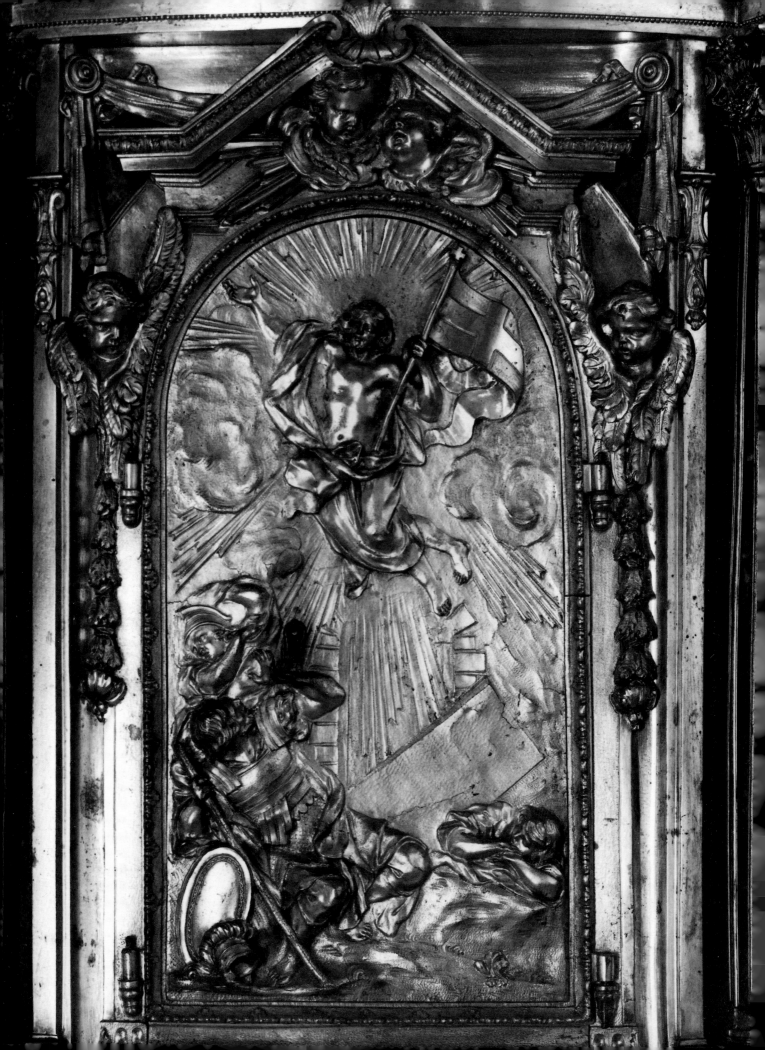

documentation has appeared in either Siena or Rome; it was given to the cathedral by the Archbishop Alessandro Zondadari in 1744,[38] but the guide-books, starting with that of Pecci of 1752, state that it was made in Rome.[39] It is quite possible that the Siena tabernacle was also designed by Marchionni, and that he was responsible for the design of the *sportello*.[40] But it is also possible that both tabernacles were cast by the Giardoni family, and that the founder used a model that was already in his workshop, even if he had to alter the scale. Whoever was responsible for providing the design, it is a superb rendition of a scene frequently used on tabernacle doors, and one which, were it removed from its context, could hold its own in the sculpture section of any museum.

I have dwelt at some length on these relatively small ciboria, because it is necessary to have an idea of the multiplicity of forms that they can take, of the sort of ornamentation that would be expected, and of the number of hands involved in the production even of something that appears to be quite simple, such as the tabernacle of Grottaferrata. It is against this background that we should set two of the most remarkable tabernacles of the Roman Seicento.

The ciborium in Sta Maria in Vallicella (Pl. VII) is hardly unknown, and has already been the subject of several studies.[41] None the less, it can still repay examination.

The Oratorian church of the Vallicella, commonly known as the Chiesa Nuova, was never rich: every stage of its adornment was subject to rigorous cost-limits. Financed by legacies from the often wealthy members of the order, or by the sale of various gifts and donations made in kind, the church's main source of income was the devotion to the order's founder, St Philip Neri. So it was typical that the first decision taken in 1653 to make a proper tabernacle of sheet-silver designed by Pietro da Cortona, assigned for this purpose 477.40 *scudi*, made up of 270 *scudi* to be raised by melting down nine chalices which had been presented annually over the past nine years by the Conservatori of Rome, plus 179.40 *scudi* to be realised by selling a jewel that had been donated by an unknown person in honour of St Philip Neri.[42] However, the model did not please the Oratorian fathers, and nothing came of this project.

This is not the place to list the various abortive attempts to fulfil the pope's wish that the Blessed Sacrament should always stand on the high altar,[43] and to provide a fitting tabernacle in which it could do so. It was in 1672 that suddenly, and without any record of a decision on the part of the Oratorian fathers, Ciro Ferri is recorded as at work on his model. Indeed, this emerges not from the archives of the Vallicella, but in the correspondence between the Florentine academy in Rome and the authorities in Florence,[44] and it is more than six months after it is mentioned in a letter from Ferri to Falconieri in Florence that there is the first reference to this model in the Vallicella archives, decreeing that the design Ferri was currently modelling in clay should be exhibited in public.[45]

The model was made with the assistance of Carlo Marcellini, a student at the Florentine academy. This would be to the advantage of all: Ferri had a sculptor to work on his designs under his supervision, for he was one of the regular teachers at the academy; Marcellini gained experience (in addition to being well paid for his work), and the grand duke who supported the academy would benefit from this public triumph of one of his protégés – or, at least, this was Ferri's argument, though it was not till Lankheit's publication in 1962 of the correspondence between Rome and Florence that anyone seems to have been aware of Marcellini's involvement. The fathers liked the design, even though it would cost 2,500 *scudi*.[46] This cost was to prove a problem throughout the execution of the project: various bequests were applied to it, and jewels sold, but still they had to assign 300 *scudi* of their own money, leaving a further sum of 103.60 *scudi* owed to the Congregation of the Fabbrica of St Peter's for bronze, which in March 1683 they decided would be repaid from the 900 *scudi* which father Cesare Massei had promised that his heirs would pay towards the cost of the tabernacle after his death.[47]

But this was not the only problem to be met before this tabernacle could be realised. Of greater interest to art historians are the changes made to the design, and the failure of part of the casting resulting in a complicated lawsuit between the Oratory and the founder, who was not the unknown Benincasa da Gubbio, as stated by Titi in 1686,[48] and followed by everyone since, but an almost equally shadowy figure, Stefano Benamati, son of Valerio, whose father did indeed

come from Gubbio.[49] We are fortunate in the fact that the Oratorian fathers were unsatisfied with Benamati's work, and took him to court; fortunate because the more demanding or dishonest the patron, or incompetent the artist, the happier the art historian, since such a situation can result in a lawsuit, and lawsuits are only marginally less advantageous to art historians than they are to lawyers.

It is not certain when the model was completed, but from January to April 1676 a total of 6,438 *libbre* of copper passed through the customs house of Rome.[50] In March and August the bronze angels were consigned by the founder to the silversmiths Antonio Mannottoli and his brother Lorenzo,[51] and in 1677 the socle was delivered to father Giovanni Battista Pascucci of the Oratory. In October 1677 the first putto was delivered to the silversmith Vincenzo Brandi, but it was not till two years later that he received the second. I can only speculate as to why Benamati should have consigned most of these bronzes to three silversmiths (the brothers Mannottoli, and Domenico Vincenzo Brandi)[52] but it seems likely that he handed them over as they came from the foundry, and that it was for the silversmiths to undertake the extensive work of finishing them. This is the more plausible in that the frame for the silver pelican on the socle, which had also been cast by Benamati, was finished by another silversmith, Giovanni Domenico Navona.[53]

So far all seems to have proceeded smoothly, and on 18 December 1679 two experts were elected, since the price had not been agreed in advance, and the value of the work was uncertain.[54] Girolamo Lucenti was chosen by father Domenico Acami, the sacristan of the Oratory, and Domenico Guidi by Benamati, both of them former assistants of Algardi, and suitable choices, being at the same time sculptors and founders;[55] if they did not agree, Bernini was to be called as a third expert. This was not necessary, and on 5 January 1680 Lucenti and Guidi presented an agreed valuation of the work done so far, that is, 'two large angels, two small, and the socle', on the basis of 'the value of the material, the moulding, the waxes which had been made several times, the wastage of the metal, the casting, and everything that has been spent on the aforesaid work till the consigment of the same'. This they estimated at 50 *baiocchi* the pound.[56]

But by 1681 things had gone badly wrong: the three remaining putti had been seized by the police, and the Oratorians claimed that they were unfit for use. The matter was put in the hands of the judge Alessandro Caprara, and new experts called in to decide on this point, and also to revalue everything, including the parts already valued by Guidi and Lucenti.[57] We have the reports from two of the experts, Carlo Fontana, the expert called by Acami, and Giovanni Battista Contini, the third expert who was called by the judge;[58] but we lack the statement of Benamati's expert, and, alas, the decision of the case, though from the accounts of Benamati it appears that the valuation of the third expert was accepted. From these documents much can be learnt about the making of the tabernacle.

From Fontana's statement it appears that the reason for the various waxes was that there had been a failure in the casting, which he accepted as a normal occurrence. He estimated the value of the work at 42½ *baiocchi* the pound, but, more important, he regarded the three disputed putti which were in the workshop of the Brandi at the Pellegrini as so defective as to be incapable of remedy, and unusable. Contini, however, was much more favourable: he estimated the value at 57½ *baiocchi* the pound, and, as for the three flying putti, he considered that if Benamati took them back, assembled them, repaired them, and finished them to the same standard as the others, the work would be of the same value. Benamati in his accounts admitted that there were some holes in the these three putti, though he described them as such as were usually encountered in every bronze casting; they were not repaired because the putti were seized on the orders of Father Acami before he could do so.

Of particular interest is the addition Contini appended to his estimate, that Benamati should be paid for the wax casts he had made, but which had not been cast in metal or delivered: the moulding and casting of the two large angels, the moulding and waxes of four little wings for the small angels with the draperies added later by Signor Ciro, a wax of a putto made for the third time on the orders of Signor Ciro, and having gone to the palace of the grand duke (presumably the Florentine academy at the Palazzo Madama) also on Ciro Ferri's orders to mould an arm for one of the putti in front of the socle, and waxes of the handles, leaves, grapes, wheat and other

79. Ciro Ferri, sketch for the Vallicella *Tabernacle*; Pen and brown ink. Rome, Istituzione Nazionale per la Grafica

80. Ciro Ferri, drawing for, or after, the Vallicella *Tabernacle*; black chalk. Windsor Castle, Royal Library

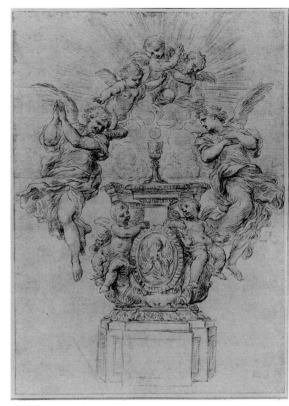

ornaments made for trial of the ornamentation of the tabernacle, and not used. For all this work he judged that the founder should receive a further 40 *scudi*.

This gives some idea of the changes in the design which Ciro Ferri must have introduced during the execution of the tabernacle. It will be noted that two things have not been mentioned in any of these statements: the relief of the pelican, which is included in both of Ferri's drawings (Figs. 79–80), and the lamb, which appears on his sketch (Fig. 79).

The absence of the pelican is not, of course, surprising, since it was of silver, and Giovanni Domenico Navona, as well as cleaning the frame, cast, added, and gilded the nest. It might be assumed that the pelican had been made by one of the silversmiths involved (Antonio and Lorenzo Mannottoli, Vincenzo Brandi) though I have found no payments to them, and there is no visible maker's mark on the relief; moreover, were this so, it must be supposed that the nest was an afterthought.[59] We should note that in his preliminary sketch for the whole tabernacle (Fig. 79)[60] Ferri appears to have had second thoughts not only on the placing of this oval, but also on its size. None the less, it is a strangely archaic image, far more so than that on his finished drawing (Fig. 80).[61] It seems most probable that it was something that already existed, possibly even part of the original ciborium of the Oratory.[62] Despite the impression conveyed in most photographs that it is attached to the socle, and might even have been intended to serve as the door of the tabernacle, its function is purely decorative – a thin relief held before the socle by the two putti, almost like a venerated image. As in the tabernacle in Bologna, the host is in fact conserved in the base, which here has no figurative decoration.

The lamb is far more worrying. We know that it was part of Ferri's original conception, not only because it appears on his sketch, but also because in his letter of 5 December 1672 concerning the work that Carlo Marcellini will be doing he said that the ciborium 'will consist of two angels and diverse cherubim who adore the immaculate Lamb';[63] moreover, the altar would look remarkably bare without it. We can certainly discount the possibility that the finished drawing in Windsor represents an alternative idea, though Ferri did on occasion make finished

drawings or *modelli* for his sculptural projects. Its purpose is obscure, and, while it may well have been made for an engraving, it is likely that the lamb was removeable, like the top part of the ciborium at Grottaferrata,[64] and that this drawing shows how the altar could have been used for the exposition of the sacrament during the Forty Hours' Devotion.[65]

Yet no lamb was cast, and it was not till 18 April 1684 that Francesco Nuvolone signed a receipt for 15 *scudi*, the full payment for the clay model he had made 'which should serve for the finishing or *chupolino* of the bronze tabernacle made by the . . . fathers, according to the design of Signor Ciro Ferri'.[66] Although the punctuation introduces an element of ambiguity, and the citation of Ferri could refer to the tabernacle, the most plausible reading is that this change in the conception of the ciborium is also to be ascribed to him.

There had been various problems with the tabernacle. In 1682 it had been replaced on the altar so that it could be adjusted and improved, but the fathers did not want it until it had been given its correct and final form.[67] In February 1684 it had been decided to make a wooden mock-up of 'that which is necessary so that it may serve appropriately' (which was presumably this upper part),[68] and in June it was decided to replace the tabernacle, but without the angels which were previously there;[69] however, when Ferri protested, it was agreed that they should be replaced to see whether they made a better effect than they had done previously.[70] Despite the word 'Angeli', I suspect that these were not the two large angels, but the flying cherubs, for, as Incisa della Rochetta has pointed out, the new voluted top surmounted by the orb serves to hide the heavy iron rods supporting these cherubs. Although the mass of clouds shown on the Windsor drawing would serve the same purpose, it is doubtful that it was ever intended such clouds should form part of the permanent structure. Apparently the fathers now accepted that the effect was satisfactory, for this is the last reference to the tabernacle in the Vallicella archives of the period.

So the ciborium as we now see it is something of a compromise. Originally, Ferri had conceived an altar, adorned with an image of the pelican in its piety, on which lay the sacrificial Lamb of God, adored by angels and cherubs. Contini's statement suggests that the grapes and wheat on the socle, not visible on the Windsor drawing,[71] may have been a substitution for the lamb on a tabernacle otherwise bare of any symbol of its eucharistic function. Certainly, it seems that Ferri intended the two flying angels to be set closer to it, making a more compact unity.[72] There are other minor differences between the Windsor drawing, which no doubt represents Ferri's definitive conception, and the tabernacle as executed, such as the omission of the drapery over the left thigh of the cherub at the left of the socle; it might be tempting to see this as one of those pieces of drapery Benamati tried out, but did not use, whereas he has added to the cloak over the right thigh of the large angel at the right. But the main changes are in the cherubs above: a leg and rather awkwardly placed arm are now visible on that at the right, and the orientation of that at the left has been changed, counteracting the slightly disturbing effect of motion in the group on the drawing; there is also a great deal more drapery over that cherub, which might possibly hide defects in the casting. Almost all of the drapery wafting around these cherubs is cast separately, and screwed on (Fig. 81).[73]

This essentially painterly invention is remarkable in its originality. At much the same time Baciccio was painting his *Adoration of the Lamb* for the apse of the Gesù,[74] but the direct combination of the lamb with the tabernacle, as, indeed, their combination in such a form as to suggest the sacrificial altar on which the lamb is placed, was a new idea.[75]

This theme of adoring angels was no doubt influenced by Rubens's altarpiece above, in which angels kneel in adoration of the Virgin and Child.[76] This was a copy of the sacred image of the Madonna della Vallicella which is still present below Rubens's painting, a hieratic image in which the Virgin holds the Child before her in a manner that could suggest the priest holding the eucharist during the mass. Indeed, while the adoration of the lamb makes perfect sense, the tabernacle would have taken on a special significance if and when it was used to support the host, as in Ferri's drawing, when the relationship of God incarnate in the human infant depicted in the altarpiece was parallelled by Christ's presence in the transubstantiated bread and wine of the eucharist.

Kneeling angels adoring the altar, or the ciborium, were not unknown in earlier art,[77] but in

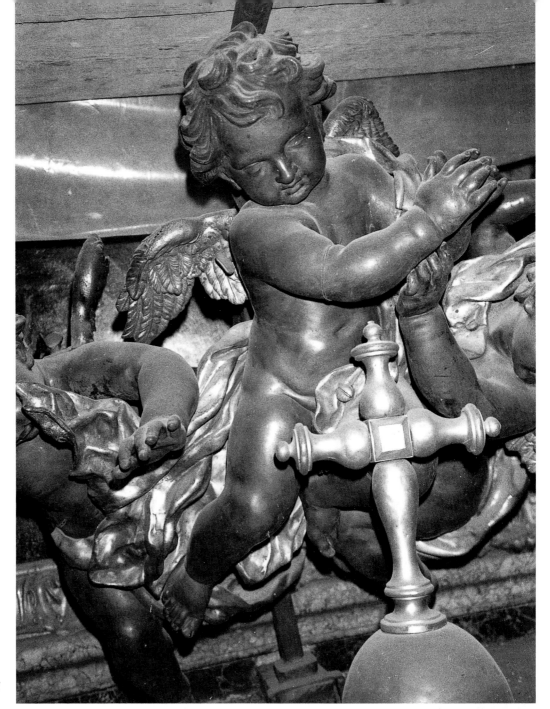

81. Ciro Ferri, Stefano Benamati, *Cherubim*; partly gilt bronze. Rome, Sta Maria in Vallicella (detail of the *Tabernacle*, Pl. VII)

the mid-seventeenth century they began to take flight. They did so first in the ephemeral decorations used for the Forty Hours' Devotion, as can be seen for example, in two such designs made by Ferri's teacher, Pietro da Cortona, for the church of S. Lorenzo in Damaso: those of 1633 (Fig. 82)[78] and 1650.[79] But by the 1670s Ferri was not the only sculptor to cast them in the permanent medium of bronze. A beautiful but almost forgotten tabernacle in Sta Maria della Vittoria in Milan (Fig. 83), which is closely dependent on such designs for the Forty Hours' Devotion, must surely be the work of Antonio Raggi, and, if no documents have been found supporting this attribution or providing a date, it is first mentioned in 1674, and was probably made shortly before.[80]

In the Vallicella, however, they do not serve to hold the tabernacle, but hover in seemingly unsupported flight, in eternal attendance upon the divine mystery of Christ's sacrifice. Rather than an intrusion into Rubens's altarpiece, these angels and cherubs, despite their smaller size,

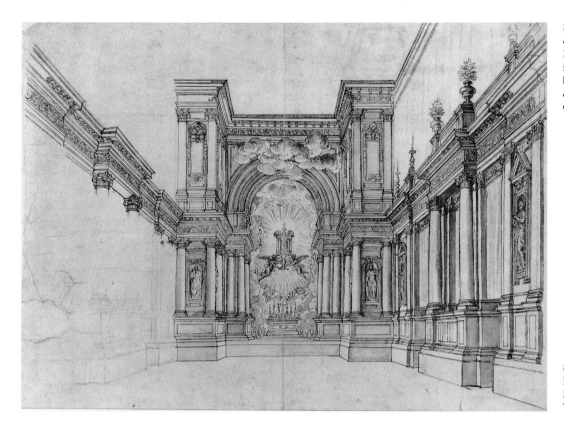

82. Pietro da Cortona, design for the 40 Hours' Devotion in S. Lorenzo in Damaso, 1633; pen and brown ink, brown wash over black chalk. Windsor Castle, Royal Library

83. Attributed to Antonio Raggi, *Tabernacle*; bronze. Milan, Sta Maria della Vittoria

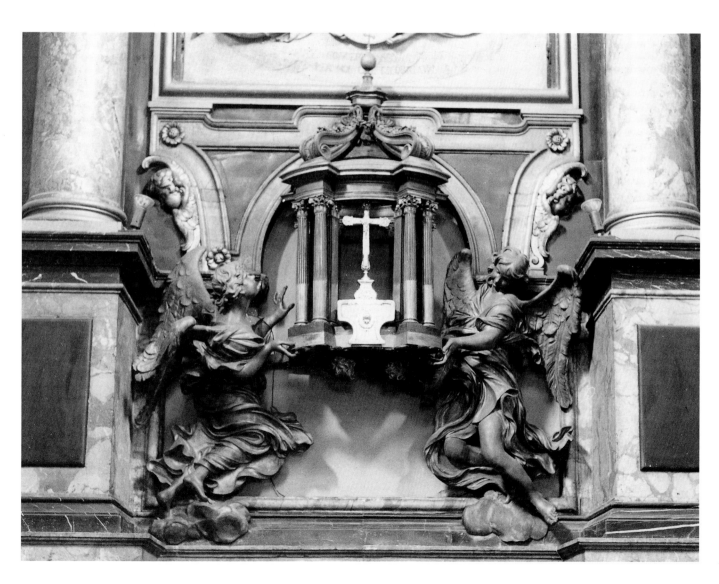

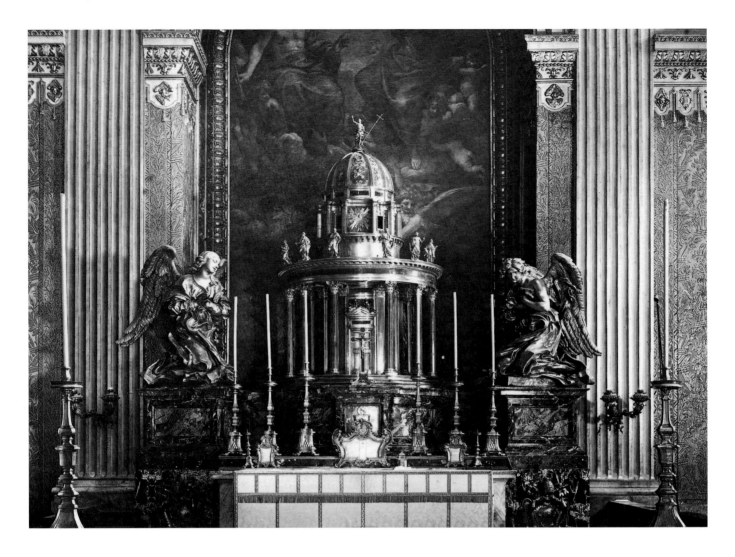

84. Gianlorenzo Bernini
and assistants, *Tabernacle*;
gilt bronze and lapis lazuli.
Vatican City, St Peter's

should be seen as having strayed out of his altarpiece, assuming three-dimensional form, but still
adoring the God made flesh.

I have emphasised the originality of Ferri's conception, but another artist was experimenting
with the combination of a tabernacle and adoring angels at about the same time. It is impossible
to prove or disprove an influence of Bernini's tabernacle on that of Ciro Ferri, since, although
Bernini began work on his project for St Peter's as early as 1629, there is no evidence that Ferri
would have known of his ideas, and the far less original ciborium that Bernini finally produced
was not set up till the end of 1674.

It was at the end of March 1629 that Urban VIII commissioned Bernini to make a metal
tabernacle for the chapel of the Most Blessed Sacrament,[81] and the year before Pietro da Cortona,
who also designed the cupola of the chapel, had been commissioned to paint the altarpiece of the
Trinity for the chapel in which the present tabernacle stands. The disturbing fact is that the
bottom of this painting comes only a short distance above the altar, so that even a small tabernacle
would inevitably obscure part of it; it is unlikely that the pope would have wanted a small
tabernacle, and, certainly, Bernini never had any intention of producing one, but it is clear from
the documentation that this tabernacle was designed for a different chapel.[82]

Just what Bernini did intend is difficult to say. A decree of five months later suspended work
on this tabernacle; however, a large circular wooden ciborium was made in the early 1630s, with
two cherubs on it, and four angels and *Sts Peter* and *Paul* somehow related to it,[83] which
presumably followed Bernini's designs.

The project for the tabernacle was taken up again under Alexander VII, but all that is known
of it are payments of 1658 and the following years to Bernini for overseeing various works,
including 'the Ciborium for the Most Holy Eucharist'.[84] But nothing came of this either. It was

not till 1672, in the Pontificate of Clement X Altieri, that the project was revived, and finally completed in time for the Holy Year of 1675 (Fig. 84).

The fact that Bernini's surviving drawings connected with the tabernacle show him experimenting with three different ideas creates a stong temptation to relate the three groups to the three periods that he must have worked on it. But the style of the drawings makes this impossible, and all the surviving drawings appear to have been produced during the early 1670s.[85] However, the one fairly constant element is the circular tabernacle itself, which may well go back to the original scheme evolved under Urban VIII.

This clearly derives from the famous *Tempietto* built by Bramante in the cloister of S. Pietro in Montorio, and we see it already in what is generally agreed to be the first of Bernini's plans for the tabernacle, in a drawing in the Hermitage Museum in St Petersburg (Fig. 85).[86] It will be remembered that Carlo Borromeo had suggested the use of angels to support the tabernacle, as was indeed done in Sta Maria Maggiore. It is perhaps not surprising that Bernini should have tried out such an obviously attractive conception, given his liking for such acts of levitation, whether it be the obelisk of the Piazza Navona fountain raised on a pierced rock, or the Cattedra Petri held aloft by the four doctors of the church, not to mention his various projects for the obelisk before the church of Sta Maria sopra Minerva,[87] or the design for the golden rose (Fig. 27). However, not only would the angels have blocked out entirely the lower part of Cortona's altarpiece, but the tabernacle itself would have risen 25 *palmi* (some 5.48 metres) above the altar.

The next stage in the development of his design concerns only the angels. Those in the Hermitage drawing, as well as supporting the tabernacle, carry torches, and this idea of surrounding the tabernacle with lighted candles, closely related to temporary decorations for the Forty Hours' Devotion, was one to which Bernini remained very deeply attached (Fig. 86).[88]

There are many drawings for these angels,[89] though just how many Bernini intended to place on the altar is not clear. It seems, from a drawing such as Fig. 87[90] that he may have planned two arcs either side, giving the impression of a semi-circle of kneeling angels surrounding the tabernacle with light. Although in its present state there would be no space for the angels behind the tabernacle, in an earlier project 'the ciborium would not have been almost adhering to the wall, but rather nearly in the middle of the chapel',[91] but in that scheme there would have been only four 'cherubim'.

Even in these drawings the function of bearing their candles is subordinated to the gestures of adoration. Once the angels had put the tabernacle down on the altar, though still not forgetting

85. Gianlorenzo Bernini, design for the *Tabernacle* of St Peter's; pen and brown ink, brown wash. St Petersburg, State Hermitage Museum

86. Gianlorenzo Bernini, study for an angel; black chalk. Windsor Castle, The Royal Library

87. Gianlorenzo Bernini, study for angels; black chalk. Leipzig, Museum der Bildenden Kunst

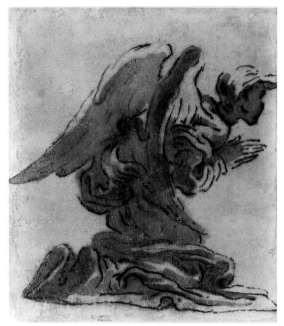
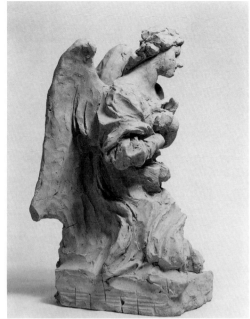

88. Gianlorenzo Bernini, study for an angel; black chalk with brown wash. Windsor Castle, The Royal Library

89. Gianlorenzo Bernini, *bozzetto* for an angel; terracotta. Cambridge (Mass.), Fogg Art Museum

to hold their great candlesticks, they were freed to concentrate on their more normal activity of adoring the sacrament (Fig. 88)[92] in accordance with the statement of the Council of Trent: 'We believe the same God to be present in the sacrament, of whom the eternal Father said, when he brought Him into the world, "Let all the angels of God adore Him"'.[93] When he came to model terracotta *bozzetti* for them (Fig. 89)[94] Bernini abandoned the idea of fitting candlesticks into gestures which, from the first, had clearly been studied without these encumbrances (Fig. 90).[95]

However, even as he approached his final design, Bernini could still not abandon this desire for lighted candles, and a workshop drawing (Fig. 91)[96] shows him placing, between the adoring angels and the base of the tabernacle, two kneeling cherubs holding candles, disposed in such a way that we must imagine there to be four of them. The putto on the left is drawn on an added piece of paper, and the candlestick behind him on another added strip; but below this addition

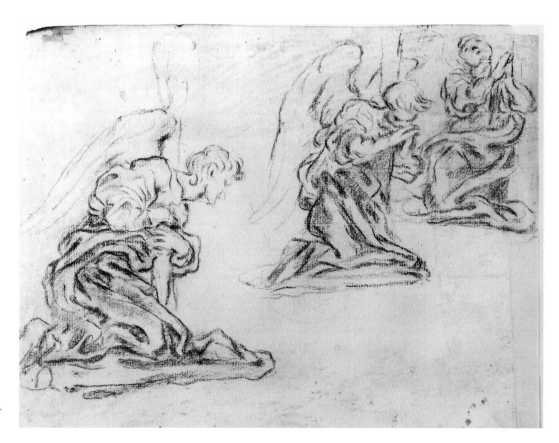

90. Gianlorenzo Bernini, study for angels; black chalk. Leipzig, Museum der Bildenden Kunst

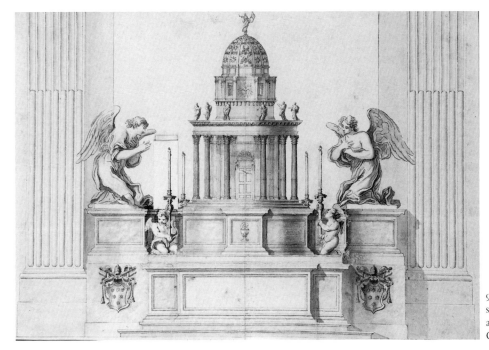

91. Workshop of Gianlorenzo Bernini, study for the *Tabernacle* of St Peter's; pen and brown ink with grey wash. Windsor Castle, The Royal Library

is a branched candelabrum. Whether supported by cherubs or free-standing, at this stage candles were still an essential part of Bernini's scheme.

Apart from this continuing desire to combine the ciborium with light, the implied presence of two more cherubs behind the base, like the previous scheme for two arcs of kneeling angels, points up Bernini's concern to emphasise the solid roundness of his *tempietto*, set forward from the altar painting. In the final formulation the bases of the two great kneeling angels curve forwards, so that they are seen obliquely, though this is not very obvious in photographs, or even before the original. There are three other points to note before turning to the construction of this tabernacle: firstly, as in Ciro Ferri's ciborium for the Vallicella, while all the effort went into the *tempietto* and the adoring angels, the sacrament itself was kept behind a small door in its base, decorated with a simple design of a chalice and host.[97] Secondly, the height of the tabernacle

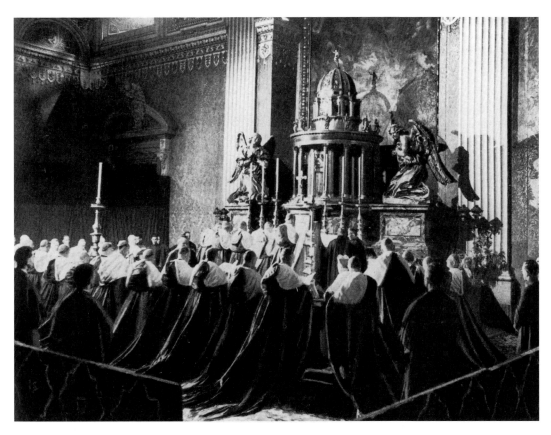

92. Worshippers at the altar of the Holy Sacrament, St Peter's

appears to have been very carefully judged: it does, inevitably, cover a large part of Pietro da Cortona's painting, in particular the celestial globe supported by six angels, but it does so in such a way that the Trinity seem to be blessing – and the angels adoring – the tabernacle, or rather the sacrament within, and Bernini has deliberately related his sculpted angels to the painted ones, very much as Ciro Ferri did with Rubens's altarpiece.[98] Thirdly, in looking at photographs it is difficult to bear in mind the scale on which Bernini was working; of course, intellectually we know the height of an altar, but, none the less, when one reads descriptions of these two angels as 'over life-size', it is hard to remember just how much over life-size they are (Fig. 92).

A number of different modellers, founders, and other craftsmen were involved, even leaving out the minor workmen.[99] There were carpenters who made the model for the tabernacle following drawings provided by Antonio Valerij, who also oversaw the cleaning of the wax and bronze – I use the term 'cleaning' as a translation of *rinettatura*, a process which, as regards the bronzes, involved chiselling, chasing, filing, punching, and all the other work involved in producing the desired surface on the rough-cast metal. But most of the cleaning of the waxes was done by a Frenchman called, in the accounts, Tibò, and, for the bronze, by the wood-carver Giovanni Perone, though the circular pieces of bronze – the architrave, base, and columns – were first turned on a lathe by Giovanni Battista Mola. These bronzes had been cast by Girolamo Lucenti, the sculptor and founder whom we have already met as one of the experts called in to value Benamati's cast of the Vallicella ciborium. The bronze was provided between 6 April 1673 and 6 February 1674, and the various pieces were cast from the spring of 1673 to the summer of 1674, and handed to the gilder, the *spadaro* Carlo Mattei.[100]

Meanwhile others were working on the two *Angels* (Fig. 2). The models were made by Giovanni Rinaldi,[101] who was also involved in the cleaning of the waxes, together with Ventura Danese, two other sculptors called simply 'Arnaldo' and 'Pietrino', and the gilder Carlo Mattei.[102] These waxes were cast by Bernardino Danese.[103] The metal was supplied to Danese in July and December 1673, and the casting completed by 22 January 1674, and these too were gilded by Carlo Mattei.[104]

On the pedestals beneath the angels are the coats-of-arms of Clement X; the models were made by a wood-carver,[105] and these were cast by Giovanni Artusi,[106] the founder who made the tabernacle for Grottaferrata, and who was also employed by Bernini on the *Cattedra Petri*, and many other works. They were cleaned by Giovanni Perone and Fulgenzio Morelli.[107]

Around the dome of the *tempietto* are figures of the twelve Apostles, and above it, fully in accordance with the advice of Borromeo, the *Risen Christ* (Fig. 93). The models for all these figures were made by Giovanni Rinaldi; the moulds were made by Giuseppe Chiari,[108] who also cast the waxes, which were then cleaned by Rinaldi,[109] and one of Bernini's most trusted assistants, Lazzaro Morelli.[110] These waxes were cast in bronze by Lucenti, with the assistance of Giovanni Artusi,[111] and most of the bronzes were cleaned by Giovanni Perone,[112] though Francesco Manciotti was paid specifically for having cleaned the *St Andrew*, and possibly another unnamed *Apostle*, and Francesco Panivolti for the *Christ*.[113] The only other figures on the ciborium are the *Faith* and *Religion* seated above the simulated door: these were modelled by the Sienese sculptor Giuseppe Mazzuoli, who also cleaned the waxes, and, though it is not clear which of the founders cast them, the bronzes were cleaned by Francesco Manciotti.[114]

I have included all these names and facts to illustrate just how many hands were involved in this project. But the very full and detailed information provided by the account books exemplifies one of the regular paradoxes encountered in the history of art: the more detailed information we have, the less do we really know, and the less able are we to say who made these statuettes. Little is known of Rinaldi, who was one of Bernini's favoured modellers at this time, particularly for stucco.[115] Although Bernini was paid the high sum of 3,000 *scudi* for overseeing the making of the tabernacle, we have no drawings, let alone models, for the statuettes, and therefore no sure way of estimating how far he was responsible for these vigorous and well-characterised figures. Admittedly, there are two documents which assert that he 'made with his hand the models, both small and large',[116] but the phrase 'with his hand' is notoriously vague,[117] and Bernini was never one to underestimate the degree of his own personal participation in such undertakings.[118]

My own opinion is that he must be credited with their invention, but that he probably exercised relatively little control over their production. If one looks at what is probably *St James*

93. Gianlorenzo Bernini and assistants, *Tabernacle* (detail); gilt bronze and lapis lazuli. Vatican City, St Peter's

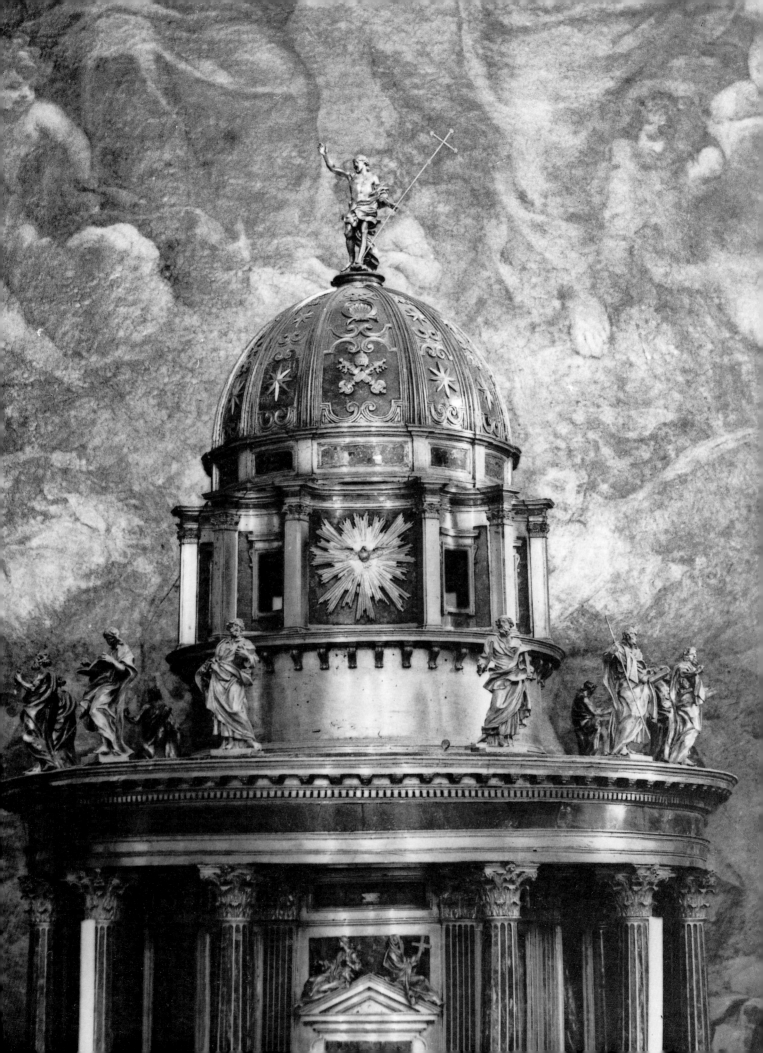

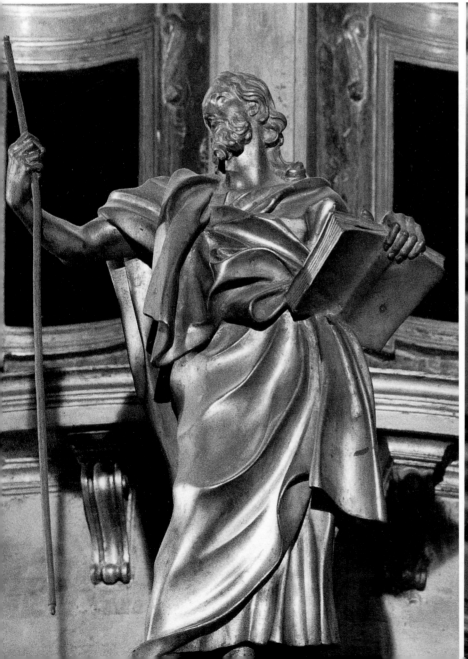

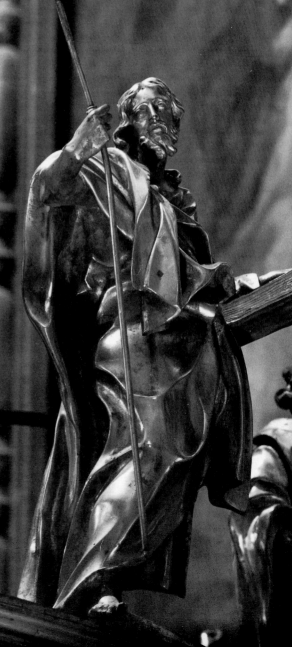

facing page

96. (*left*) Gianlorenzo Bernini and Giovanni Rinaldi, *St Peter*; gilt bronze. Vatican City, St Peter's (detail of the *Tabernacle*)

97. (*right*) Gianlorenzo Bernini and Giovanni Rinaldi, *St Paul*; gilt bronze. Vatican City, St Peter's (detail of the *Tabernacle*)

94 and 95. (*below left and right*) Gianlorenzo Bernini and Giovanni Rinaldi, *St James Major*; gilt bronze. Vatican City, St Peter's (detail of the *Tabernacle*)

Major (Fig. 94) there is a coherence in the frontal view with the sweeping scooped folds of drapery, which is not carried through with the same success from the side (Fig. 95), as if the executant had been presented with a frontal drawing, and left to work it into a three-dimensional figure for himself. Yet, even if he had little or no part in the execution, one could hardly doubt Bernini's ultimate responsibility for these splendid figures: it is sufficient to look at the *Sts Peter* (Fig. 96) and *Paul* (Fig. 97), who balance one another in the centre, complementing each-other in the flow of their garments as perfectly as in the turn of their heads, while displaying the full range of the master's inventiveness.

But how far did that inventiveness extend? In any attempt to evaluate these statuettes one is confronted by problems similar to those surrounding the tabernacle of Sta Maria Maggiore, with the added obstacle that it is extremely difficult to examine properly since the chapel is strictly reserved for prayer. However, it is evident that not only have the figures been moved around,[119] but attributes have come and gone, and at least one figure can be regarded as a replacement.

On Fig. 93, next to the putative *St James* (Fig. 94) is another figure, clearly cast from the same mould (Fig. 98). Surely Bernini could not have hoped that no one would look at the *Apostles* carefully enough to notice? It seems safe to assume that the original figure was lost, and that this

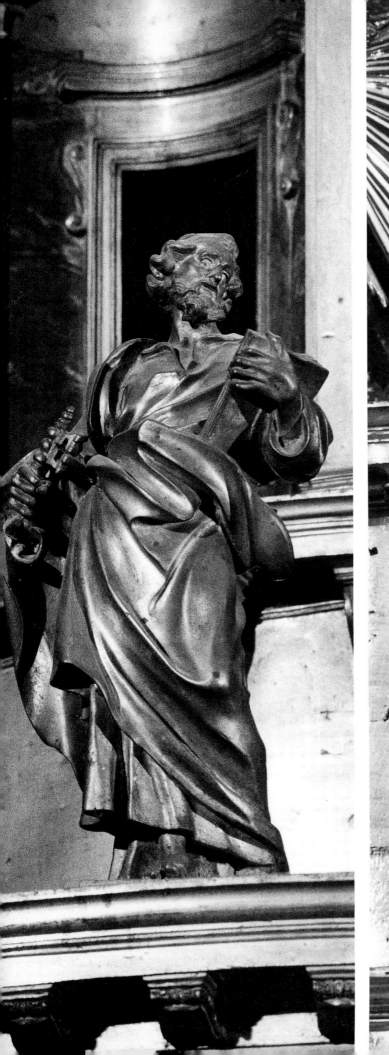

98. (*right*) Probably after Gianlorenzo Bernini and Giovanni Rinaldi, '*Pseudo St James Major*'; gilt bronze. Vatican City, St Peter's (detail of the *Tabernacle*)

99. (*below left*) Gianlorenzo Bernini and Giovanni Rinaldi, *St Bartholomew*; gilt bronze Vatican City, St Peter's (detail of the *Tabernacle*)

100. (*below right*) Gianlorenzo Bernini and Giovanni Rinaldi, *St Bartholomew*; gilt bronze. Vatican City, St Peter's (detail of the *Tabernacle*)

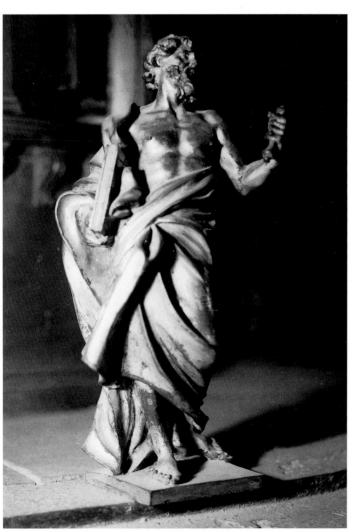

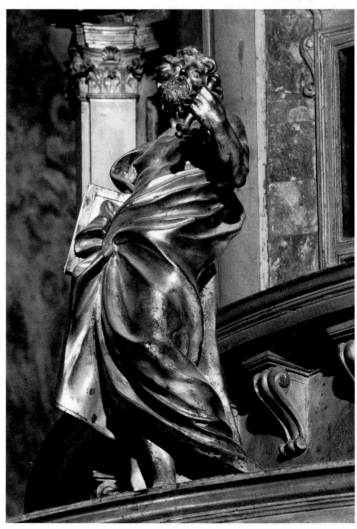

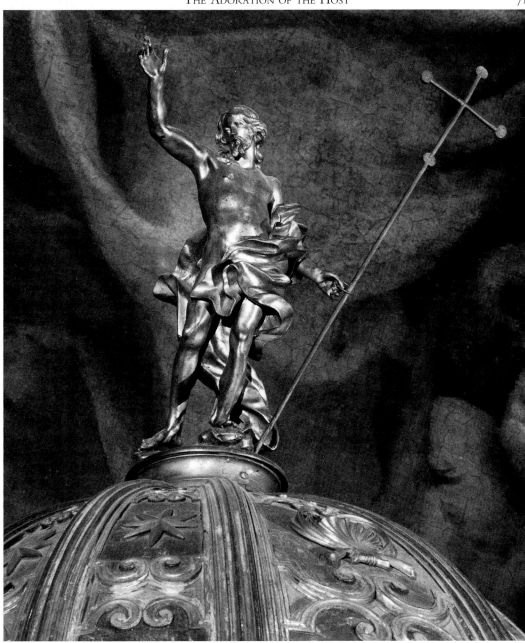

101. Gianlorenzo Bernini and Giovanni Rinaldi, *The Resurrected Christ*; gilt bronze. Vatican City, St Peter's (detail of the *Tabernacle*)

bronze, which appears to be comparatively roughly chased and less well gilded, is a later substitute. However, if we can excuse Bernini for this duplication, we must note that the *St Bartholomew* (Fig. 99)[120] is wrapped in a cloak of the most summary and unconvincing design. Yet here again, even more than in the case of the *St James*, this judgement may be unfair, for he looks much better when viewed from the side (Fig. 100), and it may well be that this was what Bernini had intended.

It is therefore possible that Bernini did indeed provide models, carefully adjusting them for the viewpoint from which they were to be seen. But it is more plausible to assume that he gave drawings, some of which may have been in three-quarter view, and left Rinaldi to complete the figures with, at most, only very minimal intervention by the master.

Such an assumption is strengthened if one looks at the *Christ* (Fig. 101), for which Bernini

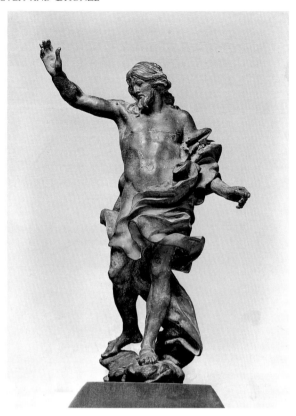

102. Gianlorenzo Bernini and Giovanni Rinaldi, discarded cast of *The Resurrected Christ*, bronze. Baltimore, Walters Art Gallery

himself must surely have taken special responsibility, even if Rinaldi was paid for the model. Above the cupola he soars triumphant;[121] the figure is superb, with the shroud rising up around him as if blown by a wind from below, while He looks down to extend His blessing on the worshippers adoring His body in the sacrament. Here the modelling of the head in particular has a delicacy which is lacking in the *Apostles* – indeed, it could be argued that it is too delicate, and that the more strongly modelled heads of the *Apostles* take better account of the distance at which they are to be seen.

One can study the *Christ* from a more convenient angle in the failed cast recognised by Mark Weil in the Walters Art Gallery (Fig. 102).[122] And, in its relatively unchiselled state, it provides an illustration of how much afterwork was done on the cold bronze. This involved not only the removal of what was presumably the remains of a rod projecting on His right shoulder, but the polishing of all the surfaces and the sharpening of all the details to bring out the anatomical structure and to differentiate more clearly the texture of hair and flesh. Even the gilding was not just a mechanical process, but by burnishing the hem inside the shroud Bernini helps us to follow its convoluted folds.

One tends to think of them as small bronzes, but it should be borne in mind that the Baltimore *Christ* is 44 centimetres high, and the *Apostles* presumably the same. Yet they represent an important aspect of Bernini's art, at least as much so as the travertine statues of the colonnade. Indeed, they have a particular interest as being among the few small bronzes that can reasonably be ascribed to Bernini. For even though, as I have argued, Rinaldi most probably made the models, Bernini surely must at least have provided drawings, and quite possibly intervened in their execution. Certainly they deserve more serious study than they have received hitherto, and no examination of Bernini's sculpture, or of the bronze statuettes of the seventeenth century, can afford to pass over such fine works as these in silence.

4

The Medal.
Some Drawings for the Hamerani

THROUGHOUT THE BAROQUE period the medal retained its traditional form of a small round disk of metal, with a portrait on the obverse, and a reverse that identified, explained, or represented some aspect or characteristic of the person depicted, or (less frequently) some event from his life. In a personal medal the reverse might be something as obvious as the sitter's coat-of-arms, but it might be something as private as a device, deliberately intended to be obscure and unintelligible to the uninitiated; occasionally it might represent the head of a friend, in which case the distinction of obverse and reverse becomes ambiguous. But during the latter half of the sixteenth century, particularly in Rome under the papacy and in Florence under the Medici, medals had been issued as propaganda, and in such cases, obviously, the reverse had to be clear and unambiguous. Few of the reverses of the papal medals treat broad historical themes, but the concentration on buildings constructed, primarily in Rome, and even papal ceremonies, manifests the munificence of the pope, and the enduring rituals of the Catholic Church; both of these were widely, and rightly, believed to impress not only the faithful, but equally the 'heretics' who visited the Eternal City, while a bland emblem of the unity or firm faith of the Church could assume a propaganda value in time of adversity.[1]

It is with such medals that this chapter will be mainly concerned; but, although I shall not be discussing them, one cannot write about Roman baroque medals without at least drawing attention to the extensive production of religious medals,[2] representing Christ, the Virgin, or the more popular saints (Fig. 103).[3] A further sub-class, falling somewhere between the personal and the religious, and which I shall also ignore, are the medals made for the foundation of a church or chapel. These usually represent the saint to whom the building is dedicated, and on the reverse would be placed an inscription, a view or plan of the building, or a portrait of the patron.

The metals used for medals were all three of those in the title of this book, and also lead. For reasons it is hardly necessary to repeat, most of those that survive are in bronze.[4]

Medals might be cast, or struck from engraved dies. The word 'struck' was originally exact, in that the steel dies were struck onto the softened medal by a hammer; by the baroque period a press was used, but the word was retained for those medals or coins made by means of an intaglio die. The die might be engraved directly, or by means of puncheons, carved in relief in steel and struck into the softened metal of the die; this method (which, as we shall see, was particularly favoured for coins) meant that elements of the composition and, of course, letters for the inscription, could be repeated on a number of different dies.[5] Most baroque Roman medals, and almost all of those to be considered here, were struck, and this method allowed for the production of larger numbers; indeed, provided the die did not crack (and, if it did, it could be remade by means of the puncheons), it could continue to be used almost idefinitely.[6] Another consequence was that the medallist was an engraver rather than a modeller, although he would normally produce a wax model to show to the patron before cutting the die, or as a guide for his own work on the puncheons – obviously he would have to make a negative cast from this in order to use it when cutting an intaglio in reverse. He was therefore likely to be a specialist in this demanding art, often working also in the related art of the goldsmith, rather than that of

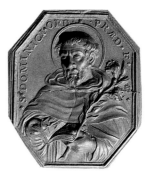

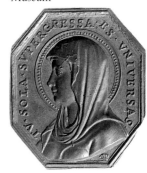

103. Hamerani, Medal of *St Dominic* and *The Virgin*; bronze. Oxford, Ashmolean Museum

sculpture as the word is normally understood. Of the medallists who will feature in the following pages, Gaspare Mola was also a famous goldsmith,[7] Gaspare Morone is recorded as making a gold paten for Mario Chigi[8] and his inventory contains numerous models for crucifixes,[9] and Ermenegildo Hamerani made gold containers for formal papal letters to be sent to foreign dignitaries as well as medals.[10]

There were a number of fine and competent medallists in baroque Rome, though they were never as numerous as painters, sculptors or goldsmiths. Although a number of medals were made representing artists, the medallists' patrons were, as one might expect, mainly the aristocracy, both secular and ecclesiastical. However, while an important personage might have a number of portraits of himself painted throughout his life, it was rare for a private individual to have more than one medal made. To this generalisation there were notable exceptions, who tended to go to the other extreme. As examples, one may cite Duke Paolo Giordano Orsini (1591–1656) who commissioned at least ten medals of himself, of which six were by Jacob Kornmann, known in Italy as Cormano,[11] or Prince Livio Odescalchi (1652–1713), of whom no less than twelve medals are known.[12] It is not surprising that Livio Odescalchi should have bought the coin and medal collection of Queen Christina, a passionate collector, who had some thirty-seven medals made of herself, and contemplated the production of a series of medals recounting her life – but Christina always regarded herself as a queen, even after her abdication.[13]

The main patron, however, was the pope, and it is on the specifically Roman production of papal medals that I shall concentrate. Occasional medals had been issued by earlier popes since the time of Martin V (1417–31), but it was with the pontificate of Paul V at the beginning of the seventeenth century that it became customary to issue a medal on 29 June – the feast day of Sts Peter and Paul. This was the so-called annual medal. In addition, medals were given to the thirteen poor 'Apostles' whose feet the pope washed on Maundy Thursday (in imitation of Christ's washing of the Apostles' feet before the Last Supper). Medals were also usually struck to celebrate the pope's election, and for his taking possession of the church of St John Lateran in his capacity as Bishop of Rome (the *possesso*), and a number of so-called extraordinary medals were also struck to celebrate some particular event.[14]

The post of Engraver of the Papal Medals, which was almost always combined with that of Engraver of the Papal Mint, was not particularly well paid, but the medallist had the advantage of retaining possession of the dies, and hence could earn additional revenue from restriking further medals from them. Gaspare Mola, who held the office from 1625 to his death in 1640, left his dies in his will to his nephew Gaspare Morone, who succeeded him,[15] and it could as well have been one of Mola's dies as one of his own that Morone used to make a gold medal of Urban VIII ordered from him in 1650 by the former pope's nephew Cardinal Francesco Barberini Senior to be given to a courtier of the Queen of Sweden.[16] Ottone Hamerani built up a large collection of dies based on those which he, his father and grandfather had made as medallists to the popes, but including those acquired from others going back to the time of Martin V, and this collection, as he realised, constituted an important capital for his descendants.[17] However, the legal position was not entirely clear, and when Ottone's descendants attempted to sell the collection to the papal mint the matter was discussed at length, until in 1765 a legal decision was reached that the payment provided for making the medals did not include any remuneration for the dies, which the medallist was therefore entitled to regard as his own property.[18]

For the modern collector or the art historian these papal medals provide fascinating records. It may appear that, unlike the personal medals, their iconographic value is slight, since the popes of the baroque era are well enough known from other sources. But the regular production of dated images can constitute a sad record of aging or sickness, as well as a useful guide to changes in the shape of a beard that can help to date other portraits which lack the medals' precise inscriptions. As for the reverses, they are important evidence as to what the pope himself considered most worthy of commemoration each year, or most impressive as propaganda. The numerous reverses depicting architecture, or occasionally sculpture, are invaluable visual evidence: often, and particularly in the case of foundation medals, they show what was originally intended rather than what was actually built, but when they depict a finished work it is done with great accuracy.

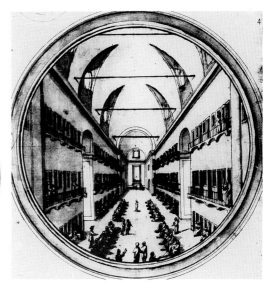

There is, for example, a payment to Alessandro Astesano to reimburse him for a visit to Civitavecchia to make a plan of the port for the medal of 1632 (Fig. 104) (at a time when he had briefly supplanted Gaspare Mola),[19] and on a drawing of the prison at San Michele to be made by Giovanni Hamerani in 1704 is written the suggestion that he should consult the architect Carlo Fontana before starting to engrave the die (Fig. 105).[20] Not least, they are in many cases considerable works of art.[21]

However, while much has been written about papal medals, many fundamental questions have not been addressed and remain to be investigated, even if it is not possible to provide conclusive answers. We have a very imperfect idea of who received them, and very little idea of what they did with them; there is only sparce evidence as to who chose the subjects to be represented on the annual medals, or how an event was to be commemorated; little is written on how they were made, and the question of who designed them has been considered only from the point of view of occasional candidates, most particularly Bernini.[22]

The first of these questions may seem surprising, at least to those who are familiar with the basic literature, since, although only one has been printed, there is no shortage of complete lists of those who received the annual medals.[23] In some years the pope himself received up to two hundred each in both gold and silver, presumably to distribute, and members of his immediate family were also given extra 'to distribute'. But the others on the list were functionaries of the papal court who received them, in effect, as part of their salary – indeed, in 1739 and successive years some clerics were added to the list as receiving medals instead of lunch.[24] Additional medals were frequently made to be given to visiting dignitaries; usually these would be of the current year, but the pope might choose an earlier issue, possibly for aesthetic reasons, or more likely because he regarded the event depicted on the reverse to be more important, or more suited to the recipient.[25] Apart from these early restrikes, there is indisputable evidence that the pope might also order that most despised of medals, a mule – that is to say a medal combining an obverse with a reverse originally created to go with a different obverse.[26] In 1679 Giovanni Hamerani and Cristofano Marchione, who at that time worked together as papal medallists, provided thirty-nine gold medals to be given to the captains of the ships, of various nationalities, that had brought grain to the port of Civitavecchia: these all had an obverse portrait of Innocent XI of the second year of his reign (1678), but they included three with the reverse from the annual medal of 1677, and two with the reverse from that of 1679.[27] Similarly, in 1709 Ermenegildo Hamerani was paid for a silver medal with the obverse of the eighth year of Clement XI's reign, and the reverse of the raising of the Antonine column which had been made for the previous year.[28]

However, apart from the question of who received those given to the pope and his family, the lists concern only the medals struck in gold and silver; yet a number of the accounts for making the annual medals include many more struck in bronze, and it may be assumed that bronze examples were also made in years where they are not listed in the accounts. There is no evidence to say who received these. The same problem applies to those struck for the foot-washing

104. Alessandro Astesano, annual medal of 1632, representing the port of Civitavecchia on the reverse; bronze, British Museum

105. Anonymous, drawing of the Prison of S. Michele, for the annual medal of 1704; brown ink and wash. BAV, MS. Vat. Lat. 15232, no. 4

ceremony: sometimes only thirteen were struck in both gold and silver, which were given to the so-called poor 'Apostles' who, attired in elaborate robes, and having had a careful pedicure the previous day, had their feet ritually washed by the pope;[29] sometimes fifteen might be made (the extra ones going to the pope), but, even if I have found only one mention that may refer to the making of examples in bronze,[30] so many of these are now to be found in medal collections that it would seem improbable that they are all later restrikes.

What people did with these medals might hardly seem worth asking, until one actually does so, and finds that there is remarkably little evidence. It is probably safe to assume that the functionaries who received annual medals each year would have sold them as bullion.[31] Other gold medals might serve for personal adornment: they could be set in filigree, as were the twelve medals that Gaspare Morone passed to the goldsmith Antonio Moretti in 1658, or the twenty that Giovanni Hamerani decorated with filigree himself in 1684.[32] Others were suspended from chains, such as that which Giovanni Hamerani made in 1678 for Innocent XI to give to the Duchess of York.[33]

But what became of the vast annual production of the medals in silver and bronze? Some of the former may also have been melted down; most, however, entered collections, but for the most part these were not collections of art. All the numerous collections of 'curiosities' of the period included medals; however contemporary medals, whether papal or personal, were far less numerous than ancient coins (usually called 'medals' in all languages during the seventeenth century), and were of less interest to their owners than exotic coins, unless the image was in some way peculiar.

There were also the great collectors of numismatics in general, such as Cardinal Francesco Barberini, or Queen Christina, but, again, modern medals feature almost as an appendix to their main concern: ancient coins. Just as these coins were valued primarily as iconographic evidence, so they appear to have been more interested in acquiring renaissance medals than those representing their contemporaries. Another notable collector, Cassiano dal Pozzo, may have been exceptional in the extent of his collection of modern medals, but these were classed under the status of the person represented, and, again, it is clear that his interest was iconographic rather than aesthetic.[34] Looking through miscellaneous Roman inventories of the period I have noted only one 'ordinary' collector who might have valued his ancient coins and modern medals as works of art, and this was Francesco Spagna who, as a silversmith, might have had a special interest in the medium;[35] but the numerous paintings that he owned, and his substantial library, suggest that he was a serious collector.[36] Alas, with rare exceptions such as two bronze medals of Cardinal Ludovico Ludovisi with St Ignatius Loyola on the reverse, his inventory describes the modern medals only generically, as popes, or cardinals. Like those in several other collections, most of his numismatic collection was set in circles of metal, wood or bone.[37] Occasionally medals might be framed, but most often they were to be found in desk drawers, and usually in very limited numbers. It seems that they were valued as images of patrons, or of a pope whom the owner particularly respected, or it may have been of an artist he admired, though Bellori, who owned medals of Pietro da Cortona, Maratti and Bernini, is more likely to have admired the medalist François Chéron, as Bellori no doubt admired Pietro da Cortona, Carlo Maratti and Bernini whose medals he owned.[38] Sometimes, of course, they were the treasured pieces presented to the owner by the pope, and this applies to most of those listed in the inventory of Carlo Maratti. This also included four silver medals of Innocent XII on the reverse of which was depicted the *Virgin and Child* which Maratti had designed for the mosaic on the Quirinal, though this had been given to him not by the pope himself, but by Cardinal Albani before he became Pope Clement XI.[39] Another artist whose family inventory included a few silver medals of popes (but only four which seemed worth naming) was Bernini, but it also included also eighty-three silver medals of popes, and 'Cardinal Antonio [Barberini?]' which were kept in a box, and by 1706, the date of the earliest surviving inventory of the family, we are told that 'of these some have been lost, because they were used as play-things by his young grandchildren when they were ill', so that only sixty-one remained.[40]

I have already had occasion to refer to the Hamerani collection of dies for papal medals, and one might well expect serious collectors to have wanted to acquire complete sets. I have not encountered any references to such sets in Rome, but, if only by chance, I am aware that the

Englishman Martin Folkes, who had an extensive and varied collection of medals, owned not only a gold medal of Pope Clement XII and a silver medal presented to him by the same pope, but also 'copper' medals of the popes from Eugenius IV to Benedict XIV;[41] which might have been acquired from the Hamerani.[42] It seems very likely that the main patrons for such sets were foreigners making the Grand Tour, and it may well be significant that in 1764 Ferdinando Hamerani claimed to have found the means to sell his family's collection of dies abroad.[43]

I have written of the pope commissioning medals, and, of course, he did pay for them, whether through the mint or the accounts of the Sacro Palazzo Apostolico, but whether he actually selected the subjects is very uncertain. In the case of Alexander VII we know that he did, because he kept a diary in which there are frequent references to discussions about the subjects to be depicted on the annual medals, or their inscriptions, but he was a man who clearly took a quite exceptional interest in the art produced under the aegis of the papacy. As it happens, the only reference in any of the accounts to a direct intervention by the pope occurs during his pontificate, when in 1656 Morone struck 180 gold medals without the inscription on the reverse, according to the sample that had been shown to the Tesoriere Generale. This was not approved by the pope, the die had to be tempered again, the letters engraved into it, and the medals restruck.[44] Admittedly, this is an extreme case – no annual medals were issued without inscriptions on both sides – but there is no record from any other pontificate to show that the pope himself took a personal interest in such matters.

This 1656 document provides valuable evidence that it was normal to show a sample (the word used is *mostra*); this may have been in wax, but, as these waxes were usually referred to as 'models', and as they were normally made without inscriptions, it was more likely a trial striking, possibly in lead. There are two other pieces of evidence as to what was involved in producing these medals, one from Gaspare Mola, and the other from the plea made in support of Ferdinando Hamerani's attempt to prove his right to his collection of dies, and presumably based on his own testimony.

Medallists, like most artists, were not backward in pointing out when a work had involved exceptional labour,[45] and in 1636 Gaspare Mola claimed that the annual medal with the church of Sta Anastasia on the reverse was larger than usual, and that it therefore required twice as much work as a smaller medal (in fact it measures between 4.2 and 4.25 cm., as against the usual size of about 4 cm.).[46] In the following year, with regard to the medal with the Baptistry of Constantine on the reverse of the same larger size, he expanded his claim for extra pay, writing of 'the poor engraver, who harvests no other fruit than this, and spends all year labouring at the strikes and the reverses to achieve this small and laboriously earned income'.[47] Taken literally, this is nonsense, because the medallist certainly did not work all year on the annual medals, and much of his time was occupied on the coinage; but it does serve to remind us of the amount of labour involved in engraving a die.

Rather more informative is the statement of the lawyer Niccolò Sala and Giuseppe Miselli in the printed plea of 1764 which they presented to the Congregation of the Papal Camera on behalf of Ferdinando Hamerani. They are concerned to emphasise the much higher value of dies for medals, which cannot be compared to what they call the extremely miserable payment received for the dies for the coinage. The latter are not at all complicated, and therefore did not require great exactitude in design and much labour in engraving, and the document refers as an example to the large silver *scudo* with the reverse of a figure symbolising the Church seated in the clouds (Fig. 106):[48]

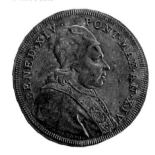

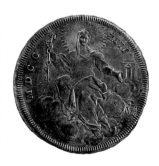

106. Ottone Hamerani, *scudo* of Benedict XIV; silver. London, British Museum

The greatest labour consists in the first engraving, which is called the matrix [*Matrice*], while the puncheon [*Ponzone*] taken from this will then serve for every other die of the same coinage. But it is quite different with respect to Medals. Once the idea has been given to the Engraver, he is obliged to make several drawings, and also to represent the same subject in wax. This is then cut in steel, certainly in greater depth [than the coin dies], and with greater care. This work is also laborious because of the complications of the image which, with its minute figures, is infinitely more tiring for the eye, and the hand. Finally, every [medal] die requires the same work from the beginning, as it is not customary to repeat the design, as is done for the coins.[49]

107. Ottone Hamerani,
St Michael and the Church;
black chalk. BAV, MS. Vat.
Lat. 15232, no. 11

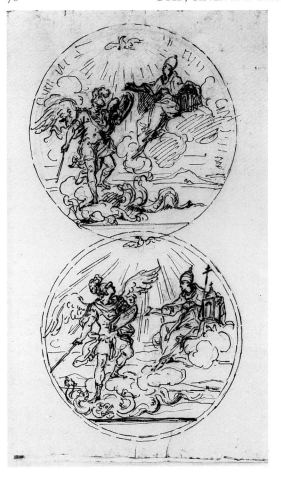

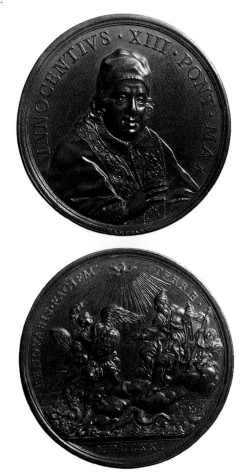

108. Ottone Hamerani,
medal of 1721, representing
St Michael and the Church
on the reverse; bronze.
London, British Museum

facing page bottom

111. (*left*) Gianlorenzo
Bernini, drawing for the
reverse of a medal to
celebrate the end of the
plague in Rome. Formerly
Truro, Cornwall County
Museum

112. (*top right*) Gaspare
Morone, annual medal of
1657; bronze. British
Museum

113. (*bottom right*) Gaspare
Morone, model for the
annual medal of 1657; wax.
London, British Museum

The use of the words *matrice* and *ponzone* is confusing: Vasari uses *madre* for the dies,[50] whereas Cellini says that the two words mean the same thing, i.e. puncheons.[51] However, the original punch can be used to make a matrix, from which a new puncheon will be formed to create a working die, the original puncheon and matrix serving as back-ups should the die wear out or crack and need replacing. Both Vasari and Cellini agree that puncheons are used on medals as well as coins, the design being broken up into various sections so that the same puncheons might serve for different compositions, even if Cellini emphasises that direct engraving on the dies, which should be avoided for coins, is a necessary part of the production of medals.[52]

Ferdinando Hamerani makes it clear that, having been given the 'idea' for the medal (by which he means the subject, and very probably the basic form of the allegory, where that was appropriate), he then made several drawings, and there is evidence that, at least in the Hamerani workshop, this was indeed the case, for the volume of drawings for medals in the Vatican includes a sheet with two variant studies for a medal of 1721, both of them designs of a true baroque bravura (Figs. 107–8).[53] But, if the general description of how coins and medals were made would apply also to earlier medallists, it is by no means certain that they provided their own drawings, and in several cases we know that they did not.

Thanks to the documentation of the papal mint (*zecca*), and the fact that most papal medals are in any case signed, there are few problems surrounding the makers, but the question of who designed them has aroused little curiosity. Such evidence as we have for these earlier medals concerns the reverses, rather than the portrait obverses. A drawing by Algardi showing Innocent X in profile could have been made for a medal, but does not correspond exactly to any that are known to have been executed;[54] Bernini too has been credited with the design of at least one

medal obverse, but only on the unsatisfactory assumption that he alone would have been capable of inventing a new form.[55] The question of whether any of the obverses were drawn by other artists therefore remains open, and in fact the modelling of a portrait head should have been within the competence of any medallist. The invention of the far more complex images for the reverses is, however, another matter.

Close though Bernini was to Urban VIII Barberini, none of the reverses of his medals or coinage suggest that Bernini was involved, and it is probable that they can be attributed to the undoubted inventive powers of Gaspare Mola.[56] On the election of Innocent X Pamphili, Bernini's close association with the Barberini resulted in a temporary loss of favour and Alessandro Algardi supplanted him as the sculptor most frequently employed by the Pamphili. Algardi was on terms of close friendship with Gaspare Morone, and, while there is no hard evidence such as documents or drawings, at least two of Morone's annual medals for Innocent X (Figs. 109–10) are exceptional in his oeuvre in depicting a single figure, and in their use of lyrically swinging draperies they come very close to Algardi's sculptural forms. It seems highly probable that they are based on drawings by the sculptor.[57]

But it is not until the pontificate of Alexander VII Chigi that it can be said with absolute certainty that Bernini, fully restored to favour at the papal court, was indubitably responsible for the design of a number of reverses for medals, and at least one coin.[58] There are several drawings for known medals from his studio, and a few by his own hand, such as the spirited design (Fig. 111)[59] for the annual medal of 1657 (Fig. 112) showing St Peter driving the plague from Rome. For this there is also a wax model (Fig. 113)[60] where the different relationship of the various

109. Gaspare Morone, annual medal of 1649, representing St Peter in the clouds on the reverse; bronze. London, British Museum

110. Gaspare Morone, annual medal of 1651, representing God the Father on the reverse; bronze. London, British Museum

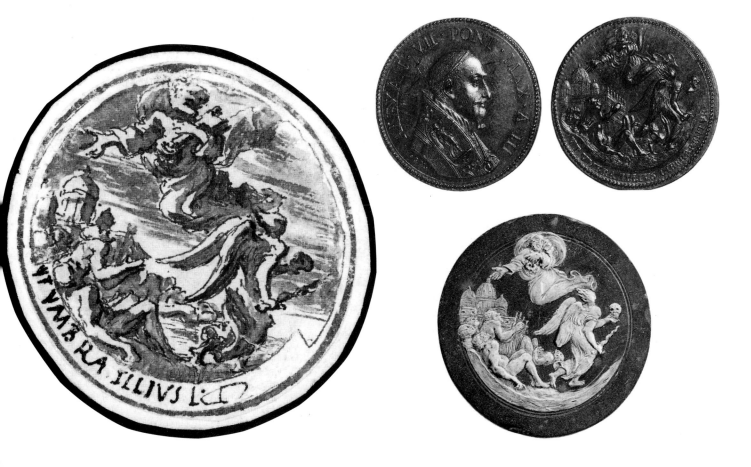

114. Gianlorenzo Bernini, drawing for the silver *scudo* of 1658; pen and brown ink with brown wash, over black pencil. London, British Museum

elements proves, should any proof be necessary, that it was made by Morone working from Bernini's drawing, and that the sculptor did not provide the relief model, which none the less differs slightly from the medal as executed. It is also reasonable to suppose that Bernini would have been involved to at least some degree in the design of those reverses that represented works he had himself created. There is, indeed, evidence from the diary kept by his greatest and most discerning patron, Alexander VII, that he was closely involved with the designs of the medals of 1659 for the Quirinal Palace (Pl. VIII) and of 1662 for the churches of Ariccia.[61] Even though no drawing survives for it, the fact that he designed the medal of the Quirinal Palace is further confirmed by the evidence submitted in support of Ferdinando Hamerani's plea of 1764, where it is stated that Morone's medal was 'taken from a drawing by Cavalier Bernini'.[62]

Nor was it only sculptors who might provide such designs. Just as Bernini gave drawings for the large silver *scudo* or *piastra* of Alexander VII (Figs. 114–15),[63] Giovanni Battista Gaulli, called Baciccio, made the drawing for the silver *scudo*, or *piastra* executed by Giovanni Pietro Travani (Figs. 116–17).[64]

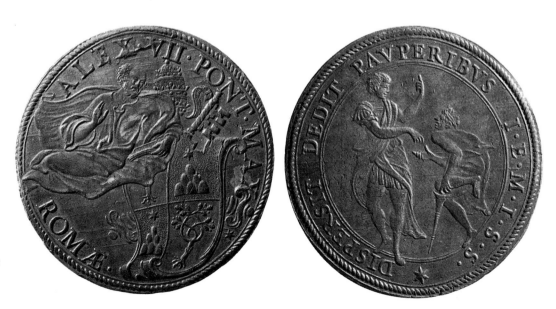

115. Gaspare Morone, silver *scudo* of 1658. London, British Museum

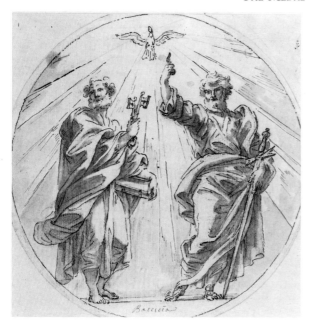

116. Giovanni Battista Gaulli, drawing for the reverse of a silver *scudo*; pen and brown ink with black wash, over black chalk. Windsor Castle, The Royal Library

Since the relationship of the designer to the executant is one of the main themes of this book, I should like to concentrate on the drawings for the medals of one family, the Hamerani, for whose medals there are a sufficient number of drawings, not only in two volumes in the Vatican Library recently published by Giancarlo Alteri,[65] but also elsewhere, to allow some reasonably firm conclusions to be reached.

The Hamerani dominated Roman medal production for more than a century.[66] They originally came from Germany, and both the German names under which the children were baptised and the adherence of the early generations to the Brotherhood of the Campo Santo Teutonico show that, however established they became in Rome, they maintained their Teutonic roots. The first to produce medals was Alberto (1620–77), though he was more frequently employed as a seal-engraver, but his son Giovanni Martino (1646–1705) was named die-engraver to the mint, together with Cristoforo Marchione. It is with him, and his sons Ermenegildo (1683–1756) and Ottone (1694–1761) that I will be principally concerned. However, much of what we know about their activities comes from documents relating to Ferdinando (1730–89),

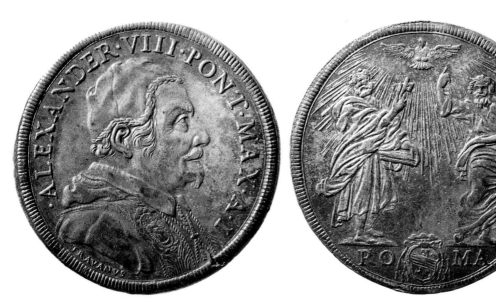

117. Giovanni Pietro Travani, silver *scudo*, with the portrait of Alexander VIII, and Sts Peter and Paul on the reverse. London, British Museum

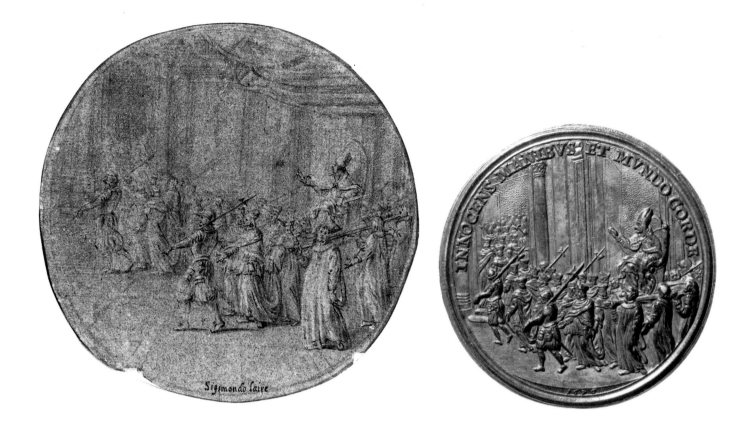

118. Anonymous, *The Procession of the Election of Innocent XI.* Mdina, Cathedral Museum

119. Giovanni Hamerani, reverse of the Election Medal of Innocent XI, 1676; bronze. London, British Museum

the son of Ottone and his wife Antonia Fuga (daughter of the architect Ferdinando Fuga). As well as working for the papal mint, between them they produced most of the official medals of the papacy from the later seventeenth to the early nineteenth century, as well as those for many other patrons, and numerous religious medals (Fig. 103).

Apart from those in the Vatican volumes, there are three drawings that can be related to medals by Giovanni. One, in the Cathedral Museum at Mdina in Malta (Fig. 118)[67] bears the inscription 'Sigismondo Laire', an artist who worked principally as a miniaturist, and who died in 1639. But it is so close to the reverse of Giovanni Hamerani's medal for the election of Innocent XI of 1676 (Fig. 119)[68] that it can hardly have been made for any other purpose: the pope borne in the *sedia gestatoria* is identical, the other figures correspond closely in their distribution, movements and gestures, and the minor changes in the background are scarcely significant; as for the indication of a curtain at the upper right, this would have conflicted with the inscription which the medallist had to incorporate. Giovanni Hamerani was to make another reverse of a procession for the

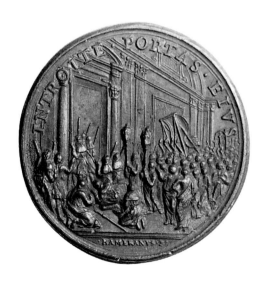

120. Giovanni Hamerani, Jubilee Medal of Innocent XII, 1700; bronze. British Museum

Jubilee medal of Innocent XII (Fig. 120)[69], but it is far less successful as a design. In that of 1676 the circular movement of the prelates echoes the circle of the medal's format, and conveys the idea that they are walking into the depth of the medal, while the emphasis on the pope and the strong verticals of the architecture keep the design firmly on the surface, and the varied actions of the figures are clearly described. The later medal is uncertain in its use of space, the movement of the procession is far less evident, and the whole design is relatively messy.

The other two drawings, both in the Kunstbibliothek in Berlin (Figs. 121–2),[70] are much further from the finished medal (Fig. 123),[71] an extraordinary issue to commemorate the Peace of Nijmegen, which Giovanni Hamerani made in 1679. But all the elements are there: the angel with the branch (even if it looks like a palm in the drawing, whereas in the medal it is clearly olive) and the figure of Innocence with the lamb at her feet. According to the standard guides to such personifications Innocence should be holding a flaming heart, but the pot of smoking incense no doubt refers to the arms of Innocent XI Odescalchi, which included six incense-boats.

121. Anonymous, *Allegory on the Peace of Nijmegen*; black pencil heightened with white. Berlin, Kunstbibliothek

122. Anonymous, *Allegory on the Peace of Nijmegen*; black pencil heightened with white. Berlin, Kunstbibliothek

123. Giovanni Hamerani, medal with the portrait of Innocent XI, and an allegory of the Peace of Nijmegen on the reverse, 1679; bronze. London, British Museum

The more finished of the two Berlin drawings looks not unlike that for the procession, and I believe it could well be by the same hand. But whose? Whitman has remarked on the exceptional 'pictorialism' of the 1679 medal, particularly evident in the background (which is very different from that in the surviving drawings, but perhaps a further design was made), and related it to the style of Pietro da Cortona;[72] none the less, the attribution of the drawing to Lazzaro Baldi given in the Berlin catalogue is unconvincing. I believe that Giovanni Hamerani himself can also be excluded, for not only is there no evidence that he was an accomplished draftsman, but the drawings are indeed pictorial rather than medallic in style, and seem to make no allowance for the inscription (if one excludes the internal line on the sketchier drawing, which appears to be an afterthought), an oversight which would be unusual for a medallist. Unfortunately, I have no other name to suggest.

The other group of drawings[73] are closely related to those at the beginning of the Vatican Manuscript Vat. Lat. 15232, and all but two are for the reverses of papal medals made by Ermenegildo Hamerani, in some cases working together with his younger brother Ottone. Of the exceptions, one is for a medal for a private individual and will be considered below. The other, no doubt made for a papal medal was never used; it is dated 1771, which would put it into the period of Ferdinando, or of Filippo Cropanese who actually did the work for him; and, as will be shown below (p. 85), it appears to be by a different hand. When Ferdinando died in November 1789 his inventory included 'various drawings of medals and other papers' described as 'of no value'.[74] This need not be taken as too damning for, apart from the fact that valuations in inventories are usually extremely low, this is much the same as our use of 'of no commercial value' on a parcel to avoid paying customs dues, and could well apply to drawings such as these: workshop sketches, or designs submitted for approval, but not the sort of artistic sheets likely to appeal to a contemporary collector. However, the entry is of no help in discovering who made these drawings.

Little is known about Ermenegildo, beyond the fact that he died unmarried, but in his will of 16 September 1755 he left some old clothes and 25 *scudi* to a certain 'Signor Mariano' (he could not remember his surname), 'having received him into my house merely for my pleasure, and also admitted him to my table so as not to sit alone, and solely so as to have someone to talk to'; Mariano was a young student of painting, and Ermenegildo provided him with paints and canvas to encourage him in his studies, and also clothed him, 'and all this I did freely, because of his good disposition'.[75] Although it may be assumed that Mariano could draw, he was obviously too young to have made designs for any of Ermenegildo's earlier medals, and, whatever other services Mariano may have performed for him, the wording does not suggest that he assisted with his professional work.

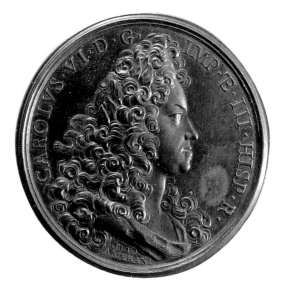

124. Ottone Hamerani, medal of the Emperor Charles VI celebrating the victories of Temesvar and Belgrade; bronze. London, British Museum

125. Anonymous, drawing for the reverse of an unexecuted medal; brown ink and grey wash over pencil. Private Collection

However, Ermenegildo's younger brother Ottone trained as a painter under Benedetto Luti, qualifying in 1715. According to Venuti, who knew him personally, his earliest medal represented the Emperor Charles VI, and celebrated the victories over the Turks at Temesvar (1716) and Belgrade (1717) (Fig. 124);[76] it is a typical young man's medal in which ambition outstrips the means: the complicated poses and foreshortened legs of the river-gods are not fully resolved in the low relief of the reverse, and the unusually large signature shows a tyro's pride, which is none the less well justified. By 1730 he was named as Engraver of the Papal Medals, and from that year he is known to have worked with his brother. Moreover, there is one payment to him for drawings which, if it does not state in so many words that they were his own, does at least imply this: on 11 July 1758 he submitted an account for his work for the annual medal of Benedict XIV for that year which, owing to the pope's death on 3 May, had not been completed, and this included 'various drawings of many figures' for the reverse, which was to represent the re-introduction of trade with the states of the Queen Hungary beyond the Po.[77] The fact that this medal was not executed no doubt explains the exceptional claim for payment for drawings, which would normally be included in the payment for the completed medal. Obviously, Ottone would be a good candidate for the authorship of all but the last of these drawings, assuming that most of them are by the same hand. The last, of 1771 (Fig. 125),[78] is less close in style, with a far less lively and vigorous line, and less sense of relief and weight in the figures; moreover, it is unlikely that the same draftsman would have worked from 1715 (or even 1722) to 1771. The others all display the same scratchy pen line, as well as morphological similarities, and cover the full range of reverse subjects; they are competent, but not brilliant, in fact, the sort of drawings that might well have been made by a medallist who had also studied drawing.

The earliest (Fig. 126)[79] is rather different in appearance, but it is unique in being of architecture. It represents the church of S. Clemente, the restoration of which was fostered by Clement XI. But the annual medal of 1715 (Fig. 127) shows the church from the front of the atrium, rather than from the side, in an extraordinary bravura design which at once denies the low relief of the medal, while this is stressed by the vertical alignment of the principal features. The church is, however, seen from a similarly elevated view-point, and this drawing, which is a finished proposal, is presumably a rejected idea. As was made clear in Ferdinando's statement, and as Ottone's account of 1758 confirms, it was customary to submit a number of drawings, and that actually used for this medal is preserved in the Vatican volume.[80] If the medal precedes any of those made by Ottone, this need not have prevented him from making a drawing used by his brother; however, the way in which the architecture is drawn is so close to that for the medal of the prison of San Michele of 1704 (Fig. 105), made when Ottone was only ten and therefore certainly not by him, that the attribution must remain open.

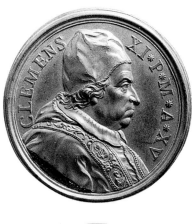

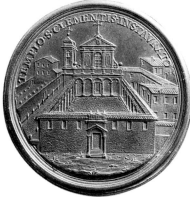

126. Here attributed to Ottone Hamerani, drawing for a medal reverse representing the church of S. Clemente; brown ink with grey and brown wash. Private Collection

127. Ermenegildo Hamerani, annual medal of 1715, with a portrait of Clement XI, and the church of S. Clemente on the reverse; bronze. London, British Museum

129. Ermenegildo Hamerani, annual medal of 1722, with a portrait of Innocent XIII, and the Church on the reverse; bronze. British Museum

128. Here attributed to Ottone Hamerani, drawing of the Church for the reverse of the annual medal of 1722; brown ink over pencil. Private Collection

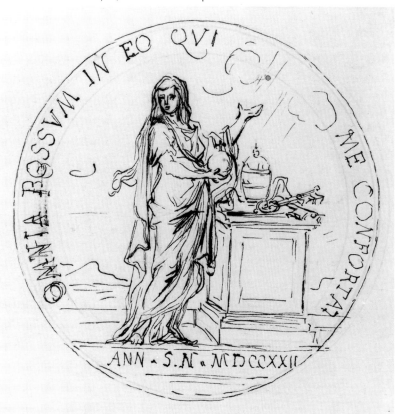

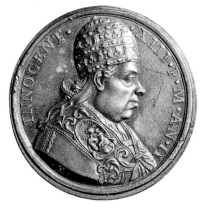

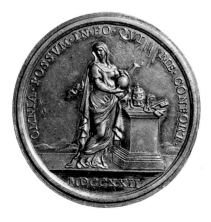

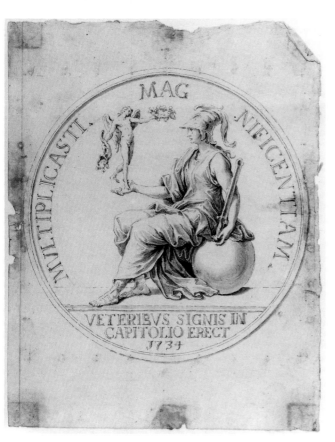

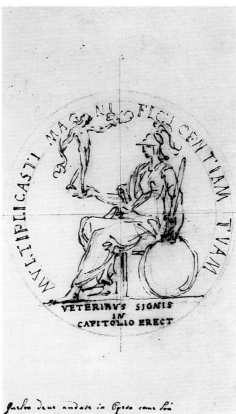

130. Here attributed to Ottone Hamerani, drawing of Roma for the reverse of the annual medal of 1734; black ink and grey wash, with pencil. Private Collection

131. Here attributed to Ottone Hamerani, drawing of Roma for the reverse of the annual medal of 1734; brown ink over pencil. BAV, MS. Vat. Lat. 15232, no. 25

132. Ermenegildo and Ottone Hamerani, annual medal of 1734, with a portrait of Clement XII, and an allegory of the enrichment of the Capitoline Museum on the reverse. British Museum

The next in date, depicting a personification of the Church, is far sketchier (Fig. 128),[81] but corresponds exactly to the annual medal of 1722 (Fig. 129) except for minor changes in the inscription.[82] This sketch is somewhat lacking in weight and solidity as compared to the medal, but this is rectified in the finished version in the Vatican (no. 13). The inscription, 'I can do all things in Him who strengthens me', celebrates that faith in God which should guide all the pope's actions, and may well have seemed appropriate to Innocent XIII whose energetic action had resulted in the Kingdom of Naples paying the tribute they had owed since many years – certainly a result worthy of celebration, but hardly a subject which it would have been diplomatic to depict too directly.

In contrast, the drawing for the medal of 1734 (Fig. 130)[83] is fully finished, but a sketchier preliminary version in the Vatican (Fig. 131)[84] has a note directing that it should be executed. This may help to explain the process of designing these medals: we may assume that several sketches were submitted, and that the one selected was then worked up into a more finished drawing; whether the sketch or the finished drawing was preserved in the volumes that entered the Vatican seems to have been a matter of chance. Here the only difference in the medal by Ermenegildo and Ottone (Fig. 132) is in the inscription in the exergue, in which the abbreviations have been replaced by the words fully spelt out, and the line-breaks are changed, while the date is transferred to the globe below the figure of Roma where it appears together with the wolf and twins (the sign of the Hamerani's shop). It was made to commemorate the enrichment of the Capitoline Museum, with an inscription from Psalm 70, verse 21: 'Thou hast multiplied thy magnificence', but it would hardly rank as one of the more inventive of the papal medals of this period, being based on a common Roman coin reverse type.[85]

The drawing for the medal of 1738 (Fig. 133)[86] is again a sketch, though enriched with wash. The actual medal (Fig. 134) is very similar in effect, and indeed the figures of the four saints canonised in that year (Giuliana Falconieri, Vincent de Paul, Jean-François de Régis and Caterina Fieschi Adorno) are very similar, though they have changed places, the two female saints being moved to the centre, and the clouds below them raised to reduce the emphasis on the straight line separating them from the exergue. The inscription within this on the drawing, taken from

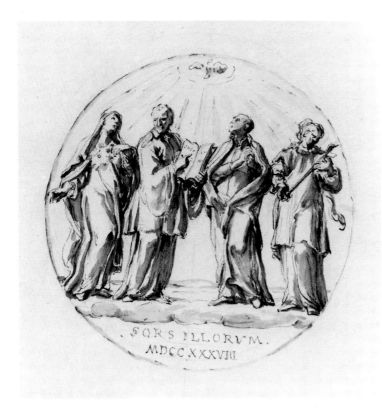

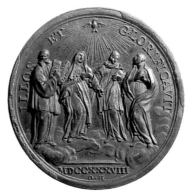

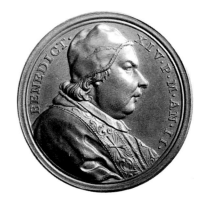

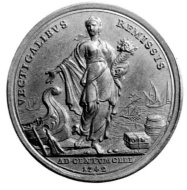

133. Here attributed to Ottone Hamerani, drawing of Four Saints Canonised in 1738, for the annual medal of 1738; brown ink and brown wash over pencil, with grey wash. Private Collection

134. Ermenegildo and Ottone Hamerani, annual medal of 1738, with the portrait of Clement XII, and four saints canonised in 1738 on the reverse; bronze. London, British Museum

the Book of Wisdom (5.5), had previously been used on the annual medal of 1712,[87] and is replaced by one from St Paul's Letter to the Romans (8.30) and set around the rim. Although the use of wash creates a rather different effect, the straight lines of the nose of St Vincent de Paul and the double lines to mark his eyes correspond to those on the figure symbolising the Church (Fig. 128), and the drawing of Caterina Fieschi Adorno's flowing drapery can also be compared to the same personification. While the payment for the medal was as usual made to both Ermenegildo and Ottone Hamerani, the reverse is signed by Ottone.

Wash is used again on the drawing for the medal of 1742 (Fig. 135),[88] with Abundance standing before the port of Civitavecchia. The reverse of the medal (Fig. 136), which is again signed by Ottone Hamerani, retains the foreground elements, but rather strangely substitutes a

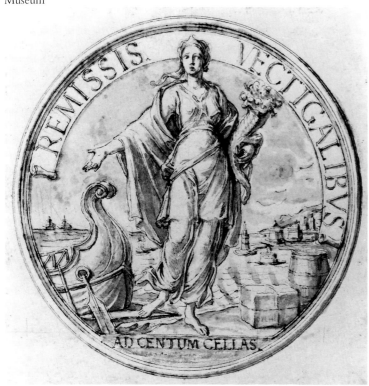

couple of ships for the view of the port itself. The date has been added in the exergue, and the order of the words of the inscription has been changed to fit more comfortably into the space, and the scroll omitted. This suppression of the scroll may have seemed desirable, as it emphasised the disparity in the length of the words, but one may none the less regret the decision: passing behind the head, the scroll projected this strong and energetic figure forward in a way that, despite the spatial confusion it caused (lying on the surface of the medal and even overlapping the rim, while her feet are placed slightly back), gave her a powerful presence which is much less evident in the medal, while emphasising the skill with which this vertical figure has been fitted into the circular format.

With the possible exception of the first drawing for the medal of 1715, all of them appear to be by the same hand, which may be identified with reasonable certainty as that of Ottone Hamerani. To this same hand can be ascribed the remaining drawing in the group (Fig. 137):[89] one could compare the profile of the sphinx to that of the seated Roma in Fig. 130, the background architecture to that of Civitavecchia (Fig. 135), or the modelling of the body of the sphinx to that of the knee of Abundance. Yet this drawing is not for a papal medal, but for one of the Englishman Martin Folkes, and, though this medal has been associated with the Hamerani by various writers,[90] this has not been universally accepted (Fig. 138).[91]

Martin Folkes (1690–1754) was an English man of learning, a Fellow of the Royal Society at the age of twenty-three, a member of the Society of Antiquaries, and a member of the Egyptian Club. This had been founded for those who had been to Egypt, though, so far as is known, Folkes had never been there, but he was possibly interested in its antiquities. He was a polymath, giving papers on subjects ranging from the aurora borealis and parhelia to the statue of Marcus Aurelius on the Capitol, and the fresh-water polypus.[92] He was a specialist on early English coinage, and on weights and measures, both ancient and modern, and was sufficiently adept at ancient astrology to propose a date for celestial sphere of the antique statue, the *Farnese Atlas*, of which he gave a plaster cast to the Royal Society. But none of this is actually relevant to the Egyptian imagery on the medal, nor the inscription, 'They knew their stars' (which comes from Virgil's *Aeneid*, VI.64) and which must refer to the Egyptians, for Folkes was a leading British Free Mason, and the date, Year of Light 5740 (5742 on the medal) is openly masonic.

The translation of these dates poses a problem. According to the librarian of the Free Masons' Libary in London, one should add 4004 to our normal date to get back to the creation of the world according to Masonic belief, and only after about 1800 was this figure habitually simplified

facing page, bottom

135. (*left*) Here attributed to Ottone Hamerani, drawing of Abundance before the port of Civitavecchia, for the annual medal of 1742; brown ink and grey wash over traces of pencil. Private Collection

136. (*right*) Ermenegildo and Ottone Hamerani, annual medal of 1742, with the portrait of Benedict XIV, and Abundance on the reverse. London, British Museum

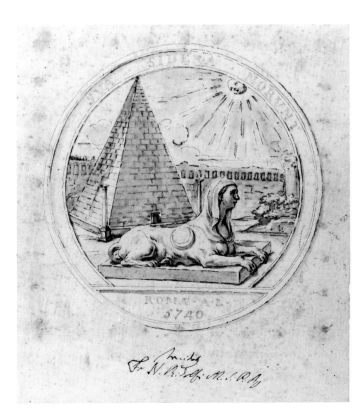

137. Here attributed to Ottone Hamerani, drawing of a Masonic allegory, for the reverse of the medal of Martin Folkes; brown ink and grey wash, with brown wash, and pencil. Private Collection

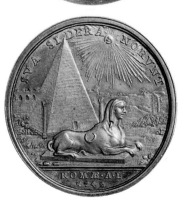

138. Here attributed to Ermenegildo or Ottone Hamerani, medal of Martin Folkes; bronze. London, British Museum

by rounding it up to 4,000.[93] This would give the date of 1736 for the drawing, and 1738 for the medal. However, the drawing has a permission signed by the Master of the Sacro Palazzo Apostolico, the Dominican Nicola (actually Luigi Nicola) Ridolfi, and he did not assume this office until 1638.[94] Possibly it took two years to get this permission, and that is why the medal was not actually issued until 1738. But it would be more plausible to assume that the simplified dating was used, so that the drawing was made in 1740 and the medal issued in 1742: on 28 May 1738 Clement XII issued a bull condemning Free Masonry,[95] and not until 1740 did matters ease off, with the election of Benedict XIV in August of that year.[96] But if one assumes that the dates are 1740/42, one has still to explain the delay in making the medal. This could well have been related to the show-trial of the Mason Tomasso Crudeli in 1740, which ended with his exile;[97] even if the trial took place in Florence, it was inspired by the Inquisition from Rome, and it could have seemed inopportune to strike a blatantly masonic medal at that time.

At neither date was Folkes in Rome (though he had visited Italy in 1733–5 and spent some time in Rome), nor is there any event in his life associated with any of the possible dates,[98] the nearest being his presidency of the Royal Society in 1741.[99] There is also the question of who commissioned the medal. The tradition that it was made on the orders of Clement XII as a surprise for Folkes on his visit to Rome can obviously be discounted;[100] rather more plausible is Francovich's assumption that it was dedicated to him by Roman Masons, and is thus evidence for the existence of a Hanoverian Lodge in Rome at this time (1742),[101] though one cannot assume that the Jacobite Lodge disappeared after the bull of 1738, and the Egyptian symbolism of the medal indicates that Folkes was a high degree Mason, and therefore very possibly a Jacobite.[102] One should not discount the possibility that Folkes himself might have ordered the medal from England.

The numerous problems surrounding the Folkes medal require greater space than even the excessive amount given to it here. In the context of this book, what matters is the question of whether it really was made by 'Hamerani', which would mean Ermenegildo and/or Ottone, and the presence of the drawing among a group of which all but one other are indubitably related to Hamerani medals makes the attribution virtually certain. Regrettably, the inventories of the dies to be sold to the papal mint concern only the papal medals, and the inventory of Ferdinando Hamerani divides the innumerable medals in his workshop into categories by type (devotional, papal, etc.) and material, and merely gives the total weight of each of these.

One can, however, look at the medal itself. The evident discrepancy between the obverse and reverse was remarked on by Marvin, who regarded the obverse as fine, but the reverse as inferior,[103] which is an anti-baroque judgement typical of the late nineteenth century. In fact, the obverse is more in the English taste, following the classic form of a bare-headed bust without

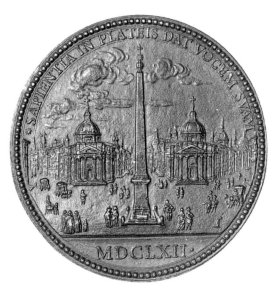

139. Gioacchino Francesco Travani, Foundation Medal for the twin churches in the Piazza del Popolo; bronze. London, British Museum

140. Giovanni Hamerani, medal for the jubilee of 1675, with a portrait of Clement X, and a view of St Peter's on the reverse (1674); bronze. British Museum

drapery, whereas the reverse would fit with no difficulty into the oeuvre of Ermenegildo or Ottone Hamerani. Such a combination is eminently plausible: a Roman die-engraver would have had to receive a portrait of Folkes, whether a drawing or possibly even a wax medallion, which would have been made in England, in the English style. The reverse, however, for all its puzzling iconography, shows a treatment of landscape and architecture such as one finds on many other Hamerani medals with their habitual competence in the handling of the varied planes and the distant background, while only a Roman medallist is likely to have combined the pyramid of Cestius with the wall behind it – a rather unfortunate decision, since this was the site of the Protestant cemetery.

This medal, with the stylistic disparity between obverse and reverse, may serve to point up the quality and stylistic coherence of the other medals produced by the Hamerani. Those illustrated here demonstrate the extreme dexterity of their die-engraving, the consummate skill in designing for a circular format, an ability to suggest great depth in the image while retaining the medal's essential flatness, and the majesty that can be given even to single figures on this small scale. Yet for all its unusual iconography, the Folkes medal also typifies the lack of any great originality in the Hamerani's conception of the medal. Even the animated views of architecture with *staffage* figures, in which the Hamerani excelled, had been adumbrated in medals such as that of the Piazza del Popolo (Fig. 139) cast by Travani in 1662,[104] and merely refined in the sharper detailing of the struck medals such as that by Giovanni Hamerani of 1674 (Fig. 140),[105] which adds to the liveliness of the view by setting the building at an oblique angle; yet even this had been anticipated in such reverses as Morone's of the Quirinal Palace on the annual medal of 1659 (Pl. VIII).

Taken together, the drawings used by the family, from Giovanni to Ottone, probably typify the way in which such medals were designed: most medallists were capable of producing their own designs, but many, such as Gaspare Morone and Giovanni Hamerani, would also make use of those provided by others, whether sculptors such as Bernini or, as is probably the case with the anonymous draftsman of Giovanni Hamerani's medals, a painter; even Ottone Hamerani, whose ability to design his own medals is amply demonstrated, and whose skill in this respect was also employed by his brother, would on occasion depend on other artists.[106] If, as a generalisation, this proves to be correct – and much further work requires to be done on this question – the medallist discussed in this chapter are not so different from the silversmiths and founders to be considered in the following chapters, though the greater number of their 'original' works give them stronger claims to be regarded as sculptors, in the sense of creators as well as executants.

Silver Tribute from a Prince to a Grand Duke. The 'Piatti di San Giovanni'

IF MUCH ECCLESIASTICAL silver has been lost over the ages, the fate of secular silver is infinitely worse. In the first chapter I illustrated some drawings, but few can be attributed to an artist with any degree of plausibility, and very few can be linked to existing objects. I should therefore prefer to concentrate on a series of silver plates which, if they no longer survive, can at least be judged in three dimensions thanks to a complete record in plaster casts.

Unprepossessing though this material may be to look at, it should be noted that the making of plaster casts of objects in silver has a respectable classical origin. Moreover, since Hellenistic and Roman work in precious metals was also subject to the same perils as that of later periods, many remarkable examples of antique silverware too can still be studied thanks to plaster casts, most of which, like those I shall be discussing in the present chapter, were made to serve as models, either for the siversmith himself, or for others to copy.[1]

The casts to which I shall be devoting this chapter are the so-called 'Piatti di San Giovanni', of which an exemplary study was published by Kirsten Aschengreen Piacenti in 1976.[2] They were presented annually on the feast day of St John the Baptist, patron saint of Florence, to the Grand Duke of Tuscany, in accordance with the will of Cardinal Lazzaro Pallavicini. The cardinal died in 1680, instructing his heirs to give each year to the grand duke a silver plate of the value of up to 300 *scudi* decorated with a scene in relief, 'For the great devotion that I bear to the Most Serene Cosimo Medici, now Grand Duke of Tuscany, and as a sign of gratitude for so many favours shown by His Royal Highness towards me . . .'.[3] This provision his heirs duly fulfilled till the house of Medici was supplanted by that of Lorraine in 1737; indeed, the last plate arrived just days before the death of the last Medici duke, Gian Gastone, concluding a series of fifty-eight plates. His successor, François Etienne de Lorraine, was in a desperate financial plight, for though he had inherited the title, the estates of the dukedom remained with Anna Maria Luisa de' Medici, Gian Gastone's sister, and he was compelled to send cart-loads of silver and gold to the mint. But these plates were part of the Medici property, and jealously guarded by Anna Maria Luisa. So they survived in the Medici Palace until 1791, when they were transferred to the Gallery; two years later the director, regarding them as works 'either of mere silverware, or of mediocre modern sculptors', and of a taste that would give neither pleasure nor useful instruction,[4] requested that they be returned to the Palazzo Vecchio. Had they remained part of the public gallery they might have survived the French invasion, but, denied this protection by the disfavour into which the baroque had fallen, they were melted down during the French occupation, around 1800.

For the preservation of these plaster records we are indebted to the energy and enthusiasm of the Ginori family who, having founded a factory at Doccia for the production of procelain, built up a large collection of casts of anything that might one day be reproduced in their new medium. This included not only copies after antique sculpture, but casts of many of the small bronzes by the sculptors of the Florentine baroque,[5] and also, in 1746, of these silver plates, at least one of which was, indeed, copied in Doccia-ware.[6] After the last world war the origin and importance

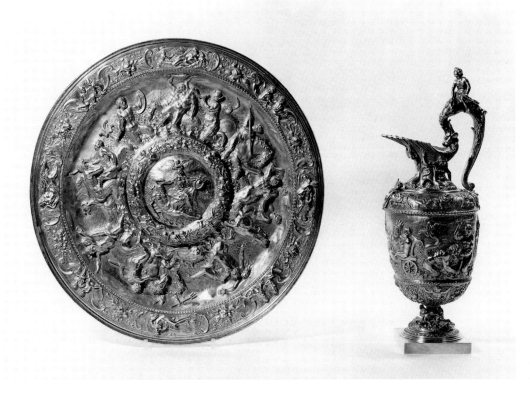

141. Anonymous Genoese (?) silversmith, plate and ewer; silver. Oxford, Ashmolean Museum

of these casts was recognised by the Soprintendente, Filippo Rossi, and the Marchese Ginori Lisci gave them to the Museo degli Argenti in the Pitti, where they are now on exhibition.

Before considering them further, a few words of explanation are required. Firstly, they have for some time been known as the 'Piatti di S. Giovanni', that is, plates, but in the accounts they are invariably called 'bacili', and in the Florentine inventory 'bacini', both of which mean basins, or bowls. For the most part I shall continue to refer to them as plates, though, I suppose, in view of their diameter of around 70 cm., 'platter' might be less misleading. Secondly, the family that gave them are the Pallavicini Rospigliosi; Cardinal Lazzaro's heir was Giovanni Battista Rospigliosi, Principe di Zagarolo, who had married the Cardinal's great-niece, Maria Camilla Pallavicini. At Giovanni Battista's death in 1722 his first son Clemente took the Rospigliosi inheritance, and his second son Nicolò that of the Pallavicini, so that it was Nicolò who became responsible for continuing the production of these plates.

The reason for a legacy of a plate needs to be looked at. Dr Piacenti has described the ceremony that took place on the feast of St John, on 24 June in the piazza between the Cathedral of Florence and the Baptistry.[7] There, after the annual procession, sat the grand duke on a special throne, its back adorned with silver and gold, and with an embroidery of St John the Baptist in the desert, studded with jewels. To him were brought a succession of tributes by the various states and cities under his jurisdiction, and by various nobles who were his vassals. Some offered money, some of the cities and civic organisations brought produce such as cattle or flasks of wine, but several of the nobles would present him with basins and jugs of silver.

So there was nothing exceptional in such a legacy, but still, I think there may be some significance in the fact that Cardinal Lazzaro Pallavicini came from Genoa, a city with a great tradition for the making of silver, including such basins. It can hardly be fortuitous that, of the few comparable basins that survive from earlier periods, several should have been made in Genoa,[8] such as the dish in Oxford (Fig. 141) which is dated 1619, and was commissioned by a member of the Lomellini family, almost certainly Giacomo Lomellini.[9]

Traditionally, basins and ewers went together, and the central boss of the basin was made to

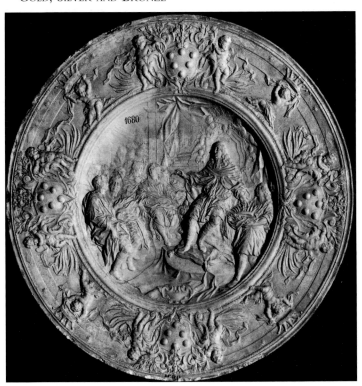

142. Ludovico Barchi, on the de-
signs of Filippo Luzi, *The Succession
Conferred on Anna Maria Luisa de'
Medici*; plaster cast of the silver
plate of 1716. Florence, Palazzo
Pitti

provide a stand for the domed foot of the ewer; but as time went on that function no longer
applied, and the boss, if it were preserved, lost its original justification. Much as in Germany the
standing cup evolved into an object for the display of virtuoso silversmithing and was not
intended to be drunk out of, so such basins or plates were designed for display on buffets, symbols
of their owners' wealth rather than objects of utility. On these buffets the ewer would be placed
beside its basin, with important results for the design of the latter.[10] While there is no evidence
that these dishes were ever so displayed, certainly they were made not for use, but to stand on
such a structure, rising high against the wall, and laden with richly worked silver and gilt.

Dr Piacenti's study left two questions unanswered. The most interesting question still remains
open: who chose the subjects from the history of the Medici family to be represented on each
of the plates? Almost certainly it was someone in Florence, or, possibly, a Florentine in Rome,
since I do not know of any published work that would have provided a source. The series of
plates demonstrates that there was no long-term project to illustrate the most glorious moments
of the Medici from the beginning to the end – which is hardly surprising, since no one could
have known just how long this particular legacy would continue. There are, however, occasional
groups, such as a series of the Medici popes, scenes from the life of the reigning Duke Cosimo
III, or of Anna Maria Luisa. This last may even have had some political relevance, with the scene
of the senators electing her as the successor to her father (Fig. 142), an election which was not
to be recognised by the emperor.

The various Pallavicini archives do not appear to contain volumes of correspondence,[11] and so
far all that has been found at the Florentine end are descriptions of the plates made a few days
after they were presented, when they passed into the *Guardaroba* of the grand ducal collections.
These are not always accurate: for example, on the plate of 1698 (Fig. 143), illustrating *Ferdinando
II de' Medici at the Accademia del Cimento*, the scientific academy which he patronised (he is not,
as it might seem, charming a snake, but pointing with his sceptre to the thermometer which he
had perfected),[12] the duke is described in the inventory as pointing with his left hand to an image
of Truth, whereas it is clearly a version of the Diana of Ephesus, a symbol of Nature; the woman

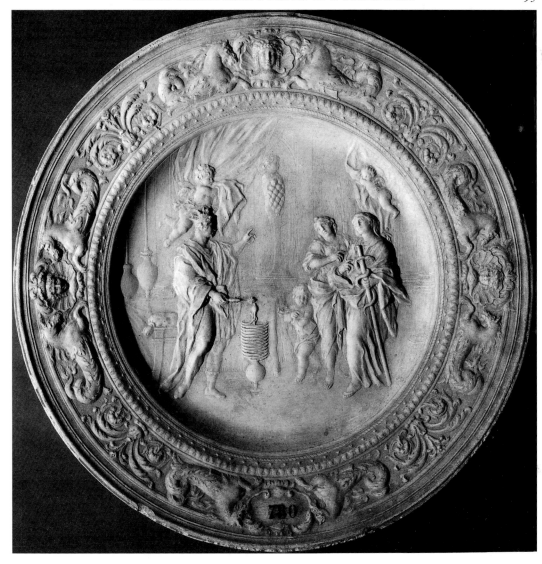

143. Gottifredo Bourhardt, on the designs of Lazzaro Baldi, *Duke Ferdinando II de' Medici at the Accademia del Cimento*; plaster cast of the silver plate of 1698. Florence, Palazzo Pitti

with an accompanying child holding a book is called Virtue, but is more likely to be Learning, and her companion with a snake round her staff cannot be Prudence, as she is called in the description, but must surely be Medicine.[13] From this and similar bits of negative evidence we can say with certainty that the programme was not given by the same court official who made the entry on the plate's arrival, and with some probability that it did not come directly from the grand ducal household. We do know that the presentation of the plate was performed by a Florentine connection of the Pallavicini, the Marchese Alessandro Capponi, and, later, Count Piero Strozzi, and possibly it was one of these who suggested the subjects to be represented.

The other question concerns the artists involved, and one reason for taking up a subject which had been so well covered is that, with a very few gaps, I can now provide names of the silversmiths, and of almost all the designers. For example, Fig. 143 was designed by Lazzaro Baldi, and executed by Gottifredo Bourhardt,[14] while Fig. 142, made in 1716 and representing of the *Election of Anna Maria Luisa*, was designed by Filippo Luzi, and executed by Ludovico Barchi.[15]

These plates differ from the bronzes discussed in previous chapters, and from most figurative sculpture, in that they were not cast, but repoussé, that is, hammered out from sheet silver, worked from the back (less usually from the front) with hammers, and from the front with finer hammers, punches and tools for chasing the surface. This fact cannot, of course, be deduced from

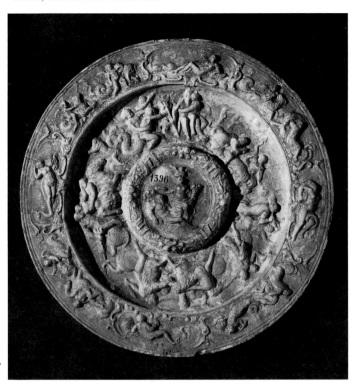

144. Anonymous Genoese (?)
silversmith, plate; plaster cast of the
silver plate of 1680. Florence, Palazzo
Pitti

the casts, but it was the way in which comparable surviving plates are made (though some of the
more elaborate Genoese dishes include some details in high relief cast and soldered on); one can
also compare the recorded weight of the silver plates with their size, since repoussé silver is of
necessity relatively thin.[16] They also differ in another way from the works discussed so far: the
first three chapters, like those that will follow, have been concerned with sculptors who made
models which they either cast themselves, or, as was far more common, passed to founders or
silversmiths to execute. As a further example, it may be noted that the Pallavicini archives contain
an account from Bartolomeo Colleoni, one of the silversmiths who was engaged to make these
plates, which includes the making of a silver setting for an Agnus Dei (a wax medallion stamped
with the image of a lamb, made from the wax of the Easter candle); this was designed by
Ludovico Gimignani, but Colleoni also paid 18 *scudi* to an unnamed sculptor for the model,[17]
and, indeed, this was a normal practice. But it was not followed for these plates, nor would a
model have been so necessary for repoussé silver: even the few full accounts we have from
Bartolomeo Colleoni do not include any payments to sculptors, and the silversmith Ludovico
Barchi was specifically called 'sculptor in silver', as were his successors, the silversmiths Simone
Martinez and Michele Gonella. They did not, however, supply their own designs, which were
invariably provided by painters.

It was Colleoni who supplied the first plate (Fig. 144). It is very similar indeed to the plate in
Oxford (Fig. 141), and even in the blunt cast one can see that the central boss is virtually
identical, replacing the coat of arms held by the female figure with a cornucopia, and placing
another cornucopia behind Neptune. In the Oxford plate the lighthouse at the right of this boss
has been identified as 'without doubt the famous Lanterna, or Torre di Faro . . . one of the most
celebrated landmarks in Genoa'.[18] The description made in Florence when the plate was
consigned to the *Guardaroba* gamely attempts to identify the reclining figure as the Florentine
river Arno, and of the seated woman it writes hopefully, if unacceptably, that she 'is believed to
be . . . Leghorn', the port near to Florence, which did, indeed, have a tower.[19] Since Cardinal
Pallavicino died on 20 April, and the feast of St John was on 24 June, it is hardly surprising that

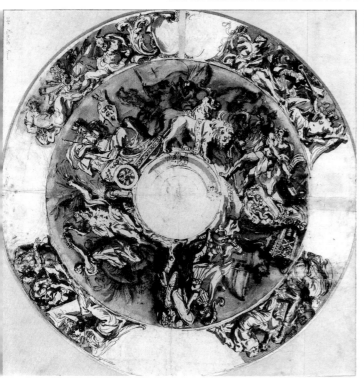

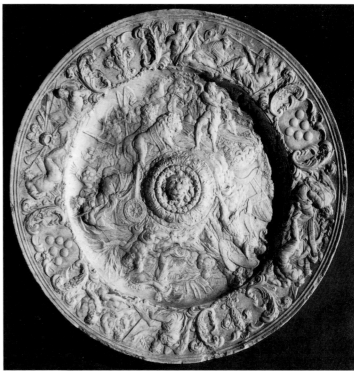

for this first gift they should have made use of an existing plate of the right value which the silversmith Bartolomeo Colleoni had in stock, and which was almost certainly Genoese; and, in fact, Colleoni claimed only to have polished it up.[20]

So the series really begins with the second plate, that of 1681, made, again, by Colleoni. It was Arnold Nesselrath who recognised the drawing (Fig. 145), together with those for the following three plates, in the collection of the Duke of Devonshire at Chatsworth. He related them to an entry in the inventory of Carlo Maratti's widow concerning various drawings, including 'I do not know how many drawings for the bowls which served for the Signori Rospigliosi to give to the His Highness of Tuscany'.[21] In this drawing Tuscany, in the guise of Cybele in a lion-drawn chariot but holding the shield with the Medici arms, is welcomed by Neptune, who invites her to embark. This, at any rate, is how the plate (Fig. 146) was described in Florence, though just why she should want to go to sea is far from clear. In format, this plate follows the tradition, with a central boss, here decorated with the mask of a lion (the Florentine *Marzocco*), a 'story' circling round it, executed in quite low relief, and a decorative border of Fames and prisoners with the Florentine iris and the Medici balls, or *palle*. This format is very much like that of the first plate, though with the higher quality of design that one would expect from Carlo Maratti, and the excellent workmanship, such as one might hope to see from one of the leading silversmiths of Rome.

Much the same could be said of the third plate (Figs. 147–8), showing the Grand Duke Cosimo I, with Victory inscribing his triumphs on a shield, and Peace burning a pile of arms, while Apollo and Minerva lead the arts and sciences to this now peaceful kingdom.[22] In the centre is a medallion of Cosimo I.[23] The only change is in the rather higher relief, and, of course, the more precisely worked-out allegory, with the inclusion of an inscription which Victory is writing on the shield.[24] These changes are even more marked in the plate of 1683 (Figs. 149–50), which shows the Medici Pope Leo X with François I of France, signing the concordat of Bologna, with what the Florentine description calls 'other figures, who allude to this actions, with three tablets', two of which bear inscriptions. Some of these figures can be easily identified, such as those of Religion and Victory either side of the protagonists, and Abundance and Peace

145. Carlo Maratti, *Tuscany, as Cybele, Welcomed by Neptune*; pen and brown ink with brown wash, over red chalk. Chatsworth, Devonshire Collection

146. Bartolomeo Colleoni, on the designs of Carlo Maratti, *Tuscany, as Cybele, Welcomed by Neptune*; plaster cast of the silver plate of 1681. Florence, Palazzo Pitti

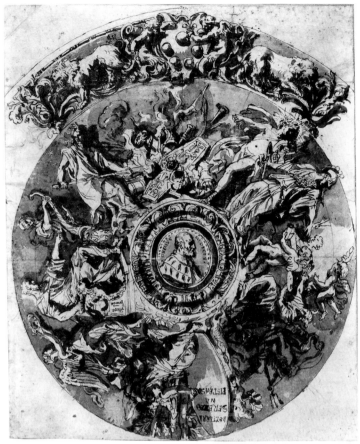

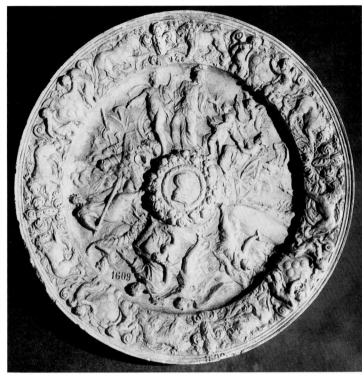

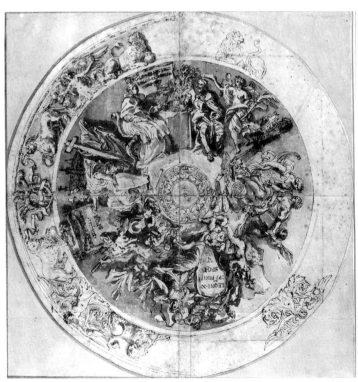

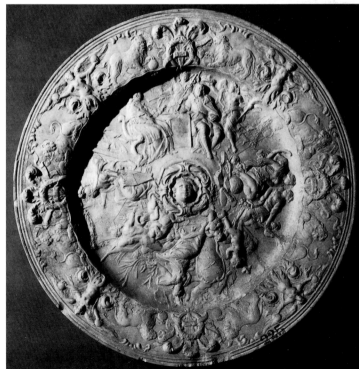

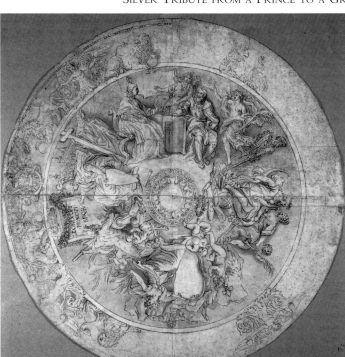

facing page top

147. (*left*) Carlo Maratti, *Grand Duke Cosimo I de' Medici with Victory and Peace*; pen and brown ink with brown wash, over red chalk. Chatsworth, Devonshire Collection

148. (*right*) Bartolomeo Colleoni, on the designs of Carlo Maratti, *Grand Duke Cosimo I de' Medici with Victory and Peace*; plaster cast of the silver plate of 1682. Florence, Palazzo Pitti

151. Workshop of Carlo Maratti, *Pope Leo X with François I of France, Signing the Concordat of Bologna*. Paris, Collection David Jones

embracing. In all of Maratti's drawings for these plates he includes the repeating motifs that will make up the borders, but in this third design the border is particularly successful, both in the inventiveness of the sirens and the lions playing with the Medici *palle*, interspersed with the feathers and diamond ring, which was a Medici device, and also in the way in which their scale and relief help to unify the whole design of the plate.

For this plate there exists another drawing (Fig. 151), which has been plausibly identified as a workshop copy, intended to make the design clearer for Bartolomeo Colleoni.[25] Apart from omitting some of the inscriptions (and one cannot tell from the cast how far those on Maratti's original drawing were copied onto the silver plate) it follows the original exactly, in the placing of the border (which will be twisted round on the silver), and, more significantly, in the double line that separates it from the historiated area, and in the surround of the boss. On the plate there is no hard line below the border, but a slightly swinging ridge, which provides a much more flexible division. The boss too has been radically changed, with the rather mannerist surround to the mask again making a softer division than the double lines and two circles of mouldings in the drawings.

With the fifth plate (Figs. 152–3) the boss has disappeared altogether, but, surprisingly for so competent an artist, Maratti has not yet learnt how to do without it. The main subject, Cardinal Giulio de' Medici (the future Pope Leo X), on horseback watching the battle of Ravenna, is represented still circling round the plate, with a horseman replacing the boss, but only very awkwardly incorporated into the battle scene. From this plate of 1684 to that of 1687 there is no record of the silversmith, but I suspect that here it was still Colleoni.

With the plate of 1685 (Fig. 154) all memory of the boss has gone, and Maratti has finally taken cognisance of the fact that the central field could be treated as a unified space, with a clearly defined direction. Tuscany sits enthroned on her land, offering a wreath of flowers to Henri IV of France and his Queen, Maria de' Medici, in their sky-borne chariot drawn by the Florentine lions. In that of 1686 (Fig. 155) the coronation of Grand Duke Cosimo I takes place in an even more normally pictorial space. Maratti is also experimenting here with the relationship of the border to the historiated space within.

facing page bottom

149. (*left*) Carlo Maratti, *Pope Leo X with François I of France, Signing the Concordat of Bologna*; pen and brown ink with brown wash, over red chalk. Chatsworth, Devonshire Collection

150. (*right*) Bartolomeo Colleoni, on the designs of Carlo Maratti, *Pope Leo X with François I of France, Signing the Concordat of Bologna*; plaster cast of the silver plate of 1683. Florence, Palazzo Pitti

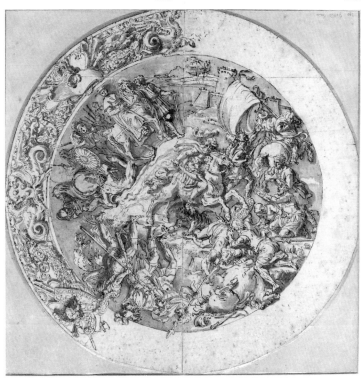

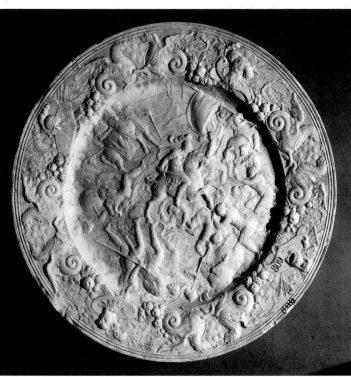

152. Carlo Maratti, *Cardinal Giulio de' Medici at the Battle of Ravenna*; pen and brown ink with brown wash, over red chalk. Chatsworth, Devonshire Collection

153. Anonymous silversmith, on the designs of Carlo Maratti, *Cardinal Giulio de' Medici at the Battle of Ravenna*; plaster cast of the silver plate of 1684. Florence, Palazzo Pitti

154. Anonymous silversmith, on the designs of Carlo Maratti (?), *Tuscany Offering a Wreath of Flowers to Henri IV of France and Maria de' Medici*; plaster cast of the silver plate of 1685. Florence, Palazzo Pitti

155. Andrea Melusi (?), on the designs of Carlo Maratti (?), *The Coronation of Grand Duke Cosimo I de' Medici*; plaster cast of the silver plate of 1686. Florence, Palazzo Pitti

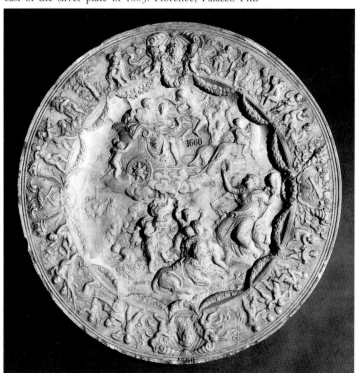

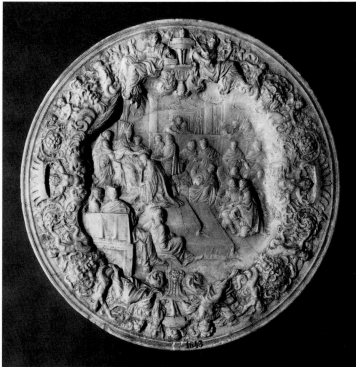

156. (*right*) Workshop of Carlo Maratti, two sections of a cartoon for the border of a plate; black chalk. Düsseldorf, Kunstmuseum

157. (*below right*) Workshop of Carlo Maratti, section of a cartoon for the border of a plate; black chalk. Düsseldorf, Kunstmuseum

158. Andrea Melusi, on the designs of Carlo Maratti, *Caterina de' Medici and her Children, with Justice, Abundance and Peace*; plaster cast of the silver plate of 1688. Florence, Palazzo Pitti

I have said that these are by Maratti, but in fact there are no documentary references to the designers of any of the these plates before 1695, and only the existence of the drawings demonstrate Maratti's responsibility for those of 1681–4. It could be argued that the fact that he was himself given a silver saucer in August of 1683,[26] a typical tip given to an artist for designs such as these, was an indication that he was being paid off. However, as he was to design at least the border of the plate of 1688, and the Pallavicini never seem to have chopped and changed the artists involved in the making of these plates, it can be assumed that he was still providing the designs. Nor have I found any payments to the silversmiths for these years, but on 3 February 1686 Andrea Mellusi was given silver 'for making the plate to be given to the Most Serene Grand Duke of Tuscany',[27] and, as he is documented as having made that of 1688, it is reasonable to suppose that he made at least the preceding two, and possibly three, plates.

In the Kunstmuseum of Düsseldorf are three sections of a pricked cartoon (Figs. 156–7), one of which is inscribed in Italian 'Carlo Maratta ornaments for the plates which are given each year to Florence in tribute', while the others have similar, if less precise, inscriptions.[28] These drawings are certainly not by the hand of Maratti, but, as Eckhard Schaar has suggested, were probably made by the silversmith and pricked directly onto the model for the silver (Fig. 158). In the

centre, according to the inventory, is Caterina de' Medici, Queen of Henri II of France, enthroned with two of her children, and before her personifications of Justice, Abundance and Peace. With this plate, for the first time, there is an inscription tablet placed in the border which identifies the subject as the virtues of Caterina de' Medici, Queen of France,[29] far more clearly than the more allusive inscriptions incorporated into the main designs.

On the next plate, of 1689 (Fig. 159), the central subject is very similar: Maria de' Medici with her son Louis XIII to whom putti present the crown and sceptre, and her two daughters, Elizabeth, future Queen of Spain, and Henrietta Maria, future Queen of England, with various virtues, and putti bearing the inscription on a banderolle. Yet the style is totally different in the treatment of the allegory, the form of the figures, their relation to the space, and the relief of the execution, almost flat in this of 1689, as compared to the unusually high relief of the previous plate. Equally distinctive is the design of the border on the 1689 plate. If this appears to have been left to the silversmith – for it is a conventional design of a type found on many other silver plates – there is no evidence as to the artist responsible for the scene within. However, I believe that it was Ludovico Gimignani, who can be documented only from the plate of 1695,[30] but all of these plates show a similar style, which cannot be entirely due to the silversmith, Gottifredo Bourhardt, who is documented as making the plates from 1689 to 1700.

Carlo Maratti had been one of the favoured artists of the Pope Clement IX Rospigliosi, and retained a close relationship with the family, particularly with Clemente Pallavicini. In the 1680s, at the height of his career as one of the leading painters in Rome, it is quite likely that he would not have been paid for such designs, mere drawings for relatively modest works, the sort of thing he might have done for a friend, and for which he would receive a gift, such as the saucer that Giovanni Battista Rospigliosi gave him in 1683.[31] Ludovico Gimignani had also been patronised by Clement IX who, like the painter, came originally from Pistoia, and Gimignani may also have had connections with Maratti, who certainly had an influence on his art. He too worked extensively for the Pallavicini Rospigliosi family, indeed, he became their house artist, in receipt of a regular salary, though, as three payments to him do exist for designing the plates of 1695 to '97 (the year of his death),[32] this cannot be why I have found no record of payments for the earlier years in the rather unsystematic accounts of that period.

If the plate of 1689 is by him, it is rather exceptional in the awkward use of the circular space. His later designs, such as that for the plate of 1691 (Fig. 160) celebrating Galileo, with Ferdinando

II kneeling on the clouds before Jupiter who holds the Medici stars that Galileo discovered, shows a much firmer grasp of the format, as does that of 1694 (Fig. 161) gorifying Lorenzo de' Medici bringing peace to Italy. Although the use of inscriptions had been abandoned after the experiment of 1687 and 1688, they were reintroduced in 1693, and, although omitted from that of 1694, thenceforth they were to become a regular feature, whether on a tablet or a banderole, usually in the border, but sometimes set at the top or bottom of the main field.[33]

There is one known drawing by Gimignani (Fig. 162),[34] for the plate of 1696 (Fig. 163), showing Cosimo I with a knight of the naval order of Sto Stefano bringing Turkish slaves to him, and St Stephen himself in the sky above. We can be reasonably sure that, like Maratti, Gimignani would have supplied a more finished drawing for Bourhardt to follow, changing the shape of the shield, the group on the right, and so forth. Although they are difficult to make out on the plaster

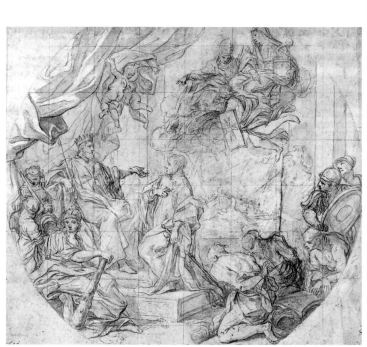

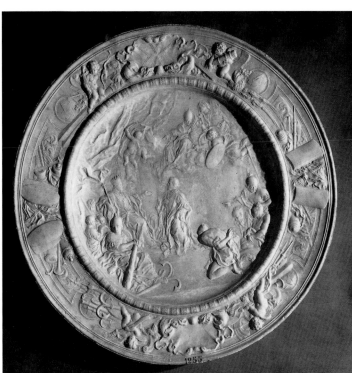

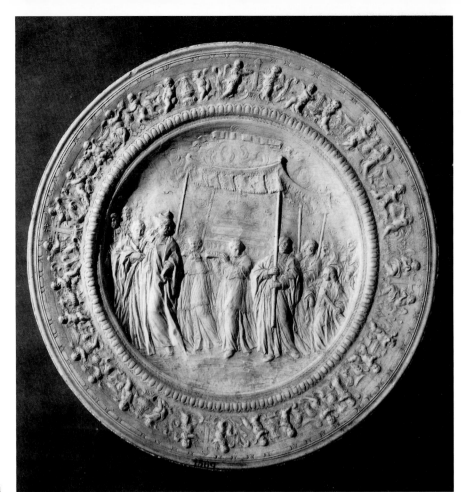

164. Gottifredo Bourhardt and Lorenzo Merlini, on the designs of Lazzaro Baldi, *The Translation of the Body of St Stephen*; plaster cast of the silver plate of 1700. Florence, Palazzo Pitti

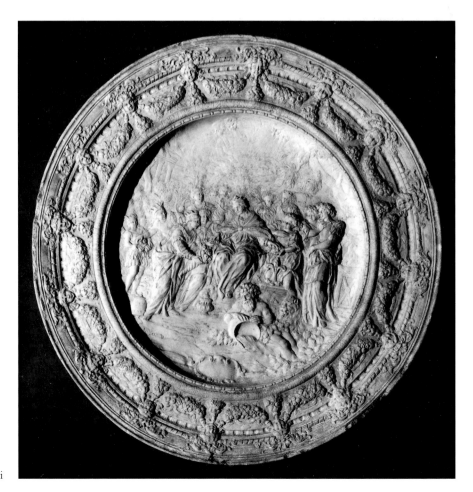

165. Ludovico Barchi, on the designs of Lazzaro Baldi, *Tuscany Receiving the Fruits of the Nations*; plaster cast of the silver plate of 1702. Florence, Palazzo Pitti

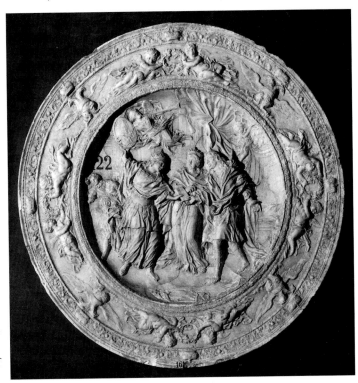

166. Ludovico Barchi, on the de-
signs of Filippo Luzi, *Cosimo III de'
Medici Receiving the Title of 'Royal
Highness' from the Emperor Leopold;*
plaster cast of the silver plate of
1706. Florence, Palazzo Pitti

its rather harsh and linear style and its sharply folded draperies and almost brutal portraiture – for
certainly Cosimo III, here seen receiving the certificate of his title of Royal Highness, did not
have an easy face to flatter, and even the Emperor Leopold in the portrait held by Fame manages
to appear rather more handsome than Cosimo. Another feature to be found in a number of
Barchi's plates is the rather uncomfortable relief, in which the bodies emerge considerably higher
than the heads.[45] We shall return to the question of the borders, which are often more attractive
than the historical scenes.

 This is a rather extreme example, and some of Barchi's work is much more subtle. I say Barchi,
because there is no trace of this hard angularity in the only certain design for these plates by
Filippo Luzi (Fig. 167),[46] which is sufficiently close in style to his only other certain drawing, the
portrait of Lazzaro Baldi,[47] that we can safely regard it as typical. This plate of 1717 (Fig. 168)
shows Cosimo III enthroned between Prudence and Wealth (the Florentine description calls her
Abundance) with an army in the background, and an inscription identifying the allegory as
Tuscany preserved from the fury of war by Counsel and Wealth.

 It is worth pausing here to consider what was required of the 'sculptor in silver'[48] to turn a
drawing such as this into a silver relief. At a casual glance, and particularly if one is looking at a
photograph rather than the actual plate, it might appear that he just copied the drawing, with
great fidelity. But the drawing is a representation of a three-dimensional conception in two
dimensions, that must be translated by the sculptor into what one might call two and a half
dimensions. Luzi uses the device of perspective to create an effect of recession, and wash
(imitating shadow) to round his forms, and to indicate that one form is in front of another. The
sculptor of a low relief has to be careful in his use of perspectivally converging lines, because a
small degree of perspective is introduced by the relief itself. If one looks at the crown by
Cosimo's left hand, in Luzi's drawing it is reasonably convincing, being slightly raised as it rests
on the sceptre, but Barchi has marginally reduced the space in the design, losing the emphatic
near edge of the table, and has slightly increased its slope, so that the relationship of the crown
to the table-top appears confused. I point out this minor error only to indicate the difficulties of
his task, which he has otherwise overcome with admirable skill. The three principal figures are

(and even more so on a photograph) the battling ships visible above the kneeling captives are present on the plate, modelled with great subtlety and consummate mastery of the lowest relief.

The question of who designed the borders is more tricky: contrary to those of Maratti, Ludovico Gimignani's drawing does not include them. But there is such similarity in these borders, most of which show putti interspersed with medallions or cartouches, that it is hard to imagine they were not all designed by the same hand, whereas after Gimignani's death they change radically. It is therefore unlikely that they were left for Bourhardt to supply.

In 1698 Gimignani was succeeded by another artist from Pistoia who was also much patronised by the Pallavicini family, Lazzaro Baldi, who continued to be paid for the designs till 1702.[35] His first, that of 1698 with Ferdinando II de' Medici at the Accademia del Cimento (Fig. 143), we have already looked at, and one can better judge his sometimes rather heavy manner from that of 1700 (Fig. 164), which shows the translation of the body of St Stephen with Cosimo III leading the procession, and that of 1702 (Fig. 165), with a generalised allegory of Tuscany receiving the fruits of various nations. That of 1700 is interesting as being the first plate with a contemporary subject; in fact, it seems that it even anticipated the event depicted, which did not take place till a month after the plate was presented.[36]

On 26 January 1700 Gottifredo Bourhardt had been given the silver for making the plate, as had become the custom, but the remaining 160 *scudi* for the silver and the making of it were paid to Lorenzo Merlini,[37] a sculptor and silversmith from Florence, who also records its manufacture with some pride in his manuscript autobiography: 'I made a basin . . . completely historiated in relief with figures illustrating the Translation of the Body of St Stephen by the order of the Knights of St Stephen in Pisa, and in the border flying putti with ecclesiastical emblems and those of the Order made on my design and model.'[38] This wording is ambiguous: was the whole made on Merlini's design, or only the border? In fact, it must have been the border only, because the Rospigliosi Pallavicini accounts record Lazzaro Baldi as receiving his customary 25 *scudi* 'in recognition of the design for the said plate'. But Merlini's autobiography provides valuable confirmation that the design of the borders for some plates were left to the silversmith, at least since the death of Gimignani.

More problematic is the question of why Merlini should have taken over the making of this plate from Bourhardt. Possibly he was employed in Bourhardt's shop, for at this time he was not himself a member of the guild.[39] A silversmith's workshop would have included many craftsmen, and the fact that a payment was made to the master need not mean that he did the work himself; he may well have passed the execution to a competent assistant, and it is very likely that particular members the shop would have had a special talent for particular types of work. Here one should also consider the intriguing problem of the great French silversmith, Thomas Germain the elder, who went to Rome in 1688, remaining there for thirteen years,[40] and who is said to have made several of the 'piatti di San Giovanni'. There seems no reason to doubt this: as he was not a member of the guild, he could not have worked on his own account, and the payments would have been made to the head of the workshop.[41] But in this case it seems more likely that for one reason or another the Pallavicini dismissed Bourhardt,[42] as he made no more of the plates. What is most surprising about Merlini's autobiography is that he says nothing at all about the plate of 1701, though that was entirely his work, with Baldi again receiving the payment for the design.[43] But in 1702 Lorenzo Merlini returned to Florence, and a new silversmith took over, Ludovico Barchi, who was to continue to produce these plates until his death by suicide in 1731.

Lazzaro Baldi died in 1703, and in the following year the plate was designed by Filippo Luzi, whose partnership with Barchi was to continue for twenty years. According to the biographer Nicola Pio, Luzi was a pupil of Baldi, who regarded him almost as a son, and at his death he entrusted the care of his inheritance to him. Pio speaks of his fertility as a draftsman, and of the facility, grace, and erudition of his drawings, saying that such qualities can be seen 'in the designs he made for many years for the Rospigliosi family, for the great historiated dishes made for the Grand Duke of Florence, in satisfaction of the legacy left to him by Cardinal Lazzaro Pallavicini'.[44] However, his lower standing may be reflected in the fact that he was paid only 20 *scudi* for his designs, as against Baldi's regular 25, and the 30 that had been paid to Gimignani.

Luzi and Barchi's first plate is less typical than some others, such as that of 1706 (Fig. 166), with

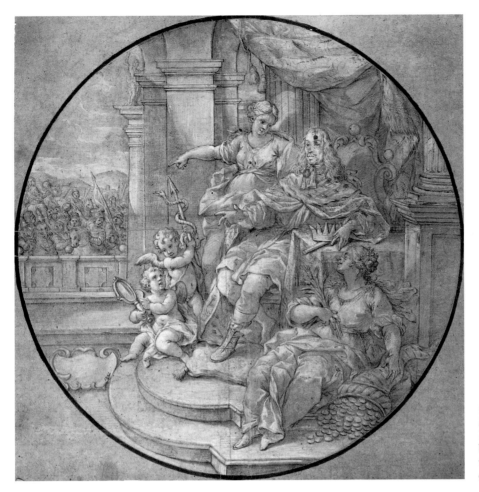

167. Filippo Luzi, *Tuscany Preserved from the Fury of War by Counsel and Wealth*; back an white chalk, brown wash. Philadelphia Museum of Art

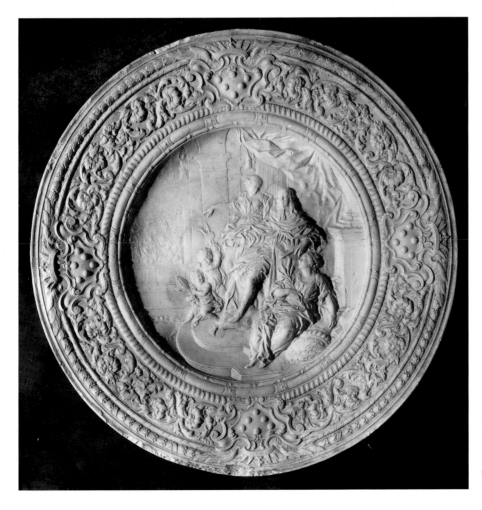

168. Ludovico Barchi, on the designs of Filippo Luzi, *Tuscany Preserved from the Fury of War by Counsel and Wealth*; plaster cast of the silver plate of 1717. Florence, Palazzo Pitti

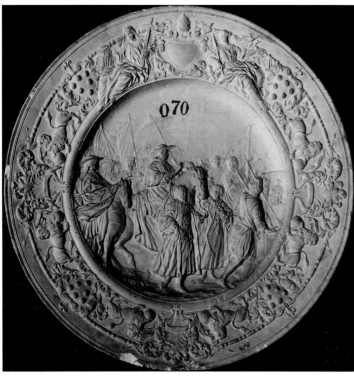

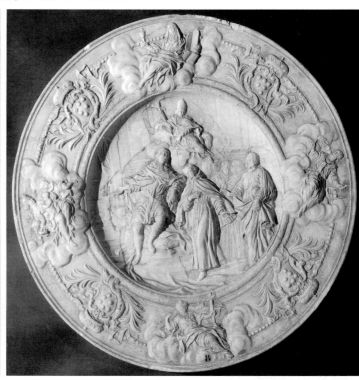

169. Ludovico Barchi, on the designs of Filippo Luzi, *Pope Leo X on Horseback*; plaster cast of the silver plate of 1713. Florence, Palazzo Pitti

170. Ludovico Barchi, on the designs of Filippo Luzi, *Cosimo III Enthroned with Representatives of Religious Orders*; plaster cast of the silver plate of 1718. Florence, Palazzo Pitti

171. Ludovico Barchi, on the designs of Filippo Luzi, *Lorenzo de' Medici Receiving Books*; plaster cast of the silver plate of 1720. Florence, Palazzo Pitti

172. Ludovico Barchi, on the designs of Giuseppe Chiari, *Pope Clement VII Ordering the Building of Civitavecchia*; plaster cast of the silver plate of 1723. Florence, Palazzo Pitti

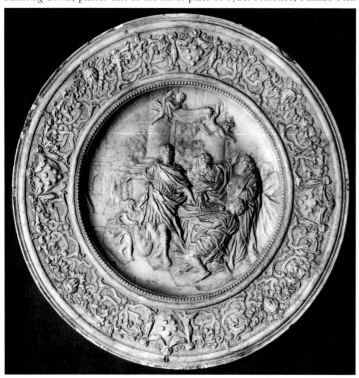

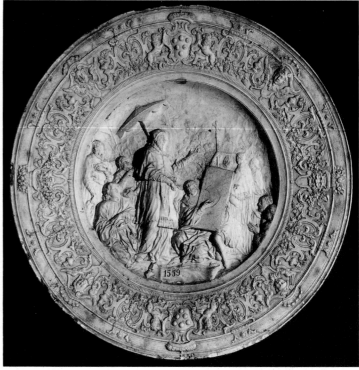

executed on almost the same plane, yet they do appear to be in diagonal recession, and the prowling host of warriors at the right are executed in very low relief, firmly kept in their place outside the balustrade protecting the states of Tuscany. Moreover, this rather confused mass of figures in the drawing has, of necessity, to be given more definition in sculpture, and here too Barchi, on the whole, succeeds brilliantly. In only one respect has Luzi given him a task that he cannot altogether fulfil: the balls surmounting the pedestals of the balustrade can be marked out in the drawing by means of their highlights and clearer outlines; these means were not available to Barchi, and it is hard to distinguish them from the heads of the soldiers behind.

These comments are not intended as a criticism of Barchi, but merely as a reminder of how much is left to the skill of the sculptor, even when presented with a clear and highly finished drawing such as this.

If I find many of Barchi's central scenes rather displeasing, it must be said that this 'sculptor in silver' often shows great inventiveness and considerable charm in his borders, as can be seen in two very different examples from 1713 (Fig. 169) and 1718 (Fig. 170), or those, in a very different style, from 1720 (Fig. 171) and 1723 (Fig. 172). But how do we know that they are by Barchi? One reason for assuming that they are by the silversmith rather than the painter is that these strap-work borders are typical of silver of the period, if rather more French in style than Italian – indeed, Dr Piacenti has drawn attention to their connection with the art of the French Régence[49] – and it is not by any means impossible that Barchi had a French assistant. Thomas Germain has previously been mentioned, but he had already left Rome, so he cannot have worked on these plates; however, there could well have been later Frenchmen who followed in his footsteps, though, of course, actual silver, or engraved patterns, could have served equally well as models for Roman craftsmen.

Another reason for ascribing the borders to the silversmith is that, while the plate of 1720 (Fig. 171) was designed by Filippo Luzi, that of 1723 (Fig. 172) which is so very similar in its border was designed by Giuseppe Chiari.[50] Finally, we know that Barchi designed the border for the plate of 1724 (Fig. 173), because he claimed 30 *scudi* above the going rate of 130 *scudi* pointing out that he had put a lot of labour into the relief in the centre, and 'also into the border having put there four medallions of the four popes of the house of Medici with putti and lions and other

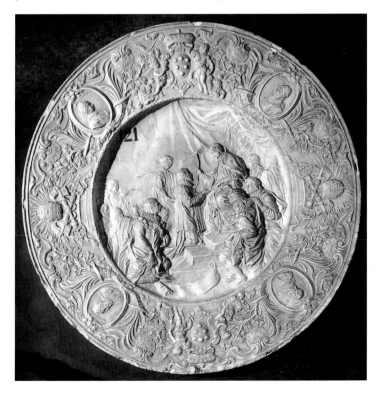

173. Ludovico Barchi, on the designs of Giuseppe Chiari, *Pope Clement VII*; plaster cast of the silver plate of 1724. Florence, Palazzo Pitti

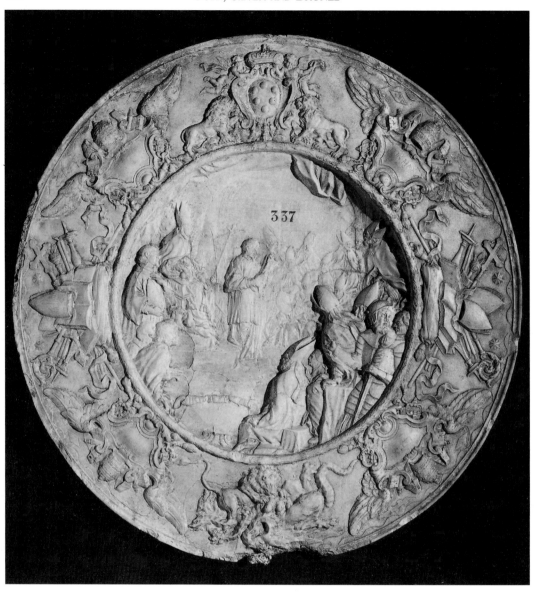

174. Ludovico Barchi, on the designs of Giuseppe Chiari, *Pope Leo X in Council*; plaster cast of the silver plate of 1725. Florence, Palazzo Pitti

ornaments of masks and grottesques, and with all this having devoted much time to invent and draw the said design of the border' for which, he claimed, he could not get less than 160 *scudi*.[51] He could, and did: his claim was amended to the standard rate of 130 *scudi*.[52] Admittedly, this could be an argument for saying that he had not designed the others, but it would be more reasonable to see this claim for extra payment as justified by the extraordinary sculptural richness of the border, comparable only to those of 1715 and 1718 (Fig. 170) for which we have only a record of the payments, and not the silversmith's own accounts.

In the following year he again attempted to get a rise, to the more modest sum of 140 *scudi*, in view of 'the quantity of figures in the relief, more than were customary'[53] (Fig. 174), but again he was slapped down to 130. He had some justification, for the scene of Pope Leo X in council does have a great many figures, even if they are in very low relief. In the border, apart from the top and bottom, Barchi has taken care to have just two motifs repeated; but there is also an innovation, for at the bottom the lion (for Pope Leo) fighting a many-headed monster (which presumably represents Heresy) is depicted the right way up, whereas always before the borders had followed the tradition which we still see on plates today, whereby feet are on the inside rim,

and heads on the outside, circling round the centre. This is further evidence of how far these plates had come from their origin as utilitarian pieces of silver to be eaten off, developing instead into decorative objects to stand on a buffet; indeed, it might seem that only the terms of Cardinal Lazzaro Pallavicini's will prevent them from abandoning any pretence of being plates.

Here I should explain that, while Cosimo III had put the plates straight into the *Guardaroba* a few days after the presentation, when Gian Gastone succeeded him in 1723 he preferred to keep them by him in the Palazzo Pitti, and only after his death were they passed to the *Guardaroba*. Since they did not come in year by year, their dates are not recorded; but silver is always inventoried with its weight, and this can be compared with the annual payments, which also noted the weight of silver used – in fact, with rather more precision, since the payment the silversmith received depended upon it. These weights enable us to date almost all the post-1723 plates with absolute certainty, and the couple of doubts that might remain, because some of the plates had the same weight, can be cleared up either by arguments from style, or by the reasonable assumption that the subjects would have been grouped together, that is to say that one would not find a plate with a scene of the current Grand Duke Gian Gastone in the middle of a series of three or four showing earlier popes.

After this series of Medici popes, in 1726 the subjects change to contemporary events, with Cosimo III led to Eternity (Fig. 175); the description identifies the woman with the snake as Prudence, but a snake biting its tail is a well-known emblem of Eternity, as are the Sirens in the border, and again it may be noted that the bottom one has been turned so as to sit upright.

The last two plates by Ludovico Barchi show a quite different type of border, reverting to the much lighter style of the French Régence. This cannot be due to Tomasso Chiari, who had taken over as designer in 1728 after the death of his brother Giuseppe, since there had been no noticeable change then, and since these are typical craftsman's designs which one would not expect to have been produced by a painter. Again, the most likely explanation is the arrival of a new assistant in Barchi's shop. That of 1730 (Fig. 176) shows the ceremony of the tribute on the feast of St John itself, with Gian Gastone enthroned, and receiving a dish, but it cannot be that of the Pallavicini, since there are keys in it. The plate of 1731 (Fig. 177), in rather better

175. Ludovico Barchi, on the designs of Giuseppe Chiari, *Cosimo III Led to Eternity*; plaster cast of the silver plate of 1726. Florence, Palazzo Pitti

176. Ludovico Barchi,
on the designs of Tomasso
Chiari, *Grand Duke Gian
Gastone de' Medici Receiving
Tribute on the Feast of St
John the Baptist*; plaster cast
of the silver plate of 1730.
Florence, Palazzo Pitti

177. Ludovico Barchi,
on the designs of Tomasso
Chiari, *Grand Duke
Gian Gastone de' Medici
Distributing Alms*; plaster cast
of the silver plate of 1731.
Florence, Palazzo Pitti

condition, shows Gian Gastone at the port of Leghorn giving out charity to the poor. In an allegorical representation such as this the grand duke does not do it himself, but orders Plenty to do it for him; even his own presence is allegorical, since he would certainly never have got this close to his indigent subjects, and, in fact, scarcely ever emerged from his bed.

Reading the account books one begins to get the depressing sensation that Barchi will go on for ever. Maybe he felt similarly depressed at the prospect, for the Roman diarist Francesco Valesio records on Monday 29 October 1731 that

> A certain Ludovico Barchi from Modena, and a silversmith by profession who had his shop near the Palazzo del Governatore, having sent his family to the country and remaining alone in his house, killed himself by firing a pistol in his throat. When the family returned they found the house locked, but forced open a window and found him dead. He had given many signs of madness for some months, and this happened yesterday.[54]

Maybe he was indeed mad, but it should be borne in mind that suicide is a mortal sin, and only madness could excuse it. Did those two hopeless attempts to get more money out of Nicolò Pallavicini indicate madness, or could his real trouble have been poverty? If he was indeed mad, it had no visible effect on his art, for the central scene with the ships and buildings of Leghorn in the most delicate low relief, and the little scene of the slaves unloading sacks, are executed with a finesse that equals anything he had done in the past. In fact, it surpasses it, in the complete absence of those fussy angular ridges and the rather heavy modelling that characterises Barchi's style. Perhaps this is a sign that he was sick, either in mind or body, and that his last commission for the Pallavicini had been executed by a talented assistant.

But not the man who was to succeed him as plate-maker. This was the sculptor and silversmith Simone Martinez, whose uncle, the Messina-born Francesco Juvarra, practised as a silversmith in Rome, and whose other uncle, the silversmith-turned-architect Filippo Juvarra, was later to summon Martinez to Turin.[55] At the same time, 1732, Tomasso Chiari gave way to his nephew Carlo, a young man who has virtually disappeared from the history of art after winning second prize in the competition at the Accademia di S. Luca in 1728 with a rather poor drawing.[56] But

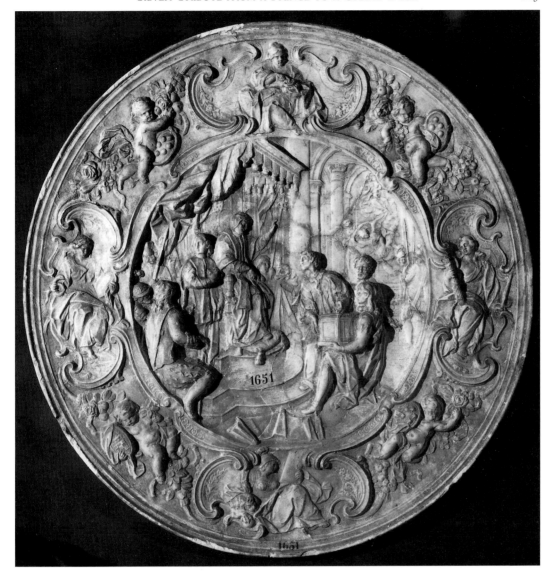

178. Simone Martinez, on the designs of Carlo Chiari, *Pope Leo X Ordering the Building of the Santa Casa di Loreto*; plaster cast of the silver plate of 1732. Florence, Palazzo Pitti

here he turns up making perfectly competent designs for the Pallavicini plates, and even when by 1735 he is given the title of 'Canon' (and also, exceptionally, called by his full name of Carlo Francesco) he is still described as a painter, for this minor ecclesiastical position had never prevented an artist from continuing to pursue his profession.[57]

Coincidentally with Carlo Chiari's arrival as draftsman the subjects revert to earlier Medici popes. The plate of 1732 (Fig. 178) represents Leo X ordering the building of the Sacra Casa di Loreto, and that of 1734 (Fig. 179) shows Pius IV ordering the building of the port of Camplì, the design of which is presented by the kneeling architect. The designs of the borders have a majesty and swinging rhythm which is totally different from anything we have seen before, and which, I think, can be ascribed to Martinez; in the first he incorporates the four Cardinal Virtues, and in both he includes not only the Medici arms, but also those of the Pallavicini.[58]

Yet Martinez made only three plates. Handsome though they are, they are bigger than most of those that had preceded them, and while those had weighed around 15 *libbre*, these weighed around 16½. Since the silver had to be paid for, these plates were costing well over the 300 *scudi* that Cardinal Lazzaro Pallavicini had specified in his will.[59]

Whether or not that was the reason, the last three plates were made not by Martinez, but by

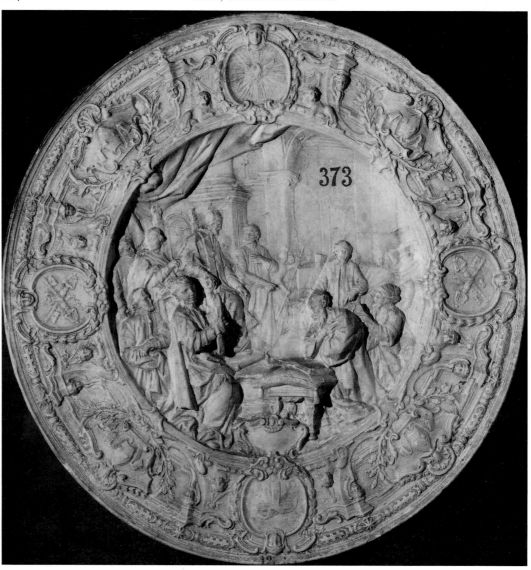

179. Simone Martinez, on the designs of Carlo Chiari, *Pope Pius IV Ordering the Building of the Port of Camplì*; plaster cast of the silver plate of 1734. Florence, Palazzo Pitti

Michele Gonella (who, in one of his three payments, is also called 'sculptor in silver'),[60] still on the designs of Carlo Chiari. I illustrate that of 1736 (Fig. 180), which continues with the life of Pius IV, and that of 1737 (Fig. 181), which changes to Grand Duke Francesco I de' Medici and the order of St Stephen which he founded. The strongly modelled borders are more architectural in their design, richly filled with ecclesiastical and Medicean symbols, fittingly proud conclusions of a series that had continued for over half a century.

In the making of these plates the Rospigliosi Pallavicini family had employed many of the leading artists of the day: if Carlo Maratti was undoubtedly the most famous, Lazzaro Baldi and Ludovico Gimignani were also well established painters, as was Giuseppe Chiari; if the same cannot be said of Filippo Luzi, or of Tomasso or Carlo Chiari, they proved to be competent followers of their predecessors' manners, introducing no innovations, but continuing a tradition with no regrettable lapses. Much the same might be said of the silversmiths, though here the lack of comparative work makes it hard to judge their standing. The fact that for their own silver the family often preferred to turn elsewhere may well mean no more than that different silversmiths had differing strengths, and that the particular skills in figure-modelling demanded for the making of these display-plates were not required for the candlesticks or simpler plates used in the Pallavicini household.

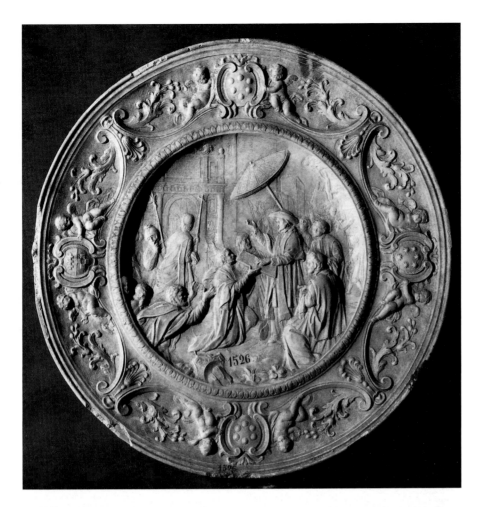

180. Michele Gonella, on the designs of Carlo Chiari, *Poge Pius IV and the Patriarch of the Chaldaeans*; plaster cast of the silver plate of 1736. Florence, Palazzo Pitti

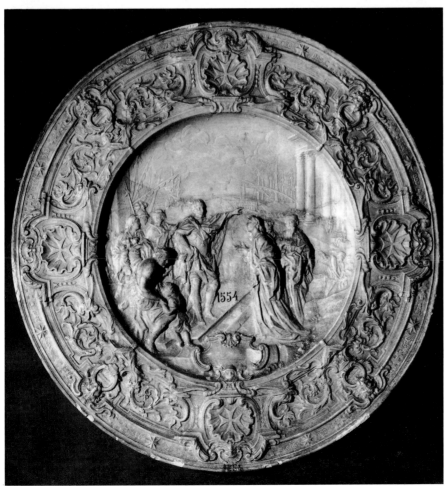

181. Michele Gonella, on the designs of Carlo Chiari, *Francesco I de' Medici and the Knights of St Stephen at the Port of Leghorn*; plaster cast of the silver plate of 1737. Florence, Palazzo Pitti

What I hope has emerged from this examination is the degree of invention that went into the production of these superficially very similar objects. Even the impression of a certain stagnation during the long collaboration of Luzi and Barchi turns out, on examination of the borders, to contain a measure of experimentation, and with the arrival of Martinez and Gonella a new life was injected into the formula. It is sufficient to compare the last plate (Fig. 181) with the first of the series (Fig. 146) to see just how far they have developed over the span of 57 years.

The other point that should be made, especially in the context of this book, is that such silverware is, indeed, sculpture, and that when the makers were described as 'sculptors in silver' it was with good reason. Even through the medium of these often defective plaster casts it is possible to see that this series of plates represents a high point of sculpture in metal. Again we may revert to classical antiquity, and note that, for the Greeks, the silversmith was not regarded as a practitioner of a minor art, but as an equal to the painter or sculptor. The work of these 'sculptors in silver' suggests that the ancients may well have had an understanding of their merits which we should do well to recover.

6

Giardini and Giardoni. Silversmiths and Founders of the Eighteenth Century

TO TREAT THE families of the Giardini and the Giardoni in a single chapter might seem to be adding unnecessarily to the confusion that must inevitably arise given the similarities of their names.[1] But between them they were far and away the most important metal-workers from the last years of the seventeenth century till the almost the end of the eighteenth; they succeeded one another as official founders of the Sacro Palazzo Apostolico (Giovanni Giardini was appointed in 1699, his nephew Giacomo in 1717, Francesco Giardoni in 1739, and his son Giuseppe in 1756)[2] which meant that they were responsible for, amongst other things, casting cannon for the papal armoury, and both Giovanni Giardini and Francesco Giardoni were papal silversmiths. This is not to say that they were without rivals, and in the following chapter we shall encounter a number of other able silversmiths and founders active in the middle years of the eighteenth century. But they were sufficiently dominant in both fields that an examination of some of their major works will provide a reasonable sample of the sort of metal sculpture produced in the eighteenth century; it will also raise some intriguing and puzzling aspects of these arts.

Giovanni Giardini (1646–1721) (Fig. 182) has acquired a particular fame amongst the silver-smiths of his period because he published a pattern-book, a set of designs for metalwork engraved from his drawings that appeared originally in 1714 as *Disegni diversi . . .*, with a dedication to the pope, and was reedited in 1750 as *Promptuarium artis argentariae . . .* with a dedication to the Accademia di S. Luca.[3] In this respect one might compare him to Benvenuto Cellini, who was indeed a great goldsmith, but much of whose fame is owed to the fact that he wrote an autobiography; his name is thus known to everyone, and any work of merit from the first half of the sixteenth century tended to be attributed to him before more diligent research began to recover the identities of other masters. Much the same could be said of Giardini; moreover, the fact that these were patterns, intended not only to demonstrate his mastery, but also to provide designs that could be used and adapted by others, has created problems of attribution, one example of which has already been examined in chapter 1.[4]

There is, however, a feature of these designs that has been strangely overlooked, and which was brought to my attention by Peter Fuhring: while the purely decorative parts are always drawn by Giardini in ink, in at least two cases the figures have been added in another hand (Fig. 183), identified on this drawing as that of Benedetto Luti.[5] There is no reason to doubt this attribution, and it gains added credence from the number of paintings by Luti that figure in Giovanni Giardini's inventory.[6] But it is an important indication of the area in which Giardini's skills lay, for, indeed, his drawing of figures throughout is fairly inept, and it suggests that where figures such as angels occur in his work it is likely that he was making use of models, or at least drawings, provided by others. There is confirmation of this in the archives of the Sacro Palazzo Apostolico: on 31 March 1711 Giardini submitted accounts for making various finials for the pope's chairs; two of these designs correspond to those engraved (nos. 89 and 95), and both include payments he had made for wax models; the third was a repetition of finials he had made the previous year; obviously no payment for models was included here, but his account of 22 December 1710 had included 28 *scudi* 'paid for models, and designs made and remade for the above [finials]'.[7]

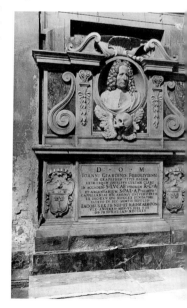

182. Anonymous sculptor, *Tomb of Giovanni Giardini*; marble. Rome, S. Eligio degli Orefici

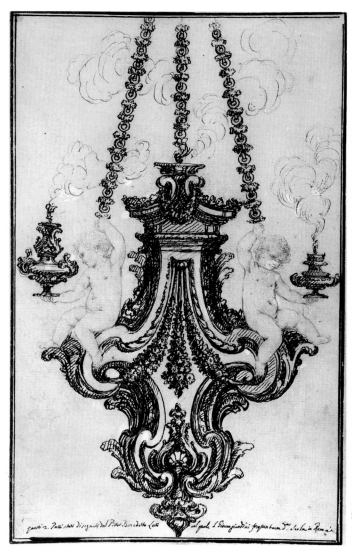

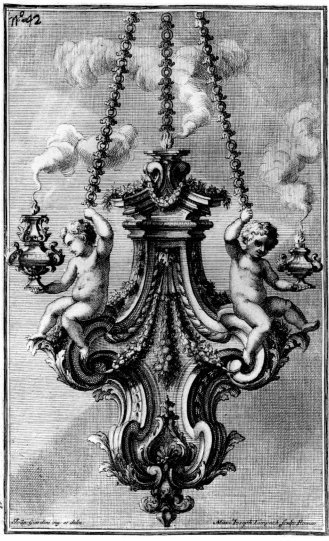

183. Giovanni Giardini and Benedetto Luti, drawing of a hanging lamp; pen and brown ink, black chalk. Berlin, Kunstbibliothek

184. Maximilian Joseph Limpach, on the design of Giovanni Giardini, *Hanging Lamp*; engraving

Another fact of some interest emerges from the comparison of the drawings with the prints (Fig. 184): in the drawings many of the decorative details are left extremely vague, for example the motifs separating the rings of the chain, or the hanging bunches of foliage (and fruit?) along the sides of the lamp behind the cherubs; all these have had to be given precise forms by the engraver, and in this design even the moulding below the broken volutes at the top have been adjusted to a more interesting shape. However, here there is little reason to doubt Giardini's personal responsibility, since he retained the engraved plates, as well as a stock of prints,[8] and evidently kept a firm control over their production.

Giovanni Giardini also has another distinction unique amongst Roman metal-workers, in that a book has been written about him.[9] It is a very peculiar book, the text consisting mainly of the author's imaginary conversation with him, but in it are published a number of important documents,[10] and part of his very long inventory. Another even longer inventory exists for his nephew Giacomo, whereas if there are any Giardoni inventories they have so far evaded discovery. So it is possible to reconstruct Giovanni Giardini's activity not only from the readily accessible account books, most notably those of the Sacro Palazzo Apostolico (that is the list of payments for work done at the official command of the pope), but we can also add a number of further works listed in the inventories, some of which we should probably never have known

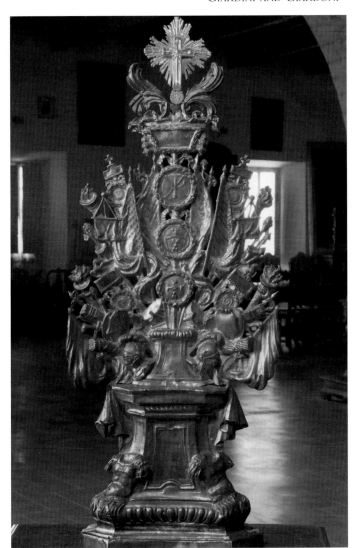

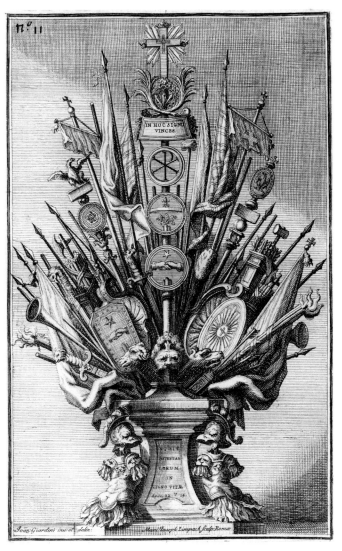

of otherwise. Others can be identified (subject to the caveat mentioned above) by comparison with the designs in his pattern-book, which indubitably records some pieces actually made as well as, in all probability, illustrating designs that could be made if desired.

There can be no doubt in the case of the impressive reliquary of the Holy Cross in Gubbio (Fig. 185), for it corresponds with minimal changes to the print (Fig. 186) for a piece of very unusual and personal design. The differences in the silver reliquary take account, on the one hand, of the fragility of the material, creating a more solid mass of this trophy of classical arms (with, strangely, mediaeval helmets instead of the battering rams, and the helmets of fancifully classic design missing from the base – perhaps lost subsequently, rather than omitted). On the other hand, they emphasise the importance of the relic, which rises in splendid glory above the standards. Apart from the Kai-Rho, these standards display, instead of Roman symbols, the arms of contemporary Italians, presumably those who commissioned the work, but which I have not succeeded in identifying.[11]

Another rather different reliquary of the Holy Cross is to be found in Vienna (Pl. IX). This was paid for in 1711,[12] incorporating a crystal reliquary cross set with diamonds provided by Pietro Paolo Gelpi;[13] given by Pope Clement XI to the Habsburg King Charles III of Naples when he passed through Milan on his way to his coronation as Karl VI of Austria, it remained

185. Giovanni Giardini, *Reliquary of the Holy Cross*; silver. Gubbio

186. Maximilian Joseph Limpach, on the design of Giovanni Giardini, *Reliquary of the Holy Cross*; engraving

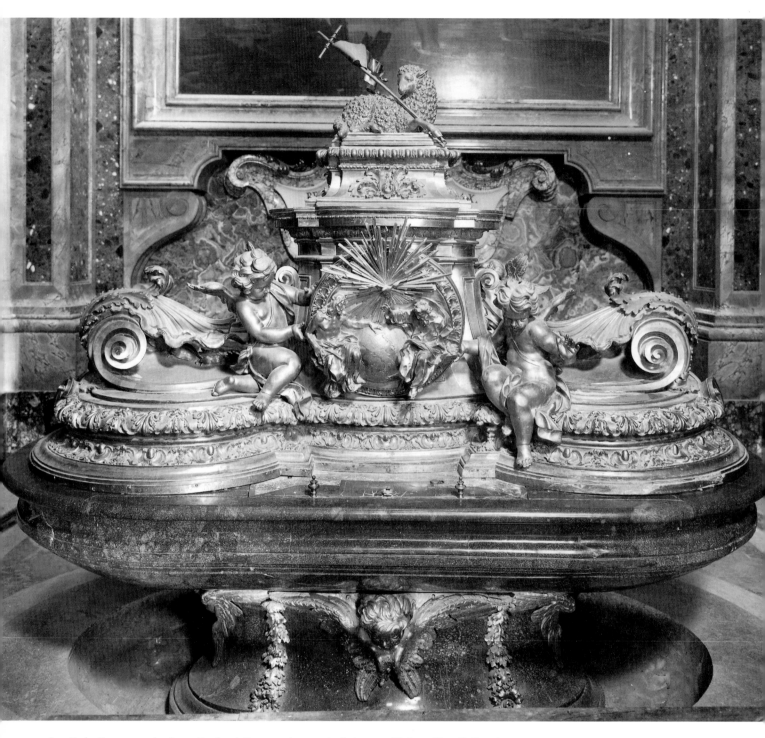

187. Carlo Fontana and others, *Baptismal Font*; porphyry and gilt bronze. Vatican City, St Peter's

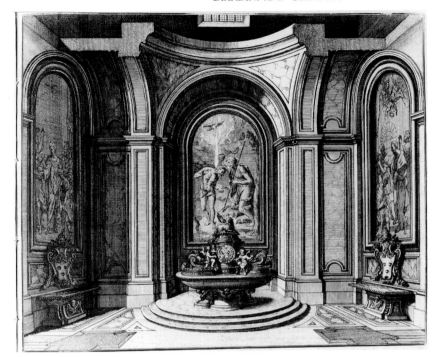

188. Alessandro Specchi, after Carlo Fontana, *Baptismal Font*; engraving

in Austria, entering the Geistliches Schatzkammer in Vienna.[14] The central motif of the trophy, with the cross rising above, is very similar to the Gubbio reliquary, and clearly a modification of the same design (assuming that the undated Gubbio reliquary is the earlier). While it is likely that Giardini may have employed a sculptor for the models of the gilt bronze angels, and possibly for the cherubs above (who have lost the Vernicle and crown of thorns they originally held), there is no reason to assume that the porphyry structure was not made in Rome, where one finds various accounts for the restoration of this very hard stone.[15] Moreover, Giardini's own inventory lists various pieces of unfinished porphyry[16] which suggests that he may quite well have worked it himself. However, even if parts were made by specialists, and not by Giardini, there is no reason to doubt his responsibility for the design, which has many features in common with the drawing illustrated here in Fig. 196.

The strongly architectural form of the Vienna reliquary is typical of Giardini's work, and it is therefore not inappropriate that one of his earliest documented activities should have been the casting of the baptismal font in St Peter's, from the designs of the architect Carlo Fontana (Fig. 187). The position of the font today is not that which Fontana intended (Fig. 188), for in 1725 Pope Benedict XIII insisted on lowering it, on the pig-headedly rational grounds that it was more appropriate to step down to the baptismal water than up, despite its most unfortunate aesthetic effect. The long and extremely complicated history of this commission has been unravelled with masterly succinctness by Hellmut Hager.[17] Its present form became possible in 1693 after the discovery of a huge porphyry basin, brought to Rome by Hadrian, and used in the undercroft of St Peter's to cover the sarcophagus of the Emperor Otto III; from that point on, Fontana's task was to design a cover that would counterbalance the wide and shallow basin, without conflicting with it. This he has splendidly achieved by a combination of long horizontal forms flanking a high central feature, emphasising the wide, flat horizontal by the great heavy volutes; he softens them, and leads the eye inwards again by the spreading cabbagy acanthus leaves, and masks the junction with the rising central pedestal by the diagonally set cherubs, holding a medallion of the Trinity. It is a fine example of that same skill we have noted in Giardini, unifying architectural forms and sculpture in a coherent whole, and, as in the Vienna reliquary, combining the richly dark and beautiful porphyry with the shimmering splendour of gilded bronze.

If Carlo Fontana designed the font, he was not, of course, responsible for the actual modelling

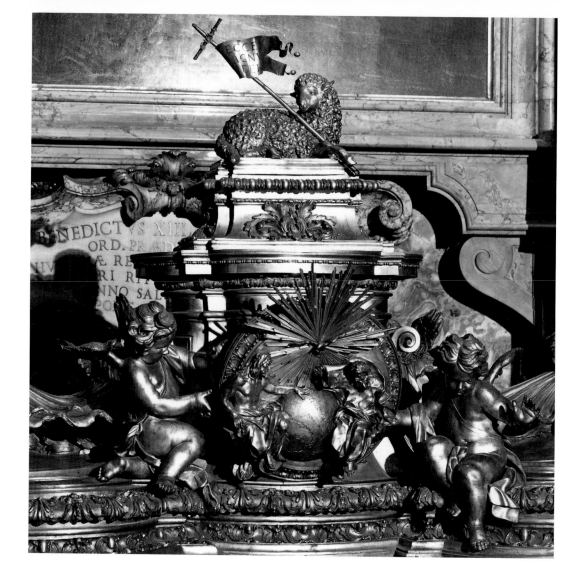

189. Giovanni Giardini, *The Holy Trinity*; gilt bronze. Vatican City, St Peters (detail of the *Baptismal Font*, Fig. 187)

of the sculpture, which was done by a team of sculptors that he frequently employed, the Frenchmen Jean Théodon and Michel Maille (known in Italy as Michele Maglia), and the Italian Lorenzo Ottone,[18] who were paid jointly for the putti and the relief of the Trinity. Only the lamb is attributed in the documents, for originally Ottone had made one of alabaster, but this did not meet with approval, and he made a new clay model which was cast in bronze. The only other documented attribution is to Théodon, for the cherub-heads below the two small tables set against the side walls of the chapel. While stylistic attributions are difficult among three artists who so frequently worked together, it seems safe to ascribe the *Trinity* (Fig. 189) to Michele Maglia, whose treatment of draperies elsewhere shows a similar liking for large, virtually flat areas surrounded by ridges, such as one sees over the legs of these figures.[19]

If the payments to the sculptors are unspecific, Giardini's contribution is documented down to the minutest detail in an account of twenty-five folios, plus a further twelve for the gilding.[20] While this is unfortunately too long to be printed in its entirety, it contains a number of facts concerning the way such objects were made that are of general interest, in that they most probably apply to works other than the font. One of these, which is why I was careful to refer to Giardini's 'work' rather than to his 'founding', is that he was responsible for making some of the models – though here we should bear in mind that he said that he had paid all the professionals who worked on it, 'such as the carpenters, modellers in clay, and in wax, chisellers, gilders, etc.',[21] so no doubt these modellers were responsible for the actual work that Giardini none the less directed.[22] These models did not, of course, include the figurative parts, but they extended beyond the decorative mouldings to the coats of arms of Innocent XII over the side tables, for which he prepared the shaped wooden board on which the arms were painted in

chiaroscuro, and he then made the clay model;[23] he also had the models for the keys and papal tiara turned in wood.

For this tiara he in fact had two models turned, one of which was used, the other not.[24] This is only one of many indications of the uncertainties and changes made in the work, which occur again and again in these accounts. They open with the casting in wax of four cherubim (for which the moulds were given him by the 'fattore' of the Reverenda Fabbrica, Antonio Valerij), which were then not used, and continue with the making of a small model, which again was not used. Similarly the model of the central pedestal with the lamb was 'moved and moved again many times, and varied in a number of different ways at the wish of the said Cavaliere Fontana',[25] and the clay models of the mouldings on the base of the cover were 'remade many times, and in various ways at the wish of . . . Fontana'.[26] He also made clay models of palm-fronds, following the small model, which were not used,[27] and he also prepared models for the side tables, with a large shell in the centre, lions' feet, and garlands of oak leaves, which were not used because Fontana changed his mind, and decided to make them of wood.[28]

Another aspect of the work which Giardini emphasised was the finishing of the work 'in the manner of silver',[29] and we may also note the polishing, burnishing and fine-filing that were necessary for the mercury gilding to hold. The question of how the work should be gilded is one which gave rise to a dispute among the deputies of the Fabbrica; the leading experts in Rome were called in, who gave their support to Fontana's preference for mercury gilding.[30] The documents in the archives of the Fabbrica include this statement drawn up by ten brass-workers and founders of bronze, copper, etc. on the relative advantages of gilding *a spadaro* and *ad oro macinato* (i.e. using gold leaf, with or without mercury, or pulverised gold mixed with mercury): the former would require some seven leaves of gold, one above the other, whereas in the latter the gold is spread only once, but it requires far more labour in preparing the surface, which makes it more expensive. It is, however, 'the more noble, perfect, and durable because of its resistance to any sort of injury from time, humidity, etc., and with a simple polishing will look like new', and they cited the contrary examples of Clement VIII's altar in the Lateran, and the *Baldacchino* and *Cattedra* in St Peter's. It also has the further advantage that, should one wish to melt the work down, the gold can easily be separated from the bronze.[31]

There is one further point that is emphasised at some length in these documents: the extraordinary thinness of the casting, which is compared to that of Bernini's *Baldacchino* and *Cattedra*, each part of the *Baldacchino* being measured by means of drilling small holes through the bronze, whereas the *Cattedra*, with its supporting figures, was judged only where the edge of the bronze was visible, pending further orders.[32] The importance of this should by now be obvious: a thin casting saved the Fabbrica money in that less bronze was used, but it was very unfavourable to Giardini, since, as we have seen in the case of Benamati's cast of the Vallicella tabernacle, it was normal practice to value a work at so many *scudi* per pound. Giardini did not fail to point this out in the long account of the work which he submitted, the so-called *Esposito*,[33] and Filippo Ferreri, the expert acting on behalf of Giardini, even wrote a second opinion, changing his former valuation of 1.30 *scudi* per pound to 1.50 *scudi*, since only after seeing the completed work did he appreciate that its relative lightness was caused by 'the thinness of the cast, and the work, which increases the value, and price'.[34]

As for Fontana's boast that, at his insistence, it was cast in one piece, this is nonsense, though it was certainly cast in large sections.[35] It does appear that the base was cast in a single piece and this may be what Fontana meant by his claim that it would be stronger. Giardini pointed out that he had had to make a special furnace to cast it, which he said was now useless for other work.[36]

The whole undertaking had lasted some five years.[37]

In Giovanni Giardini's inventory of 10 February 1711 was listed 'a round model of cast wax representing the Trinity, which is the model of that existing in the Baptistry of St Peter's'[38], but when we encounter it again in the inventories of his nephew Giacomo Giardini, drawn up in 1739, the material is described as 'bronze-coloured plaster', and the measurements given as 3 *palmi*.[39] Three *palmi* is the measurement cited for the bronze relief,[40] and the change of material is not a serious problem as, if it were painted, it might be difficult to determine the underlying

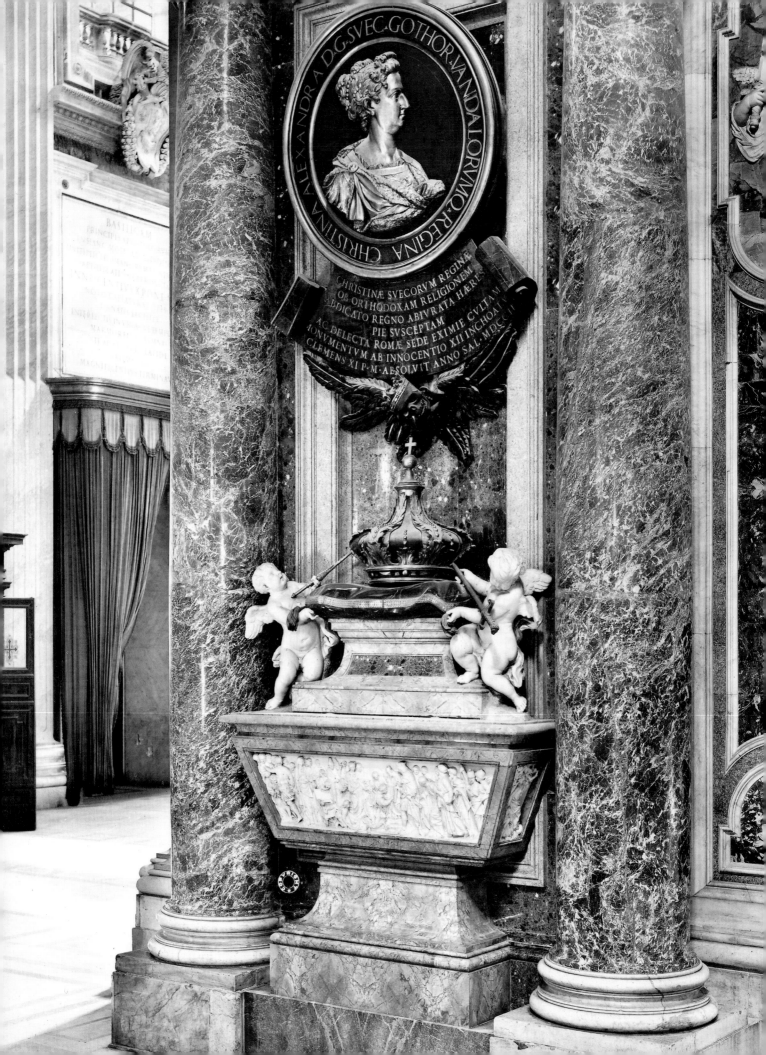

ALEXANDRA D.G. SVEC. GOTHOR. VANDALORVMQ. REGINA CHRISTINA

CHRISTINÆ SVECORVM REGINÆ
OB ORTHODOXAM RELIGIONEM
ABDICATO REGNO ABIVRATA HÆRESI
PIE SVSCEPTAM
AC DELECTA ROMÆ SEDE EXIMIE CVLTAM
MONVMENTVM AB INNOCENTIO XII INCHOATVM
CLEMENS XI P.M. ABSOLVIT ANNO SAL. MDCCII

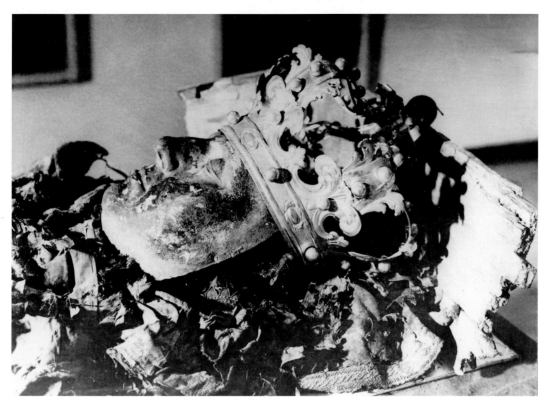

substance. Giardini had made a plaster mould of the clay model, and cast a wax from it,[41] but this wax was presumably the one used for making the bronze cast; however, there is no reason why he should not have made a second cast, either in wax or in plaster, for his own pleasure.

The same inventory of Giovanni Giardini includes 'Another large model of wax, or rather bas-relief, the original of which is on the tomb of Queen Christina in St Peter's in Rome, with various statues, and figures alluding to the deeds (*fatti*) of the said Queen'.[42] It might not seem surprising that Giardini should have had such a model, since he had been much involved with the tomb of Queen Christina (Fig. 190). When she was buried in 1689, it was he who made the silver mask to cover her face, the crown on her head (Fig. 191), and the sceptre that she holds.[43] He also made the bronze parts for the tomb designed by Carlo Fontana: the great medallion portrait[44] with the inscription below, borne up by an eagle, and the crown on the cushion, were all cast by Giardini.[45] Once again Fontana turned to the sculptors Lorenzo Ottone and Jean Théodon: Ottone carved the two putti, and Théodon carved the marble reliefs with the assistance of Lorenzo Merlini,[46] and prepared the model for the death's head, and the medallion portrait of the queen.[47]

None the less, it would be unusual for Giardini to have preserved, among the models which were, almost without exception, for works he had cast himself, a cast of one of the marble reliefs which were carved by Théodon. This model reappears in the two inventories of Giacomo Giardini, and again, as with the model of the *Trinity*, the material is described not as wax, but as bronze-coloured plaster. While nothing is said about the tomb in St Peter's, the subject is given as 'the entry of Queen Christina into Rome', and the dimensions are given as 10 by 3½ *palmi*.[48] However, there is no such subject as the Entry of Queen Christina into Rome on the tomb, where the main relief on the front of the sarcophagus represents her conversion to Catholicism; while in Protestant England one can talk about someone going over to Rome, there is no ambiguity in the Italian phrase, which can mean only a physical entry into the city. In fact, the tomb of Queen Christina went through nearly as many different designs as the font of the Baptistry, and we know that at one stage Giardini had made a wax model 'of all the figure of the Queen as in the medal' which was discarded; if the words 'as in the medal' are hard to interpret, none the less this must have been a whole-length figure, presumably much as Christina appears on two of Fontana's drawings.[49] In one of these drawings (Fig. 192) there is an empty circle which Braham states originally showed a portrait of the queen in profile,[50] and the front of

facing page

193. Giovanni Giardini, *Tabernacle of the Madonna del Fuoco*, gilt bronze and lapis lazuli. Forlì, Duomo

facing page

194. Giovanni or Giacomo Giardini, *Angel*; gilt bronze. Forlì, Duomo (detail of the *Tabernacle of the Madonna del Fuoco*)

195. Giovanni or Giacomo Giardini, *Angel*; gilt bronze. Forlì Duomo (detail of the *Tabernacle of the Madonna del Fuoco*)

the sarcophagus is left blank; but it was intended to contain a relief,[51] for the tomb was planned from the first to be a counterpart to Bernini's memorial to the Countess Matilda, and I strongly suspect that, at some stage of the long process of the tomb's gestation, Giardini prepared a bronze relief for the sarcophagus representing the *Entry into Rome*.[52]

The last major work by Giovanni Giardini was for the chapel of the Madonna del Fuoco in his native city of Forlì. The renovation of this chapel, below the cupola painted by Cignani, was commissioned by another Forlivese, Cardinal Fabrizio Paolucci, and completed in January 1718. It is likely to have been Giardini's origin in the city, as much as his positions as Founder of the Reverenda Camera Apostolica and Silversmith of the Palazzo Apostolico, which secured for him the execution of the tabernacle for the venerated woodcut of the *Madonna del Fuoco* (Fig. 193).[53]

Here for once I find that the design is not wholly successful, and the two angels (Figs. 194–5), beautiful though they are in themselves, do not appear to be an integrated part of the

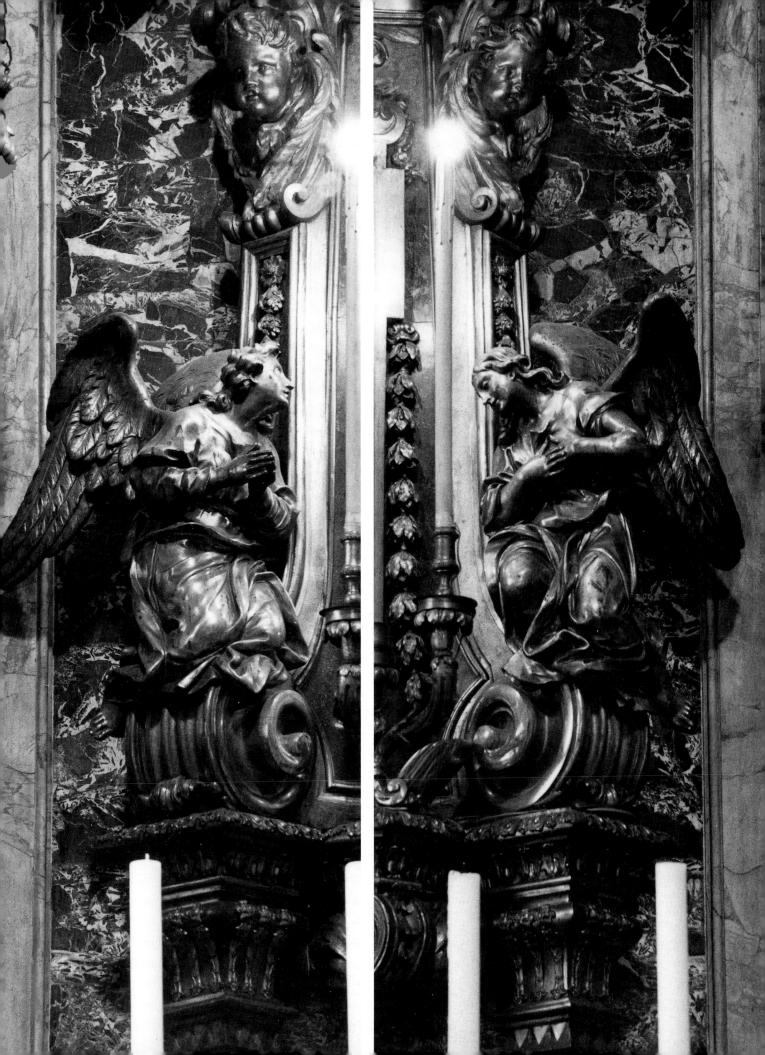

196. Giovanni Giardini, drawing for a holy-water stoup (?) and a tabernacle; pen and brown ink. Berlin, Kunstbibliotek

197. Giacomo Giardini, *Tabernacle of the Madonna del Fuoco*; engraving. Forlì, Biblioteca A. Saffi

structure. Rather, they are perched, and a bit awkwardly at that, on the volutes, which would stand perfectly well without them. It is true that Giovanni Giardini included a very similar angel in a design for a tabernacle (Fig. 196),[54] which, though it cannot have been made for the rectangular woodcut in Forlì, includes many elements to be found in this work, but that angel does not kneel on a volute. Moreover, the angels in Forlì are out of proportion – not just with the cherub-heads (I do not want to suggest that angels and cherub-heads in a decorative complex must correspond naturalistically in size; nor do I want to get involved in any dispute about the relative sizes of cherubs and angels, or how many of either could dance on the head of a pin) – but they are out of proportion with the scale of the other forms, including the festoons of leaves against which they are set. They do appear in the rather crude print of the tabernacle, dedicated to Cardinal Paolucci in 1725 (Fig. 197), in which it is interesting to note that the disparity in scale between the heads of the (strangely inaccurately drawn) angels, and those of the cherubim above, has been corrected.[55] But why was it made so late, seven years after the tabernacle was set up? And why does the inscription say that Giacomo Giardini drew and engraved the print, but not who made the tabernacle?[56] While I have no proof, I have a strong suspicion that Giacomo, who also worked for the same church,[57] added these angels to his uncle's tabernacle. Although I have no evidence whatever for such a suggestion, it seems not inconceivable that the print was made before the angels, so different are those in the engraving to those on the tabernacle, and that it was intended as a proposal of how the whole should appear; if that were so, then Giacomo, like his uncle, would doubtless have approached a sculptor, who would have made the far superior models actually cast.[58]

Nor is it only the angels that raise questions. The design of the tabernacle could well be by Giovanni Giardini, who was certainly capable of designing goldsmiths' work; moreover it is composed of elements all of which occur on his engravings for silver, and, like those prints, it displays its firm architectural structure despite the proliferation of ornamentation. None the less, it seems more likely that it would have been designed by an architect, and the inclusion of lapis lazuli and coloured marbles within the tabernacle itself serves both to add colour, and to unite it

with the extremely rich and varicoloured marbles of the chapel.[59] But, whoever the designer, it was still bronze, with its capacity to assume forms at once delicate and strong, and gold, with its ability to reflect and multiply light, which were deemed the most suitable media for enframing the most sacred icon of the city; in the hands of a major craftsman, and on the designs of a sensitive artist, they draw the eye to the central point of this elaborate chapel, and hold it entranced.

If these large-scale sculptures considered so far are typical of the bronze-founder, I should like finally to examine a small sculpture I believe to be by Giovanni Giardini, a gilt bronze, which has all the quality of the finest goldsmith's work (Fig. 198).[60] In Giardini's inventory were 'Two low reliefs in gilt metal, about two *palmi* high, one representing Our Lord, taken down from the Cross, with a glory of angels and God the Father, and the other Christ in the Garden of Olives with a background of lapis lazuli lacking their frame and ornament, made by the hand of Angelo de Rossi, and chiselled by Monsù Germano', that is to say the Frenchman Thomas Germain, who worked in Italy, and was for a time in the shop of Giardini.[61] These two reliefs reappear in the inventories of Giacomo Giardini, without an attribution. The former is here described as 'Jesus Christ dead with a glory of angels and God the Father', and these inventories provide the further information that both reliefs had rounded tops, and were now set on grounds of amethyst, but the architectural frames, with copper and silver ornaments, and intended to be set with lapis lazuli, were still incomplete.[62] But in 1744 they were acquired by Pope Benedict XIV, with their backgrounds of amethyst, and their frames now completed with panels of lapis lazuli and flowers of silver, and they were presented to King Carlos III of Spain on his visit to Rome.[63]

I have hunted unavailingly for some trace of them in Spain, and in this cast the quality of the chiselling is so high that I am tempted to see it as the lost original. This quality is the more apparent if one compares it with a version in the Palazzo Pitti (Fig. 199), in a partially gilt frame.[64] Unfortunately the silver relief in Florence contains no punch-mark which might identify its author, but the architectural frame is not unlike Giardini's work, and the angel on the right is strikingly similar to that on the left of the tabernacle design in Fig. 196, suggesting that it might well have been made by Giardini, when he no longer had the assistance of his expert chaser.

But are we justified in connecting the *Dead Christ* with this documented work? To begin with, it is known that Angelo De' Rossi had made a relief of the *Agony in the Garden* for the musician Angelo Corelli, who could not afford the price, and instead the sculptor presented it to Corelli's patron Cardinal Ottoboni.[65] This relief could well have been recast by Giardini for the companion piece. We also know that Giardini had an original terracotta model of an altar-frontal by Angelo de Rossi, for it was inherited by Giacomo,[66] so he certainly had some connection with the sculptor, who had died in 1715. As for the style of the image, even before I found the references to Giardini's cast this had struck me as characteristic of De' Rossi's native town of Genoa, particularly in a detail such as the cherub-head kissing the hand of the dead Christ, which was reminiscent of that kissing the Virgin's foot in Pierre Puget's relief of the *Assumption of the Virgin*.[67] While I admit that there remain worrying features, such as the types of the cherubs which are rather different from those usually found in De' Rossi's sculpture, one can compare it with another, much earlier version of the *Pietà* (Fig. 200),[68] which was cast in bronze by Angelo De' Rossi before he left Genoa. There is the same vigour and strength of the modelling, and a close similarity in such typical details as the long ribbon-like panels of cloth, straight or twisting, the scooped folds that one sees in the kneeling angel's sleeve in the gilt bronze relief, and the straight line of the cheeks running from eye to chin, not to mention the pathetically broken body of Christ. Moreover, the argument that the model described in the inventories is to be identified with the surviving gilt bronze relief is strengthened by the fact that the subject of the dead Christ, with God the Father but without the mourning Virgin, is extremely rare. Finally, the composition was clearly designed for a rounded top, and in this superb version it was evidently made to be set on a background of semi-precious stone.

So I believe that this relief is at least the same model, and very probably the same actual cast that appears in the Giardini inventories, and that, despite the lack of an attribution in those of Giacomo, the earlier inventory is correct in ascribing it to De' Rossi. Although Giacomo

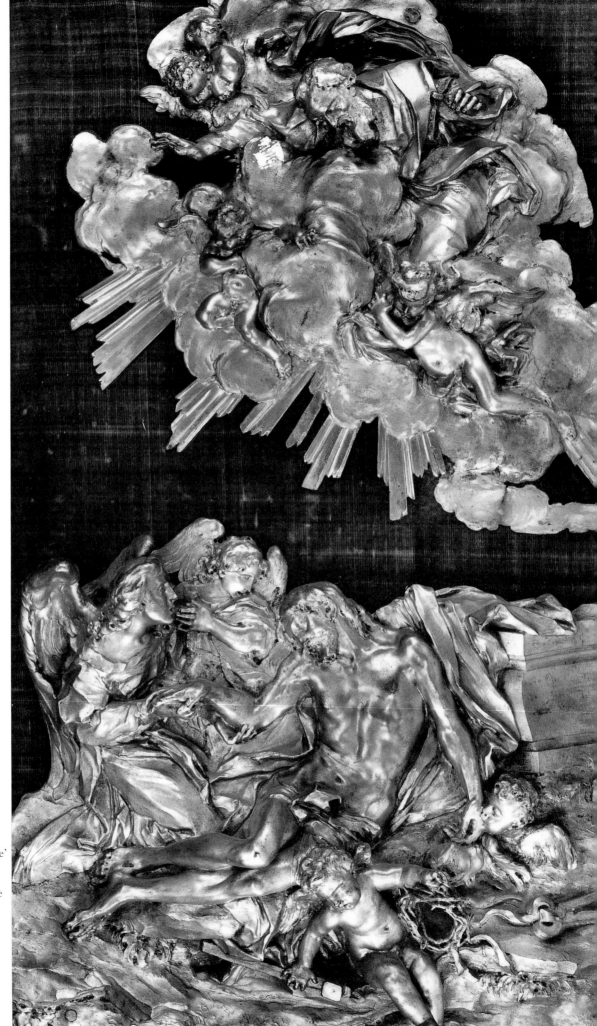

198. Giovanni Giardini, on a model by Angelo De' Rossi, *The Dead Christ Mourned by Angels, with God the Father*; gilt bronze on velvet. Marseilles, Collection Rau

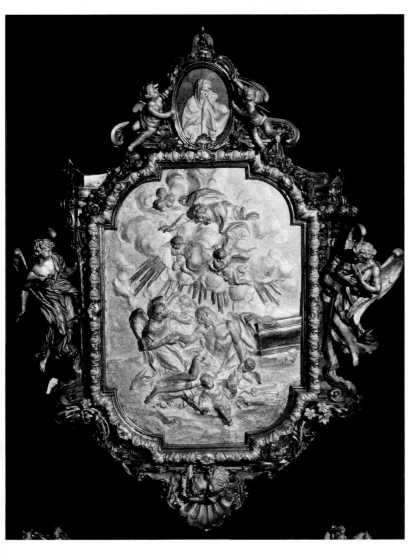

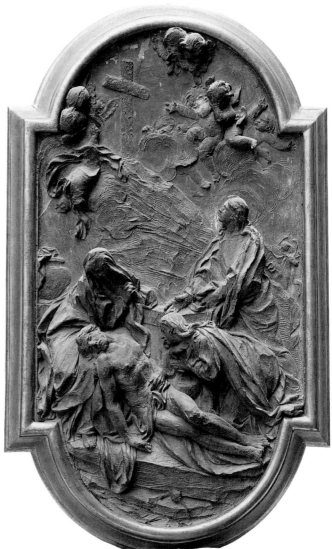

Giardini's inventory links Thomas Germain only with the lost *Agony in the Garden*, I would also follow the earlier inventory in seeing him as responsible for chiselling both reliefs, for certainly this was worked by a quite exceptionally skilled craftsman. No photograph can do justice to the superb and varied finish, the burnished flesh and draperies contrasting with the softer texture of the clouds and terrain, of which the grassy tussocks, like the curls of the hair, are enlivened by minute bored holes. Everything shimmers with light, absorbed or reflected from the surface, yet the modelling, at once firm and delicate, renders the largest forms and the smallest details completely legible. It is typical of the most virtuoso silversmiths, far surpassing even the best chiselling normally found on bronze, and, whether or not my attribution is right, such a piece perfectly exemplifies the subject of this chapter, dealing with four men who were all both bronze-founders and silversmiths.

The other two such craftsmen were Francesco and Carlo Giardoni. In considering the Giardoni one has to regard the two brothers Francesco and Carlo almost as a single person: not only did they work together on all their major enterprises, but, as was not uncommon, only one, Francesco, was a member of the guild of silversmiths, a convenient arrangement that allowed his brother to collaborate on silver produced in the workshop.[69] However, it was Francesco who had the higher profile, possibly also physically (Figs. 201–2). Like Giardini, Francesco worked for the Sacro Palazzo Apostolico, and this furnishes much of our evidence as to his production. Also like

199. Anonymous silversmith on the model of Angelo De' Rossi, *The Dead Christ Mourned by Angels, with God the Father*; partly gilt silver. Florence, Palazzo Pitti

200. Angelo De' Rossi, *Pietà*; painted terracotta. Rome, Private Collection

201. Carlo Marchionni, *Francesco Giardoni*; pen and black ink. Biblioteca Apostolica Vaticana, cod. Rossiano 619, f.17

202. Pier Leone Ghezzi, *Francesco Giardoni*; pen and black ink. Collection of the Duke of Wellington

Giardini, he was appointed Founder of the Reverenda Camera Apostolica, and so was similarly active in casting cannon for the papal armoury.[70] He had been trained under Giacomo Pozzi, for whom it seems that he specialised in the larger silverwork, and after Pozzi's death in 1735[71] Giardoni completed his outstanding commissions. His first known independent work was the over-life-size silver and gilt bronze statue of S. Feliciano on the model of Giovanni Battista Maini, commissioned in 1730, to which we shall return. In 1734 he was commissioned, together with Pozzi, to cast the gilt bronze statue of Clement XII, again from the model of Maini, for his tomb in the Lateran, to which also we shall return, and in 1737 another bronze statue of the same pope for the Campidoglio, this time on the model of Pietro Bracci, which no longer exists.

One can see the range of his oeuvre by comparing the broadly worked 4.70 m. high *Angel* (Fig. 203) completed in 1752 from the model of Peter Anton Verschaffelt which stands proudly on the summit of the Castel Sant'Angelo,[72] with the frame for a mosaic picture of the *Virgin* (Fig. 204), with its elaborate and delicately worked decoration;[73] this was a pair to a similarly framed mosaic of the *Ecce Homo*, and both were sent as gifts by Benedict XIV to the King of Spain in 1741. While the *Angel* was certainly the more prestigious undertaking, the frame is more relevant to our subject: its remarkable cresting is in itself a piece of small-scale sculpture, and the carefully contrasted use of gilding and 'coppering' demonstrates a refined sensibility for the total colouristic effect. It is one of a number of such frames which, combined with suitably devotional images, were a favoured diplomatic gift of Pope Benedict XIV, and undoubtedly he regarded Giardoni's masterly casting as exemplifying the quality of Roman craftsmanship quite as much as the more typically Roman speciality of micro-mosaic.[74]

It was, however, the large-scale sculptures which justified the statement that his fellow-artists made in support of Carlo Giardoni: 'In our time almost all the large and magnificent works that were made in Rome were always made by the celebrated Carlo Giardoni . . . together with his brother Signor Francesco'.[75] Although predominant as a bronze-founder, Francesco Giardoni never deserted his original training as a silversmith, and exercised both professions.

Two splendid examples of his skill which both survive (at least in part) in Bologna demonstrate

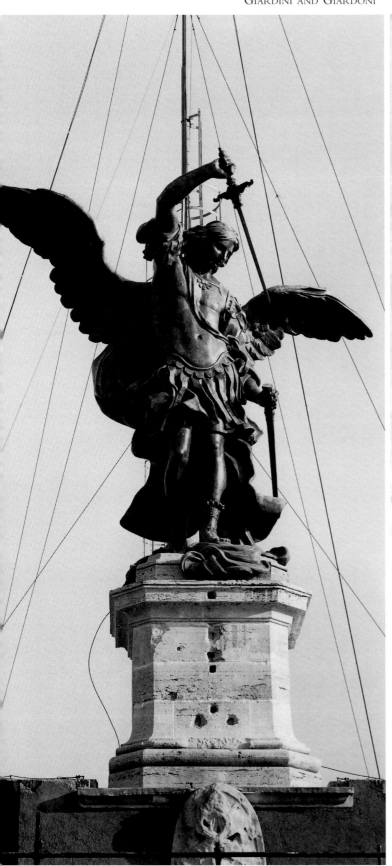

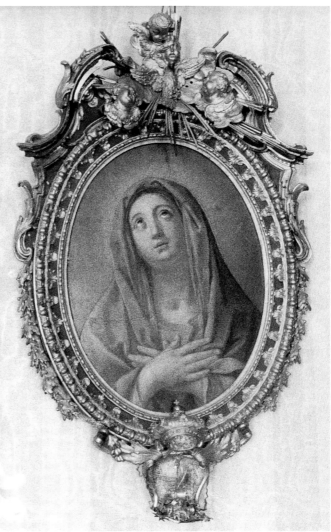

204. Francesco Giardoni, *Frame for a mosaic of the Virgin Annunciate*; partly gilt bronze. Aranjuez, Palacio Real

203. Francesco Giardoni, on the model of Pieter Anton Verschaffelt, *St Michael*; bronze. Rome, Castel Sant'Angelo

205. (*facing page*) Francesco Giardoni, *Reliquary of S. Petronio*; partly gilt silver and lapis lazuli. Bologna, S. Petronio

206. Giovanni Carlo Galli Bibiena, on the design of Giuseppe Benedetti, *Reliquary of S. Petronio, on its Stand*; engraving

not only the difference between the two metals, but also between Rome and Bologna. In 1743 the Bolognese Pope Benedict XIV Lambertini gave to the basilica of S. Petronio in his native city the head of its patron saint, in a highly elaborate reliquary (Fig. 205) of silver, partly gilt and adorned with lapis lazuli. This he had had made by Francesco Giardoni.[76] Who made the models of the supporting cherubs is not known, but certainly it must have been a Roman sculptor. As for the reliquary casket itself, and the base on which the cherubs stand, these can be regarded as typically Roman in the firm architecture of their structure that underlies the volutes and broken pediments, the cherub-herms, the proliferation of cherub-heads, and the use of the symbols of S. Petronio, Bishop of Bologna, as an essential part of the structure. If the cherub on the right looks a little awkward, he is: as is evident from an early engraving (Fig. 206), he was originally meant to be kneeling on a larger cloud, at a much more comfortable angle.[77]

This engraving shows the original stand of bronze and rare wood for the display of the relic, which is now lost, but even from the print one can see the different aesthetic that underlies this bronze structure as compared to the silver reliquary: the sense of richness and elaboration derives largely from the extremely complex moulding of the base itself, while the ornamentation of this solid structure is far more restrained, and broader in its modelling.[78]

Giardoni accompanied his work to Bologna, and it is worth quoting the letter of 29 August 1743 in which Pope Benedict XIV himself wrote of this projected visit: 'He is a great man, and the work shows it. He is coming to Bologna for his own pleasure, and to look at paintings, being an accomplished draftsman. You might find someone who could guide him, and show him the country, and on occasion also provide him with a carriage, since he is a corpulent man.'[79] We may remark that the pope was himself well placed to appreciate this last point, since he was far from slim himself.

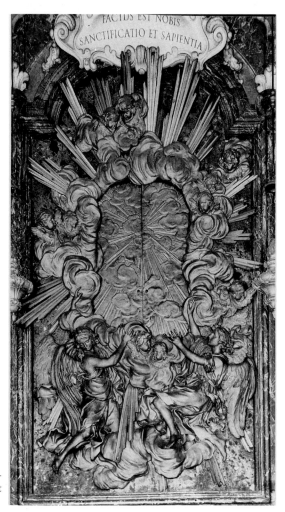

207. Francesco Giardoni, on the model of an anonymous sculptor, *Tabernacle for the Relic of S. Petronio*; gilt bronze. Bologna, S. Petronio

The relic is housed in the Aldrovandi chapel in S. Petronio, within a tabernacle above the altar (Fig. 207). The bronze doors of this, completed two years later, were again commissioned from Francesco Giardoni, the contract stating that they were to be modelled by a sculptor, without specifying whom.[80] Pietro Bracci is a possible candidate, not only because Giardoni had collaborated with him on the statue of Clement XII in 1737 (and was to do so again in 1749, making the bronze draperies around the marble angels Bracci carved to surmount the baldachin in Sta Maria Maggiore), but also because of the resemblance between the bronze tabernacle in Bologna and the marble angels similarly supporting a tabernacle that Bracci completed in 1752 for Ravenna Cathedral.[81] Whoever actually made the models, the designs had been provided by the Bolognese architect of the chapel, Domenico Gregorini, but he may well have left the sculptor considerable freedom of interpretation, for these doors provide yet a third type of metal-work, in this case largely figurative, and, apart from the sharply profiled rays of the glory, in no way distinctively 'metalic'. It is not so much the distance of more than a quarter of a century that separates it from the tabernacle of the Madonna del Fuoco, as the wholly different approach to the task of framing a relic − a sculptor's vision, rather than that of a silversmith.

I should not want to suggest that Giardoni was incapable of making his own designs; in fact, in 1716 he had won the first prize in the second class of sculpture at the Accademia di S. Luca with a well modelled, if rather drearily classical high relief of an ancient Roman *Triumphing Captain*.[82] But the fame of the Giardoni rests on their work as founders of models made by others, and I should like to concentrate on the two large statues modelled by Giovanni Battista Maini.

In the cathedral of Foligno was a venerated wooden statue of the patron saint of the city, S. Feliciano.[83] When the city was spared from a plague that had ravaged the neighbouring towns in 1656 the citizens decided to honour the statue with a silver throne. They set about raising the money by such means as cancelling the annual horse-race and devoting the prize-money to this

208. Giacinto Montecatini and Johann Adolf Gaap, *Personification of the Church*; silver. Foligno, Duomo (detail of the *Throne of S. Feliciano*)

more noble cause, then by witholding the regular remuneration to certain city officials, then by borrowing money from the Monte di Pietà, then by imposing a small tax on bread, then by a stamp tax, and then by melting down a silver crozier, not to mention public donations. Meanwhile, such money as had been collected by these means began to be eaten up in paying the interest on the loan from the bank of the Monte di Pietà. It was not till 1692 that a sufficient sum was in hand, and they actually commissioned the throne from a silversmith called Giovanni Francesco Belli.[84]

But even thirty years after the plague, and the original pious decision, we have not yet arrived at the silver throne. Evidently the design was considered defective, and in 1698 the Jesuit painter and architect Andrea Pozzo produced a new design. While the local sculptor Antonio Calcioni made the wooden framework, it was a silversmith in Rome, but a native of Foligno, Giacinto Montecatini, who was paid for the silver throne. Yet one of the receipts is signed not only by Montecatini, but also by 'Gio: Adolfo Guap', and it was to 'Signor Adolfo Guap, silversmith and engraver of Augsburg in Germany, living in Rome', that a further commission for a baldachin to accompany the completed throne was given in 1701.[85]

The throne is traditionally, and no doubt correctly, regarded as the work of Johann Adolf Gaap.[86] It is not of solid silver but of bronze (or brass) covered with silver plates (apparently repoussée), and below the later foliage there appear to be legs in the form of lions' paws, which had subsequently been amputated. At the sides are handsome, rather classicising reliefs of the Church (Fig. 208) and Constancy, and behind the head of the statue a more baroque image of

209. Giacinto Montecatini
and Johann Adolf Gaap,
Personification of Charity;
silver. Foligno, Duomo
(detail of the *Throne of
S. Feliciano*)

Charity (Fig. 209). But it is the back of the throne that is the most spectacular (Fig. 210): between
the arms of the city and a splendid head of the Medusa flanked by trophies of arms is a relief
image of extraordinary pictorial detail of the martyrdom of S. Feliciano. On his return from
subduing the Medes and Persians, the Emperor Decius stopped at Foligno, and, keen to persecute
Christians in order to please the gods who had granted him victory, he had the ninety-four year-
old bishop Feliciano tortured, and thrown into prison with the oriental Kings Abdon and Sennen,
whom Feliciano promptly converted. Decius then proceeded to Rome, with the three Christians
bound before his chariot, but on the way Feliciano died. It is this moment, when the saint has
fallen to the ground, that Pozzo and Gaap have represented in one of the most superb examples
of baroque silver sculpture. Abdon and Sennen are still bound to the chariot, but the horrified
onlookers are entirely concentrated on their beloved bishop, fallen like Christ beneath the cross,
whom a soldier is vainly trying to raise.[87]

So far nothing has been said of either Maini or Giardoni, but the story is far from ended. What

210. Giacinto Montecatini and Johann Adolf Gaap, *Martyrdom of S. Feliciano*; silver. Foligno, Duomo (detail of the back of the *Throne of S. Feliciano*)

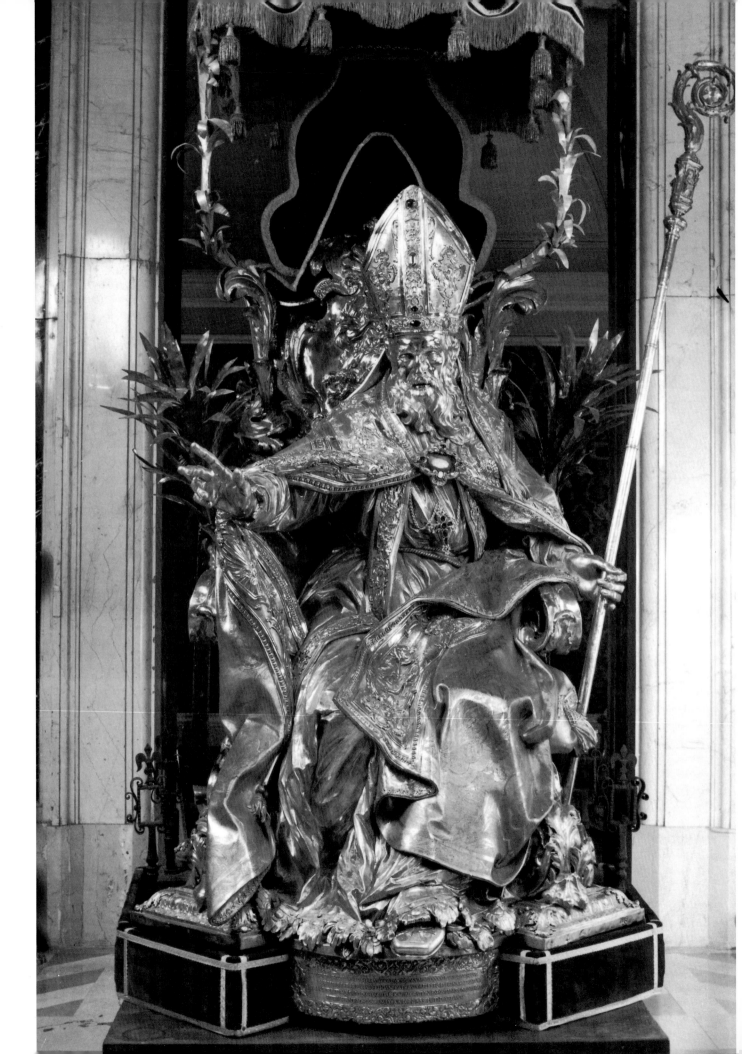

happened next will hardly come as a surprise to anyone who has tried to make improvements piece-meal: confronted with the magnificence of the throne, the wooden statue began to look distinctly mean, and when in 1701 Gaap was commissioned to make a baldachin he was also asked to supply a small model for the statue of the saint.[88] Once again, the city set about raising funds, this time by using the interest on money deposited by generous citizens in a special bank. If the means were rather simpler than the financing of the throne, the time taken was still some twenty-five years, and it was not till 1730 that the committee of the citizens commissioned a model from Giovanni Battista Maini 'foremost sculptor in Rome'. As for the actual making of the statue (Fig. 211), partly in gilt bronze and partly in silver, this was to be done by Francesco Giardoni and Filippo Tofani, 'principal silversmiths in Rome'.[89]

Cast images of seated ecclesiastics are legion, in the numerous figures of popes on their tombs or the many honorific statues raised to them. The statue of S. Feliciano follows the traditional formula, as it had been established in Bernini's bronze and marble statues of *Urban VIII* and Algardi's bronze *Innocent X*.[90] Maini appears to have been well versed in the art of the preceding century; we may imagine that he owned casts of the classic exemplars of baroque sculpture, and of fragments of work by his predecessors, and, indeed, we know that his pupil Innocenzo Spinazzi owned many such casts, as well as models by his teacher, among them the hands of Algardi's bust of Giovanni Garzia Mellini.[91] I am tempted to suggest that Maini may have had a cast of the blessing hand of Algardi's bronze seated *Innocent X*, so similar is the hand of *S. Feliciano* (Fig. 212) to that of the pope (Fig. 213).

A plaster statue, which I believe to be Maini's original model, survives in the museum of Foligno (Fig. 214);[92] it is a rather rough model, that represents the basic form of the statue, but gives no idea of the quality of the final work; significantly it includes only the arms and the lower part of the throne, that is to say the parts that would have been remade by Maini. Not only are the head and hands of silver, but over this bronze form are attached sheets of silver repoussé relief, and plain silver sheets form the lining of the cope; where it is not covered in silver, the bronze is chiselled in a damask pattern, and gilded.[93] Seen close-up in the cupboard in which it is kept it is a remarkable example of metal sculpture, a work of great power and dignity, the silver reliefs

212. Francesco Giardoni and Filippo Tofani, on the model of Giovanni Battista Maini, *Right Hand of S. Feliciano*; silver. Foligno, Duomo (detail of Fig. 211)

213. Alessandro Algardi, *Right Hand of Innocent X*; bronze. Rome, Palazzo dei Conservatori

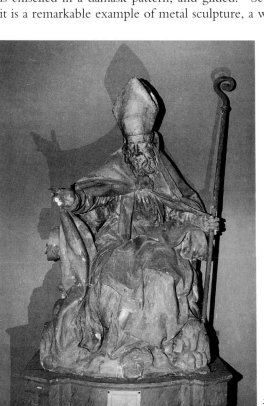

214. Giovanni Battista Maini, *Model of S. Feliciano*; plaster. Foligno, Palazzo Trinci

211. (*facing page*) Francesco Giardoni and Filippo Tofani, on the model of Giovanni Battista Maini, *S. Feliciano*; bronze and silver. Foligno, Duomo

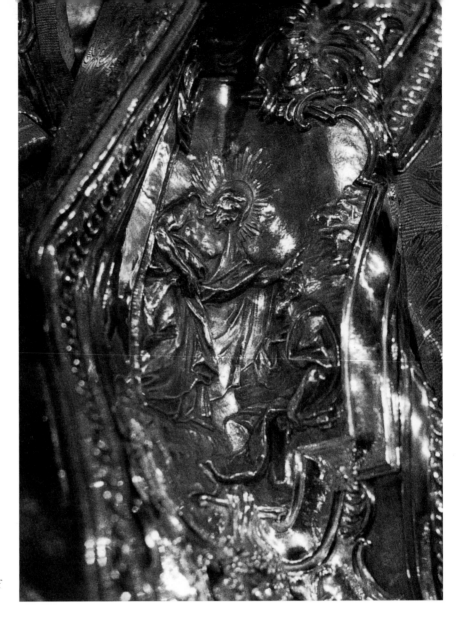

142

215. Francesco
Giardoni and
Filippo Tofani,
'*Feed My Sheep*';
silver. Foligno,
Duomo (detail of
S. Feliciano)

of the highest quality in both design and execution. Carried in procession through the streets, glittering in gold and silver, it must be a truly impressive sight, an icon at once vividly real in its modelling, and reflecting a divine radiance in the richness of its materials.

As well as the damask patterning which breaks the gold surface of the cope, there are three low reliefs on the silver borders of the cope which are far more sculptural in conception than the rather flat and painterly images designed by Pozzo for the throne. The subjects are from the life of St Peter: they are not easy to make out on the photographs, but on Feliciano's left shoulder is the *Calling of Peter and Andrew* (Fig. 219), with the disciple scrambling in a most undignified manner out of his fishing-boat; on the right shoulder is the *Giving of the Keys to Peter* (Fig. 220), and, at the bottom, the resurrected Christ's charge to Peter, '*Feed my sheep*' (Figs. 215, 223) – the sheep can just be made out, up on the hill, taking no interest, and presumably not feeling hungry.

If the arrival of the throne had inspired the urge to renew the statue, even before this reached Foligno in 1733 the authorities were thinking of further improvements, and in 1732 they commissioned two angels for the baldachin from the silversmith Angelo Pulignani.[94] The historian of the church, Monsignor Faloci Pulignano, was uncertain whether this project was due to Maini; I am in a position to assure him that it was, for among a clutch of drawings by Maini and his school belonging to a private collector are two almost identical drawings for a baldachin held by two flying angels, below which can be recognised without any shadow of doubt the head of the completed statue of St Feliciano (Fig. 216).[95] It is evident that the drawings concern the two cherubs; the baldachin itself is almost as sketchy of the head of the saint, and corresponds to

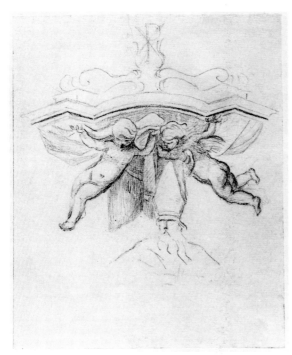

216. Giovanni Battista Maini, drawing for the cherubs supporting the baldachin over the statue of S. Feliciano; black chalk. Private Collection

that which is still over the head of the statue, and which had been ordered in 1701 from Gaap.[96] Despite several attempts over succeeding years, these cherubs were never made.[97]

I wish I could say that this was the end of this long saga, but, alas, it was not. On the night of 7/8 September 1982 a thief broke into the church, and stole the head, hands, and much of the other silver of the statue.[98] Some of this has been recovered, but other missing parts had to be replaced in 1984.[99]

Only slightly less complex is the history of the other seated statue that Giardoni cast from Maini's model, that of Clement XII in the chapel the Corsini pope built for himself and his family in S. Giovanni in Laterano.[100] Orginally this tomb was completed in 1734 by Carlo Monaldi, no doubt following a basic design by the architect of the chapel, Alessandro Galilei (Fig. 217);[101] there are full payments recorded for Monaldi's statues of the two allegorical figures either side, but for the marble statue of the seated pope there are no such payments, because the figure was converted from one that had been made for Clement's predecessor, Benedict XIII. Any change of a pope was generally greeted with joy, and hopes of a new and more propitious era, but in this case the known corruption of the administration of Benedict XIII made it particularly unlikely that anyone would wish to continue with the project of raising a statue in his honour. So the marble statue of Benedict XIII was taken over for the statue of his successor, and the head recarved.

Once it was placed on the tomb it must have been evident that this fidgety and unconvincing pope fell even below the level of the accompanying allegories, themselves by no means the most impressive statues of the chapel; but, although it was planned to replace them,[102] no doubt cost prohibited a complete revision of the tomb. It was, however, decided to remove the marble statue of the pope and commission a new bronze statue by Giovanni Battista Maini, who had achieved a resounding success with his marble figure of the pope's uncle, Cardinal Neri Corsini Senior, for the opposite niche.

The contract of 29 August 1734 was with the two silversmiths (as they call themselves) Giacomo Pozzi and Francesco Giardoni,[103] though Pozzi was to die early in March 1735, and Francesco was to be assisted by his brother, Carlo, and by Filippo Tofani.[104] It was to be made on the model of Maini, in a fine bronze suitable for gilding on whatever part was required and

217. Carlo Monaldi, *Tomb of Clement XII*; marbles (composite photo)

218. (*facing page*) Francesco Giardoni on the model of Giovanni Battista Maini, *Clement XII*; partly gilt bronze. Rome, S. Giovanni in Laterano

ordered by Galilei, 'and all the metals of the same must be cast, cleaned, chiselled and finished with the greatest diligence possible according to the art of the silversmith',[105] and completed in about six months from the day that Maini gave them the models. When it was completed to the satisfaction of Maini and Galilei, its value was to be estimated according to the quality of the work and its weight. However, as the weight would depend on the thickness of the cast, it was laid down that this should not exceeded the thickness of one and a half minutes of an *oncia*; if it did, the value was to be reduced to what the weight would have been had the cast been of the stipulated thickness.[106]

Maini's calm and noble figure was ready for casting by the autumn of 1735,[107] and by August of the following year was in its place on the tomb.[108] Again, the type of the seated, blessing pope (Fig. 218) follows the conventional formula, but it attains a noble simplicity that evaded Monaldi. The portrait head is idealised, giving an aspect of strength and decisiveness to a pope who was old and infirm at the time of his election, and regularly expected to die throughout the ten years of his reign, and who for most of this reign was blind. But I should like to concentrate on the cope: it is of smoothly finished bronze, with gilded details, and three reliefs; these are not easy to photograph, but I hope it will be evident that in design, even if possibly not in scale, they correspond to those on the cope of S. Feliciano (Figs. 219–20). Those on the shoulders have been reversed, so that the *Calling of Peter and Andrew* (Fig. 221) appears on Clement's right shoulder, and the *Giving of the Keys* (Fig. 222) on the left, but the '*Feed My Sheep*' (Fig. 223) is repeated on the bottom (Fig. 224). Even the morse that closes the cope is of the same shape, and, if on the final version of S. Feliciano the sides have been altered to take an inset topaz covering a relic of the saint, on the model (Fig. 214) one can make out the same cherub-head above, and scallop-like decorations at the sides.

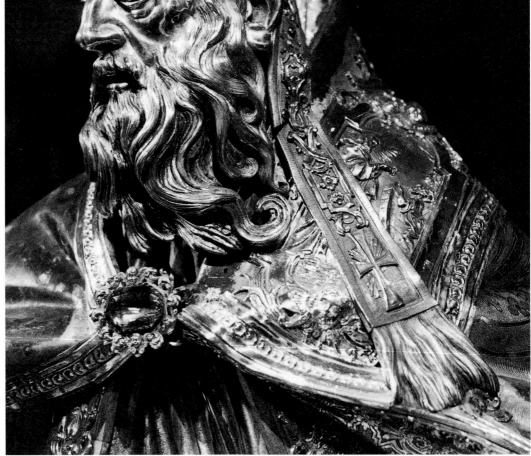

219. Francesco Giardoni and Filippo Tofani, on the model of Giovanni Battista Maini, *The Calling of Peter and Andrew*; silver. Foligno, Duomo (detail of *S. Feliciano*)

220. Francesco Giardoni and Filippo Tofani, on the model of Giovanni Battista Maini, *Christ Giving the Keys to St Peter*; silver. Foligno, Duomo (detail of *S. Feliciano*)

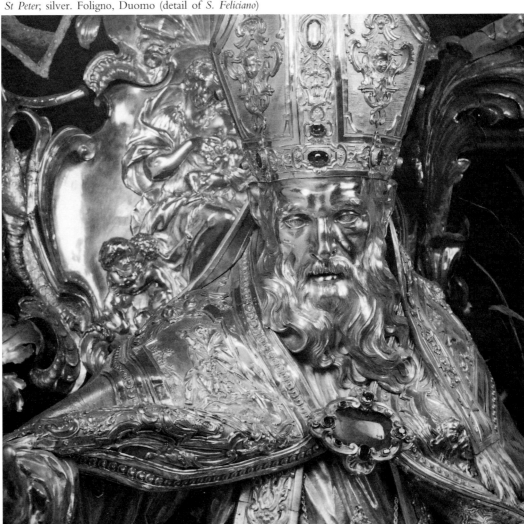

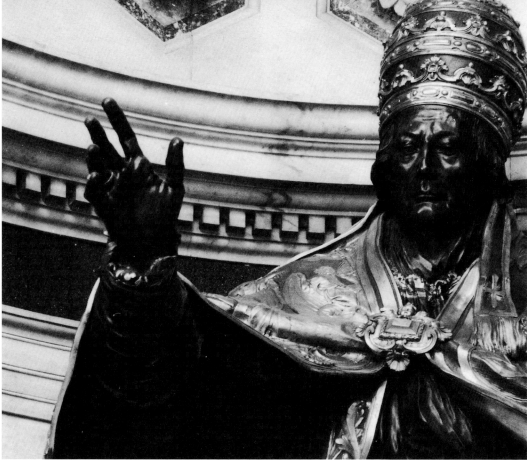

221. Francesco Giardoni, on the model of Giovanni Battista Maini, *The Calling of Peter and Andrew*; partly gilt bronze. Rome, S. Giovanni in Laterano (detail of *Clement XII*)

222. Francesco Giardoni, on the model of Giovanni Battista Maini, *Christ Giving the Keys to St Peter*; partly gilt bronze. Rome, S. Giovanni in Laterano (detail of *Clement XII*)

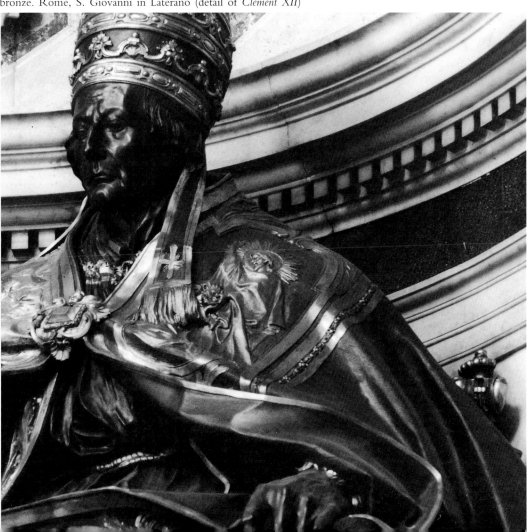

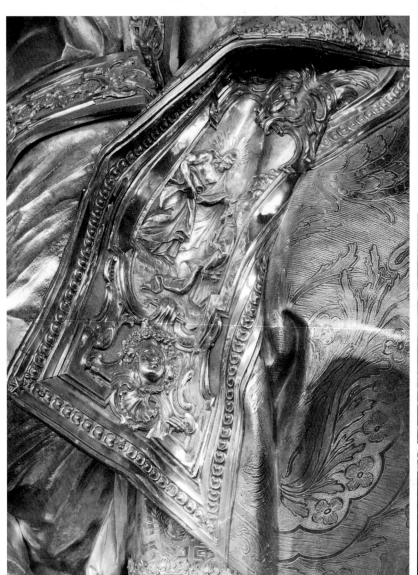

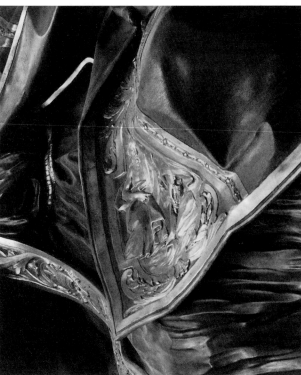

223. Francesco Giardoni, and Filippo Tofani, on the model of Giovanni Battista Maini, '*Feed My Sheep*'; silver. Foligno, Duomo (detail of *S. Feliciano*)

224. Francesco Giardoni, on the model of Giovanni Battista Maini, '*Feed My Sheep*'; partly gilt bronze. Rome, S. Giovanni in Laterano (detail of *Clement XII*)

Such subjects are normal enough on papal vestments, for the pope was in the direct line of succession from Peter, and, moreover, two of the scenes, the *Giving of the Keys* and the charge to '*Feed my Sheep*' are standard images justifying papal power and papal duty. What, then, are they doing on the cope of St Feliciano, who was a bishop, but not a pope? I wish I knew! My first thought was that perhaps the commissions had overlapped, and, having made the models for Clement XII, Maini simply reused them on the statue of S. Feliciano, but the dates do not allow for this: *S. Feliciano* was delivered to Foligno in 1733, and the Monaldi statue of Clement was set up in 1734; only after that can Maini have received the commission for his bronze. I am therefore compelled to take refuge in that last resort of the baffled art historian, the hypothesis of the existence of a lost original, from which both surviving works derive. That this was another papal statue seems unlikely (certainly, had it been more than a project, it would have been recorded), but such reliefs might have been designed for some other, rather less prestigious purpose, such as a silver altar-frontal, which would almost certainly have been melted down.[109]

Three of the strands examined in this chapter, the work of the Giardini and of De Rossi and Maini, come together in the patronage of Clement XII's successor, the Bolognese Pope Benedict XIV, in the gifts which he made annually to the church of S. Pietro, the Metropolitana of his native city.[110] Benedict claimed that his extensive patronage in Rome (a new wing of the hospital of the Spirito Santo, the restoration of Sta Croce in Gerusalemme, the work on Sta Maria Maggiore, the collection of statues on the Campidoglio, a gallery of porcelain at Monte Cavallo)

225. Giacomo Giardini
and workshop, *Ciborium*;
gilt bronze. Bologna,
S. Pietro

had been achieved 'without taking a penny from the Camera [Apostolica]'; only for the work on
the Trevi Fountain and the Coffee House at Monte Cavallo had the Camera Apostolica
contributed.[111] While the major works in Rome none the less passed through the account books
of the Sacro Palazzo Apostolico, this does not apply to his gifts for Bologna, which, most of them
not bearing even a goldsmith's mark, remain in all too many cases anonymous.[112]

His generosity towards the Metropolitana appears to have begun before his elevation to the
papacy in 1740, when he was merely Cardinal Prospero Lambertini. Before the death in 1739 of
Giovanni Giardini's nephew, Giacomo Giardini, Lambertini had commissioned two large coats of
arms, which are listed in Giacomo's inventory, one finished and chiselled, but awaiting its gilding,
and the other not yet chiselled, a frame for a mass-card, and a ciborium, described in the
inventory as 'a ciborium, or rather a wooden model with its decoration modelled in wax, which
is said by the workshop assistants to belong to His Eminence Lambertini'.[113] It seems extremely
probable that these were for the Metropolitana, where indeed there is a noble ciborium of gilt
bronze on the altar (Fig. 234), and the gilt bronze arms of Cardinal Lambertini on the bases of
the flanking columns.

Once he was elected pope the possibilities for extensive patronage were greatly increased, and
his gifts included a reliquary containing the chains of St Peter that had been paid for by Emanuele
Pereira de Sampajo, and six candlesticks and a cross presented to the pope by the same Portuguese
plenipotentiary, not to mention a incense-boat, a censer, and a bucket for holy water with its

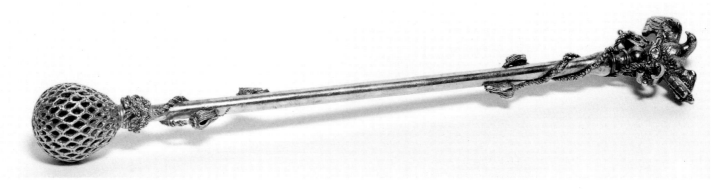

226. Anonymous silversmith, *Aspergillum*; silvergilt. Bologna, St Peter's, Treasury

aspergillum, originally made on the orders of Sampajo for the chapel in Lisbon but given to Benedict when he blessed the sacred objects, to which we shall return in the next chapter. However, one other aspergillum (Fig. 226) is so delightful that I cannot pass over it: the part containing the sponge is made to resemble a fisherman's net, wittily appropriate for a church dedicated to St Peter, and the knop is made up of the dove of the Holy Spirit (or, as it has usually been described, an eagle) above the crossed keys.[114]

Amongst the gifts of 1750 was a book of the mass according to the Roman Rite, bound in velvet with a pierced silver appliqué (Fig. 227);[115] it has no maker's mark, but I believe that the design can be attributed to Giovanni Battista Maini, for among his drawings is a sketch that resembles it very closely (Fig. 228).[116] Already established are the central feature of the papal arms,

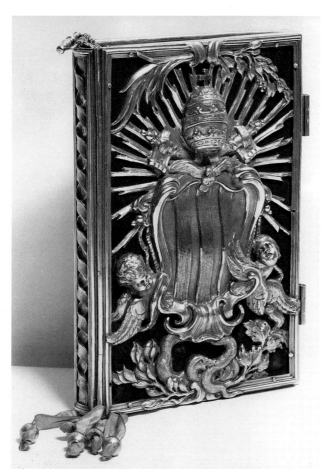

227. Anonymous silversmith, *Cover of the Rituale Romano*; silver on scarlet velvet. Bologna, St Peter's, Treasury

228. Giovanni Battista Maini, drawing for a book cover; black chalk. Private Collection

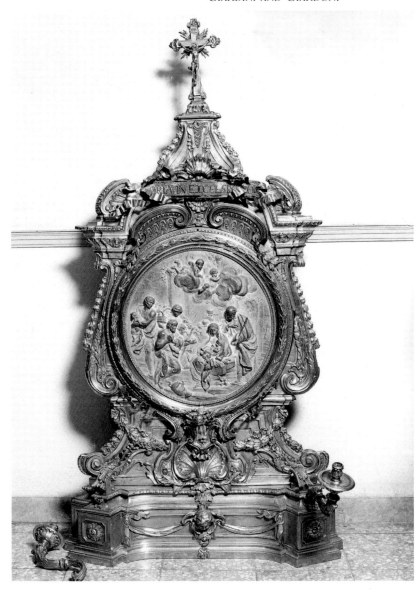

229. Anonymous
silversmith, *Anconetta*;
partly gilt silver.
Bologna, St Peter's,
Treasury

supported by winged cherub-heads, though the rest of the decoration, and, in particular, the
snake biting its tail, is as yet rather different.

Although Maini had said nine years earlier that he had no special relationship with Benedict
XIV, such as he had had with his predecessor,[117] he was involved, if only indirectly, with one of
Benedict's major gifts, the *Anconetta* with a silver relief of the *Adoration of the Shepherds* (Fig. 229),
presented in 1744.[118] It is generally agreed that this relief is of Roman workmanship, but it had
not been recognised that the central relief of the *Adoration of the Shepherds* (Fig. 230) is a cast of
one of the more famous reliefs of the early eighteenth century, made by that short-lived genius
Angelo De' Rossi as his presentation-piece for the Accademia di S. Luca.[119] Its importance to De'
Rossi can be judged by the thirteen surviving drawings that he made for it,[120] of which Figs. 231
and 232 will indicate the trouble he took over the composition, and the elaboration of the
individual figures. So popular was this relief that Maini made a mould from it, and, while the
original is now broken, with only a few fragments remaining, a plaster cast no doubt made from
Maini's mould survives in the Palazzo Venezia in Rome (Fig. 233).[121] Presumably the same
mould inspired this silver replica, though it has lost some of the grace of De' Rossi's movement,

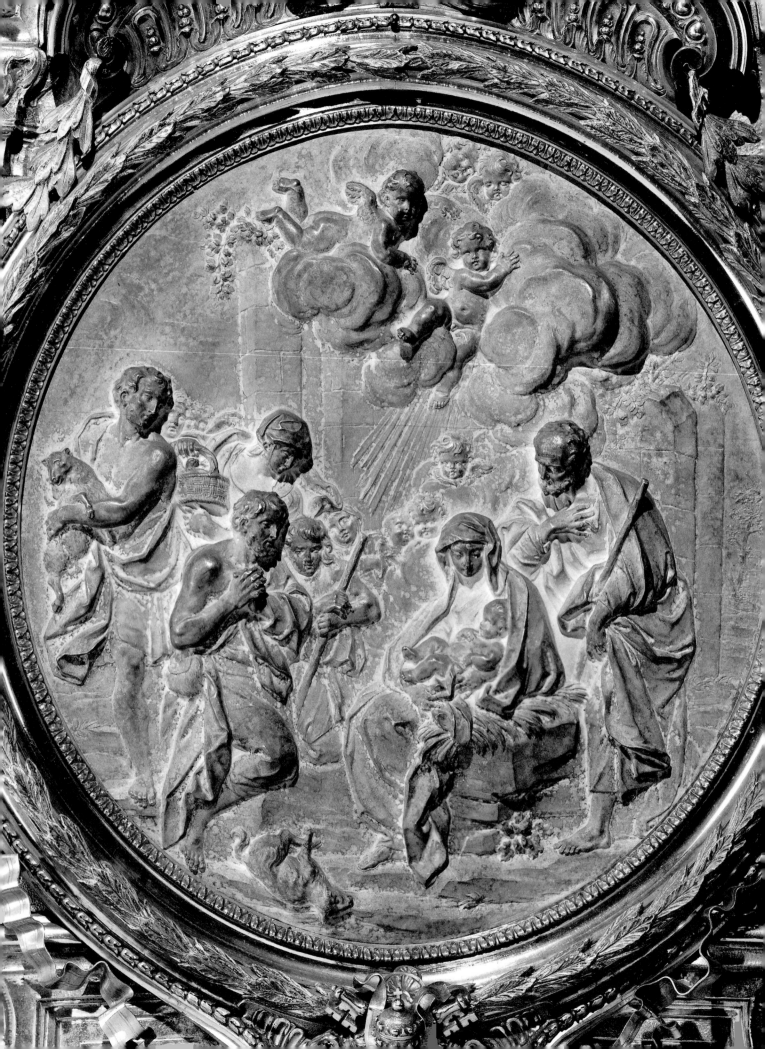

230. (*facing page*) Anonymous silversmith on the model of Angelo De' Rossi, *Adoration of the Shepherds*; silver. Bologna, St Peter's, Treasury (detail of the *Anconetta*)

231. Angelo De' Rossi, *Adoration of the Shepherds*; pen and brown ink, brown wash. Berlin, Kupferstichkabinett

232. Angelo De' Rossi, *Figure Studies*; pen and black ink over black chalk. Berlin, Kupferstichkabinett

233. Giovanni Battista Maini, cast from a model by Angelo De' Rossi, *Adoration of the Shepherds*; plaster. Rome, Museo Nazionale di Palazzo Venezia

and something of the force of his modelling which was retained even in the plaster cast. Although the founder of this silver relief is unknown, it was certainly made in Rome.

It is not only a piece of considerable distinction in itself, but an unusual reversal of the norm. Despite the destruction of so much silver, including a number of the gifts that Benedict XIV made to his native city, here we have a silver cast that can serve as a record of one of the more important lost sculptures of the eighteenth century.

From Rome to Lisbon.
The Patronage of King John V[1]

THE PROTAGONIST OF this chapter is the Commendatore Manoel Pereira de Sampajo, the Portuguese 'Ministro Plenipoteziario' in Rome. The character of Sampajo was, to say the least, open to discussion, but of one thing there can be no doubt: he was rich. Portugal was the recipient of the immense wealth in gold and diamonds from Brazil, and this wealth, which went exclusively to the court and did nothing to alleviate the poverty of the Portuguese people or the backwardness of its economy, was for the most part spent in Rome.[2] The largesse of the Portuguese King, John V, so liberally dispensed by his minister, was something that could not be overlooked by those in charge of the depleted coffers of the Papal Curia.[3] This does not mean that Sampajo did not have many enemies in Rome, not to mention the papal nunzio in Portugal, who described him as 'the son of priest, a curate in the Algarve, and of a mulatta',[4] and certainly the pope's feelings towards him were ambivalent. However, Benedict XIV valued the support of John V; moreover, gold does not smell, and the vast sums that Sampajo gave to assist in Benedict's building projects in S. Apollinare and Sta Maria Maggiore, not to mention the handsome gifts (or what today might be called *tangenti*) that he gave to the pope and members of the Curia, not only ensured his entré into the papal entourage, but also helped to secure the long-desired title of 'Fedelissimo' for his royal master.[5]

This was one of the hobby-horses of John V, proclaimed in a bull of Benedict XIV in 1748; another, granted by Clement XI in 1716, had been the elevation of his palace chapel to the status of a Patriarcate, and the creation of a building worthy of this title was entrusted to the German Johann Friedrich Ludwig, better known under the Italianised form of his name as Ludovici, or in the Portuguese form Ludovice. Ludovici had been trained as a silversmith and bronze-founder, employing these skills in Rome before being sent by the Jesuits to Portugal as a silversmith, and he practised this art for some years before turning to architecture.[6] This Italian experience would certainly have ensured the favour of John V, who had a passion for things Italian, and, above all, papal: demands for drawings of the major ecclesiastical buildings and fittings from the holy city, and for accounts of papal ritual, flowed from Lisbon to Rome;[7] among the drawings and copies sent from Rome to Lisbon was a wooden model of the tabernacle from the sacrament altar in St Peter's, complete with copies of its statuettes.[8] It was from Italy, and in particular from Rome, that such objects as the font and the chapel grilles of the Patriarcate were commissioned,[9] all of which perished in the fire that followed the earthquake of 1755.

One of these grilles (Fig. 234),[10] for the chapel of the Immaculate Conception, was made by Antonio Montauti, the Florentine sculptor settled in Rome, some of whose bronzes were examined in chapter 1. It was left unfinished at his death in June 1746, but he wanted his assistant Gasparo Cristelli to complete it and to go to Lisbon to set it up, and it is clear that the payment that would be received on its completion would constitute the bulk of his fortune.[11] This grille caused a problem, because its gilding had absorbed an excessive amount of gold, which was attributed to the low quality of the metal Montauti had used.[12] The Portuguese had grave doubts as to Montauti's abilities, and on 27 December 1747 Sampajo gave an assurance that he was

234. After Antonio Montauti, *Grille for the Chapel of the Immaculate Conception*; engraving (from *The Builder*)

considered one of the best sculptors, but he added that as a bronze-worker he was evidently incompetent;[13] however, he also sent a letter from Cardinal Corsini, who as Montauti's executor was deeply concerned in the matter, making various excuses for the use of poor metal, and adding the assurance that Montauti was recognised in Florence as one of the best bronze-workers.[14]

Montauti had had an even more disastrous experience when the oval relief of the *Virgin and Child* that he had carved in marble in 1743 for the façade of the Patriarcate broke in transit, but it was in any case regarded as unsatisfactory because the relief was insufficiently high for it to be properly visible over the door.[15] So a replacement was ordered in 1745, and this time, to avoid the fragility of marble, it was to be cast in bronze by Francesco Giardoni from a model by Giovanni Battista Maini. The specifications were minutely detailed, with a repeated insistence on the height of the relief:[16] it was to show the Christ-Child standing in the lap of the Virgin against her right breast; he was to bless with his right hand (which should project from the relief), and in his left he should hold the orb; the Portuguese were very concerned that his private parts should be veiled, especially since many artists ignored this essential decency. The rest (though there seems to be precious little remaining undetermined) was left to the judgement of the sculptor, who might also include a piece of architecture and a curtain in the background, so long as it did not cover the figures. Not only was the material in which the relief was to be packed laid down, the appearance of the gilding specified, and the quality of the chiselling, but the writer insisted on the fact, which would have been obvious to anyone who knew the first thing about casting, that a bronze shrinks in cooling. The commission is pedantic in the extreme; although these commissioning letters are anonymous, Ludovici was undoubtedly in charge of all such orders from Rome; moreover, it is typical of Ludovici, who never lost an opportunity to display his technical expertise. But it should also be borne in mind that the letter presumably served, like a legal document, to cover the authorities in Portugal should anything go wrong: the relief was

235. Giovanni Battista Maini, *The Virgin and Child*; black chalk. Private Collection

to fit into a pre-existing frame, and it is possible that they wished to pre-empt any excuse by the artist in the event that the finished work proved to be the wrong size. It is also probable that in requiring that Maini sign the work the authorities in Portugal were hoping that natural pride would ensure that he gave of his best.

The relief was destroyed with the rest of the building, but a drawing by Maini (Fig. 235)[17] fulfils almost all the requirements, and, if the child does not actually rest against the Virgin's right breast, the Portuguese gained two cherub-heads – assuming that this drawing was accepted. One may hope that it was, for although the commission seems to be anticipating a far more conventional image, it is just this departure from the traditional static and hieratic image which constitutes the charm and freshness of Maini's invention. It could well be that in modelling it he would have made the Virgin's head lean forward somewhat, and surely the child would have done so; the orb too might well have projected, supported by the Virgin's cloak and the heads of the cherubs, its sphere balancing the heads of Christ and his mother. For all its originality and simplicity, there is no doubt that when Maini's relief arrived in 1750 and was set in place it would have been easily legible at a distance, unlike Montauti's previous attempt.

Another of Maini's commissions for the Patriarcate was a silver-gilt image of the *Virgin of the Immaculate Conception* about 9 *palmi* high, which was cast by Giuseppe Gagliardi. This statue, like the relief cast by Giardoni, and the work for the chapel of St Roch which will concern us later, was commissioned by Sampajo. However, it was the two sculptures for the Patriarcate that the king was particularly anxious to have finished, and instructions were sent to Sampajo in the autumn of 1748 that they should take precedence over all the other work.[18] But in 1748 there had been a crisis: there was a hold-up in the shipments of gold from Brazil, which was said to be due to the lack of secure neutral ships.[19] In fact, by this time the gold was beginning to run out. Sampajo found himself in difficulties: every day the demands of the various workmen were becoming more insistent; work which was well advanced could not be finished, and, in

particular, there was no money for gilding it. In earlier letters Sampajo, and even more the authorities in Lisbon, had tended to blame the artists, describing them as ungrateful. This applied most forcefully to Gagliardi, who was at one point even called 'malign'; his work on the *Virgin*, and on the *torcieri* to which we shall return, was the most expensive, and also the most complex, so he had already received vast sums and was now demanding even more, without having completed anything.[20] But by the summer Sampajo's tone changed as he came to appreciate the plight of the artists who were in debt up to their eyes, and having to dismiss their workmen and pawn their belongings,[21] and who complained, with justification, that they had had to turn down other commissions to work on those for Portugal which they were now unable to complete.[22] By the autumn the situation began to improve, and Gagliardi was given the money to finish his *Virgin of the Immaculate Conception*.[23]

If this was a temporary hiccup (but one which, as we shall see, had dire consequences for Gagliardi's casting of the statue of the *Immaculate Conception*), the real problems were to occur later, after Sampajo's death in February 1750, some six months before his king.[24] The responsibility for completing the unfinished business, which included paying the artists, passed to the Jesuit Father Antonio Cabral. It was Cabral's decision to have the silver valued again by his own experts, without, as was the normal practice, a corresponding expert acting on behalf of the artist, that resulted in a lawsuit. Here I should refer again to the point made in chapter 2, that the more incompetent the artist, or demanding or dishonest the patron, the happier the art historian who can look forward to a well-documented court case. This time it was the patron's attempt to cheat the artists of their due rewards that led to the legal process; in the course of this trial evidence was taken from almost all the founders and silversmiths, and the various assistants who had participated in the work, constituting one of the most fascinating and revealing collections of material to survive on workshop practice.[25]

For this statue of the *Virgin of the Immaculate Conception* Ludovici gave less precise instructions on the configuration of the image,[26] confining himself instead to a survey of the major paintings of this subject by the leading painters of seventeenth-century Rome,[27] and suggesting that careful thought and the opinion of scholars would be desirable. However, he offered his own gratuitous advice on both the casting and the finishing of the statue. The figure was to stand isolated, so should be worked completely in the round.[28] As it should be cast in one piece, it would be unwise to cast it by the method used for large bronze statues, which is liable to produce cracks; instead he recommended using several furnaces and casting with baskets,[29] emptying the metal from one after the other until the mould was full. He put forward his own solution for filling in the holes caused by the rods that hold the core: either these holes could be filled with silver screws, which he warned could cause problems, or the wax could be built up round the projecting ends of these rods so that, when it had been cast in silver and the rods removed, this excess metal could be smoothed over the holes. He also specified the manner in which the surface was to be finished: the drapery should not be polished, so that the play of its folds should not be obscured by reflections, and the Virgin's dress, cloak and veil should each be worked differently so as to indicate their various materials.[30]

Again, there exists a drawing by Maini which provides some indication of the appearance of the finished statue (Fig. 236).[31] The actual statue would have differed in various ways, as we are told that a model that was in the palace of Cardinal Neri Corsini, one of Sampajo's executors, was 'the merest skeleton', because after the wax was cast Maini made many changes, including more draperies, and more ornamentation on the base, as well as adding a plinth.[32] Yet all the elements that appear in the documents[33] are visible, from the diadem of stars to the crescent moon, the cherub (the appearance of a second cherub-head on the drawing is more likely to be a first thought as to its position), and the serpent; however the clouds, which would contain a further three large winged cherub-heads, are only indicated.[34] Even in this sketch one can appreciate the grace of the gentle but complex contraposto, and the daring contrast created by the cloak pulled tight across one side of the body, and billowing out in two long curling folds from the other.

The making of it was not plain sailing. Gagliardi had to make a second wax model and a

236. Giovanni Battista Maini, *Virgin of the Immaculate Conception*; black chalk. Private Collection

second mould, because the first had been made in the church of S. Martinello, opposite the Monte di Pietà, which was bought by the church of S. Giacomo dei Spagnoli to build a house, and he had not been given sufficient money to make the cast before the workshop was demolished.[35] Gagliardi followed the advice of Ludovici in not melting the metal in a single furnace, but instead of using baskets he preferred to use ladles, twenty-four of them, a method which, as the testimony stated, was extremely unusual for large-scale work.[36] As the letter of instruction had anticipated, it was not cast altogether in one piece, the head and hands being cast separately[37] and held together with screws on the inside so that they would not be visible, something that added greatly to the difficulty of the work.[38]

The gilding was done three times, and so much of it regilded yet again that it came to virtually a fourth gilding;[39] Sampajo had wanted it gilded seven times, but that could not be done because there was not enough gold available, and because of the pressure of time,[40] which also required the workmen to labour during the night and (by special dispensation) on feast days, thus greatly adding to Gagliardi's expenses – we may also note that the cost of materials and workmen increased during the five years of work.[41] Altogether, according to witnesses who had known him since he was a boy, the work that he did for Portugal ruined Gagliardi, who had enjoyed considerable wealth and lived in great comfort, with a well-furnished house with carriages and servants, and tutors for his seven children, but who now found himself constrained to sell his belongings and *luoghi di monte* (the equivalent of shares), and economise on his way of life to finance the expenses he had incurred.[42]

The putto which had been cast during the last illness of Giuseppe Gagliardi came out too heavy, and had to be recast by his son Leandro, because Sampajo insisted the whole group should be as light as possible.[43] Presumably this was because the thinner and lighter the casting, the less expensive metal would be needed. As has been seen in the case of Giardini's cast of the font in St Peter's, such thin casting can work against the financial interests of the founder, so those whose task it was to estimate the value, if they were favourable to Gagliardi, would compensate for it by stressing the skill and craftsmanship required to make such an exceptionally thin cast. It was also necessary to prove that the amount of gold used had not been excessive, and we are told that when the 'Signori Gagliardi' (presumably both of Giuseppe's sons, Filippo and Leandro) gilded it they placed it on boards, and took the utmost care to catch any gold that fell off as it was being applied, instead of leaving it for scavengers to collect, as was apparently the norm.[44]

Ludovici had trained in Rome in the last years of the seventeenth century, and by the 1740s Roman taste had changed. The prototypes he had regarded as relevant to Maini's *Virgin of the Immaculate Conception* had all been painted in the seventeenth century, but nowhere was his familiarity with the past, and now outmoded, glories of Rome more apparent than in the reply he sent to the architect Vanvitelli's criticisms of the drawings Ludovici had made for the chapel in St Roch, in which examples of the high renaissance and early baroque are bandied about like citations from the church fathers in a theological dispute.[45] This correspondence was, for the most part, concerned with architecture and the architectural decoration, but Ludovici used the occasion to make his own criticisms of Vanvitelli's design for the font of the Patriarcate. Although he did not actually object to the lamb on it, in response to what must have been a criticism by Vanvitelli of Ludovici's own project for placing a very small lamb above the high altar of St Roch,[46] he could not resist remarking that the head and neck of a lamb on a drawing for the font, which, he says, is perhaps by the hand of Vanvitelli (Pl. X),[47] look more like those of a donkey.[48] If this is indeed the drawing to which his comments applied, it must be admitted that he had a point. His more serious objection was to the excessive gilt-bronze ornamentation, which was probably to be made by Francesco Giardoni; this was intended to disguise the fact that the porphyry bowl was made up of several pieces, but this was unacceptable to the Portuguese, and, if no single piece of porphyry could be found of adequate size, they would prefer the use of marble, or alabaster, provided it were hard and took a polish.[49]

How this was resolved is unknown, for the font no longer exists, but this drawing can serve as an example of the way in which Roman models were adapted for Portugal, as well as of the way that taste had developed and changed in less than twenty years since its prototype, the font in St Peter's, had been made on the designs of Carlo Fontana (Figs. 187–8). The basic structure of the cover is the same: a pedestal flanked by curving volutes decorated with acanthus leaves, and surmounted by the lamb. But the over-all effect is lighter, the heavy and rather cabbagy leaves that linked the volutes to the pedestal in St Peter's replaced with swags, and the figurative elements reduced to a pair of conventional cherub-heads, or replaced by a shell and reeds that look forward to the rococo. This reduction of figurative sculpture in favour of decorative motifs, which in turn means a limitation of the overt iconographic content,[50] is typical of the aesthetic change that was taking place in Roman art, and of the style that is conveniently known as the *barochetto*.

Work was still continuing on the Patriarcate when, in 1642, King John V decided to found a chapel in the church of St Roch in Lisbon, dedicated to the Holy Spirit and St John the Baptist (Fig. 237). It was an extraordinary enterprise, the whole chapel being built in Rome, and shipped over to Portugal to be installed in the church. The architect was Luigi Vanvitelli, assisted by Antonio Salvi, but his plans were subject to approval by Ludovici, the court architect in Portugal.[51]

Built on the top of a high hill, the church of St Roch survived the earthquake; not only that, most of the furnishings of the chapel survived the Napoleonic wars.[52] This is one reason for its fascination, but by no means the only one. It is remarkable for the extent of its documentation, and as a very rare example of a whole chapel that was created as a unit, with its complete furnishings, in a short span of time – in fact no more than eight years. Last, but by no means least,

237. Giuseppe Palms, and others, model for the chapel of the Holy Spirit and St John the Baptist. Lisbon, Museu de São Roque

it was commissioned with scant regard for cost, at least on the part of Sampajo, who appears to have been willing to spend the wealth of his king with abandon, provided that he could obtain the best design and the highest quality workmanship.[53]

The chapel of St John itself is resplendent with gilded bronze. Not only the capitals and bases of the columns and the frames of the mosaic pictures, but the mouldings, the rosettes of the vault, and even the verde antico frieze glitter with gold (Pl. XI). Nor are these just plain filets, but delicately cast and chiselled mouldings of consummate workmanship. The cost of this structural metalwork alone was estimated to come to over 89,576 *scudi*, and would certainly have cost more by the time it was actually completed. Not surprisingly, a number of different metal-workers (including at least one described as a silversmith) were employed on this massive labour for what is just a very small side-chapel.[54]

Among them was Francesco Giardoni, who was responsible for the capitals and bases of the columns, and the metal strips enclosing the panels of lapis lazuli. It was probably Francesco Rosa who cast the open-work ornament of the frieze with its trailing flowers and foliage, though it appears to have been Antonio Arighi who cast the heavy garland above the altarpiece. Anyone who has tried to assemble a piece of knock-down furniture will no doubt sympathise with the workmen who accompanied the chapel from Rome to Lisbon, and, when they put it up, found there were bits left over. A wreath (Fig. 238),[55] which did not seem to belong anywhere, has also been attributed to Giardoni, and demonstrates not only the vitality of the modelling, but the perfection of the casting, and the delicacy of the chiselling and punching of the surfaces, fully justifying the requirement expressed in the letter ordering the construction of the chapel, that 'in the said chapel both the value of the material and the inventiveness of the workmanship should shine out with equal splendour'.[56] This same richness of decoration and crispness of execution informs almost all the metalwork of the chapel.

Yet not everything was done according to the instructions sent from Portugal, which had stressed the connection with St John the Baptist even in the ornaments, asking for shells, reeds, and fishes, allusive to water. The drawings illustrating these demands have been lost, but Ludovici did produce drawings for the monogram of crossed 'J's for the sides of the altar-table, incorporating a pair of dolphins swimming through shells and water-reeds (Fig. 239).[57] These designs were considerably simplified, and the fishes omitted (Fig. 240), but not before Ludovici and Vanvitelli had had a slanging match as to the suitability of dolphins for St John, who baptised with the waters of the river Jordan. Apparently Vanvitelli had said that these waters were fresh, and therefore could not contain dolphins, which are salt-water fish. This produced an ironic lesson from Ludovici on the waters of the Holy Land, and the identification of the Lake of Tiberias and the Sea of Galilee, through which the river Jordan flowed, and in which Christ had produced the miraculous draught of fishes, including large fishes like dolphins. In any case, Ludovici said, they were more appropriate as decorative motifs than eels, which look like venomous snakes, and are therefore quite unsuited to a holy chapel.[58]

A monogram of comparable complexity, if reduced legibility, was included in the side doors of the chapel (Fig. 241), and if the crossed 'J's also form a 'V', for five, that can hardly have been accidental. These are the work of the silversmith Silvestro Doria, and, while there are Roman prototypes for the low doors by Francesco Guarnieri in the balustrade incorporating similar monograms, I know of nothing comparable in Rome to these large and heavy pierced bronze panels.[59]

While one might justifiably regard the modelling and casting of flowers, not to mention cherub-heads, as sculpture, it is in the silverware produced for the liturgical functions of this chapel that the most interesting and remarkable sculpture is to be found.

It was in March of 1744 that an order was sent from Lisbon for this silver. In October 1749, before it was loaded on a ship at Civitavecchia, it was solemnly blessed by Pope Benedict XIV.[60]

Much was said in the correspondence, and particularly in the original command for the chapel, of its function in containing a tabernacle, and of a *machinetta* of silver and gilded bronze to go on it, for the exhibition of the host.[61] Regrettably, the tabernacle made by Antonio Arighi on the designs of Vanvitelli is one of the objects that have been lost.[62] But in any consideration of the

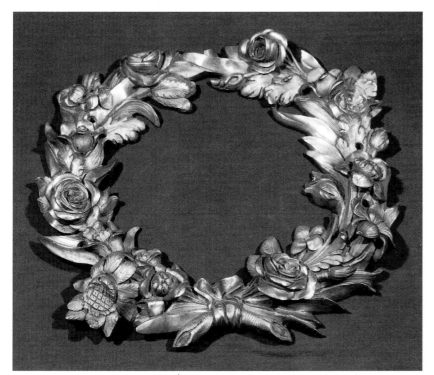

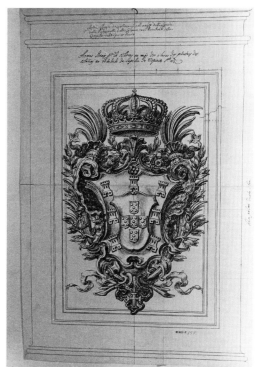

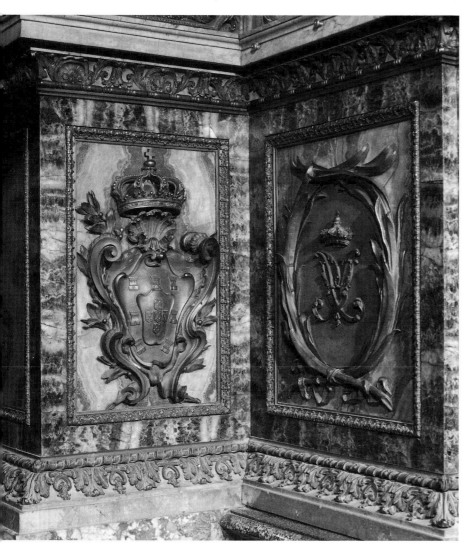

chapel and its furnishings one receives some help from the so-called Weale album. In 1745 Sampajo sent to Lisbon two books, 'one with the names of the artists and sum of the cost, the other of drawings of all the commissions, and individual costs of the parts of each of them';[63] the second of these must be the volume that somehow passed to the London book-dealer John Weale, and was published in a full, if not always reliable, translation, in 1843–4.[64] It was entitled 'PATRIARCALE.LISBON.MDCCLV', despite the fact that only a few of the drawings refered to the Patriarcate, the majority being of work to be done for the chapel in St Roch. It has since disappeared, but its fundamental importance for our understanding of the chapel cannot be over-estimated: not only did it include drawings for the objects now lost, but some, as we shall see, were subsequently modified.

Even if the central object, the ciborium, has been lost, fortunately most of the other work survives, including the most obviously sculptural work, the great altar-frontal (Pl. XII) representing the twenty-four elders worshipping the lamb, according to chapter 29 of the Book of Revelations, though the sculptor has omitted the four beasts, that is to say the symbols of the Evangelists. The word used in this place in the Book of Revelation is 'God', but, of course, the lamb is the symbol of Christ, and one particularly suited to a chapel dedicated to St John, who referred to Christ as the Lamb of God; in fact, as mentioned above, Ludovici had even wanted a small lamb placed over the frame of the altarpiece. The whole altar-frontal is the work of the siversmith Antonio Arighi, and the model for the relief was given by the Bolognese sculptor established in Rome, Agostino Corsini. It was a difficult task for a sculptor to show twenty-four virtually identical figures in low relief, and one feels a sense of freedom when he breaks out into higher relief in the foremost figures. But if one judges the general effect, as surely one is supposed to do, the combination of silver and lapis lazuli, the way in which the curling smoke of the incense pots seems to dissolve into the silvery markings of the stone, and the distancing of the lamb in glory on his throne supported by etherial angels, is a complete success.

It has, however, an inherent sense of realism, which is negated by its position, confined within a frame, overlapped by the fleshy acanthus leaves and resting above a garland of roses; moreover, it is held by two silver cherubs, modelled virtually in the round by another artist of a very different temperament, Bernardino Ludovisi, and these shifting levels of reality remain slightly disturbing, as would not be the case were the *Adoration of the Lamb* a painting or a mosaic. However, the general effect of this altar-frontal, with the harmonious play of the silver and lapis against the gilt bronze of the structure, added to the high quality of the sculpture, remains extremely satisfying.

The altar-frontal is the only piece of church furniture in the chapel for which we have firmly documented sculptors. Yet so much of the silver incorporates figurative elements that seem to go beyond the competence of the named silversmiths that one must surely look for the hand of a sculptor in the models.

Not, perhaps, for the thurible (Fig. 242),[65] and possibly not even for the *navicella*, or incense-boat (Fig. 243), with its figure of Religion on the poop. Both these are the work of Leandro Gagliardi,[66] but they are copies of other, rather finer ones made by Antonio Gigli (Fig. 244).[67] When the pope blessed the silver in 1749 he was presented with the holy-water bucket with its aspergillum, and the incense-boat and thurible.[68] This (possibly) spontaneous gesture, in response to Benedict's admiration, meant that the substitutes had to be made within some six months,[69] and one cannot exclude the possibility that the gift was planned in advance. Whether it was spontaneous or not, it must be admitted, that the pope got the best of the deal: if one compares the face of Religion, or the modelling and chasing of the waves on the underside of the boat, or, indeed, any part of the ornament, the Gagliardi appears relatively coarse and mechanical in execution, and devoid of the rhythmic flow which relates Gigli's boat to the incipient rococo. They form an interesting and instructive pair: seen by itself the Gagliardi boat would be rightly judged a fine piece of liturgical silver; only when set beside Gigli's original in Bologna does one realise how much better it could have been.

It is the estimate of Leandro Gagliardi's work on the thurible and incense-boat which stresses the imaginative and entertaining idea of taking the traditional name of an incense-boat (*navicella*

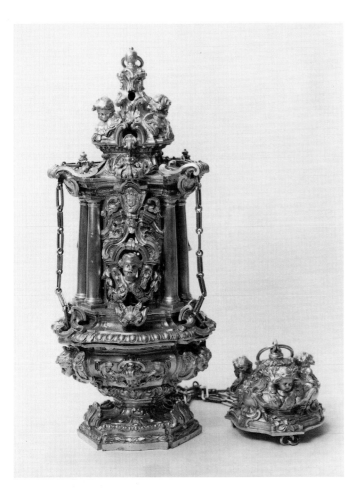

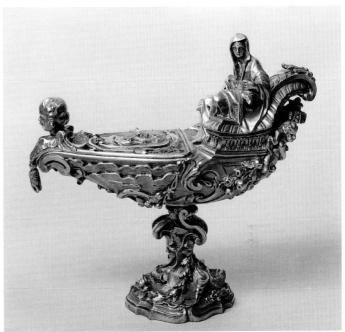

242. (*left*) Leandro Gagliardi, *Thurible*; silver-gilt. Lisbon, Museu de São Roque

243. Leandro Gagliardi, *Incense-Boat*; silver-gilt. Lisbon, Museu de São Roque

244. Antonio Gigli, *Thurible* and *Incense-Boat*; silver-gilt. Bologna, Treasury of S. Pietro

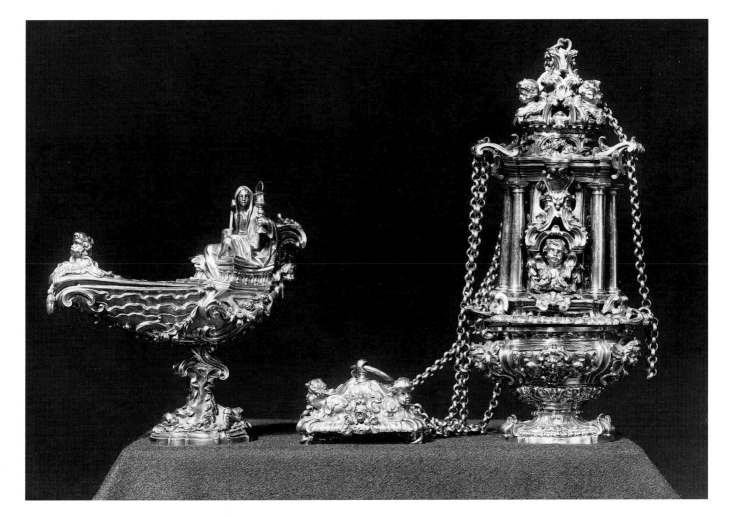

245. Antonio Vendetti, *Mass-card*; silver and silver-gilt. Lisbon, Museu de São Roque

in Italian) so literally, referring to Religion as sitting on the poop, and pointing out that the base is formed of waves with dolphins swimming in them.[70] It is entertaining precisely because it is not taken too seriously: garlands of fruit and flowers are hung round the boat, and on the base are not only waves, but also eucharistic grapes. Whether it was really the silversmith Antonio Gigli who invented this 'concetto' we cannot say for sure, though the fact that the model must have been passed to a totally different workshop makes it rather unlikely.

The most significant question raised by the liturgical silver of this chapel is exemplified in an extreme form by the mass-cards, called *cartaglorie* in Italian, which were all made by Antonio Vendetti. There are six of these, three in silver-gilt, and three in gilt bronze. Indeed, most of the

246. Antonio Vendetti, *Mass-card*; silver and silver-gilt. Lisbon, Museu de São Roque

liturgical metalwork is doubled in this way, the gilt bronze being used on ordinary days, and the finer silver-gilt reserved for special festivals. It is the silver-gilt set that is the most remarkable, using a sheet of ungilt silver for the text instead of the more usual parchment, with the frames embellished with reliefs and figures in the round. One of them (Fig. 245), made for the Gospel side, makes use of the same subject of the Elders adoring the Lamb already encountered on the altar-frontal; appropriately, the relief is of St John the Evangelist, author of the Book of Revelation. The mass-card for the centre (Fig. 246) shows Faith enthroned above the other theological virtues (Charity and Hope) and flanked by the Church and Religion, with a relief of the Institution of the Eucharist, typologically relevant figures of Melchisedek and Aaron, and

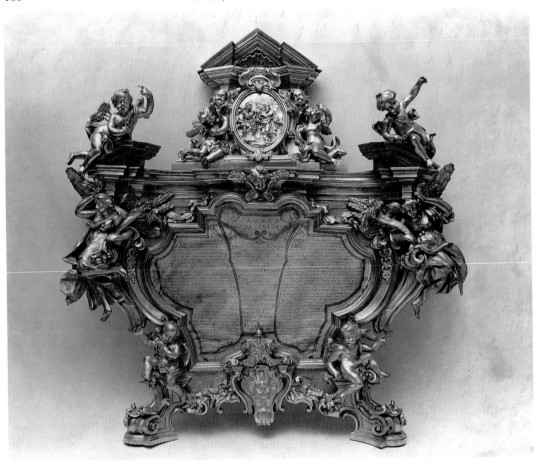

247. Antonio Vendetti,
Mass-card; gilt bronze.
Lisbon, Museu de São
Roque

decoration featuring the eucharistic grapes and wheat. The third, for the Epistle side, has a relief
of the Ecce Homo, and above it a miniature scene of Pilate washing his hands. The gilt bronze
set are less remarkable in their decoration: in the pair made for the Gospel and Epistle sides this
consists of cherubs of various sizes, medallion reliefs of Sts John the Evangelist and Baptist, and
smaller medallions of a pelican in its piety and another bird; the central one (Fig. 247) has two
angels with cornucopias, a medallion of the spies with the grapes, and the Portuguese royal arms.

Undoubtedly they are by Vendetti (though he paid another specialist for the inscriptions). But
according to his fellow goldsmiths Vendetti 'never made a magnificent, or important, work, but
only small and trivial things, and moreover he is incapable of drawing, or modelling, so much so
that when it was necessary he always made use of other experts who had that ability to make the
drawings and models as he was helped by the late Luigi Landinelli and Lorenzo Morelli, and
others.'[71] There was a reason for this hostile judgement: it was made during the lawsuit which was
specifically about two works by Giuseppe Gagliardi which were beyond any question magnificent
and important; and one of those who had made the contested valuation for father Cabral was
Antonio Vendetti. There was, therefore, a clear motive for those who wished to support the
claims of Gagliardi to denigrate the ability of Vendetti. Certainly, as compared to Galgliardi's
works, such as the *Virgin of the Immaculate Conception*, and the *torcieri* that we shall examine shortly,
the decoration of these mass-cards could be described as 'small and trivial'. Even so, it must be
admitted that, in comparison with the other silver of St Roch, the figures on Vendetti's silver
mass-cards are not very successful,[72] and those on the bronze set are frankly bad, crudely modelled
and coarsely finished; they would look poor in any company, and seen with the silver from the
chapel the low quality of their workmanship is blatantly apparent.

If he was given drawings and models (and we know that Lorenzo Morelli was involved in the
making of the silver mass-cards),[73] it appears that even his ability to execute the sculptural parts

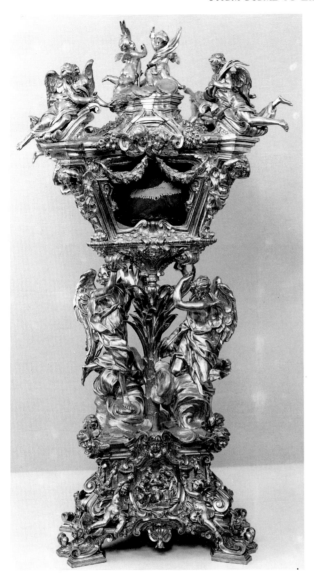

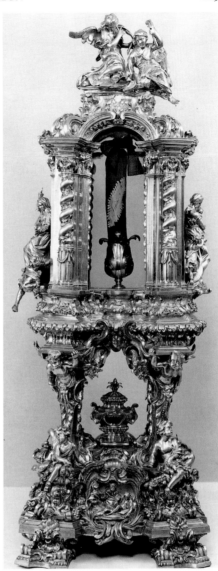

248. Carlo Guarnieri *Reliquary of St Valentin*; silver-gilt. Lisbon, Museu de São Roque

249. Carlo Guarnieri, *Reliquary of St Felix*; silver-gilt. Lisbon, Museu de São Roque

was relatively limited. Interestingly, on these silver mass-cards it is the simpler figures, such as the small cherubs at the base that any silversmith should be able to make without assistance, which look less professional than those which would have been invented specifically for these pieces.

But the important question concerns the design. Could the relatively unknown Lorenzo Morelli, or the otherwise totally unknown Luigi Landinelli,[74] have provided these designs? I believe that in such cases 'drawings' have to be understood in a special sense. If one considers a drawing such as that which Giardini provided for the engraver (Fig. 183), it is evident, as was shown by a comparison with the engraving by Limpach (Fig. 184), that many details had to be clarified. If Vendetti were given such a drawing, or one that was even less precise, he would need to elaborate it into a working drawing, and make the models. Here Morelli or Landinelli may well have helped with the more important parts of the silver set, leaving some standard cherubim for Vendetti, who would also have been left largely to his own devices for elaborating the designs for the bronze set.

Similar problems are raised by many of the pieces of silver made for this chapel. Eight reliquaries were ordered, originally all from Carlo Guarnieri,[75] but four were later passed to Leandro Gagliardi.[76] Only the four by Guanieri survive, two pairs of identical forms (Figs. 248–

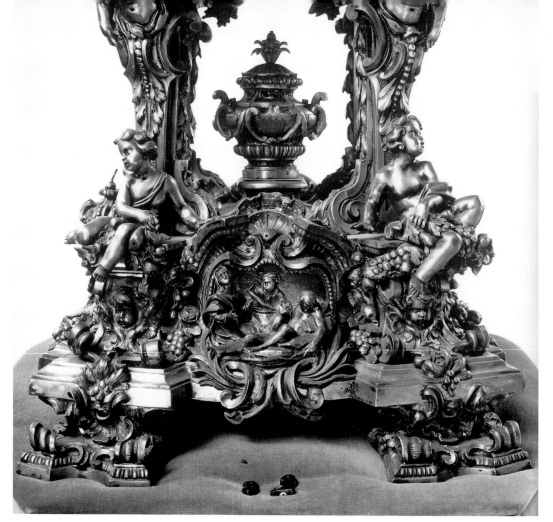

250. Carlo Guarnieri, *Scene of Martyrdom*; silver-gilt. Lisbon, Museu de São Roque (detail of the *Reliquary of St Felix*)

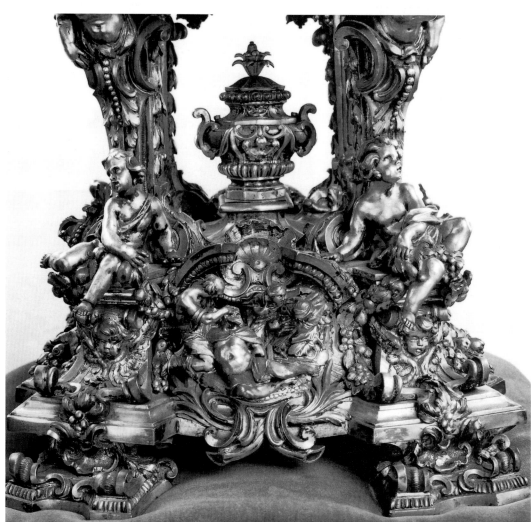

251. Carlo Guarnieri, *Scene of Martyrdom*; silver-gilt. Lisbon, Museu de São Roque (detail of the *Reliquary of St Felix*)

9).[77] Those which Gagliardi made, while described in the same terms as being in the form of 'urns' and 'temples' (*a tempietto*), were presumably from different designs,[78] though we know nothing about the appearance of these lost reliquaries beyond the fact that they were lighter, and therefore presumably smaller, or simpler, than Guarnieri's surviving four.[79]

Comparing even such standard features as the cherubs with those by Vendetti, it is evident that we are here dealing with a much more competent executant, and I should suggest that for such figurative parts Guarnieri may well have had models provided by a sculptor. I feel even more convinced that this was so of the small but very precisely drawn and modelled scenes that decorate the two longer sides of each of these reliquaries. Obviously, they should refer to the martyrdoms of the saints whose relics they contain (Felix, Urban, Valentino and Prospero), but I have not been able to identify which of the many saints with those names are commemorated. As late as May 1748 a letter from Sampajo in Rome requested information about the relics of confessors or martyrs the Portuguese wished to have placed in these splendid shrines, for Sampajo needed to know what symbols to include before allowing Guarnieri to proceed, and before trying to procure the correct relics.[80] Those eventually used came from the catacombs of St Calixtus;[81] possibly it had been sufficient to know that the Portuguese preferred martyrs.[82] In any case, while the scenes look very specific, it seems that they do not necessarily depict events from the lives of the previous owners of the relics, since those on the reliquary of St Felix (Figs. 250–51) appear to represent two different martyrs, a bearded soldier of advanced middle-age and a beardless youth.[83]

The involvement of a sculptor is also probable for the angels who surmount these reliquaries, and even more so for the figures of Charity and Faith triumphing over Heresy (Fig. 252), which could well be enlarged to monumental scale. At the time when these were made Lorenzo Morelli was working under Guarnieri,[84] but, although we are told that Vendetti relied upon him, it seems doubtful that Guarnieri could have produced such models even with this assistance.[85]

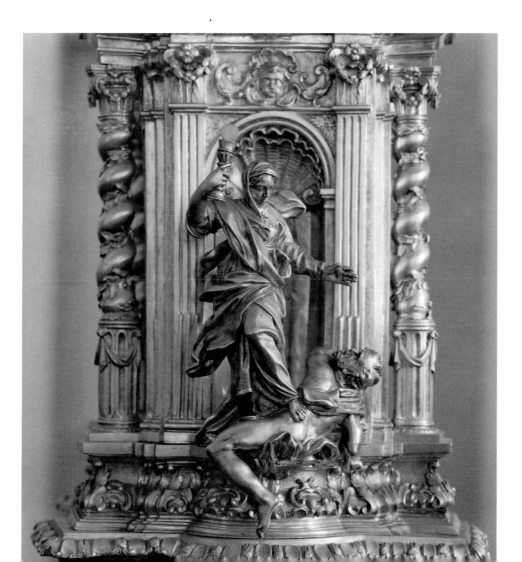

252. Carlo Guarnieri, *Faith Triumphing over Heresy*; silver-gilt. Lisbon, Museu de São Roque (detail of the *Reliquary of St Felix*)

Guarnieri, together with two other silversmiths Francesco Baislach and Giovanni Bettati,[86] had their own lawsuit against Sampajo's heirs before the judge Pirelli. Guarnieri, like so many of those involved in the chapel in St Roch, had been forced to accept the low payment for his reliquaries because he had no other means of keeping his workshop open or himself alive.[87] Baislach and Bettati claimed that after two of the three lamps they had been commissioned to make had been completed and valued, the experts elected by the two sides could not agree on the value of the third; this was seized by Cabral's agents and secretly valued, together with the previous two lamps, at a sum which the silversmiths did not wish to accept, but they were forced to do so.[88]

Another who claimed outstanding payments was Francesco Giardoni.[89] Amongst the work for which he said that he was yet to be paid in full was the relief of the *Virgin and Child* modelled by Maini, which had been valued by Sampajo at 8,000 *scudi*, but Giardoni apparently agreed on 5,000, and had received 4,000;[90] however, by the time Cabral had reduced the price to 2,555.70, the unfortunate Giardoni ended up owing the Portuguese crown 1,444.30 *scudi*. He claimed also for money still owed by the king, and that owed for various plate and other objects he had made or acquired for Sampajo himself, and for other work such as the designs he had made for the thirty silver candlesticks for the exposition of the sacrament, after those of six other 'professori' (it is not clear whether these were silversmiths, sculptors or designers) had been rejected.[91]

What happened to the silversmiths who made these candlesticks gives some idea of the sort of problems created by Father Cabral's succession to Sampajo. It was not just that none of them were content with the valuations made for Cabral, but had been forced to accept them. Giovanni Battista Carosi's four were valued when only two were finished; in 1750 when all four were made, but one still ungilded, its case was taken to be used for a candlestick made by another of the silversmiths involved, with the promise to replace it, which was never fulfilled. At the end of November he was told to produce the remaining candlestick, or he would get no pay; but, as he had no money with which to pay for the gilding, it was given to Filippo Tofani to complete. Although he had at least received his full pay (as estimated for Cabral), he claimed for loss of earnings on the gilding.[92] Lorenzo Pozzi had also finished two of his four early in 1750, and all of them were taken from him, with the promise that the unfinished two would be returned; but this was done only a month before the ship left for Lisbon, and, when he said they could not be completed in time, they too were given to Filippo Tofani who, with the aid of Michele Gonella, took about seven months to do the work.[93]

Another commission for which Giardoni claimed he was owed money was for two gilt bronze candlesticks of about 12 *palmi* (over 2.5 m. without their bases) which had been ordered for 'the chapel of His Majesty', which means that in St Roch. These were never finished because Sampajo had asked him to switch his activities to the more urgent tasks for the chapel, for the font of the Patriarcate, and the casting the relief of the *Virgin and Child*, modelled by Maini.[94] He had made the studies and the design *in grande*; Lorenzo Sacchi had made the wooden model, with its mouldings for the base, stem, drip-pan and candle-holder, to which had been applied the wax models with the assistance of Giacomo Francisi. Moulds had been made by, amongst others, Giacomo Zoffoli;[95] these took many months, and it is evident that they were not for the casting, but for parts that were to be repeated, and for copying from one model to the other.

Because they were never finished these have never entered the literature, but their size relates them to the great silver-gilt *torcieri* of 11 *palmi* made by Giuseppe Gagliardi. Amongst the smaller altar candlesticks there are two sets of six, the so-called *muta nobile* of silver-gilt, and another set of six in gilt bronze, with lapis lazuli; it is therefore probable that, like the silver-gilt candlesticks and the mass-cards, the everyday bronze set were also to have their accompanying bronze *torcieri*.

The testimony collected in the *busta* 493 of the 'Giura diversa' in the Archivio Segreto Vaticano concerns the case brought against the heirs of Sampajo by the heirs of Giuseppe Gagliardi. This, which the Gagliardi family eventually won,[96] concerned the payment received for the silver-gilt statue of the *Virgin of the Immaculate Conception* and the pair of silver-gilt *torcieri* (Fig. 253),[97] both of them left incomplete on Giuseppe's death and finished by his son Leandro.[98] Giuseppe Gagliardi, the son of Pietro, a prominent brass-worker, was born in 1697;[99] he studied modelling and sculpture[100] until, apparently in 1720, his father's ill-health required him to take

253. Giuseppe Gagliardi and Giovanni Battista Maini, *Torciere*; silver-gilt. Lisbon, Museu de São Roque

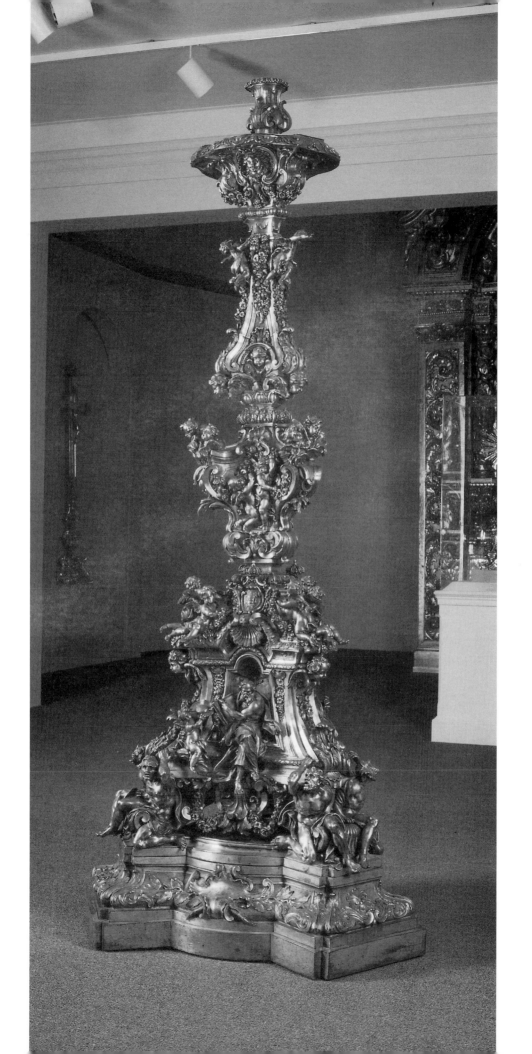

over the family workshop,[101] where he continued to work in brass.[102] Although in 1642 he received a licence to work in silver, he was not a member of the guild, and in 1745 the guild attempted to move against him by forbidding the officials to stamp his work. This background is of some relevance, both because his ambiguous status could be used against him, and because his capacity as a sculptor, while at issue in the case,[103] will be of even greater relevance to an examination of the true authorship of the *torcieri*.

The numerous depositions taken during the course of the lawsuit seem to have been designed to answer various questions: the value of the work, which includes the exceptionally thin silver casting; the quality of the gilding; the extent of Gagliardi's contribution to the work; the status, and therefore credibility, of the various experts who valued it, and finally – and crucially – the fact that the silversmith Matteo Piroli, one of those who had made the valuation for Sampajo, had signed a paper stating that this valuation was too high,[104] but was later said to have admitted to various witnesses that he had done this only because the terrible Cabral had threatened to withold the payment for Piroli's own work unless he did so.[105]

Each of the two works was estimated three times: once on the death of Gagliardi, a second time shortly after, when it was completed – and each of them had many additions, though how extensive these additions were was one of the points that had to be proved – and finally by Cabral, in secret. As has been seen previously, it was the established practice that a valuation should be made by at least two experts, one acting for the man who had commissioned the work, and the other for the artist; it was Cabral's failure to have this second expert that was one of the bases of the claim that this valuation should be overturned. The difference between the last two valuations was very considerable: for the *Virgin of the Immaculate Conception* it was between 49,185.59 *scudi* and 29,233.30; for the *torcieri* between 61,726.55 *scudi* and 39,156.27.[106]

Not surprisingly, considering the amount of work in the *torcieri*, a great many assistants were employed. Among them was Giacomo Francisi, whom we have met helping to make the models of Giardoni's candlesticks. He passed on from Giardoni to Gagliardi, for whom he worked as a chiseller.[107] But part of the fun of reading the testimony provided for Gagliardi's lawsuit is the picture it provides of the silversmiths' workshops, in which we find many of the assistants apparently working for several different silversmiths, passing successively from one studio to another. Lorenzo Morelli, whom we met making waxes for Guarnieri and on whom Antonio Vendetti was said to have relied for his models, reappears here casting waxes for the *torcieri*.[108] Some were obviously freelance workers, and this applies particularly to specialists, like the mould-maker, Filippo Filiberti. Gilders, too, were often called in, such as the 'public gilder', Antonio Petrucci, who gilded Guarnieri's reliquaries, and who also worked on the gilding of the *torcieri*.[109]

The system of construction was much the same as that of Giardoni's bronze pair: a wooden structure, on which the decorative parts were modelled in wax. We know that the wood-turner Giovanni Rota provided the cores both for the preliminary model of one face only that was submitted for approval, and for the two finished models prepared for the casting.[110] From the complete model each of the decorative parts would be moulded, and, in many cases, cast separately. In fact, we know that the two silver *torcieri* consist of 296 pieces,[111] and since, as with *Virgin of the Immaculate Conception*, it was essential that the casting should be thin, many pieces that were judged to be too heavy had to be cast a second time. By 1748 only one of the pair was in a fit state to display in the Palazzo Capponi, though it was not yet gilded, and some of the putti were made of wax, silvered for the occasion.[112] One important consideration when establishing the value of Gagliardi's work was the extent of the changes demanded in the first single-face model, and again when the complete model was made, but it was impossible to provide evidence; the single-face model had remained in the workshop, and we get a vivid idea of conditions in Gagliardi's shop in reading that pieces had been knocked off it by the many workmen passing it in the confined space, that the wax had been further damaged by the great heat from the braziers which were kept burning continuously; moreover, some of the wax pieces had been replaced by variants modelled in clay.[113]

It is not just the splendour of the whole that makes these supreme examples of the silversmith's art, but the chasing, chiselling and punching that raises them above the level of the rest of even

254. Giuseppe Gagliardi, detail of one of the pair of *Torciere*; silver-gilt. Lisbon, Museu de São Roque

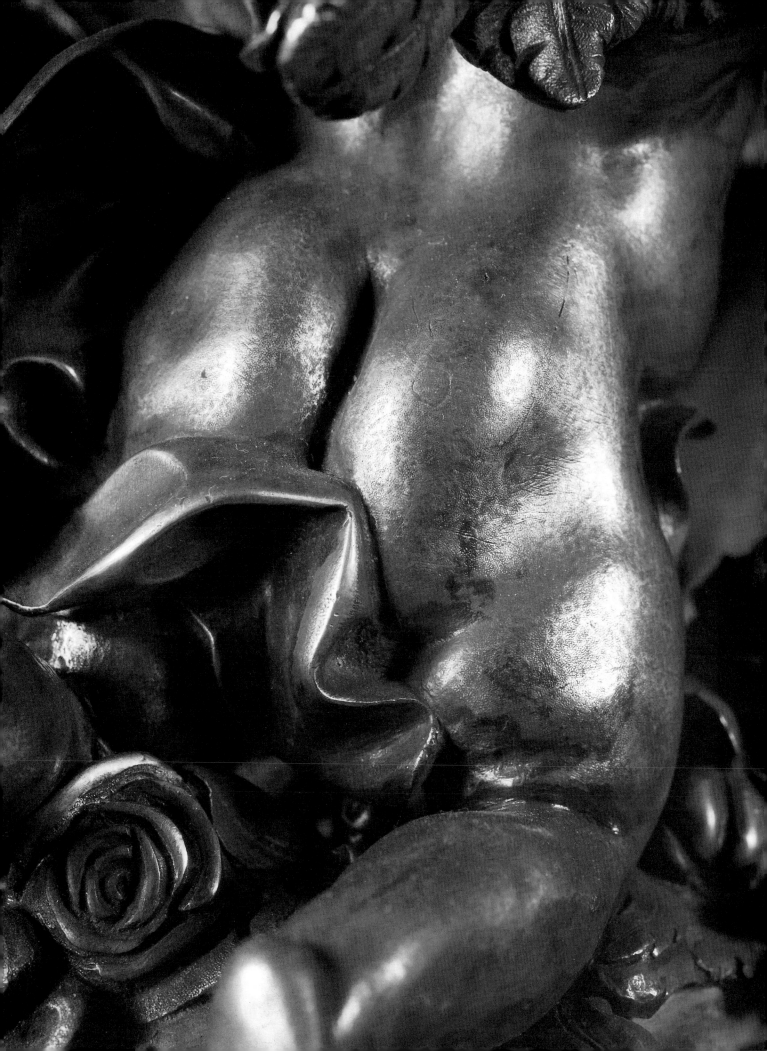

the extraordinary assemblage in Lisbon (Fig. 254). We may attribute this in great part to the skill of Francisi, but he himself insisted that 'I never chiselled a single piece, until . . . Gagliardi had first approved the surface'; moreover, Gagliardi had ordered him to make several samples, from which Gagliardi would select that which pleased him most.[114] The immense care taken over this finish appears through the gilding, which, despite the many people who were prepared to swear that it was particularly good, and above the normal quality, seems to have worn exceptionally badly.

But who was really responsible for the design of these masterpieces? One of them is signed 'Josephus Gagliardus romanus inventor fu[n]dit et fecit',[115] which should be clear enough, especially as we know that Gagliardi studied sculpture. But there are good reasons to doubt this.

There are three pieces of literary evidence to suggest that the man ultimately responsible was Giovanni Battista Maini. The first is a report in the newsletter, the *Diario ordinario* published by Chracas, which reported on the occasion when all the liturgical silver and gold for Lisbon was assembled ready for shipping, and Benedict XIV gave it his papal blessing: this describes the *Virgin of the Immaculate Conception*, and, in some detail, the two *torcieri*, and says that 'all these excellent works made on the design of the celebrated Giovanni Battista Maini, were begun by the late silversmith Giuseppe Gagliardi, and finished by Signor Leandro his son . . .'.[116] Chracas can occasionally be wrong, and it could be that he was confused, because Maini had certainly made the model of the *Virgin*. The same sort of elision could apply to a statement by Maini himself, recording a conversation he had with Filippo Tofani (one of those who had valued the *Virgin* and the *torcieri* for Cabral), saying that Tofani had assured him that he had found the work good, 'and truly one knew that it was done with my [*i.e.* Maini's] assistance'.[117] But the third statement leaves no doubt that Maini was, at the very least, involved. Here I must explain that, although the model of a single face had been approved, when the whole candlestick was shown in 1748 Sampajo found it defective, and asked for various things to be changed, and, in particular, for further bits to be added. According to the evidence given by Carlo Pacilli and his son Pietro, who claim to have made the '*disegni*' for the *torcieri* under the direction of Gagliardi, they had seen 'these variations and additions made by Signor Giambattista Maini, formerly the master of me, Pietro'.[118] If this is incontrovertible evidence that Maini made at least some of the additions and alterations, it does not prove his reponsibility for the basic design.

What these changes were can be deduced from a poor and uninspired, but highly revealing drawing, recently discovered by Alvar González-Palacios (Fig. 255),[119] which corresponds quite closely to the description of the drawing in the Weale album, that is, the drawing sent to Lisbon in 1745.[120] The prophets in the niches (*Moses* is shown in the drawing) have been changed to the Doctors of the Church, of which *Jerome* (Fig. 256 and frontispiece) looks remarkably like an enlarged and improved version of the *Moses*. The supporting figures, described in the Weale album as 'children', have become atlantes (and if on the drawing these supporting figures on the base are not actually putti, as are the other figures Weale describes as 'children', they are considerably younger than the atlantes), and there are various enrichments to the ornamentation. The decoration of the base has been extensively changed, and the Portuguese royal arms raised above the scallop-shell, which is seen from the inside, instead of from the back; the upper part has been elongated, and the cherubs who clung to it now seem to be about to take flight from it. Admittedly, it is just the Doctors of the Church and the atlantes that look most like the work of Maini, and it may be noted that the atlantes are clearly dependent on the Titans below the *Jupiter Firedog* by Algardi (Fig. 257), an artist whom Maini apparently admired.[121]

But this drawing points up another highly significant fact about the *torcieri*, that has never before been noted: the same basic design was used not only for the *torcieri*, but also for the set of six silver-gilt candlesticks and cross, the so-called *muta nobile* (noble set) (Fig. 258) said to have been designed by Angelo Spinazzi, which was intended to be used on the altar on special feast days. Ignoring the figures in the niches, one can see that the bottom register is virtually identical except that it is supported by putti such as may well have appeared on the original drawing described in the Weale album; so too is the section with the cherubs in relief (on the smaller *muta*

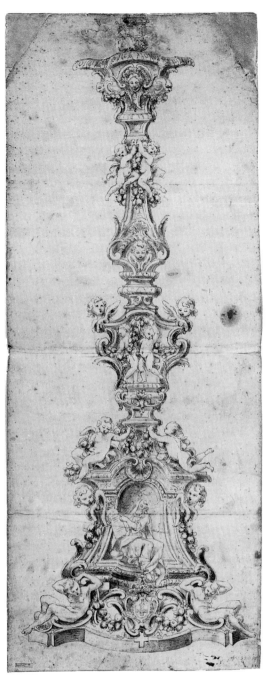

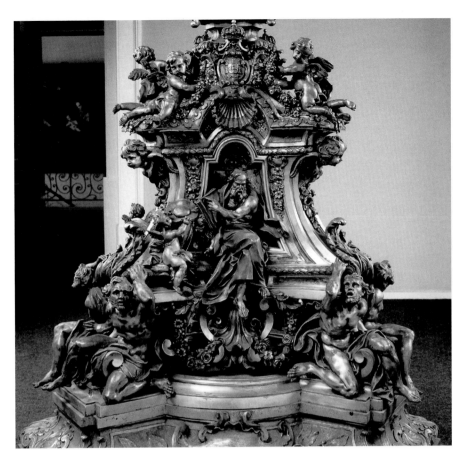

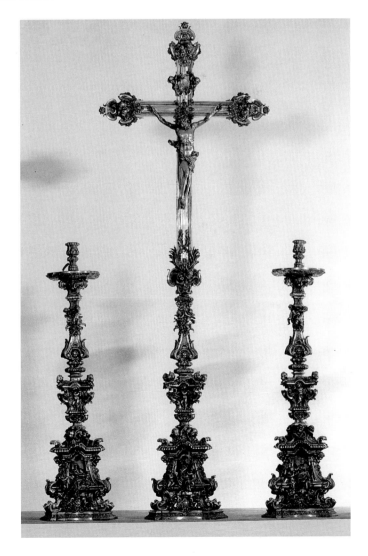

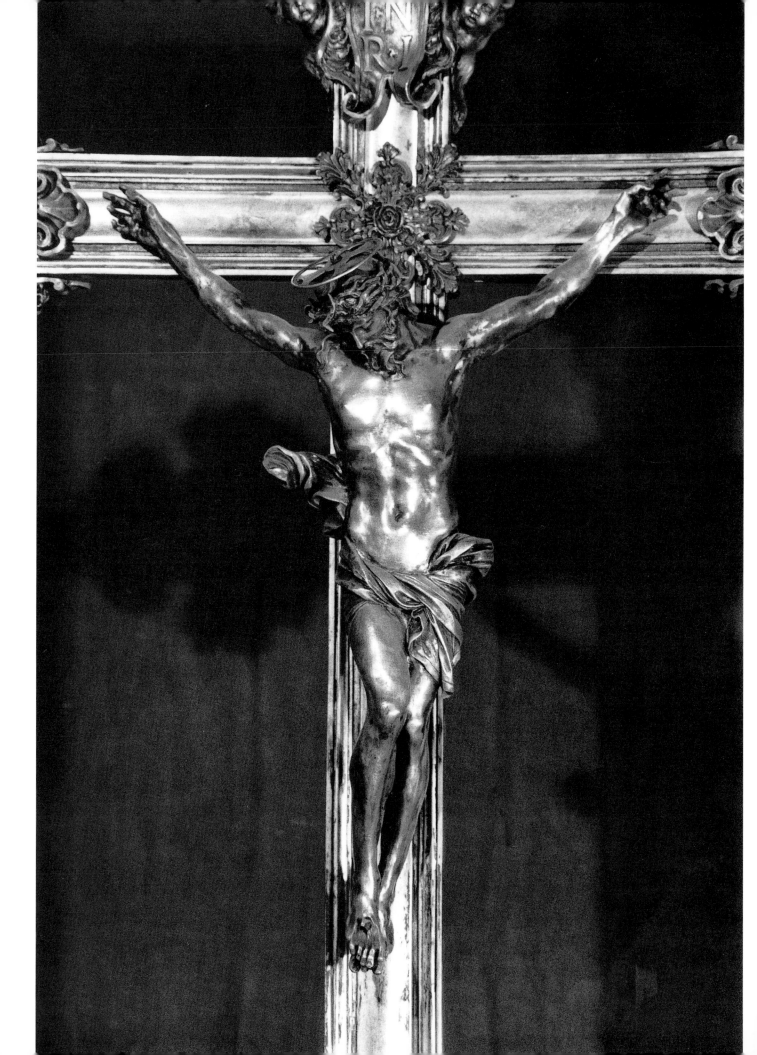

nobile there is only one cherub), and the baluster with its little cherubs at the top. Only the drip-pan and candle-holder have been significantly simplified.

In the same deposition in which Carlo and Pietro Pacilli said that Maini had provided the designs and models for the changes, they also insist that the *torcieri* are 'infinitely richer, more worked, and more noble' than the candlesticks of the *muta nobile*, and they also maintain that the designs for these latter had not been seen by those working in the Gagliardi shop until all the silver was brought together for the papal blessing.[122] The mould-maker Filippo Filiberti, who assisted Gagliardi, and went frequently to the workshop of Spinazzi with moulds and waxes, also affirmed that these candlesticks were twice as heavy and much thicker than the *torcieri*,[123] which suggests that he was answering a charge from the Sampajo side of the case which recognised that the two were comparable.[124]

There are four possibilities: that they were both designed by Spinazzi, by Gagliardi, by Maini, or by a fourth man unknown. Spinazzi I think we can dismiss, not because he was not a fine silversmith, but because no such suggestion was made in the evidence submitted;[125] for the same reason it seems safe to dismiss the idea that they were designed by a fourth, unnamed artist. In favour of Gagliardi's authorship, as well as the inscription claiming that he was the 'inventor' of the work, is the fact that in their estimate of both the *Virgin* and the *torcieri*, Francesco Juvarra and Carlo Giardoni include 1,000 *scudi* for 'the large and small drawings' and 'the models, both in clay and in wax' for the *torcieri*,[126] but they say nothing of such work for the *Virgin*, which was merely cast from a finished model by Maini – though 'merely' hardly suggests the labour that was involved. However, I should here repeat what was said above in connection with Vendetti's mass-cards: even if the silversmith were given reasonably finished designs, he would still have to work them up to make them sufficiently precise to serve his purpose, particularly if assistants were to execute them. He would also have to make the models, and all the more so if the designs showed only one face of the triangular candlesticks. However much work Gagliardi may have contributed, even though the experts specifically mention 'figures', I do not believe that Gagliardi would have been capable of inventing, or even modelling, the Doctors of the Church or the atlantes, and I very much doubt that he could have invented the other figurative parts, or the design as a whole.

So, taking all the evidence into account, I am convinced that the basic designs of both the pair of *torcieri* and the *muta nobile* was provided by Giovanni Battista Maini, and that he supplied models of at least the most truly sculptural parts. These figures I suspect were made at one of the stages when the numerous changes were introduced, and we know that many such changes were made in the ornaments, the putti, and other additions, after the wax model of a single face had been approved. Further changes were also made after the single unfinished candlestick was displayed in the Palazzo Capponi, and again after many of the pieces had already been cast and even chiselled.[127]

Although it has been generally accepted that the *muta nobile* was designed by Angelo Spinazzi, this set of six candlesticks consists of three pairs of different sizes, of which only one pair was actually made by Spinazzi, the other two pairs being by Tommaso Puliti and Francesco Antonio Salci. Puliti and Salci were to complain that they had been forced to pay 1,000 *scudi* to Spinazzi for the clay models and moulds, though the moulds were of no assistance, since they were old and the wire and nails holding the core had coroded, and they broke when they tried to use them, leaving Puliti and Salci to remake the moulds from the models.[128] The crucifix was made by yet another artist, Giovanni Felice Sanini, and here we know that the Corpus (Fig. 259) was designed, and probably also modelled, by Maini.[129]

On the base of the cross[130] are the three theological virtues, Faith, Hope and Charity. Many of the other personifications, however, have proved difficult to interpret,[131] because for the most part they do not correspond to those found in the *Iconologia* of Cesare Ripa, the handbook that was almost invariably used for creating images of such abstract ideas. I too was puzzled, until looking at the figure described by Madeira Rodriguez as 'Intellect' (Fig. 260) something clicked, and I recognised her as the image of Majesty that Bernini had created for the catafalque of Pope Paul V (Fig. 261). This turned out to be the key: apart from the obvious theological and cardinal

259. Giovanni Felice Sanini, on the model of Giovanni Battista Maini, *Crucifix of the 'Muta Nobile'*; silver-gilt. Lisbon, Museu de São Roque

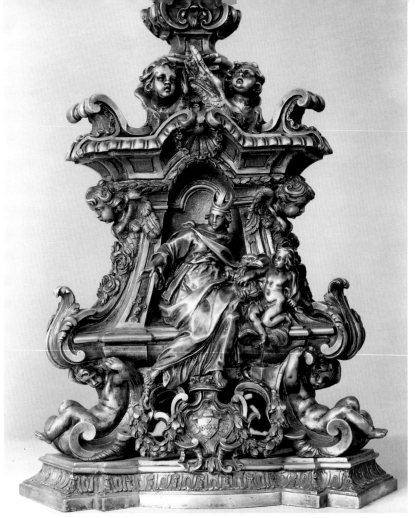

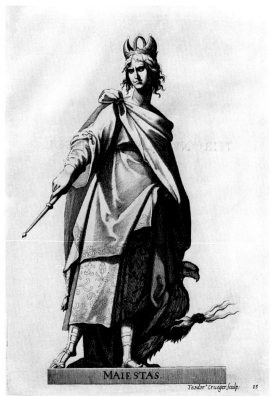

260. (*left*) Tommaso Puliti and Francesco Antonio Salci, *Majesty*, detail of a candlestick of the '*Muta Nobile*'; silver-gilt. Lisbon, Museu de São Roque

261. (*below*) Giovanni Lanfranco, after Gianlorenzo Bernini, *Maiestas*; engraving from Lelio Guidiccioni, *Breve racconto*, 1623

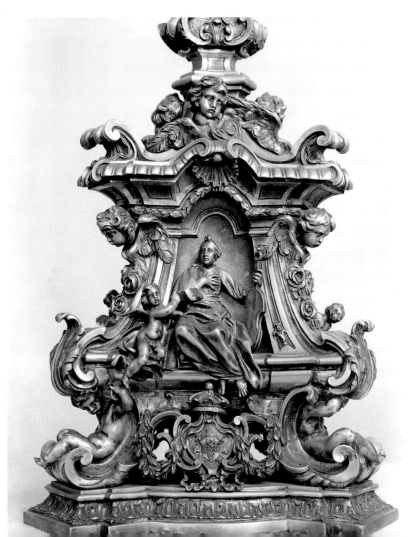

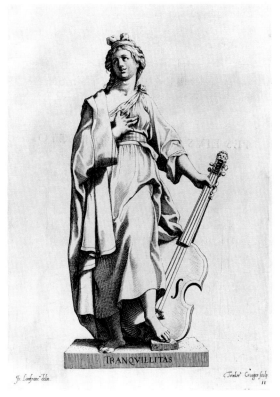

263. (*above*) Giovanni Lanfranco, after Gianlorenzo Bernini, *Tranquilitas*; engraving from Lelio Guidiccioni, *Breve racconto*, 1623

262. (*left*) Angelo Spinazzi, *Tranquillity*, detail of a candlestick of the '*Muta Nobile*'; silver-gilt. Lisbon, Museu de São Roque

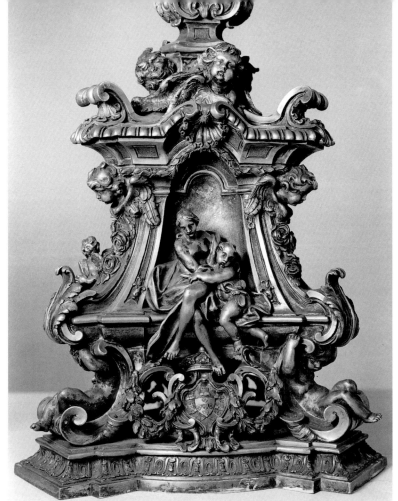

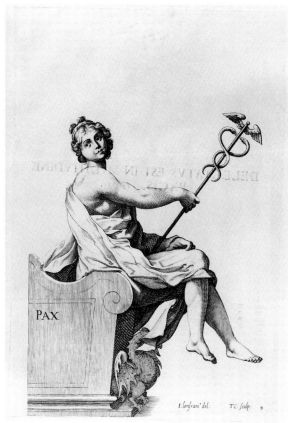

virtues,[132] almost all the other figures were taken from the engravings made from Giovanni Lanfranco's drawings after Bernini's sculptures of more than a hundred years earlier.[133] So the woman with a cello (Fig. 262) who might plausibly have appeared to represent Harmony (however implausible this would be in such a context) is actually Tranquillity (Fig. 263), while the woman with a caduceus (Fig. 264), quite inappropriately called 'Morality', is to be recognised as Peace (Fig. 265).[134]

The question of where Bernini took these personifications from has apparently never troubled the students of that master.[135] Lelio Guidiccioni, who gave the fullest account of this catafalque, said that he would write of these figures, with their meaning, in another place, but so far as I can discover he never did so.[136] Fortunately for our purpose it is sufficient to recognise that this was the source from which these figures on the candlesticks were taken, and to admire the skill with which Bernini's standing figures have been converted to sit within niches, and, where necessary, provided with accompanying putti.

Again, the question arises as to whether the silversmiths who made these candlesticks provided the models. From what has been said above it is evident that their basic structure must have been given by the same artist who designed the *torcieri*, whom I believe to have been Maini, and very possibly he also made drawings for the personifications. However, it should be noted that, whether or not they were responsible for the designs, the silversmiths were well aware of what they were doing: when Tommaso Puliti and his companion Francesco Antonio Salci consigned four candlesticks, two gilt and two ungilt,[137] they described one of the ungilt pair as having Prudence in the front niche, and the other as 'with the figure in front of *Sapienza*, with the lance, and shield'[138] (Fig. 266), which proves that, unlike those who would see this figure as representing Courage, they were well aware of her true identity (Fig. 267).[139]

The dependence of these figures on ephemeral statues of feigned marble made over a century previously may serve as a reminder that neither art nor history can be carved up into isolated

264. Tommaso Puliti and Francesco Antonio Salci, *Peace*, detail of a candlestick of the '*Muta Nobile*'; silver-gilt. Lisbon, Museu de São Roque

265. Giovanni Lanfranco, after Gianlorenzo Bernini, *Pax*; engraving from Lelio Guidiccioni, *Breve racconto*, 1623

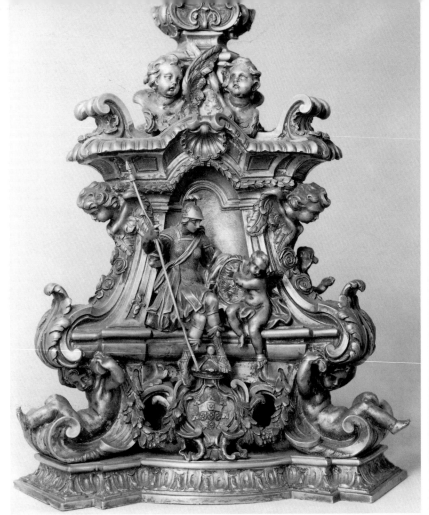

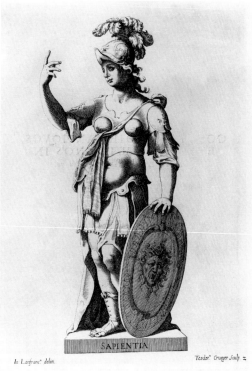

SAPIENTIA

la. Lanfranc. delin. *Teodor.* Crueger *Sculp.* z

266. Tommaso Puliti and Francesco Antonio Salci, *Wisdom*, detail of a candlestick of the '*Muta Nobile*'; silver-gilt. Lisbon, Museu de São Roque

267. Giovanni Lanfranco, after Gianlorenzo Bernini, *Sapientia*; engraving from Lelio Guidiccioni, *Breve racconto*, 1623

sections. One cannot study the 'minor' art of the silversmith without an awareness of the 'major' art of the sculptor, nor can one understand any part of it without a knowledge of what went before, and one can appreciate none of it fully without some knowledge of what came after. I have decided to end here, in the mid eighteenth century, because the later part of the century saw a turning away from the baroque ideals under the growing influence of neo-classicism. The collection of metalwork made for the church of St Roch, of which I have examined only a small part, marks the culmination of the tradition of baroque silver and bronze, a tradition that began a hundred and fifty years before. It is of a quality that had never been achieved previously, at least in any surviving pieces, and that was never to be surpassed in Italy. Its particular splendour derives from a combination of the skill of the bronze-founders and silversmiths who made it, with the unrivalled talents of the sculptors who provided the designs and models. So it is appropriate that we should end with these mid eighteenth-century masterpieces of the silversmiths' art, that look back to the creative genius of the baroque, Gainlorenzo Bernini.

Colour Plates

1. Giovanni Battista Maini and Giuseppe Gagliardi, *St Ambrose*; silver-gilt. Lisbon, Museu de São Roque (detail of a *Torciere*)

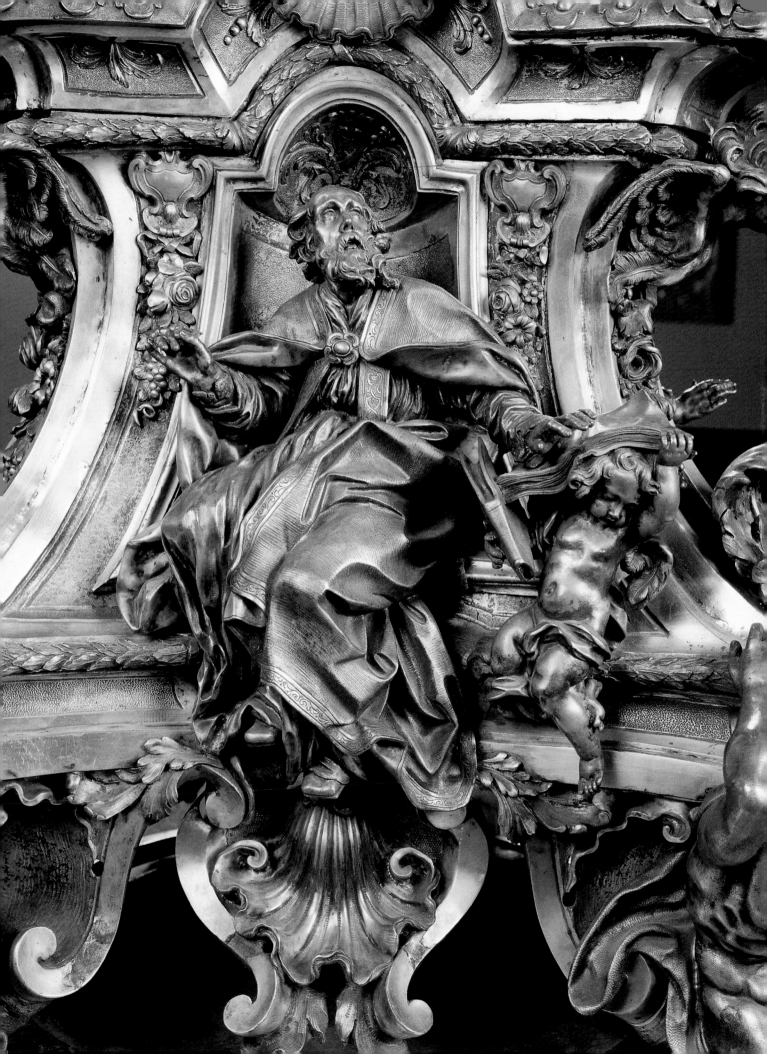

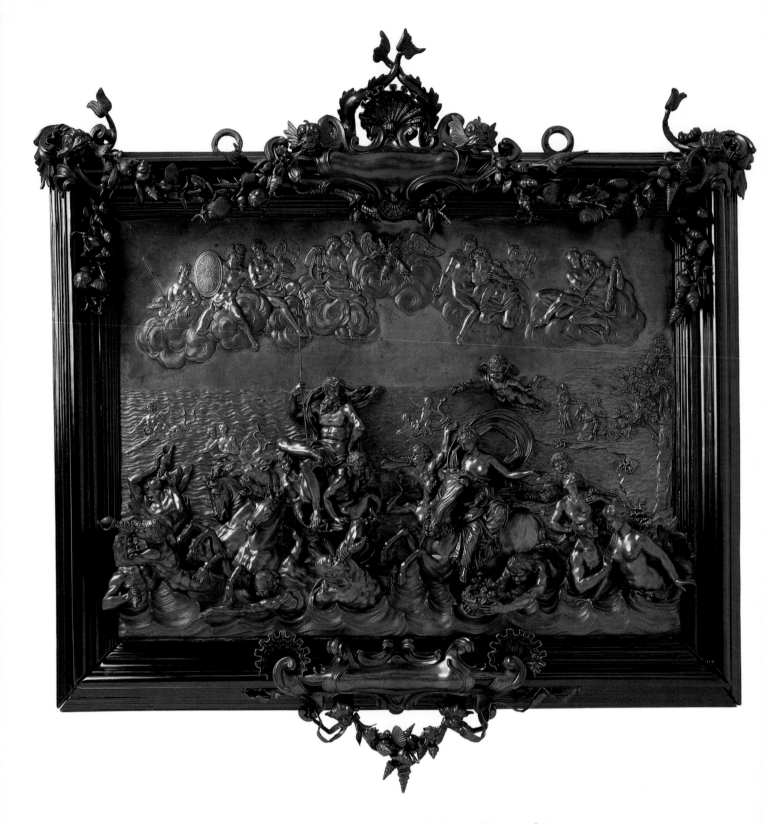

II. Antonio Montauti, *The Triumph of Neptune/Rape of Europa*; bronze. Los Angeles County Museum of Art

III. Alessandro Algardi, *Flagellator*; silver. Washington, National Gallery of Art

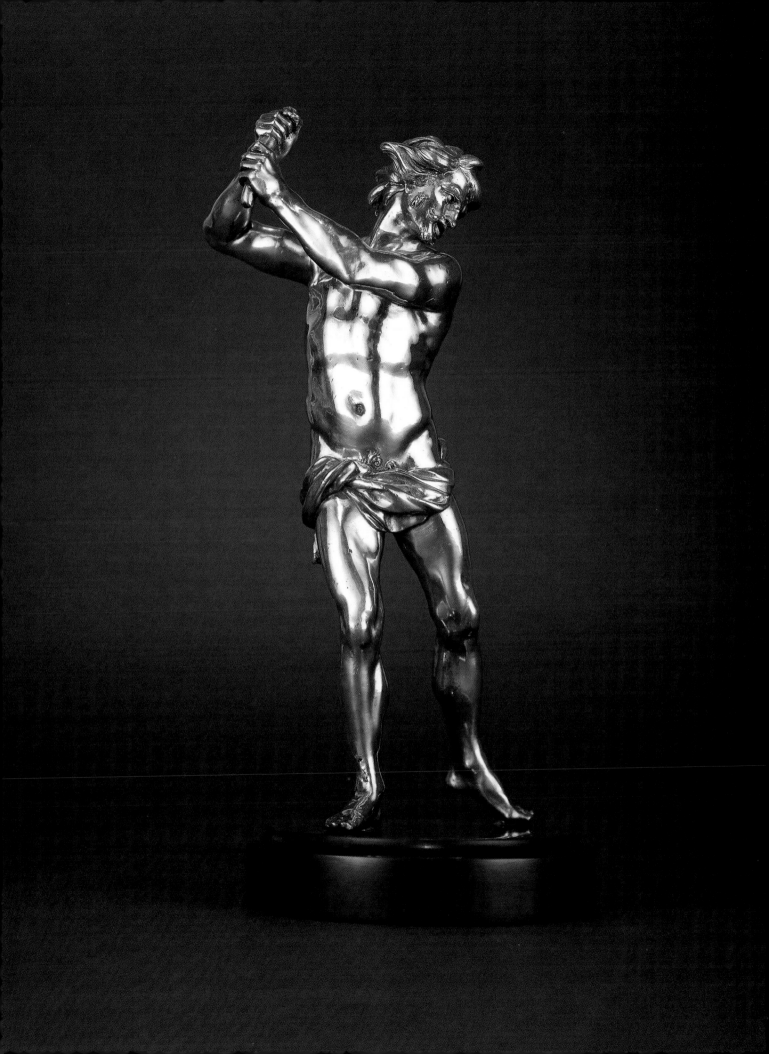

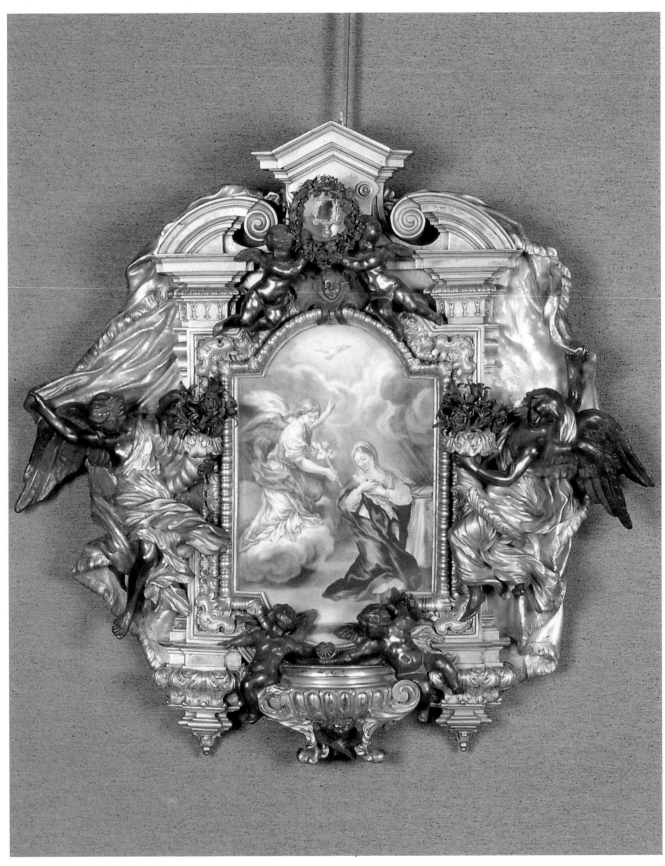

IV. Urbano Bartelesi, *Holy-Water Stoup*; gilt bronze and silver. Versailles, Château

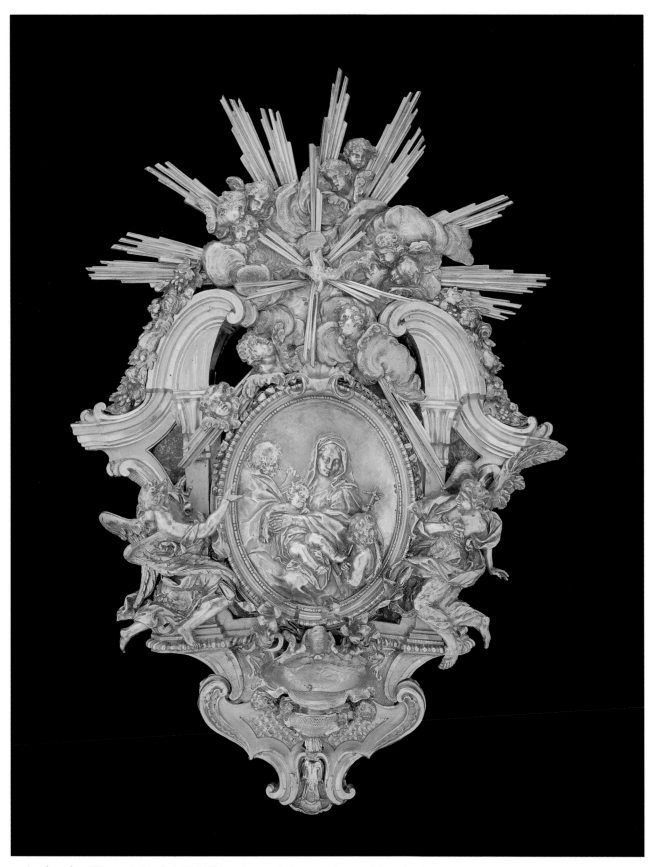

v. Attributed to Giovanni Giardini, *Holy-Water Stoup*; gilt bronze, silver and lapis lazuli. Minneapolis Institute of Arts

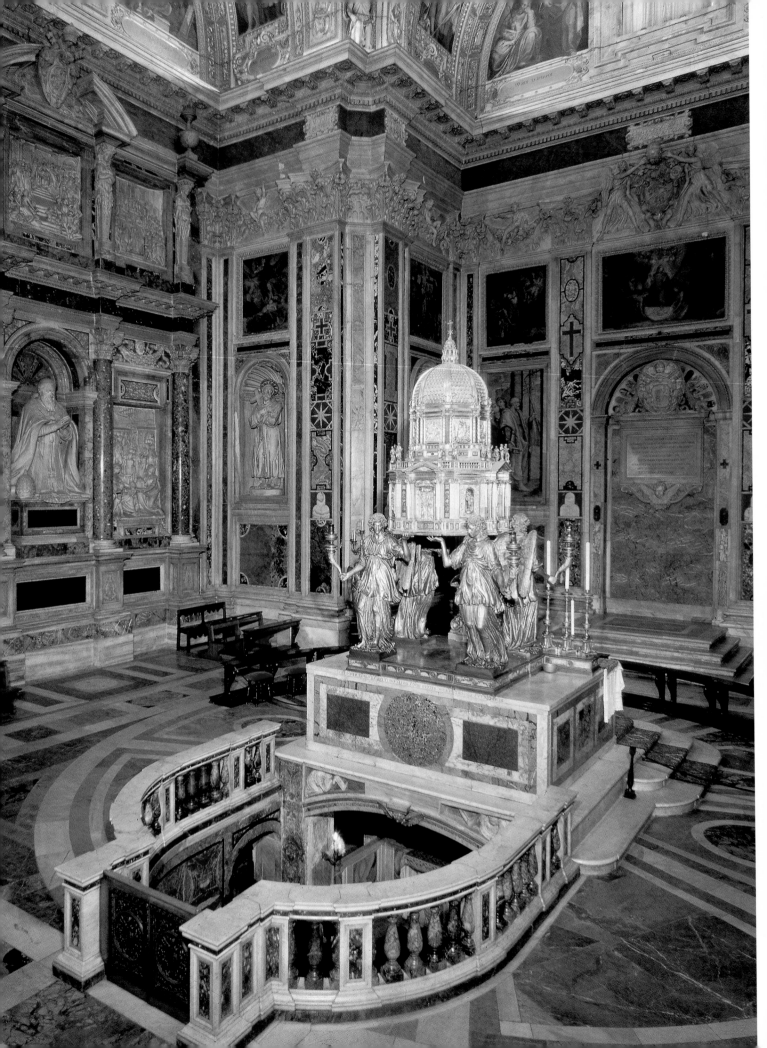

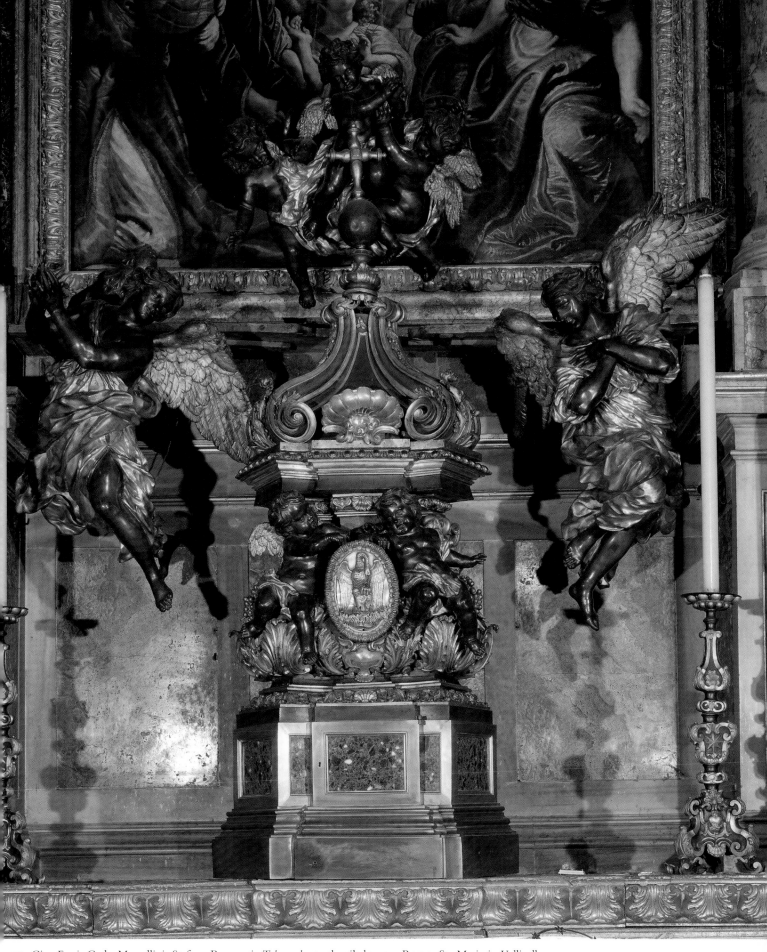

VII. Ciro Ferri, Carlo Marcellini, Stefano Benamati, *Tabernacle*; partly gilt bronze. Rome, Sta Maria in Vallicella

VI. (*facing page*) Sebastiano Torrigiani and Ludovico del Duca, *Tabernacle*; gilt bronze. Rome, Sta Maria Maggiore

VIII. Gaspare Morone, annual medal of 1659, representing the Quirinal Palace on the reverse; silver. Biblioteca Apostolica Vaticana

IX. Giovanni Giardini and Pietro Paolo Gelpi, *Reliquary of the Holy Cross*; porphyry, gilt bronze, silver, crystal, gems, and paste. Vienna, Geistliche Schatzkammer

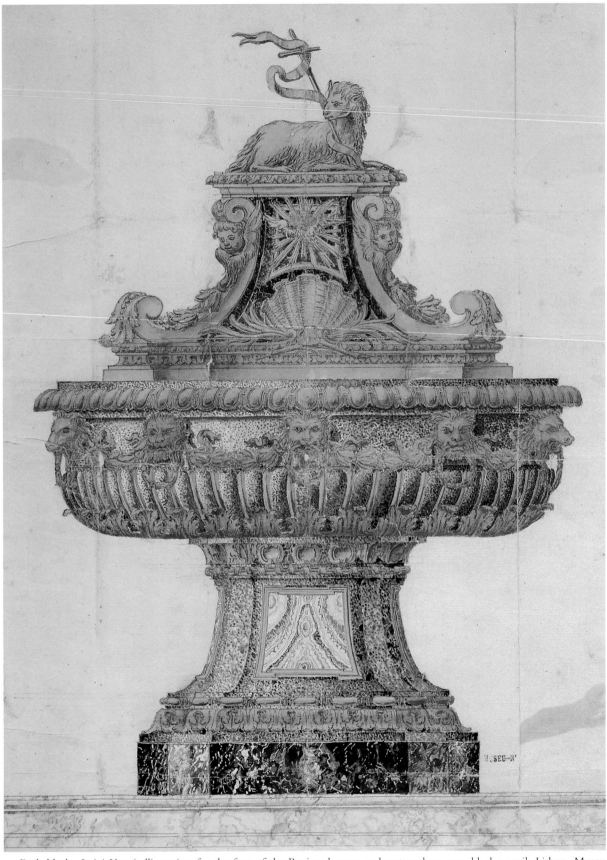

x. Probably by Luigi Vanvitelli, project for the font of the Patriarcale; pen and watercolour over black pencil. Lisbon, Museu
Nacional de Arte Antiga

XI. Detail of the chapel of the Holy Spirit and St John the Baptist; gilt bronze and marble. Lisbon, St Roch

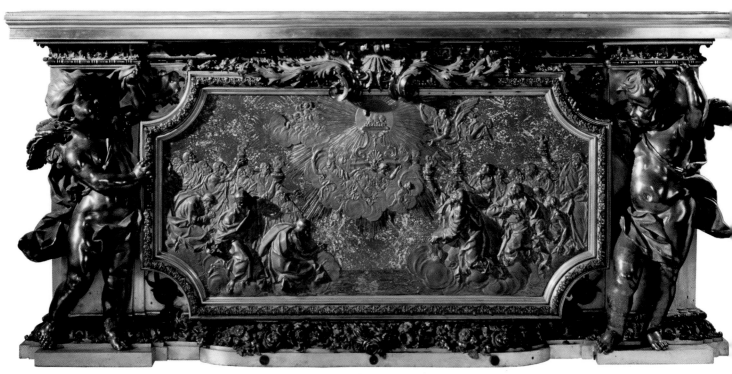

XII. Antonio Arighi, on the models of Agostino Corsini and Bernardino Ludovisi, *Altar-frontal*; silver, gilt bronze and lapis lazuli. Lisbon, Museu de São Roque

Appendices

The Tabernacles of Jacopo del Duca

There are four references to tabernacles by Jacopo del Duca based on Michelangelo's design which have been associated with that in Padula. Although much of the material was assembled by Paola Barocchi in her commentary on Giorgio Vasari, *La Vita di Michelangelo* (IV, Milan/Naples, 1962, pp. 1784–9), it is worth doing so again. Not only are there some references she overlooked, but it is necessary to consider more clearly how the references relate to each other, and to the tabernacle in Padula.

(1) Vasari recorded that Michelangelo was to make a tabernacle for Sta Maria degli Angeli, which was to be executed by Jacopo del Duca (Giorgio Vasari, *Le Vite de'più eccellenti pittori scultori ed architettori*, ed. G. Milanesi, Florence, 1881, p. 261; G. Vasari, *La Vita di Michelangelo*, ed. Paola Barocchi, I, pp. 111–12).

(2) Jacopo del Duca wrote to Lionardo Buonarotti on 15 March 1565 to say that he was making a tabernacle at his own expense on the designs of Michelangelo, that it was half done, and was to be 20 *palmi* high (about 4.5 m.) (G. Daelli [publisher], *Carte michelangioleschi inediti*, Milan,) 1865, pp. 64–5; G. Vasari, *La Vita di Michelangelo*, ed. P. Barocchi, IV, pp. 1785–6; Sandro Benedetti, *Giacomo Del Duca e l'architettura del cinquecento*, Rome, 1973, Documentary Appendix A, p. 446).

(3) Previously, on 3 January 1565, Jacopo del Duca and Jacomo Rochetto 'scultori et pittori' signed a contract with Marco Antonio Hortensio, who was to put up the sum of 1,400 *scudi*, to make a tabernacle on the designs of Michelangelo, but there is no description, or indication of its dimensions in the contract, which is concerned with the financial details of what was evidently a speculative undertaking. The designs were in the possession of del Duca; they said it could be done within a year ('sia possibilie in spatio d'un anno al più tarde fare sia del tutto finito et perfetto'). Rochetta should be paid 5 *scudi* per month for his needs, and when the tabernacle was sold Hortensio should be repaid (ASR, Notai del Tribunale dell'Auditor Camerae, Riccobonus, vol. 6248, ff. 203–97r; printed in Benedetti, *Giacomo Del Duca*, Appendix C: Tabernacolo Farnese, pp. 453–5; Armando Schiavo, *La Vita e le opere architettoniche di Michelangelo*, Rome, 1953, pp. 287–92).

(4) In 1574 there was an attempt to interest Philip II in a large tabernacle on a marble pedestal of 10 *palmi* (2.23 m.) made by various masters in several pieces, which would be available for 2,500 *scudi*. To cite only the principal features described: the octagonal base enclosed a spiral staircase by which one could enter the octagonal tabernacle. This would be lined with wood, partly gilded, and contain eight lamps, which, on feast days would allow the populace to see the sacrament through its eight windows of about 3 *palmi*, and this view would not be obscured by statuettes of eight Evangelists 3 *palmi* high placed before the windows. Within one window would be a crucifix, and within that opposite it the Risen Christ. Below the windows would be sixteen scenes of the passion, each of over 1 *palmo*, with figures almost in the round. Each face would be ornamented with two columns, bearing an entablature, above which would rise the second part of about 4 *palmi*, composed of eight compartments with sixteen capitals supporting the cupola, and in four of these compartments were statuettes of the seated evangelists, also 3 *palmi* high. The cupola was also to be octagonal, but with its faces smooth, and above it a baluster of 5 *palmi* on which was a ball of 3 *palmi* supporting an Ascending Christ of 4 *palmi*. The marble base was the narrowest part, enclosing the stairs; it was also octagonal, and decorated with four angels the size of a child, bearing on their shoulders the instruments of the passion, and on the other four faces seated statuettes of the Apostles, of the same height as those above, so as to complete the series of the twelve Apostles, the four Evangelists, and the cross, with the Resurrected Christ within one of the windows. The whole would be further decorated with seraphim, flowers, roses, and especially vines and grapes cast from nature, and wheat symbolising the sacrament. Once finished it could be heighted with gold, and the rest patinated with green varnish (Jean Babelon, *Jacopo da Trezzo et la construction de l'Escorial*, Paris, 1922, pp. 315–16 and pp. 134–8; Vasari, *La Vita di Michelangelo*, ed. Barocchi, IV, pp. 1786–7).

Richard Kagan has kindly drawn my attention to letters dating from 1573–7, preserved in Madrid in the Archivio de la Embajada de España circa de la Santa Sede, now in the Ministerio de Asuntos Exteriores in Madrid (leg. 19, int. 4, ff. 318–29). Photocopies of these papers, which are partly

burned and in places illegible, were most kindly supplied to me by Jose Buces and Elisa Carolina de Santos. They include, besides a description of the tabernacle (ff. 3204–321r) which, with the exception of a couple of words, corresponds to that published by Babelon, an unsigned and undated letter (f. 319) certainly from Spain, stating that, among the parts to be completed were the windows and the gilded panels within, suggesting that the marble pedestal could well be made in Spain using Spanish marble or other stone, and other workmen, and raising the possibility that, if Jacomo del Duca came to Spain, he might also be employed on other work. A letter from Hortensio of 1 February 1573 (f. 322) is concerned with the financial arrangements. Another undated letter (f. 324) appears to be from del Duca (though it is not in his hand); it opens with a reference to the Sicilian usage of not using words such as '*vendere*' or '*comprare*' when discussing figures of saints or works created for the honour of God, but it is, in fact, also concerned with what remains to be paid. It appears that Hortensio (who is referred to in person, and not his heirs) has already been paid, or at least that such a payment has been agreed. It is this letter which gives the first name of 'Jacomo Rocchetto compagno pro tempore in detta opera' , and it ends with the statement that 'io mi contento di tutto quello che posso pretender de mie fatiche per detto conto farne un presente a V.S. Reverendissima' . Finally, there is a letter from del Duca, in his own hand, beginning 'Sopra il negotio del Tabernacolo di Mitallo fu concluso tra Mo' Sr de Torres et Jaco de Duca Siciliano, che detto mo' Sre accordasse per una parte li heredi de M. Marco Anto hortensij et per un altra parte come apparisce, se douessero pagare certi debbiti quale ascendino alla somma de scudi 419. del Resto quanto alla mia manifactura me remetteno a quel tanto che paresse di dar me sua Sria Rma et questo per quanto a tutta quella parte del opera fatta fino al presente.' It continues concerning the agreement that workmen will be provided to complete the work if necessary, and also the materials still required, and that if Jacomo comes to Spain he will be given 30 *scudi* per month.

Letters concerning this proposed purchase from the Spanish archives in Samancas were published by Rudolf Beer in the *Jahrbuch der Kunsthistorischen Sammlungen des Allerhöchsten Kaiserhauses*, XII, 1891, pp. cxcvii–cxcviii (nos. 8470–3). The first three from Juan de Çuniga (Juan de Zuñiga), from 1577–

8, are all in support of the tabernacle. It was in various parts by various masters, but he had had it assembled; he quotes the favourable estimate of del Duca's capacity given by Bishop de Torres, who said he was even better as a founder and sculptor than an architect, and, in a further letter, Zuñiga says that Cardinal Granvella agrees with this, though he would have preferred Giambologna or Nicolò Pippi. However, the final letter is from the Escorial, dated 14 August 1578, giving the opinion of the king: he had shown the drawings to Fray Antonio de Villacastin and to Juan de Herrera, who considered 'que aun no se offrece, donde pudiese estar bien este tabernaculo, y que assi seria poco necesario'. It was Herrera himself who was finally to design a tabernacle for the Escorial, to be made by Jacopo da Trezzo (these letters are summarised in Babelon, *Jacopo da Trezzo*, pp. 135–6).

It is certain that 3 and 4 refer to the same tabernacle, which could well be identical with 2 (which was very possibly based on 1), even if the claim that 2 was done at Jacopo's own expense is incorrect, since he had already signed the contract with Rochetto and Hortensio.

This cannot be associated with the tabernacle in Padula of 2.20 m., since the measured parts come to at least 20 *palmi* (4.46 metres), and these exclude the cupola, as well as the connecting architecture, not to mention the marble pedestal. Since the Padula tabernacle has the grid-iron of St Lawrence on its dome, it must have been made, or at least adapted, specially for the church; although the grid-iron would have been an equally suitable emblem for the church of St Lawrence at the Escorial, the description of that offered to Philip states that the dome was to be plain.

However, it may well be that the octagonal form of the Padula tabernacle was inspired by Michelangelo's project, and the intention that this Michelangelesque tabernacle should be patinated green and heightened with gold may well have influenced the colouring of Lodovico del Duca's tabernacle for Sta Maria Maggiore. It would seem virtually certain that the scenes of the Passion used at both Padula and Rome were based on those of this Michelangelesque project, and the fact that those were to be 'mas alta que un palmo' confirms that those in Padula were subsequently extended. As for the figures, these cannot be directly related, since those offered to Spain were 67.9 cm.

APPENDIX I

The Ciborium of Sta Maria Maggiore

Archivio Segreto Vaticano, Archivium Arcis, Arm B, vol 7, ff. 126–33v

[f. 125] Conto del Tabernacolo
[f. 126] A di p.º di Apli.ˢ 1590

Stima fatta per noi sottoscritti Eletti periti, à stimare tutta l'opera del Tabernacolo, et angeli che lo sostengano posto nella Capella del S.ᵐᵒ Presepio à S.ᵗᵃ Maria Maggiore tragittato di metallo di ordine di N.S. Papa Sisto Quinto fatto per mano di piu mastri à tutte sue spese eccetto il metallo, perche il metallo è tutto della R.ᵈᵃ Cammera, come qui sotto si vede alli suoi luoghi, à m.ʳᵒ per m.ʳᵒ et partita per partita, et Essendo stato chiamato Io Antonio da faenza da Monsig.ᵉ Ill.ᵐᵒ della Cornia et Cavalier fontana per parte di N.S., et per la parte delli m.ʳⁱ è stato chia mato m.ʳᵒ Paolo Tornierj et havendo noi visto et ben considerato tutta la d.º opera di d.º Tabernacolo et Angeli che lo sostengano et tutte le sue spese et manifattura giudichiamo come qui sotto si vede. E p.ª

La parte che tocca à ms. Bastian Torrigiano il quale ha gettato li quattro Angeli con le sue ale, et cornocoppij

P.ᵐᵃ per haver fatto doi Modelli di creta dell'angeli qual'hanno servito per formarlo di gesso et poi gettarli dentro la cera per gettarli poi di metallo qual 2. modelli anno servito per tutti 4. fatti giusti come stanno hoggi tragettati di metallo montano insieme------------------------------------s.200-

[f. 126v] Per haver fatto sopra d.ᵗⁱ modelli le 2. forme di gesso qual'hanno servito per tutti quattro come di sopra insieme tutti 2. con il gesso------------------------s.120-

Per haver renettato di cera tutte 4. le d.ᵗᵉ figure di d.ᵗⁱ angeli con lale et 4. cornecoppij insieme--------------------s.130-
Sommano insieme tutte le sopra et rietroscritte 3. partite--s.450-

Per il getto di d.ᵗⁱ 4 Agnoli

Per lib. 1000. incirca di cera qual si addoperò per far tutti li 4. Angioli di cera et attaccarli li suoi condottj et getti –
E piu per la fattura d'haver gettati d.ᵗⁱ Angioli con detta cera à pezzo à pezzo et haverli messi insieme insieme et fatte

le base et giustate tutti quattro li d.ᵗⁱ angioli accio potessero reggere giustamente il Tabernacolo –

E piu spesa di ferramenti per haver fatto 4. grade per fabricarli sopra le forme con 4. pali di d.º ferro quall' arivano sopra le teste dell'angeli con molti altri ferri attorno che passavano le forme per il traverso per tenere il maschio fermo al suo luogo –

E piu la fattura di d.ᵗⁱ maschi con la spesa del gesso et altre terre per d.º maschio –

E piu la fattura per haverli attaccato li suoi condotti et getti di cera in varij et diversi modi come sie [sic ?] visto –

E piu la spesa della cimatura et terre composte per haver fatto le forme dalla banda di fuora –

[f. 127] E piu la fattura di haver fatto d.ᵗᵉ forme et armate con spiagge et filo di ferro

E piu la spesa d'haver riacommodato la fornace per cocere le forme à guisa di quelle con che si cocono li mattoni –

E piu per haver calate le forme in d.ᵃ fornace con argani con haverli messi li mattoni et tevole rotte per riempire il vano tra una forma et l'altra

E piu spesa di legna per haver cotto d.ᵗᵉ forme et fosso il metallo et haver gettato l'angioli

E piu la fattura d'haver desotterrati d.ᵗⁱ Angioli et haverli tirati fuor della fornace con largani et haverli levato le forme cotte da dosso et tagliato li condotti et getti et serrato li busi delli ferri et finalmente haverli renett.ᵗⁱ et cond.ᵗⁱ à S.ᵗᵃ Ma.ʳⁱᵃ Mag.ʳᵉ et messe inopera con molte altre spese che ci sonno andate

Considerato tutte le sopra d.ᵗᵉ partite del getto fatto dad.º m.ʳᵒ Bastia.º Torrigiano come di sopra sie scritto dichiamo et giudichiamo meritare s.ᵈⁱ dumila quattrocento di moneta dico --s.2400-

Io antonio Gentili da faenza hiamato da Monsiniore Ill.ᵐᵒ Dalacornia e dal Siniore cavaliere fontana per la parte de N.S.ʳᵉ o stimato come disopra e soto scrito de mano propria –
 Io antonio Gentili sopradeto mano propria

Io pauolo tornieri per la parte di mastro bastiano torigano et m. benedeto efilizano sopra deti ostimato come di sopra
 Io pauolo tornieri mano propria

[f. 127v] Stima dell' indoratura messa à mordente delli 4. Angioli di metallo che reggeno il tabernacolo con suoi ale et cornecoppij et una fascia nel fond.º del Tabernacolo che corre attorno attorno per di fuora et n.º16. figurette E p.ª

Per l'indora.ra delli 4. Angioli d.ti grandi messi à d.º Mordente come si vede con la spesa di d.º oro monta------- ---s.240-

Per l'indora.ra de 4. cornecoppij de divitie che tengano in mano d.ti Angioli con loro et fattura sti-----------------s.8-

Per l'indora.ta et oro di una fascia la. ¹/₂ p.mo nel fondo che gira intorno sti-------------------------------s.4-

Per l'indora.ta di n.º 16. figure et oro per indorare montano--s.19-20
 s.271-20

Somma insieme tutta la sopra d.ª indoratura come di sopra monta s.di ducento settantuno b. 20. dico----------s.271-20-

Io ludovico de duca chiamato da Mon.S.r Ill.mo della Cornia et dal Caval.r fontana per la parte de N. S.re ho stimato come di sop.ª et sotto scritta

Io ludovico del duca mano pp.ª

Io bastiano guerra pitore perito per laparte di Ma.ro ferante condopuli indoratore o stimato come disopra sicontiene io bastiano mano proprio

[f. 128] M. Lodovico Duchi ha fatto tutto il Tabernacolo

E p.ª ha fatto il fondo del Tabernacolo qual resta sotto attaccato à una borgia di metallo con 4. teste de cherubini con 4. monti et otto rami di pere et foglie con 8. cartelle qual fanno hornam.to al d.º fondo con 4. stelle incima alli monti

E piu 8. Colonne Ioniche scanellate con otto piedistali et 8. base et 8. capitelli con 4. frontespitij et 4. teste de cherubini dentro á d.ti frontespitij con 4. porticelle con suoi frontespitij rotti et cartelle et altri ornamenti con le sue 4. porticelle dentro istoriate di rilievo con suoi pilastri scanellati et lisci con suoi piedistalli et busi et Capitelli con 4. nicchie con 4. figure dentro di d.te nicchie con suo architrave fregio et cornice che corre intorno intorno con suoi resalti et festoni et altri hornamenti che correno intorno al primo giro et sopra il cornicione vi sonno li balaustri con suoi piedistalli et cornice et n.º 16. figurette sopra d.ti piedistalli tutti gettati di metallo con molti altri ornamenti

Il tamburo di dentro è di Rame qual ha fatto fare et pagato il d.º m. lodovico

Il 2.º Giro vi sono n.º 16. colonne composite lavorate à foglie con sue base et capitelli et zoccoli sotto d.te base et cornice che corre attorno fra un Zoccolo et l'altro et sopra d.te Colonne vi sonno archi.vi [f. 128v] fregio et cornice con suoi resalti et tra una Colonna et laltra vi sonno n.º 8. Istorie di rilievo delli misterij della passione di N.S. Jesu Cristo con suoi adornamenti intorno à d.te Storie con suoi resalti sopra la cornice con 16. puttini tutti tondi con suo tamburo dentro di rame

E piu la sua Cuppola sopra fatta à scaglioni con sue costole di rilievo et lanternina sopra con sua Cupoletta monte stella et Croce et tutte queste sopra d.te cose sonno gettate di Metallo con haver fatto li suoi modelli et forme et gettate et renettate

et accommodate messe inopera insieme ogni qualunque cosa con il sopra piu del Costo del rame piu del metallo mettendo insieme quel manco che costa il ferro che vie dentro stimiamo tutto insieme la d.ta valuta di d.to-----------s.3280-

E piu il d.º m. lodovico à speso li sottoscritti denari per il costo di un tamburino di albuccio qual sie messo dentro al ['tramezzo' cancelled] tabernacolo per defesa dell'ummidità et per essere il vaso grande per restrengerlo monta---------s.4-

Per una Cassetta di accipresso dove star à il S.mo Sagramento---s.2-

Per una ca.na et mezza di veluto cremesino per fodrar d.ª cassetta monta--------------------------------s.14-40

Per chiodetti indorati per d.ª cassetta n.º 200 fatti à rosette---s.2-

Per la trina d'oro dentro à d.ª cassetta----------------s.3-

Per la fattura di mettere il veluto et trina dentro alla d.ª cassetta di accipresso--------------------------------s.-50
 s.3305-90

[f. 129] Per far portare il d.º tabernacolo in piu partite in d.ª Chiesa di S.ta Ma.ª Mag.re-----------------------------s.6-

Per la fattura delli ponti per mettere sopra il d.to tabernacolo in piu partite et per indorare monta--------s.6-

Per haver fatto metter loro macinato lavorato à gottesche sopra il verde di d.º tabernacolo qual fa ornamento-----s.15-
 s.27-

Somma insieme ogni qualunque cosa fatta dal d.º m.ro lodovico del d.to Tabernacolo insieme s.di tremila trecentotrentadoi b. novanta dico-----------s.3332-90-

Io antonio Gentili dafaenza hiamato da monsiniore ill.mo delacornia e dal Siniore cavaliero fontana per laparte de N.S.re ostimato come disopra e soto scrito de mia propria mano

Io antonio Gentili sopra deto mano propria

Io pauolo tornieri per laparte de mastro lodovico deduca ostimato come di sopra esoto shrito de mano propria·

Io pauolo tornieri sopra deto mano propria

[f. 129v] Stima dell'indoratura fatta à d.º Tabernacolo à fuoco in foglie fatto da m.ro Gio: Piccardi indoratore

Per l'indora.ª di una laterna con suo lanternino cuppoletta monti stella et croce monta----------------------------s.50-

E piu per lindoratura di tutta la Cuppola fatta à 8. fa.te à scaglioni---s.120-

E piu per l'indoratura di 16. costole sopra della Cuppola grande---s.32-

E piu per lindora.ª à fuoco di 16. Zoccoletti dove stanno l'angioli attorno della Cupola----------------------s.12-80

E piu per lindoratura de tutte le cornice delli quadri et quelle che girano attorno dalla Cuppola sino alla balaustra --s.90-

E piu per lindoratura di n.º 16. colonne attorno della Cuppola con li suoi capitelli base et piedistalli---------s.110-

E piu per lindoratura à fuoco dell'altro ordine cioue di n.º 68. balaustri con sue cornice sotto et sopra-----------s.32-

E piu per lindoratura di n.º 8. piedistalli doppij nelli cantoni della Balaustrata------------------------------s.15-

E piu per lindoratura di otto piedistalli sempij nella d.^{ta} balaustrata---s.8-

E piu per lindoratura de 4. frontespitij al piano da basso dell'ordine Ionico---s.48-

E piu per lindoratura di 4. cherubini sotto alli frontespitij--s.6-

E piu per lindoratura de 4. cherubini overo dell'architravi con le cornici che sporgeno in fuora dove posano li frontespitij--s.48-

E piu per lindoratura di 4. porte con sue cornice dalle bande et sopra con cherubini et Epitafij con il nome di Jesù---s.60-

s.631-80

[f.130] E piu per lindoratura delle cantonate piane di qua et di la alle porte doppo alle Colonne con suoi Capitelli base et piedistalli ---s.100-

E piu per lindoratura di 8. colonne canalate con li suoi Capitelli base et piedistalli-----------------------------s.110-

E piu per lindoratura della cornice sotto alla balaus.^{ta} che gira attorno per scontro all'architravi et frontespitij con 4. festoni--s.70-

Per lindora.^{ra} di 8. pilastri scanalati con capitelli base et piedistalli--s.100-

E piu per lindoratura di 4. nicchie dove son le figure-s.48-

E piu per lindoratura de tutte le cornice dalle nicchie in giù---s.40-

E piu per lindora.^{ra} del fondo con la stella in mezzo et borchia attaccata al fondo------------------------------s.20-

E piu per lindoratura di 4 cherubini nel d.º fondo---s.100-

E piu per lindoratura delli monti stelle rami de pere scartocci e coro.^e---s.80-

s.668-

Sommano insieme tutti le sopra et rietroscritte partite dell' indoratura di d.^{to} tabernacolo fatta d'oro in foglio messo à fuoco monta s.^{di} mille ducento novantanove b. 80 dico s.1299-80- qual spesa à fatta fare m. lodovico Duca da d.º m.^{ro} Gio: Piccardi et pagata da d.º m. lodovico dico--s.1299-80-

Io m.^{ro} marcho di Berttinelli chimatto da monsig.^{re} Ilustisimo della Corgnia et dal S.^e cavalere fonttana per la parte de N.Si.^{re} ho stimato come di sopra ett sotto schritto demano propria

Io mastro marcho di Berttinelli mano propria

Io M.º Giovanni Docci per la parte di m.º Gio Pichardi Indoratore ho stimato come di sopra et sottoscritto de mano propria

Io M.º Giovanni docci mano propria

[f.130v] Sommano li modelli delli 4. angeli forme di gesso et renettatura della Cera monta------------------------s.450-

Somma la manifattura del getto di d.^{ti} 4. angeli qual'ha fatto m. Bastiano Torrigiano----------------------------------s.2400-

Somma la mettitura dell'oro à mordente sopra d.^{ti} 4. angeli ale, et cornocoppij sonno----------------------------s.271-20

Somma tutta la spesa delli angeli s.3121-20-

Somma la spesa fatta in gettare tutto il tabernacolo rami cassetta di legname velluto et altre cose come quì à dietro si vedono sonno---s.3332-90

Somma tutta lindoratura fatta et messa attorno à d.º Tabernacolo in foglio à fuoco qual'ha fatto m. Lodovico Duca sonno---s.1299-80

Somma tutta la spesa del Tabernacolo s.4632-70

Somma sommata insieme tutta la spesa dell'angeli et Tabernacolo s.^{di} settemila settecento cinquanta tre b. 90 dico--s.7753-90-

Havendo noi rivisto il presente conto di lavori e spesa di nostro espresso ordine fatta da Bastiano Torrigiano nelli 4. Angeli e da lodovico Duca nel tabernacolo posto sopra detti Angeli nella capela del Presepio in S.^{ta} Maria [f.131] maggiore, come alle restroscritte partiti si contiene et havendo il tutto fatto rivedere, misurare, epesare, laqual spesa ascende alla somma di scudi settemila settecento cinquantatre e baiocchi novanta riduciamo detto conto a s.^{di} seimila settecentocinq.^{ta} tre ['b. 90.' added above] et intanto lo saldiamo e per la detta somma di s.^{di} 6753.90 dichiaramo creditor nostro e della nostra Camera li detti Bastiano Torrigiani e lodovico Duca all'incontro di quello che devono per denari in più partite havuti d'ordine nostro, e Comandiamo al R.^{mo} Camerlengo, Tesoriere e Chierici della nostra Camera, che in ogni tempo di tanta somma per li sopradetti lavori contenute nelle restroscritte partite debbano tener creditore li predettti Bastiano e lodovico senza darli molestia alcuna di verificar le partite del sopradetto conto, poiche a noi costa esser vere, e percio doversi ammettere, e cosi ordiniamo, non ostante che questo conto non sia stato dato egiurato in Camera, ne saldato con la solennità della bolla della fel. mem. di Pio 4. nostro predecessore nemeno la presente nostra dechiaratione di saldo non sia registrata in Camera conforme all'altre costitutioni del d. nostro predecess.^{re} di registrare infra certo tempo queste o simil gratie alleq.^{li} e a tutte l'altre cose che facesser in contrario di certa nostra scienza eplenitudin di potesta per questa sol volta deroghiamo.

Dal nostro Palazzo Ap.^{lo} li 15 d'Aprile 1590.

Sixtus PP V.

[f.131v] Conto del Tabernacolo

Noi Bastiano Turigiani et Ludovico del Duca per il retro scritto conto delli Agneli et tabernaculo ci contentiamo della retro scritta reduttione abiamo recevuto li sop.^a detti scuti semilia settecento cinquantatre et b. 90. de moneta in piu mandati fattoci da Nostro S.^e in diversi tempi et perche restiamo interamenti sodisfatti per tal conto pero abiamo fatto la presenti seconda quietanza ultra alle altre prime fatte sotto le mandati d.^{tti} [?] sa presenti sarra sotto scritta di nostra propria mano questo di [blank] di magio 1590

Io bastiano torisano mano propria
Io ludovico del Duca mano propria

[f.132] [Accounts for the metal used by Torrigiano for the statues of *Sts Peter* and *Paul*, and for the grille in Sta Maria Maggiore]

[f.132v] E piu il d.º m. Bastiano à consegnato il metallo delli 4. Angeli con le ale et cornocoppij che reggeno il Tabernacolo in d.^{ta} Capella del S.^{mo} Presepio li quali ogni

cosa insieme pesorno lib. 6002. segli accresce per il calo che fa il metallo à fonderlo à ragione de lib. 8. per cento che sonno lib. nº 480. che in tutto fanno---------------lib. 6482-

Il metallo della ferrata antiscritto <u>lib. 1357-</u>

Somma insieme tutto li metalli lavorati consegnati da m. Bastiano Torrigiano sonno--------lib. 8019-

Il metallo che dº m. Bastiano ha havuto nelle mani sonno lib. 11425. del quale ne ha dato lavorato con il calo in diverse partite come di sopra lib. 8019. à tal che resta nelli manj à dº m. Bastiano lib. tremila quattrocentosei il quale è da consegnare alla Rᵈᵃ Camera----------------------lib. 3406

Io Bastiano torisano aferme quanto di sopra

M. lodovico Duca Tragittatore il qual ha fatto il tabernacolo in dᵃ Capella

Gli resto nelle mani quando gli se saldò il conto delli Leoni della guglia di S. Pietro et di S. Gio: [in Laterano] come nel dº conto si vede lib. 3865. di metallo il dº m. lodovico à Gettato tutto il Tabernacolo con tutti li suoi ornamenᵗⁱ

[f. 133] Il quale ha pesato lib. 3336. se gl'acresce per il calo del fondere et limare per esser lavori gentili et minuti à ragione de lib. 10. per cento che sonno lib. 333 che in tutto sonno---s.3669

Et lui ha comprato m. lodovico, il fondo, li 2. tamburi di rame, che val più che non vale il metallo pero se valutato tanto il rame comè il metallo per esservi dentro un cerchio di ferro che val manco del metallo à tal che s'e compensato un per l'altro

Somma il metallo che ha havuto il dº m. Lodovico dalla Camera --lb.3865-

Somma il metallo che il dº m. Lodovico à dato lavorato con il calo--lib.3669-

sotrato resta lib.196

A tal' che il dº m. Lodovico resta debitore alla Camera de lib. cento novantasei di metallo dico resta----------lib.196-

Io ludovico del Duca afermo quanto di sopra mano propria

Havendo noi revisto il presente conto delli metalli di nostro ordine consegnati a Bastiano Torrisani e lodovico Duca doppo il saldo fatto alli 4. d'ottobre 1588 che sono lb. 1425. a Bastiano, e lb. 3865 a lodovico predetti come si vede [f.133v] di sopra, e che d'essi metalli ne sono stati messi in opera da Bastiano lb. ottomila diecinove, 8019. col callo fattoli buono, e da lodovico lb. 3669. col callo fattoli buono, negli Angeli, tabernacolo, et altre cose sopranominate per la presente dichiaramo restar in mano delli predetti lb. 3602. cioè di Bastiano lb. tremila quattrocento sei, e di lodovico lb. cento novantasei e per tanta somma lo dichiaramo debitor nostro e della nostra Camera per doverli metter in opra, o restituire secondo che da noi li sarà comandato, non volendo che per li sopradetti metalli pervenuti in man loro sieno obligati a render altro conto, ne gli possa esser data molestia alcuna poiche a noi costa il presente conto star bene e per ciò doversi ammettere, e cosi ordiniamo non ostante che questo conto non sia stato dato e giurato in Camera, ne saldato con la solennità della bolla della fel. mem. di Pio 4º. nostro predecessore, ne meno che la presente nostra dichiaratione non sia registrata in Camera conforme all'altre costitutioni del d. nostro predecessore di registrare infra certo tempo queste o simil gratie, allequali et a tutte l'altre cose che facesser in contrario di certa nostra scienza eplenitudin di potestà per questa volta sola deroghiamo Dal nostro Palazzo Appᶜᵒ li 15. di Aprile 1590.

Sixtus PP V.

APPENDIX II

The Ciborium of Sta Maria in Vallicella

Archivio di Santa Maria in Vallicella, Busta A.V. 16.a.

[f. 149] Spesa del Ciborio, et Angeli di Bronzo nell Altare maggiore aggiunto, e postato di Benamati fonditore.

[f. 149v] Dare

Del Sig.r Stefano Benamati fonditore per la fusa del Ciborio della Chiesa Nova consistente in 2. Angeli Grandi, zoccolo, ò sia Tabernacolo, cinque Putti, et la cornige del Pellicano, et altro etc.

p.ma Per haver ricevuto parte in contanti, e parte per essere stati pagati per d.o sig.r Stefano come per ricevute prodotte dal R. Padre. Acami per gl'atti del Belleti [word cancelled] li 21 8bre 1679 overo etc. riservandosi però di rivedere d.e ricevute che pare non debba essere tanto la somma, et non altrim.te etc. in tutto------------------------------------s.618.85

2.o Per haver ricevuto libre due mila Rame in Lastra per non potere il sud.o Padre Domenico dare li denari, che à baiocchi quindici la lib. conforme se vedeva di quel tempo sono--s.300-

3.o Per haver ricevuto libre quattromila di metallo per la raggione come sopra à baoicchi sedici la lib. senza però pregiuditio del metallo che non poté servire, essendo parte di mala qualità sono in tutto------------------------s.640-

4.o Per haver libre cento sessanta stagno a b. 16 la lib.--s.25.60

 in tutto----s.1584.45

 Havere---s.1986:20¹/₂
 Dare--- s.1584:45
 0401:75¹/₂

E cio senza pregiuditio di maggiore, o piu vera somma, à miglior calcolo et non altrim.te etc.

[f. 150] Havere
Del Sig.r Stefano per il dicontro lavoro di metallo

P.mo per il p.mo Angelo grande come per ricevuta dal S.r Antonio Mannottoli li 5. Marzo 1676 di peso lib.---lib. 523-

2.o per il 2.o Angelo grande per ricevuta del S. Lorenzo Mannottoli li ii Agosto 1676 di peso lib.----------lib. 535-

3.o per il Zoccolo per ricevuta dal Padre Gio. Battista Pascucci 1677 di peso----------------------------lib. 1392-

4.o per uno de cinque Putti per ricevuta dal S.r Vincenzo Brandi li 2 8bre 1677 di peso----------------------lib. 123-

5.o per l'altro Putto per ricevuta dal d.o Brandi li 6 8bre 1679 di peso--------------------------------------lib. 100-

6.o per l'altro Putto per ricevuta dello Sbirro di peso---lib.240-

7.o per il quarto Putto per ricevuta dello Sbirro di peso---lib.250-

8.o per il quinto Putto per ricevuta del d.o Sbirro di peso--lib. 165

9.o per il cornige del Pellicano di peso------------lib. 30-

 in tutto----lib. 3358-

Dalle quale libre 3358 levate libre 405 che pesano due delli tre Putti ultimam.te gettati senza pregiud.o però d'havere ad accommodare in qualche parte che vi sia qualche bugio conforme è solito venire in ogni fusa di metallo, secondo la relatione del 3.o Perito, e non accommodato per che subito gettati il Padre Acami li fece propria autoritate levare dalli sbirri, e farsiti portare ãe, [?] restano lib 2953------lib. 2953

Quali libre 2953 a b. 57¹/₂ la lib. secondo la 3.ª Peritia fanno la somma di------------------------------------s.1687.97¹/₂

Calcolato la lib. 405 delli Due Putti pro nunc e senza pregiud.o d'haverli à accommodare al b. 40 la lib. come dice il Perito sono--s.162

Per lib. 245 di metallo dato all'Argentiero d'ord.e del Padre Acami parte in script. e parte in voce a b. 16 la lib. sono--s.39:20

Per le cere, et altro non meso in opera come dice il 3.o Perito--s.40-

Per ripolitura, e cisellatura della cornige del Pellicano--s.15-

Per il calo del metallo alla lega per lib. 2160 à lib. 6 per cento come dice il 3.o Perito sono lib. 129, e onc. 8. importano--s.22.03

Per le rinetature d'alcune cere come dice il 3.o Perito--s.10-

 1986:20¹/₂

[f. 151] A di 4 Marzo 1681

Essendo che per lite, che verte tra il Molto R.P. Domenico Acami, e Sig.r Stefano Benamati fonditore per l'opera di metallo, e Gettito, che si fà per esporre il Santiss.mo nella Chiesa de R.R. P.P. di S.ta Maria in Valicella, la quale vien fatta sotto la direttione, e disegni del Sig.r Cirro Ferri, e perche nell'esecutione di dett. opera vi sono insorti litigij fra li sud.tti, rispetto di alcune pretese cose, come costa avanti Monsig.r Ill.mo, e Re.mo Caprara Giudice della Causa, dove è la deputatione. Io sottoscritto Carlo Fontana eletto per parte del sud.tto R.P. Acami ad effetto di riconoscere la quantità dell'opera di Metallo fatta dal detto per farne diligente esame con indagarne la stima di un tanto la libra del detto Gettito; onde havendo io quella ben vista, e maturam.e considerata si nelle formature, fatture di cere doppie, et anche gettature simili, come anche alla qualità dell'opera in parte di essa sottile, come anche la parte centinata del zoccolo, piedestalli, e suoi fogliami con cornice basamenti intagliati, e dui Putti con dui Angeli grandi, suo ovato, cartelle, festone, e maniglie, et altro con rinettatura delle cere, e mettitura insieme secondo li modelli, e calo di metallo, et ogni altra pretensione come anche si di Cera, gesso, foco, polve di mattoni e tutto quello, che puol concernere per far d.tto lavoro secondo l'arte, et anche di quanto il d.tto Sig.r Benamati puol generalmente pretendere in tutto, e per tutto; che percio secondo la mia Peritia, e Pratica stimo, e giudico compreso le fatture doppie, che non essendovi, come suole cadere parimenti intelligentemente fatti in altri simili lavori, sarebbe da me stimato meno, ma per le d.tte fatture come sopra, benche non in tutta l'opera, cioè a baiochi quarantadue ½ la libra. In oltre havendo ancora di più fatta particolar recognitione delli tre putti del medemo Gettati per adempimento dell'opera sud.tta visti da me nella bottega del Brandi havendoli Io trovati di tal scompositione, e deformi, Incavati, e stropij, che si rendono Impossibili per servire al proseguimento della d.tta opera con suo bon disegno, et ordinatione, che perciò anche in questo mediante la mi Peritia Affermo, e dico non poter essi servire. Onde secondo la mia conscienza cosi referisco, e stimo questo di 4 marzo sud.tto 1681 in Roma

[word illegible] a b. quaranta due e mezzo la lb.

Io Carlo fontana Perito come sopra m.opp.a [?]

[f. 152. Accounts of the Roman Customs house 1676 for the duty on lb. 6438 of 'rame', submitted on 7 January 1682]

[f. 153v] Conto del R.R.e P.P. di S. Filippo Neri in Chiesa Nova con Gio: Domenico Navona Argentiere

[f. 153] Per haver rinettato la Cornice del Pelicano e saldato in diversi lochi con pezze et haver fatto il nido gettato et aggiustatovi il Pelicano in d.a Cornice importa scudi Dicidotto --s. 18-

E più per le vite che tengono il Pelicano in detta cornice di Argento pesano oncie dua e denari cinque importa scudi Dua e b. 17---s. 2.17

E per la indoratura di d.a ['cornice' cancelled] nido importa scudi uno e b. 80---s. 1.80
 21.97
Ridotto questo conto à quindici scudi--------------s. 15

Urbano Bartalesi

[f. 154r–v. Copy of the original text of Carlo Fontana, from f. 151]

[f. 155] Copia A di 28 Luglio 1681
Io infrascritto terzo perito eletto ex off.o dell'Illustrissimo e Reverendissimo Mons.re Cap.a nella Causa che verte trà il molto R. Padre Dom.co Acami sagrestano della Chiesa Nova di S. M.a in Vallicella, et il S.r Stefano Benamati fonditore, ad eff.o di vedere, considerare, e stimare il lavoro, et opera di Getto di Metallo del Tabernacolo fatto, e gettato dal med.o Benamati per l'Altar Mag.re di d.a Chiesa con disegno, et ordine del Sig.r Ciro Ferri, come il tutto consta per gli atti del Belletti Not.aro AC

Essendo dunq. andata à riconoscere il sud.o lavoro nella sagrestia de PP. della Chiesa nova hò trovato il Tabernacolo ad uso di Piedestallo con il Corpo rilevato centinato, guarnito con fronde e dalle Bande con Maniglioni rampazzi, e foglie d'uva spighe di Grano, e cornice in mezzo, attorno l'ovato del Pellicano, et altro con sua cornice, e Base resaltato con zoccolo sotto attorno il qual Tabernacolo sono doi Angeli grandi del naturale, parte nudi, e parte panneggiati, e tre altri Angeletti, o Putti con pannicini simili, cioè doi avanti al d.o Tabernacolo, et uno s.a in aria, quali non è in d.a Sagrestia, qual lavoro, e getto considerato la sua qualità, e sottigliezza la stimo baiocchi cinquanta sette, e mezzo per ciaschuna libra, compresoci le formature di gesso, fatture di cere doppie mettiture assieme, e guarnitura del Tabernacolo con suoi ornamenti, et ogn'altro lavoro, fattura, fatica, e spesa, che possa esser andata a formare, far di cera gettare, e mettere assieme d.a opera di Metallo

[Dico di più d'haver trovato, e visto doi altri Angeletti, o Putti gettati simili di metallo in una Bottega d'un Argentiere al Pellegrino, quali vanno similm.e nell'opera in aria s.a [f. 155v] il Tabernacolo conforme il disegno del S.r Ciro, quali Putti pretende il P. Dom.co non esser tenuto a pigliarli per esser il getto difettoso, che perciò quando il S.r Stefano Benamati voglia rapezzarli, accomodarli, ridurli, et terminarli simili all'altri li stimo l'istesso prezzo di baiocchi cinquanta sette, e mezzo la libra, et il P. Dom.co è in obligo di pigliarli come l'altri, havendoglieli ordinati, e fatti fare e potendoli se si compiace assegnare Mons.re Illustrissimo il temine di doi, ò tre Mesi à perfettionarli, e con la sicurtà [?] se li renderanno i d.i dui Putti, overo quando il S.re Stefano non voglia finirli, e perfettionarli come ho detto dovrà il P. Dom.co pagarli come hoggi si ritrovano nella Bottega dell'Argentiere à rag.ne di ba: quaranta la libra così stimandoli per le fatture, formature, cere, et ogn'altro lavoro fatto simile all'altri con la considerat.e del getto venuto malam.te, che per accomodarli vi andarebbe gran spesa, oltre il peso grande, e grossezza del metallo diverso dall'altri getti]

Dichiaro però che nel sud.o prezzo di ba: cinquantasette, e mezzo la libra come s.a non vi è compreso la rinettatura delle cere, quando il S.r Benamati l'habbia fatto, ne il calo alla maurea [?] di libre sei per cento solito darsi al fonditore per la lega

Aggiungo doversi pagare al S.r Stefano Benamati tutto il Lavoro dal med.o formato fatto di cera, e non gettato di metallo nè compreso nelli getti pesati, e consegnati alli PP. i

quali lavori fatti di più sono la formatura, e cere fatte delle due Angeli grandi, la formatura [f. 156] e cere fatte di quattro Alette dell'Angeli piccoli con li pannini aggiunti doppo dal S.r Ciro una cera di un Putto fatto la terza volta d'ordine del S.r Ciro, e l'esser andato al Palazzo del gran duca a formare un Braccio per un Putto avanti il Zoccolo d'ordine come s.a con la formatura e fattura delle cere delli maniglioni per farce [?] del Tabernacolo con fronde, e rampazzi d'uva, e spighe di grano, e per l'altre formature, e fatture di cera d'altri rabeschi e foglie fatte per prova per ornam.to del Taernacolo, che non sene andate in opera, che in tutto assieme trà formature, cere, et altre fatture importa s.di 40 di più delli getti detti di s.a, e cosi dico, e riferisco secondo la mia peritia, non solo in q.o ma in ogn'altro migl.r modo havendone per magg.re sodisfazione, e sicurezza della mia conscienza preso parere da altri Periti de getti di metalli, formature, e simili lavori. Et in fede q.o di, et anno sud.o

Gio: B.a Contini Perito come s.a mano propria

APPENDIX III

The Tabernacle of the
Cappella Aldobrandini in Bologna

ASB, Fondo Aldrovandi Marescotti, vol. 230, int. 8, 8 July 1743

. . . Volendo l'Eminentissimo e Reverendissimo Sig.r Card.l Pompeo Aldrovandi adornare maggiormente la di lui Cappella di S. Petronio in Bologna d'alcuni Ornati di Metalli dorati, cioè due Angeloni, Teste di Cherubini, novole, e raggi, et havendo per tal effetto l'Eminenza sua contrattate i d.i lavori per il prezzo di scudi tremila, e settecento con il Sig.e Fran.co Giardoni argentiere, e Fonditore della Rev: Camera Aostolica, e con esso convenuti, e stabilite più, e diverse condizioni, come dalli capitoli sottoscritti sotto li 2: del corrente tanto dell'Eminenza sua, che da d.o S.r Giardoni, quali capitoli si consegnano à me Not.o originalm.te in due foglie per inserirli nel presente Istromento del tenore seguente cioe:

Capitoli, ed obligo da osservarsi da me sottoscritto nell'opera delli Metalli dorati da farsi per la Cappella di S.Petronio in Bologna ordinati dall' Emminentissimo, e Reverendissimo Sig.r Card.l Aldrovandi, à me Fran.co Giardoni Argentiere, Scultore, e Fonditore della Rev.da Camera Apostolica, come qui sotto cioè:

P.o Terminato, che averà il Sig.r scultore il Bassorilievo delli due Angeloni, Teste di Cherubini nuvole, e raggi che vanno attorno li sportelli della Santa Reliquia atteso l'ordine già dattomi da Sua Eminenza Padrone d'incominciar l'opera di metallo mi obligo à mie spese di mandar à prendere dal Sig.r Scultore sud.o li modelli da lui fatti sopra il fusto, e portarli dove si hanno da formar di Gesso.

2.o Che condotto sarà d.o Modello, dove và formato mi obligo formare il tutto à mie spese cioè gesso, uomini, ed ogn' altra spesa, che vi vole per d.a formatura.

3.o Che formato sarà d.o Modello in tutte le sue parti mi obligo à mie spese di gettar tutto di Cera tanto l'Angelloni, come le Teste di Cherubini, nuvole, e raggi da poterle mettere insieme sopra un Fusto di Legno, quale fusto doverà farsi fare da sua Eminenza.

4.o Che messe in opera sopra il sud.o fusto tutte le Cere mi obligo darne subbito parte à Sua Eminenza Padrone, acciò Le veda, e riconosca, e faccia riconoscere tanto dal Sig.r Scultore, come dal Sig.r Architetto, anzi se per avantaggio dell'opera volessero mover qualche cosa del Modello fatto mi obligo di far tutto l'occorrente senza poter pretendere crescimento del convenuto già fatto per vantaggio dell'opera.

5.o Che stabilite ed approvate le cere sud.e, e ben rinettate, e commesse in modo, prometto, e mi obligo gettarle di Bronzo in maniera che ciaschedun pezzo non sia di maggior peso di lib. 250: al più, acciò sia commodo di poter il tutto trasportare in Bologna con somma facilità.

6.o Che stabilite come sopra le Cere sud.e debbono à mie spese farsi le forme, cuocerle, e gettarle di Bronzo di perfetta qualità.

7.o Che Gettato tutto di Bronzo mi obligo di rinettarli, scuoprirli con raspini, e che il tutto sia cisellato con attenzione, e polizia tanto l'Angioli, che Teste di Cherubini, nuvole, e raggi, e che debba essere riconosciuto, et approvato, tanto da Sua Eminenza Padrone, come dal Sig.r Architetto, ò da chi altro à Sua Eminenza parerà, e piacerà.

8.o Che rinettato tutto come sopra mi obligo di comporne insieme tutti li metalli sopra il fusto di Legno, dove prima sono state poste le Cere e dopo di ciò smontarli, e dorarli à Zecchino macinato à tutte mie spese, cioè oro chi vi bisognerci, spese di Mercurio, Grattabuscie acqua forte, spese di uomini, ed ogn' altra spesa, che vi vole per d.a doratura, et il tutto da riconoscersi come sopra, come anche di coprire li sportelli, che devono chiudere la S. Reliquia di Lastre di Rame con suoi requadri di cornici, e raggi, e dorarli à riserva del Lavoro di Ferraro, quale debba restare à spesa si Sua Eminenza.

9.o Parimente mi obligo di dare terminata tutta la sopra scritta opera nel temine di un anno principiando da Giorno mi sarà consegnato il Modello dal S.r Scultore. Riservandomi solo, che per disgrazia, che Dio non voglia venisse male qualche cosa nel gettarsi, mi sia solam.te da sua Eminenza Padrone allongato il tempo, che potesse portare il rifar quello fosse venuto malamente, mà tutto à mie spese, e Danni come sopra.

X. Che dorato tutto mi obligo ricomporlo sopra il suo fusto dove prima era stato e di cera, e di Bronzo con farvi ò occhi, ò codette ò perni di Metallo inginochiati conforme stimerà meglio Sua Eminenza, e Sig.r Architetto, quali occhi ò perni serviranno per fermarli in opera nella Cappella sopra le Pietre.

XI: Che terminato sarà il tutto mi obligo quando Sua Eminenza mi commandasse di assistere, quando s'incaseranno d.ⁱ Metalli per mandarli fuori, acciò restino ben custoditi nelle loro Casse, e non patischino nocumento veruno in particolare il Dorato.

XII: Che per fare dett'opera principiando dalle prime spese di sopra descritte, e tutte l'altre nominate in tutti li altri Capitoli, mi obligo di farla per la somma di scudi tremila settecento. E quelli riceverli cioè al principio dell'opera la quarta parte dell'importo sud.^o, e l'altra quarta parte, quando il tutto sarà gettato di Metallo parimente à piacere di Sua Eminenza L'altra quarta parte quando s'incominciarà à dorare dett'opera à piacere comesopra, e consegnato, e terminato il tutto ricevere il saldo. E per l'osservanza di tutte le cose sud.^e le parti Contraenti obligano le sue beni, et Eredi nella più ampla forma della R.C.A. etc. delli quali Capitoli se ne sono fatte due consimili copie ad effetto di ritenersene una per parte. In fede li 2 luglio 1643.

P. Card.^l Aldrovandi
Fran.^{co} Giardoni

[The document continues with an acknowledgement that Francesco Giardoni had on that day received the model, that he binds himself to execute the contract, and that Cardinal Aldrovandi binds himself to pay him.]

The Virgin and Child for Lisbon

Ajuda, 49. VIII. 29, ff. 62v–6v[1]

Ordinazione della Lamina di Bronzo Dorato venuta con lettere delli 28. Marzo 1745.

Si manda a fare una Lamina ovata di Bronzo dorato giustamente per la grandezza esatta della misura, che stà delineata nella carta inclusa, con tale avvertenza, che non diferenzi cos'alcuna da quello, che si è disegnato nella carta, perche la cornice, in cui si deve collocare stà di già fatta di marmo, e se fosse maggiore non capirà in esso, ne empirà il vanno interiore della medesima essendo minore, per lo che si raccomanda molto queste circostanze avvertendo nel medesimo tempo, che nel farsi il modello si deve considerare quanto possa diminuire nel gettarsi, regolandosi in ciò secondo l'uso, e pratica di simili gettiti, per questa medesima ragione si farà maggiore il modello, ad effetto, che gettato la Lamina sia eguale, e conforme alla sopradetta misura, che si manda.

Deve la detta Lamina rappresentare del maggiore rilievo, che sarà possibile, Nostra Signora à sedere con il Bambino Gesù accostato al Petto dalla parte dritta assiso nel suo seno dando la benedizione con la mano dritta, e tenendo la sinistra sopra di un globo, in cima di cui vi sia una Crocetta, e per maggiore decenza sia la parte coperta con un velo artificiosamente fatto, e questo si avverte, perchè eccelenti Autori fecero detta parte ignuda, e discoperta.

Le Teste di ambedue le dette Immagini saranno del tutto distaccate, et isolate, perchè così richiede il Luogo, che stà sopra di una gran porta, così ancora di tutto l'altro rilievo, e particolarmente come se fosse fuori della Cornice della Lamina la mano dritta del Bambino, con cui dà la Benedizione.

L'altezza, e larghezza della Lamina danno luogo acciò si faccino le teste della misura al naturale, perche la Madonna non si vedrà più che sino al ginocchio in atto di stare a sedere, e questo sarà poco più, o meno, si raccomanda però molto l'essere grande per essere molta la distanza, in cui si hà da vedere.

Le altre azzioni delle sudette Imagini si lasciano al arbitrio dell'Artefice, il fondo della Lamina potrà avere qualche piccolo ornato di architettura con un panno spiegato con arteficio in forma di Cortina, ma che non confonda, e non copra le due Immagini, tutta questa opera deve essere molto ben considerata, e sopra tutta molto bene terminata dal megliore Cisellatore, acciò non si perda nel ripolirla, e lavorarla il buono, che sarà nel suo modello.

Il modello di dª Lamina si ordina, che lo faccia il Sig.ᵣ Gio: Battista Maini, essendosi egli portato molto bene nelli due Angeli S. Gabriele, e S. Michele, e nella Sig.ʳᵃ Isabella Regina d'Ungaria, che fece per la Chiesa di Mafra, e per le altre statue principalmente quella di S. Filippo Neri, che fece in S. Pietro, e non essendo più vivo il d.º Maini, sarà preferito il Sig.ʳᵉ Pietro Bracci, e mancando questi il Si.ʳᵉ Carlo Monaldi, e nuovamente si raccomanda il molto rilievo di Nostra Signora, e del Bambino Gesù, perche nell'altro bassorilievo, che si fece venire da Roma di marmo, fù tanto poco il rilievo, che in qualunque distanza non si conosce, e perche costi con certezza dell'Autore, che farà il Modello della Lamina, si avverte, che esprima il suo Nome con lettera di Rilievo nel medesimo Modello, o nella parte inferiore della Lamina in alcun pezzo di Piedestallo che potrà esservi nel fondo ò campo di essa, anche si avverte, che qualunque delli tre Artefici, che farà il Modello siegua lo stile di Carlo Maratti, o del S.ᵣ Agostino Masucci, avendo essi un singolarisssimo gusto nelle Imagini riferite.

Per il di dietro deve avere la detta Lamina cinque occhi, cioè nel mezzo uno, et a linea retta li altri due nelli lati . . .[2] Questa Lamina sarà tutta intiera, e non composta di pezzi non avérà Tasselli per il cativo gettito nè bughi, e sarà di sufficiente grossezza per evitarsi li detti difetti, sarà dorata con bastante oro, e si averà gran diligenza, che non vi siano macchie manacamento di oro, e che sia tutto eguale con il megliore color d'oro.

La Cassa in cui si manderà deve essere ben forte, e con molte traverse, e per di dentro con molti Baggioli di legno per stare bastantemente ferma, però le teste e li Bracci ch'è il maggiore rilievo devono stare nella Cassa senza toccare in alcuna cosa per non corrodersi ne moversi con pericolo di troncarsi, come succedèe nello ultimo Basso Rilievo di mamo che arrivò con la testa del Bambino Gesù distaccata dal Corpo, per il che molto si raccomanda, che venga tutta la Lamina molto bene involtata prima in Bambace, e poi coperta con retagli di Carta, e panni bianchi raddoppiati molte volte, acciò non possa scrostarsi, osservandosi in tutto la maggiore cautela, che sarà possibile, e si stimerà necessario, et ultimamente si raccomanda, che si faccia con la maggiore brevità, che sarà possibile senza pregiudizio della perfezione dell'Opera della Lamina Sopradetta.

Appendix V

The Virgin of the Immaculate Conception
for Lisbon

Ajuda, MS. 49. VIII. 29, ff. 70–5v, 25 September 1744[1]

Si rimette la seguente istruzione per una Statua della Mad.ª Santissima della Concezione che si manda a fare d'argento dorato, si rimette, acciochè l'eccellente artefice, al quale sarà commessa, metta in opera con ogni libertà quell'idea, che li parerà più propria, grave, e devota, riflettendo però alle circostanze requisiti, colli quali hanno rappresentate li migliori autori somiglianti Imagini nell'esempij che si riferiscono.

La Statua dovrà essere d'altezza di otto palmi Romani, e a misura del palmo costa dalla carta acclusa, acciò che paia d'altezza naturale, vista in proporzionata distanza.

La Statua deve essere tutta isolata, e non aperta nella schiena, acciò possa godersi perfetta da ogni parte, dandosi il caso, che venga [added 'debba essere'] esposta nel mezzo d'una Chiesa, o Cappella senza appoggio.

L'argento, de quale si farà detta Statua, sarà di Carlino, cioè di undici denari, che sono undici parti eguali d'argento finissimo, et una di rame, o lega.

Deve esser gettata in una grossezza competente, respettiva alla sua grandezza, e non deve eccedere la grossezza maggiore mezzo minuto, e nella parti più sottili di un terzo di minuto, e si concede questa conveniente grossezza, perchè si pretende, che la detta Statua sia tutta intiera, e non di diversi pezzi, separando [verbi gratia] la testa, le braccia, e qualche panneggiamento svolazzante, poiche essendo fatti a parte, nell'unirsi, e saldarsi al corpo pole apparire qualche difformità, non incontrando colla vera postura del modello, e molto peggio sarebbe, qualora si facesse di due metà, o di più pezzi, lo che molte volte è successo per la considerazione fatta dall'artefice di abbreviare, facilitare, et risparmiare materia, e tempo, e poi li è successo il contrario, poichè si perde il tempo, si fatica, si strapazza la materia, e quello che è peggio l'opera riesce notoriamente imperfetta; riesce però perfettissima essendo gettata tutta intiera, colli buchetti solam.te causati dalli ferri, che sostengono l'anima, ò maschio di dentro, intorno de quali subito si accresce una striscia della medesima cera, acciò che venga in argento, e serva per turare il buco, incastrandoglisi di sorte col cisello, che resti impercettibile che vi sia stato tal buco.

Per turare i detti buchi possono parimente mettersi in opera perni d'argento della med.ª bontà della Statua, che incastrino nel buco, e poi si ribattono col cisello, questo modo però è meno sicuro, poiche li perni col molto fogo nel saldare qualche rottura, ricocersi, o imbiancare possono smoversi, e uscire dal loro luogo, lo che tutto il perito Artefice saprà considerare, e prevenire; getandosi la detta Statua intiera, si sà che farà grandi crepature, se l'argento si fonderà in forno, ò fornace, come si fonde il bronzo per statue stragrandi, come sono li quattro Dottori della Cathedra di S. Pietro, et ad effetto di sfuggire le dette crepature si avverta, che facendosi il getto in sito o Officina molto spaziosa, possono prepararsi otto, o dieci fucine, e ciasuna con fornello per due, o tre catini, et in ogni catino trenta e più libre d'argento, tutto fuso nel medesimo tempo e disposto con bon ordine, et ad ogni catino destinata una persona, che successivamente uno dopo l'altro votino il proprio catino, finchè sia piena la forma, tenendosi in ordine altri catini d'avanzo, ad effetto che non succeda mancare l'argento, e prevenendo egualmente altre circostanze, che sono proprie dell'arte, si farà perfettamente il gettito, senza valersi di fornace, che in argento credesi, che causarebbe grandi crepature; e siccome la sopradetta disposizione si è praticata alcune volte in opere molto grandi d'argento, et ancora di bronzo, si rappresenta per consiglio sperimentato al perito artefice, ad effetto che la Statua venga tutta intiera, e non giuntata di pezzi, e senza crepature staordinarie; Si danno parimente queste avvertenze, acciò che la Statua sia di una competente grossezza, poichè non si pretende ostentare un eccessivo peso d'argento, e per più che si procuri di farla sottile, essendo gettata, sempre riuscirà molto grossa, e quanto basta per sostentarsi senz'anima di ferro, nè di legno, e però non gli si farà di veruna sorte. – da capo – Si proibisce che la detta Statua si faccia di lastra, o tirata a martello, ancorche in questa forma si farebbe di meno peso, poichè è certo, che qualora non fosse lavorata da un grande disegnatore, ò dal medesimo Soggetto che avesse fatto il modello, mai riuscirebbe così perfettam.te come il modello, nè intera come si pretende.

Il Modello della d.ª Statua lo farà Gio: Battista Maini Scolaro di Rusconi, e se fosse morto questo lo farà Pietro Bracci, et in mancanza di questi Giuseppe Lirone, o Carlo Monaldi. Se però sarà vivo il d.º Gio: Battista Maini, il Modello dovrà farlo lui, senz'altra replica.

Quello delli sopradetti Scultori che farà il modello, per rappresentare la d.ª Statua considerarà tutte quelle che vi sono fatte dalli più celebri Artefici, e quelle, che quà sono a memoria sono le seguenti.

La Madonna della Concezzione di Guido Reni, che stà trà mezzo le nuvole, e di sopra il Padre eterno parimente trà le nuvole li mette le mani sopra le spalle, e per quanto quà ci ricordiamo, ci è una Stampa, che la rappresenta; Del med.º Guido Reni vi è un'altra Madonna della Concezzione a sedere in mezzo profilo, colle mani sopra il petto, colla gloria intorno, et al di sotto quattro Santi in atto di contemplare, venerare, et ammirare; in questa forma le dipinse in un quadro, che dicesi fosse comprato in Roma, e portato in Inghilterra, e vi è una Stampa in rame del med.º fatta singolarm.te da Giacomo Frei 15, in 20 anni a questa parte.

Di Carlo Maratta vi sono tre Imagini principali della Madonna della Concezzione, una dipinta nel quadro ovato dell'Altare di una Cappella di S. Isidoro in Roma, la quale stà in piedi sopra un globo, col Bambino Gesù nelle braccia, il quale con una Lancia che tiene in mano ferisce il Serpente che stà sotto de piedi della Madonna, e la detta Lancia nella parte superiore hà una piccola traversa che forma una Croce balaustrata; Un'altra nella medesima azzione, ma però senza Bambino in braccio, e colle mani al petto, e molto ricca con manto graziosam.te svolazzante; E un altra dipinta nella Cappella del Cardinal Cibo nella Chiesa del Popolo a sedere sopa le nuvole. . . . Nell'Altar maggiore della Chiesa de' Cappuccini di Roma a Piazza Barberini vi è un Quadro di Lanfranco. . . . In occasione della lavanda che si fa la Settimana Santa nel Palazzo Vaticano, in una Stanza di quel quarto fù veduto un quadro di Pietro da Cortona, nel quale stava dipinta la Madonna della Concezzione in piedi, sotto i piedi della quale vi era un Dragone, e sopra della med.ª il Padre eterno colle braccia aperte. . . . Nel volta della Chiesa del Gesù di Roma trovasi dipinta l'Imagine della Concezzione, sotto i piedi della quale vi è un Dragone, e sopra della med.ª il Padre eterno colle braccia aperte . . . lo che tutto è opera di Gio: Battista Gaulli celebre Pittore.

D'altre celebri imagini della Concezzione quà non ce n'è notizia, potranno bensì esservi d'autori insigni; Quelle che si sono allegate colla loro positura, et accompagnamento sono d'autori, i quali non ostante l'esser stati così celebri nella pittura, e nel disegno, con tutto ciò non facevano cosa alcuna senza prima consigliarsi con Uomini dotti, e pij, per sapere da loro in che forma più propria potevano esprimere ciò che volevano dipingere, trattandosi d'ogetto si alto, e misterioso.

Si rifletta, che rappresentadosi l'Imagine della Madonna della Concezione in aria sopra globo, o nuvole, o mezza luna,

l'hanno dipinta ancora a sedere, come hà fatto Maratti, e Guido Reni, nesuno però l'hà rappresentata in ginocchioni.

In un disegno fatto in Roma della Madonna della Concezione, si è veduta l'Imagine della medema in piedi sopra un Cuscino riccamente ornato colli suoi lavori etc.

Oltre di quello che si è detto rispetto all'idea, disegno, modello, e gettito della Statua, si da ancora qualche istruzione sopra la fattura.

La veste dovrà essere cisellata con cisello fosco, cioè non lustro, nè aspro, il qual in lingua Francese Tedesca e fiammenga si chiama *matte*, e non è granito, nè spruzzato. Il manto sarà liscio, raspinato, e pulito colla pomice, ma non brunito, atteso che la differenza di queste due superficie bastantemente si distinguono trà di loro, senza che col brunito sia confuso l'artificioso delle pieghe a causa dell'eccessivo lustro. Il velo che averà in testa sarà più gentile nella forma che è differente dalla seta la tela di lino.

La detta Statua sarà dorata tutta con oro sufficiente, principalmente nelle parte di maggior rilievo, che sono quelle che più si consumano nel moversi, e sarà bene il dorarsi due volte principalm.te le dette parti di maggior rilievo, poichè siccome è lavoro di gettito, e non hà niente di brunito, no v'è pericolo che si levi nè si sguagli l'oro, ancorche vada molte volte al foco; in questo caso, doppo esser stata dorata la prima volta si grattabusciarà per dorarsi nuovamente e si deve avvertire, che la Statua non riuscendo tutta dorata la prima volta, e che abbia delle mancanze, dovranno le medeme ritoccarsi, ad effetto di esser sicuro, che tutta l'opera sia coperta d'oro prima che venga dorata la seconda volta.

Le dodici Stelle, colle quali hà da essere coronata la detta Statua, devono essere parimente dorate molto bene, e inbrunite.

Si raccomanda sopra tutto, che il colore sia del più perfetto che si mette in opera in Roma e non di colori superficiali di Germania, nelli quali entrandoci il solfo col tempo si fa negro.

Tutte le riferite circostanze si sono esposte, ad effetto di far considerare all'insigne artefice quanto si desidera che l'opera riesca della maggior perfezione che dà l'arte, e che sia lontana [added 'fugga'] d'ogni stravaganza, et affettazione, non intendosi però con questo di legarli le mani nell'operare, lasciandosi tutta la libertà al di lui ingegno dal quale si sperano meraviglie. Lisbona 25 7bre 1744.

NOTES

Chapter 1: Introduction

1. However, it should be noted that Antonia Nava Cellini mentions the pair of great candlesticks from which this figure comes in her book *La Scultura del Settecento* (La Storia dell'arte in Italia), Turin, 1982, p. 226; so far as I am aware this, and her companion volume *La Scultura del Seicento*, published in the same year in the same series by UTET, are the only books on Italian baroque sculpture to include chapters on silversmiths' work. Nicholas Penny, in his *Catalogue of European Sculpture in the Ashmolean Museum, 1540 to the Present Day*, Oxford, 1992, includes as cat. 247 the Genoese silver basin (together with its ewer, cat. 248) which is directly related to the basins discussed here in chapter 5.

2. C. Bulgari, *Argentieri, gemmari e orafi d'Italia; Parte prima – Roma*, Rome, 1958–9, I, p. 481.

3. See above, pp. 63–5.

4. Marilyn Aronberg Lavin, *Seventeenth-Century Barberini Documents and Inventories of Art*, New York, 1975, pp. 393–4. The 1626–31 inventory of Cardinal Francesco Barberini senior's collection includes 'Una statuetta di metallo di due palmi incirca, che rappresenta la carita con tre putti, e sotto i piedi lavaritia, con un pedistallo d'hebbano nero alto un palmo inc[irc]a [ca. 45.68 cm.]' (*ibid.*, p. 76, no. 45). In the inventory of 1633–6 the height is given as 'un p[al]mo e mezzo' (*ibid.*, p. 255, no. 969). This and all other inventories omit any mention of *Avarice* in what was, presumably, the same statuette (1649, *ibid.*, p. 116, and 1679, *ibid.*, p. 356). The subject of *Charity and Avarice* is sufficiently rare that it is very tempting to associate this with the only other known example of such iconography, the model which exists in both bronze and terracotta, commonly attributed to Giuseppe Mazzuoli, who was born in 1644 (Ursula Schlegel, *Staatliche Museen Preussischer Kulturbesitz. Die Bildwerke der Skulpturengalerie Berlin, Band I: Die italienischen Bildwerke des 17. und 18. Jahrhunderts*, Berlin, 1978, cat. 21; Sergei Androsov *et al.*, *Alle origini di Canova; le terracotte della collezione Farsetti* [exibition catalogue], Palazzo Ruspoli, Rome, and Ca' d'Oro, Venice, 1991–2, cat. 49). However, the attribution to Mazzuoli appears reasonably convincing, and certainly it would be difficult to date the bronze or terracotta before the middle of the century. So what was Francesco Barberini's bronze?

5. BAV, Arch. Barb., Computisteria, vol. 297 (Libro Mastro of Cardinal Carlo Barberini), p. 70 (22 October 1674). Carlo Barberini's bronze is presumably that listed in his inventory of 1692–1704 (Lavin, *Barberini Inventories*, p. 450, no. 547).

6. ASV, Arch. Boncompagni Ludovisi, Protocolo 611, no. 12; the 'Stanza dei Metalli' is described on pp. 18–22. For other collections of bronzes by Giambologna of the early seventeenth century, see Zygmunt Waźbiński, 'I Bronzetti del Giambologna nelle collezione romane e ambiente del cardinale Francesco Maria del Monte', in *Musagetes. Festschrift für Wolfram Prinz*, ed. R. G. Kecks, Berlin, 1991, pp. 323–34.

7. Arch. Cap., Arch. Urb., Sez. XLIV, protocolo 10 (Not. A.C., Cesare Colonna). See further chapter 2, note 51.

8. That of Moretti, of 1690, is in ASR, Not. Trib. A.C., Laurentius Bellus, vol. 919, ff. 929–1111r; that of Lorenzani, of 1712, in Arch. Cap., Sez. LVII, Protocolo 20 (Not. del Borgo Domenico Angelo Seri), unfoliated. One might also note that Pietro Paolo Avilla had a collection of over forty-five sculptures, but while thirteen are described as of terracotta, one of ivory and one of 'metallo', in most cases the medium is not specified (inventory of 1657, ASR, Not. Trib. A.C., Lollius, vol. 3873, ff. 619–23v, 644–8).

9. The inventory of 1798–1800/1801 published by Giuseppina Magnanimi ('Inventari della collezione romana dei principi Corsini. Parte II', *Bollettino d'arte*, serie VI, anno LXV, no. 8, 1980, pp. 73–114) is often vague about subjects, but many bronzes from the collection are on view in the Galleria Corsini in Rome.

10. See *The Twilight of the Medici. Late Baroque Art in Florence, 1670–1743* (exhibition catalogue), Detroit and Florence, 1974, cat. 25, 26.

11. The will was opened on 10 June 1746. See ASR, 30 Not. Cap., Uff. 34 (Notai del Borgo; Antonio Seri), vol. 258, ff. 776–7v, 789r.

12. Montauti's inventory is in ASR, 30 Not. Cap., Uff. 34, vol. 259, ff. 1–8v, 39–46v; the contents of his studio are on ff. 41v–2v.

13. Ulderigo Medici, *Catalogo della Galleria dei Principi Corsini*, Florence, 1886, p. 140, no. 479; Scott Schaefer and Peter Fusco, *European Painting and Sculpture in the Los Angeles County Museum of Art*, Los Angeles, 1987, p. 147. Estimated by Antonio Vendetti at 400 *scudi*, it was four times as expensive as the large group of the *Wrestlers* (Fig. 3), valued at 100 *scudi*; other groups were mostly valued at 60 *scudi*, and single figures at 40 to 50.

14. On the various names given to this group see Francis Haskell and Nicholas Penny, *Taste and the Antique*, New Haven/London, 1981, pp. 291–6. Although it bears the 'P.C.' stamp of the Corsini collection, it is the only one of these copies after the antique not specifically identifiable in the Corsini inventory (assuming that the *Venus* is the 'Donna' paired with the 'Favo' [sic, for 'Fauno']). For the *Venus and Adonis* and the *Ganymede* see J. Montagu, 'Antonio Montauti's "Return of the Prodigal Son"', *Bulletin of the Detroit Institute of Arts*, LIV, 1975, pp. 15–23, figs. 8 and 6.

15. Compare the case of the bronze reduction of the *Ildefonso Faun*, long accepted as the work of Soldani (*The Twilight of the Medici*, cat. 73), and now proved to be by Giuseppe Piamontini (Sandro Bellesi, 'L'Antico e i virtuosismi tardobarocchi nell'opera di Giuseppe Piamontini', *Paragone (Arte)*, XLII, no. 497, 1991, p. 27).

16. Published in Klaus Lankheit, *Florentinische Barockplastik*, Munich, 1962, p. 229. Lankheit also quotes another source which claimed that he lost 'tutti i suoi marmi, e bronze, e studi, e altri suoi arnesi' (*ibid.*, p. 186), but it seems that this must have been an exaggeration.

17. The little bust of Paolo Giordano Orsini, formerly regarded as his work (Rudolf Wittkower, *Gian Lorenzo Bernini*, 2nd ed., London, 1966, cat. 36a, pp. 203–4), has been shown to be by the medallist Cormanno (Gisela Rubsamen, 'Bernini and the Orsini Portrait Busts', *Abstracts of Papers Delivered in the Art History Sessions: 63rd Annual Meeting, College Art Association of America, January 22–25, 1975*, Washington, 1975, p. 92).

18. See J. Montagu, *Roman Baroque Sculpture: The Industry of Art*, New Haven/London, 1989, p. 122, and note 81, p. 211, with earlier literature.

19. See above, note 4. For the six known casts of this model (one of which is in the Barberini collection) see Michael P. Mezzatesta, *The Art of Gianlorenzo Bernini* (exhibition catalogue), Fort Worth, 1982, cat. 2, 3, 4, figs. 17–19.

20. See Mezzatesta, *The Art of Gianlorenzo Bernini*, cat. 5, 6, and fig. 24; Valentino Martinelli (ed.), *Le Statue berniniane del Colonnato di San Pietro*, Rome, 1987, p. 26, fig. 34.

21. The bronze is in a private collection, paired with a similar cast of the *St Agnes* model; see Martinelli, *Le Statue berniniane del Colonnato*, p. 26, fig. 35. For the figure of *St Catherine* on the colonnade, see *ibid.*, p. 102.

22. Sold Christie's, 16 December 1986, lot 36; at 36.5 cm it is approximately the same size as the casts of *St Agnes*.

23. See François Souchal, 'La Collection du sculpteur Girardon d'après son inventaire après décès', *Gazette des beaux-arts*, LXXXII, 1973, p. 62; it is described on René Charpentier's engraving of Girardon's *Galerie* as 'David en cire du Cavalier Bernin'; other works are there described as 'par', or, in the case of most of his terracottas by du Quesnoy, 'modelé par'.

24. Jules Guiffrey, *Inventaire général du mobilier de la couronne sous Louis XIV (1663–1715)*, Paris, 1885, I, pp. 68–9.

25. Giovan Pietro Bellori *Le Vite de' pittori, scultori e architetti moderni*, ed. E. Borea and G. Previtali, Turin, 1976, p. 300. This cast in the collection of the Prince of Liechtenstein is 66 cm. high, and paired with a cast of the *Mercury*. For a full bibliography see the entry by Olga Raggio in *Die Bronzen der Fürstlichen Sammlung Liechtenstein* (exhibition catalogue), Frankfurt am Main, 1986, cat. 6; see also the essay in the same catalogue by Brita von Götz-Mohr, 'Der neue Umgang mit der Antike: Merkur und Apollo von François Duquesnoy', pp. 87–95.

26. Bellori, *Le Vite de' pittori*, p. 295.

27. 'Un altro che sedendo con la tazza e 'l cannellino in mano enfia la bocca, soffiando globi di spuma, come sogliono i fanciulli' (*ibid.*, p. 295).

28. These casts, according to Bellori, were 'rinettati da Francesco [du Quesnoy] medesimo' (*ibid.*, p. 301). For the terracotta see Lavin, *Barberini Inventories*, p. 360, no. 186.

29. '. . . in far modelli di putti, figurine, teste, crocifissi ed ornamenti per gli orefici' (Bellori, *Le Vite de' pittori*, p. 402); 'Ma nel riconoscere la sufficienza e 'l valore di questo maestro, chi non compatirà la sorte sua e della scoltura, quando egli consumò il piú bel tempo e 'l fiore dell'età e dell'ingegno senza operare, passando i giorni nel far modelletti di creta e di cera, e non essendo riputato atto a lavorare il marmo' (*ibid.*, p. 417).

30. See J. Montagu, *Alessandro Algardi*, New Haven/London, 1985, cat. L.8, 8.C.10.

31. Bellori, who believed the model to be by du Quesnoy, says that casts were circulating in both media, without specifying for which the model had originally been made (Bellori, *Le Vite de' pittori*, pp. 301–2). On the question of authorship see Montagu, *Alessandro Algardi*, pp. 315–16. The long-lasting popularity of this model is proved by the existence of a drawing from the workshop of Giuseppe Valadier (1785–1817) reproducing the Christ and the flagellator from the left of the group (implausibly placed at the right, so that he appears to be attempting to swat an invisble fly) while a kneeling figure is binding rods at the left; see *Valadier: Three Generations of Roman Goldsmiths. An Exhibition of Drawings and Works of Art* (exhibition catalogue, by Artemis group), London, 1991, cat. 62. It is quite possible that the Valadier family workshop, which was active from the early eighteenth century, was also responsible for some of the many orthodox casts of Algardi's group.

32. Montagu, *Alessandro Algardi*, cat. 104, pp. 394–5.

33. 275 × 224 cm. See Laura Meli Bassi *et al.*, *Disegni dei Ligari dalle collezioni del Museo Valtellinese di Storia e d'Arte*, Sondrio, 1982, cat. 24, p. 59.

34. J. Montagu, 'Antonio and Giuseppe Giorgetti: Sculptors to Cardinal Francesco Barberini', *Art Bulletin*, LII, 1970, pp. 297–8.

35. For his moulds and plaster casts for Philip IV of Spain see Montagu, *Roman Baroque Sculpture*, p. 226.

36. Federigo Alizeri, *Guida illustrativa . . . per la città di Genova*, Genoa, 1875, p. 240; Santo Varni, *Ricordi di alcuni fonditori in bronzo*, Genoa, 1879, p. 48. On 24 April 1986 Christie's sold a *Mercury* after Giambologna, inscribed 'Copia del Mercurio posto nel Giardino di Medici in Roma/Tragettato di Bronzzo Tutto d'vn pezzo da Horatio Albritio Romano l'anno 1624'.

37. This cast was exhibited at the Heim Gallery in London in 1982 ('Seven Centuries of European Sculpture', no. 16). The inscription, which is only partially legible, reads 'A.m.t.X Copia di M. arelio pio posto a Campidoglio . . . /di bronzo fatto di modello da Horatio Albrizi Romano . . . '. It is 73 cm. high, and came from the Trivulzio collection in Milan. A cast of Giambologna's *Neptune* from the same source, and probably also by Albrizi, had been exhibited by the Heim Gallery in the summer of 1966, no. 46.

38. See Souchal, 'La Collection du sculpteur Girardon', nos. 51 and 178.

39. For Mochi and Guidi see Montagu, *Roman Baroque Sculpture*, pp. 62–4.

40. Pen and brown ink over black chalk, heightened with white, on brown paper; 39.8 × 26.3 cm. This drawing was included in *17th Century Art in Europe* (exhibition catalogue, Royal Academy), London, 1938, no. 417; it was then in the collection of Arthur Hobhouse, and I have been unable to ascertain whether it still belongs to the same owner.

41. On this altar see Montagu, *Roman Baroque Sculpture*, pp. 78–83, with references to earlier literature. The payments for this work are recorded in ASV, SPA, Computisteria, vols. 652 and 653 (unfoliated); they run from 19 December 1656 to 11 September 1657. After the unfinished cast had been shown to the pope in July 1657, it was completed and taken to the church in November. It may be noted that one payment of 60 *scudi* made to

Cosimo Fancelli 21 October/6 November 1656 was listed as 'a bon conto del modello e forma del quadro della S^ma Trinita' (vol. 652), but it is clear that Luna made the mould used for the cast.

42. ASV, SPA, Computisteria, vol. 653; Bolina's order was made on 25 January 1657, and passed for payment on 26 January.

43. Luke, 22.19–20; see also Matthew, 26.26–28, Mark, 14.22–24.

44. Carlo Borromeo, *Instructiones Fabricae et Supellectilis Ecclesiasticae*, first printed in 1577. The first book, which contains his instructions for the tabernacle as chapter 13, is reprinted (based on Achille Ratti's edition) in Paola Barocchi, *Trattati d'arte del Cinquecento*, III, Bari, 1962 (relevant pages 22–4). An English translation is provided in the doctoral thesis of Evelyn C. Voelker (Syracuse University), *Charles Borromeo's* Instructiones Fabricae et Supellectilis Ecclesiasticae, 1577. *A Translation with Commentary and Analysis*, Ann Arbor, 1977, and my references will be to that translation.

45. Giovanni Artusi in all probability made the moulds in which Santi Loti cast this reduction of Algardi's great relief of *The Encounter of Pope Leo the Great and Attila* (see Montagu, *Alessandro Algardi*, cat. 61.D.1.C.1; *idem*, 'Un Dono del Cardinale Francesco Barberini al Re di Spagna', *Arte illustrata*, IV, 43/44, Sept.–Oct., 1971, pp. 42–51).

46. Emilio Rufini, *S. Giovanni de' Fiorentini* (Le Chiese di Roma illustrate), Rome, 1957, p. 60.

47. '...un bel basso rilievo di rame dorato disegno dell'Algardi, con un cornice d'argento' (ASR, FSV, 614 [unfoliated], letter of 24 January 1674).

48. In Orazio Spada's comments on the cases of goods sent to his son, the nunzio Fabrizio, in Paris, he described the contents of one as being from Tamburone, 'e dentro vi sono modelli e forme da gettare in arg^to o rame' (ASV, Segreteria di Stato: Francia, 435, f. 220). This is rather disturbing evidence that Italian models might also have been cast in France.

49. See chapter 3, p. 56.

50. Montagu, *Roman Baroque Sculpture*, p. 210, note 60, referring to Giacinto Gigli, *Diario Romano*, ed. G. Ricciotti, Rome, 1958, p. 235.

51. See Zenaide Giunta di Roccagiovine, 'Argentieri, gemmari e orafi romani', *Atti della Accademia Nazionale di San Luca*, N.S. VI, 2, 1962, pp. 12–13; Salvatore Fornari, *Gli Argenti romani*, Rome, 1968, p. 156.

52. Giunta di Roccagiovine, 'Argentieri, gemmari e orafi', p. 9. On this equestrian figure, see now Valentina Gazzaniga, 'La Vita e le opere di Fantino Taglietti...', in Alberto di Castro, Paolo Peccolo, V. Gazzaniga, *Marmorari e argentieri in Roma e nel Lazio tra Cinquecento e Seicento*, Rome, 1994, pp. 234–6, pp. 221–36.

53. See Ségolène de Dainville, 'Maison, dépenses et ressources d'un Nonce en France sous Louis XIV, d'après les papiers du Cardinal Fabrizio Spada', *Mélanges d'archéologie et d'histoire*, LXXXII, 1970, p. 969.

54. See the letters of Orazio Spada to Fabrizio, ASR, FSV, 614 (unfoliated), esp. 22 February 1674.

55. *Ibid.*, 14 March 1674, 15 March 1674. On the attribution of the figures, see Dainville, 'Maison, dépense et ressources', p. 968.

56. ASR, FSV, 614, 20 January 1674. Maratti had confirmed that the king appreciated 'statue basi rilievi, urne e vasi d'alabastro ò porfido'; on 22 January 1674 Orazio visited Maratti 'à vedere il pensiero che ha fatto per il piede e coperchio di nostro vaso d'alabastro per dargli figura più nobile' (*loc. cit.*). The handle broke and the cover cracked in transport, but they were re-

paired by a stone-carver in Paris (ASR, FSV, 634, pp. 349, 357, letters of Fabrizio Spada to Orazio, 12 and 18 July 1674). There are many references in these letters to the porphyry table, for which Fabrizio had a foot carved in wood, as well as interesting instructions on how to freshen up the painting, which should on no account be varnished.

57. ASR, FSV, 614. Originally Orazio had thought of keeping these relics at his country estate of Castel Viscardo (*ibid.*, letters of 28 February, 23 March). It may be noted that relics of the same two precious garments were among the most highly regarded relics of St Peter's (BAV, Arch. Capitolari S. Petri in Vaticano, MSS. Varie 13 [Raffaele Sindone, 'Circa gli altari de le relique della Basilica Vaticana], unpaginated, 'Ordine che si tiene di mostrare al popolo le Sac. Reliquie nella feria 2. di Pasqua'). Orazio Spada obtained authentications for both relics; that of St Joseph's cloak was among the miscellaneous relics of saints, and it is not stated who received it, but possibly it was included in the 'gran Reliquirario d'ebano con reliquie dentro beniss^me agiustate, con fiorami di fuori d'argento, e alle Cantonate con Angeli d'Argento dorati, e riporti simili' (ASV, Segreteria di Stato: Francia, 435, f. 210).

58. 'A Vrbano Bartalesi Argentiero s.353 m^ta . . . , cioè s.350 per un Lavoro di Rilievo di Rame dorato et argento con angeli 2 grandi dalle bande con cornucopie con fiori, 2 piccioli che regono una corona di fiori dentro la quale è un Reliquiario, e 2 altre da piedi sopra un Vaso per Aqua Santa, s.1.20 per arg^to fatt^a e indorat^ra dove hà da collocarsi la reliquia, e s.1.80 per anconelli d'arg^to per la scattola —s.353' (ASV, Segreteria di Stato: Francia, 435, f. 46; There are other copies of this payment, e.g. ASR, FSV, Arm. G. 993 [13.G.3º], p. 9, no. 73, 15 March 1674).

59. See the 'Avvertimenti sopra l'Inventario delle Robbe mandati à Mons.^r Nuntio di Francia (ASV, Segreterio di Stato: Francia, 435, f. 219r–v): 'N.º 52: Q^to ornamento è piacciuto assai. Il disegno è di Ciro Ferri allievo di Pietro di Cortona, il quale hà q^te disgratie, che per quanto s'intende non è in stima trà francesi, mà senza ragione, però non occore nominarlo. Fecè fare q^to lavoro il Card. de' Medici per regalare (dice l'Argentiere la Reg^na d'Inghilterra) mà io credo più [219v] per l'Arciduchessa d'Inspruch che gli era parente, ò altri di casa d'Austria. Li Cornucopia che sono in mani à due Angeli servivano per Candelieri, mà perche non è parso che stano bene seci sono messi de' fiori, che riempiono meglio. Nel festone che è in Cima và collocata la Reliquia del Velo della S^ma Vergine, che è in un Cerchio d'argento trà due Cristalli, e si manda dentro una scattolletta à parte sigillata, la quale si deve aprire alla presenza di testimonij, et immediatam^te reporla alluogo dove ha da stare, e sigillarla accioche non possa esser' aperta sinò nella med^a maniera.' He contines with instructions on how to fix the relic, which was sent in another case, and attach its authentication.

60. See the previous note.

61. ASR, FSV, 634, p. 374, letter of Giacinto Asevolino, Fabrizio's maggiordomo, 27 July 1674.

62. Giuliano Briganti, *Pietro da Cortona, o della pittura barocca*, Florence, 1962, fig. 281, and pp. 266–7.

63. See Montagu, *Roman Baroque Sculpture*, pp. 84–90.

64. See Maria Giannatiempo, *Disegni di Pietro da Cortona e Ciro Ferri dalle collezioni del Gabinetto Nazionale delle Stampe* (exhibition catalogue), Rome, 1977, cat. 117. In fact, Ferri's authorship had been suggested by the curator at Versailles, Béatrix Saule, without knowing the documents.

65. BAV, MS. Barb. Lat. 9900. I am grateful to Marc Worsdale for

bringing this volume to my attention. The drawings were evidently made for Cardinal Carlo Barberini.

66. *Ibid.*, f. 7r; 31.7 × 22.4 cm, brown ink and grey wash, apparently over pencil. The inscription reads 'alto palmi 3⅘ Li capifochi con tutti[?] li suoi finim.^ti palletini molle tirabrace forcina sofficeto etc. lb. 88'.

67. *Ibid.*, f. 9; brown ink and brown wash, 26.9 × 19.7 cm.

68. *Ibid.*, f. 44; pencil and brown wash, 48.5 × 37.5 cm. A much rougher drawing on f. 42 for what was probably the same vase (though the handles are different) shows a variant treatment of the pedestal, with olive-branches replacing the fluting.

69. BAV, AB, Indice II, 2695; this also includes accounts for the making of a brazier (begun by Michele Sprinati, who died in 1665), which may well correspond to the drawings on Fig. 17, and a perfume-burner and two candlesticks made for Cardinal Carlo Barberini by Gamberucci; however, while we are told what they weigh, and also what silver was melted down and given to the silversmiths, there are no descriptions. Payments for the brazier can be found in Carlo Barberini's 'Libro d'Entrata e Uscita, 1664–8' (BAV, AB, Computisteria, vol. 314); rather surprisingly, Gamberucci was still receiving 'a conto' payments for 'Due vasi d'argento grandi' in 1676 (BAV, AB, Computisteria, vol. 297 [*Libro Mastro* A.I of Cardinal Carlo Barberini], 16 January 1674–9, January 1676, p. 66). But the cabinet-maker 'Jacomo Erban' [Erman?] was paid 320 *scudi* for 'due Piedi stalli d'Ebano . . . per li dui Vasi grandi d'Argento' on 31 December 1674 (*ibid.*, p. 70).

70. BAV, Archivio Barberini, Indice II, 2696 (b); black ink, 26.5 × 40.5 cm. (to border). The brazier is quite similar to the more elaborate one drawn in BAV, MS. Barb. Lat. 9900, f. 28r.

71. BAV, MS. Barb. Lat. 9900, f. 12r; brown ink and grey wash over pencil, 40.8 × 27.5 cm. The inscription reads 'Disegno che deve restare in mano del S.^r Card Carlo Barberini. L'ornam. del quale s'é obligato fare il b.[?] Michele Sprinati Argentiere come dalla poliza fatta', and is signed by Francesco Santini, Carlo Barberini's maggiordomo, and Sprinati. On the verso is written 'Ornam.^to della Cornice d'argento fatto per lo specchio donato al Conestabile etc.'.

72. BVA, AB, Computisteria, vol. 312, 'Entrata et Uscita' of Cardinal Carlo Barberini, 1660–1, pp. 54 right, 57 left.

73. Carol Togneri has kindly printed out for me all references to mirrors in the long Colonna inventory no. 77 of 1714–16, copied by Eduard Safarik for the Getty Provenance Index. In it is the following description: 'Un specchio dj luce dj miusura palmi quattro, e tre per alto con cornice, cioé battente dj rame dorato, et attorno putti, festonj, fiori, e Cartelle d'Argento con suo Cordone dj seta rossa con fiocchi grossi numero tre di seta, et oro con sirena d'Argento alta un palmo in Circa . . .'. Although the mirror in the drawing is 3 *palmi* wide, it is considerably more than 4 *palmi* high, and the siren would have measured more than 1½ *palmi*. However, single pieces of glass of such size were extemely rare (most large mirrors were made up of several pieces of glass) so that the identification remains tempting.

74. Inscribed 'Romanelli per il Car. Carlo Barberin'; this drawing is stuck to a page in the first of the two Talman albums from the collection of Rudolf von Gutmann sold by Sotheby's in London, 2 April 1993, lot 96, no. 9.

75. BAV, AB, Computisteria, vol. 83, *Registro dei Mandati* of Cardinal Francesco Barberini Senior, 1649–54, f. 237v, no. 2099, of 3 December 1653; a previous payment was made on 4 August, f. 220v, no. 1960. Brandi's mace weighed 24 Roman pounds, though in his own first account he adds a

further quarter.

76. BAV, AB, *Giustificazioni* of Cardinal Francesco Barberini Senior, 7151–7232, no. 7226, and 7234–7312, nos. 7239 and 7247; these volumes have not been catalogued, or numbered.

77. 'E piu scudi trè, e b. 70. sono per once quattro d'arg.^to andato di piu nelle pezzi della mazza [reduced to 3.65 *scudi*]. E piu per la fattura di due pezzi fatti di nuovo alla mazza, e risaldata in diversi luoghi, e ricolorita tutta, e imbronita, e smaltato li scudi dell'arme scudi dodici' [reduced to 10 *scudi*] (*ibid.*, no. 7274).

78. The same question applies to two drawings for cardinals' maces with Barberini symbols by Pietro da Cortona in the Victoria and Albert Museum (Peter Ward-Jackson, *Italian Drawings* II, London, 1980, cat. 681, 682, pp. 42–3). The first, with a Maltese cross, is related by Ward-Jackson to Cardinal Antonio Barberini the younger; the second is topped with a club sprouting olive-branches, a device that appears on Pietro da Cortona's ceiling of the Salone of the Barberini Palace (see John Beldon Scott, *Images of Nepotism*, Princeton, 1991, p. 140), but which was also used on the reverse of a medal Cardinal Francesco Barberini senior (*Museum Mazzuchellianum*, II, Venice, 1763, pl. CXXVIII.I). So the mace could well have been designed for Francesco, even if there is no evident justification for Mazzuchelli's statement that this, and another emblematical reverse, display 'embelmi, che il C. Francesco soleva addottare per esprimere i segreti suoi pensimenti' (*ibid.*, pp. 123–4).

79. Inventory 646–1906. For a comparable re-use of a mace, see that by Matteo Piroli in the Biblioteca Malatestiana at Cesena (Franco Faranda, 'La Mazza di Pio VI e l'attività in Romagna dell'orafo romano Matteo Piroli', *Accademia Clementina. Atti e memorie*, N.S., XXV, 1990, pp. 97–102).

80. Sotheby's 2 April 1993, lot 96, no. 23; a sketchier drawing by Francesco Bartoli was included in the same volume, lot 96, no. 24.

81. '. . . per il martello tutto d'Argento dorato, et tutto lavorato con Angioletti, figure, imprese, et arme requadrato, che serve per aprire la porta santa, pesato in Zecca . . . peso lb. quattro o. sette d.^ri dodici'. (ASR, Camerale I^o, Giust. di Tesoreria, busta 55, interno 7, p. 12). The payment for making this small object was 80 *scudi*, as against 50.85 for the silver and 16.50 for the gold, and Spagna also paid 2.50 *scudi* for a red velvet bag, lined, and decorated with the pope's arms.

82. It may be noted that in the inventory of his son Francesco of 15 October 1640 was 'Un Modello del Martello da aprire la Portasanta di legno tutto dorato' (ASR, Not. Trib. A.C., Fonthia, 3137, f. 944). The fact that he retained such a model suggests either that he made it himself, or, more likely, that he paid for it, and he did not claim the usual repayment. The date of the inventory for Francesco, who was indisputably dead at the time, disproves Bulgari's dating of his death to 1642 (Bulgari *Argentieri, gemmari e orafi d'Italia; Roma*, II, pp. 422–5).

83. The trowel was perhaps not new, since the heirs of Giuseppe Giuliani together with Girolamo Rota, 'compagni spadari', were paid for silvering and engraving Urban's arms on three mason's trowels (ASR, Camerale I^o, Giustificazioni di Tesoreria, busta 55, interno 11, 'Artigiani minori').

84. Sotheby's 2 April 1993. lot 96, no. 124 (in the second album).

85. BAV, MS. Barb. Lat. 9900, f. 6r. The weight of the pair of candlesticks was 176 Roman *libbre*, 7 *once*, 1 *denaro*.

86. Minna Heimbürger Ravalli, 'Supplementary Information Concerning the Spada Chapel in San Girolamo della Carità in Rome', *Paragone (Arte)*, 329, 1977, pp. 39–45; the documents are published in her *Architettura scultura e arti minori nel barocco italiano: Ricerche nell'archivio Spada*, Florence, 1977, pp. 85, note

32, and 113, note 116. It was Marc Worsdale who pointed out to me the relationship of the drawing to the Spada candlesticks.

87. Compare those by Guglielmo della Porta, illustrated in Werner Gramberg, *Die Düsseldorfer Skizzenbücher des Guglielmo della Porta*, Berlin, 1964, Second Sketchbook, cat. 61, 62.

88. Werner Gramberg, 'Das Kalvarienberg-Relief des Guglielmo della Porta und seine Silber-Gold-Ausführung von Antonio Gentile da Faenza', *Intuition und Kunstwissenschaft; Festschrift für Hanns Swarzenski*, Berlin, 1973, pp. 450–60; Ulrich Middeldorf, 'In the Wake of Guglielmo della Porta', *Connoisseur*, CXCIV, 1977, pp. 82–3. The model was certainly in existence in Italy before du Quesnoy's arrival, and it is implausible that he would have introduced the minor variations in this poorly modelled example.

89. On Giardini's pattern-book see Angelo Lipinsky, 'Arte orafa a Roma: Giovanni Giardini da Forlì', *Arte illustrata*, IV 45/46, Nov. 1971, pp. 18–34; the work is better known in the Augsburg edition of 1750. The first edition was reprinted by SPES, Florence, 1978.

90. Ethel Morrison Van Derlip Fund, inv. 63.35; 73.7 × 50.4 cm. See Michael Conforti, 'Continental Decorative Arts', *Apollo*, CXVII, no. 253, 1983, p. 203.

91. The fact that he probably would not have designed or modelled these figures (see above, p. 117) is not entirely relevant to this argument. The central image adapts one of the most popular designs of the *Virgin and Child* by Giovani Battista Foggini (see Klaus Lankheit, *Die Modellsammlung der Porzellanmanufaktur Doccia*, Munich, 1982, p. 135, 35.82,5, and fig. 192; J. Montagu 'The Roman Fortune of a Relief by Foggini', *Antologia di belle arti*, La Sculture, N.S. 48–51, 1994, pp. 86–91).

92. See, for example, the rather earlier *Corpus* in the museum at Rimini, which is in repoussé, except for the extremities, which are cast solid (see Pier Giorgio Pasini, *La Pinacoteca di Rimini*, Rimini, 1983, cat. 45).

93. BAV, Archivio Barberini, computisteria, vol. 85, f. 100v *mandato* 1065; 'A Balduino Blavier Argenterie s. setantasei b. 50 m^ta che gli facciamo pagare cioè s.67.50 per s. 45 d'oro in oro posti nel gettito di un Christo crucifisso, con corona di spini, chiodi, titolo e capitelli della Croce tutto di oro fatto da lui di ordine nostro, e s.9 m^ta per fattura del med^mo . . . li 15 Marzo 1657—s.76:50'. See also BAV, Archivio Barberini, Computisteria, *Giustificazioni* of Cardinal Francesco Barberini Senior, no. 7634.

94. On the history and ceremony of the gift of the golden rose see Gaetano Moroni, *Dizionario di erudizione storico-ecclesiastica*, LIX, Venice, 1852, pp. 111–49; Elisabeth Cornides, *Rose und Schwert im päpstlichen Zeremoniell von den Anfängen bis zum Pontifikat Gregors XIII.*, Vienna, 1967 (with full bibliography, but concerned with an earlier period).

95. See Hermann Fillitz and Erwin Neumann, *Kunsthistorisches Museum. Katalog der Weltlichen und der Geistlichen Schatzkammer*, Vienna, 1971, p. 69, cat. 43. This botanically bizarre object, hung with phials of relics rather than leaves or blossoms, is illustrated by Marc Worsdale in *Vatican Splendour* (exhibition catalogue, National Gallery of Canada), Ottawa, 1986, p. 33, fig. 15.

96. This is in Munich, see Hans Thoma (ed.), *Schatzkammer der Residenz München, Katalog*, Munich, 1958, p. 101, no. 214. Francesco Spagna's accounts for making it are in ASR, Cam. I°, Giustificazioni di Tesoreria, vol. 77; the basic account is dated 17 March (the rose was blessed on the fourth Sunday of Lent), but there is another account of 5 July for 'per havere aggiunta . . . n° 12 rame di fronde, con sette fronde per rama'

before it was sent to Munich for the wedding of the duke.

97. Moroni states that it cost 1,200 *scudi* (*Dizionario di erudizione*, 59, pp. 136–7), but he does not give his source. On Moretti see Bulgari, *Argentieri, gemmari e orafi d'Italia; Roma*, II, pp. 179–80; Leandro Ozzola prints payments to Moretti for the golden rose of 1656 (Leandro Ozzola, 'L'Arte alla corte di Alessandro VII', *Archivio della Reale Società Romana di Storia Patria*, XXXI, 1908, p. 72).

98. Paris, École Nationale Supérieure des Beaux-Arts, Masson Collection, inv. 0.1472; brown ink and wash, 45.2 × 21.5 cm. See Montagu, *Roman Baroque Sculpture*, p. 122, fig. 152.

99. ASV, SPA, Computisteria, vol. 3036, pp. 15–16 (12 April 1715). This account had still to be 'tarato', i.e. reviewed and approved, which invariably meant reduced; he had already received 300 *scudi* on account in September 1714, and 200 in December (vol. 3035, pp. 360, 369).

100. It may be noted that, although the rose was melted down, the highly attractive silver base of that given by Benedict XIII to Urbino still survives, serving as the foot of a monstrance; see Giuseppe Cucco, *Urbino, Museo Albani* (Musei d'Italia – Meraviglie d'Italia), Bologna, 1984, cat. 295. A similar type of base was used for the rose that Benedict XIV to the Metropolitana of Bologna in 1751 which is lost, but known through two prints, a rough woodcut, and an engraving by Pietro Locatelli; disturbingly, these show notable differences one from the other (BUB, Aula V, Capsula 108, no. 1); for that by Locatelli see Irene Folli Ventura, Laura Miani (ed.), *Due carteggi inediti di Benedetto XIV* (Emilia Romagna –Bibliotheche archivi, no. 10), Bologna, 1987, fig. 16.

101. ASV, SPA, Computisteria, vol. 210, no. 316.47; for the payment see also *ibid.*, vol. 3041, no. 316.47.

102. See Hieronymus Lauretus, *Silva Allegoriarum Totius Sacrae Scripturae*, ed. F. Ohly, Munich, 1971, pp. 163–5. On the religious significance of gold, and its symbolism, see *Reallexikon für Antike und Christentum*, XI, Stuttgart, 1981, cols. 913–22.

103. See Voelker, *Charles Borromeo's* Instructiones, pp. 160–1, 209–10, 214.

Chapter 2: Roman Bronze Sculpture around 1600

1. S. F. Ostrow, *The Sistine Chapel at S. Maria Maggiore: Sixtus V and the Art of the Counter Reformation* (Doctoral Thesis, Princeton University, 1987), Ann Arbor, 1989. This thesis is currently being reworked for publication.

2. On this work see chapter 1, note 44.

3. Staale Sinding-Larsen, 'Some functional and iconographical aspects of the centralized church in the Italian Renaissance', *Acta ad archaeologiam et artium historiam pertinentia*, II, 1965, pp. 221–3.

4. *Ibid.*, pp. 223–4.

5. On this tabernacle, its making and restoration, see Pietro Cannata's entry on the *Tabernacolo*, in Maria Luisa Madonna (ed.), *Roma di Sisto V. Le arti e la cultura* (exhibition catalogue), Rome, 1993, pp. 394–9.

6. This idea, too, may come from Carlo Borromeo, see Evelyn C. Voelker, *Charles Borromeo's* Instructiones Fabricae et Supellectilis Ecclesiasticae, 1577. *A Translation with Commentary and Analysis*, Ann Arbor, 1977, p. 161.

7. On prototypes, and other meanings that can be seen in this angelic adoration (e.g. the Ark of the Covenant), see Ostrow, *The Sistine Chapel*, pp. 207–10.

8. Cf. Domenico Fontana, *Della Trasportatione dell'obelisco vaticano*

e delle fabbriche di Nostro Signore Papa Sisto .V. fatte dal Cavalier Domenico Fontana architetto di Sua Santita, Rome, 1590, fig. 42.

9. Ostrow publishes an interesting drawing in Angers (Inv. 6 f. 1839) which cannot be a copy of the finished work, as it differs from it in many details, and which he suggests may have been a presentation drawing. It appears that different hands drew the angels and the *tempietto*, and Ostrow proposes the name of Cesare Nebbia for the former on stylistic grounds, and that of Giovanni Guerra (who was both a painter and an architect) for the latter, with the suggestion that they should be seen as the designers, working in collaboration with Fontana (*The Sistine Chapel*, pp. 201–2).

10. . . . fù modello di Riccio Stuccatore' (Pietro Rossini, *Il Mercurio errante*, Rome, 1693, III, p. 157).

11. Filippo Titi, *Studio di pittura, scoltura, et architettura nelle chiese di Roma (1674–1763)*, ed. Bruno Contardi and Serena Romana, Florence, 1987, p. 138. Early editions give the founder of the *tempietto* as Lodovico Scalzo, only in the edition of 1763 did this guide-book add that others said it was Ludovico del Duca, and that the four angels were cast by Sebastiano Torrigiani (*loc. cit.*).

12. *Ritratto di Roma moderna*, Rome, 1645, p. 488. Giovanni Battista Mola, *Breve racconto delle miglior opere d'architettura, scultura et pittura fatte in Roma . . .*, ed. Karl Noehles, Berlin, 1966 [first published 1663], p. 76 (original p. 123), also names Ludovico del Duca for the tabernacle, but states that Domenico Ferreri and his relatives cast the supporting angels. Mola was obviously relying on Giovanni Baglione's 'Life' of Ferreri in his *Le Vite de' pittori scultori et architetti. Dal pontificato di Gregorio XIII. del 1572. In fino à tempi di Papa Vrbano Ottavo nel 1642.* (Rome, 1642, p. 324), and he failed to note that these 'relatives' include Torrigiani, to whom Baglione rightly ascribes the angels while correctly stating that the tabernacle itself is by Ludovico del Duca (pp. 55, 324).

13. He did design the stuccoes in the Portico of St Peter's (see Howard Hibbard, *Carlo Maderno and Roman Architecture 1580–1630*, London, 1971, pp. 162, 178), and those in the new choir in St Peter's (Oskar Pollak, *Die Kunsttätigkeit unter Urban VIII.*, II, Vienna, 1931, pp. 10, 227–8.), but there is no suggestion that he executed them; he also painted a model of a ciborium destined for St Peter's (Irving Lavin, *Bernini and the Crossing of St Peter's*, New York, 1968, p. 44; but see also W. Chandler Kirwin, 'Bernini's Baldacchino Reconsidered', *Römisches Jahrbuch für Kunstgeschichte*, XIX, 1981, p. 160, note 118), but, again, there is no suggestion that he was involved in any way in its construction.

14. Antonio Bertolotti, *Artisti urbinati in Roma prima del secolo XVIII*, Urbino. 1881 [extract from *Il Raffaello*], p. 22.

15. F. Titi, *ed. cit.*, p. 142. The church contains the body of St Matthias; see Pietro Martire Felini, *Trattato nuovo delle cose maravigliose dell' alma Città di Roma*, ed. Stephan Waetzoldt, Berlin, 1969 [first published 1610], p. 19.

16. See the documents published by Maria Cristina Dorati, 'Gli scultori della Cappella Paolina di Santa Maria Maggiore', *Commentari*, XVIII, 1967, p. 240. On Caporale's birth-place see J. Montagu, *Roman Baroque Sculpture: The Industry of Art*, New Haven/London, 1989, p. 199, note 32.

17. Camerale 1º, Fabriche, 1527, int. 4, ff. 11r–v; Camerale 1º, Fabriche, 1528, pp. 87–8; Mandati Camerali, 937, f. 28v. The payments, dated from October 1588 to December 1589 are listed in ASV, Archivium Arcis, Arm. B, vol. 26, ff. 236, 249v, 262v, 268v, 279v, 299r, 305r–v, 310r–v, 311v, 316r, 317v, 323v. That the founder Gregorio de Rossi also collaborated

with Ludovico del Duca on the tabernacle emerges from his evidence in a trial concerning some stollen wax (Antonio Bertolotti, 'Gian Domenico Angelini pittore perugino e suoi scolari', *Giornale di erudizione artistica*, V, 1876, p. 83; the relevant passage is printed in Sylvia Pressouyre, *Nicolas Cordier. Recherches sur la sculpture à Rome autour de 1600*, Rome, 1984, I, p. 97, note 25). Similarly, it appears that 'benedeto efilizano' collaborated with Torrigiani, since Pietro Tornieri claims to be acting for both of them (appendix 1, f. 127), but I cannot identify any sculptor or founder by the name of Benedetto, who possibly came from Fivizzano. In both cases they must have worked in a subordinate capacity, since all the payments are to Torrigiani and del Duca, who must have been in charge of their respective works.

18. ASV, Archivium Arcis, Arm. B, vol. 7, ff. 125–30v; this is transcribed in appendix I. Also included in this document, but not printed here, is the making of the grille (ff. 117–20).

19. It should be noted that Baglione writes of Torrigiani that 'Fu egli inventore di gettare in forme fatte di gesso, e di polvere di mattoni, perilche havendo reso facile, e spedito il modo de' getti, è stato di grandissimo utile alla professione di quest'arte virtuosa' (Baglione, *Le Vite de' pittori*, p. 324).

20. Both the use of poplar-wood to protect the eucharist from damp, and the silk lining (red for the Ambrosian rite, and white for the Roman rite) were recommended by Saint Carlo Borromeo for the churches of his diocese of Milan (Voelker, *Charles Borromeo's* Instructiones, pp. 160, 162).

21. See appendix I, pp. 202–3.

22. Appendix I, p. 202.

23. P. Cannata, '*Tabernacolo*', in Madonna, *Roma di Sisto V*, p. 397. For an example of the effectiveness of gilding on green bronze, see, for example, Pollaiuolo's tomb of Innocent VIII in St Peter's.

24. 'Lavori gentili e minuti' (ASR, Camerale 1º, Fabriche, vol. 1528, p. 88 right).

25. Bruno Molajoli, *Notizie su Capodimonte*, Naples, 1958, p. 108, fig. 137. While the origin of the tabernacle in Padula, first proposed by Schiavo (Armando Schiavo, 'Il michelangiolesco tabernacolo di Jacopo del Duca', *Studi Romani*, XXI, 1973, pp. 215–20), is now beyond question, d'Aniello's denial of Jacopo del Duca's involvement ignores the often-stated and indisputable relationship with Ludovico's tabernacle in Sta Maria Maggiore (A. d'Aniello, 'Il Ciborio della Certosa', in *La Certosa ritrovata*, Rome, 1988, pp. 30–5). In her earlier essay on 'La Sagrestia' in *La Certosa di Padula*, Florence, 1985, pp. 68–71, she had been less categorical in her rejection of this attribution.

26. See appendix A.

27. See Adolfo Venturi, *Storia dell'arte italiana*, X, 2 (*La Scultura del Cinquecento*), Milan, 1936, pp. 162–73, including illustrations of many of the reliefs.

28. Oxford, Ashmolean Museum, Karl T. Parker, *Catalogue of the Collection of Drawings in the Ashmolean Museum*, II, *Italian Schools*, Oxford, 1956, cat. 339; black chalk, 10.8 × 28.1 cm.

29. Boston, Isabella Stewart Gardner Museum; black chalk, 29 × 19 cm. Given the popularity of this image, there is no justification for attributing other reliefs of it to Jacopo del Duca (cf. M. d'Orsi, 'Gallerie di Roma: Galleria Nazionale romana', *Bollettino d'arte*, ser. 4, XXXIX, 1954, pp. 365–6).

30. Sandro Benedetti, *Giacomo Del Duca e l'architettura del Cinquecento*, Rome, 1973, p. 71.

31. Thomas Salmon in 1763 described a risen Christ above the cupola, and eight little angels bearing instruments of the passion on the cornice (Salmon, *Storia del Regno di Napoli antica*

e moderna, Naples, 1763, pp. 167–8, quoted in Schiavo, 'Il michelangiolesco tabernacolo', p. 218), and Antonio Racioppi noted that the columns were of lapis lazuli (A. Racioppi, 'La Certosa di San Lorenzo a Padula', *Poliorama pittoresco*, Naples, 1845–6, pp. 181–3, 298–300, cited in Schiavo, 'Il michelangiolesco tabernacolo', p. 218). Benedetti remarks that the ring around the base visible in the old Anderson photograph (Fig. 30), taken when the tabernacle was still in the museum in Naples, is no longer present in Padula.

32. '. . . maestro Jacopo Ciciliano eccellente gettatore di bronzi, che fa che vengano le cose sottilissimamente senza bave, che con poca fatica si rinettano; che in questo genere è raro maestro, e molto piaceva a Michelagnolo' (Giorgio Vasari, *Le Vite de' più eccellenti pittori et architettori*, ed. G. Milanesi, Florence, VII, 1881, p. 261).

33. Cannata blames the evident defects of the sculpture on the heavy gilding applied in 1870 ('*Tabernacolo*', in Madonna, *Roma di Sisto V*, p. 399), but I cannot share this view.

34. Undated; Elena died in 1570. For an illustration of the tomb see Venturi, *Storia dell'arte italiana*, X, 2, pp. 174–5, figs. 153, 154.

35. Georg Sobotka, in Ulrich Thieme and Felix Becker, *Allgemeines Lexikon der bildenden Künstler*, Leipzig, 1914, X, pp. 22–3; see also B. Hernad, in *Dizionario biografico degli italiani*, XXXVI, Rome, 1988, p. 490. I have not examined the document myself, but it should be noted that these models cannot have been left at Giacomo's death, as both authors assume, because Giacomo did not die until 1604 (Sandro Benedetti, in *Dizionario biografico degli Italiani*, XXXVI, p. 487). However, in 1592 he had left Rome for his native Sicily, and, whether or not he intended to return to Rome, he never did so.

36. The same applies to the *Carrying the Cross*. The *Last Supper* on the Sistine tabernacle (Fig. 48) is quite different, while the *Carrying of the Cross* contains many variants.

37. Benedetti, *Giacomo Del Duca e l'architettura*, p. 68. His explanation of the contrast of a crowded lower half and empty upper half of the Padula reliefs, 'la dialettica alto-libero, basso-congestionato bene si lega al Tema della Morte e Resurezione del Cristo-Dio', does not appear to me to be worthy of discussion.

38. Matthew 28.2. This subject is extremely rare in post-Byzantine art. It was engraved by Jacques de Gheyn II after Karel van Mander in 1596 (Elisabeth Valentiner, *Karel van Mander als Maler*, Strassburg, 1930, p. 38); Benjamin Gerritsz Cuyp was to paint at least three versions of the angel opening the tomb at night, but without the two Maries. The del Duca reliefs differ from the traditional Byzantine type, which shows the angel seated on the stone, which, as would be expected from the text, is round (see Gabriel Millet *Recherches sur l'iconographie de l'évangile aux XIV^e, XV^e et XVI^e siècles . . .*, Paris, 1916, p. 517 ff.).

39. If I am correct in assuming that the Padula reliefs are adaptations of a design originally conceived for a lower format, it may be relevant that the tabernacle based on designs by Michelangelo, to be made by Jacopo del Duca and proposed for the Escorial, would have had sixteen reliefs of the passion, of more than one *palmo* (Babelon, *Jacopo da Trezzo et la construction de l'Escorial*, Paris, 1922, pp. 315–16; see also appendix A). Those on the tabernacle of Sta Maria Maggiore (which I have not measured) must be about 1½ *palmi*. A terracotta model of the *Flagellation* in the Collection Thiers in the Louvre is 34.5 cm. high, which would be almost exactly 1½ *palmi* (see Carlo Horst, 'Un Rilievo in terracotta da un disegno di Michelangelo', *Bollettino d'arte*, XXV, 1932, pp. 385–8), and

therefore comes closer in size to that in Sta Maria Maggiore than to Jacopo del Duca's earlier version in Padula.

40. See John Goldsmith Phillips, 'A Crucifixion Group after Michelangelo', *Bulletin of the Metropolitan Museum of Art*, XXXII, 1937, p. 212.

41. See chapter 1, p. 15, and note 88.

42. See, however, Eric Apfelstadt, 'Andrea Ferrucci's "Crucifixion" altar-piece in the Victoria and Albert Museum', *Burlington Magazine*, CXXXV, 1993, pp. 811–12.

43. *Moses*, inv. 379; *Elijah*, inv. 344. On these bronzes see the entry by Pietro Cannata, 'Elia e Moisè', in Madonna, *Roma di Sisto V*, pp. 436–7; I cannot share his judgement that these are by Ludovico del Duca.

44. The *Moses* is no longer there, and the *David* has also been stolen.

45. They are greatly superior in finish to the signed statuette of *Marcus Aurelius* in the Bargello, for which see Pietro Cannata's entry in Madonna, *Roma di Sisto V*, pp. 465–6.

46. '. . . furono ricavate ché sottoposte all'azione del fuoco furono trovate difettose a segno di non poter essere risarcite' (Cannata, in Madonna, *Roma di Sisto V*, p. 397). This firing was presumably undertaken in the course of regilding the statuettes.

47. I agree with Cannata in seeing all eight of the smaller figures on square bases in the centre of each side as by Galli. He regards the casts of *Elijah* on the balustrade as possibly by del Duca (he does not consider a possible transposition), while regarding the *Prophet* with a raised arm as a later recasting.

48. One thing that can be said with assurance is that they cannot be related to the work of Jacopo Sansovino, as suggested in *Bronzetti da XV al XVII secolo (Museo Nazionale del Bargello; Itinerari*, 3), ed. Beatrice Paolozzi Strozzi, Florence, 1989, p. 30, nos. 24, 25. See also note 43, above.

49. John Pope-Hennessy and Ronald Lightbown, *Catalogue of Italian Sculpture in the Victoria and Albert Museum*, London, 1964, text vol. II, p. 663, cat. 709 (inv. A.57–1951), height 49.5 cm.

50. 'Ratto delle Sabine con due figure equestri, e sei altre figure in [illegible] et un Cane rinetto stimo valere s.200' (Montpellier, MS. 267, [ff. 46–7v], f. 46v). The problem word looks like 'cera' (wax), but this would be an odd place in the description to mention the material, and elsewhere this is invariably in the more usual form of 'di' rather than 'in', and where it is wax its colour is given; moreover, it would be unusual to state that wax was 'rinetto'. I should prefer to read it as 'in circa' (about), which would be justified by an uncertainty as to whether a dying horse counts as a figure.

51. Possibly it was made after the death of Duke Francesco Sannesi in 1644, but he had been attempting to sell paintings in the previous year to clear his debts; see Patrick Michel, 'Rome et la formation des collections du Cardinal Mazarin', *Histoire de l'art*, XXI/XXII, 1993 (Collections et colletionneurs), p. 11 and note 63. If it had been sold previously, this would explain why there is no mention of such a group in the inventory of his belongings begun on 17 February 1744 (Arch. Cap., Arch. Urb., Sez. XLIV, vol. 10, unfoliated; the copy in the Archivio di Stato, ASR, Not. A.C., Cesare Colonna, vol. 2091, ff. 761–801, lacks the first few pages, ff. 766–74, which were removed in connection with a legal dispute).

52. The tabernacle was, of course, cited in books on the church, including *L'Eglise de St-Louis-des-Français de Rome: Petit guide des visiteurs*, Rome, 1909, which described the tabernacle and the statuettes of the Evangelists on it as 'digne de la tradition qui les a attribuées au ciseau de Benvenuto Cellini'. The far more serious work by Albert d'Armailhacq, *L'Eglise nationale de Saint*

Louis des français à Rome, Rome, 1894, makes no such claim, but describes it in detail (p. 159). Unlike the *Petit guide*, or Charles Roulet, 'Un bienfaiteur de Saint-Louis le Cardinal Cointerel (1519–1585)', *Annales de Saint-Louis-des-Français*, IV, 1899, p. 68, d'Armailhacq recognised that the four seated figures belong to the tabernacle, regretting their separation. The tabernacle is also recorded in Walther Buchowiecki, *Handbuch der Kirchen Roms*, II, Vienna, 1970, pp. 320–1, identifying it as that left by Cardinal Cointerel, but making no reference to the figures which had remained on the high altar.

53. Two of them were shown under the same title, but now ascribed to the beginning of the seventeenth century, at the *XIII Mostra europea del turismo, artigianato e delle tradizioni culturali* at the Museo Nazionale di Castel Sant'Angelo, April–June 1994; all four are illustrated in the 'catalogue' (in fact, apart from the illustrations and brief captions, a series of detective stories), Valerio M. Manfredi, *Tesori dal buio. Le inchieste del colonello Reggiani*, pp. 30–1.

54. I was able to study them, and attempt to photograph them, thanks to the Economo of the church; later, when the tabernacle itself was better displayed, the Recteur allowed me to photograph it and its statuettes, with the permission of the Pieux Établissement des Lieux Français.

55. 'Vir doctissimus et integrae vitae' (*Dictionnaire de biographie*, IX, 1961, col. 161).

56. 'Materia molto aromatico' (*Dizionario biografico*, XXVIII, 1983, p. 70).

57. The documents concerning the history of this chapel, including the tabernacle and the later marble figure of *St Matthew*, are most conveniently reprinted in Maurizio Marini, *Io Michelangelo da Caravaggio*, Rome, 1974, pp. 482–92. See also the inventory of Cardinal Contarelli of 2 December 1585 made for Virgilio Crescenzi in ASR, Not. RCA, Pontus Seva, vol. 1852, ff. 435–52v, with its reference to 'un tabernaculo di metalo con diverse statuine del medesimo per San Luigi' (f. 449v), together with the coins left for its gilding, listed on the same folio (information also given in APEF, S. Luigi dei Francesi, Liasse 13, int. 2).

58. Arch. Cap., Arch. Urb., Sez. I, vol. 476, Vincentius Monaldus, ff. 191–8v.

59. 'Tabernaculus aeneus et aeneas angelis . . . lilijs respersu'; see e.g. APEF, S. Luigi dei Francesi, Liasse 13, int. 2. See also the document in the APEF printed by Luigi Spezzaferro, 'Caravaggio rifutato? I. Il problema della prima versione del "San Matteo"', *Ricerche di storia dell'arte*, X, p. 57.

60. Ill. d. Franciscus Contarellus, et Mag.ius. D. Franciscus Belgeus Rectores Ecclesiae et Hospitalis pii ac R. D. Ludovicus Rinaldi ac Mag. d. Jacobus Burlurault . . . receperunt ab eod. Ill. et R. Abb. Jacobo Crescentio Tabernaculum suprad.m cum omnibus statuis illi adiectis merè coiflatum, et perpolitum quae statuae ['inf' crossed out] et alia Tabernaculum concernentia sunt inferias specificata. Item Angeli ['gran' crossed out] sei grandi di bronzo d'altezza d'un palmo, e mezzo in circa quali tengono la lampana [or possibly 'campana], quattro Profeti di bronzo a sedere, e quattro Evangelisti in piedi, Quattro Angeli vestiti à sedere piccoli con li mistieri dela passione in mano, sei Angeletti ignudi à sedere, quattro Terminetti di metallo, che rappresentano mezzi Angeli, Tre festoni di metallo tutti per ornamento del Tabernaculo. . . .' (Archivio Capitolino, Sez. I, vol. 476, f. 196v). For the angels, see also the document in the APEF printed by Spezzaferro (*loc. cit.*).

61. 'Per il tabernacolo della Ven. Chiesa di S. Luigi della natione Francese sono stati fatti da Pietro Mentinoes scultore doi modelli differenti per potersi da essi fare l'opera quali sono stati

veduti sopra l'altare essendo stati fatti con la mia assistenza si puol sodisfare in scudi venti m.ª cosi da me giudicati. 30 maggio 1673. Gio Antonio de Rossi Arch.' (APEF, S. Luigi dei Francesi, Liasse 65.b, Giust. 1673, no. 539); 'Al S. Pietro Montinues scultore scudi venti m.ta sono per finale pagamento di quanto possa pretendere per tutti li modelli fatti per il tabernacolo di bronzo di n.ra chiesa che stante la sud.ª relatione fatta dal Sig.re De Rossi n.ro Architetto et ord.e sottoscritto dalli dep.ti . . . e sua ri.ta. Di casa li 27 luglio 1673 –s.20' (APEF, S. Luigi dei Francesi, vol. 207/5, Registro dei Mandati 1666–74, f. 132r). I am indebted to the kindness of Olivier Michel for the citations from this archive, which is difficult of access.

62. See Valentino Martinelli, *Le Statue berniniane del Colonnato di San Pietro*, Rome, 1987, p. 137, no. 78. See also Thomas Pickrel, 'Two Stucco Sculpture Groups by Antonio Gherardi', *Antologia di belle arti*, II, 7/8, 1978, pp. 216–24, for the stucco angels 'Monsù Pietro Mentinovese' modelled on the designs of Antonio Gherardi for the church of the SS. Sudario in Rome.

63. '. . . s.76 . . . per l'indoratura d'otto statue de bronzo del tabernacolo di d.o metallo' (APEF, vol. 224, Libro Mastro B, 1673–1682, f. 194 [9 September]. He was paid a further 190 *scudi* between 9 September 1675 and 1 October 1676. This information was kindly given me by Olivier Michel.

64. *Ibid.*, to Giovanni Terrillion 'intagliatore', 400 *scudi*, 17 November 1673–6 December 1674 (f. 158); to Andrea Scoccante 'intagliatore', 26 *scudi*, 30 September 1675–1 April 1676 (f. 193). These payments refer only to the 'tabernacolo' (material unstated, but presumably of wood), as do those to Biagio Onofri 'indoratore', of 64 *scudi*, 11 August 1674–15 January 1678 (f. 179). The tabernacle was finished by 10 August 1676 (APEF, vol. 36, *Congregazioni*). I am again indebted to Olivier Michel for this information.

65. There are also two reliefs, of the heads of *Christ* and the *Virgin*, which are of poorer quality, but could possibly be original; the door with its relief of the chalice and cherub-heads looks later. All are repoussé, presumably in gilded copper, rather than cast.

66. E.g. private collection (bought Sotheby's 15 December 1977, lot 216, as Venetian, probably derived from Vittoria); Museo Arqueologico, Madrid; sale Palais des Beaux-Arts, Brussels, 16–18 October 1963, as Flemish, seventeenth-century; Sotheby's New York 20 May 1988, as probably Italian (very poor casts); *Luke*, Palazzo Venezia, Rome (L. Pollak, *Raccolta Alfredo Barsanti . . .*, Rome, 1922, p. 125, no. 86), as Venetian, second half of the sixteenth century; *John* and *Matthew* (seemingly identical to those in the sale of May 1988), Sotheby's New York, 9 and 10 January 1990; *John*, Galleria Barberini, Terni, exhibited at the Mostra dell'Antiquariato, Rome, 1993 (very poor cast). The Kunsthistorisches Institut in Florence has photographs of a set of passable quality in a Florentine private collection ca. 1976, and of another set of poor quality, with tooled draperies and octagonal marble bases, the location of which is unknown. I have also been shown photographs of a silver set, ca. 30 cm. high, in a private collection.

67. They are between 25 and 25.5 cm. high, including their bases.

68. They vary in height: *Moses* 26.5 cm., the unidentified *Prophet* 27.5 cm., *St Louis* 25.5 cm., and *David* 26 cm.

69. *The Prophets Hosea and Jonah*; pen and brown ink with brown wash over black chalk, heightened with white; 26.6 × 20 cm. Washington, National Gallery of Art, inv. 1991.217.4./DR.

70. The anonymous *Prophet* also has an 'O'.

71. This photograph, and that of the following illustration, were taken when the figures were on the market.

72. See, however, the drawing by Guglielmo della Porta of David similarly attired as a shepherd, standing holding the head of

73. See the account of the trial in 1609 for the theft of the models left by Guglielmo della Porta, in which Cobaert appeared as a witness, published in Antonio Bertolotti, *Artisti lombardi a Roma*, Milan, 1881, II, pp. 119–61. Bertolotti had already published these documents in his 'Guglielmo della Porta scultore milanese' *Archivio storico lombardo*, II, 1875, pp. 295–318; my references, however, will be to Bertolotti's *Artisti lombardi*. Cobaert is there described as 'degens in urbe ad sanctum Petrum' (p. 138), and states that 'Doppo la morte del d.to sig.r Guglielmo . . . io lavoravo con il datario del Papa', i.e. Cointerel (p. 141); Cobaert lived in the parish of St Peter's from at least 1587 (Marini, *Io Michelangelo da Caravaggio*, p. 483), and it was in that parish that he died on 1 June 1615 (Godefridus J. Hoogewerff, *Bescheiden in Italië omtrent nederlandsche Kunstenaars en Geleerden*, The Hague, II, 1913, p. 253). According to Baglione he was then at least 80 (*Le Vite de' pittori*, p. 100); although no documentary confirmation has been found for his date of birth, he is described as from 'Enge' in Flanders, which might mean Enghien (ASR, 30 Not. Cap., Uff. 24, vol. 109, p. 85).

74. This is a small ivory group of the *Deposition*, now in the Museo del Palazzo Venezia, which comes from the Patrizi family with a long tradition that it was by Cobaert; see Maria Giulia Barberini, 'Cope scultore fiammingo ed un avorio di casa Patrizi', in *Per Carla Guglielmi. Scritti di allievi*, ed. Teresa Calvano and Mauro Cristofani, Rome, 1989, pp. 17–25. Sergio Lombardi catalogued this piece as by Jacob Cobaert, in Madonna, *Roma di Sisto V*, p. 438. This group is fully consistent in style with both Cobaert's certain marble *St Matthew* (Fig. 69) and the tabernacle figures, allowing for the fact that the head of the Virgin and her right arm appear to be restorations. Various ivory reliefs related to the plaquettes of the *Metamorphoses* which he modelled have been associated with him, but, in view of the great popularity of these designs, there is no reason to assume that these copies are by Cobaert. Nor do I see any reason to associate Guglielmo della Porta (and hence his assistant Cobaert) with a terracotta relief of the *Rape of the Sabines* in the Victoria and Albert Museum (Pope-Hennessy and Lightbown, *Catalogue of Italian Sculpture*, II, pp. 493–4, cat. 522). For a list of works ascribed to Cobaert, and a now outdated bibliography, see L. Ficacci in *Dizionario biografico degli italiani*, XXVI, Rome, 1982, pp. 424–6.

75. 'Allevato', by which he presumably meant trained (Bertolotti, *Artisti lombardi*, II, p. 138); Werner Gramberg uses the word 'allievo', which, if not what is written, is no doubt what is meant (Werner Gramberg, 'Guglielmo della Porta, Coppe Fiammingo und Antonio Gentili da Faenza', *Jahrbuch der Hamburger Kunstsammlungen*, V, 1960, p. 32).

76. See Bertolotti, *Artisti lombardi*, II, pp. 140–1, 143; this is confirmed by many other witnesses in the trial, and in the inventory of della Porta, where they are described as 'dodici storiette d'Ovidio per adornare Tavole fatte per mano di Coppo' (Gian Ludovico Masetti Zannini, 'Notizie biografiche di Guglielmo della Porta in documenti notarili romani', *Commentari*, XXIII, 1972, p. 305). On the *Metamorphoses* see Baglione, *Le Vite de' pittori*, p. 100, and, most fully, Gramberg, 'Guglielmo della Porta, Coppe Fiammingo und Antonio Gentili', pp. 31–52. Gramberg is ambiguous as to whether Cobaert modelled the originals (as would be implied by his attribution to him of the two terracottas in the Victoria and Albert Museum, which, however, being considerably smaller than the bronze casts, are

unlikely to be the original models from which the bronzes were cast), or cast and repaired subsequent casts; see also Werner Gramberg, 'Vier Zeichnungen des Guglielmo della Porta zu seiner Serie mythologischer Reliefs', *Jahrbuch der Hamburger Kunstsammlungen*, XIII, 1968, p. 69. However, the evidence suggests that Cobaert made the original models, following della Porta's drawings, but of course some intervention by the master cannot be excluded. It is interesting to note the similarity between the clinging draperies of the women in these reliefs, especially the way they cling to the stomach, with those of the angel by the St Matthew on the tabernacle. On the *Descent from the Cross* see Egon Verheyen, 'A Deposition by Guglielmo della Porta', *University of Michigan Museum of Art Bulletin*, N.S. IV, 1969, pp. 2–9 (strangely, while well aware of the records of the trial, Verheyen never mentions Cobaert); one might note the insistent circling lines of the draperies in this relief, which could well have influenced Cobaert in his own models for the seated figures.

77. Baglione, *Le Vite de' pittori*, pp. 100–1. Gramberg has very tentatively suggested that he might have been the Flemish goldsmith called 'Giacomo' who in 1568 struck a man with his sword, cutting him to the bone ('Guglielmo della Porta, Coppe Fiamming und Antonio Gentili', p. 32, note 5, citing Bertolotti, *Artisti lombardi*, I, pp. 323–4); but this was nothing exceptional in a violent age. However, there is no evidence to suggest that Cobaert was a goldsmith; for Cobaert's involvement with silver see note 81 below (however, if the silversmith Montingus had to execute the designs in silver, that would suggest that Cobaert did not have the right to work in precious metals).

78. The best study of Guglielmo's work in his later, Roman period remains Gramberg, *Die Düsseldorfer Skizzenbücher*.

79. One might mention specifically Tommaso della Porta's *Deposition* in the Oratory of SS. Ambrogio e Carlo al Corso (for which see Gerda S. Panofsky, 'Tommaso della Porta's "Castles in the Air"', *Journal of the Warburg and Courtauld Institutes*, LVI, 1993, pp. 126–7, 137–42, and plates 16b, 19a), a sculpture so bizarre, and so contrary to all expectations of Cinquecento sculpture, that one feels it ought not to have happened. Gramberg has suggested that Tommaso was a nephew of Guglielmo (Gramberg, *Die Düsseldorfer Skizzenbücher*, text volume, p. 21), but, while some relationship is virtually certain, it is impossible to say precisely what it was.

80. See the documents published in Marini, *Io Michelangelo Caravaggio*; see also Pressouyre, *Nicolas Cordier*, pp. 211–13; Sergio Lombardi, in Madonna, *Roma di Sisto V*, pp. 432–3. In 1625 the inventory of Francesco Contarelli lists 'a piedi le scale una statua di S. Matteo di marmo' (Arch. Cap., Arch. Urb., Sez. 1, vol. 335, Demofonte Ferrino, Instrumenti, ff. 722–42v, f. 740r). It was later transferred to SS. Trinità dei Pellegrini, and replaced on the altar of the Contarelli chapel by a painting by Caravaggio – though he also had difficulties, and only his second attempt was accepted. But cf. Spezzaferro, 'Caravaggio rifutato?'. I cannot accept Spezzaferro's argument (p. 52) that Contarelli's retention of the statue (for which his family had paid) indicates that he must have approved of the work.

81. On 1 January 1596 Virgilio's son, the Abbate Jacopo Crescenzi, gave Jacob Cobaert the last payment for 'unius Calacis argentei figurati', part of the inheritance from Cardinal Contarelli (ASR, 30 Not. Cap., Agostino Amatucci, Uff. 24, vol. 109, ff. 85r–v); this may (or may not) be identical with the chalices which, on 22 January 1695, the Fleming 'Joannes Montingus' promised Jacopo Crescenzi to finish and gild: 'rinettare et finire un calice d'argento istoriato con figure secondo il modello fatto

da M[aestro] Jacomo Coba fiammengo scultore, et un altro calice pur d'argento senza historia . . .' (ASR, 30 Not. Cap., Uff. 24, vol. 107, ff. 100r–v). On 25 January 1596 Cobaert promised to finish for Jacopo Crescenzi not only the *St Matthew and the Angel*, but also an ivory relief of the Virgin, St Elizabeth, St Joseph, another woman and two putti, and a wax *Deposition* with the Virgin and St John, together with its plaster mould (Marini, *Io Michelangelo Caravaggio*, p. 485). Cobaert's relationship with the Contarelli and Crescenzi can be judged from the evidence of a witness in the 1609 trial, Giovanni Battista Montano: 'Il dº Mʳ Guglielmo [della Porta] lassò molte cose et molte cose appartenente alla scoltura bellissime d'importantia come forme, rilievi di gessi, di cera, di creta cavi et altre cose . . . et credo che le portassero dal Card. Contarello, allora Datario di N.S. a quel tempo, quali cavi, gessi et forme erano fatte di mano di un chiamato Coppe fiammengo, che tra l'altra ci era una passione di cera di circa quattro palmi di altezza e di lunghezza, quale era bellissima et di queste cose ne ha molte in casa sua il sigʳ Gio Battista Crescentii, che io l'ho visto in casa sua, che me l'ha mostrato lui' (Bertolotti, *Artisti lombardi*, II, p. 144). On 30 April 1588 Virgilio Crescenzi added to the inventory of his inheritance from Matteo Contarelli 'forme di cera ò stampe da gettare di bronzo in mano di Giacº Coppo fiamengo' (ASR, Not. RCA, Pontus Seva, vol. 1852, f. 619v; this was kindly brought to my attention by Sebastiano Roberto).

82. I cannot accept Gramberg's view that the marble depends on a drawing by Guglielmo della Porta (Gramberg, 'Guglielmo della Porta, Coppe Fiamming und Antonio Gentili', p. 44).

83. On this *Angel*, completed ca. 1615, see Valentino Martinelli, 'Contributi alla scultura del Seicento. III. Pompeo Ferrucci', *Commentari*, III, 1952, pp. 44–5. Martinelli's suggestion of an influence from Mochi seems hard to sustain, since it is visible nowhere else in the static and constipatedly classicising work of Ferrucci, who is known to have spent much of his time on restoring antiques (Baglione, *Le Vite de' pittori*, p. 347). Moreover, contrary to what Martinelli states, Ferrucci was not the expert chosen by Mochi to estimate his *St Philip*, but the third expert, chosen jointly by Mochi and the other party, and there is no reason to assume any particular friendship between them.

84. Guglielmo left at his death '12 forme de apostoli de doi palmi scarzi de tutto rilievo' (Bertolotti, *Artisti lombardi*, I, p. 143) which, strictly speaking, should not include Sts Luke and Mark, but the term was sometimes used rather vaguely. These would have been considerably larger than the bronze *Evangelists* on the tabernacle, of which *Mark* measures 25.5 cm. and *Luke* 24.5 cm. (just over one *palmo*), but the inventory actually taken at Guglielmo's death in 1577 described them as 'Dodezi apostoli di cera renetti di uno palmo in circha' (Masetti Zannini, 'Notizie biografiche', p. 305). However, it must be admitted that they are extremely common subjects which any sculptor might have needed to create.

85. The *Descent from the Cross*, though modelled by Cobaert for della Porta, was not cast in his life-time (Bertolotti, *Artisti lombardi*, II, p. 141). The same might apply to these *Evangelists*.

Chapter 3: The Adoration of the Host. Tabernacles of the Baroque

1. I take this opportunity to mention that made for the church of Sta Margherita in Bologna, for which Alessandro Algardi furnished the stone from Rome, in order to correct the latest monograph on the artist, which, with unforgiveable careless-ness, asserted that it was lost after the church was destroyed (J. Montagu, *Alessandro Algardi*, New Haven/London, 1985, L. 98). In fact it had been found in S. Petronio, and published twice: see Giuseppe Fornasini, 'La Cappella del Sacramento in San Petronio', *L'Archiginnasio*, XXXVII, 1942, pp. 160–1; Mario Fanti, 'Spigolature d'archivio per la storia dell'arte a Bologna (VI): 2. Un tabernacolo disegnato dall'Algardi di San Petronio', *Il Carrobbio*, IX, 1983, pp. 166–8.

2. It is equally rare to find them mentioned in sculptors' biographies, but it may be noted that Nicola Pio records Bernardino Cametti as having made the model for the bronze ciborium in Sta Marta (N. Pio, *Le Vite di pittori scultori et architetti* (Studi e testi 278), ed. Catherine and Robert Enggass, Vatican City, 1977, p. 153, and note p. 227). C. and R. Enggass assume this to have been for Sta Marta al Collegio Romano, as does Marilyn R. Dunn ('Nuns as Art Patrons: The Decoration of S. Marta al Collegio Romano', *Art Bulletin*, LXX, 1988, p. 461). However, when Pio refers to 'Santa Marta', as against 'Santa Marta incontro al Colleggio Romano', he means Sta Marta al Vaticano, which was embellished under Clement XI. In year 7 of the Republic (1856–7) the 'ciborio di pietra guarnito di metallo esistente nella Chiesa di S. Marta al Vaticano' was transported to the Convertite in the Strada del Corso (ASR, Camerale IIIᵒ, busta 1881, fasc. 65) which had been secularised in 1789. During the French occupation the monastery was used for the exhibition of works of art (Carlo Pietrangeli, *Guide rionale di Roma, III, Colonna*, part 1, Rome, 1977, p. 68), which confirms that the tabernacle was of some artistic importance. What became of it after that I have not discovered.

3. The inscription, 'Ex legato P. Gen. Io. Pauli Oliva 1697' is inscribed on the plain moulding just above the cornice; see Gualberto Giachi and Guglielmo Matthiae, *S. Andrea al Quirinale* (Le Chiese di Roma illustrate, no. 107), Rome, 1969, p. 54. Johannes Terhalle has kindly told me that Oliva left 5,000 *scudi* 'per fare tanta argenteria, e una Tabernacolo d'argento all'altare maggiore di Chiesa' (ARSI, F.G.1017, f. 150). Since the photo illustrated was taken the cross above the cupola has disappeared, and instead a crucifix is now placed behind the tabernacle.

4. Walther Buchowiecki says that it was made in 1716 by Étienne François (W. Buchowiecki, *Handbuch der Kirchen Roms*, I, Vienna, 1967, p. 346), whom Giachi and Matthiae more plausibly name as having made the urn of St Stanislas Kostka in that year (*S. Andrea al Quirinale*, p. 59).

5. Andrea Caravita, *I Codici e le arti a Monte Cassino*, III, Monte Cassino, 1870, p. 445, quoting a printed description of that year, in which it is said to be 'composta con bel disegno del Bernini'.

6. '. . . conforme li disegni che saranno consegnati dal Signor Antonio Canevaro a similitudine di quello dell'altare maggiore di S. Andrea a Monte Cavallo de Padri Gesuiti' (*ibid.*, p. 447; the full documentation is reprinted on pp. 446–50). Schiavo points out that Milizia attributed the tabernacle of Monte Cassino to Nicola Salvi (Francesco Milizia, *Le Vite de' più celebri architetti d'ogni nazione e d'ogni tempo*, Venice, 1768, p. 416), which is perfectly possible, given that Salvi was the leading pupil of Canevari, and was left in charge of the Roman workshop when Canevari left for Portugal in 1727 (Armando Schiavo, *La Fontana di Trevi e le altre opere di Nicola Salvi*, Rome, 1956, pp. 27–31).

7. These are described by Schiavo, *La Fontana di Trevi*, p. 30.

8. '. . . e farne il modello a nostre spese a tutto piacere dell'

Architetto . . .' (Caravita, *I Codici e l'arte*, p. 448).

9. 'Ci oblighiamo di fare la facciata, e fianchi di detto Ciborio riquadrato, e centinato conforme il disegno all'intorno delle pietre, e pilastri di pietra dura, che riquadrano detto Ciborio conforme il disegno, e secondo dirà l'Architetto tutto di metallo dorato a zecchino, ma però senza li rabbeschi sopra le pietre, e senza li pilastri, che devono esser di pietra, e senza le teste de Cherubini da piedi d'argento' (*ibid.*, p. 448).

10. I am indebted to Elisabeth Kieven for calling my attention to the tabernacle of Monte Cassino, and to John Pinto for providing me with the bibliography.

11. I am grateful to Marc Worsdale for bringing it to my notice. It was placed on the altar in 1761; perhaps not surprisingly, given its location, it has been described as 'di evidente ispirazione borrominiana' (Mario Bosi, *S. Maria dei Sette Dolori* [Le Chiese di Roma illustrate, no. 117], Rome, 1971, p. 57) Indeed, one could argue that the S. Andrea tabernacle is at least as close to Borromini's style as to Bernini's, and compare the crowning palms to the flames at the top of the spire of Borromini's S. Ivo. It must be said that the bands of ornamentation are hardly typical of either artist.

12. Minna Heimbürger Ravalli, *Architettura, scultura e arti minori nel barocco italiano*, Florence, 1977, pp. 54, 130–3.

13. *Ibid.*, p. 54, note 64; see ASR, Archivio Spada Veralli, vol. 832 (Libro Mastro E, 1647–8), pp. 133, 148, 169, 187, vol. 833 (Libro Mastro F, 1649–50), pp. 33, 38.

14. Heimbürger Ravalli, *Architettura, scultura*, p. 54, note 64; ASR, Archivio Spada Veralli, vol. 490, ff. 245–6; payments are recorded in vol. 832, pp. 133, 177, 181. The crown is not mentioned, and appears to be a later addition.

15. ASR, Archivio Spada Veralli, vol. 832, ff. 133, 179, vol. 835, pp. 43, 45 (a belated payment of 10 July 1653).

16. '. . . a di ult° Xbre [1650] s.151.63 spese in d.ª capella per il tabernacolo altare e sportello' (ASR, Archivio Spada Veralli, vol. 833, p. 38); it is not possible that 'sportello' could mean Algardi's medallion of the *Beheading of St Paul* on the altarfrontal, which is never referred to in that way elsewhere in the accounts, and had been finished in 1648. The relief has sometimes been, absurdly, attributed to Algardi (for a reference to such a confusion see Heimbürger Ravalli, *Architettura, scultura*, p. 53, note 61).

17. See Irving Lavin, *Bernini and the Unity of the Visual Arts*, New York/London, 1980, pp. 95–8.

18. See Karl Noehles, 'Scenografia per le quarant'ore e altari barocchi', in Antoine Schnapper (ed.), *La Scenografia barocca* (Atti del XXIV congresso CIHA, 1979, vol V), Bologna, 1982, pp. 151–5. The strip-lighting now placed inside the tabernacle, while of a monstrous vulgarity, does serve to make it even more eye-catching.

19. BAV, AB, Giustificazioni di Cardinale Francesco Barberini Senior, no. 9472. For the altar see J. Montagu, 'Antonio and Gioseppe Giorgetti: Sculptors to Cardinal Francesco Barberini', *Art Bulletin*, LII, 1970, pp. 283–5; at the time of that article I had not examined this document.

20. '[For having made the models and worked on the waxes for the draperies of the angels on the altar] et fatto diversi altri modelli per d° altare et per il ciborio di metallo et altro–s. 35' (*ibid.*, Giustificazione no. 9472, f. 202).

21. *Ibid.*, Giustificazione no. 9441.

22. BAV, AB, Giustificazioni di Cardinale Francesco Barberini Senior, no. 9259. The total cost of his work (some of which was covered by old metal given him by Francesco Barberini's architect, Paolo Picchetti) was 668 *scudi*. For the basic tabernacle he received 588 *scudi*, with a further 80 for the 'tagliatura, rinettatura et messe agiustati ad opera le sudette 4 porticelli'. In his account he states that 250 *libbre* 'di metallo Vecchio cativo' worth 30 *scudi* was given him by Giorgetti, which was valued by Picchetti (who adjusted the account) at 37.50 *scudi*; however, in the payment this is listed as 'metallo vecchio, e novo' given him by Picchetti, and valued at 30.30 *scudi* (BAV, AB, computisteria, vol. 87, f. 57, mandato 503).

23. BAV, AB, Giustificazione no. 9472, f. 200v.

24. *Ibid.*, Giustificazione no. 9383. Although now only three sides are visible, it is clear from these accounts that the back contains, or contained, decoration similar to that on the sides. It was presumably lined with wood, which was gilded within by Rocco Lolli, who received 17.90 *scudi* for this and other work for Grottaferrata (Computisteria, vol. 87, f. 97v, mandato 840; Giustificazione no. 9395).

25. 'Per haver gettato il suo finim. sopra la cuppoletta da poter Levare et Mettere come Vogliono nettato limato polito etc.' (*ibid.*, Ginstificazione no. 9259).

26. On such devotions see Mark S. Weil, 'The Devotion of the Forty Hours and Roman Baroque Illusions', *Journal of the Warburg and Courtauld Institutes*, XXXVII, 1974, pp. 218–48; Maurizio Fagiolo Dell'Arco and Silvia Carandini, *L'Effimero barocco, strutture della festa nella Roma del '600*, Rome, 1977–8, *passim*; Karl Noehles, 'Visualisierte Eucharistietheologie', *Münchner Jahrbuch der Bildenden Kunst*, XXIX, 1978, pp. 92–116.

27. The tabernacle is illustrated (in colour), but not discussed, in Luigi Salerno's short entry on the high altar of Sta Caterina in Emilio Lavagnino (ed.), *Altari barocchi in Roma*, Rome, 1959, pp. 135–8. It was Mario Bevilacqua who provided the reference to the documents concerning it, and published a brief account of the history of its making with a reasonably accurate transcription of the long account for the metalwork submitted by Nicola Giardoni (Mario Bevilacqua, 'Un ciborio di Carlo Marchionni a S. Caterina da Siena a Magnanapoli', in E. Debenedetti (ed.), *Carlo Marchionni: Architettura, decorazione e scenografia contemporanea* [Studi sul Settecento romano, 4], 1988, pp. 145–51), from which he omitted the reduced sums allowed by the architect, and, more importantly, the founder's name, while listing the names of such minor artisans as Martino Fumet (who made the ironwork), Alessio Bonaccorsi (locksmith), Basilio Marini (gilder –though another gilder is omitted, no doubt because his name, which may be Andrea Ighi, or Igri, is illegible), Francesco Sartori and Carlo (or Cristoforo) Zannetti (companion lead-workers). The substance of that article, with some added information, is printed in *idem*, *Santa Caterina da Siena a Magnanapoli*, Rome, 1993, p. 104.

28. ASR, Cong. Rel. Fem., Domenicani, S. Caterina a Magnanapoli, vol. 4651, int. 330, f. 4.

29. On Marchionni, see Bruno Contardi and Giovanna Curcio (ed.), *In Urbe architectus. Modelli, disegni, misure: la professione dell'architetto romano 1680–1750* (exhibition catalogue), Rome, 1991, pp. 394–6.

30. ASR, Cong. Rel. Fem., Domenicani, S. Caterina a Magnanapoli, vol. 4651, unfoliated.

31. But see below, chapter 6, note 2.

32. BAV, MS. Rossiano 619, ff. 17, 25; the latter is inscribed 'Lo stesso Giardoni in abbito quando va all'Accademia di S. Luca'). In contrast to the well-known caricatures by Pier Leone Ghezzi which seem to have been made for commercial purposes, those of Marchionni are more personal, including members of his

own family and the tradesmen they dealt with.

33. 'E piu per aver cisellate le braccie ad uno delli due Angioli che restano sopra al gradino colle quattro ali delli med.[i] messe assieme, e saldate l'altre braccie dell'altro assestati tutti, e due al piedistallo di d.[o] Ciborio per essere lavoro incommodo; d.[i] Angioli sono stati pagati nel conto Vecchio, arriserva delle fatture sud.[o] che importano s.18.50' (ASR, Cong. Rel. Fem., Domenicani, S. Caterina a Magnanapoli, vol. 4651, unfoliated, item 16 of the account). Antinori reduced the payment to 14 *scudi*.

34. It seems possible that this feature was inspired by the tabernacle in St Peter's (for which see above, p. 66), which stands before the altar-painting by Pietro da Cortona, where four angels support the celestial sphere below the blessing Trinity (see Karl Noehles, 'Teatri per le quarant'ore e altari barocchi', in *Barocco romano e barocco italiano: il teatro, l'effimero, l'allegoria*, ed. Marcello Fagiolo and Maria Luisa Madonna, Rome/Reggio Calabria, 1985, p. 96).

35. 'Per modelli di ogni genere serviti per il d.[o] Ciborio' (ASR, Cong. Rel. Fem., Domenicani, S. Caterina a Magnanapoli, vol. 4651, item 37). This, together with the gilding and the gold used in it, totalled $470.67\frac{1}{2}$ *scudi*, and Antinori lumped them together before reducing the payment to 400 *scudi*. This is unfortunate, for had the various parts been reviewed separately it is certain that if the payment had been made to another workman, such as a sculptor, it would not have been reduced.

36. 'Segue per aver fatto il Bassorilievo di metallo di getto, che rappresenta la resurrezione di N. S. lungo p.[mi] $2\frac{1}{8}$ largo p.[mi] $1\frac{1}{24}$, con piastra dietro con sua anima di legno framezzo che rinchiude la serratura con n.[o] 8 vite e madrevite, che tengano la sud.[o] piastra con suo incastro, che fra metallo gettatura cisellatura, e fattura di tutto il resto importa s. 30' (*ibid.*, item 28). Antinori allowed him 26 *scudi*.

37. That in Rome has been extended on all sides. It was said by Giardoni to measure 47.28 × 23 cm. (see the previous note; I measured it as approximately 46.5 × 22 cm.), whereas that in Siena measures 38 × 20 cm. (Archivio dell'Opera della Metropolitana di Siena, 888 [Inventory of 1863], p. 8; I have been unable to confirm this measurement myself). I am deeply grateful to Monika Butzek for this, and all other references cited from this archive, and for her search in Siena for further information.

38. This emerges from the payment to Giovanni Frittelli, the 'fattore dell'Opera', in AOMS, 744 (Bastardello), f. 105: 'Adi 30 di.mbre [1744]. A M. Giovanni Frittelli lire sessanta cont. per suo rimborso per mancia data alla Corte di Mon.[r] Arcivescovo Zondadari per occasione d'aver regalato il detto Prelato il ricco ciborio del San.[mo] Sacramento per decreto 68 — £60- -' (this payment is also recorded in vol. 2439 [Mandati], 1744, no. 68).

39. Giovanni Antonio Pecci, *Relazione delle cose più notabili della città di Siena . . .*, Siena, 1752, p. 4. See also Ottavio Fratini and Alessandro Bruni, *Descrizione del Duomo di Siena . . .*, Siena, 1818, p. 72, and Guido Mucci, *Nuova guida della città di Siena . . .*, Siena, 1822, pp. 15–16 (which dates the donation 1742). Frattini and Bruni state that it is 'ornato di belle Statuette, ed Angioli a basso rilievo', and the inventory of 1820 also refers to 'statuette ed Angeli a bassorilievo' (AOMS, 886, p. 18); while the 'angels' could refer to the cherub-heads around the door, there are today no signs of anything that could be called statuettes.

40. One might compare the drawing of the *Resurrection* (Würzburg 7784), illustrated in Rudolf Berliner, 'Zeichnungen von Carlo und Filippo Marchionni', *Münchner Jahrbuch der Bildenden Kunst*, 3. Folge, IX/X, 1958–9, fig. 22, p. 283; this rather different representation of the scene cannot have been intended as a study for either tabernacle, as it was to measure about $2\frac{1}{12}$ × $1\frac{3}{12}$ *palmi*, i.e. about 46.54 × 27.92 cm.

41. Most notably Luigi Salerno in Emilio Lavagnino (ed.), *Altari barocchi*, pp. 61–5; Karl Noehles, 'Das Tabernakel des Ciro Ferri in der Chiesa Nuova zu Rom', *Miscellanea Bibliothecae Hertzianae*, Vienna/Munich, 1961, pp. 429–36; Giovanni Incisa della Rocchetta, 'Del ciborio di Ciro Ferri alla Vallicella', *L'Oratorio di S. Filippo Neri*, XIX, 10, October 1962, pp. 1–6; Giovanni Incisa della Rochetta and Joseph Connors, 'Documenti sul complesso Borrominiano alla Vallicella (1617–1800)', *Archivio della Società Romana di Storia Patria*, CIV, 1981, pp. 99–136, Bruce W. Davis, *The Drawings of Ciro Ferri* (Ph.D. thesis for the University of California, Santa Barbara), Ann Arbor, 1984, pp. 28–9. What follows is virtually a repetition, with some omissions, of my own article, 'Ciro Ferri's Ciborium in Santa Maria in Vallicella', *Source*, VIII/IX, nos. 4/1, 1989 ('Essays in Honor of Rudolf Wittkower'), pp. 49–57; I am grateful to the editors of *Source* for allowing me to include it here.

42. A.Val., C.I.8, p. 43.

43. See A.Val., C.I.8, p. 162. For a summary discussion of these, see my article cited in note 41.

44. Klaus Lankheit, *Florentinische Barockplastik. Die Kunst am Hofe der letzten Medici 1670–1743*, Munich, 1962, doc. 55; for other references to the tabernacle see also docs. 62, 81, 83, 84, 87 and 91.

45. A.Val., C.I.8, p. 386.

46. A.Val., C.I.8, p. 387.

47. A.Val., C.I.8, pp. 410 433, 445, 446; C.I.9, p. 3; ASR, Oratorio, 208, *mandati* 1679, nos. 122, 131; *mandati* 1681, nos. 85; 209, *mandati* 1683, no. 28, *mandati* 1684, no. 69. The metal supplied is listed in Archivio della Reverenda Fabbrica di S. Pietro, 1.[o] Piano, Serie Armadi, 339 (Entrata di Munitione dela R. Fabrica . . .), under dates in the spring and autumn of 1674: pp. 45–6 (*metallo*), 76, 79 (*rame*), 111 (*stagno*). On Cesare Massei (or Mazzei) see Carlo Gasbarri, *L'Oratorio romano dal Cinquecento al Novecento*, Rome, 1962, pp. 178–9; it may be noted that Ferri's statuettes of gilt bronze saints in the Gesù were paid for from a legacy of Cesare Massei (see Lankheit, *Florentinische Barockplastik*, p. 39; there are, in fact, eight, not four as Lankheit says).

48. Filippo Titi, *Ammaestramento utile, e curioso di pittura scoltura et architettura nelle chiese di Roma*, Rome, 1686, p. 301.

49. Antonio Bertolotti found a reference to Stefano in the Roman archives in 1671, but does not say where, nor what it concerned (A. Bertolotti, *Artisti bolognesi, ferraresi ed alcuni altri del già stato pontificio in Roma nei secoli XV, XVI e XVII*, Bologna, 1886, p. 202); this must be the finials (*vasi*) for the pope's chair, for which payments are listed in ASV, SPA Computisteria, vol. 3028 (second series of numbers) nos. 30, 35, 53 and 68, and vol. 147, f. 7; the fact that this last *mandato* is approved by Giovanni Paolo Schor suggests that he may have designed them.

50. This, and the following facts, emerge from the various documents assembled in the unpaginated *busta*, A.Val., 16.a, printed here as appendix II.

51. Antonio Mannotoli had died on 19 April 1676 (Costantino G. Bulgari, *Argentieri, gemmari e orafi d'Italia; Parte prima – Roma*, II, Rome, 1959, p. 85).

52. Although Domenico Vincenzo normally used only his second name, his full name appears in the documents concerning plates he and his brother Giovanni Stefano were making for count

Giuseppe Malvasia, which involved his temporary imprisonment (ASR, Not. A.C., Belletus, vol. 814, ff. 199–202v, 251–2v); it is possible that he did so to avoid confusion with their father, also a silversmith, Domenico Brandi from Siena (see Bulgari, *Argentieri*, I, Rome, 1958, pp. 207–9; to complicate matters, the Oratorians had earlier employed their father). It should be noted that, although they held a shop in common, only Giovanni Stefano was a member of the guild (Belletus, vol. 814, f. 201; Bulgari, *Argentieri*, I, p. 208; Anna Bulgari Calissoni, *Maestri argentieri gemmari e orafi di Roma*, Rome, 1987, p. 114), which may be why only he was named elsewhere in the accounts of the Oratory. Such an arrangement whereby only one of two brothers working together was actually a member of the guild was quite common (see above, p. 131).

53. See appendix II.

54. ASR, Notaro A. C., Belletus, vol. 813, ff. 709r–v, 728r.

55. Both were also asked to act as experts in 1655 in the case concerning a marble group of *Latona* by Domenico Pieratti (see Claudio Pizzorusso, *A Boboli e altrove: sculture e scultori fiorentini del Seicento*, Florence, 1989, p. 17).

56. '. . . due Angeli grandi, due piccoli, . . . il valore della materia, formatura, cere anche più volte fatte, calo di metallo, gettito, e tutto quello che è stato di spesa per sue lavori sino alla consegna del med^me . . . (ASR, Not. A.C., Belletus, vol. 814, ff. 168r, 169r). In these estimates they did not include 'la rinettitura delle cere, ne il calo di lb. sei per cento che è solito pagarsi al fonditore per la lega che aver fatto di rame e stagnio, . . . etc.'.

57. The documents concerning this dispute are assembled in A.Val., busta 16.a, reproduced here in appendix II.

58. Both these experts were architects and not known to have had any experience of bronze casting, though Contini claimed to have consulted others with such experience. As will be seen in chapter 6, Fontana was later to be much involved with bronzes cast from his designs.

59. It is true that Ciro Ferri seems to have liked the motif, for he included it in another design, presumably for a monstrance, now in Düsseldorf, (inv. 11605; black pencil, 25.7 × 13.3 cm.); this is illustrated J. Montagu, 'A Bozzetto in Bronze by Ciro Ferri', *Jahrbuch der Hamburger Kunstsammlungen*, XVIII, 1973, p. 124, fig. 5.

60. Rome, Istituto Nazionale per la Grafica, inv. 124451; pen and brown ink, 19.8 × 11 cm. See Maria Giannatiempo, *Disegni di Pietro da Cortona e Ciro Ferri* (exhibition catalogue, Istituto Nazionale per la Grafica, Gabinetto Nazionale delle Stampe), Rome, 1977, no. 68; Davis, *The Drawings*, p. 292.

61. Windsor Castle, Royal Library, inv. 4482; black chalk, 35.2 × 26 cm. See principally Anthony Blunt and Hereward L. Cooke, *Roman Drawings of the XVII and XVIII Centuries in the Collection of Her Majesty the Queen at Windsor Castle*, London, 1960, cat. 657; Noehles, 'Das Tabernakel des Ciro Ferri . . .', p. 432; Anthony Blunt, *Supplements to the Catalogues of Italian and French Drawings with a History of the Royal Collection of Drawings* [in Edmund Schilling, *The German Drawings in the Collection of Her Majesty the Queen at Windsor Castle*], London, 1960, no. 172; Davis, *The Drawings*, p. 310.

62. If this were so, one might be tempted to suggest that the drawing by Algardi in the British Museum, previously held to be for an altar with its ciborium, but which I described as for a reliquary (London, British Museum, At-10-100; see Montagu, *Alessandro Algardi*, p. 484, no. 70), could have been an earlier idea for the altar and tabernacle of the Vallicella, for the empty oval would fit this relief. There is no evidence that Algardi made such a design, but he had close connections with the

church. If this (entirely hypothetical) suggestion were correct, it would be an interesting prefiguration of the connection of angels with the ciborium, which was to be developed by Ciro Ferri.

63. Lankheit, *Florentinische Barockplastik*, doc. 55.

64. See also that in Sta Maria della Scala, discussed below, note 75.

65. As Karl Noehles has written, 'da un punto di vista esegetico il trono dell'agnello è intercambiabile con la sede della gloria celeste dell'eucaristia' (Noehles, 'Teatri per le quarant'ore', p. 94).

66. 'Adi 18 aprile 1684. Io infrascritto ho ricevuto dal Padre Giovan Benedetto Colocii, prefetto della sagrestia de la Chiesa Nova di Roma, scudi quindici, quali sono per intiero e total pagamento del modello di creta, da me fatto, che deve servire per compimento o chupolino del tabernacolo di bronzo, fatto da detti Padri, secondo il disegno del Sig. Ciro Feri, dichiarandomi interamente sodisfatto, questo dì et anno sudetto. Io Francesco Novelone mano propria.' (Incisa della Rocchetta, 'del Ciborio', p. 4, citing A.Val, Cassetta 44); I have been unable to trace the original document.

67. A.Val., C.I.8, p. 456.

68. 'Si riduca il Tabernacolo di bronzo a forma migliore, con far, per adesso, di legno quello che è necessario, acciò possa servire convenientemente.' (A.Val., C.I.9, p. 19).

69. A.Val., C.I.9, p. 22.

70. A.Val., C.I.9, p. 22.

71. It remains possible that they were part of the original conception; being on the sides Ferri may not have included them, though the grapes can in fact be seen from the front.

72. Despite their solid appearance, these angels have no backs.

73. It does not appear to be added in sheet-metal, as was more often the case with repairs to failed casts (see Chandler W. Kirwin and Philipp Fehl, 'Bernini's *decoro*: Some Preliminary Observations on the Baldachin and on his Tombs in St. Peter's', *Studies in Iconography*, VII–VIII, 1981–2, p. 353).

74. The apse fresco was probably begun in 1680, and completed by July 1683; see Robert Enggass, *The Paintings of Baciccio – Giovanni Battista Gaulli 1639–1709*, University Park, Pennsylvania, 1964, pp. 67–8, 137–8.

75. A lamb appears on the altar which Carlo Rainaldi designed in 1647 for Sta Maria della Scala; see Furio Fasolo, *L'Opera di Hieronimo e Carlo Rainaldi (1570–1655 e 1611–1691)*, Rome [1960], p. 114. However, the pedestal with the lamb dates from 1725, and we may note that this gilt bronze lamb could be removed for solemn ceremonies, and replaced by the sacrament (*Cenni storici sui conventi dei PP. Carmelitani Scalzi della provincia romana*, Rome, 1929, p. 16). It is probable that the bronze-coloured terracotta saints above the side columns were made at the same time, since they are copied from those in the nave niches of S. Giovanni in Laterano.

76. For the painting see Michael Jaffé, *Rubens and Italy*, Oxford, 1977, pp. 85–99.

77. A minor, but influential early example is by Jacopo Sansovino in Sta Croce in Gerusalemme in Rome; see Bruce Boucher, *The Sculpture of Jacopo Sansovino*, New Haven/London, 1991, II, pp. 325–6 (cat. 16), and figs. 110–11. Ferri himself was to make use of angels kneeling in adoration of a relic in the reliquary he made for the Co-Cathedral in Valletta, delivered in 1689; see Hano-Walter Kruft, 'A Reliquary by Ciro Ferri in Malta', *Burlington Magazine*, CXII, 1970, pp. 692–5.

78. Windsor Castle, Royal Library, inv. 4448; pen and brown wash over black chalk, 39.8 × 56.8 cm. See Blunt and Cooke, *Roman Drawings*, cat. 591.

79. See Noehles, 'Visualisierte Eucharistietheologie', fig. 11; on the date of this project, see Fagiolo Dell'Arco and Carandini, *L'Effimero barocco*, I, pp. 153–4. See also the closely related project by Ferri in Stockholm, Nationalmuseum, Celsing Collection 10/1875 (Noehles, 'Visualisierte Eucharistietheologie', fig. 12; it was this article by Noehles which first related the Vallicella ciborium to Quarant'Ore designs). It may be noted that this project also includes a rather similar pelican, which Noehles associates with an *impresa* of Clement IX.

80. I put forward this attribution in 'Bernini Sculptures Not by Bernini', in Irving Lavin (ed.), *Gianlorenzo Bernini. New Aspects of His Art and Thought*, University Park (Penn.)/London, 1985, p. 31. Andrea Spiriti has also recently published the tabernacle as the work of Raggi, dating it to around 1673 on the basis of a not wholly satisfying assumption of its close relationship to Bernini's developing ideas for his tabernacle in St Peter's, and apparently in ignorance of the fact that it is mentioned in Carlo Torre's *Il Ritratto di Milano*, Milan, 1674, p. 103; however, it is not fully described (still without an attribution) until 1737, in Serviliano Latuada's *Descrizione di Milano*, Milan, 1737–8, III, p. 252 (A. Spiriti, 'La Cultura del Bernini a Milano: Santa Maria della Vittoria (1655–1685)', *Arte lombarda*, N.S., 108–9, 1944, pp. 108–14).

81. Oskar Pollak, *Die Kunsttätigkeit unter Urban VIII*, II, Vienna, 1931, p. 302.

82. See Karl Noehles, 'Zu Cortonas Dreifaltigkeitsgemälde und Berninis Ziborium in der Sakramentskapelle von St. Peter', *Römisches Jahrbuch für Kunstgeschichte*, XV, 1975, pp. 169–82; idem, 'Teatri per le quarant'ore', p. 96; Jörg Martin Merz, *Pietro da Cortona: Der Aufstieg zum führenden Maler im barocken Rom*, Tübingen, 1991, pp. 204–9. At the time of the commission of both the tabernacle and the painting, the sacrament was kept in the Cappella Gregoriana, and not till the late 1630s was it moved to the present Sacrament Chapel; despite the arguments of Noehles and Merz, it is therefore not possible that Cortona designed his altarpiece with its complex iconography in the knowledge that the lower part would be almost entirely obscured. I am grateful to Louise Rice for discussing this question with me, and showing me the convincing arguments she will be advancing in her forthcoming book, *Altars and Altarpieces of New St. Peter's. Outfitting the Basilica, 1621–1666*.

83. Pollak, *Die Kunsttätigkeit*, II, pp. 302–5. It was apparently only some 70 cm. smaller than the final bronze tabernacle (Merz, *Pietro da Cortona*, p. 208).

84. See Heinrich Brauer and Rudolf Wittkower, *Die Zeichnungen des Gianlorenzo Bernini*, Berlin, 1931, p. 174.

85. The similarity of the Hermitage drawing (Fig. 85) to the idea of the Cattedra does not prove that it is of same date; cf. Maurizio and Marcello Fagiolo dell'Arco, *Bernini. Una introduzione al gran teatro del barocco*, Rome, 1967, cat. 169.

86. State Hermitage Museum, no. 126; pen with brown ink and wash, 38 × 26 cm.

87. Including, of course, the final executed elephant, with the open space between his two pairs of legs.

88. Windsor Castle, Royal Library, no. 5561; black chalk, 14.1 × 15.2 cm. See Blunt and Cooke, *Roman Drawings*, cat. 29.

89. See Brauer and Wittkower, *Die Zeichnungen*, pls. 131 b-136. Many of these are illustrated and discussed in Linda Klinger's contribution on the 'Sacrament Altar', in Irving Lavin (ed.), *Drawings by Gianlorenzo Bernini* (exhibition catalogue), Princeton, 1981, pp. 316–35.

90. Leipzig, Museum der Bildenden Kunst, no. 7877; black chalk, 14.9 × 10 cm.

91. '. . . il ciborio non sarebbe stato quasi aderente alla parete, ma bensì presso che nel mezzo della cappella . . .' (F. M. Mignanti, *Istoria della Sacrosanta Patriarcale Basilica Vaticana*, Rome, 1867, II, p. 107, quoted in Brauer and Wittkower, *Die Zeichnungen*, p. 173).

92. Windsor Castle, Royal Library, 5562; pen and brown ink with brown wash over black chalk, 15.3 × 13.6 cm. See Blunt and Cooke, *Roman Drawings*, cat. 30.

93. *Canones, et Decreta Sacrosancti Oecumenici, et Generalis Concilii Tridentini*, Rome, 1564, p. LXXIIII (Session XIII, chapter 5).

94. Cambridge (Mass.), Fogg Museum of Art, inv. 1937.63.

95. Leipzig, Museum der Bildenden Kunst, no. 7836; black chalk, 15.6 × 16.1 cm. It is generally assumed that, instead of the kneeling angels with candles, he experimented with the idea of setting angels bearing candelabra against the walls, though there is no certainty that the existing drawing for such angels (Leipzig, Museum der Bildenden Kunst, no. 7817r) is related to the tabernacle projects (see Brauer and Wittkower, *Die Zeichnungen*, pl. 127 b, and p. 175; Klinger, 'Sacrament altar', cat. no. 98, and p. 320). One problem it raises is the question of which wall they should have been attached to: they are all seen in profile, but in the Sacrament Chapel there are no projecting pilasters to which they could be attached, and the side walls of this broad and relatively shallow chapel are much too far from the altar to have been used for this purpose. The altar painting is recessed some distance behind the circular tabernacle (see the plan in de Rossi' *Studi d'architettura civile*, reproduced in Klinger, 'Sacrament altar', p. 321, fig. 120), but, as the angels are all shown looking inwards, they could hardly have been set against these walls.

96. Windsor Castle, Royal Library, inv. 11592; pen and grey wash, 51 × 74.5 cm. Blunt and Cooke, *Roman Drawings*, cat. 31.

97. This door was presumably made by Carlo Padredio (or Patredio), who claimed payment for a sheet-copper relief of 'un Calice con lostia con fronde e piede lavorato', as well as the 'caseta che va dentro al tamuro [sic., for 'tamburo'?] la quale deve servire per tener lostensorio di piastra di rame' also of sheet-copper (ARFSP, 1° Piano, Serie 3, no. 4a, int. 10).

98. Karl Noehles has suggested that Cortona conceived his image well aware that the globe would be covered, and that 'sia otticamente sia iconologicamente, un grande tabernacolo avrebbe preso il posto del globo, il tabernacolo come Arca del nuovo patto' (Noehles, 'Teatri per le quarant'ore', p. 96). This seems to me highly questionable; see above, note 82.

99. After this book was in proof Anna Menichella published most of the relevant documents in her article 'Documenti della Reverenda Fabbrica di San Pietro per il ciborio berniniano del Santissimo Sacramento', *Archivio della Società Romana di Storia Patria*, CXVI, 1993, pp. 218–41. Mention should however be made of the templates for the lapis lazuli sill preserved in the ARFSP, 1° Piano, Serie 3, no. 4a.

100. Payments for this work are to be found in RFSP, 1° Piano, Arm, 348, pp. 137–64. Other documents concerning the tabernacle are to be found in Arm. 312, ff. 35–6 (the metal given to Lucenti and the weight of each piece of the tabernacle); Arm. 339, pp. 42–6, 75 (concerning the metal given out, and returned); Arm. 373, pp. 3–58 (*mandati*); 2° Piano, serie 4, vol. 15, ff. 4–230 (*Giustificazioni*). Many payments are repeated from one volume to another. Frequently they are unspecific, being merely for work on the 'ciborio' and I have cited in the

following notes only those that refer to the particular work. Further material is to be found in RFSP, 1º Piano, Serie 3, no. 4a, int. 10.

101. The first payment of 25 *scudi* was simply 'per lavorare nelli modelli di Ciborio . . .' (RFSP, 1º Piano, Arm. 348, p. 144 left), but, as all the following payments were for work on the *Angels*, or the *Apostles*, it seems improbable that a sculptor would have been called on to contribute to the *tempietto*.

102. RFSP, 1º Piano, Arm. 348, pp. 155–6, 163.

103. RFSP, 1º Piano, Arm. 312, ff. 35v–36; Arm. 339, p. 55.

104. RFSP, 2º Piano, ser. 4, vol. 15, ff. 24–70 *passim*. Mattei also cleaned the metal (*ibid.*, ff. 4, 11, 17v).

105. His name is difficult to read, but it could be Lorenzo Chiani, or possibly Chiavij (RFSP, 2º Piano, ser. 4, vol. 15, f. 4v).

106. RFSP, 1º Piano, Arm. 312, ff. 35–6; Arm. 339, p. 55; 2º Piano, Serie 4, vol. 15, ff. 229v–30.

107. RFSP, 1º Piano, Arm. 373, p. 19; 2º Piano, ser. 4, vol. 15, f. 30.

108. *Ibid.*, ff. 31, 46v; see also ff. 158, 209, 213.

109. RFSP, 2º Piano, Serie 4, vol. 15, f. 70.

110. RFSP, 2º Piano, ser. 4, vol. 15, f. 17.

111. RFSP, 1º Piano, Arm. 312, f. 35; Arm. 348, p. 164; Arm. 339, p. 53.

112. RFSP, 1º Piano, Arm. 348, p. 144; Arm. 373, p. 19, 25; 2º Piano, Serie 4, vol. 15, ff. 17v, 30, 70.

113. RFSP, 2º Piano, Serie 4, vol. 15, ff. 46, 46v, 55.

114. RFSP, 2º Piano, Serie 4, vol. 15, ff. 74, 306. See J. Montagu, 'Two Small Bronzes from the Studio of Bernini', *Burlington Magazine*, CIX, 1967, pp. 570–1.

115. He worked extensively as a modeller for Bernini: in 1669 he made the cloth behind the figure of *Constantine* and the two angels supporting the arms of the pope (RFSP, Arm. 348, p. 111), in 1670 he made the *Fames* supporting the Pamphili arms over the door of S. Andrea al Quirinale, and the stuccos of the altar (Ugo Donati, 'Gli Autori degli stucchi in S. Andrea al Quirinale', *Rivista del R. Istituto d'Archeologia e Storia dell'Arte*, VIII, 1940–1, pp. 144–5) and in 1672 the small and large clay models for the figures of *Charity, Justice, Prudence*, and *Death*, and also the model for the great cloth, for the tomb of Alexander VII (Vincenzo Golzio, *Documenti artistici sul Seicento nell'archivio Chigi*, Rome, 1939, pp. 109, 117–20). Other works have been ascribed to him by Donati, who claimed for the most insubstantial reasons that he came from the Ticino (Ugo Donati, *Artisti ticinesi a Roma*, Bellinzona, 1942, p. 501). He was almost certainly the Frenchman Jean Regnault (Rinaldi) whom Bousquet found recorded in the Stati d'Anime from 1672–82 (Jacques Bousquet, *Recherches sur le séjour des peintres français à Rome au XVIIème siècle*, Montpellier, 1980, p. 233). However, as early as 1674 Titi ascribed the *Fames* in S. Andrea to 'Giovanni Sciampagna Francese' (Filippo Titi, *Studio di pittura, scoltura, et architettura, nelle chiese di Roma (1674–1763)*, ed. Bruno Contardi and Serena Romana, Florence, 1987, p. 162), since when it has been widely accepted that Rinaldi (who, throughout the payments for the ciborium, and often elsewhere, is called 'Monsù' – an indication that he was foreign, but not necessarily French) is to be identified with the Frenchman Jean Champagne (Stanislas Lami, *Dictionnaire des sculpteurs de l'école française sous le règne de Louis XIV*, Paris, 1906, pp. 83–4, followed by Ulrich Thieme, *Allgemeines Lexikon der bildenden Künstler*, Leipzig, VI, 1912, p. 352). Donati rejected this on the basis that, according to Lami, Jean Champagne arrived in Rome as a pensioner of the Academy in 1679, but this is a misunderstanding: he was accepted into the Academy in that year, and must already have come independently to Rome

(Anatole de Montaiglon, *Correspondance des Directeurs de l'Académie de France à Rome avec les Surintendants des Bâtiments*, I, Paris, 1887, p. 88); however, it is none the less questionable whether an established artist of a certain age would have been accepted among the students. If the identification of Rinaldi with Champagne can almost certainly be rejected, one may still ask whether the lost high altar of S. Trinità dei Monti, which Titi also ascribed to 'Sciampagna' in 1684 (*Studio di pittura*, p. 198), was by Rinaldi or Champagne, and whether this Jean Champagne is to be identified with the 'Monsieur Giovanni di Sciampagna' who executed a number of works in Perugia, including the altar of S. Carlo in S. Ercolano dated 1682 (Baldassarre Orsini, *Guida al forestiere per l'augusta città di Perugia*, Perugia, 1784, p. 80).

116. 'Il Ciborio . . . che hà fatto fare S. Stà e la Sagª Cong. al dº Bernino s'è perfettionato in mese venticinque nel quale continuamente ha sopraintendento all'opera, e Maestranze, e fatto di sua mano i modelli piccoli, e grandi.' (See Brauer and Wittkower, *Die Zeichnungen*, p. 174, note 3).

117. See J. Montagu, *Roman Baroque Sculpture: The Industry of Art*, New Haven/London, 1989, pp. 99–103.

118. See *ibid.*, pp. 70–2.

119. It is sufficient to compare my Figs. 84 and 93: in the former *Simon* appears to the left of *Peter*, and to the right of *Paul* are two figures I cannot identify; in the latter, *Bartholomew* and *John* appear to the left of *Peter*, and *James*, and another *Apostle* I shall call the *Pseudo-James* (to be discussed later in the text) are to the right of *Paul*.

120. I owe this photograph to the kindness of Irving Lavin, for whom it was made.

121. It is extremely unfortunate that his cross should now be attached by a ring, totally changing its angle. I have no faith in the engraving by Bombelli (illustrated in Mark S. Weil, 'A Statuette of the Risen Christ Designed by Gian Lorenzo Bernini' *Journal of the Walters Art Gallery*, XXIX–XXX, 1966–7, fig. 4, p. 13), which omits the clouds, and, by resting the base of the cross on the cupola, makes it appear too short, while also probably altering its original angle.

122. Baltimore, Walters Art Gallery, Inv. no. 54.2281; 44 cm.

Chapter 4: The Medal. Some Drawings for the Hamerani

1. Nathan Whitman has stressed the propaganda aspect of papal medals (see his introduction to Nathan T. Whitman and John L. Varriano, *Roma Resurgens: Papal Medals fom the Age of the Baroque* [exhibition catalogue], Ann Arbor, 1983, p. 9). Graham Pollard has denied this, on the basis of his useful analysis of the subjects represented on the reverses, but his argument depends on a rather narrow interpretation of propaganda (Graham Pollard, 'La Medaglia con ritratto di epoca barocca in Italia', in *La Medaglia d'arte; Atti del primo convegno internazionale di studio, Udine, 1970*, Udine, 1973, p. 142).

2. A special class of medal, rather smaller and lighter, was made to be attached to rosaries. Usually these would be made by a goldsmith, or the rosary-maker, rather than a medallist.

3. Both sides of this octagonal medal in the Ashmolean Museum (inv. VI.5.98) are signed with the Roman wolf and twins, the sign of the Hamerani shop.

4. For a brief period in the second half of the 1620s and early '30s the accounts describe the bronze used for the papal medals as 'Corinthian bronze' (*metallo di corinto*) which was part of that taken by Urban VIII from the Pantheon (ASR, Cam. IIº,

Zecca, busta 27; this definition is given for those made by Gaspare Mola in 1628).

5. Cellini described the method (*The Treatises of Benvenuto Cellini on Goldsmithing and Sculpture*, transl. C. R. Ashbee, London, 1888 [reprinted Dover Publications, Inc., New York, 1967], pp. 67–74). Puncheons are illustrated in *La Médaille au temps de Louis XIV* (exhibition catalogue), Paris (Hôtel de la Monnaie), 1970, pp. 389–91, following a description of the striking of medals. For a list of puncheons used for papal coins in the mid-eighteenth century, see ASR, Cam. II°, Zecca, Antichità e belle arti, 4, int. 137, the *Sommario* (justifying documents) of Sala and Miselli's printed plea on behalf of Ferdinando Hamerani of 1764, point 11B. For illustrations of presses, see *Roma Resurgens*, p. 14.

6. Late restrikes are usually spurned by collectors, but, provided that the die has not been damaged, a restrike may be sharper than an earlier example abraided by time. This common-sense approach was taken by Whitman in his introduction to *Roma Resurgens*, p. 10.

7. See Antonio Bertolotti, *Artisti lombardi a Roma nei secoli XV, XVI, XVII*, Milan, 1881, II, pp. 189–230; Costantino G. Bulgari, *Argentieri, gemmari e orafi d'Italia; Parte prima – Roma*, Rome, II, 1959, p. 160; Mara Visonà, in *Il Seicento fiorentino*, Florence, 1986, III, pp. 129–32. Surprisingly, an account for an elaborate frame in semi-precious stones and gold made by Mola in 1730 is included in the accounts of the papal mint (ASR, Cam. II°, Zecca, busta 27; see Bertolotti, *Artisti lombardi*, II, p. 196). From his inventory it is evident that he specialised in the inlaying of semi-precious stones (*ibid.*, pp. 224–8) such as the 'quadro della Madonna di Loreto' made for Cardinal Scipione Borghese in 1630–1 (ASV, Arch. Borghese, vol. 6093, mandati nos. [1630] 400, 407, 439, [1631] 102).

8. BAV, Arch. Chigi, vol. 447, f. 33, mandato of 14 August 1663.

9. ASR, Not. Trib. A.C., Fonthia, vol. 3175, ff. 268–73v, 326–8v.

10. ASV, SPA Computista vol. 3036, pp. 265, 309, vol. 3037 no. 214.164. An as yet unexplored aspect of the Hamerani's work is suggested by the inclusion in the 1764 inventory of the shop of the rosary-maker Nicola Haim of 'quattro Crocefissi d'argento in Croce d'ottone dorato modello d'Amerani' (ASR, 30 Not. Cap., Uff. 21 [Oliverius], vol. 458, f. 231v). On Ermenegildo's death his brother Ottone was compelled to join the goldsmiths' guild if he wished to continue as medallist to the Sacro Palazzo Apostolico (Bulgari, *Argentieri, gemmari e orafi*, II, p. 10).

11. The inventory taken after his death included fifty-four silver medals of the duke, for which presumably had found no suitable recipients (Gisela Rubsamen, *The Orsini Inventories*, Malibu, 1980, p. 16, no. 247).

12. See Ivan Mirnik, 'Livio Odescalchi on Medals', *The Medal*, no. 25, Autumn 1994, pp. 50–5.

13. See Carl Nils Daniel de Bildt, *Les Médailles romaines de Christine de Suède*, Rome, 1908; some obverses were combined with more than one reverse.

14. For these various medals see Franco Bartolotti's preface to his *La Medaglia annuale dei romani pontefici da Paolo V a Paolo VI, 1605–1967*, Rimini, 1967, pp. VII–X.

15. ASR, Not. Trib. A.C., Fonthia, Testamenti, vol. 28, f. 363. This will, and the final will of 1640, are printed in Bertolotti, *Artisti lombardi*, II, pp. 202–11; the references to his dies occur on pp. 204 and 209–10.

16. BAV, AB, Giust. 7026. Varriano had doubted that anyone but the pope would acquire restrikes in anything other than bronze (John L. Varriano, 'Some Documentary Evidence on the Restriking of Early Papal Medals', *American Numismatic Society. Museum Notes*, XXVI, 1981, p. 216).

17. See his will, ASR, 30 Not. Cap., Uff. 3 (Cataldus) vol. 406, ff. 323–6v, 353r–v, on f. 326v.

18. ASR, Cam. II°, Antichità e Belle Arti, busta 4, int. 137 (unfoliated). Attempts had been made to sell the collection in 1778 and 1785, before agreement on a price was finally reached in 1796. Ferdinando Hamerani had been in financial difficulties for many years, and in 1769 his creditors took over his business, leasing it back to him (ASR, 30 Not. Cap., Uff. 2 [Paulettus], vol. 596, ff. 11–20v). Gaspare Morone from 1641 to 1649 had included a sum for the making of the dies, which was regularly crossed out (ASR, Cam. II°, Zecca, busta 28). Only once after this did he repeat the attempt, in 1658, for the foundation medals for the Piazza di S. Pietro and the church of Castel Gandolfo; although the sums he requested, 40 *scudi* and 30 *scudi* respectively, were disallowed, he was given 40 *scudi* for the two, 'per essersi di queste fatta poca quantità et esser più grandi del solito con che non passi per l'avenire in essempio' (*ibid.*, int. 11). However, Sala and Miselli in their *Sommario* (see above, note 5), point 8, refer to reduced payments Morone received for dies in the 1660s, in accounts missing from the archives.

19. Bartolotti, *La Medaglia annuale*, doc. 10, p. 405.

20. See Giancarlo Alteri, *Vat. Lat. 15232. Disegni degli incisori Hamerani eseguiti dai medesimi in medalglie e monete pontificie*, Rome, 1995, no. 4.

21. For an excellent overview of papal medals, with a rare appreciation of their artistic value, see *Roma Resurgens*.

22. The question of drawings for medals was the theme of the conference organised as part of the FIDEM meeting in London in 1992 (most of the papers are published in Mark Jones [ed.], *Designs on Posterity*, British Art Medal Trust, 1994), but only two (unpublished) papers dealt with the Roman baroque. One of those forms the basis of this chapter.

23. Bartolotti prints the list of those who received the annual medal in 1671 (*La Medaglia annuale*, doc. 45, pp. 416–17), but lists for many other years exist, most notably those covering the years 1670–89 (ASR, Cam. II°, Zecca, busta 28); in the same collection of accounts is the lists for the *possesso* of 1670 and 1676 (it may be noted that the pages who took part in the *possesso* of 1670 each received a medal with images of the Holy Sacrament on one side, and St Elizabeth of Portugal on the other), 1690–'96, 1699, 1739–'69 (*ibid.*, busta 29, which also includes the distribution lists for the *possesso* of 1692 and 1758). Other lists turn up in various places, e.g. that of 1729 in ASR, Cam. I°, Giustificazione di Tesoreria, busta 545, interno 18, and that of 1758 in ASR, Computisteria Generale della RCA, serie verde, busta 36, no. 98. It should be remembered that in most years some people got left off the list, and often a few extra medals had to be struck for them; none the less, the numbers cited by Bartolotti serve to indicate how these fluctuated, with, for example, the lavish distribution of Clement X drastically reduced in the economy drive of Innocent XI. In some years those medals not distributed the previous year were melted down, and the metal reused.

24. ASR, Cam II°, busta 29, int. 96.

25. To give only two of the numerous examples: in August 1682 Giovanni Hamerani struck not only twelve gold medals of the current year, but also twelve silver medals of 1677, 'Salva nos domine' (ASV, SPA, Computisteria, 148, f. 154); in September 1708 Ermenegildo Hamerani struck examples of the

medal with the Porta di Ripetta, issued the previous year, to be sent to the Tsar of Moscow (*ibid.*, 154, f. 14, no. 163).

26. Often accounts concerning the making of medals with reverses from previous years do not specify the date of the obverse, so it is possible that some may have had obverses of the current year. There are also numerous accounts for a number of medals with various reverses, where the obverse is simply described as bearing 'il ritratto di Sua Santità' (or a similar phrase), which might suggest that the same obverse was used for all of the reverses, but need not necessarily mean that. It should also be noted that during the negotiations for the 1778 sale of the Hamerani dies to the papal mint it was observed that various obverses were missing, and the suggestion made that they had been reused with other reverses, 'anche si osservano molte Medaglie di Paolo III. ad Alessandro VII., le quali sono state imprese con conj di anni diversi . . .' (ASR, Cam. II⁰, Antichità e Belle Arti, busta 4, int. 137 [unfoliated]), so the widely held opinion that such mules were made only after the Hamerani and other collections had entered the papal mint is certainly false. For the rather different matter of the reuse of existing reverses as a lazy way to make some of the medals of Sixtus V, and the question of mules in general, see Giancarlo Alteri, in Maria Luisa Madonna (ed.), *Roma di Sisto V. Le arti e la cultura* (exhibition catalogue), Rome, 1993, pp. 447–9.

27. 'Adi 21 Marzo 1679. La Revᵃ Camera Apᶜᵃ deve dare a Noi Gio: Hamerani e Critofano Marchione Medagliarij di nostro Sigʳᵉ scudi Doi cento Vinti Cinque e grani vintiuno di oro stampe per valuta di Libre doi oncie due e denari dodici grani quattro di oro di carati venti dui che anno pesato N⁰ trenta sette medaglio d'oro Papali nelle quali da Una parte vi e Lefigie de Nostro Sigʳᵉ con Lettre attorno, Innocen. XI. Pont. Max. An. II. e per rinverscio a N.ᵗᵒ 24. di dette Medaglie ci e S. Pietro e S. Paolo con Lettre a Torno, Audite Voces. Supplicum et a altre otto ci era Cristo Con li Dodici Apostoli con Lettre Tu Domine. et Magister. Exemplum dedi vobis. et tre altre con Christo e S. Pietro con la Navicella con Lettre Salva Nos Domine, et Doi altre con il S. Pietro a sedere del Anno III . . .' (ASR, Cam. II⁰, Zecca, busta 28, int. 29).

28. 'Adi 3 Aprile per una medagᵃ di Argᵗᵒ con il ritratto di S.B. dell' Anno VIII. e per roverscio il Castello fatto per calare la Colonna Antonina . . .' (ASV, SPA, Computisteria vol. 155, f. 12). Any suspicion that this might be a scribal error is confuted by the following entry for a silver medal 'con il Ritratto sudᵒ e per roverscio l'Altare di Urbino', which was the correct reverse for the medal of the eighth year.

29. For an account of the making of thirteen such robes in 1658, at the cost of eight *scudi* each, see ASV, SPA, Computisteria vol. 654 (unfoliated, account of 19 April 1658). On the ceremony in general, see Gaetano Moroni, *Dizionario di erudizione storico-ecclesiastica*, VIII, Venice, 1841, pp. 296–300.

30. We may note that Ermenegildo and Ottone Hamerani were also employed to make the brass medals that Clement XII distributed to the thirteen pilgrims he fed daily in his palace. Nothing is known of these cheap objects, which were presumably small religious medals such as were normally attached to rosaries.

31. The fact that the gold and silver medals were struck in two weights, 'grosse' and 'sottile', is further evidence that they were valued for their metal content, rather than their aesthetic qualities (see, for example, Bartolotti, *La Medaglia annuale*, doc. 34, p. 412, or ASR, Cam. II⁰, Zecca, busta 28, int. 1, f. 61); I do not know whether this practice continued beyond the mid-seventeenth century. Medals, like coins, could be used as a means of holding wealth, and those who drew up the inventory of Bartolomeo de Barbari on 9 May 1612 are unlikely to have been exceptional in lumping 'una medaglia d'oro con l'effigie di Papa da una banna et l'altro quando Nostro Sigʳᵉ lava li piedi all'Apostoli' together with Roman and foreign gold coins and valuing them simply for their gold content (ASR, 30 Not. Cap., Uff. 34, vol. 37, f. 461v).

32. For Morone, see ASR, Cam. II⁰, Zecca, 28, int. 11 (he gave in all twenty-four that year, having given thirteen in 1656 [*ibid.*, int. 10]), and ASR, Cam. I⁰, Giustificazione di Tesoreria, busta 138, int. 15. For Hamerani, see ASR, Cam. II⁰, Zecca, busta 28, int. 40.

33. ASR, Cam. II⁰, Zecca, busta 28, int. 40.

34. See Donatella L. Sparti, *Le Collezioni dal Pozzo. Storia di una famiglia e del suo museo nella Roma seicentesca*, Modena, 1992, pp. 137, 199–203.

35. Giovanni Andrea Lorenzani, as a brass-worker and himself an occasional medallist, cannot be regarded as an 'ordinary' collector, but it should be noted that he owned a number of medals by various artists and two sets of six medals of Giovanni Paolo Orsini by Cormano, of which he owned the dies. He also owned a set of 115 portraits of popes, which he had made himself, and which Filippo Buonanni described as 'numismatum', though, as they were some 23 cm. in diameter and apparently uniface, they are hardly what one would normally describe as medals (Filippo Buonanni, *Numismata pontificum romanorum*, Rome, 1699, p. 804). On Lorenzani see Giorgio Morelli, 'Giovanni Andrea Lorenzani artista e letterato romano del Seicento', *Studi secenteschi*, XIII, 1972, p. 242 (the information he gives on p. 205 is inexact), and Lorenzani's inventory, Arch. Cap., Sez. LVII, Protocollo 20 (Not. del Borgo Domenico Angelo Seri), Testamenti 1712–14, 24 May 1740 (unfoliated).

36. ASR, Not. Trib. A.C., Fonthius, vol. 3173, ff. 868–77v, 880–954; inventory of 15 October 1640.

37. *Ibid.*, ff. 924–5, 943; he also had 'cerchietti n⁰ quarantasei di legno, et alcuni di osso da medaglie', presumably awaiting the time to fit the medals (*ibid.*, f. 925). Bone was also used for setting medals by Paolo Vittoria; see his inventory of 1624, ASR, Not. Trib. A.C., Olivellus, vol. 4686, ff. 760–95. It may be noted that, probably in 1636, Charles I showed Abraham Van der Doort '27 goulden meddalls in black torned hoopes', though 'meddalls' could well mean ancient coins (Ronald Lightbown, 'Charles I and the Tradition of European Princely Collecting', in *The Late King's Goods*, ed. A. MacGregor, London, 1989, p. 65).

38. See his inventory, ASR, 30 Not. Cap., Uff. 27, vol. 225, f. 210v Chéron made medals of all three artists.

39. See the inventory published by David L. Bershad, 'The newly discovered testament and inventories of Carlo Maratti and his wife Francesca', *Antologia di belle arti*, N.S. 25–26, 1985, p. 75. For the medal see Giulio Berni, *Le Medaglie degli anni santi*, Barcelona, 1950, nos. 190, 192; the same image, but from a different die, was to be reused as the reverse of the annual medal of Clement XI in 1717, after Maratti's death (Bartolotti, *La Medaglia annuale*, p. 128).

40. 'Una scatola tonda di pastiglia con numero ottantatre medaglie dentro d'argento grandi e grosse, come un piccolo testone de' diversi Papi, e dal Cardinal'Antonio, de quali medaglie se ne sono perse alcune per servire a giocare alli signori nepoti, quando erano piccoli e stavano male, e sono restati in numero 61' (Franco Borsi, Cristina Acidini Luchinat, Franceso Quinterio [ed.], *Gian Lorenzo Bernini: Il Testamento, la casa, la*

raccolta dei beni, Florence, 1981, p. 116).

41. *A Catalogue of the Genuine, Entire and Choice Collection of Coins, Medals, and Medallions, in Gold, Silver, and Brass, of the Learned and Ingenious Martin Folkes, Esq. . . .*, London, 1756, p. 16, lots 55–60; the medals of Clement XII formed lot 50 (p. 10).

42. For Folkes's connection with the Hamerani see pp. 89 ff.

43. ASR, Cam. II°, Antichità e Belle Arti, busta 4, int. 137. In 1764 he obtained the licence to sell the collection abroad, but he did not do so, and his motive may have been to try to frighten the pope into buying it. During his later negotiations it was generally agreed that, while the export of one or two might be acceptable, to have the complete series of dies of papal medals go abroad would be an affront to the dignity of the papacy.

44. See Bartolotti, *La Medaglia annuale*, doc. 36, p. 413 (from ASR, Cam. II°, Zecca, busta 28, int. 10). On at least one other occasion, in 1653, the medals had to be remade with a changed reverse (*ibid.*, p. 54, from the accounts of the Zecca, busta 28, int. 7), but we know only that this was ordered by the Tesoriere Generale, and not whether the Pope himself, Innocent X, was involved.

45. See, for example, the accounts of Gaspare Morone of 1642 and 1643, when he claimed that in both cases he had made two different medals for the same year, and that in the former the dies required extraordinary labour because one of the medals was surrounded with laurel branches and bees (Bartolotti, *La Medaglia annuale*, docs. 21 and 22, pp. 408–9). These claims for payment for the dies were, as usual, cancelled.

46. '. . . per esser questa hora tanto grande e grosse molto più faticose, che se ne farebbe dua delle più piccole, con men fastidio e travaglio che una di queste grosse' (ASR, Cam. II°, Zecca, busta 27; quoted in part in Bartolotti, *La Medaglia annuale*, doc. 15, p. 407).

47. '. . . povero incisore che non ha altro che questa Vendemia, e tutto l'anno sta fabricando le stampe e rovescie per venire a questa pocco, e faticoso guadagno' (ASR, II°, Zecca, busta 27); these words are omitted from Bartolotti's doc. 16 (*La Medaglia annuale*, p. 407).

48. British Museum, G III Papal, C AR 37. The choice of this example was not fortuitous: the die made for the *scudo* of 1753 served until the pontificate of Pius VI – at least there is no evident change; but under Pius VII the image was rethought in a different style. The earliest use of this composition was on the *zecchino* of 1738, and different dies of varying sizes were used for the different coins through this period. A drawing for this image is in Vat. Lat. 15232, no. 104.

49. 'La maggior fatica consiste nel primo Intaglio, che chiamasi *Matrice*; mentre ricavandosi dalla medesima il *Ponzone*, serve poi questo per ogni altro Conio della stessa moneta. Non è però così rispetto alle Medaglie. Propostasene all'Incisore l'idea, egli è in obligo di formarne uno, e più disegni, e di esprimerne il soggetto anche in cera. S'incide quindi nell'acciajo, e certamente con maggior profondità, e con più minuta ricerca. Il travaglio n'è anche più penoso per la complicazione delle rappresentanze, la quale impicciolando le figure, stanca infinitamente più l'occhio, e la mano. Finalmente ogni Conio esige da capo lo stesso lavoro, non essendo solito di replicarsi, come accade nella monete' (ASR, Cam. II°, Antichità e Belle Arti, busta 4, int. 137).

50. Giorgio Vasari, *Le Vite de' più eccellenti pittori scultori ed architettori*, ed. G. Milanesi, I, Florence, 1878, p. 164.

51. Benvenuto Cellini, *I Trattati dell' oreficeria e della scultura*, ed. C. Milanesi, Florence, 1857, pp. 112–13.

52. *Ibid.*, p. 118.

53. For the medal, struck to commemorate Innocent XIII's election, see *Roma Resurgens*, cat. 162, pp. 174–5. The drawing is Vat. Lat. 15232, no. 11.

54. J. Montagu, *Alessandro Algardi*, New Haven/London, 1985, cat. (drawings) 55, fig. 172; see also p. 93.

55. See Marc Worsdale, referring to the portrait of Clement X on the annual medal of 1675 (*Bernini in Vaticano* [exhibition catalogue], Rome, 1981, p. 283; the medal is cat. 326), but the use of a three-quarter view is not unprecedented, and occurs on a medal of Cardinal Francesco Barberini of 1625, with a reverse depicting him celebrating mass before Louis XIV (British Museum, 598, 21.4.6). The drawing of Urban VIII (Uffizi 95635, see *Bernini in Vaticano*, p. 286), is unconvincing as a work by Bernini, and that of Clement X in Leipzig (*ibid.*, p. 307) is not necessarily for a medal.

56. The one annual medal produced by Astesano has already been referred to (see above, p. 175), and there is every reason to believe that he designed it.

57. See Montagu, *Alessandro Algardi*, p. 93.

58. All the known drawings by Bernini for, or connected with, medals are reproduced in the section 'Bernini nelle medaglie e nelle monete' by Luigi Michelini Tocci and Marc Worsdale in the exhibition catalogue, *Bernini in Vaticano*, pp. 281–309, with earlier bibliography on the subject of Bernini as a designer of medals. See also Pollard, 'La Medaglia con ritratto di epoca barocca in Italia', pp. 139–61, for an excellent critique of earlier over-inclusive attributions of medals to Bernini.

59. Pen and brown ink with wash; diameter ca. 15 cm. This sheet was in the De Pass collection in the Cornwall County Museum in Truro, but its present whereabouts are unknown. It was published by Ann Sutherland Harris, *Selected Drawings of Gian Lorenzo Bernini*, New York, 1977, pl. 67.

60. British Museum, inv. 1932-8-6-24.

61. *Bernini in Vaticano*, p. 330 (8 September 1660, concerning the medal of the Quirinal Palace), p. 332 (13 December 1661, concerning the medals of the churches in Ariccia; the entry in fact refers only to a discussion of the placing of the inscription), and possibly p. 324 (6 April 1658, concerning the medal of the church at Castel Gandolfo, which features on the annual medal issued only in 1659); in a number of other cases Bernini does not appear to have been consulted on the inscriptions (e.g. *ibid.*, p. 330 [29 January 1661]).

62. '. . . cavato da un Disegno del Cavalier Bernini' (ASR, Cam. II°, Antichità e Belle Arti, busta 4, int. 137, Sala and Miselli, *Sommario*, point 8A [for this see note 5 above]). His evidence comes from a document which is now lost. It may be noted that he also said that Morone's dies for this reverse, and for the foundation medal for the arsenal at Civitavecchia of 1660, were used by Francesco Travani in these cases where two types of medal of each are known, with a single reverse combined with obverse portraits by Morone and Travani (*ibid.*, point 8A); this evidence confirms the judgement as to the authorship of the reverse of the Civitavecchia medal in *Roma Resurgens* (cat. 92, pp. 110–11).

63. The drawing is in pen and brown ink with brown wash, over black pencil, 8.8 × 16.3 cm; British Museum, inv. 1946-7-13-689[b]; see Sutherland Harris, *Selected Drawings*, pl. 67. For the medal see *Corpus Nummorum Italicorum*, XVI, *Roma parte II – dal 1572 al 1700*, Rome, 1936, pp. 402–3, no. 9. For an analysis of the differences between the drawing and the coin, see *Bernini in Vaticano*, cat. 290. For this medal a wax model survives in the British Museum, inv. 1932-8-6-10; See George F. Hill, 'Notes on Italian Medals – XXVI', *Burlington Magazine*, XXXI, 1917,

pp. 212–15; Luke Syson, 'Designs on Posterity: Drawings for Medals' (posthumous catalogue of the exhibition in the British Museum, 11 September–25 October 1992), in Jones (ed.), *Designs on Posterity*. Although it is habitually related to the canonisation of St Thomas of Villanueva, proclaimed in 1658, Thomas was a bishop, not a soldier.

64. Windsor Castle, inv. 6746; pen and brown ink with black wash, over black chalk, 16.6 × 16.4 cm. It was ascribed to a follower of Gaulli by Anthony Blunt and Hereward L. Cooke (*Roman Drawings of the XVII and XVIII Centuries in the Collection of Her Majesty the Queen at Windsor Castle*, London, 1960, cat. 168) but was accepted as by the master by both Pollard ('La medaglia con ritratto', p. 150) and Hugh Macandrew ('Baciccio's Later Drawings: A Re-discovered Group Acquired by the Ashmolean Museum' [in collaboration with Dieter Graf], *Master Drawings*, X, 1972, p. 258, note 9). For the coin see *Corpus Nummorum Italicorum*, XVI, *Roma parte II*, p. 473, no. 31; The same two figures, but with haloes, were used for the *quattro scudi d'oro* coin, also dated to the first year of the pontificate (*ibid.*, p. 470, no. 12). The single figure of St Peter was used on both the *grosso*, without rays, and the *scudo d'oro*, with rays (*ibid.*, pp. 469, 470, nos. 30, 35), and also on the *quattrino* issued by the Gubbio mint in 1690 (*ibid.*, XIV, *Umbria, Lazio [zecche minori]*, Rome, 1933, p. 76, no. 8). It appears that the same punch may have been used for the Roman *grosso* and *scudo d'oro*.

65. Giancarlo Alteri has recently rediscovered the two volumes of drawings for medals of the Hamerani in the Vatican which had been known to de Bildt in 1908, but mislaid for many years, and has published them under the title *Vat. Lat.* 15232. *Disegni degli incisori Hamerani eseguiti dai medesimi in medaglie e monete pontificie* (Rome, 1995). I am grateful to him for allowing me to look at the one volume of drawings that was available when I was in Rome, but this chapter has had to be basically written prior to the publication, and I have therefore been unable take advantage of his interpretation or commentary.

66. The fullest source for this family is still Friedrich Noack, 'Die Hamerans in Rom', *Archiv für Medaillen- und Plaketten-Kunde*, III, 1921–2, pp. 23–40. Unless otherwise stated, facts about the various members of this family are taken from this source.

67. Black chalk, pen and black ink, with slight indications of white heightening, on bluish-grey paper, diameter ca. 16 cm.

68. See Antonio Patrignani, 'Le medaglie papali del periodo neoclassico (1605–1730)', part 2, *Bollettino del circolo numismatico napoletano*, XXXVIII, 1953, p. 71, year 1.

69. See Giulio Berni, *Le Medaglie degli anni santi*, Barcelona, 1950, no. 193.

70. Sabine Jacob, *Staatliche Museen Preussischer Kulturbesitz: Italienische Zeichnungen der Kunstbibliothek Berlin, Architektur und Dekoration 16. bis 18. Jahrhundert*, Berlin, 1975, cat. 459 (diameter 17.3–17.5 cm.); cat. 458 (diameter 14.5–14.8 cm.), both are in black pencil heightened with white. They are ascribed to Lazzaro Baldi, and implausibly identified as representing St Agnes with an angel.

71. See *Roma Resurgens*, cat. 125, pp. 142–3. The figure on the reverse is there described as representing Peace, but this is clearly wrong, and the inventory of the dies of the Hamerani printed in N. Sala and G. Miselli's *Sommario* [for this see note 5 above], point 5, confirm that she symbolises Innocence.

72. *Roma Resurgens*, p. 142.

73. These drawings are in a private collection, and I owe my knowlege of them to the kindness of Julien Stock; I am deeply indebted to the owner for enabling me to study them. All but one measure 22.6 × 21 cm.

74. 'Diversi Disegni di Medaglie ed altre carte di veruna considerazione' (ASR, 30 Not. Cap., Uff. 2 [Conflenti], vol. 648, f. 690v). This long inventory of 30 November 1789 (ff. 669–733v) includes 'diversi disegni', subjects unspecified, but also of no value (f. 679v), 'divesi studj di Medaglie di Piombo rappresentanti ritratti', valued for the lead only at 4 *scudi*, and 'diversi studj, e Modelli di medaglie in Cera, solfi, Piombi, ed ottone con loro Cornicetti' worth 2 *scudi* (ff. 688r–v), as well as 'diverse Ponzioni' which belonged to the Zecca (f. 690). There were also a number of 'studj' and 'Modelli' in various materials belonging to Ferdinando's son and successor Gioacchino (ff. 684v, 688v, 699).

75. 'Voglio ancora, che al Sig.r Mariano . . . si dia un Vestito delli miei, cioè Giustacore Camicciola, e Calzoni, et un paro di Calzette delle mie di seta, con un Cappello, e quattro camiccie di quelle, che erano di mio uso, il tutto a scelta del mio Esecutore sud.º, e di più voglio che se li diano scudi venticinque moneta per farli conoscere la mia benevolenza, senza però, che mai possa pretendere altra cosa alcuna, avendolo io ricettato in mia casa per puro mio piacere, et anche ammesso alla mia Tavola per non stare solo, e solamente per avere occasione di dire qualche cosa, essendo Sig.r Mariano sud.º giovane studente di Pittura, onde per farlo esercitare gli hò fatto fare qualche quadretto con averli somministrato il denaro di mio, sì per le Tele, che per li Colori, ed affinchè sempre più s'incoraggisse in d. studio, gli hò fatto fare di quando in quando qualche abito con aver anche pagato tutti li suoi finimenti, e tuttociò l'hò fatto per farli cosa grata atteso il suo buon costume. E se mai (che non credo) reclamase da questa mia dichiarazione di cose tutte a lui notissime, intendo che sia privo di tutto, come se non l'avessi mai mentovato' (ASR, 30 Not. Cap., Uff. 9 [Lorenzinus], Testamenti vol. 19, ff. 377r–v. The will is on ff. 335–7v, 377–8v).

76. British Museum, G III Germ. M 69. See Ridolfino Venuti, *Numismata Romanorum Pontificum Praestantia a Martino V. ad Benedictum XIV.*, Rome, 1744, p. XXXV. His next medal was of John V of Portugal, dated 1718. The fact that Ottone's name first occurs in the payments for papal medals in 1730 (Bartolotti, *La Medaglia annuale*, doc. 99, pp. 429–30), when Ermenegildo was in Palermo, and that henceforth payments are to both, suggests that Ottone might well have been involved earlier.

77. ASR, Computisteria Generale della R.C.A., serie verde, busta 36 (Giustificazione del Libro Mastro Generale . . . 1758, no. 1–102), no. 98.

78. Brown ink and grey wash over pencil; the paper has a watermark of an anchor in a circle.

79. At 20.5 × 17.5 cm. it is smaller than the other drawings considered here; it is executed in brown ink with grey and brown wash.

80. Vat. Lat. 15232, no. 6. See *Roma Resurgens*, cat. 156, pp. 169–70 for a discussion of the unusual viewpoint, and the evident desire to emphasise the building's most distinguishing feature, the spacious atrium.

81. Brown ink over pencil. Bartolotti describes the figure as representing Faith (*La Medaglia annuale*, p. 135), but the Hamerani inventories of dies identify her as Ecclesia.

82. The medal omits the final 'AT' in the verse from St Paul's Letter to the Philipians (4.13), and in the exergue only the year is given.

83. Black ink and grey wash, with pencil used on the borders.

84. Vat. Lat. 15232, no. 25.

85. The figure of Roma holding a statuette of Victory occurs on numerous coins from Nero to Gordian, but she there holds a spear in her other hand. She never sits on a globe, but this might be a misunderstanding of the shield that is frequently placed below her, perhaps helped by a confusion with Italia, who is sometimes shown seated on a sphere.

86. Brown ink and brown wash over pencil, with grey wash used on the clouds.

87. Bartolotti, *La Medalgia annuale*, p. 123; this also commemorated the canonisation of four saints.

88. Brown ink and grey wash over traces of pencil, which are especially evident in the inscription. A drawing for this reverse in the Vatican (Vat. Lat. 15232, no. 33) shows a very similar figure, but the cornucopia has been reversed, and there is neither town nor shipping in the background.

89. Brown ink and grey wash, with brown wash on the architecture; the inscription is in pencil.

90. This attribution has been made mainly by Masonic writers; see William T. R. Marvin, *The Medals of the Masonic Fraternity Described and Illustrated*, Boston, 1880, pp. 194–5.

91. See Edward Hawkins, *Medallic Illustrations of the History of Great Britain and Ireland*, London, 1885, II, p. 571, no. 206. Hawkins says that the British Museum has 'an early proof of the medal struck before the legends were added or the type of the reverse finished'; however it is evident that in this supposed proof the legends and the background have been scraped off, particularly if one looks at the left side of the pyramid where the projection of the top of the wall is still visible, and too much of the side of the pyramid below has been removed so that it is almost vertical.

92. The best summary of Folkes's life and interest remains the entry in the *Dictionary of National Biography*, VII, Oxford/London, 1917, pp. 361–2; see also the manuscript biography by Thomas Birch, BL, MS. Add. 6269, ff. 292–301.

93. I am grateful to Stanley Parker-Ross for providing this information.

94. Gaetano Moroni, *Dizionario di erudizione storico-ecclesiastica*, XLI, Venice, 1846, p. 206. The requirement that all printed matter, not only books and prints but also medals, should be so authorised was promulgated by Alexander VII in 1655, and regularly repeated. Article XIII of the edict stated 'Che nissun Medalista, Fonditore, Incisore di Sigilli tanto in acciajo, che in ferro, bronzo, o altra materia ardisca incidere, fondere, e gettare alcuna effigie, sia sagra, o profana, con lettere, o senza lettere, se non ne ha licenza dal Maestro del Sagro Palazzo, o de' suoi Compagni . . .' (Pierre [Hippolyte] Hélyot, *Storia degli ordini monastici, religiosi, e militari*, transl. G. F. Fontana, III, Lucca, 1738, pp. 236–7; the whole edict is printed on pp. 233–8).

95. Carlo Francovich, *Storia della Massoneria in Italia dalle origini alla rivoluzione francese*, Florence, 1974, p. 45.

96. According to McLynn, Benedict XIV was to say that the banning of Free Masonry had been the worst political error of his predecessor (Frank McLynn, *Charles Edward Stuart*, Oxford/New York, 1991, p. 533, referring to the State Papers in the Public Record Office, Tuscany 46, ff. 182–3). There was a belief that Benedict himself was a Mason (Francovich, *Storia della Massoneria*, pp. 120–3). Yet in 1751 Benedict was to issue a similar anathema (*ibid.*, p. 123).

97. *Ibid.*, pp. 79–83.

98. Francovich, though he dates the medal to 1742, accepts that Folkes was the author of the *Relation apologique et historique de la Société des Francs-Maçons*, published in Dublin in 1738 by an author who signed himself 'J.G.D.M.F.M' (*ibid.*, p. 71), but this is highly improbable for a number of reasons.

99. However, there is no reference to Folkes's connection with the Royal Society on the medal, unlike that of the same sitter by Dassier, inscribed on the reverse 'SOCIETAS REGALIS LONDINI SODALIS. M.DCC.XL.' (Hawkins, *Medallic Illustrations*, II, pp. 558–9, no. 185).

100. *Ibid.*, p. 571, no. 206. This may be due to a confusion: at his death in 1764 Folkes left his house in Queen's Square with its contents to his daughter Lucretia, and she promptly sold everything, including his medals, among which were four of Clement XII, one of which was described as 'given by the said pope to Mr. Folkes in 1733' (*A Catalogue of the Genuine, Entire and Choice Collection of Coins, Medals, and Medallions . . .*, p. 10). There was no example of a medal of Folkes himself, but it is reasonable to suppose his daughter might have retained this.

101. Francovich, *Storia della Massoneria*, p. 71.

102. I owe this information and suggestion to Jane Clark, who provided much invaluable assistance with my investigations of Free Masonry and the Jacobites. Since no one could publicly admit to being a Jacobite, adherence to this cause is virtually impossible to prove.

103. Marvin, *The Medals of the Masonic Fraternity*, p. 195. Moss agreed with this, but went further, suggesting that Folkes had had the die of the obverse cut in Rome, and later had the reverse engraved in France in 1738 (a date which suited Moss's purpose), 'with ROMAE added impishly' (W. E. Moss, 'A Note on the Relation Apologique et Historique de la Société des Francs-Maçons . . .', *Ars Quatuor Coronatorum*, LI, 1940, pp. 230–1).

104. See *Roma Resurgens*, cat. 100, pp. 118–19, and the comments in Whitman's introduction, p. 10.

105. *Ibid.*, cat. 121, p. 138. Originally issued with the year V on the obverse (the Porta Santa of St Peter's is opened at the end of the preceding year, marking the official beginning of the Holy Year) coinciding with the date of 1664 on the reverse; with the date erased it is found again with the portrait of Benedict XIII on medals for the Holy Year of 1725; see Berni, *Le Medaglie degli anni santi*, nos. 166, 206.

106. This will no doubt be discussed in the forthcoming book by Giancarlo Alteri.

Chapter 5: Silver Tribute from a Prince to a Grand Duke. The Piatti di San Giovanni

1. See the chapter by Otto Kurz, 'Begram et l'occident gréco-romain' in Joseph Hackin, *Nouvelles recherches archéologiques à Begram* (Mémoires de la délégation archéologique française en Afghanistan, XI), Paris, 1954, esp. pp. 137–40.

2. K. Aschengreen Piacenti, 'I Piatti in argento di San Giovanni', in *Kunst des Barock in der Toskana*, Munich, 1976, pp. 188–207. I shall be drawing extensively on her findings published there. It was Dr Piacenti who with great generosity provided me with the photographs of the plates that will illustrate this chapter.

3. Per la molta devozione che professo al Serenissimo Cosimo Medici, ora Granduca della Toscana, e in segno di gratitudine verso tante cortesie da S.A.R. usato meco . . .' (*ibid.*, p. 188).

4. '. . . i quali come opera o di semplici argentieri, o di mediocri moderni scultori sembrano più fatti per servire capo, che all'altrui istruzione e diletto . . .' (*ibid.*, p. 191).

5. See Klaus Lankheit, *Die Modellsammlung der Porzellanmanufaktur Doccia. Ein Dokument italienischer Barockplastik*, Munich, 1982.

6. Naples, Floridiana. See Aschengreen Piacenti, 'I Piatti in argento', p. 191.

7. *Ibid.*, p. 188.

8. On such Genoese silver see Franco Boggero and Farida Simonetti, *Argenti genovesi da parata tra Cinque e Seicento*, Turin, 1991.

9. Ashmolean Museum, inv. 1974.234; see Hugh Macandrew, 'A Silver Basin designed by Strozzi', *Burlington Magazine*, CXIII, 1971, pp. 4–11; Boggero and Simonetti, *Argenti genovesi*, cat. 4; Nicholas Penny, *Catalogue of European Sculpture in the Ashmolean Museum*, Oxford, 1992, I, cat. 247, 248. There is an identical basin, also together with its ewer, in the Birmingham City Museum and Art Gallery (Boggero and Simonetti, *Argenti genovesi*, cat. 4).

10. On this point, and its relevance to the 'piatti di San Giovanni', see John F. Hayward, 'Roman Baroque Display Dishes', *Festschrift Kurt Rossacher. Imagination und Imago*, Salzburg, 1983, pp. 85–93, especially pp. 85–7.

11. The archives that remain with the family are divided between the building of the Administrazione (here called A.Pal.), and the Palazzo (here called P.Pal.). I am deeply indebted to the Pricipessa Pallavicini Rospigliosi for her kindness in allowing me to consult both collections, and to Alvar González-Palacios for his assistance in gaining access to the latter. The holdings of the Archivio Segreto Vaticano are mainly concerned with the Rospigliosi inheritance, but contain a number of *mandati* for the making of these plates, which for the most part duplicate, but occasionally supplement the information from the archives preserved by the family; I am grateful to Angela Negro who generously made her transcriptions available to me.

12. On this thermometer see R. Vollmann, 'Die Erfindung des geschlossenen Thermometers', *Ciba Zeitchrift*, VIII, no. 93, March 1944 (*Das Thermometer*), pp. 3301–3; W. E. Knowles Middleton, *A History of the Thermometer and its Use in Meteorology*, Baltimore, 1966, pp. 30–5. I am indebted to Dr Will Ryan for providing these references. It is possible that the instrument on the plate was copied from the illustration in the *Saggi di naturali esperienze fatte nell' Accademia del Cimento*; see the illustrations in Vollmann, p. 3301, and Middleton, frontispiece.

13. These descriptions are printed in Aschengreen Piacenti, 'I Piatti in argento'; that of the plate of 1698 is on p. 202.

14. A.Pal., B.1.1 ('Mastrini dell'Entrate e spese dell'anno 1695 à tutto l'anno 1704'), 1698, p. 37 (it should be noted that in these *mastrini* the pagination restarts with the beginning of each year). Bourhardt (a Flemish silversmith, whose name is variously spelt in the documents), is presumably to be identified with Goffredo Bouchard, for whom see Costantino C. Bulgari, *Argentieri, gemmari e orafi d'Italia; Parte prima – Roma*, Rome, 1958–9, I, pp. 204–5. He must be identical with the Godefridus Bourhardt who in 1702 signed the receipt for payment for the gilt bronze fringe on Pierre Legros's monument to Cardinal Casanate in the Lateran (see Gerhard Schuster, 'Zu ehren Casanates. Père Cloches Kunstaufträge in der Frühzeit der Biblioteca Casantense', *Mitteilungen des Kunsthistorischen Institutes in Florenz*, XXXV, 1991, p. 333, note 13); so Bourhardt, like so many of the silversmiths discussed here, must also have worked in bronze.

15. A.Pal., B.1.4, ('Mastrini dell'Entrate e Spese dell'Anno 1716 à tutto l'anno 1720'), 1716, p. 141.

16. For this observation I am indebted to Ubaldo Vitali, who combines an interest in the 'piatti di S. Giovanni' with practical experience of the silversmith's art.

17. The accounts for this (and also for other work, including the frame with an *attacaglia* with a putto and other ornaments 'nella forma ha ordinato il Sig.r Carlo Maratta', made for 'un quadro ottangola d'un Crocefisso') are in P.Pal., Giovanni Battista Pallavicini, Filza IX, no. 120. The account runs from November 1682, but both the setting for the Agnus Dei and the frame were from April 1683.

18. Macandrew, 'A Silver Basin', p. 612.

19. Aschengreen Piacenti, 'I Piatti in argento', p. 199.

20. A.Pal., A.2.4, no. 49 ('Conto dell'Ecc.mo Sig.re Duca di Zagarola Con Bart.mo Colleone Arg.re'). These accounts clearly refer to two different plates: the first (undated) account begins with the entry 'A Bart.mo Coleoni Arg.re per pr.o del Bacile per il seren.e Sig. Duca di Toscana—s. 294.86 m.a'; it then continues 'Per haver fatto di nuovo un Bacile instoriato di argento di francia simile ad un altro che si mandò per regalo al sereniss.mo Gran duca di fiorenza . . .', and the payment for the case in which it was placed is dated 15 March 1681, so this clearly refers to the second plate which, with its case, cost 214.86 *scudi*. The second account is dated 15 June 1680, 'Per haver Dicirate [?] bianchito e brenito il bacile grande storiate che fu mandato a fiorenza al Prencipe Gra Duca di Toscana', and for this work Colleoni received only 5 *scudi*, though, as for the other plate, he provided the case, lined with red velvet and decorated with gold braid. It can therefore be assumed that this was the first plate, valued at 294.86 *scudi*, that had been bought from him.

21. 'Molti disegni del Med.o Sig.r Cav.r Maratti, trà quali vi sono li Pensieri della Sala Altieri . . . e non sò quanti pezzi de disegni per li bacili serviti per li Sig.n Rospigliosi per donare à Sua Altezza di Toscana' (Arnold Nesselrath, 'Carlo Maratti's Designs for the "Piatti di S. Giovanni"', *Master Drawings* XVII, 4, 1979, pp. 417–18).

22. I shall not continue to give the references to the articles by Aschengreen Piacenti and Nesselrath, except where I have borrowed directly from them, or they provide significant additional – or conflicting – material.

23. The source of this may well be the engraving by Agostino Carracci (Adam Bartsch, *Le Peintre Graveur* [new edition], XVIII, Leipzig, 1870, 112.140), which similarly shows him in his grand ducal robes, though in three-quarter profile to the left.

24. It is not certain whether this inscription was included on the plate, as, exceptionally, no inscription is quoted in the Florentine documents. There is no sign of it on the inevitably less detailed cast.

25. Pen and brown ink with brown wash, over traces of red chalk; diameter 63.3 cm. The drawing was exhibited in Paris in 1988 by David Jones (see his catalogue, *Old Master Drawings*, cat. 24). It was Dieter Graf who made the suggestion that it was drawn by one of Maratti's 'well-trained scholars' to provide a clearer image for the silversmith.

26. On 18 August 1683 Francesco de Martinis was paid 25.40 *scudi* for a 'sottocoppa . . . data al Sig.r Don Lodovico Ribotta Mastro di Casa del Ecc.m Sig.r Duca di Zagarola lb.2 oncie 2 di.18', and 's. venti cinque m.ta sono per una sottocopa come sopra data al S.r Carlo Marata . . .' (P.Pal, Giovanni Battista Pallavicini, Filza IX, no. 68). However, it will be remembered that in April 1683 Maratti had ordered, and presumably designed, the cresting for a frame (see above, note 17).

27. '...per far il Bacile da darsi al ser.mo gran Duca di Toscana' (A.Pal. A.2.1, A [inventory of silver] ff. 48, 301).

28. Düsseldorf, Kunstmuseum, FP 7285, FP 7288, FP 7289; they are in light black chalk on thin paper strips 8.9 to 9 cm. wide. All the inscriptions are cut; the fullest (on FP 7285, Fig. 157) reads 'Carlo Maratta ornamenti di Piatti, che ognij Anno sono son'mandatj a fiorenza per tributo...'. See Eckhard Schaar, in Ann Sutherland Harris and Eckhard Schaar, *Die Handzeichnungen von Andrea Sacchi und Carlo Maratta*, Düsseldorf, 1967, p. 199, cat. 719–21; Nesselrath, 'Carlo Maratti's Designs', p. 423.

29. The inscription is evident on the cast, but illegible. However, it was transcribed in the Florentine description: 'Caterina Medices Enrici Galliarum regis uxor francisci o/2; e Caroli nono Mater in Utriusque minori etate regens, regnique moderatrix' (see Aschengreen Piacenti, 'I Piatti in argento', p. 200).

30. His work on the 'piatti di San Giovanni' is recorded by Nicola Pio, *Le Vite di pittori scultori et architetti* (Studi e Testi, 278), ed. Catherine and Robert Enggass, Vatican City, 1977, p. 62, a fact of less interest for the documenting of this work, as Pio does not state how many Gimignani designed, than as evidence of the importance the 'famosissimo bacile istoriato' held in the estimation of a Roman contemporary. See also note 44.

31. See above, note 26.

32. A.Pal., B.1.1 (Mastrini dell'Entrate e spese dell'anno 1695 à tutto l'anno 1704), 1695, p. 67; 1696, pp. 19, 33; 1697, p. 35. His regular payment for these designs was 30 *scudi*.

33. Occasionally they appear written on a feature of the main scene, such as a pedestal or a throne. Only in that of 1726 (Aschengreen Piacenti, 'I Piatti in argento', p. 206, 'calco n. 7') is there no inscription.

34. Munich, Staatliche Graphische Sammlung, inv. 2772; red and black chalk, brown wash, with corrections in white gouache, 39.7 × 45.2 cm. The drawing was formerly ascribed to Sebastiano Conca, and the correct attribution was given by Ursula Fischer Pace.

35. A.Pal., B.1.1, 1698, p. 37; 1699, p. 91; 1700, p. 82; 1701, p. 75; 1702, p. 60. His regular payment was 25 *scudi*.

36. Ursula Fischer Pace has recently identified two drawings in Düsseldorf for the 'piatti', for those of 1699 and 1701; although Baldi was paid for both these designs, she would attribute these drawings to his close friend and assistant Filippo Luzi, who was to take over as the designer. While little is yet known of Luzi's style as a draftsman, should this attribution prove correct it would raise the possibility that some at least of Baldi's designs were made by others in his shop, a method that certainly applied to the work of the silversmiths involved.

37. A.Pal., B.1.1, 1700, p. 82. Bourhardt had received 200 *scudi* 'a conto' on 16 January; Merlini received his payment in two instalments in June and July.

38. '...feci un Bacile d'Argento di diametro quattro palmi romani di peso ll. 15 tutto storiato di Bassorilievo con figure rappresentanti la Traslazione del corpo di S. Stefano fatta in Pisa dalla Religione de' Cavalieri, e nel fregio putti volanti con geroglifici ecclesiastici della Religione fatto con mio disegno e modello' (Klaus Lankheit, *Florentinische Barockplastik*, Munich, 1962, p. 239).

39. See Bulgari, *Argentieri, gemmari e orafi d'Italia; Roma*, II, p. 142.

40. See Claude François Lambert, *Histoire littéraire du règne de Louis XIV*, III, Paris, 1751, pp. 283–4; J. B. D. Lempereur, 'Dictionnaire général des artistes anciens et modernes...' (Paris, BN, Estampes, MS. Ya² 10, 4°), II, pp. 451–2. I am indebted to Peter Fuhring for the latter reference; Fuhring has also pointed out that Germain travelled within Italy during that time.

41. It is known that he worked in the shop of Giovanni Giardini (see chapter 6, p. 129), but it is not known who was the silversmith to whom he apprenticed himself for six years (see Lambert, *Histoire littéraire du règne de Louis XIV*, III, pp. 283–8).

42. He was to continue to live and work till 1712 (Bulgari, *Argentieri, gemmari e orafi*, I, pp. 204–5).

43. A.Pal., A.1.1, 1700, p. 75; Merlini received a total of 295.45 *scudi*, including the silver.

44. 'Nel disegnare è stato fertile, come nel comporre facile, grazioso et erodito, vedendosi apunto quella facilità nelli disegni da lui fatti per molti anni alla casa Rospigliosi, per il gran bacile istoriato che si faceva per il gran duca di Firenze, in sodisfatione del legato lassotogli dalla ch. mem. del card. Lazzaro Pallavicino' (Pio, *Le Vite di pittori*, p. 39).

45. This is not evident in frontal photographs, but appears disconcertingly so when the plates, such as this and those of 1704 and 1729, are viewed from the side.

46. Philadelphia Museum of Art, Accession no. PAFA # 586; black and white chalk with brown wash, 17⁶/₈ × 17⁵/₈ in.; see Jean K. Westin and Robert H. Westin, *Carlo Maratti and his contemporaries. Figurative Drawings from the Roman Baroque* (exhibition catalogue), Philadelphia, 1975, cat. 61, where it was attributed to an anonymous follower of Ciro Ferri.

47. Stockholm, Nationalmuseum 3025/1863; see Anthony M. Clark, 'The Portraits of Artists Drawn for Nicola Pio', *Master Drawings*, V, 1967, p. 22, no. 220 (without illustration).

48. In contrast to the previous silversmiths who were described in the accounts as 'Argentiere', Barchi is usually (though not invariably) referred to as 'scultore', and in 1730 as 'scultore in Argento' (P.Pal., Nicolò Pallavicini, Filza XXXI, no. 186).

49. Aschengreen Piacenti, 'I Piatti in argento', p. 193.

50. A.Pal., B.1.4, ('Mastrini dell'Entrate e Spese dell'Anno 1716 à tutto l'anno 1720), 1720, p. 126; P.Pal., Nicolò Pallavicini, Filza 1, no. 78 (for the making of the plate of 1723 see P.Pal., Nicolò Pallavicini, Filza 2a, no. 313). Giuseppe Chiari received 30 *scudi* for his designs, as did the other members of his family who succeeded him, Tomasso, and Carlo (see below, note 57).

51. 'E per fattura del medemo ateso esercitato molto fattura si nel basso rilievo di mezo come anche nel contorno col avervi impreso in quatro Medaglie li 4 Pontefici dela casa Medici con putti leoni et altri ornamenti di mascheroni e groteschi col di più di avere impiegato molto tempo per inventare e disegnare detto disegno del contorno non si puo fare ameno di scudi cento sesanta—s. 160' (P.Pal., Nicolò Pallavicini, Filza 8a, no. 300).

52. He was also paid 80 *baiocchi* for a carriage to take this plate and show it, presumably, to the prince: 'E più in una caroza servito per mezo giornato per far vedere deto bacile dordine di S.E. Sig.ʳ Prencipe Palvicini—s. −80' (*loc. cit.*).

53. 'Per fattura del medemo ateso ala quantita di figure nel baso rilievo piu del solito' (P.Pal., Nicolò Pallavicini, Filza XIIIa, no. 283).

54. Francesco Valesio, *Diario di Roma*, ed. Gaetana Scano, V, Milan, 1979, p. 419; I am grateful to Angela Negro for calling my attention to this source.

55. For a convenient summary of the biographical facts, see Alessandro Baudi di Vesme, *Schede Vesme*, II, Turin, 1966, pp.

657–60. Simone Martinez is a rare case of a man who worked both as a sculptor in marble and as a silversmith. Like Barchi, he is referred to in the accounts as 'scultore d'argento' (P.Pal., Nicolò Pallavicini, Filza XXXXI, no. 125, and Filza XXXXV, no. 69); in 1732, however, he had simply been called 'Argentiero' (P.Pal., Nicolò Pallavicini, Filza XXXVIII, no. 207).

56. This drawing of *Belshazar's Feast* is illustrated by Angela Negro, 'I Pallavicini e la ricostruzione della chiesa di Sant'Andrea a Gallicano: un cantiere periferico del rococò', in *L'Arte per i papi e per i principi nella campagna romana: grande pittura del '600 e del '700*, II (*Saggi*), Rome, 1990, p. 246, fig. 6 (for the winning drawing by Francesco Caccianiga, see Angela Cipriani, ed., *I Premiati dell'Accademia 1682–1754* [exhibition catalogue, Rome, Accademia di San Luca], Rome, 1989, no. 57). Negro has found a reference to his only known commission for a painting, the *Holy Family* for the high altar of S. Andrea a Gallicano for which he was paid 40 *scudi* in 1733, but this is unfortunately lost (*loc. cit.*).

57. '... page al Sig.re Can.co Carlo Fan.co Chiari Pittore, per il disegno del Bacile istoriato fatto il corr.e anno. questo di 21 Marzo 1735'-s. 30' (P. Pal., Nicolò Pallavicini, Filza XXXXIX, no. 133). In 1736 he is called 'S.re D. Carlo Canonico Chiari Pittore' (P.Pal., Nicolò Pallavicini, Filza LII, no. 180), as also (in an abbreviated form) in 1737 (P.Pal., Nicolò Pallavicini, Filza LV, no. 70). We may note that Filippo Luzi was also a priest.

58. I have found no explanation for the circle of stars.

59. 316.60 *scudi* for that of 1732, 317.43 *scudi* for that of 1733, and 310 *scudi* for that of 1734, excluding the regular 30 *scudi* for the designs.

60. P.Pal., Nicolò Pallavicini, Filza XXXXIX, no. 84; in the next he has no title (P.Pal., Nicolò Pallavicini, LII, 47), and in the last he is called 'Argentiere' (P.Pal., Nicolò Pallavicini, LV, nos. 25, 180).

Chpater 6: Giardini and Giardoni. Silversmiths and Founders of the Eighteenth Century

1. As helpful mnemonics, one might remember that, just as 'i' comes before 'o' in the alphabet, so the Giardini family dominated the first quarter of the eighteenth century and the Giardoni the second. While both families worked in both silver and bronze, the Giardini (with an 'i') are best known as silversmiths, and the Giardoni (with an 'o') as bronze-founders.

2. As has been seen in chapter 3, Giuseppe Giardoni died in 1787, but his brother Nicola continued the family tradition of bronze-founding, even if he was not a member of the goldsmiths' guild, and succeeded to Giuseppe's position in 1787 (see *L'Angelo e la città* [exhibition catalogue], I, Rome, 1987, p. 176, note 4). I have not attempted to follow Nicola's career, but his son Francesco is listed as 'fonditore' in the Stati d'anime of S. Nicola della Pagnotta in 1784, where his age is given as 22. It may be noted that Giuseppe was responsible for the great bell of 1759 on the Castel S. Angelo, for which see *L'Angelo e la città*, I, pp. 64, 176–7, 223–4.

3. See Angelo Lipinsky, 'Arte orafa a Roma: Giovanni Giardini da Forlì', *Arte illustrata*, 45/46, November 1971, pp. 18–34.

4. See above, pp. 15–16.

5. 'questi 2. putti stati disegnati dal Pittor Benedetto Luti col quale il Giovan Giardini frequentava d.a scola in Roma'. Berlin, Kunstbibliothek, OZ 133, no. 50; pen and brown ink, the putti in black chalk, the main form traced for tansfer, 28 × 17.9 cm. The other in which the figures have been added in black chalk by an unknown hand is no. 125, for print no. 19. In several others there are changes in chalk or pencil, and often the figurative parts have been changed; for example in drawing no. 78 (Fig. 196), for print no. 23, the central scene of Hagar in the desert was changed in the print to St John the Baptist, possibly by Limpach.

6. ASR, 30 Not. Cap., Uff. 10 (Parchettus), vol. 391, ff. 225v–47; out of nearly a hundred and fifty paintings, of which sixteen are by named artists, ten are by Luti. When this book was in the press Alvar Gonález-Palacios published his richly informative article, 'Giovanni Giardini: new works and new documents' (Burlington Magazine, CXXXVII, 1995, pp. 367–76), including a splendid holy-water stoup just acquired by the Metropolitan Museum of Art in New York, incorporating a silver relief of *St Mary of Egypt* after a painting by Luti.

7. ASV, SPA, computisteria, 159, no. 348; *ibid.*, 156, no. 100, f. 39. We may also note that when on 10 October 1712 he submitted his account for a number of different designs, and models, for the grille in the Sistine Chapel no such payments were included for work which was highly decorative, but did not involve figures (*ibid.*, 158, no. 264). Yet the second part of his book of designs for silverwork is dedicated to the Accademia di S. Luca, and it was apparently on the strength of these designs that in 1714 he was elected to the Accademia di S. Luca as a sculptor; see Lipinsky, 'Arte orafa a Roma', p. 21.

8. ASR, 30 Not. Cap., Uff. 10, vol. 391, f. 227v.

9. Carlo Grigioni, *Giovanni Giardini da Forlì (24.VI.1646–31.XII.1721) argentiere e fonditore in Roma*, Rocca San Casciano, 1963.

10. These included the licence of 23 April 1703 to export to Malta the two marble statues of the *Baptism* by Giuseppe Mazzuoli, and the enormous bronze glory that surmounts it, made by Giovanni Giardini (*ibid.*, p. 40). It is illustrated in Hannibal P. Scicluna, *The Church of St. John in Valletta*, San Martin (Malta), 1955, fig. 215.

11. Lipinsky refers to a plate in a private Roman collection, bearing the same two arms, and dated by the stamp of the Roman mint to 1697 ('Arte orafa a Roma', p. 20); it would be tempting to assume that the commission for the Gubbio reliquary was made about the same time.

12. See Giardini's account of 12 October 1711: 'Il Sagro Palazzo Apostolico deve, per un Tabernacolo fatto di porfido, con Architettura, con pilastri, e contro pilastri, e nichia in mezzo, e suo finimento Incima, e suo Zocholo sotto, fatto à sguzzio, risaltato, guarnito con cornici di rame dorato lavorate, che girano, secondo la pianta del med.o, con due Angioli, uno di quà, et uno di la di detta nichia, che posano sopra un dado di porfido, che risalta in fuori dalla Base de pilastri, e viene retto da due cartelloni sotto, di rame dorato; con due puttini, che stanno a sedere, sopra il risalto del Cornicione, che viene retto da una mensole di porfido, uno de quali, tiene il Volto Santo, l'altro il Corona di Spine, e sono di rame dorato, come anco li soprad! Angioli: Dentro la sud.a Nichia, vi è un reliquiario, fatto d'arg.to dorato, dentro, e fuori, che forma piede di Croce, con suo piedestallo angolato, sopra il quale, posano diversi Trofei, in mezzo à quali è [? word changed] piantata la Croce, con havervi fatti molti splendori, attorno a detta Croce, à piedi della quale, vi è uno scudo, lavorato ad uso di Cartella, con sua Cassa dietro, e Contra Cassa, che ritiene la Santa Reliquia, e è il tutto d'arg.to dorato come sopra. [There follows an entry 'per Una

Urna di porfido'] Che ascende la somma di tutti due li sopradetti lavori tra Porfido, oro, arg.^{to}, e Rame, e fattura in scudi Duemila, e quattro cento – s. 2400' (ASV, SPA, Computisteria, 156, ff. 279r–v, no. 163; his payment of 2,100 *scudi* is recorded in vol. 3035, no. 163).

13. Contrary to what is written in the entry in the latest and most authoritative guide to the Geistliche Schatzkammer which states that Gelpi's cross was made in 1709 (*Kunsthistorisches Museum Wien. Weltliche und Geistliche Schatzkammer, Bildführer*, Vienna, 1987, cat. 165, pp. 322–3), it is likely that Gelpi's account of 1709 was for a different crystal cross, for there is another account of 21 October 1711 for a number of diamonds, three emeralds, a silver setting for the diamonds, and also a payment he had made of 45 *scudi* for 'Cristallo di monte in forma di Croce' (ASV, SPA, Computisteria, 156, ff. 170r–v, no. 161). It is not clear from this account whether the silver ornament was something separate from the crystal cross; if it was, then it would seem that only the emeralds were related to the cross. See also vol. 156, f. 252, no. 154, of 17 October 1711, recording the sale of 18 diamonds from 'Rinaldo le Viù', i.e. Rénaud le Vieu, to Gelpi, 'e questi servano per ornare una Croce di Cristallo di monte con altri Diamanti e Smeraldi dove va Colocato il Legno della Sant^{ma} Croce . . .'.

14. This Habsburg Charles III (Carlos III of Naples) is not to be confused with the later Bourbon King Carlos III of Spain, who also ruled Naples.

15. Lipinsky suggested that it would have been made in the Opificio delle Pietre Dure in Florence ('Arte orafa a Roma', p. 20). However, apart from the strong possibility that Giardini might have made it himself, there was at least one specialist in porphyry-work in Rome. On 10 December 1711 Marcello Bigeri was paid for repairing a porphyry *tazza* (ASV, SPA, Computisteria, 3035, no. 165, and other references to this work), and he had also repaired the urn used for the baptismal font in St Peter's. The two parts, the reliquary and the porphyry niche, were rightly recognised as two distinct objects by Chiapponi: he listed the 'ostensorio', enriched with diamonds, containing the wood of the Cross, and carrying indulgences, and continued 'Per tal'effetto era stato portato, e disposto sopra un tavolino nella stanza dell'udienza Reale una gran nicchia di porfido, con legature, e forniciamenti di metallo dorato di ben'inteso disegno, con un vano in mezzo, da collocarvisi l'accennato Ostensorio, a cui andava unito' (Giustiniano Chiapponi, *Legazione dell'Eminentissimo, e Reverendissimo Sig. Cardinale Giuseppe Renato Imperiali alla Sacra Real Cattolica Maestà di Carlo III. Rè delle Spagne l'anno MDCCXI.*, Rome, 1712, pp. 97–8).

16. ASR, 30 Not. Cap., Uff. 10, vol. 391, f. 242. Nor was this the only time Giardini was to use porphyry, for in the same account he includes a porphyry urn (see above, note 12), which suggests that such small porphyry objects were readily available in Rome.

17. Allan Braham and Hellmut Hager, *Carlo Fontana: The Drawings at Windsor Castle*, London, 1977, pp. 39–51; see also J. Montagu, *Alessandro Algardi*, New Haven/London, 1985, cat. L. 99, pp. 392–3.

18. For other work undertaken by the same 'team', see Elena Bianca di Gioia, in *Le Immagini del Santissimo Salvatore. Fabbriche e sculture per l'Ospizio Apostolico dei Poveri Invalidi* (exhibition catalogue), Rome, 1988, esp. pp. 284–344, which includes biographies.

19. Compare the sculptures illustrated in *ibid.*, pp. 319, 341, and especially p. 318. See also the *bozzetto* in Maria Giulia

Barberini, *Sculture in terracotta del barocco romano: bozzetti e modelli del Museo Nazionale del Palazzo Venezia* (exhibition catalogue), Rome, 1991, p. 58.

20. ARFSP, I^o piano, serie 3, no. 4a, int. 12, ff. 342–79. A shorter series of *Espositi* by the founder occupies ff. 272–5v.

21. '. . . per le di essi mani è passato il denaro pagato à tutti i Professori, che hanno lavorato intorno alla med^a., come sono falegname, modellatori di Creta, e di Cera, Rinettatori, Cisellatori, Indoratori, et altri . . .' (*ibid.*, f. 338).

22. In his first *Esposito*, in which he claims a total of 21,220 *scudi*, he claims 1,500 *scudi* 'per li Modelli, et altri lavori altrimenti soliti pagarsi à parte . . .' (*ibid.*, f. 272v). It should be borne in mind that part of the work of the modellers would have consisted of repetitive patterns on the mouldings, which he would certainly not have done himself, though how much else he might have done will never be known.

23. 'Per haver fatto il fusto di legno contornato con traverse che serve per l'arme di Nostro Sig^{re} cavato dal disgno in piccolo del Sig^{re} Cav^{re} Fontana, e questo hà servito per dare al Pittore per dipingerlo di chiaroscuro alto p.^{mi} 7½ compresovi Regno, e Chiavi largo da un festone all'altro p.^{mi} 9¾ con due Traverse di dietro.
 Per havere fatto un fusto di Tavolino di Albuccio . . .
 Per havere fatto il modello di Creta della detta Arme sopra il detto fusto, con sua ossatura di legni, Verzella, chiodi, e filo di ferro, per detta Arme con Targa, e sopra targa, con due festoni . . . con dento l'impresa di Nostro Sig^{re} di basso rilievo . . . Il tutto à similitudine dell' opera di metallo, et à gusto del Sig^{re} Cavaliere Fontana' (*ibid.*, ff. 350–1).

24. 'Speso per haver fatto tornire due altri modelli per li Regni alti p.^{mi} 1¾ e larghi à proportione, uno servito, e l'altro non servito – s. 1.50' (*ibid.*, f. 351v). Although he ends with the statement that the whole work was worth 21,000 *scudi*, only these entries concerning payments made to others are priced.

25. '. . . mosso e rimosso più volte e variato in più e diversi modi à gusto del d.^o Cav^{re} Fontana' (*ibid.*, f. 343v).

26. Per havere fatto il modello di creta delli intagli, che servono per la Guarnitione delli due Tori tondi e del Guscio e della parte di mezzo in più e diversi modi cioè baccelli Cartelle, fiori, e foglie e rifatti più volte, et in più modi à gusto del Sig^{re} Cav^{re} Fontana et à similitudine dell' Opera, che si fà di presente di metallo' (*ibid.*, ff. 347r–v).

27. 'Per havere abbozzato di Creta due palme lunghe p.^{mi} 4½ l'una larghe con le sue foglie à proportione che uscivano dalla volute grande del Cartellone, et andavano a battere con le sue punte sino alla metà del Tamburo in conformità del modellino in piccolo, che poi non servirono.
 Per havere fatto un altra Palma di grandezza simile alle due già dette Isolata con ossatura di verzella, e filo di ferro – finita di Creta, che nè meno servi, perche fù risoluto di non farvi più palma' (*op. cit.*, ff. 347v–8).

28. *Op. cit.*, ff. 352–3v. In fact, they are of marble, and on 23 January and 20 March 1697 Angelo Melone was paid for having supplied porphyry for these 'due tavolini' (ARFSP, I^o piano, serie Armadi, no. 391, ff. 119v, 122).

29. For example, ARFSP, I^o piano, serie 3, no. 4a, int. 12, ff. 357, 361; see also the expertise of Filippo Ferreri, which described the work as 'lavorata cisellata ad uso d'Argentiere' (*ibid.* f. 287).

30. See the transcription of Fontana's report of 1704 in Braham and Hager, *Carlo Fontana*, p. 50.

31. ARFSP, I^o piano, serie 3, no. 4a, int. 12, ff. 283–4 (a detailed description of the gilding of the various parts of the *Baldacchino*

is provided on ff. 278r–v). This was summarised in Fontana's report of 1704 concerning the work in the chapel (see the previous note), in which he added to the examples of unsuccessful gilding *a spadaro* Bernini's tabernacle in St Peter's, which was gilded by the *spadaro* Carlo Mattei (see chapter 3).

32. ARFSP, I° piano, serie 3, no. 4a, int. 12, ff. 274–5, 279–82.

33. *Ibid.*, ff. 274v–5; he claimed that the font had been worked 'con la sottigliezza sud.ª ad uso di Argentiere' (f. 274v).

34. *Ibid.*, ff. 287–8 (4 November 1698). For the documents of March 1698 by which Fontana elects Ferreri, and the authorities of the Fabrica elect Urbano Bartelesi, see ASR, 30 Not. Cap., Uff. 38 (S. Augustinis), vol. 70, ff. 187, 188.

35. See Braham and Hager, *Carlo Fontana*, p. 49. The casting of the various sections is described in the ARFSP, I° piano, serie 3, no. 4a, int. 12, ff. 360–3v.

36. *Ibid.*, f. 275v.

37. However, it was not until 1720 that Giardini received a final 200 *scudi* 'per resto, saldo, e final pagam.to di tutte le presentationi del medemo Giardini haute sopra il lavoro da esso fatto del fonte Battesimale in San Pietro . . .' (ARFSP, I° piano, serie Armadi, no. 396, p. 167).

38. 'Un modello di cera gettata tondo rapp.te la Santissima Trinità, che è modello di quella esist.e nel Battesimo di S. Pietro' (ASR, 30 Not. Cap., Uff. 10 (Parchettus), vol. 391, f. 225v).

39. 'Un Basso rilievo intondo di tre palmi di Gesso colorito di Bronzo rapp.te la Santissima Trinità –s. 2' (ASV, 30 Not. Cap., Uff. 10, vol. 444, f. 91); this is repeated in the inventory of the possessions from the inheritance of the former Giovanni Giardini, which were to pass after Giacomo's death to Giacomo's son, Gregorio (ASR, 30 Not. Cap., Uff. 10, vol. 444, f. 404).

40. ARFSP, I° piano, serie 3, no. 4a, int. 12, f. 360.

41. *Ibid.*, f. 249v.

42. 'Altro modello di cera grande, ò sià basso rilievo, il di cui orig.le stà nel sepolcro della Regina di Svetia in S. Pietro di Roma, con diverse statue, e figure allusive à i fatti di d.a Regina on cor.e negra filettata d'oro' (ASR, 30 Not. Cap., Uff. 10 (Parchettus), vol. 391, f. 226).

43. See Carl-Herman Hjortsjö, 'The Opening of Queen Christina's Sarcophagus in Rome', in *Analecta Reginensia I. Queen Christina of Sweden: Documents and Studies*, Stockholm, 1966, p. 145; Lipinsky, 'Arte orafa a Roma', p. 18.

44. In a report recommending that Giardini should be paid less, it was argued (among other things) that this was indeed of great size, but that it had been cast in two pieces, which greatly diminished the risks involved (ARFSP, I° piano, serie 3, no. 4a, int. 12, f. 3023); however, it is possible that this included the frame, which was certainly cast separately.

45. For a full discussion of the genesis of the tomb, the drawings, and artists involved, see Braham and Hager, *Carlo Fontana*, pp. 56–60; Allan Braham, 'The Tomb of Queen Christina', in *Analecta Reginensia I. Queen Christina of Sweden: Documents and Studies*, Stockholm, 1966, pp. 48–58 (with a documentary appendix by Hellmut Hager).

46. See Robert Enggass, *Early Eighteenth-Century Sculpture in Rome*, University Park (Pennsylvania), 1976, I, p. 69, quoting Merlini's autobiography, for which see Klaus Lankheit, *Florentinische Barockplastik*, Munich, 1962, p. 239; Merlini claimed to have carved the reliefs at either end from Théodon's models, which is by no means impossible, as the French sculptor relied extensively on assistants for his marble sculpture.

47. Pietro Rasina received 30 *scudi* for having painted a model of

the medallion portrait 'che apparisce di bronzo, et oro', and he had also painted a project for the arms, etc. (ARFSP, I° piano, serie Armadi, no. 391, f. 260).

48. 'Un Basso rilievo di gesso colorato a Bronzo per longo palmi dieci rappresentante l'Ingresso della Regina di Svezia in Roma, e per alto palmi tre, e mezzo con cornice nera, et oro –s. 12' (ASR, 30 Not. Cap., Uff. 10, vol. 444, ff. 91r–v, 404v). On these two inventories, see above, note 39. The height of 3½ *palmi* should be just over 78 cm; I measured the tomb relief roughly as about 75 cm. and, given the imprecision of fractions of a *palmo*, and the imprecision of my measurement, the discrepancy is irrelevant.

49. This phrase is quoted by Hager without giving the source (in Braham, 'The Tomb of Queen Christina', p. 57); The only similar phrase that I have noted is in Giardini's account (ARFSP, I° piano, serie 3, no. 4a, int. 12, f. 304): 'per fattura d'haver gettato una Cera di tutta la figura della Regina s.di 10'. For the drawings, see Braham and Hager, *Carlo Fontana*, figs. 33 and 34.

50. Braham, 'The Tomb of Queen Christina', p. 52.

51. Braham and Hager, *Carlo Fontana*, cat. 62, fig. 34, a tracing of a more developed version of the design in the Busiri Vici collection includes a relief on the sarcophagus of an allegorical representation of Christina kneeling before a figure of the Church. However, this is a repetition of a drawing by Ciro Ferri (Musée du Louvre, inv. 3092 bis). This was included in Roseline Bacou and Jacob Bean, *Le Dessin à Rome au XVII.e siècle* (exhibition catalogue), Paris, 1988, cat. 65b, but not illustrated; it was there identified as made for an engraving to decorate Niccolò Maria Pallavicino and Francesco Rasponi, *Difesa della divina providenza, contro i nemici d'ogni religione; e della chiesa cattolica, contro i nemici della vera religione*, written in 1655, but published only in 1679; I am grateful to Ursula Fischer Pace for pointing out its connection with the Fontana drawing. I suspect, however, that this reuse of a rather painterly allegory was intended merely to show how the space of the sarcophagus could be filled, and that it was never seriously proposed that this design should be used there.

52. Hugh Honour, knowing only Giovanni's inventory, says that he was given the task of casting Théodon's reliefs for the tomb, implying that this was the relief actually used, and ignoring the fact that it is in marble. (H. Honour, *Goldsmiths and Silversmiths*, London, 1971, p. 121).

53. Giacomo Giardini had inherited from his uncle Giovanni a book entitled 'l'Istoria della Madonna Santissima del fuoco della Città di Forlì' (ASR, 30 Not. Cap., Uff. 10, vol. 444, f. 409v); he also had 'Un Quadro di palmi quattro per alto con cornice nera filettata d'Oro rappresentante il ritratto del Cardinal Paulucci' (*ibid.*, f. 416v).

54. Berlin, Kunstbibliothek, OZ 133, drawing no. 78; pen and brown ink.

55. The image is in fact set against the wall above an altar, and not, as it appears to be on the print, a few centimetres above the floor.

56. He does not appear to have been a very practised engraver, but his inventory does include 'rami da intagliare', including an 'altro ramino principiato ad intagliare' (ASR, 30 Not. Cap., Uff. 10, vol. 444, f. 217). The only drawings that I know by him are two that were included in Christie's auction in Rome of 16 November 1987, lots 37 and 55; the former (for an altar with the arms of Cardinal Bishop Lambertini) includes figures of Christ and two angel herms, with rather woolly draperies such as one sees on the print.

57. His inventory includes 'Un Obligo del d.º Sig.ʳ Giardini sotto li 15. Febraro 1738 di fare per servitio della Cappella della Santissima Verg.ᵉ del fuoco di Forli il lavoro di num.º sei Candelieri d'argento Triangolari e sua Croce' (*ibid.*, ff. 97v–8); pieces of these are mentioned on ff. 92v, 101v–2, 110v–11; see also f. 104. On f. 92v it is stated that these were 'ordinato del Sig.ʳ Marchesse Paulucci'.

58. It should be noted that his inventory included 'altra [ricevuta] di Agostino Corsini scultore di scudi dodici per un Modello di Creta' (*ibid.*, f. 105v), and 'Un Modelletto di Creta rapp.ᵗᵉ S. Fran.ᶜᵒ che dise il d.º Sig.ʳ D. Vincenzo [Cicognini, his cousin and executor] essere d'Un scultore che non è stato pagato' (*ibid.*, f. 110). The payment of 100 *scudi* to Paolo Benaglia on 25 July 1736 (*ibid.*, f. 104v) is too large a sum to have been for models, and seems too late to have been for Giovanni's tomb.

59. For a colour illustration of the chapel, see Lipinsky, 'Arte orafa a Roma', p. 31.

60. 54.5 × 33.5 cm; it was in Sotheby's sale of 9 April 1973, lot 114 (ascribed to Tomasso Amantini) and is now in the collection of Dr G. Rau in Marseilles.

61. 'Due bassi rilievi di metallo grandi due palmi in circa dorati, uno rapp.ᵗᵉ Nostro Signore deposto dalla Croce con gloria di putti, e Padre Eterno e l'altro Christo nell' orto con fondo di lapis lazzoli senza cor.ᵉ; et ornam.º fatti di mano di Angelo de Rossi, e cesellati da' Monsù Germano' (ASR, 30 Not. Cap., Uff. 10, vol. 391, f. 234v). For Germain see above, chapter 5, note 40.

62. 'Due Bassirilievi di metallo dorato alti palmi due, e quattro oncie e mezzo e larghi Vn palmo, e mezzo per ciascheduno mezzo tondo in Cima rapp.ᵗⁱ Vno L'Oratione all' Orto con Gloria de Angeli ben Cisellati da Monsù Germano con suo ornato attorno d'architettura, e Cartocci di rame con guarnitione d'arg.ᵗᵒ e parte mancante che e quella descritta nella cassetta foderata di pelle nera e chiodi d'acciaro con lapis lazzaro nelli sfondi dell'architettura, et il fondo del basso rilievo d'Amatista, L'altro rappresentante Giesù Cristo Morto con Goria d'Angeli, et il Padre eterno con Ovato attorno simile senza guarnitione d'Argento, e pietre con loro casse di Albuccio foderate di pelle rosso gialono ad Uso di cuscinetto. Una Canestra – con dentro – Le pietre di lapis lazzaro in diversi pezzi per ponerli in Opera in d.º ornato il tutto non terminate Le dd. Cornice –s. 1500 [sic]' (ASR, 30 Not. Cap., Uff. 10, vol. 444, ff. 215v–16v). 'Due Bassi rilievi di metallo dorato alti palmi due, e quattro oncie, e mezzo per ciacheduno mezzo tondo in Cima rappresentanti Uno l'Oratione all' Orto con Gloria d'Angeli ben ciselati da Monsù Germano, e l'altro rappresentante Giesù Cristo Morto con Gloria d'Angeli ben cisellati ['da Monsù Germano, e l'altro rappresentante' (underlined for cancellation)] et il Padre Eterno senza ornati sono stati fatti dal fù Sig.ʳ Giacomo [sic] –s. 500 [sic]' (*ibid.*, ff. 431v–2).

63 'A di 10 Nov.ʳᵉ [1744]. Mons. Ill.ᵐᵒ Gio Battista Mesmer etc. à fav.ᵉ degl'Eredi del q.ᵐ Giacomo Giardini, e per essi al Sig.ʳ D. Vincenzo Ciccognini, come Essecutore della volontà, e libero Amm.ʳᵉ deputato dal detto q.ᵐ Giacomo nel suo Testam.ᵗᵒ, e codicillo aperto per gl'atti del Parchetti Not.º Cap.ⁿᵒ li 10 Mag. 1739 al quale etc. s. Millecinquanta m.ᵗᵃ, quali sono per saldo, et intiero pagamento del prezzo così d'accordo stablito, con il med. S.ʳ D. Vincenzo, di n.º Due Bassi rilievi di Metallo dorati, che uno rappresentante l'Orazione all'Orto, e l'altro la deposizione della Croce di N.S., con fondo d'Amatista, guarniti con Cornice sim.ᵉ, fondo di lapis lazzuli, e fiori d'Argento, alti p.ᵐⁱ 5 –Ereditarij del sudetto q.ᵐ Giacomo Giardini, da Noi Compri d'ordine di Sua Santità e dalla med.ᵃ Santità Sua donati li 3 del corr.ᵉ mese, alla Maestà delle due Sicilie, in occasione gli si portò alla visita del suo arrivo in Roma etc. –s. 1050'(SPA, Computisteria, vol. 3044 f. 119, no. 176).

The donation itself is recorded in Giuseppe Vasi's *Delle Magnificenze di Roma antica e moderna*, I, Rome, 1747, p. XVIII: On Tuesday 3 November 1744 the king went up the Scala Regia to the papal apartments, 'ove erano disposte trè nobili Cassette guarnite di Velluto cremesi, e Galloni d'oro, con dentro Agnus Dei, e Reliquie, e due Bassi rilievi di bronzo dorati sopra un fondo d'Ametisto, con ricche cornici di Lapislazzulo, ed ornamenti di fiori d'argento, delle quali cose mostrò S.M. un pienissimo gradimento'. After lunch he visited the Lateran, and then hastened back to Velletri. I am indebted to Elisabeth Kieven for this reference.

64. Museo degli Argenti, inv. ASE 74. I am grateful to Kirsten Aschengreen Piacenti for enabling me to examine it, and for the information that it was added to the 1818 inventory on 3 January 1820 (no. 736), and has a case with the arms of Pius VI Braschi (1775–99), which provides clear evidence that it was a gift from Rome. The scallop-shell with the two cherub-heads below seems out of character with the rest of the frame, and might be a later addition, possibly replacing a bowl for holy water. A silver-gilt pax with an image of the *Pietà*, datable to c. 1720 and with Giardini's stamp, was exhibited in 1995 at the Newhouse Galleries in New York by Trinity Fine Arts (*Old Master Drawings and European Works of Art*, cat. 105). It is well chased, but cannot be compared with either the gilt bronze Rau relief, or the silver relief in the Metropolitan Museum (see above, p. 235, note 6).

65. Carlo Giusepe Ratti and Raffaello Soprani, *Delle Vite de' pittori, scultori, ed architetti genovesi*, Genoa, 1769, II, p. 239; Helga N. Franz-Duhme, *Angelo De Rossi. Ein Bildhauer um 1700 in Rom*, Berlin, 1986, p. 228, cat. 14. De Rossi made a marble bust of Corelli, now in the Protomoteca Capitolina in Rome, which Franz-Duhme suggests was made for his tomb, in which case it would be datable 1713–14 (*ibid.*, cat. 19, pp. 231–2).

66. ASR, 30 Not. Cap., Uff. 10, vol. 391, ff. 404v–5; vol. 444, f. 91v. It measured 10 *palmi* 7 *oncie* by 3 *palmi*, and was valued at 30 *scudi*.

67. It was made in Genoa about 1664, on the commission of the Duke of Mantua, Carlo II Gonzaga. See Klaus Herding, *Pierre Puget: das bildnerische Werk*, Berlin, 1970, figs. 141, 144, cat. 30; Ursula Schlegel, *Staatliche Museen Preussischer Kulturbesitz, die Bildwerke der Skulpturengalerie Berlin, Band I: die itlienischen Bildwerke des 17. und 18. Jahrhunderts in Stein, Ton, Wachs und Bronze . . .*, Berlin, 1978, cat. 19, pp. 63–70, with earlier literature. Although Puget's marble relief left Genoa almost at once, the motif of the angel kissing the foot of the Madonna reappears on Parodi's marble sculpture in S. Carlo in Genoa; see Paola Rotondi Bianco, *Filippo Parodi*, Genoa, 1962, fig. 12, and also note 21 on pp. 67–8.

68. Ratti and Soprani, *Delle Vite de' Pittori*, II, p. 239; H. N. Franz-Duhme, 'Un Rilievo poco noto e un disegno di Angelo de' Rossi', *Antologia di belle arti*, n. s., 23–4, 1984 pp. 80–3; *idem*, *Angelo De' Rossi*, cat. 3, pp. 184–6; *idem*, 'Zum Reliefstil von Angelo De Rossi (1671–1715), *Jahrbuch der Berliner Museen*, n. f., XXIX/XXX, 1987/8, pp. 218–21. A replica of this relief, in a gilt bronze and porphyry frame, was drawn in the workshop of Luigi Valadier, see *Valadier: Three Generations of Roman Goldsmiths. An Exhibition of Drawings and Works of Art* (exhibition catalogue, by Artemis group), Lon-

don, 1991, cat. 56.

69. On this arrangement see ASV, S.R. Rota, Giura diversa 493, testimony dated 24 October 1756; in the same testimony it was said that this applied also to the Arrighi (or Arighi) brothers, and it has already been seen that of the brothers Domenico Vincenzo and Giovanni Stefano Brandi, only the latter was a member of the guild (see above, chapter 3, note 52).

70. On Francesco Giardoni, and his work as a bronze-founder, see the essay by Flavia Pastina, 'Francesco Giardoni fonditore camerale' in *l'Angelo e la città*, I, pp. 73–81.

71. See Bulgari, *Argentieri, gemmari e orafi d'Italia; Parte prima – Roma*, II, Rome, 1959, p. 308. For his will and inventory see ASR, 30 Not. Cap., Uff. 6 (Hieronymus Sercamillo), vol. 310, ff. 358–65, 411–49v. The silver (most of which was in the room next to that in which he died, but appears to be stock, rather than household property) contains virtually no figurative pieces except one silver and gilt bronze relief of a saint (f. 414), valued at 10 *scudi*, though some of the chalices and dishes would have been decorated; one silver reliquary (f. 412v) was valued at 20 *scudi*, but the others (ff. 416v–17v) range from 1 to 6 *scudi*. However, it should be borne in mind that values given in inventories tend to be low, sometimes ridiculously so.

72. On this statue see *L'Angelo e la città*, I. It should be remarked that the whole surface is worked with a round chisel to produce an effect well compared to lizard-skin, no doubt to reduce the reflection of bright sunlight on the bronze which, with its high zinc content, would originally have shone like gold (see Gianluigi Colalucci, in *ibid.*, p. 216),

73. Partly gilt bronze, 128 × 76 cm; see Alvar González-Palacios, in Sandra Vasco Rocca and Gabriele Borghini, *Giovanni V di Portogallo . . . e la cultura romana del suo tempo* (exhibition catalogue), Rome, 1995, cat. 94. The payment is recorded in ASV, SPA, Computisteria vol. 3043, p. 149, no. 158: '. . . A favore di Franc.co Giardoni Argentiere . . . per saldo d'un conto di due Ornati di Rame dorati, alti palmi cinque in circa, con Festoni, Frontispizij, cartelle, e Glorie de Serafini, et à piè di essi l'Arme della Maestà delle due Sicilie con Corone Reali, e Collana dell'Ordine dello Spirito Santo, e S. Giorgio, il tutto cesellato, e dorato à Zecchino macinato, et alli Fondi di Rame macinato, per collocarvi due Quadri di Musaico, che uno rappresent.e il Santissimo Salvatore, e l'altro la Madonna Santissima, già mandati in dono dalla S. mem.a di Clemente XII.o alle Maestà sud.e, e per altri lavori, e spese fatte per detti musaici . . . li 17 Lug.o 1741 – s. 650'. The mosaic by Pietro Paolo Cristofori had cost 860 *scudi* (*ibid.*, p. 149, no. 159).

74. Although there is no documentary proof of Giardoni's responsibility, González-Palacios also noted the existence of almost identical frames around mosaics of the *Virgin* and the *Ecce Homo* in the Museu di Arte Antiga in Lisbon, with the royal arms of Braganza. Further, there are two references to a presumably rather similar frame for a mosaic of *St Peter*. (1) ASV, SPA, Computisteria 3045, p. 74, no. 104 (4 August 1751): '. . . A favore di Fran.co Giardoni Argentiere scultore di s. Seicentoventicinque m.ta quali sono per saldo, et intiero pagam.to d'un conto d'haver fatta una cornice di Metallo ovata, con festonj Arme di N.S.e et altro, dorata ad'oro di zecchino, e posta ad'un Quadro di Musaico rappresentant.e S. Pietro . . .'. (2) *Ibid.*, pp. 143–4, no. 141 (19 August 1752): '. . . à fav.e di Fran.co Giardoni Argentiere del Sag.ro Pal.o Ap.co di s. trecento m.re quali sono per saldo, et intiero pagam.to d'un

conto d'una cornice di metallo ovata, alta circa p.mi 5. parte dorata, e parte color di rame con ornati di fiori, festonj, et altro la med.a fatta d'ord.e di Sua Santità, in restituz.e d'altra sim.e con dentro Pittura in Musaico rapp.e S. Pietro Apostolo, data dall'Ecc.ma casa Albani per donarsi dà Sua Santità ad'un Personaggio Forestiere . . . –s. 300'. These may not have been the first such frames, for in January 1746 the pope wrote of having sent to Moscow to Mikhail Ilarionovich Vorontsov, Vice-Chancellor and Counsellor of State to the Emperor of Russia, who had admired the mosaics and tapestries he saw at his audience, 'un bel Quadro di musaico di cinque palmi d'altezza colla sua cornice di bronze dorato, e per la Moglie un Quadro d'Arazzo ben travagliato con una simile cornice . . .' (BUB, MS. 237, letter 21, ff. 48r–v).

75. 'A nostri tempi quasi tutte le Opere grandi, e Magnifiche, che sono state fatte in Roma sono state sempre fatte, e respettivam.e vi à avuta sempre mano il celebre Sig.re Carlo Giardoni, avendo il med.o unitamente col sig.re Francesco suo Fratello fusa, e Lavorata la Statua di Clemente XII: tanto in S. Gio: in Laterano, quanto in Campidoglio . . .' (ASV, S.R. Rota, Giura diversa 493, 25 November 1756). Carlo's standing was of relevance to the trial, which will be discussed in the following chapter, as he had been one of those to make the first two valuations of Giuseppe Gagliardi's work.

76. See Francesca Montefusco Bignozzi, 'Opere plastiche dal barocco al neoclassico', in *La Basilica di San Petronio in Bologna*, Bologna, 1984, II, p. 126.

77. There are numerous differences between the reliquary as it survives today and the print, but most of these, such as the direction of the heads of the cherub-herms on the reliquary casket, are minor, and probably due to a misinterpretation of the drawing.

78. It is described as a 'sontuosa macchina di getto, mirabilmente dorata, intrecciata con Cirmolo, legno assai singolare, vantando eziamdio questa il predetto rinomato Artefice' (Celestino Petracchi, *Della insigne abbaziale Basilica di S. Stefano di Bologna*, Bologna, 1747, p. 62; 'cirmolo' can mean either a Swiss, or Siberian pine, or a Peruvian custard apple). According to Benedict XIV, Giardoni wanted it carried to Bologna in two parts, 'che la parte di legno dorato, sù cui deve posare il Ciborio, quando si porterà in processione, venga su lo strascino. E che l'altra parte, id est il Ciborio d'argento di metallo e di lapis lazzolo, e cristallo venga su le stanghe di Palazzo (BUB, MS. 4331, part 1, no. 187, letter of 24 August 1743, ff. 369r–v). It may be that the words 'legno dorato' are an elision for wood and gilded bronze.

79. 'Esso è un grand'Uomo, e l'opera lo dimostra. Viene a Bologna per compiacerci, e per veder pitture, essendo buon Professore di disegno. Ella poi ritrovi chi lo vada conducendo, e gli faccia vedere il Paese, ed in qualche congiuntura ritrovi anche il comodo di qualche carrozza, essendo Uomo pingue' (*ibid.*, ff. 369v–70). On this visit, and other work commissioned from Giardoni by the pope, there are numerous comments in other letters; see Irene Folli Ventura and Laura Miani (ed.), *Due carteggi inediti di Benedetto XIV*, Bologna, 1987, *passim*.

80. See Bignozzi, 'Opere plastiche dal Barocco', p. 132; Claudio Varagnoli, 'Domenico Gregorini e il cardinal Aldrovandi: il progetto, la committenza, il cantiere alla metà del XVIII secolo', in Elisa Debenedetti, *L'Architettura da Clemente XI a Benedetto XIV: pluralità di tendenze (Studi sul Settecento romano, 5)*, 1989, pp. 131–55; ASB, Fondo Aldrovandi Marescotti, b. 230, reproduced here in appendix III. Varagnoli reproduces

some letters from Gregorini in Rome, reporting on Giardoni's progress with the work. This was one of the sculptures on which we are specifically informed that Carlo Giardoni collaborated (ASV, Giura diversa 493, testimony of 25 November 1756).

81. See Costanza Gradara, *Pietro Bracci, scultore romano 1700–1773*, Rome, [1920], pp. 64–6, pl. XXI. Bracci is, strangely, not among those artists mentioned by Bignozzi as collaborating with Giardoni; she sees these angels as reflecting the style of Rusconi, and suggests that Ludovisi might be the author ('Opere plastiche dal Barocco', p. 132, and note 37 on p. 141). The only time that I am aware of Giardini casting models by Bernardino Ludovisi was in 1740, when Giardoni was paid 1,340.94½ *scudi* for silver statues of *Sts Matthias* and *John* from models for which Ludovisi received 70 *scudi* (ASV, SPA, Computisteria, vol. 215, no. 75/15, vol. 216, no. 95/33, vol. 3042, p. 78, no. 34, and p. 95, no. 33). However, Ludovisi did make a bust of Cardinal Pompeo Aldrovandi (Bignozzi, p. 141, note 37), and might have been favoured by this Bolognese patron.

82. Vincenzo Golzio, *Le Terracotte della R. Accademia di S. Luca*, Rome, 1933, pp. 13–14. It may be noted that in a payment of 1749 for his work for Sta Maria Maggiore Francesco Giardoni was described as 'scultore de Metalli' (ASR. Cam. I°, Fabbriche, vol. 1556, p. 13; elsewhere in the same list of payments he is called 'Argentiere').

83. For what follows I am largely dependent on Michele Faloci Pulignani, *Storia della statua di S. Feliciano in Foligno*, Foligno, 1926.

84. *Ibid.*, pp. 40–2.

85. *Ibid.*, pp. 43–55.

86. While it is plausible that a silversmith from Foligno would have been preferred, it is also possible that he was a 'front' for Gaap, who was not a member of the guild. Montecatini and Gaap received in all some 2,750 *scudi*.

87. See Ludovico Jacobilli, *Vita di San Feliciano martire, vescovo, e protettore della citta di Foligno . . .*, Foligno, 1626, pp. 45–53. On this throne see the article by Angelo Lipinsky, 'Ein schwäbischer Goldschmied in Umbrien: Johann Adolf Gaap aus Augsburg in Perugia', *Das Münster*, XXX, 1980, pp. 57–60.

88. 'Un modello in piccolo per la statua di S. Feliciano' (Faloci Pulignani, *Storia della statua*, p. 58).

89. 'Ed essendo ancora, che per venire all'effettuazione del lavoro di d.a Statua procurassero dd. Sigg. Mercanti e Negozianti di averne un modello di tutta perfezione, come l'ebbero dal valore del Sig. Gio. Battista Maini Primario Scultore di Roma, e ne concordassero il lavoro d'argento con altri accompagnamenti di rame dorato con i Sigg. Francesco Giardoni, e Filippo Tofani principali Argentieri della med.a Città di Roma . . .' (M. Faloci Pulignani, *I Priori della cattedrale di Foligno*, Perugia, 1914, p. 332); this quotation is from the document of 20 January 1733, consigning the finished statue to the chapter of the cathedral. On the 1.85 m. high statue, see also Angelo Messini, *Per il XVII centenario del martirio di San Feliciano (251–1951). La Statua d'argento del santo patrono di Foligno. Notizie storiche*, Foligno, 1943.

90. For the statues of Urban VIII, on his tomb in St Peter's and in the Palazzo dei Conservatori, see Rudolf Wittkower, *Gian Lorenzo Bernini*, 2nd ed., London, 1966, cat. 30 and 38, pp. 198–9, 206–7. For that of Innocent X in the Palazzo dei Conservatori see J. Montagu, *Alessandro Algardi*, New Haven/London, 1985, p. 428, cat. 152.

91. ASR, Camerale II°, Antichità e Belle Arte, Busta 9, fasc. 226 (description of sculptures left by Innocenzo Spinazzi in the care of Giovachino Falcioni, 1807). I owe this reference to David Bershad.

92. It is covered with goldish-coloured paint on a red ground, and according to the museum's records measures 180 × 125 cm. Although these records give no provenance, this must surely be the gesso model which Faloci Pulignani believed to be Maini's original, which in 1932 was in the possession of Avvocato Pierani, in Palazzo Gregori; Giovanni Battista Gregori was one of the representatives of the merchants of Foligno responsible for arranging its consignment to the church, and it was to his palazzo that it had been sent from Rome (M. Faloci Pulignani, *Indulgenze concesse dai Sommi Pontefici a chi visiterà la statua di S. Feliciano*, Foligno, 1932, p. 6; *idem*, *Storia della statua*, pp. 60–2). I am grateful to Dott. ssa Montevecchi for helping me to gain access to the closed museum, and to Architetto Finauri for opening it for me, and for other assistance in Foligno.

93. Possibly this combination of two techniques and materials, cast bronze and repoussé silver, explains the involvement of two metal-workers.

94. Faloci Pulignano, *Storia della statua*, p. 67.

95. Private collection; black chalk, 19.7 × 16.1 cm. The other drawing, in the same collection (also black chalk, 21 × 11 cm.) is very similar; indeed, both seem to be drawn over the same traced image of the saint.

96. It cost 930 *scudi* (Faloci Pulignano, *Storia della statua*, p. 57).

97. In 1797 another silversmith was commissioned to make cherubs from a pre-existing model, presumably that of Maini which would have been made for Pulignani. This was a rather suprising commission, considering that it came only a year after the dire Armistice of Bologna, when so much silver was melted down to satisfy the demands of the French, and the statue had to be walled up in a hidden corner of the church. Not surprisingly, this attempt also failed to produce any result, but in 1800, when the danger was passed, and the statue emerged from its hiding place tarnished from the damp, yet another silversmith was commissioned to polish it up, and to make the angels. Nor was this the last vain effort to complete the statue as Maini had intended (*ibid.*, pp. 69–71).

98. See *Gazzetta di Foligno*, Wednesday 8 September 1982, 'Edizione straordinario'.

99. This was done by Nicola Morelli; see *L'Angelo e la città*, I, p. 73, note 6. The replaced parts included the head: compare Fig. 219, which shows Morelli's replacement, with the other illustrations of the statue, taken before the theft.

100. The full and entertaining story is unravelled by Elisabeth Kieven, 'Die Statue Clemens' XII. im Palazzo Corsini in Florenz, ein Werk des Carlo Monaldi', *Mitteilungen des Kunsthistorischen Institutes in Florenz*, XXIX, 1985, pp. 410–17.

101. This is a reconstruction by Elisabeth Kieven; I am grateful to her for allowing me to reproduce it, and to Gunter Passavant for providing the photograph.

102. For the history of this chapel see Elisabeth Kieven, 'Überlegungen zu Architektur und Ausstattung der Cappella Corsini', in Elisa Debenedetti, *L'Architettura da Clemente XI a Benedetto XIV: pluralità di tendenze (Studi sul Settecento romano, 5)*, 1989, pp. 69–95.

103. ASF, Carte Galilei, filza 14, unpaginated.

104. This is known from the evidence given in the lawsuit between the heirs of Giuseppe Gagliardi and those of the Commendatore Sampajo (for which see the following chap-

ter) testimony of Carlo Giardoni, 6 September 1753, which also states that Pozzi assisted. However, he cannot have done much: the first payment of 500 *scudi* on 26 January 1735 was to Pozzi, the second of 600 *scudi* on 31 March 'per esso al S.^r Fran.^{co} Giardoni', and the third on 1 April 'al S.^{re} Fran.^{co} Giardoni, e Eredi di Giacomo Pozzi' (ASF, Carte Galilei, filza 14). Pozzi's will was opened on 5 March (see above, note 71), which would have been the day of his death, or immediately following his death. The same testimony of Carlo Giardoni in Gagliardi's lawsuit also informs us that they were given the use of the foundry of the Reverenda Camera in the Belvedere.

105. 2° Che tutta l'opera sopradetta debba essere gettata di Rame fine che formi un metallo perfettissimo, da potersi dorare à macinato con oro di Zecchino in qualunque parte piacerà, è sarà ordinata dal Sig.^r Galilei, e che tutti li metalli della medema debbano essere gettati, rinettati, cisellati, e terminati cola maggior diligenza possibile secondo l'arte ad uso d'argento, e à tutta perfezzione, e di più abili Professori dell'arte, che siino in Roma' (ASF, Carte Galilei, filza 14).

106. It may be noted that the architect Luigi Vanvitelli, writing on 25 March 1758 to his brother about the casting of the doors for St Peter's by Francesco Giardoni's son Giuseppe, advised him to specify 'le precise grossezze e conseguentemente il peso che devono avere le lastre per ogni palmo . . . per non cadere nella pania' (Franco Strazzulo [ed.], *Le Lettere di Luigi Vanvitelli della Biblioteca Palatina di Caserta*, II, Galatina, 1976, letter 547, p. 195). Vanvitelli had on occasion manifested a poor opinion of Francesco Giardoni's honesty, and, as for his son, 'se non à ereditata la facilità di modellare del padre, à ereditato la malizia più dell'istesso suo padre' (*loc. cit.*).

107. On 22 August 1735 Maini was paid 800 *scudi* 'per li modelli della statua di N.S. di metallo, ed assistenza al med.^a fino a tanto che sara posta in opera' (ASF, Carte Galilei, filza 14). On 6 August 1735 Giardoni had been given 530 *zecchini* costing 1,795.25 *scudi* to gild the statue, 'stante la grandezza del opera' (*ibid.*).

108. See Chracas, *Diario ordinario*, 2843, 22 October 1735, p. 2, and 2966, 4 August 1736, p. 5. The casting must have been judged satisfactory, for in 1737 Francesco Giardoni was selected to cast another bronze statue of the Clement XII for the Campidoglio, this time from a model by Pietro Bracci, because he was Roman, and 'perche anche hà auto l'onore d'aver fatto l'altra statua di bronzo à sua Santità nella cappella . . . Corsini', though again this was a joint work by the brothers. For the Campidoglio statue the contract stipulated that the founder was to take the moulds from the sculptor's model, and make a wax from these moulds, which was then to be approved by the sculptor before Giardoni proceeded with the work. The price was agreed in advance (4,800 *scudi*), but the weight was laid down, and the thickness ('circa due minuti almeno di oncia di passetto Romano') and, if either were exceeded, an appropriate deduction could be made from the payment (Arch. Cap., Credenza VI, vol. 118, ff. 184–5v, 190). On this statue see Gradara, *Pietro Bracci*, pp. 40–4; Pastini, in *L'Angelo e la città*, I, p. 74.

109. See, for example, the altar-frontal made by Angelo Spinazzi with models by Giuseppe Rusconi for the church of the Annunziata in Siena in 1732–4, and now in the Museo dell'Opera del Duomo (Daniella Gallavotti Cavallero, 'Angelo Maria Spinazzi e Giuseppe Rusconi, artisti romani, e un paliotto inedito a Siena', *Studi romani*, XXXIII, 1985, pp. 263–7). On 5 November 1722 Simone Martines (or Martinez) had been contracted to make a silver altar-frontal for Sta

Maria Máddalena in Rome, with a scene of the *Feast in the House of Simon the Pharisee* (see ASR, 30 Not. Cap., Uff. 10, vol. 393, ff. 297r–v, 312; Luisa Mortari, *S. Maria Maddalena* [Le Chiese di Roma illustrate, N.S. 20], Rome, 1987, p. 101; apart from the 50 *libbre* of silver specified in the contract, Martines was also paid for gilt bronze). In 1753 Benedict XIV gave to the Metropolitana in Bologna a 'pallio d'argento, in cui si rappresenta Gesù Cristo che dà le chiavi a S. Pietro con tutti gli Apostoli. Il peso dell'argento è di lib. 174' (*Diario benedettino*, Bologna, 1754, p. 47; Bruno Trebbi, *L'Artigianato nelle chiese bolognesi*, 1958, p. 22). This has been confused with the 'gradino da Altare' (see Trebbi, figs. 1, 2; Angelo Lipinsky, 'Gli arredi sacri di Benedetto XIV per S. Pietro di Bologna', *Fede e arte*, 1964, 4, pp. 188–93); however, the *gradino* (which rises behind the altar-table, and serves as a support for the cross and candlesticks), with its 'fondo di lapilazzulo con bassi rilievi d'argento' representing St Peter attempting to walk on the water, flanked by figures of Faith and Religion, was made by Angelo Spinazzi and presented in 1755 (see Chracas, *Diario ordinario*, 5910, 31 May 1755, pp. 16–17; it was also mentioned in *ibid.*, 5907, 24 May 1755, pp. 15–16, and 5913, 7 June 1755, pp. 9–10 – for these and other references to Spinazzi in Chracas I am indebted to Geneviève Michel). The entry for the central relief of the *gradino* in Jadranka Bentini (ed.), *L'Arredo sacro e profano a Bologna e nelle legazioni ponteficie* (exhibition catalogue, X Biennale d'arte antica: l'arte del Settecento emiliano), Bologna, 1979, cat. 259, states that Filippo Tofani stamped some of the reliefs, but, if this is so, he must have been working for Spinazzi.

110. The *Diario benedettino*, which lists these gifts, omits any for 1752; it was published in 1754, and therefore omits various later donations made during the last four years of his reign. It is reprinted in Trebbi, *L'Artigianato*, pp. 17–22.

111. BUB, MS. 237, letter 21 (to the marchionessa Camilla Caprara Bentivoglio Duglioli), ff. 47v–8.

112. A few pieces are signed, such as the chalice made by Giuseppe Politi in 1707 and given in 1740, or stamped, such as the pyx by Francesco Baislach; see Bentini (ed.), *L'Arredo sacro e profano*, cat. 246, 249. Giardoni made the reliquary for the chains of St Peter (Ajuda, MS. 49-IX-22, f. 103), and there is also evidence to ascribe to Giardoni the rock-crystal and gold chalice and paten given in 1646 (Luigi Samoggia, 'Benedetto XIV e il Portogallo; su alcuni aspetti delle relazioni diplomatiche e culturali durante il regno di Giovanni V', *Giornale di studi padani*, Cento, 18 December 1977, p. 194). The two large silver candlesticks, each 15 *palmi* high, and twelve gilt bronze crosses, sent in 1656, were by Angelo Spinazzi (Chracas, *Diario ordinario*, 6069, 5 June 1656, pp. 12–13; see also ASV, S.R. Rota, Giura diversa 493, testimony of 1 December 1756, which refers to the candlesticks made 'ultimamente' by Spinazzi for the Metropolitana in Bologna). For other work by Spinazzi commissioned by Benedict XIV for the Metropolitana, see above, note 109.

113. ASR, 30 Not. Cap., Uff. 10, vol. 391: 'Un Arme in grande di getto di Metallo dell'Eminentissimo Sig.^r Cardinale Lambertini finita, e Cisellata restando solamente d'Indorare di peso lib: 165./Altra Arme simile alla sudetta non finita di Cisellare, quali si disse esser di d.° Card: di peso lib: 176' (f. 85). 'Una Piccola Cartagloria di Piastra di Rame sopra il legno con Arme dell'Eccelentissimo Lambertini' (f. 92). 'Un Ciborio, o sia Modello di legno con suoi ornati di Cera modellati che si disse dalli Giovani lavorante spettare all'Eccelentissimo Lambertini' (f. 90). There were also 'Tre Teste di Cherubbine

di Metallo in gettito con quattro pezzi di Nuvole parim.te di Getto quale stanno lavorando e sono dello stesso Sig.r Cardinale [Lambertini] il tutto di peso lib: duecento tre' (f. 85), the purpose of which is unknown. On f. 100v is listed 'Un libretto . . . di carattere di d.o Sig.r Giardini in cui sono notati li denari receuti dall'Eccelentissimo Lambertini, Capitolo di S. P.ro, et altri per lavori', and on f. 108 'Un Mazzetto di Lettere Concernente il Lavoro dell'Eminentissimo Lambertini di Bologna in numero otto'. Amongst Giacomo Giardini's receipts should be noted 'Altra di Giacomo Galli 31 Lug.o 1738 di s. 5 per Modello d'Una targa, altra del d.o Galli s. 4 di 27 Agosto 1738 per Modello d'Una Carta Gloria' (f. 95); Galli normally worked as a stuccoist.

114. It measures 36 cm., and was given in 1750; see *Diario bendettino*, p. 46; Lipinsky, 'Gli Arredi sacri . . .', p. 203; Bentini (ed.), *L'Arredo sacro e profano*, cat. 254.

115. Silver on velvet, 25 × 17 cm. See *Diario benedettino*, p. 46; Trebbi *L'Artigianato*, fig. 137; Lipinsky, 'Gli Arredi sacri', p. 204; Bentini (ed.), *L'Arredo sacro e profano*, cat. 255.

116. Private collection; black chalk, image 7.2 × 5.5 cm.

117. Giulio Colombo, 'Lo Scultore Giambattista Maino: Notizie – epistolario', *Rassegna gallaratese di storia e d'arte*, XXV, 1966, pp. 29–45. This seems to be true.

118. The whole silver-gilt structure measures 127 × 45 cm., and the height of the central relief is 60 cm. See Trebbi, *L'Artigianato*, figs. 21, 22; Lipinsky, 'Gli Arredi sacri', pp. 193–4; Bentini (ed.), *L'Arredo sacro e profano*, cat. 252.

119. Franz-Duhme, *Angelo De Rossi*, cat. 13, pp. 222–7.

120. To the eleven drawings catalogued by Franz-Duhme (*loc. cit.*), can be added one in the Louvre (Mary Newcome-Schleier, *Le Dessin à Gênes du XVI^e au XVIII^e siècle* [exhibition catalogue], Paris, 1985, cat. 98, pp. 113–14), and one at Darmstadt (cited by Newcome-Schleier, *loc. cit.*).

121. Inv. P.V. 10388; 60 × 52 cm. See Antonino Santangelo, *Museo di Palazzo Venezia. Catalogo delle sculture*, Rome, 1954, p. 78 (as Bolognese); Franz-Duhme, 'Zum Reliefstil', pp. 227–34. For the fragments of the original terracotta, see Maria Giulia Barberini, *Sculture in terracotta del barocco romano*, p. 67.

Chapter 7: From Rome to Lisbon. The Patronage of King John V

1. For the documents from the Biblioteca da Ajuda, including those reproduced in appendices IV and V, I am indebted to the transcriptions made by Sandra Vasco Rocca and Gabriele Borghini, for whose generosity I express my sincere gratitude. My own work there was very limited, and guided by their references. The volume they edited, *Giovanni V di Portogallo (1707–1750) e la cultura romana del suo tempo* (Rome, 1995), appeared when this book was in proof, and, although it covers much of the material dealt with in this chapter, references to it are given only for specific works cited there.

2. On the relationship between Portugal and Rome see in particular the excellent and extensively documented essay by Angela Delaforce, 'Lisbon, "This New Rome": Dom João V of Portugal and Relations between Rome and Lisbon', in Jay Levenson (ed.), *The Age of the Baroque in Portugal* (exhibition catalogue), Washington, National Gallery of Art, 1993, pp. 48–79; a more general overview of the period is provided in the essay by Armindo Ayres de Carvalho, 'Dom João V and the Artists of Papal Rome' in the same catalogue, pp. 30–47.

3. One should not overlook the splendour of Sampajo's own residence as described in his inventory, ASR, 30 Not. Cap., Uff. 29 (6 May 1750), ff. 977–1002; see also the various descriptions of his belongings in Bibl. Corsini, MS. 35.D.9 (Eredità Sampajo II), ff. 155–317. Documents concerning the case brought against him by Francesco Giardoni include references to domestic silver, which was certainly provided for Sampajo himself (Bibl. Corsini, MS. 35.D.8, especially ff. 128v–32, 134–5v, 138–40); the list of payments by the Banco di Santo Spirito made to Filippo and Leandro Gagliardi and to their mother, widow of Giuseppe Gagliardi, for work done for Sampajo, some of which is secular, was also presumably for him rather than the King of Portugal (ASV, S. R. Rota, Giura diversa 493, unfoliated).

4. In 1742 the nunzio, Jacopo Oddi, wrote to Cardinal Valenti, 'Deve Vostra Eminenza sapere che Sampajo è figlio d'un prete curato dell'Algarve e d'una mulatta', and added that the Jesuit Father Carboni 'più volte mi ha inteso ch'esso lo conosce per un falso e per un mal uomo' (Luigi Samoggia, 'Benedetto XIV e il Portogallo; su alcuni aspetti delle relazioni diplomatiche e culturali durante il regno di Giovanni V', *Giornale di studi padani*, Cento, 18 December 1977, p. 190).

5. For the relationship between Benedict XIV and the Portuguese I am following Samoggia, 'Benedetto XIV e il Portogallo'.

6. Robert C. Smith, 'João Frederico Ludovice, an Eighteenth Century Architect in Portugal', *Art Bulletin*, XVIII, 1936, pp. 273–370. Ludovici was in Portugal at least by 1701.

7. Ajuda, 49-VII-13, 49-VIII-26.

8. Ajuda, 49-VIII-26, ff. 25v–26v. It was made by Carlo Pacilli (*ibid.*, 49-VIII-12, no. 202a).

9. For the drawing of that by Andrea Valadier, see *Valadier: Three Generations of Roman Goldsmiths. An Exhibition of Drawings and Works of Art* (exhibition catalogue, by Artemis group), London, 1991, cat. 3; it is also reproduced by Delaforce in Levenson (ed.), *The Age of the Baroque in Portugal*, p. 72, fig. 12.

10. This engraving comes from *The Builder*, VIII, January 1850, p. 42, and is after the lost set of drawings known as the Weale Album, for which see p. 164. For the Patriarcate, see the valuable article by Marie-Thérèse Mandroux-França, 'La Patriarcale du Roi Jean V de Portugal', *Colóquio artes*, LXXXIII, December 1989, pp. 34–43.

11. See the will of Antonio Montauti, opened 10 June 1746, ASR, 30 Not. Cap., Uff. 34, vol. 258, ff. 487v–8.

12. Comparing Montauti's grille with the others, it was stated that, 'non ostante il suo lavoro sia quasi per metà meno di quello di Matteo Piroli, e di altri pure lo fà ascendere a costo maggiore . . . la colpa è riferibile unicamente al Professore [Montauti] per aver posto in opera il metallo vergine di Salerno, che di natura sua beve maggior quantità di oro di quello, che possa assorbire il metallo di perfetta qualità, come sono le altre Cancellate' (Ajuda, 49-VIII-6, f. 65v).

13. '. . . il Montauti era riconosciuto in Firenze per uno de migliori Professori . . . che riguardo al suo principalle impiego fosse uno di migliori . . . ma riguardo a quello di Bronzista, ne à dato poco saggio' (Ajuda, 49-VIII-6, f. 112).

14. '. . . il Montauti era riconosciuto in Firenze per uno dei migliori Bronzisti, e scolaro del Piamontini . . .' (*ibid.*, f. 114v). For Corsini's concern that the payment be made, see *ibid.*, ff. 309v, 375 (letters from Sampajo of 5 June 1748, 24 July 1748); in the latter Sampajo promised to complete the payments by 20 August.

15. See appendix IV.

16. See appendix IV.

17. Private collection; black chalk heightened with white, 21.5 × 31 cm.

18. Ajuda, 49-VIII-6, f. 436.

19. *Ibid.*, f. 244.

20. *Ibid.*, f. 139v, letter of 17 November 1747.

21. *Ibid.*, ff. 308, 310, 323. It was the wife of the embroiderer, Giuliano Saturni, who had to pawn her jewels.

22. *Ibid.*, f. 308v.

23. *Ibid.*, f. 434, letter of 11 September 1748. Interestingly, Sampajo decided not to provide similar help to Giardoni, who was going ahead easily enough ('a mano sciolta') on the relief; Sampajo judged that he was not in similar need, and that he would continue to work without being paid in advance (*loc. cit.*).

24. The crisis of 1747–8 was increased by the king's illness in 1747, which everyone in Rome knew about, so that all the artists wanted to make sure of being paid before he died (*ibid.*, f. 33).

25. ASV, S. R. Rota, Giura diversa 493, 23 April 1757. This *busta* is not foliated, and, as most of the testimonials are signed by a large number of workmen, I am merely providing the date for each; regrettably, they are not in strict chronological order. It may be of use here to indicate some of the material to be found in these documents, which I shall not be referring to. Because of the nature of the case, it was necessary to establish the standing of those involved, particularly in the making of the various estimates, so there is information on Matteo Piroli (25 October 1756), Francesco Juvarra (9 November 1756), and Filippo Tofani (7 November 1756, 1 December 1756). It was also necessary to show whether or not such estimates had been made according to custom, so we learn that larger works were normally estimated at a higher rate than small, and lighter works at a higher rate than heavier (29 September 1756), and that it was not normal to subtract the weight of the gilding when weighing gilded metalwork (6 December 1756, 10 March 1757), apart from the fact that it is impossible to judge the weight of gilding by the appearance of the finished work (14 November 1756). It was impossible to estimate the value of a finished work on the basis of a model, and still less so on the drawing (22 November 1756, 23 April 1757). Although casting from a furnace was usually more difficult than casting from ladles (for which see below, note 36), this was not so for a large sculpture (1 December 1756).

26. For Ludovici's advice concerning the statue of the *Virgin of the Immaculate Conception*, see appendix V. Surprisingly, there is no mention of a crown (nor was one included), despite the fact that in 1645–6 the Virgin of the Immaculate Conception had been named patron of Portugal, and that João I had presented her with the royal crown of Portugal; see Levenson (ed.), *The Age of the Baroque in Portugal*, p. 269, cat. 94.

27. One of those, the oval painting by Carlo Maratti in S. Isidoro, was apparently studied by Maini, for amongst the drawings by him in a private collection is what is clearly a tracing of this image. I have not attempted to discover whether this might have been made from an engraving.

28. In this it was unlike such comparably sized bronzes as the two *Angels* in the Vallicella, or the tomb-statue of Clement XII; for the *Clement XII* see the evidence of Carlo Giardoni, ASV, Giura diversa 493, 6 September 1753.

29. On this method see Vannoccio Biringuccio, *Pirotechnia*, translated by Cyril S. Smith and Martha Teach Gnudi, 4th ed.,

Cambridge (Massachustts)/London, 1966, pp. 288–9.

30. Francesco Juvarra and Carlo Giardoni, who estimated the finished statue on 4 July 1752, accentuated this variety in the silver cast, referring to 'il velo all'Egizziaca, il manto ad uso di Cordellone, e la veste a guisa di spomiglione con suo merletto nel estremità' (ASV, Giura diversa 493, 4 July 1752).

31. Private collection; black chalk, 19.5 × 14.7 cm. It should be noted that Maini was paid 1,300 *scudi* for the model (Ajuda, 49-VIII-35, f. 85).

32. '. . . il Modello della Statua della Santissima Concezione . . . che presentemente si dice esistente presso l'Eminentissimo Sig.^re Cardinale Corsini è la mera prima ossatura . . . La quale Ossatura doppo gettata la Cera fu dal . . . Sig.^re Maini variata in diversi Luoghi di molti panni, come anche il Zoccolo fu accresciuto di varj ornati, ingrandito, e aggiuntovi il Plinto' (ASV, Giura diversa 493, 23 April 1757). Maini's first models of the cherub, clouds and cherub-heads, etc., no longer existed, as they were taken to Gagliardi's house and cut into pieces to make the moulds, and it was the waxes cast from these moulds that were altered by Maini (*ibid.*). In 1751 the model of the statue had been taken 'dalla casa del Sig.^r Gio. B.^a Maini Scultore vicino a Piazza Barberini alla casa sotto l'Araceli, ritenuta per servizio della Corte di Lisbona' (Ajuda, 49-VIII-21, no. 190).

33. See, in particular, ASV, Giura diversa 493, 5 March 1751.

34. It may be remarked that the 'putto' was 5 *palmi* high, and the serpent about 18 *palmi* long (*ibid.*, 4 July 1752).

35. Ajuda, 49-VIII-6, ff. 254v–5 (letter of 4 May 1748), 486; this was evidently one of the results of the lack of money at that time. See also ASV, Giura diversa 493, 4 July 1752, point 11, which adds the information that he had had to rent a new foundry, and remake the casting pit of 25 square *palmi*. It also claims that the money required for the casting had been promised to Gagliardi by Sampajo. In view of the cause of this set-back, it is somewhat surprising to learn that Gagliardi was 'Esattore, e Camerlengo di S. Giacomo di Spagnoli' (*ibid.*, 1 December 1756).

36. On the casting of this statue see also *ibid.*, 1 December 1756, 22 September 1750 (Giovanni Antonio Menesatti and Filippo Belli, who assisted). For the method of casting *a crogiolo* see Biringuccio, *Pirotechnia*, pp. 290–1; Biringuccio also states that it is normally used for small casts.

37. ASV, Giura diversa 493, 22 September 1750.

38. *Ibid.*, 4 July 1752, valuation by Francesco Juvarra and Carlo Giardoni, point 9; this applied also to the *torcieri*.

39. ASV, Giura diversa 493, 7 July 1750; see also 1 March 1757.

40. *Ibid.*, 30 July 1752; Sampajo had insisted that it should be finished by 1 October 1749. It should also be noted that there was insufficient silver available, and Gagliardi had had to make use of old silver, with the additional time required to refine it (*ibid.*, 4 July 1752).

41. On the expenses of Gagliardi, see 7 July 1750 (work on feast days), 8 July 1750 (the quantity of workmen; because of the haste, some pieces of the candlesticks came out badly, and had to be redone); 4 July 1752 (the need for expert workmen – Carlo Giardoni added here that he knew the expense of this from his own experience – the need to work on feast days); 2 December 1756 (the increase in costs). Luigi Vinaccesi, Curate of S. Giovanni in Statua di Rieti, affirmed that Gagliardi had had to borrow money to complete the work, including 3,000 *scudi* at 24 per cent, because he was unable to get such a sum at a lower rate of interest (21 July 1750; see also the testimony of Antonio de Marchis of 23 April 1756).

42. *Ibid.*, 1 December 1756; see also 22 July 1756.

43. *Ibid.*, 8 July 1750, 4 July 1752, 7 December 1756. The second casting was done after the first estimate had been made in May 1749.

44. *Ibid.*, 20 November 1756; on the gilding see also 7 July 1750, 16 August 1750. It was apparently normal to gild such works out of doors, possibly because of the mercury fumes.

45. See Francisco Marques Sousa Viterbo, and Rodrigo Vicente d'Almeida, *A Capella de S. João Baptista erecta na Egreja de S. Roque. Fundação da Companhia de Jesus e hoje pertencente à Santa Casa da Misericórdia. Noticia histórica e descriptiva*, Lisbon, 1900, doc. IX; an Italian translation is to be found in Ajuda, 49-VIII-29, ff. 33–50v. Vanvitelli's letter is lost, but evidently his criticisms were based on the examples by earlier architects, and Ludovici made great play of turning these examples against his critic.

46. Apparently Vanvitelli had said it was too small, especially in relation to the adoring angels. This produced the response that, as it was a symbol of the Saviour, its size was no more important than that of the host, which contained the whole body of Christ. Moreover, the resurrected Christ that Bernini had placed on the tabernacle of St Peter's was less than a quarter of the size of the angels – in fact it is much less, but then the angels are rather less intimately related to it.

47. Lisbon, Museu Nacional de Arte Antiga, inv. 171; pen and black ink, and watercolour, over pencil; 42 × 31 cm. On this drawing see M.-T. Mandroux-França, 'La Patriaracle', p. 39; *idem*, in Vasco Rocca and Borghini (ed.), *Giovanni V di Portogallo* cat. 9. Although one cannot be certain, this is very probably the drawing in question.

48. Sousa Viterbo, *A Capella de S. João Baptista*, doc. IX, p. 126; the Italian text is in Ajuda, 49-VIII-29, f. 44v.

49. *Ibid.*, doc. IX, p. 128 (21 May 1744). See also the letter of 12 March 1744, in which Ludovici had written: 'Di tutti li Fonti battesimale, de quali si mandarono li disegni di Roma solamente è piaciuto la tazza di quest'ultimo, che si rimanda segnato X; però nell'ornato della dª Tazza non vi si deve mettere lastre e bassorilievi, nè teste di Leoni, nè tanti Festoni, che coprino la preziosità del Porfido . . .'. On the pedestal, which should be of baluster form with gilt bronze ornaments, he wanted no figures whether of men or animals, nor even just heads or any other part of the human body, 'ma bensì qualche altra qualità di ornati, com di targhe, manti, e pelli, secondo lo stile del Bernini, Algardi, e Fiammengo . . .' (Ajuda, 49-VIII-29, ff. 67r–v). Even though the decorative designs of Bernini and Algardi were still much admired in the eighteenth century (see, for example, Filippo Juvarra's *Raccolta di targhe fatte da professori primarij in Roma . . .* , Rome, 1722), this demand for something in the style of the early Seicento can hardly have gone down well with the Roman artists of a century later.

50. For an iconographical justification of the use of shells and reeds, which would also apply to a baptismal font, see p. 162.

51. On this chapel see Maria João Madeira Rodriguez, *A Capela de S. João Baptista e as suas colecções na Igreja de S. Roque, em Lisboa*, Lisbon, 1988, a book more valuable for the photographs than for the text, which is not always reliable. Although all the silverware that I shall be discussing is included in that book, I shall cite it only where relevant.

52. All the work in gold, and some of the silver, has been lost; see Angelo Lipinsky, 'Il Tesoro di San Giovanni in Lisbona', *Fede e arte*, IX, 1961, pp. 56–89.

53. 'Dᵒ Commʳᵉ non badava alla spesa, purche l'opera fosse riuscita bene' (ASV, Giura diversa 493, testimony of Giacomo Francisi and Leopoldo Pars, 8 July 1750).

54. The estimate of the cost is provided in the Weale album, for which see page 164 above.

55. In the museum attached to the church are two such wreaths, and two bosses composed of intricate foliage.

56. '. . . nella dª Cappella Risplende agualmente il prezioso della materia e la bizzaria dell'Arte' (Ajuda, 49-VIII-29, f. 1r–v).

57. Lisbon, Museu Nacional de Arte Antiga, inv. 195, pen with black and grey ink, 520 × 344 mm. See M.-T. Mandraux-França, in Vasco Rocca and Borghini (ed.), *Giovanni V di Portogallo*, cat. 26.

58. Sousa Viterbo, *A Capella de S. João Baptista*, doc. IX, p. 125; the Italian text is in Ajuda 49-VIII-29, ff. 43v–4. There was a similar argument over the reeds included in Ludovici's drawing: Vanvitelli had said these were found only by stagnant water, but Ludovici countered with the observation that they were a regular attribute in personifications of rivers, a highly contorted interpretation of Luke 7.24, and a reminder that John the Baptist was habitually shown with a reed in his hand, which would not have been an appropriate attribute for the greatest saint if it were the product of stagnant water (see Sousa Viterbo, *A Capella de S. João Baptista*, doc. IX, p. 125; the Italian text is in Ajuda 49-VIII-29, ff. 43r–v).

59. There were, however, rather similar panels designed by Ciro Ferri for Sta Maria Maddalena de' Pazzi in Florence (see Klaus Lankheit, *Florentinische Barockplastik*, Munich, 1962, fig. 2). The great gates made in Rome for the Chigi chapel in the Duomo of Siena are very much lighter in form. The gates of the balustrade in Lisbon might be compared with the bronze panels in the balustrade of S. Lorenzo in Lucina in Roma.

60. Strangely, he was under the impression that not only the *Virgin of the Immaculate Conception* (which according to his own account was the only object he actually blessed), but also the *torcieri* and the rest of the silver was destined for the Patriarcate; see his letter to Cardinal de Tencin of 8 October 1749 (*Le Lettere di Benedetto XIV al Card. de Tencin*, ed. Emilio Morelli [Storia e letteratura, Raccolta di studi e testi], II, Rome, 1965, p. 205). In the same letter he writes that a silver-gilt inscription recording this benediction was affixed to the base of the *Immacolata*.

61. Sousa Viterbo, *A Capella de S. João Baptista*, especially doc. I, p. 106 (Ajuda, 49-VIII-27, f. 1), and doc. III, p. 110. This was made by Antonio Arighi.

62. When it was sent to Lisbon it was described as 'Un Cibborio composto di metallo dorato, bassorilievi, e statuette d'argento con diverse pietre framiste . . .'. As well as a gilt-bronze cross set with lapis lazuli and with cherub-heads at the ends of the cross, which went above the globe of gilt-bronze above the cupola, there was a removable silver cross and Corpus over the door (Ajuda, 49-VIII-35, f. 76).

63. Sousa Viterbo, *A Capella de S. João Baptista*, doc. X, p. 142 (Ajuda, 49-VII-34, f. 397v), letter from Sampajo in Rome of 29 May 1745.

64. John Woody Papworth, 'On Artistic Ecclesiastic Decoration, as Exhibited in a Collection of Designs Made about the Middle of the Last Century', *Weale's Quarterly Papers on Architecture*, London, 1843–4, I, pp. 1–32. Invaluable though the attributions are, it should be borne in mind that these are the artists Sampajo originally intended to employ, and changes may have been made in the artists, as well as the designs.

65. Lipinsky has remarked on the similarity of this thurible to designs by Giardini ('Arte orafa a Roma: Giovanni Giardini da Forlì, *Arte illustrata*, IV, 45/46, November 1971, p. 19, see his fig. 8, containing three such designs, all of which were en-

graved). This is indeed valid, and is what one might expect from the circulation of Limpach's prints.

66. Although Leandro inherited his father's shop, his brother Filippo may well have assisted him there, even though he was not a member of the guild.

67. See J. Montagu, in Vasco Rocca and Borghini (ed.), *Giovanni V di Portogallo*, cat. 72, 73.

68. The bucket and aspergillum create something of a problem: Benedict gave the originals to Bologna in 1749 (*Diario benedettini*, p. 45, which also lists the gift of Antonio Gigli's incense-boat and thurible in 1750 on p. 46). These are marked with the 'A' and three lilies of Andrea Valadier; see Jadranka Bentini (ed.), *L'Arredo sacro e profano a Bologna e nelle legazioni ponteficie* (exhibition catalogue, X Biennale d'arte antica: l'arte del Settecento emiliano), Bologna, 1979, cat. 262; Trebbi read the letter as a 'V', see Bruno Trebbi, *L'Artigianato nelle chiese bolognesi*, Bologna, 1958, pl. 25. According to an order from the executors of Sampajo to the Banco di Santo Spirito, in October 1749 the brothers Filippo and Leandro Gagliardi and their mother (as responsible for the other children of Giuseppe Gagliardi) were paid 362.21 *scudi* for 'un Secchietto, o sia Acquasantana d'argento con suo aspersorio' (ASV, Giura diversa 493, 13 March 1751). It is not stated that this was for Lisbon, though that is virtually certain, but it seems that no replacements were ever sent there; they are not there now, nor do they figure in early inventories.

69. On 8 April 1750 they were valued at 901.33½ *scudi* (against the silversmith's own valuation of 1,201.33½ *scudi*) by B. Burroni, G. B. Carosi, F. Juvarra and F. Giardoni – one case where both Cabral and the Gagliardi heirs appointed the appraisers – and the payment was made during that month.

70. '. . . con Delfini nel piede fatta tutta a onda di Mare con una figura rappresentante la Religione posta a sedere sulla Poppa' (Copy in ASV, Giura diversa 493, 8 April 1750). One would otherwise have been inclined to identify the figure as Faith.

71. 'Il Sig.ᵉ Antonio Vendetta Argentiero in Roma non à mai a tempi nostri fatta e lavorata alcuna Opera Magnifica, ed insigne, ma solo opere piccole, e triviale, ed inoltre non è capace del disegno, e del Modello, tanto che nelle occasioni si è sempre prevaluto di altri Professori capaci per farsi fare li disegni, e Modelli, come si è servito del q.ᵐ Luigi Landinelli e di Lorenzo Morelli, ed altri' (ASV, Giura diversa 493, evidence of Giovanni Bettata and Giacomo Francisi, 1 December 1756).

72. He had made a number of changes, replacing no less than twenty-three pieces that he had already finished (Ajuda, 49-VIII-21, no. 196).

73. In an attestation by Carlo Guarnieri and Giovanni Bettata as to their weight, there is a reference to 'quando furono terminate dal Sig.ʳ Lorenzo Morelli, che l'aveva riattate' (*ibid.*, 12 June 1756). It was quite normal to weigh silver not only assembled, but also in pieces.

74. On these silversmiths see Costantino G. Bulgari, *Argentieri, gemmari e orafi d'Italia; Parte prima – Roma*, II, Rome, 1959, pp. 39, 177; Landinelli is known only from this reference.

75. In his account for the four he actually made Guarnieri included the 'conto delli spesi di altri quatro Reliquiari soprasedutomi et avendo fatto disegni in grande et in picholo e fatti modelli chavi cere e forme', and continued: 'per disegni e modelli delli sopradetti Reliquiari et essendo due Modelli e sono di maggiore fattura degli altri due prima s.700', the same sum he had claimed for the previous two models. He further claimed 300 *scudi* for the keys, and 1,800 *scudi* 'per avere gettato le cere rinetate et asestate et attachato li getti e tutte mese in forma per gettarsi l'Argento'. His total of 2,800 *scudi* was re-

duced by Francesco Juvarra and Matteo Piroli to 2,180 (Ajuda, 49-VIII-21, no. 155). When Guarnieri's reliquaries were dispatched to Lisbon in 1750 he was paid 400 *scudi* for one reliquary of each type, and a further 2,180 *scudi* 'Per Forme, Cavi, Disegni, Cere rimutate tanto dei sudetti due Reliquari [which presumably means for all four that he made, two on each model], quanto d'altri quattro Reliquiarj, secondo l'avvertenza che si dirà . . .'. This 'avvertenza' explains that he was originally commissioned to make eight reliquaries, but four were passed to another silversmith: 'perciò è convenuto abbonarli i Disegni, Modelli, Cavi, Cere, e Forme, che aveva già fatte per li rimanenti quattro Reliquiari sudetti . . .' (Ajuda, 49-VIII-35, pp. 151–9).

76. Ajuda, 49-VIII-35, ff. 153–4. The Gagliardi brothers (who evidently made these together) were persuaded to pass some parts of them to the temporarily unemployed Filipo Tofani, but they turned out to be so badly worked and incompetently chiselled that the Gagliardi had to rework them, or rather get their assistant Giacomo Francisi to rework them in his house, so that the disgrace would not become public knowledge (ASV, Giura diversa 439, 7 November 1756).

77. See J. Montagu, in Vasco Rocca and Borghini (ed.), *Giovanni V di Portogallo*, cat. 74. Interesting information on the technique of making and gilding these is provided in ASV, Giura diversa 493, testimony of Lorenzo Morelli, 1 December 1756.

78. Ajuda 49-VIII-35, pp. 157–60 (contents of cases 75 and 76 dispatched to Lisbon, each containing one reliquary of each type), which notes the value, including 500 *scudi* 'per Modelli, Disegni, Cavo, Forme e Getti de medesimi' for each case. Elsewhere they are described a 'da Testa' and 'per Mano' (terms which could equally well apply to the surviving reliquaries of Guarnieri), again with two of each type (Ajuda, 49-VIII-21, no. 146).

79. Gagliardi's urn-types weighed 74 *libbre*, 02 *once*, 12 *denari* and 72.07.21; Guarnieri's 95.04.12 and 96.8.9. Gagliardi's temple-types weighed 59.05.12 and 56.09.12; Guarnieri's 87.09.09 and 91.1.18 (Ajuda, 49-VIII-21, nos. 146, 155).

80. Ajuda, 49-VIII-6, f. 257.

81. Sousa Viterbo, *A Capella de S. João Baptista*, pp. 36–7 (authentication of the relics, dated 20 January 1752).

82. The catacombs of Rome yielded a continuous supply of 'Corpi Santi'. For centuries there were debates as to how to be certain that those buried were indeed martyrs, and whether the phials of blood (which were regarded as the surest sign) were to be found exclusively on the tombs of martyrs, and even as to whether the contents were actually blood (see the history of this debate in Giovanni Battista De Rossi, 'Sulla questione del vaso di sangue', published with an introduction by Antonio Ferrua in *Studi di antichità cristiana*, XVIII, 1944). While martyrs were automatically saints, and it was unnecessary to know anything of their life or martyrdom, nor did there need to be any miracles, for confessors a careful examination was required of their virtues and the miracles wrought by their relics (see Marc'Antonio Boldetti, *Osservazioni sopra i cimiterj de' santi martiri, ed antichi cristiani di Roma . . .*, Rome, 1720, pp. 117–18). I am endebted to Simon Ditchfield for a bibliography on this subject.

83. I cannot accept the statement of Madeira Rodrigues that at least one of the two reliefs on each of these reliquaries represents a scene from the life of St John the Baptist (Maria João Madeira Rodrigues, *Museu de São Roque: Metais*, 2nd ed., Lisbon, 1988, cat. 1.2–4.2).

84. In the evidence which he gave together with the gilder Antonio Petrucci on 7 November 1756 he refers to Guarnieri

as 'mio principale' (ASV, Giura diversa 493); see also the testimony he alone signed on 1 December 1756.

85. 2,180 *scudi* had been paid 'per Forme, Cavi, Disegni, Cere . . .' for these reliquaries (Ajuda, 49-VIII-35, f. 152).

86. On Giovanni Bettato (or Bettati), see *Valadier*, 1991, pp. 57–61; John Winter, 'Further Drawings from Valadier's Workshop – the silver designs of Giovanni Bettati', *Apollo Magazine*, CXXXIII, May 1991, pp. 320–6. He was described as 'compagnio' of the possibly older and more established Baislach (ASV, Giura diversa 493, 22 August 1756), and had worked also for Gagliardi.

87. ASV, Giura diversa 493, 21 October 1756.

88. *Ibid.*, 10 March 1756. In a plea for some money on account from Sampajo's executors they refer to it, and to the expense of going to law, which they say they cannot afford (Bibl. Corsini, MS. 35.D.8, ff. 12r–v).

89. *Ibid.*, ff. 117–43v. See also Bibl. Corsini, MS. 35.D.9, ff. 151v–3.

90. It appears from the lists in Bibl. Corsini, MS 35.D.9, ff. 151v–3, as if 8,000 *scudi* was the sum for Giardoni's work, and did not include the payment to Maini.

91. *Ibid.*, ff. 122, 128–30; see also Papworth, 'On Artistic Ecclesiastic Decoration', p. 22.

92. ASV, Giura diversa 493, 20 March 1751, 2 July 1756, 1 October 1756.

93. *Ibid.*, 10 September 1756; see also Ajuda 49-VIII-21, no. 170, for Gonella's payment on 1 May 1751. For Pozzi's complaint about his payment see Sousa Viterbo, *A Capella de S. João Baptista*, doc. XIII, pp. 157–8. Another who had problems was Francesco Antonio Salci, working together with Tommaso Puliti on the candlesticks for the *muta nobile*. They had completed two in silver, and, being unable to show them to Cabral who was out of Rome, went ahead and gilded them; Cabral claimed that this was against his orders to consign them ungilded, and refused to pay for the gilding, finally conceding 400 *scudi* for the gold, instead of the 900 at which the work had been estimated (ASV, Giura diversa 493, 20 September 1756 and 5 October 1756; Ajuda 49-VIII-21, no. 207).

94. Bibl. Corsini, MS. 35.D.8, ff. 121–2, 127, 133–4.

95. *Ibid.*, ff. 126v–7v; Zoffoli's connection with the studio of Giardoni appears to have been unremarked.

96. See the reference to two decisions of the Sacra Rota in their favour, Bibl. Corsini, MS. 35.D.8, f. 173v. One of these was the decision of Stadion, of 5 July 1756 (of which a copy is in *ibid.*, ff. 175–8v), the other I have not found, but, since the evidence was still being collected in 1757, it was presumably later.

97. These *torcieri* have been frequently reproduced and discussed in the literature on goldsmiths' work, as well as that on the chapel, but without the benefit of the documentary evidence which will be adduced here; for the most recent discussion, summarising what will be said below, see Levenson (ed.), *The Age of the Baroque in Portugal*, cat. 107.

98. We may note that on 3 August 1749 Giovanni Rota made a model 1½ *palmi* long (33.51 cm.) to be sent to Venice as a model for the candles to be set in them (Ajuda, 49-VIII-21, no. 133).

99. Bulgari, *Argentieri, gemmari e orafi*, I, p. 480.

100. It is tempting to wonder whether he might have been the 'certo Gagliardi' who carved the marble figures of *Truth* and *Religion* on the tomb of Alexander VIII, which were completed in 1724 (see Carlo Giuseppe Ratti and Raffaello Soprani, *Delle Vite de' pittori, scultori, ed architetti genovesi*, II, Genoa, 1769, p. 237; Helga N. Franz-Duhme, *Angelo De Rossi. Ein Bildhauer um*

1700 *in Rom*, Berlin, 1986, p. 213); however, there is no evidence to suggest that he ever practised marble-carving, and two long-term friends said at the trial only that he 'essercitava allo studio della scoltura' (ASV, Giura diversa 493, 1 December 1756), which does not sound as if he had made sufficient progress for such prestigious work, which would surely have been mentioned.

101. See the *Declaratio animi* of Pietro Gagliardi of 14 April 1734, ASR, 30 Not. Cap., Uff. 34 (Not. del Borgo), vol. 236, ff. 324–5v, 336r–v. Giuseppe was the good son caring for the workshop and for his father; his brother Giovanni, the bad son, had left the paternal home wishing to have nothing further to do with it, or to follow his father's profession, and not being capable 'd'alimentare altri, ma ne pure se stesso, si per naturali suoi difetti, si anche per propria colpa', and seems to have given nothing but trouble.

102. Many payments to him for brasswork appear in the accounts of the Sacro Palazzo Apostolico; on 2 April 1745 he was paid by Sampajo for brasswork for two carriages (ASV, Giura diversa 493, 13 March 1751).

103. Pietro Amici and Stefano Vio attested that, as well as being 'capacissimo nel fondere, e lavorare qualunque sorta di metallo e dirigere qualunque lavoro', Gagliardi 'sapeva ottimam.te disegnare, e modelare Ornati, e figure'; they had worked many years for him, 'ed averlo co' nostri proprj occhj veduti moltissime volte disegnare, e modellare et Ornati e figure di giorno, e di notte' (*ibid.*, 3 April 1751).

104. Sousa Viterbo, *A Capella de S. João Baptista*, doc. XIV, p. 159.

105. ASV, Giura diversa 493, 1750 (evidence of Carlo Giardoni), 28 February 1751 (evidence of Carlo Guarnieri). Guarnieri said that Piroli had told him that this declaration could easily be overturned by comparing its date with that of his payment; in fact, it is dated 24 June 1750, and Cabral signed the order for payment on 27 June 1750 (*ibid.*).

106. Bibl. Corsini, MS. 35.D.9, f. 151v, repeated f. 152v.

107. Giacomo Francisi claimed to have worked in Giuseppe Gagliardi's 'bottega' from 1747 till Gagliardi's death (ASV, Giura diversa 493, 12 March 1751).

108. Lorenzo Morelli 'Arg.re e Gettatore', together with Filippo Filibeti, attested to the exceptional thinness and lightness of all the figures and other pieces of the *torcieri*, 'per aver fuse molte cere, e molti de! pezzi, e per aver visti, e manegiati gli altri nel Negozio del d.o Sig.r Gagliardi dove alora lavoramo' (*ibid.*, 28 August 1756).

109. It may be noted that Benvenuto Cellini said of gilding that 'gli eccellenti maestri non la debbono mai far loro stessi, questo si è perchè lo argento vivo è un veleno smisurato . . .', and, after explaining in some detail the various methods of gilding and of colouring the gold surface, he says that he does so only because it is necessary for the artist to know how it is done, but that 'si debbe lasciar fare a certi che non attendono ad altro, perchè è cosa perniziosissima, come di sopra si è detto' (*I Trattati dell' oreficeria e della scultura di Benvenuto Cellini*, ed. C. Milanesi, Florence, 1857, pp. 146–7, 154).

110. Ajuda, 49-VIII-21, no. 133.

111. ASV, Giura diversa 493, 4 July 1752 (estimation of Juvarra and Giardoni).

112. ASV, Giura diversa 493, 1 December 1756.

113. *Ibid.*, 27 September 1756. Gagliardi's sons had been ordered in 1655 to put together the moulds used for the silver casts, but this proved to be impossible because those of the foot and the 'vaso' were too big to keep in the workrooms, and had had to be put in the courtyard where they had been damaged by the

elements, while other smaller moulds had been broken and thrown away (*ibid.*, 25 October 1756).

114. '. . . nè io hò mai cisellato alcun pezzo, senza che prima ne approvasse la pelle il detto Sig.ʳ Gagliardi, il quale perciò voleva, che facessi prima più Mostre, frà le quali sceglieva egli quella, che più gli gradiva e quella appunto doveva io mettere in essecuzione' (*ibid.*, 24 March 1751).

115. The other is inscribed 'Ioseph Gagliardi romanus hoc opus sex annorum perficit anno 1749'.

116. 'Due nobilissimi Torcieri di argento dorato di altezza palmi 12. in circa, non compresovi il zoccolo (. . .), lavorati con grand'artificio, e di finissimo gusto. Ogn' uno di essi sostenuto nel suo piede da sei Figure di rilievo, & è ornato di varj Angeli, palme, e fiori, oltre delle sue cornici, le quali nella parte inferiore lasciano l'intervallo a tre Statue de' Dottori di S. Chiesa nelle sue nicchie. Tutte dette eccellenti opere lavorate con disegno del celebre Sig. Gio: Battista Maini Scultore, furono principiate dal fù Giuseppe Gagliardi Argentiere, e terminate dal Sig. Leandro suo Figliolo con tutta perfezione, tal che ne ha riportato molto applauso' (Chracas, *Diario ordinario*, no. 5025, 4 October 1749, pp. 15–16).

117. 'E rispetto alla bonta del lavoro, era questo ben fatto. e che veram.ᵗᵉ si conosceva, che era stato fatto coll'assistenza mia' (Testimony of G. B. Maini, ASV, Giura diversa 493, 28 August 1750).

118. See below, note 122.

119. Rome, Istituto per la Grafica, FN 6599 (22070). See González-Palacios, in Vasco Rocca and Borghini (ed.), *Giovanni V di Portogallo*, cat. 92; the suggestion that it might be by Maini can be discounted on grounds of style.

120. 'Both [there were two drawings] consist of a plinth, with a shield for heraldic ornaments, and figures of children on either side supporting the base, in which is represented a seated figure under a double scrolled pediment resting on heads of cherubim, and supporting other youthful figures; above these bases both designs exhibit children standing midst arabesque ornament enclosed in scrolls again terminated by heads of cherubim; from this point, the remaining third of each design is absolutely identical: consisting of stems of foliage ending in scrolls, confined about the middle by children clinging to them, and which are surmounted by an enriched capping, forming a dish at the summit as usual. The close correspondence, observable between these two drawings, shews how carefully the unity of the arrangements was attended to' (Papworth, 'On Artistic Ecclesiastic Decoration', nos. 51 and 52, pp. 17–18).

121. See above, chapter 5, p. 141.

122. They affirmed that 'il disegno delli torcieri di argento dorato fatti dal fù Sig.ʳ Giusᵉ Gagliardi . . . fu da noi fatto secondo le precise direzioni, gusto, e volonta del dᵒ Sig.ʳ Gagliardi, ed esser totalmente diverso dal disegno delli Candelieri fatti dal Sig.ʳ Angelo Spinazi per Portogallo, da cui non ci siamo mai portati, nè abbiamo mandato alcuno per vederlo, e prenderne pensiero, e non l'abbiamo mai in alcun tempo veduto, se non posto in esecuzione in argento, e allorchè furono i dd.ᵗ Candelieri teminati, ed esposti alla pubblica vista unitam.ᵗᵉ colli sud.ᵗ Torcieri, i quali erano infinitam.ᵗᵉ più ricchi, più lavorati, e più nobili delli med.ᵗ Candelieri. Attestiamo inoltre, che li nominati Torcieri riuscirono del tutto diversi in opera dal medᵒ disegno, che ne faccemmo attese le molte variazioni, innovazioni, e aggiunte di Figure, di teste, e di altri moltissimi ornati fatte con ordine del Sig.ʳ Commend.ʳᵉ sudᵒ tanto dopo terminato il Modello ed approvato dal Sig.ʳ D. Francesco Feliziani allora Soprintendente a tali lavori per parte dal Sig.ʳ Comm.ʳᵉ, quanto

ancora dopo terminato il lavoro in argento. E questo noi l'attestiamo per aver fatto il sudᵒ disegno, e Modello, e per aver fatte gran parte di dᵉ variazioni, e aggiunte avendovi a tal fine lavorato lo spazio continuo di un anno, e mezzo, e per aver vedute anche quelle variazioni, e aggiunte fatte dal Sig.ʳ Giambattista Maini già Maestro di me Pietro . . .' (ASV, Giura diversa 493, 2 April 1751).

123. *Ibid.*, 28 August 1756.

124. Filiberti specifically said that he had 'fin d'allora fatta riflessione sul paragone, e proporzione respettiva di dᵒ peso de' Pezzi de' Torcieri, e Candelieri sud.' (*ibid.*).

125. To those works cited by Bulgari (*Argentieri*, II, p. 433) should be added the *Angels* cast on the models of Agostino Cornacchini and other silverware paid for in 1634–5 for the Corsini chapel in the Lateran (González-Palacios, in Vasco Rocca and Borghini (ed.), *Giovanni V di Portogallo*, pp. 442–3, and cat. 92). Geneviève Michel has also told me of work he did for the Borghese in 1729, the payments for which are recorded in ASV, Archivio Borghese vol. 7397.

126. 'Li disegni in grande, ed in piccolo, i modelli di tutto il sudᵒ Lavoro tanto in Creta, che di Cera sono stati da noi apprezzati scudi mille per esser stati i disegni di somma gusto, per essere stati i modelli in grandissima quantità, modelli di figure, putti, teste, testine, e di moltissimi altri ornati, ripieni di Architettura, et in Triangolo, che sogliono riuscire piu dificoltosi, e per essere stati rifatti più volte' (ASV, Giura diversa 493, 4 July 1752). It appears that he received this sum (Ajuda, 49-VIII-35, f. 83).

127. ASV, Giura diversa 493, testimony of Giacomo Francisi and Leopoldo Pars, 8 July 1750. They also admit that, because of the haste, some of the replaced pieces were defective, while others were indeed changed because those executed did not please Sampaio, although they had looked satisfactory on the model, and yet others were added (testimony of G. Francisi, Antonio Petrucci and Matteo Piermattei, 1 December 1756).

128. '. . . ma furono ritrovate inservibili, perche essendo state fatte molti anni avanti essendosi perciò arruginiti li fili di ferro, e li chiodi che sostenavano l'anime volanti delle dd.ᵉ forme, [added 'di loto'], e non essendo perciò sufficienti a più reggirle, succedeva che ogni volta si gettava l'argento dentro le suddᵉ forme, cadevano le ddᵉ Anime, si frammischiavano coll'argento, onde il lavoro non riusciva bene; per il chè fussimo necessitati a rifare quasi tutte le ddᵉ forme di nuovo sul modello datoci dal Sig.ʳᵉ Commendᵉ sudᵒ, servendoci a tal fine dell'opera del Sig.ʳᵉ Filippo Filiberti publico formatore con somma nostro discapito, e dispendio' (*ibid.*, evidence of Francesco Antonio Salci and Filippo Filiberti of 5 October 1756). After the death of Sampaio, Filippo Tofani and Antonio Arighi, 'stimatori del R. P. Cabral' together with Paolo Niccoli insisted that Salci pay Spinazzi 1,000 scudi 'per le dette forme che erano di Loto benche inservibili', otherwise they would have taken away the work on the other two unfinished candlesticks (*ibid.*).

129. This is asserted in all the literature (Sousa Viterbo, *A Capella de S. João Baptista*, p. 30; Lipinsky, 'Il Tesoro di S. Giovanni, p. 73; Madeira Rodrigues, *A Capela de S. João Baptista*, p. 151), but I do not know on what evidence. However, in 1744 it had been demanded from Lisbon that this cross should have a figure of the dead Christ 'che dovrà farsi con modello del più eccelente Scultore che vi sia' (Ajuda, 49-VIII-28, f. 24v), and it is abundantly clear from other letters concerning sculpture to be sent from Rome that the Portuguese regarded Maini as the best sculptor available (see appendices IV and V). It should also be

noted that the same Corpus was used for the cross on the altar of the Blessed Virgin in S. Carlo al Corso (cast, as it happens, by Leandro Gagliardi) where there is good reason to believe that the sculpture, executed in part by Innocenzo Spinazzi, the son of Angelo and pupil of Maini, followed earlier designs prepared by Maini; see Roberta Roani Villani, 'Due opere di Innocenzo Spinazzi e la decorazione della Cappella della Beata Vergine in San Carlo al Corso a Roma', *Paragone (Arte)*, no. 395/361, XXXI, 1980, pp. 60–83, especially fig. 70. Unfortunately the archives are closed, and further research is at present impossible.

130. It took two attempts to get the size of this base right, according to the accounts of Giovanni Rota. He made the wooden core for 1.50 *scudi*, and claimed a further 50 *baiocchi* 'per aver fatto un'altra anima ad un base più grande fatta con l'istessa fattura come sopra centinata servita per la base fatta di nuova per il d⁰ piede della Croce, che l'altra riusciva piccola, et averle incavata sopra per mettervi del piombo per reggere la Croce' (Ajuda, 49-VIII-21, no. 133).

131. See Madeira Rodrigues, *A Capela de S. João Baptista*, pp. 130–51.

132. Madeira Rodrigues, *ibid.*, identified Fortitude (her fig. p. 130) as 'Constancy', while her 'Fortitude' (her fig. p. 146) is, in fact, Clemency.

133. These were published in Lelio Guidiccioni, *Breve racconto della trasportatione del corpo di Papa Paolo V. dalla Basilica di S. Pietro à quella di S. Maria Maggiore*, Rome, 1623.

134. It should be noted also that Madeira Rodrigues's near-duplication of 'Temperance' and 'Sobriety' (her figs. pp. 131, 142) is resolved by the fact that the former is copied from Bernini's Alms-Giving (*Elemosina*), leaving Madeira Rodrigues's 'Sobriety' free to represent the cardinal virtue of Temperance.

135. See Maurizio Fagiolo Dell'Arco and Silvia Carandini, *L'Effimero barocco, strutture della festa nella Roma del '600*, I, Rome, 1977, pp. 46–53. The earlier literature is equally uninterested in this problem.

136. 'Di questa Mole, & delle sue figure, & d'ogni suo particolare intendimento, altrove si rappresenta da alcuni belli ingegni una più piena notitia, con significatione de gl'habiti, & de gl'attributi delle Virtù in essa comprese. Onde non facendo quì luogo di fermarsi sopra questa parte . . .' (Lelio Guidiccioni, *Breve racconto della trasportatione del corpo di Papa Paolo V.*, p. 19).

137. For the dispute over these candlesticks, see above, note 93.

138. 'Altro candelieri con figura davanti della Sapienza con lancia e scudo' (Ajuda, 49-VIII-21, no. 181).

139. In fact such a figure may be related to Ripa's description of the ancients' image of *Sapienza* as a figure of Minerva with the olive by her, and holding a shield with the head of Medusa (Cesare Ripa, *Iconologia*, edition of Rome, 1603, pp. 442–3). Although Bernini's figure has neither the olive nor the lance (though it would be easy to imagine the latter in her raised hand), it is sufficient to compare the cloak and armour to see that this image is the source of that on the candlestick.

Appendix IV: The Virgin and Child for Lisbon

1. This is preceded on ff. 61v–2v by a slightly different version of the beginning of this commission, of the same date.

2. A diagram is included, showing three small circles on the central horizontal line, and one above and one below. However, the plans for fixing it may have been changed, because on 15 May 1748 Sampajo wrote that he had 'consegnato a Giardoni il foglio dell'Armatura, che deve farsi dietro al Bassorilievo di Metallo dorato' (Ajuda, 48-VIII-6, f. 280); this had been sent on 28 March (*ibid.*, f. 279).

Appendix V: The Virgin of the Immaculate Conception for Lisbon

1. This is a draft, in the same clear hand as appendix IV, leaving some spaces for additions in another hand. This second hand has also made some corrections, a few of which improve the Italian, but most provide more technical terms, e.g. substituting 'crepature' for 'rotture' or 'fosco' for 'rozzo'.

BIBLIOGRAPHY

ACIDINI LUCHINAT, Cristina; see BORSI, Franco

ALIZERI, Federigo, *Guida illustrativa del cittadino e del forastiero per la città di Genova e sue adiacenze*, Genoa, 1875

ALMEIDA, Rodrigo Vicente d'; see SOUSA VITERBO, Francisco Marques

ALTERI, Giancarlo, *Vat. Lat. 15232. Disegni degli incisori Hamerani eseguiti dai medesimi in medaglie e monete pontificie*, Rome, 1995

ALTERI, Giancarlo; see MADONNA, Maria Luisa

ANDROSOV, Sergei, *et al.*, *Alle origini di Canova; le terracotte della collezione Farsetti* (exhibition catalogue), Palazzo Ruspoli, Rome, and Ca' d'Oro, Venice, 1991–2

L'Angelo e la città (exhibition catalogue), Rome, 1987

ANIELLO, Antonia d', 'Il Ciborio della Certosa', in *La Certosa ritrovata*, Rome, 1988, pp. 30–5

ANIELLO, Antonia d', 'La Sagrestia', in *La Certosa di Padula*, Florence, 1985, pp. 68–71

APFELSTADT, Eric, 'Andrea Ferrucci's "Crucifixion" altarpiece in the Victoria and Albert Museum', *Burlington Magazine*, CXXXV, 1993, pp. 807–17

ARMAILHACQ, Albert d', *L'Eglise nationale de Saint Louis des français à Rome*, Rome, 1894

L'Arte per i papi e per i principi nella campagna romana: grande pittura del '600 e del '700, II (*Saggi*), Rome, 1990

BABELON, Jean, *Jacopo da Trezzo et la construction de l'Escurial. Essai sur les arts à la cour de Philippe II, 1519–1589*, Paris, 1922

BACOU, Roseline, and BEAN, Jacob, *Le Dessin à Rome au XVIIᵉ siècle* (exhibition catalogue), Paris, Musée du Louvre, 1988

BAGLIONE, Giovanni, *Le Nove chiese di Roma*, ed. L. Barroero, Rome, 1990 [first published 1639]

BAGLIONE, Giovanni, *Le Vite de' pittori scultori et architetti. Dal pontificato di Gregorio XIII. del 1572. In fino a' tempi di Papa Urbano Ottavo nel 1642.*, Rome, 1642

BARBERINI, Maria Giulia, 'Cope scultore fiammingo ed un avorio di casa Patrizi', in *Per Carla Guglielmi. Scritti di allievi*, ed. Teresa Calvano and Mauro Cristofani, Rome, 1989, pp. 17–25

BARBERINI, Maria Giulia, *Sculture in terracotta del barocco romano: bozzetti e modelli del Museo Nazionale del Palazzo Venezia* (exhibition catalogue), Rome, 1991

BAROCCHI, Paola, *Trattati d'arte del Cinquecento*, III, Bari, 1962

BARTOLOTTI, Franco, *La Medaglia annuale dei romani pontefici da Paolo V a Paolo VI, 1605–1967*, Rimini, 1967

BARTSCH, Adam, *Le Peintre Graveur*, new ed., Leipzig, 1854–76

BAUDI DI VESME, Alessandro, *Schede Vesme*, Turin, 1963–82

BEER, Rudolf, 'Acten, Regesten und Inventare aus dem Archivio General zu Simancas', *Jahrbuch der Kunsthistorischen Sammlungen des Allerhöchsten Kaiserhauses*, XII, 1891, pt. II, pp. xci–cciv

BELLESI, Sandro, 'L'Antico e i virtuosismi tardobarocchi nell'opera di Giuseppe Piamontini", *Paragone (Arte)*, XLII, no. 497, 1991, pp. 21–38

BELLORI, Giovan Pietro, *Le Vite de' pittori, scultori e architetti moderni*, ed. E. Borea and G. Previtali, Turin, 1976

BENEDETTI, Sandro, *Giacomo Del Duca e l'architettura del cinquecento*, Rome, 1973

BENEDICT XIV, *Le Lettere di Benedetto XIV al Card. de Tencin*, ed. Emilio Morelli (Storia e letteratura, Raccolta di studi e testi), Rome, 1955–84

BENTINI, Jadranka (ed.), *L'Arredo sacro e profano a Bologna e nelle legazioni pontificie* (exhibition catalogue, X Biennale d'arte antica: l'arte del Settecento emiliano), Bologna, 1979

BERLINER, Rudolf, 'Zeichnungen von Carlo und Filippo Marchionni. Ein Beitrag zur Kunst und Kulturgeschichte Roms im 18. Jahrhundert', *Münchner Jahrbuch der Bildenden Kunst*, 3. Folge, IX/X, 1958–9, pp. 267–396

BERNI, Giulio, *Le Medaglie degli anni santi*, Barcelona, 1950

Bernini in Vaticano (exhibition catalogue), Rome, 1981

BERSHAD, David L., 'The newly discovered testament and inventories of Carlo Maratti and his wife Francesca', *Antologia di belle arti*, N.S. 25–26, 1985, pp. 65–84

BERTOLOTTI, Antonio, *Artisti bolognesi, ferraresi ed alcuni altri del già stato pontificio in Roma nei secoli XV, XVI e XVII*, Bologna, 1886

BERTOLOTTI, Antonio, *Artisti lombardi a Roma nei secoli XV, XVI, XVII. Studi e ricerche negli archivi romani*, Milan, 1881

BERTOLOTTI, Antonio, *Artisti urbinati in Roma prima del secolo XVIII. Notizie e documenti raccolti negli archivi romani*, Urbino. 1881 [extract from *Il Raffaello*]

BERTOLOTTI, Antonio, 'Gian Domenico Angelini pittore perugino e suoi scolari', *Giornale di erudizione artistica*, V, fasc. iii–iv, March/April 1876, pp. 64–87

BERTOLOTTI, Antonio, 'Guglielmo della Porta scultore milanese', *Archivio storico lombardo*, II, 1875, pp. 295–322

BEVILACQUA, Mario, 'Un ciborio di Carlo Marchionni a S. Caterina da Siena a Magnanapoli', in E. Debenedetti (ed.), *Carlo Marchionni: Architettura, decorazione e scenografia contemporanea* (Studi sul Settecento romano), 4, 1988, pp. 145–51

BEVILACQUA, Mario, *Santa Caterina da Siena a Magnanapoli. Arte e storia di una comunità religiosa romana nell'età della*

Controriforma, Rome, 1993

BIGNOZZI, Francesca Montefusco, 'Opere plastiche dal barocco al neoclassico', in *La Basilica di San Petronio in Bologna*, Bologna, 1984, II, pp. 117–42

BILDT, Carl Nils Daniel de, *Les Médailles romaines de Christine de Suède*, Rome, 1908

BIRINGUCCIO, Vannoccio, *Pirotechnia*, translated by Cyril S. Smith and Martha Teach Gnudi, 4th ed., Cambridge (Massachustts)/London, 1966

BLUNT, Anthony, and COOKE, Hereward L., *Roman Drawings of the XVII and XVIII Centuries in the Collection of Her Majesty the Queen at Windsor Castle*, London, 1960

BLUNT, Anthony, *Supplements to the Catalogues of Italian and French Drawings with a History of the Royal Collection of Drawings* [in Edmund Schilling, *The German Drawings in the Collection of Her Majesty the Queen at Windsor Castle*], London, 1960

BOGGERO, Franco and SIMONETTI, Farida, *Argenti genovesi da parata tra Cinque e Seicento*, Turin, 1991

BOLDETTI, Marc'Antonio, *Osservazioni sopra i cimiterj de' santi martiri, ed antichi cristiani di Roma . . .* , Rome, 1720

BORGHINI, Gabriele; see VASCO ROCCA, Sandra

BORSI, Franco, ACIDINI LUCHINAT, Cristina, QUINTERIO, Francesco (ed.), *Gian Lorenzo Bernini: Il Testamento, la casa, la raccolta dei beni*, Florence (Biblioteca di Architettura. Saggi e documenti, no. 27), 1981

BOSI, Mario, *S. Maria dei Sette Dolori* (Le Chiese di Roma illustrate, no. 117), Rome, 1971

BOUCHER, Bruce, *The Sculpture of Jacopo Sansovino*, New Haven/London, 1991

BOUSQUET, Jacques, *Recherches sur le séjour des peintres français à Rome au XVIIème siècle*, Montpellier, 1980

BRAHAM, Allan, 'The Tomb of Queen Christina', in *Analecta Reginensia I. Queen Christina of Sweden: Documents and Studies*, Stockholm, 1966, pp. 48–58 (with a documentary appendix by Hellmut Hager)

BRAHAM, Allan, and HAGER, Hellmut, *Carlo Fontana: The Drawings at Windsor Castle*, London, 1977

BRAUER, Heinrich, and WITTKOWER, Rudolf, *Die Zeichnungen des Gianlorenzo Bernini*, Berlin, 1931

BRIGANTI, Giuliano, *Pietro da Cortona, o della pittura barocca*, Florence, 1962

BRUNI, Alessandro; see FRATINI, Ottavio

BUCHOWIECKI, Walther, *Handbuch der Kirchen Roms*, Vienna, 1967–74

BULGARI, Costantino G., *Argentieri, gemmari e orafi d'Italia; Parte prima – Roma*, Rome, 1958–9

BUONANNI, Filippo, *Numismata pontificum romanorum, quae à tempore Martini V. usque ad annum M.DC.XCIX vel authoritate publica, vel privato genio in lucem prodiere, explicata*, Rome, 1699

CALISSONI, Anna Bulgari, *Maestri argentieri gemmari e orafi di Roma*, Rome, 1987

CANNATA, Pietro; see MADONNA, Maria Luisa

Canones, et Decreta Sacrosancti Oecumenici, et Generalis Concilii Tridentini, Rome, 1564

CARANDINI, Silvia; see FAGIOLO DELL'ARCO, Maurizio

CARAVITA, Andrea, *I Codici e le arti a Monte Cassino*, Monte Cassino, 1869–71

A Catalogue of the Genuine, Entire and Choice Collection of Coins, Medals, and Medallions, in Gold, Silver, and Brass, of the Learned and Ingenious Martin Folkes, Esq. . . . sold by . . . Mr. Langford, At his House in the Great Piazza, Covent Garden, 27–30 January, 1756, London, 1756

CELLINI, Benvenuto, *I Trattati dell' oreficeria e della scultura di*

Benvenuto Cellini, ed. C. Milanesi, Florence, 1857

CELLINI, Benvenuto, *The Treatises of Benvenuto Cellini on Goldsmithing and Sculpture*, transl. C. R. Ashbee, London, 1888 (reprinted Dover Publications, Inc., New York, 1967)

Cenni storici sui conventi dei PP. Carmelitani Scalzi della provincia romana, Rome, 1929

La Certosa di Padula, Florence, 1985

La Certosa ritrovata, Rome, 1988

CHARPENTIER, René, *Cabinet du Sr. Girardon*, Paris [c. 1708]

CHIAPPONI, Giustiniano, *Legazione dell'Eminentissimo, e Reverendissiomo Sig. Cardinale Giuseppe Renato Imperiali alla Sacra Real Cattolica Maestà Carlo III Re delle Spagne l'anno MDCCXI*, Rome, 1712

CHRACAS, *Diario ordinario*, Rome

CIPRIANI, Angela (ed.), *I Premiati dell'Accademia 1682–1754* (exhibition catalogue, Rome, Accademia di San Luca), Rome, 1989

Civiltà del '700 a Napoli, 1734–1799 (exhibition catalogue), Florence, 1979

CLARK, Anthony M., 'The Portraits of Artists Drawn for Nicola Pio', *Master Drawings*, V, 1967, pp. 3–23

COLOMBO, Giulio, 'Lo Scultore Giambattista Maino: Notizie – epistolario', *Rassegna gallaratese di storia e d'arte*, XXV, 1966, pp. 29–45

CONFORTI, Michael, 'Continental Decorative Arts', *Apollo*, CXVII, no. 253, 1983, pp. 201–7

CONNORS, Joseph; see INCISA DELLA ROCHETTA, Giovanni

COOKE, Hereward L.; see BLUNT, Anthony

CONTARDI, Bruno, CURTIO, Giovanna (ed.), *In Urbe architectus. Modelli, disegni, misure: la professione dell'architetto romano 1680–1750* (exhibition catalogue), Rome, 1991

Corpus Nummorum Italicorum, XIV, *Umbria, Lazio (zecche minori)*, Rome, 1933

Corpus Nummorum Italicorum, XVI, *Roma parte II – dal 1572 al 1700*, Rome, 1936

CORNIDES, Elisabeth, *Rose und Schwert im päpstlichen Zeremoniell von den Anfängen bis zum Pontifikat Gregors XIII.*, Vienna, 1967

CUCCO, Giuseppe, *Urbino, Museo Albani* (Musei d'Italia – Meraviglie d'Italia), Bologna, 1984

DAELLI, G., *Carte michelangiolesche*, Milan, 1865

DAINVILLE, Ségolène de, 'Maison, dépenses et ressources d'un Nonce en France sous Louis XIV, d'après les papiers du Cardinal Fabrizio Spada', *Mélanges d'archéologie et d'histoire*, LXXXII, 1970, pp. 919–70

DAVIS, Bruce W., *The Drawings of Ciro Ferri* (Ph.D. thesis for the University of California, Santa Barbara), Ann Arbor, 1984

DEBENEDETTI, Elisa (ed.), *L'Architettura da Clemente XI a Benedetto XIV. Pluralità di tendenze* (Studi sul Settecento romano, 5), 1989

DEBENEDETTI, Elisa (ed.), *Carlo Marchionni* (Studi sul Settecento romano, 4), 1988

DE ROSSI, Giovanni Battista, 'Sulla questione del vaso di sangue', published with an introduction by Antonio Ferrua in *Studi di antichità cristiana*, XVIII, 1944

Diario benedettino, Bologna, 1754

Dictionnaire de biographie française, Paris, 1933 ff.

Dizionario biografico degli italiani, Rome, 1960 ff.

DONATI, Ugo, *Artisti ticinesi a Roma*, Bellinzona, 1942

DONATI, Ugo, 'Gli Autori degli stucchi in S. Andrea al Quirinale', *Rivista del R. Istituto d'Archeologia e Storia dell'Arte*, VIII, 1940–1, pp. 144–50

DORATI, Maria Cristina, 'Gli scultori della Cappella Paolina di

Santa Maria Maggiore', *Commentari*, XVIII, 1967, pp. 231–60

DUNN, Marilyn R., 'Nuns as Art Patrons: The Decoration of S. Marta al Collegio Romano', *Art Bulletin*, LXX, 1988, pp. 451–77

L'Eglise de St-Louis-des-Français de Rome: Petit guide des visiteurs, Rome, 1909

ENGGASS, Robert, *Early Eighteenth-Century Sculpture in Rome*, University Park (Pennsylvania), 1976

ENGGASS, Robert, *The Paintings of Baciccio – Giovanni Battista Gaulli 1639–1709*, University Park (Pennsylvania), 1964

FAGIOLO DELL'ARCO, Maurizio, and CARANDINI, Silvia, *L'Effimero barocco, strutture della festa nella Roma del '600*, Rome, 1977–8

FAGIOLO DELL'ARCO, Maurizio and Marcello, *Bernini. Una introduzione al gran teatro del barocco*, Rome, 1967

FALOCI PULIGNANI, Michele, *Indulgenze concesse dai Sommi Pontefici a chi visiterà la statua di San Feliciano*, Foligno, 1932

FALOCI PULIGNANI, Michele, *I Priori della cattedrale di Foligno*, Perugia, 1914

FALOCI PULIGNANI, Michele, *Storia della statua di S. Feliciano in Foligno*, Foligno, 1926

FANTI, Mario, 'Spigolature d'archivio per la storia dell'arte a Bologna (VI): 2. Un tabernacolo disegnato dall'Algardi di San Petronio', *Il Carrobbio*, IX, 1983, pp. 166–8

FARANDA, Franco, 'La Mazza di Pio VI e l'attività in Romagna dell'orafo romano Matteo Piroli', *Accademia Clementina. Atti e memorie*, N.S., XXV, 1990, pp. 97–104.

FASOLO, Furio, *L'Opera di Hieronimo e Carlo Rainaldi (1570–1655 e 1611–1691)*, Rome [1960]

FEHL, Philipp; see KIRWIN, Chandler W.

FELINI, Pietro Martire, *Trattato nuovo delle cose maravigliose dell' alma Città di Roma*, ed. Stephan Waetzoldt, Berlin, 1969 [first published 1610]

FILLITZ, Hermann, and NEUMANN, Erwin, *Kunsthistorisches Museum. Katalog der Weltlichen und Geistlichen Schatzkammer*, Vienna, 1970

FOLLI VENTURA, Irene, MIANI, Laura (ed.), *Due carteggi inediti di Benedetto XIV* (Emilia Romagna – Biblioteche archivi, no. 10), Bologna, 1987

FONTANA, Domenico, *Della Trasportatione dell'obelisco vaticano e delle fabbriche di Nostro Signore Papa Sisto .V. Fatte dal Cavalier Domenico Fontana architetto di Sua Santita*, Rome, 1590

FORNARI, Salvatore, *Gli argenti romani*, Rome, 1968

FORNASINI, Giuseppe, 'La Cappella del Sacramento in San Petronio', *L'Archiginnasio*, XXXVII, 1942, pp. 151–63

FRANCOVICH, Carlo, *Storia della Massoneria in Italia dalle origini alla rivoluzione francese*, Florence, 1974

FRANZ-DUHME, Helga N., *Angelo De Rossi. Ein Bildhauer um 1700 in Rom*, Berlin, 1986

FRANZ-DUHME, Helga N., 'Zum Reliefstil von Angelo De Rossi (1671–1715), *Jahrbuch der Berliner Museen*, n. f., XXIX/XXX, 1987/8, pp. 218–34

FRANZ-DUHME, Helga N., 'Un Rilievo poco noto e un disegno di Angelo de' Rossi', *Antologia di belle arti*, nuova serie, 23–4, 1984, pp, 80–3

FRATINI, Ottavio, and BRUNI, Alessandro, *Descrizione del Duomo di Siena dedicata a Sua Eminenza Reverendissima il Sig. Cardinale Anton Felice Zondadari Arcivescovo della medesima città*, Siena, 1818

GALLAVOTTI CAVALLERO, Daniella, 'Angelo Maria Spinazzi e Giuseppe Rusconi, artisti romani, e un paliotto inedito a Siena', *Studi romani*, XXXIII, 1985, pp. 263–7

GASBARRI, Carlo, *L'Oratorio romano dal Cinquecento al Novecento*, Rome, 1962

GAZZANIGA, Valentina, 'La Vita e le opere di Fantino Taglietti argentiere e altri protagonisti della produzione argentaria a Roma tra Cinquecento e Seicento', in Alberto Di Castro, Paolo Peccolo, and Valentina Gazzaniga, *Marmorari e argentieri a Roma e nel Lazio tra Cinquecento e Seicento*, Rome, 1995, pp. 221–86

GIACHI, Gualberto, and MATTHIAE, Guglielmo, *S. Andrea al Quirinale* (Le Chiese di Roma illustre, no. 107), Rome, 1969, p. 54.

GIANNATIEMPO, Maria, *Disegni di Pietro da Cortona e Ciro Ferri*, (exhibition catalogue, Istituto Nazionale per la Grafica, Gabinetto Nazionale delle Stampe), Rome, 1977

GIGLI, Giacinto, *Diario Romano*, ed. G. Ricciotti, Rome, 1958

GIUNTA DI ROCCAGIOVINE, Zenaide, 'Argentieri, gemmari e orafi romani', *Atti della Accademia Nazionale di San Luca*, N.S. VI, 2, 1962

GOLZIO, Vincenzo, *Documenti artistici sul Seicento nell'archivio Chigi*, Rome, 1939

GOLZIO, Vincenzo, *Le Terracotte della R. Accademia di S. Luca*, Rome, 1933

GONZALEZ-PALACIOS, Alvar, 'Giovanni Giardini: new works and new documents', *Burlington Magazine*, CXXXVI, 1995, pp. 367–76

GRADARA, Costanza, *Pietro Bracci, scultore romano 1700–1773*, Rome, [1920]

GRAMBERG, Werner, *Die Düsseldorfer Skizzenbücher des Guglielmo della Porta*, Berlin, 1964

GRAMBERG, Werner, 'Guglielmo della Porta, Coppe Fiammingo und Antonio Gentili da Faenza', *Jahrbuch der Hamburger Kunstsammlungen*, V, 1960, pp. 31–52

GRAMBERG, Werner, 'Das Kalvarienberg-Relief des Guglielmo della Porta und seine Silber-Gold-Ausführung von Antonio Gentile da Faenza', *Intuition und Kunstwissenschaft; Festschrift Hanns Swarzenski*, Berlin, 1973, pp. 450–60

GRAMBERG, Werner, 'Vier Zeichnungen des Guglielmo della Porta zu seiner Serie mythologischer Reliefs', *Jahrbuch der Hamburger Kunstsammlungen*, XIII, 1968, pp. 69–94

GRIGIONI, Carlo, *Giovanni Giardini da Forlì (24.VI.1646–31.XII.1721), argentiere e fonditore in Roma*, Rocca San Casciano, 1963

GUIDICCIONI, Lelio, *Breve racconto della trasportatione del corpo di Papa Paolo V. dalla Basilica di S. Pietro à quella di S. Maria Maggiore con loratione recitata nelle sue esequie, et alcuni versi fatti nell'apparato*, Rome, 1623

GUIFFREY, Jules, *Inventaire général du mobilier de la couronne sous Louis XIV (1663–1715)*, Paris, 1885

HARTT, Frederick, *The Drawings of Michelangelo*, London, 1971

HASKELL, Francis, and PENNY, Nicholas, *Taste and the Antique*, New Haven/London, 1981

HAWKINS, Edward, *Medallic Illustrations of the History of Great Britain and Ireland*, London, 1885

HAYWARD, John F., 'Roman Baroque Display Dishes', *Festschrift Kurt Rossacher. Imagination und Imago*, Salzburg, 1983, pp. 85–93

HEIMBÜRGER RAVALLI, Minna, 'Supplementary Information Concerning the Spada Chapel in San Girolamo della Carità in Rome', *Paragone (Arte)*, 329, 1977, pp. 39–45

HEIMBÜRGER RAVALLI, Minna, *Architettura scultura e arti minori nel barocco italiano: Ricerche nell'archivio Spada*, Florence, 1977

HERDING, Klaus, *Pierre Puget: das bildnerische Werk*, Berlin, 1970

HIBBARD, Howard, *Carlo Maderno and Roman Architecture 1580–1630*, London, 1971

HILL, George F., 'Notes on Italian Medals – XXVI', *Burlington Magazine*, XXXI, 1917, pp. 211–17

HJORTSJÖ, Carl-Herman, 'The Opening of Queen Christina's Sarcophagus in Rome', in *Analecta Reginensia I. Queen Christina of Sweden: Documents and Studies*, Stockholm, 1966, pp. 138–58

HONOUR, Hugh, *Goldsmiths and Silversmiths*, London, 1971

HOOGEWERFF, Godefridus J., see ORBAAN, Johannes A. F.

HORST, Carlo, 'Un Rilievo in terracotta da un disegno di Michelangelo', *Bollettino d'arte*, XXV, 1932

Le Immagini del Santissimo Salvatore. Fabbriche e sculture per l'Ospizio Apostolico dei Poveri Invalidi (exhibition catalogue), Rome, 1988

INCISA DELLA ROCCHETTA, Giovanni, 'Del ciborio di Ciro Ferri alla Vallicella', *L'Oratorio di S. Filippo Neri*, XIX, 10, October 1962, pp. 1–6

INCISA DELLA ROCHETTA, Giovanni, and CONNORS, Joseph, 'Documenti sul complesso Borrominiano alla Vallicella (1617–1800)', *Archivio della Società Romana di Storia Patria*, CIV, 1981, pp. 159–326

JACOB, Sabine, *Staatliche Museen Preussischer Kulturbesitz: Italienische Zeichnungen der Kunstbibliothek Berlin, Architektur und Dekoration 16. bis 18. Jahrhundert*, Berlin, 1975

JACOBILLI, Lodovico, *Vita di San Feliciano martire, vescovo, e protettore della citta di Foligno . . .* , Foligno, 1626

JAFFÉ, Michael, *Rubens and Italy*, Oxford, 1977

JONES, Mark (ed.), *Designs on Posterity*, British Art Medal Trust, 1994

JUVARRA, Filippo, *Raccolta di targhe fatte da professori primarij in Roma . . .* , Rome, 1722

KIEVEN, Elisabeth, 'Die Statue Clemens' XII. im Palazzo Corsini in Florenz, ein Werk des Carlo Monaldi', *Mitteilungen des Kunsthistorischen Institutes in Florenz*, XXIX, 1985, pp. 410–17

KIEVEN, Elisabeth, 'Überlegungen zu Architektur und Ausstattung der Cappella Corsini', in Elisa Debenedetti (ed.), *L'Architettura da Clemente XI a Benedetto XIV: pluralità di tendenze* (Studi sul Settecento romano, 5), 1989, pp. 69–95

KIRWIN, W. Chandler, 'Bernini's Baldacchino Reconsidered', *Römisches Jahrbuch für Kunstgeschichte*, XIX, 1981, pp. 141–71

KIRWIN, Chandler W., and FEHL, Philipp, 'Bernini's *decoro*: Some Preliminary Observations on the Baldachin and on his Tombs in St. Peter's', *Studies in Iconography*, VII–VIII, 1981–2

KLINGER, Linda, 'Sacrament Altar', in Irving Lavin (ed.), *Drawings by Gianlorenzo Bernini* (exhibition catalogue), Princeton, 1982, pp. 316–35

KRUFT, Hano-Walter, 'A Reliquary by Ciro Ferri in Malta', *Burlington Magazine*, CXII, 1970, pp. 692–5

Kunsthistorisches Museum Wien. Weltliche und Geistliche Schatzkammer, Bildführer, Vienna, 1987

KURZ, Otto, 'Begram et l'occident gréco-romain' in Joseph Hackin, *Rencontre de trois civilisations, Inde, Grèce, Chine. Nouvelles recherches archéologiques à Begram* (Mémoires de la délégation archéologique française en Afghanistan, XI), Paris, 1954, pp. 93–150

LAMBERT, Claude François, *Histoire littéraire du règne de Louis XIV*, Paris, 1751

LAMI, Stanislas, *Dictionnaire des sculpteurs de l'école française sous le règne de Louis XIV*, Paris, 1906

LANDUCCI, Ambrogio, 'Pratica per estrarre li corpi de Santi Martiri da sagri cimiteri di Roma. Per istruttione del Sagrista Pontifica per tempore', BAV, MS. Chigi, G.III.82

LANKHEIT, Klaus, *Florentinische Barockplastik. Die Kunst am Hofe der letzten Medici 1670–1743*, Munich, 1962

LANKHEIT, Klaus, *Die Modellsammlung der Porzellanmanufaktur Doccia. Ein Dokument italienischer Barockplastik*, Munich, 1982

LATUADA, Serviliano, *Descrizione di Milano*, Milan, 1737–8

LAURETUS, Hieronymus, *Silva Allegoriarum Totius Sacrae Scripturae*, ed. F. Ohly, Munich, 1971 [first published 1570]

LAVAGNINO, Emilio (ed.), *Altari barocchi in Roma*, Rome, 1959

LAVAGNINO, Emilio, 'Un Ciborio di Jacopo del Duca', *Rivista del Reale Istituto d'Archeologia e Storia dell'Arte*, II, 1930, pp. 110–14

LAVIN, Irving, *Bernini and the Unity of the Visual Arts*, New York/London, 1980

LAVIN, Irving, *Bernini and the Crossing of St Peter's*, New York, 1968

LAVIN, Irving (ed.), *Drawings by Gianlorenzo Bernini* (exhibition catalogue), Princeton, 1981

LAVIN, Marilyn Aronberg, *Seventeenth-Century Barberini Documents and Inventories of Art*, New York, 1975

LEMPEREUR, J. B. D. S, 'Dictionnaire général des artistes anciens et modernes, peintres, sculpteurs, architectes, graveurs, graveurs en pierres fines, graveurs en médailles, orfèvres et autres qui ont exercé les arts qui dépendent du dessin', n.p., 1795 (Paris, B.N., MS. Ya² 10, 4°)

LEVENSON, Jay (ed.), *The Age of the Baroque in Portugal* (exhibition catalogue), Washington, National Gallery of Art, 1993

LIGHTBOWN, Ronald, 'Charles I and the Tradition of European Princely Collecting', in *The Late King's Goods*, ed. A. MacGregor, London, 1989, pp. 53–70

LIPINSKY, Angelo, 'Gli Arredi sacri di Benedetto XIV per S. Pietro di Bologna', *Fede e arte*, XI, 1963, 4, pp. 186–208

LIPINSKY, Angelo, 'Arte orafa a Roma: Giovanni Giardini da Forlì', *Arte illustrata*, IV, 45/46, Nov. 1971, pp. 18–34

LIPINSKY, Angelo, 'Ein schwäbischer Goldschmied in Umbrien: Johann Adolf Gaap aus Augsburg in Perugia', *Das Münster*, XXX, 1980, pp. 53–60

LIPINSKY, Angelo, 'Il Tesoro di San Giovanni in Lisbona', *Fede e arte*, IX, 1961, pp. 56–89

LOMBARDI, Sergio; see MADONNA, Maria Luisa

MACANDREW, Hugh, 'Baciccio's Later Drawings: A Rediscovered Group Acquired by the Ashmolean Museum' [in collaboration with Dieter Graf], *Master Drawings*, X, 1972, pp. 231–59

MADEIRA RODRIGUES, Maria João, *A Capela de S. João Baptista e as suas colecções na Igreja de S. Roque, em Lisboa*, Lisbon, 1988

MADEIRA RODRIGUES, Maria João, *Museu de São Roque: Metais*, 2nd ed., Lisbon, 1988

MADONNA, Maria Luisa (ed.), *Roma di Sisto V. Le arti e la cultura* (exhibition catalogue), Rome, 1993

MAGNANIMI, Giuseppina, 'Inventari della collezione romana dei principi Corsini. Parte II', *Bollettino d'arte*, serie VI, anno LXV, no. 8, 1980, pp. 73–114

MANDROUX-FRANÇA, Marie-Thérèse, 'La Patriarcale du Roi Jean V de Portugal', *Colóquio artes*, LXXXIII, December 1989, pp. 34–43

MANFREDI, Valerio M., *Tesori dal buio. Le inchieste del colonello Reggiani* (exhibition catalogue), Rome, 1994

MARINI, Maurizio, *Io Michelangelo da Caravaggio*, Rome, 1974

MARTINELLI, Valentino, 'Contributi alla scultura del Seicento. III. Pompeo Ferrucci', *Commentari*, III, 1952, pp. 44–50

MARTINELLI, Valentino (ed.), *Le Statue berniniane del Colonnato di San Pietro*, Rome, 1987

MARVIN, William T. R., *The Medals of the Masonic Fraternity Described and Illustrated*, Boston, 1880

MASETTI ZANNINI, Gian Ludovico, 'Notizie biografiche di Guglielmo della Porta in documenti notarili romani', *Commentari*, XXIII, 1972, pp. 299–305

MATTHIAE, Guglielmo; see GIACHI, Gualberto

McLYNN, Frank, *Charles Edward Stuart, a Tragedy in Many Acts*, Oxford/New York, 1991

La Médaille au temps de Louis XIV (exhibition catalogue), Paris (Hôtel de la Monnaie), 1970

MEDICI, Ulderigo, *Catalogo della Galleria dei Principi Corsini*, Florence, 1886

MELI BASSI, Laura, *et al.*, *disegni dei Ligari dalle collezioni del Museo Valtellinese di Storia e d'Arte*, Sondrio, 1982

MERZ, Jörg Martin, *Pietro da Cortona: Der Aufstieg zum führenden Maler im barocken Rom*, Tübingen, 1991

MENICHELLA, Anna, 'Documenti della Reverenda Fabbrica di San Pietro per il ciborio berniniano del Santissimo Sacramento', *Archivio della Società Romana di Storia Patria*, CXVI, 1993, pp. 213–41

MESSINI, Angelo, *Per il XVII centenario del martirio di San Feliciano 1251–1951. La Statua d'argento del santo patrono di Foligno. Notizie storiche*, Foligno, 1943

MEZZATESTA, Michael P., *The Art of Gianlorenzo Bernini* (exhibition catalogue), Fort Worth, 1982

MIANI, Laura; see FOLLI VENTURA, Irene

MIDDELDORF, Ulrich, 'Eine seltene Bronze der Spätrenaissance', *Giessener Beiträge zur Kunstgeschichte*, I, 1970, pp. 77–85

MIDDELDORF, Ulrich, 'In the Wake of Guglielmo della Porta', *Connoisseur*, CXCIV, Feb. 1977, pp. 75–84

MIDDLETON, W. E. Knowles, *A History of the Thermometer and its Use in Meteorology*, Baltimore, 1966

MILIZIA, Francesco, *Le Vite de' più celebri architetti d'ogni nazione e d'ogni tempo*, Venice, 1768

MILLET, Gabriel, *Recherches sur l'iconographie de l'évangile aux XIV^e, XV^e et XVI^e siècles . . .*, Paris, 1916

MIRNIK, Ivan, 'Livio Odescalchi on Medals', *The Medal*, no. 25, Autumn 1994, pp. 50–5

MOLA, Giovanni Battista, *Breve racconto delle miglior opere d'architettura, scultura et pittura fatte in Roma . . .*, ed. Karl Noehles, Berlin, 1966 [first published 1663]

MOLAJOLI, Bruno, *Notizie su Capodimonte*, Naples, 1958

MONTAGU, Jennifer, 'A Bozzetto in Bronze by Ciro Ferri', *Jahrbuch der Hamburger Kunstsammlungen*, XVIII, 1973, pp. 119–24

MONTAGU, Jennifer, *Alessandro Algardi*, New Haven/London, 1985

MONTAGU, Jennifer, 'Antonio and Giuseppe Giorgetti: Sculptors to Cardinal Francesco Barberini', *Art Bulletin*, LII, 1970, pp. 278–98

MONTAGU, Jennifer, 'Antonio Montauti's "Return of the Prodigal Son"', *Bulletin of the Detroit Institute of Arts*, LIV, 1975, pp. 15–23

MONTAGU, Jennifer, 'Bernini Sculptures Not by Bernini', in Irving Lavin (ed.), *Gianlorenzo Bernini. New Aspects of His Art and Thought*, University Park (Pennsylvania)/London, 1985, pp. 25–61

MONTAGU, Jennifer, 'Ciro Ferri's Ciborium in Santa Maria in Vallicella', *Source*, VIII/IX, nos. 4/1, 1989 ('Essays in Honor of Rudolf Wittkower'), pp. 49–57

MONTAGU, Jennifer, 'Un Dono del Cardinale Francesco Barberini al Re di Spagna', *Arte illustrata*, IV, 43/44, Sept.–Oct. 1971, pp. 42–51

MONTAGU, Jennifer, *Roman Baroque Sculpture: The Industry of Art*, New Haven/London, 1989

MONTAGU, Jennifer, 'The Roman Fortune of a Relief by Foggini', *Antologia di belle arti. La Scultura: Sudi in onore di Andrew S. Ciechanowiecki*, N.S. 48–51, 1994, pp. 86–91

MONTAGU, Jennifer 'Two Small Bronzes from the Studio of Bernini', *Burlington Magazine*, CIX, 1967, pp. 566–71

MONTAIGLON, Anatole de, *Correspondance des Directeurs de l'Académie de France à Rome avec les Surintendants des Bâtiments*, I, Paris, 1887

MORELLI, 'Giovanni Andrea Lorenzani artista e letterato romano del Seicento', *Studi secenteschi*, XIII, 1972, pp. 193–251

MORONI, Gaetano, *Dizionario di erudizione storico-ecclesiastica*, Venice, 1860–79

MORTARI, Luisa, *S. Maria Maddalena* (Le Chiese di Roma illustrate, N.S. 20), Rome, 1987

MOSS, W. E., 'A Note on the Relation Apologique et Historique de la Société des Francs-Maçons . . .', *Ars Quatuor Coronatorum*, LI, 1940, pp. 226–31

MUCCI, Guido, *Nuova guida della città di Siena per gli amatori delle belle arti*, Siena, 1822

Museum Mazzuchellianum, Venice, 1761–3

NAVA CELLINI, Antonia, *La Scultura del Seicento* (Storia dell'arte in Italia), Turin, 1982

NAVA CELLINI, Antonia, *La Scultura del Settecento* (Storia dell'arte in Italia), Turin, 1982

NEGRO, Angela, 'Committenza e produzione artistica nel ducato di Zagarolo dai Ludovisi ai Rospigliosi', in *L'Arte per i papi e per i principi nella campagna romana: grande pittura del '600 e del '700*, II (Saggi), Rome, 1990, pp. 201–39

NEGRO, Angela, 'I Pallavicini e la ricostruzione della chiesa di Sant'Andrea a Gallicano: un cantiere periferico del rococò', in *L'Arte per i papi e per i principi nella campagna romana: grande pittura del '600 e del '700*, II (Saggi), Rome, 1990, pp. 241–56

NESSELRATH, Arnold, 'Carlo Maratti's Designs for the "Piatti di S. Giovanni"', *Master Drawings* XVII, 4, 1979, pp. 417–26

NOACK, Friedrich, 'Die Hamerans in Rom', *Archiv für Medaillen- und Plaketten-Kunde*, III, 1921–2, pp. 23–40

NOEHLES, Karl, 'Scenografia per le quarant'ore e altari barocchi', in Antoine Schnapper (ed.), *La Scenografia barocca* (Atti del XXIV congresso CIHA, 1979, vol. V), Bologna, 1982, pp. 151–5

NOEHLES, Karl, 'Das Tabernakel des Ciro Ferri in der Chiesa Nuova zu Rom', *Miscellanea Bibliothecae Hertzianae*, Vienna/Munich, 1961, pp. 329–36

NOEHLES, Karl, 'Teatri per le quarant'ore e altari barocchi', in *Barocco romano e barocco italiano: il teatro, l'effimero, l'allegoria*, ed. Marcello Fagiolo and Maria Luisa Madonna, Rome/Reggio Calabria, 1985, pp. 88–99

NOEHLES, Karl, 'Visualisierte Eucharistietheologie', *Münchner Jahrbuch der Bildenden Kunst*, XXIX, 1978, pp. 92–116

NOEHLES, Karl, 'Zu Cortonas Dreifaltigkeitsgemälde und Berninis Ziborium in der Sakramentskapelle von St. Peter', *Römisches Jahrbuch für Kunstgeschichte*, XV, 1975, pp. 169–82

ORBAAN, Johannes A. F., and HOOGEWERFF, Godefridus J., *Bescheiden in Italië omtrent nederlandsche Kunstenaars en Geleerden*, The Hague, 1911–17

ORSI, M. d', 'Gallerie di Roma: Galleria Nazionale romana', *Bollettino d'arte*, ser. 4, XXXIX, 1954, pp. 365–6

ORSINI, Baldassarre, *Guida al forestiere per l'augusta città di Perugia*, Perugia, 1784

OSTROW, Steven F., *The Sistine Chapel at S. Maria Maggiore: Sixtus V and the Art of the Counter Reformation* (Doctoral Thesis, Princeton University, 1987), Ann Arbor, 1989

OZZOLA, Leandro, 'L'Arte alla corte di Alessandro VII', *Archivio della Reale Società Romana di Storia Patria*, XXXI, 1908, pp. 5–91

PALLAVICINO, Niccolò Maria, and RASPONI, Francesco, *Difesa della divina providenza, contro i nemici d'ogni religione; e della chiesa cattolica, contro i nemici della vera religione*, Rome, 1679

PANOFSKY, Gerda S., 'Tommaso della Porta's "Castles in the Air"', *Journal of the Warburg and Courtauld Institutes*, LVI, 1993, pp. 119–67

PAOLOZZI STROZZI, Beatrice (ed.), *Bronzetti da XV al XVII secolo* (Museo Nazionale del Bargello; Itinerari, 3), Florence, 1989

PAPWORTH, John Woody, 'On Artistic Ecclesiastic Decoration, as Exhibited in a Collection of Designs Made about the Middle of the Last Century', *Weale's Quarterly Papers on Architecture*, London, 1843–4, I, pp. 1–32

PARKER, Karl T., *Catalogue of the Collection of Drawings in the Ashmolean Museum*, II, *Italian Schools*, Oxford, 1956

PASINI, Pier Giorgio, *La Pinacoteca di Rimini*, Rimini, 1983

PASTINA, Flavia, 'Francesco Giardoni fonditore camerale', in *l'Angelo e la città* (exhibition catalogue), Rome, 1987, pp. 73–81

PATRIGNANI, Antonio, 'Le medaglie papali del periodo neoclassico (1605–1730)', part 2, *Bollettino del circolo numismatico napoletano*, XXXVIII, 1953, pp. 65–109

PECCI, Giovanni Antonio, *Relazione delle cose più notabili della città di Siena si antiche, come moderne, descritta in compendio del Cavaliere Gio. Antonio Pecci patrizio della medessima città a benefizio di forestieri, e degli intendenti da tali materie*, Siena, 1752

PENNY, Nicholas, *Catalogue of European Sculpture in the Ashmolean Museum, 1540 to the Present Day*, Oxford, 1992

PETRACCHI, Celestino, *Della insigne abbaziale Basilica di S. Stefano di Bologna*, Bologna, 1747

PHILLIPS, John Goldsmith, 'A Crucifixion Group after Michelangelo', *Bulletin of the Metropolitan Museum of Art*, XXXII, 1937, pp. 210–14

PIACENTI, Kirsten Aschengreen, 'I Piatti in argento di San Giovanni', in *Kunst des Barock in der Toskana*, Munich, 1976, pp. 188–207

PICKREL, Thomas, 'Two Stucco Sculpture Groups by Antonio Gherardi', *Antologia di belle arti*, II, 7/8, 1978, pp. 216–24

PIETRANGELI, Carlo, *Guide rionale di Roma, III, Colonna*, part 1, Rome, 1977

PIO, Nicola, *Le Vite di pittori scultori et architetti* (Studi e testi, 278), ed. Catherine and Robert Enggass, Vatican City, 1977

PIZZORUSSO, Claudio, *A Boboli e altrove: sculture e scultori Fiorentini del Seicento*, Florence, 1989

POLLAK, Ludwig, *Raccolta Alfredo Barsanti . . .* , Rome, 1922

POLLAK, Oskar, *Die Kunsttätigkeit unter Urban VIII.*, II, Vienna, 1931

POLLARD, Graham, 'La Medaglia con ritratto di epoca barocca in Italia', in *La Medaglia d'arte; Atti del primo convegno internazionale di studio, Udine, 1970*, Udine, 1973, pp. 139–61

POPE-HENNESSY, John, and LIGHTBOWN, Ronald, *Catalogue of Italian Sculpture in the Victoria and Albert Museum*, London, 1964

POPE-HENNESSY, John, *Italian Renaissance Sculpture*, London, 1958

PRESSOUYRE, Sylvia, *Nicolas Cordier. Recherches sur la sculpture à Rome autour de 1600*, Rome, 1984

QUINTERIO, Francesco; see BORSI, Franco

RASPONI, Francesco; see PALLAVICINO, Niccolò Maria

RATTI, Carlo Giusepe, and SOPRANI, Raffaello, *Delle Vite de' pittori, scultori, ed architetti genovesi*, Genoa, 1768–9

Reallexikon für Antike und Christentum, Stuttgart, 1950–92

RICE, Louise, *Altars and Altarpieces of New St. Peter's. Outfitting the Basilica, 1621–1666* (in the press)

RIPA, Cesare, *Iconologia overo descrittione di diverse imagini cavate dall'antichità & di propria inventione*, Rome, 1603

Ritratto di Roma moderna, Rome, 1645

ROANI VILLANI, Roberta, 'Due opere di Innocenzo Spinazzi e la decorazione della Cappella della Beata Vergine in San Carlo al Corso a Roma', *Paragone (Arte)*, no. 395/361, XXXI, 1980, pp. 60–8

Roma Resurgens; see WHITMAN, Nathan T.

ROSSINI, [Giovanni] Pietro, *Il Mercurio errante*, Rome, 1693

ROTHLISBERGER, Marcel G., 'Le Thème de Léda en sculpture', *Genava*, XXXV (N. S.), 1987, pp. 65–89

ROTONDI BIANCO, Paola, *Filippo Parodi*, Genoa, 1962

ROULET, Charles, 'Un bienfaiteur de Saint-Louis le Cardinal Cointerel (1519–1585)', *Annales de Saint-Louis-des-Français*, IV, 1899, pp. 53–70

RUBSAMEN, Gisela, 'Bernini and the Orsini Portrait Busts', *Abstracts of Papers Delivered in the Art History Sessions: 63rd Annual Meeting, College Art Association of America, January 22–25, 1975*, Washington, 1975, p. 92

RUBSAMEN, Gisela, *The Orsini Inventories*, Malibu, 1980

RUFINI, Emilio, *S. Giovanni de' Fiorentini* (Le Chiese di Roma illustrate, no. 39), Rome, 1957

SALMON, Thomas, *Storia del Regno di Napoli antica e moderna*, Naples, 1763

SAMOGGIA, Luigi, 'Benedetto XIV e il Portogallo; su alcuni aspetti delle relazioni diplomatiche e culturali durante il regno di Giovanni V', *Giornale di studi padani*, Cento, 18 December 1977, pp. 183–99

SANTANGELO, Antonino, *Museo di Palazzo Venezia. Catalogo delle sculture*, Rome, 1954

SCHAAR, Eckhard; see SUTHERLAND HARRIS, Ann

SCHAEFER, Scott, and FUSCO, Peter, *European Painting and Sculpture in the Los Angeles County Museum of Art*, Los Angeles, 1987

SCHERER, Christian, *Die Braunschweiger Elfenbeinsammlung. Katalog der Elfenbeinwerke des Herzog-Anton-Ulrich-Museums*, Leipzig, 1931

SCHIAVO, Armando, *La Fontana di Trevi e le altre opere di Nicola Salvi*, Rome, 1956

SCHIAVO, Armando, 'Il michelangiolesco tabernacolo di Jacopo del Duca', *Studi Romani*, XXI, 1973, pp. 215–20

SCHIAVO, Armando, *La Vita e le opere architettoniche di Michelangelo*, Rome, 1953

SCHILLING, Edmund; see BLUNT, Anthony

SCHLEGEL, Ursula, *Staatliche Museen Preussischer Kulturbesitz. Die Bildwerke der Skulpturengalerie Berlin, Band I: Die italienischen Bildwerke des 17. und 18. Jahrhunderts in Stein, Ton, Wachs und Bronze mit Ausnahme der Plaketten und Medaillen*, Berlin, 1978

SCHUSTER, Gerhard, 'Zu ehren Casanates. Père Cloches Kunstaufträge in der Frühzeit der Biblioteca Casanatense', *Mitteilungen des Kunsthistorischen Institutes in Florenz*, XXXV, 1991, pp. 323–36

SCICLUNA, Hannibal R., *The Church of St. John in Valletta*, San Martin (Malta), 1955

SCOTT, John Beldon, *Images of Nepotism*, Princeton, 1991

Il Seicento fiorentino (exhibition catalogue), Florence, 1986

17th Century Art in Europe (exhibition catalogue, Royal Academy), London, 1938

Seven Centuries of European Sculpture (exhibition catalogue), Heim Gallery, London, 1982

SIMONETTI, Farida; see BOGGERO, Franco

SINDING-LARSEN, Staale, 'Some functional and iconographical aspects of the centralized church in the Italian Renaissance', *Acta ad archaeologiam et artium historiam pertinentia*, II, 1965, pp. 203–52

SMITH, Robert C., 'João Frederico Ludovice, an Eighteenth Century Architect in Portugal', *Art Bulletin*, XVIII, 1936, pp. 273–370

SOUCHAL, François, 'La Collection du sculpteur Girardon d'après son inventaire après décès', *Gazette des beaux-arts*, LXXXII, 1973

SOUSA VITERBO, Francisco Marques, and ALMEIDA, Rodrigo Vicente d', *A Capella de S. João Baptista erecta na Egreja de S. Roque. Fundação da Companhia de Jesus e hoje pertencente à Santa Casa da Misericórdia. Noticia histórica e descriptiva*, Lisbon, 1900

SPARTI, Donatella L., *Le Collezioni dal Pozzo. Storia di una famiglia e del suo museo nella Roma seicentesca*, Modena, 1992

SPEZZAFERRO, Luigi, 'Caravaggio rifutato? I. Il problema della prima versione del "San Matteo"', *Ricerche di storia dell'arte*, X, 1980, pp. 49–64

SPIRITI, Andrea, 'La Cultura del Bernini a Milano: Santa Maria della Vittoria (1655–1685)', *Arte Lombarda*, 108/109, 1994, pp. 108–14

STRAZZULO, Franco (ed.), *Le Lettere di Luigi Vanvitelli della Biblioteca Palatina di Caserta*, Galatina, 1976–7

SUTHERLAND HARRIS, Ann, *Selected Drawings of Gian Lorenzo Bernini*, New York, 1977

SUTHERLAND HARRIS, Ann, and SCHAAR, Eckhard, *Die Handzeichnungen von Andrea Sacchi und Carlo Maratta*, Düsseldorf, 1967

THIEME, Ulrich, and BECKER, Felix, *Allgemeines Lexikon der bildenden Künstler*, Leipzig, 1907–50

THOMA, Hans (ed.), *Schatzkammer der Residenz München, Katalog*, Munich, 1958

TITI, Filippo, *Ammaestramento utile, e curioso di pittura scoltura et architettura nelle chiese di Roma*, Rome, 1686

TITI, Filippo, *Studio di pittura, scoltura, et architettura, nelle chiese di Roma (1674–1763)*, ed. Bruno Contardi and Serena Romana, Florence, 1987

TORRE, Carlo, *Il Ritratto di Milano*, Milan, 1674

TREBBI, Bruno, *L'Artigianato nelle chiese bolognesi*, Bologna, 1958

The Twilight of the Medici. Late Baroque Art in Florence, 1670–1743 (exhibition catalogue), Detroit and Florence, 1974

Valadier: Three Generations of Roman Goldsmiths. An Exhibition of Drawings and Works of Art (exhibition catalogue, by Artemis group), London, 1991

VALENTINER, Elisabeth, *Karel van Mander als Maler*, Strassburg, 1930

VALESIO, Francesco, *Diario di Roma*, ed. Gaetano Scana and Giuseppe Groglio, Milan, 1971–9

VARAGNOLI, Claudio, 'Domenico Gregorini e il cardinal Aldrovandi: il progetto, la committenza, il cantiere alla metà del XVIII secolo', in Elisa Debenedetti, *L'Architettura da Clemente XI a Benedetto XIV: pluralità di tendenze (Studi sul Settecento romano, 5)*, 1989, pp. 131–55

VARNI, Santo, *Ricordi di alcuni fonditori in bronzo*, Genoa, 1879

VARRIANO, John L., 'Some Documentary Evidence on the Restriking of Early Papal Medals', *American Numismatic Society. Museum Notes*, XXVI, 1981, pp. 215–23

VARRIANO, John L.; see also WHITMAN, Nathan T.

VASARI, Giorgio, *Le Vite de' più eccellenti pittori scultori ed architettori*, ed. G. Milanesi, Florence, 1878–85

VASARI, Giorgio, *La Vita di Michelangelo*, ed. Paola Barocchi, Milan/Naples, 1962

VASCO ROCCA, Sandra, and BORGHINI, Gabriele (ed.), *Giovanni V di Portogallo (1707–1750) e la cultura romana del suo tempo*, Rome, 1995

VASI, Giuseppe, *Delle Magnificenze di Roma antica e moderna*, Rome, 1747–53

Vatican Splendour (exhibition catalogue, National Gallery of Canada), Ottawa, 1986

VENTURI, Adolfo, *Storia dell'arte italiana*, X, 2 (*La Scultura del Cinquecento*), Milan, 1936

VENUTI, Ridolfino, *Numismata Romanorum Pontificum Praestantiora a Martino V. ad Benedictum XIV.*, Rome, 1744

VERHEYEN, Egon, 'A Deposition by Guglielmo della Porta', *University of Michigan Museum of Art Bulletin*, N.S. IV, 1969, pp. 2–9

VISONÀ, Mara; see *Il Seicento fiorentino*

VOELKER, Evelyn C., *Charles Borromeo's Instructiones Fabricae et Supellectilis Ecclesiasticae, 1577. A Translation with Commentary and Analysis*, Ann Arbor, 1977

VOLLMANN, R., 'Die Erfindung des geschlossenen Thermometers', *Ciba Zeitchrift*, VIII, no. 93, March 1944 (*Das Thermometer*), pp. 3301–3

WARD-JACKSON, Peter, *Victoria and Albert Museum. Italian Drawings II*, London, 1980

WAŹBIŃSKI, Zygmunt, 'I Bronzetti del Giambologna nelle collezione romane: ambiente del Cardinale Francesco Maria del Monte', in *Musagetes. Festschrift für Wolfram Prinz*, ed. R. G. Kecks, Berlin, 1991, pp. 323–34

WEIL, Mark S., 'The Devotion of the Forty Hours and Roman Baroque Illusions', *Journal of the Warburg and Courtauld Institutes*, XXXVII, 1974, pp. 218–48

WEIL, Mark S., 'A Statuette of the Risen Christ Designed by Gian Lorenzo Bernini', *Journal of the Walters Art Gallery*, XXIX–XXX, 1966–7, pp. 6–15

WESTIN, Jean K., and WESTIN, Robert H., *Carlo Maratti and his contemporaries. Figurative Drawings from the Roman Baroque* (exhibition catalogue), Philadelphia, 1975

WHITMAN, Nathan T., and VARRIANO, John L., *Roma Resurgens: Papal Medals fom the Age of the Baroque* (exhibition catalogue), Ann Arbor, 1983

WINTER, John, 'Further Drawings from Valadier's Workshop – the silver designs of Giovanni Bettati', *Apollo Magazine*, CXXXIII, May 1991, pp. 320–2

WITTKOWER, Rudolf, *Gian Lorenzo Bernini*, 2nd ed., London, 1966

WITTKOWER, Rudolf; see also BRAUER, Heinrich

Index of Names and Locations

Authors are not included. Material in the notes is not indexed when these merely expand on persons already indexed in the text to which the note refers; however, additional persons mentioned in such notes are indexed.